ART NOW VOL 2

ART NOW
VOL 2

The new directory to 136 international contemporary artists
Der neue Wegweiser zu 136 internationalen zeitgenössischen Künstlern
Le nouveau panorama de l'art contemporain à travers 136 artistes internationaux
Including illustrated appendix with price guide

Edited by Uta Grosenick

TASCHEN

KÖLN LONDON LOS ANGELES MADRID PARIS TOKYO

Contents — Inhalt — Sommaire

Preface

ART NOW Vol 2 is a volume to follow ART AT THE TURN OF THE MILLENNIUM (1999), and ART NOW (2002).

Within just the last three years the international art scene has changed with exceptional speed: Artists have rediscovered painting – particularly figurative painting – and have been dealing intensively with political topics in an art world becoming continually more global. ART NOW Vol 2 reflects these two currents as well as other positions that, beyond all common artistic directions, use artistic means to fashion an individual world view. Additionally, ART NOW Vol 2 follows the further development of those artists already discussed in the two predecessor volumes, by showing exclusively newer, post-2002 works when illustrating these artist's works.

Burkhard Riemschneider, my co-editor for the first two volumes, did not assist in compiling the list of 136 artists shown here. In his stead, the publisher Benedikt Taschen participated with great dedication in the compilation.

Also for ART NOW Vol 2 it must be stressed that the choice of artists is ultimately a subjective one, based on close observation of the international exhibition scene and art market, as well as upon an intensive analysis of reviews and publications regarding occurrences in art around the world.

The artists – as usual – are presented in alphabetical order and on four pages each, including a selection of their most important works. These are accompanied by a short overview of their major exhibitions and publications, a portrait and an artist statement, and naturally also by a short text by young, internationally established authors.

Not every artist we wanted to include in ART NOW Vol 2 was interested in being represented in the book, Kai Althoff and Damien Hirst decided not to participate in the project.

In the appendix Christian Domínguez provides detailed information about the galleries representing the artists, the prices at which their works may be acquired, and the price levels they have attained at auctions.

I would like to thank all of the people who have made important contributions to this book's production in its various stages:
– all the artists presented, the gallery-owners who represent them, and the photographers who document their work
– the authors Jens Asthoff, Kirsty Bell, Ariane Beyn, Stéphane Corréard, Caroline Eggel, Eva Kernbauer, Astrid Mania, Daniel Marzona, Christiane Rekade, Brian Sholis, Raimar Stange, Amy Smith-Stewart and Ossian Ward
– the translators Wolf Fruhtrunk, Sean Gallagher, Gisela Rueb and Ralf Schauff
– the designers Andy Disl and Birgit Reber, the editor Sabine Bleßmann and the producer Ute Wachendorf.

Uta Grosenick
Cologne, autumn 2005

The TASCHEN Verlag and Uta Grosenick would like to thank the following galleries and institutions and their employees for having generously provided pictorial material and information for this book:

Vorwort

Mit ART NOW Vol 2 liegt nun ein Nachfolgeband für ART AT THE TURN OF THE MILLENNIUM (1999) und ART NOW (2002) vor.
Gerade in den letzten drei Jahren hat sich die internationale Kunstszene ungewöhnlich schnell verändert: Die Künstlerinnen und Künstler haben die Malerei – insbesondere die figurative Malerei – wiederentdeckt und setzen sich intensiver mit politischen Themen in einem immer globaler werdenden Kunstbetrieb auseinander. ART NOW Vol 2 spiegelt beide Strömungen ebenso wie andere Positionen, die jenseits aller gängigen Richtungen eine individuelle Weltsicht mit künstlerischen Mitteln gestalten. Außerdem begleitet ART NOW Vol 2 die Weiterentwicklung jener Künstler, die in den beiden Vorgängerbänden schon besprochen wurden, indem es ausschließlich neuere Werke abbildet, die ab 2002 entstanden sind.

Burkhard Riemschneider, mein Mitherausgeber der ersten beiden Bände, hat an der Liste der hier gezeigten 136 Künstlerinnen und Künstler nicht mehr mitgewirkt, dafür hat sich der Verleger Benedikt Taschen mit großem Engagement an ihrer Zusammenstellung beteiligt.

Auch für ART NOW Vol 2 muss betont werden, dass es sich letztendlich um eine subjektive Auswahl von Künstlerinnen und Künstlern handelt, die auf genauen Beobachtungen der internationalen Ausstellungsszene und des Kunstmarktes sowie intensiver Auswertung von Rezensionen und Publikationen zum weltweiten Kunstgeschehen basiert.

Die Künstlerinnen und Künstler werden – wie gehabt – in alphabetischer Reihenfolge auf jeweils vier Seiten mit einer Auswahl ihrer wichtigsten Arbeiten vorgestellt. Begleitet von einer Kurzübersicht über ihre zentralen Ausstellungen und Publikationen, einem Porträt und einem Künstlerstatement und natürlich von einem kurzen Text von jungen, international etablierten Autorinnen und Autoren.

Nicht jeder Künstler, den wir gerne in ART NOW Vol 2 aufgenommen hätten, wollte auch in dem Buch vertreten sein, so haben sich Kai Althoff und Damien Hirst entschlossen, nicht an dem Projekt teilzunehmen.

Im Anhang des Buches gibt Christian Domínguez detaillierte Informationen darüber, welche Galerien die Künstlerinnen und Künstler vertreten, zu welchen Preisen ihre Arbeiten erworben werden können und welche Erlöse sie auf Auktionen erzielt haben.

Dank sagen möchte ich allen Personen, die die Produktion des Buches in ihren verschiedenen Etappen entscheidend mitgeprägt haben:
– allen vorgestellten Künstlerinnen und Künstlern, den Galeristinnen und Galeristen, die sie vertreten, und den Fotografinnen und
 Fotografen, die ihre Arbeiten dokumentieren
– den Autorinnen und Autoren Jens Asthoff, Kirsty Bell, Ariane Beyn, Stéphane Corréard, Caroline Eggel, Eva Kernbauer, Astrid Mania,
 Daniel Marzona, Christiane Rekade, Brian Sholis, Raimar Stange, Amy Smith-Stewart und Ossian Ward
– den Übersetzern Wolf Fruhtrunk, Sean Gallagher, Gisela Rueb und Ralf Schauff
– den Designern Andy Disl und Birgit Reber, der Redakteurin Sabine Bleßmann und der Herstellerin Ute Wachendorf.

Uta Grosenick
Köln, im Herbst 2005

Der TASCHEN Verlag und Uta Grosenick danken den folgenden Galerien und Institutionen und ihren Mitarbeiterinnen und Mitarbeitern, die großzügig Bildmaterial und Informationen für dieses Buch zur Verfügung gestellt haben:

Préface

La parution d'ART NOW Vol 2 s'inscrit dans le sillage des publications ART AT THE TURN OF THE MILLENIUM (1999) et ART NOW (2002). Au cours des trois dernières années, la scène artistique internationale a connu une évolution exceptionnellement rapide. Les artistes ont redécouvert la peinture – particulièrement la peinture figurative – et s'attachent aujourd'hui plus fortement à des thèmes politiques au sein d'un marché de l'art en voie de globalisation. ART NOW Vol 2 rend compte de cette double tendance, mais aussi d'autres positions qui, au-delà des courants les plus connus, élaborent une vision individuelle du monde à l'appui de moyens artistiques. De plus, ART NOW Vol 2 accompagne le développement des artistes traités dans les volumes précédents en reproduisant uniquement des œuvres récentes réalisées après 2002.

Burkhard Riemschneider, coéditeur des deux premiers ouvrages, n'a pas participé à l'élaboration de la liste des 136 artistes présentés dans cet ouvrage ; l'éditeur Benedikt Taschen s'est en revanche fortement impliqué en prenant une part active à sa compilation.

Pour ART NOW Vol 2 comme pour les précédents volumes, il convient de souligner qu'il s'agit en définitive d'un choix d'artistes subjectif nourri d'une observation précise de la scène internationale des expositions et du marché de l'art et d'une exploitation active des critiques et autres publications qui ont accompagné les grands événements artistiques mondiaux.

Comme précédemment, les artistes sont présentés par ordre alphabétique, respectivement sur quatre pages, avec une sélection d'œuvres majeures, un aperçu de leurs expositions et publications principales, un portrait et une déclaration d'artiste, le tout accompagné bien sûr d'un court texte de présentation écrit par de jeunes auteurs de renommée internationale.

Parmi les artistes que nous aurions aimé voir figurer dans ART NOW Vol 2, certains n'ont pas souhaité être représentés. Kai Althoff et Damien Hirst ont choisi de ne pas prendre part à ce projet.

En annexe, Christian Domínguez donne des informations détaillées sur les galeries qui représentent les artistes, sur les prix auxquels on peut acquérir leurs œuvres et sur les cotes résultant des ventes publiques.

Je voudrais remercier ici tous ceux qui ont marqué de leur empreinte les différentes étapes de la production de ce livre :
– tout d'abord les artistes, leurs galeristes et les photographes qui documentent leur travail ;
– les auteurs Jens Asthoff, Kirsty Bell, Ariane Beyn, Stéphane Corréard, Caroline Eggel, Eva Kernbauer, Astrid Mania, Daniel Marzona, Christiane Rekade, Brian Sholis, Raimar Stange, Amy Smith-Stewart et Ossian Ward ;
– les traducteurs Wolf Fruhtrunk, Sean Gallagher, et Gisela Rueb et Ralf Schauff ;
– les designers Andy Disl et Birgit Reber, la rédactrice Sabine Bleßmann ainsi que la productrice Ute Wachendorf.

Uta Grosenick
Cologne, automne 2005

Les Editions TASCHEN et Uta Grosenick remercient les différentes galeries et institutions et leurs collaboratrices et collaborateurs, qui ont généreusement mis à leur disposition les documents iconiques et les éléments d'information qui ont permis la réalisation de ce livre :

21st Century Museum of Contemporary Art, Kanazawa – 303 Gallery, New York, Lisa Spellman – Air de Paris, Paris, Keren Detton – Alexander and Bonin, New York – Galerie Paul Andriesse, Amsterdam – Arndt & Partner, Berlin/Zurich, Eleonora Holthoff – Artangel, London – Vanessa Beecroft Studio, Ian Davies, Maresa Rohrer – Blum & Poe, Los Angeles, Silke Taprogge – Marianne Boesky Gallery, New York – Museum Boijmans van Beuningen, Rotterdam – Tanya Bonakdar Gallery, New York – Candice Breitz Studio – Gavin Brown's enterprise (modern), New York – Galerie Daniel Buchholz, Cologne, Katharina Forero, Michael Kerkmann, Christopher Müller – c/o – Atle Gerhardsen, Berlin, Sabine Schmidt – Galerie Gisela Capitain, Cologne, Regina Fiorito, Nina Kretzschmar – carlier I gebauer, Berlin, Andreas Bunte, Philipp Selzer – Galleria Massimo de Carlo, Milan – Sadie Coles HQ, London, Sara Harrison, Katy Reed, Jackie Daish – John Connelly Presents, New York, Alex Tuttle – Contemporary Fine Arts, Berlin, Hannah Koch, Imke Wagener, Tse-Ling Uh – CRG Gallery, New York, London – Galerie Chantal Crousel, Paris, Karen Tanguy – Deitch Projects, New York – Thomas Demand Studio, Miriam Böhm – Marlene Dumas Studio, Jolie van Leeuwen – EIGEN + ART, Leipzig/Berlin, Ulrike Bernhard – Elmgreen & Dragset Studio, Eise Frederiksen, Jasmin Jouhar – Elger Esser Studio – Galleria Emi Fontana, Milan, Barbara Carneglia – Foksal Gallery Foundation, Warsaw – Galeria Fortes Vilaça, São Paulo, Daniele Dal Col – Stephen Friedman Gallery, London – Fundament Foundation – De Pont, Tilburg – Gagosian Gallery, New York, Natasha Roje, Kara Vander Weg – Gasser & Grunert, New York, Tim Hawkinson – Barbara Gladstone Gallery, New York, Adam Ottavi-Schiesl – Marian Goodman Gallery, New York, Catherine Belloy, Rose Lord – Galerie Bärbel Grässlin, Frankfurt am Main, Susanne Hofmann – Galeria Enrique Guerrero, Mexico City – Galerie Hammelehle und Ahrens, Cologne – Hauser & Wirth Zurich/London, Barbara Corti, Natalia Stachon – Galerie Max Hetzler, Berlin, Wolfram Aue, Samia Saouma, Anne Schwarz – Thomas Hirschhorn Studio, Romain Lopez, Sophie Pulicani – Candida Höfer Studio, Anne Ganteführer-Trier – Rhona Hoffman Gallery, Chicago, Kat Parker – Pierre Huyghe Studio, Melissa Dubbin – Johnen + Schöttle, Cologne, Markus Lüttgen, Tan Morben, Zbigniew Wendt – K21 – Kunstsammlung Nordrhein-Westfalen, Düsseldorf, Antje Zeschmar – Kaikai Kiki, New York, Nobuko Sakamoto – Casey Kaplan, New York, Chana Budgazad, Joanna Kleinberg – galleria francesca kaufmann, Milan – Mike Kelley Studio – Anton Kern Gallery, New York, Michael Clifton, Christoph Gerozissis – Galerie Peter Kilchmann, Zurich, Claudia Friedli, Cynthia Krell – Klosterfelde, Berlin, Bettina Klein – Johann König, Berlin, Eva Heineke, Timo Kappeller – Jeff Koons Studio, Sara Wolfe – Tomio Koyama Gallery, Tokyo, Tomoko Omori – kurimanzutto, Mexico City, Gaby de la O – Galerie Yvon Lambert, Paris – Galerie Gebrüder Lehmann, Dresden, Meike Kross – Lehmann Maupin Gallery, New York, Stephanie Smith – Zoe Leonard Studio, Jocelyn Davis – Lisson Gallery, London, Justyna Niewiara – Galerie Hervé Loevenbruck, Paris, Alexandra Schillinger – Museum Ludwig, Cologne, Annegret Buchholtz – Luhring Augustine Gallery, New York – Vera Lutter Studio, Josh Brown – Matthew Marks Gallery, New York, Victoria Cuthbert – Metro Pictures, New York, Peter Schuette – Victoria Miro Gallery, London, Erin Manns, Nina Øverli, Kathy Stephenson – Mizuma Gallery, Tokyo – Modern Art, London, Jo Brinton, Stuart Shave – The Modern Institute, Glasgow, Kath Steedman – Mariko Mori Studio, Shinobu Suzuki – Sarah Morris Studio, Joe Brittain, Ania Siwanowicz – Vik Muniz Studio, Barney Kulok – Galerie Christian Nagel, Köln/Berlin, Bettina Rheinbay – National Gallery of Australia, Canberra – Galerie Neu, Berlin, Lara Brekenfeld, Sasha Rossman – neugerriemschneider, Berlin, Florian Seefelder, Salome Sommer – Galleria Franco Noero, Turin, Luisa Salvi Del Pero – Galerie Nathalie Obadia, Paris, Céline Cléron – Patrick Painter, Santa Monica, Michele Bigler, Sachi Yoshimoto – Peres Projects, Los Angeles, Berlin – Galerie Emmanuel Perrotin, Paris – Friedrich Petzel Gallery, New York, Colby Bird – Galerie Eva Presenhuber, Zurich, Angelika Hunziker, Markus Rischgasser – The Project, New York/Los Angeles, Lori Salmon – Regen Projects, Los Angeles, Amra Brooks, Dawson Weber – Anthony Reynolds Gallery, London, Costanza Mazzonis di Pralafera, Marcelo Spinelli – Andrea Rosen Gallery, New York, Jordan Bastien, Jeremy Lawson – Thomas Ruff Studio, Jens Ullrich – Tom Sachs Studio, Emily Rounds, Samuel Roy-Bois – Thomas Scheibitz Studio, Lisa Junghanss – Galerie Aurel Scheibler, Cologne, Daniel Schmidt – Esther Schipper, Berlin, Iris Scheffler, Annika von Taube, Christophe Wiesner – Schirn Kunsthalle, Frankfurt am Main, Simone Krämer – Gregor Schneider Studio – Sfeir Semler Galerie, Hamburg – ShanghART, Shanghai, Helen Zhu – Brent Sikkema, New York, Ellie Bronson – Sonnabend Gallery, New York – Monika Sprüth/Philomene Magers, Cologne/Munich, Lilian Haberer, Franziska von Hasselbach, Agnes Kornas, Julia Lenz – Galeria Luisa Strina, São Paulo, Gabriela Inui – Thomas Struth Studio, Katharina Hohenhörst – TORCH Gallery, Amsterdam, Adriaan van der Have – Emily Tsingou Gallery, London – Ujadowski Center of Contemporary Art, Warsaw – Union Gallery, London, Anthony Petrou – Francesco Vezzoli Studio, Luca Corbetta – Galleri Nicolai Wallner, Copenhagen – White Cube, London, Sara McDonald – Yamamoto Gendai, Tokyo, Nao Sakai, Yuko Yamamoto – Zeno X Gallery, Antwerp, Frank Demaegd – Galerie Zink und Gegner, Munich – David Zwirner Gallery, New York, Adrian Anagnost

ARTISTS

Franz Ackermann

1963 born in Neumarkt St. Veit, lives and works in Berlin and Karlsruhe, Germany

Operating at the intersection of international politics and mass tourism, Franz Ackermann's drawings, paintings and environments offer a multi-faceted view of the 21st century urban metropolis. His watercolours are dense studies in which aerial cartographic perspectives, minutely rendered architectural details, teetering city-scapes or geological fault lines collapse together amidst intricate swirls of paint. Small enough to fit into a suitcase, he calls them "Mental maps" and makes them only when he is travelling, as a form of "visual diary". The paintings, in contrast, represent not only a change in scale but a switch from the cerebral activity of his tightly executed drawings to the physical demands of painting with oil on a canvas often considerably taller than he is. Here, fragmentary architectural elements and nodes of activity provide dizzying multiple perspectives held together only by vivid swathes of colour in centripetal patterns. The physical aspect of travelling, of a body moving through space, is as vital to Ackermann as the intellectual faculty which recognizes the "foreign". He completes his journey by finally rooting his work firmly in his destination, transforming museum or gallery spaces through bold wall paintings that extend the psychogeographic territory of the paintings and drawings. But a coy relativism is often implied through the inclusion of an emblematic self-portrait, mock-heroic in stark graphics, or a sleeping bag left on the floor to symbolize the lonely, possessionless nomad, the imaginative individual alone in a complex world.

An der Schnittstelle zwischen internationaler Politik und Massentourismus operieren die Zeichnungen, Gemälde und Environments von Franz Ackermann und bieten einen facettenreichen Blick auf die urbane Metropole im 21. Jahrhundert. Seine Aquarelle sind verdichtete Studien, in denen kartografische Luftbildperspektiven, minuziös ausgeführte Architekturdetails, taumelnde Stadtlandschaften oder geologische Bruchlinien inmitten verworrener Farbwirbel aufeinander treffen. Die von ihm als „Mental maps" bezeichneten Arbeiten sind klein genug, um in seinen Koffer zu passen. Sie entstehen als eine Art „visuelles Tagebuch" ausschließlich auf Reisen. Im Gegensatz dazu stehen die Gemälde nicht nur für eine Veränderung im Maßstab, sondern auch für eine Umstellung von der für seine dicht ausgeführten Zeichnungen erforderlichen Denkarbeit hin zu den physischen Anforderungen, die sich bei der Ölmalerei auf einer Leinwand stellen, die häufig erheblich größer ist als er selbst. Hier erzeugen Architekturfragmente und Handlungsknoten Schwindel erregende Mehrfachperspektiven, die nur durch lebhafte Farbschwaden in zentripetal ausgerichteten Mustern zusammengehalten werden. Der physische Aspekt des Reisens, eines Körpers, der sich durch den Raum bewegt, ist für Ackermann ebenso bedeutsam wie die intellektuelle Fähigkeit, das „Fremde" zu erkennen. Am Ende der Reise steht schließlich die Verwurzelung der Arbeit im Zielort sowie die Transformation des Museums- oder Galerieraums vermittels kühner Wandgemälde, die das psychogeografische Territorium der Gemälde und Zeichnungen erweitern. Allerdings deutet sich oft ein verschämter Relativismus an, sei es durch ein emblematisches Selbstbildnis, heroisch-komisch und krass grafisch, oder einen auf dem Boden zurückgelassenen Schlafsack als Symbol für den einsamen, besitzlosen Nomaden, das imaginäre Individuum, das allein in einer komplexen Welt existiert.

Les dessins, peintures et environnements de Franz Ackermann, qui œuvrent au carrefour de la politique internationale et du tourisme de masse, proposent une vision à facettes multiples de la métropole urbaine du XXIᵉ siècle. Les aquarelles d'Ackermann se présentent comme des études compactes dans lesquelles des perspectives cartographiques, des détails d'architecture minutieusement rendus, des paysages urbains vertigineux ou des lignes de faille géologiques s'entrechoquent dans des tourbillons de peinture intimement imbriqués. Suffisamment petites pour pouvoir être transportées dans une valise, l'artiste les qualifie de « Mental maps » et ne les réalise qu'au cours de ses voyages, comme une forme de « journal visuel ». Ses œuvres picturales ne sont pas seulement caractérisées par le changement de format, mais transposent l'activité cérébrale des dessins minutieux dans les exigences physiques de la peinture à l'huile, qui s'étale sur des toiles dont le format dépasse souvent de beaucoup la taille du peintre. Les éléments architecturaux fragmentaires et les nœuds d'activité y déploient de vertigineuses perspectives multiples dont la cohérence est uniquement assurée par des bandes de couleurs vives qui suivent un schéma centripète. L'aspect physique du voyage, du corps se déplaçant dans l'espace, est aussi vital que l'aptitude intellectuelle à reconnaître l'« étranger ». Ackermann complète son voyage en enracinant fermement son travail dans sa destination, transformant les espaces des musées et des galeries par d'audacieuses peintures murales qui développent les psychogéographies de ses dessins et peintures. Mais un relativisme modéré ressort souvent de l'intégration d'un autoportrait emblématique, mi-railleur, mi-héroïque, au graphisme âpre, ou d'un sac de couchage laissé à même le sol pour symboliser le nomade sans possessions, l'individu imaginatif vivant solitaire dans un monde marqué par la complexité. K.B.

SELECTED EXHIBITIONS →
2004 *tourist*, Städtische Galerie im Lenbachhaus und Kunstbau, Munich **2003** *Naherholungsgebiet*, Kunstmuseum Wolfsburg; *Eine Nacht in den Tropen*, Kunsthalle Nürnberg; 50. Biennale di Venezia, Venice **2002** *Seasons in the Sun*, Stedelijk Museum, Amsterdam; *Eine Nacht in den Tropen*, Kunsthalle Basel, Basle; *Drawing Now: Eight Propositions*, The Museum of Modern Art, New York; 25. Bienal de São Paulo

SELECTED PUBLICATIONS →
2003 *Franz Ackermann: Eine Nacht in den Tropen*, Kunsthalle Nürnberg; *Franz Ackermann. Naherholungsgebiet*, Kunstmuseum Wolfsburg **2002** *Seasons in the Sun*, Stedelijk Museum, Amsterdam; *Transatlantic*, Bienal de São Paulo; *Franz Ackermann*, Kunsthalle Basel, Basle

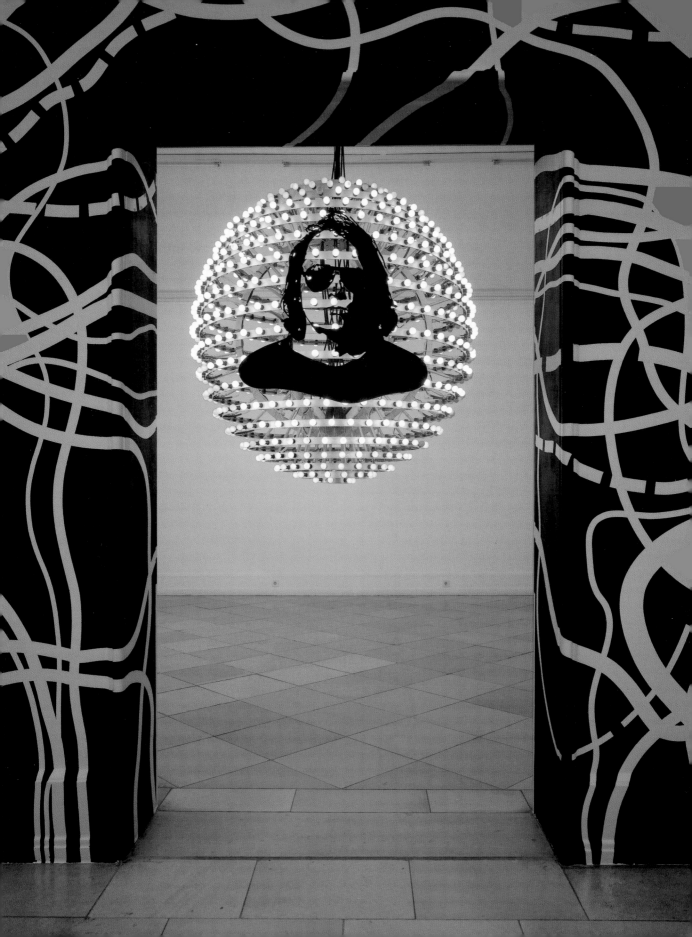

1 **Faceland II (You better keep the light on)**, 2002, installation view,
 Kunsthalle Nürnberg
2 **Amaryllis**, 2003, oil on canvas, 235 x 325 cm

3 **Untitled (Mental map: Die Festung)**, 2004, mixed media on paper,
 150 x 149 cm
4 **Travelantitravel**, 2004, installation view, neugerriemschneider, Berlin

„Der Ort selbst ist Auslöser und niemals Abbild."

«Le lieu lui-même est déclencheur, jamais la représentation.»

"The place itself is the trigger and never the image."

2

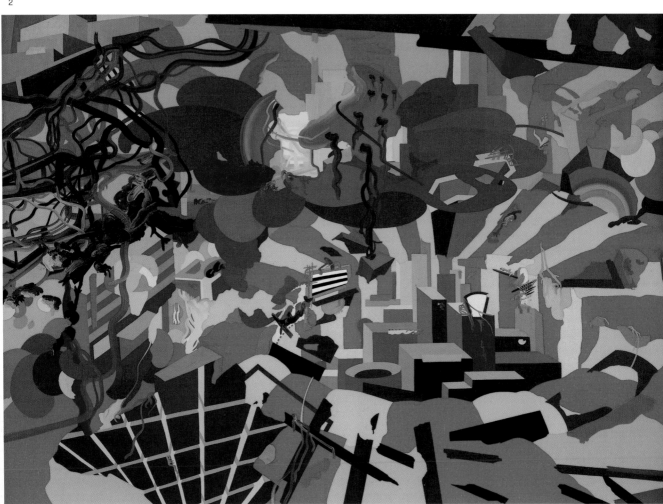

3

4

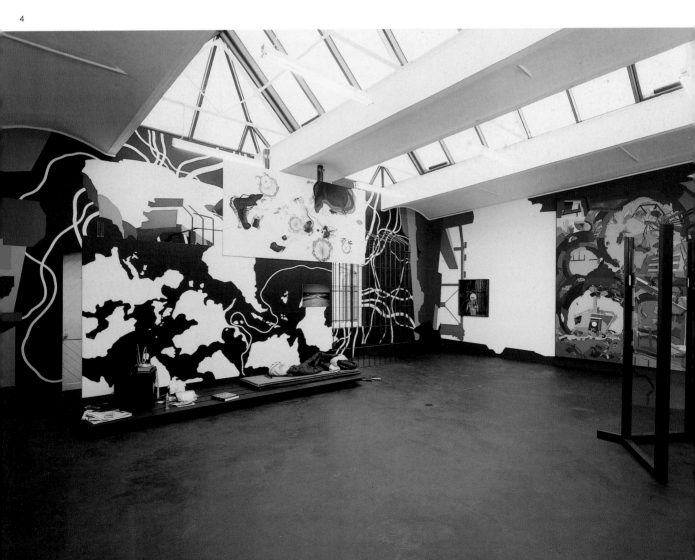

Eija-Liisa Ahtila

1959 born in Hämeenlinna, lives and works in Helsinki, Finland

Eija-Liisa Ahtila once described her films as "human dramas". They deal with borderline situations, and describe phases in the transition and self-discovery of their protagonists. Ahtila has developed various representational forms for this, orienting herself on feature films, documentaries, music videos, and commercials, without confining her films to any single defined genre. This reflection of the media is never self-referential; instead it is completely oriented on cinematic narrative. The images, language, and plotlines coalesce into their own reality, which radiates a characteristic fascination and mystery. The films almost always deal with strong emotions, and the figures manifest vulnerability and sensibility. This expresses itself as distraction and disruption, like the psychotic condition of the young woman in *The House* (2002), or the young man's schizophrenia in *Anne, Aki & God* (1998). Ahtila also presents *The House* together with four sculptures – architectural models that seem like excerpts, or like stylized interpretations and abstracting intensifications of the mysterious film house. They also act as projection screens for the introverted subject. In films, photos and sculptures, Ahtila depicts self-engrossed versions of a self – sometimes hesitant, sometimes self-confident, and sometimes just slipping away. She enchants these versions within the spell of her fictions, devising a language for them with dreamlike lucidity. For this she invents intriguing forms of discontinuous narrative, and weaves her figures' identities together, such as by letting individuals speak with different voices, or having several people speak with one voice. She shows personal identity as a fragile construct that is constantly in the process of transformation into "the other".

Eija-Liisa Ahtila hat ihre Filme einmal als „menschliche Dramen" bezeichnet. Sie handeln von Grenzsituationen, erzählen von Phasen des Übergangs und der Selbstfindung ihrer Protagonisten. Ahtila entwickelt dafür verschiedene Darstellungsformen, orientiert sich an Spiel- und Dokumentarfilm, Musikvideo und Werbespot, ohne dass ihre Filme dabei in einem bestimmten Genre aufgingen. Diese Medienreflexion ist nie selbstbezüglich, sondern ganz aufs filmische Erzählen ausgerichtet: Bilder, Sprache, Handlungsstränge verdichten sich darin zu eigener Realität. Davon geht eine charakteristische Faszination und Rätselhaftigkeit aus. Fast immer handeln die Filme von starken Emotionen, die Figuren offenbaren Verletzlichkeit und Sensibilität, die sich auch als Verstörung und Zerbrechen ausdrücken, etwa in psychotischen Zuständen der jungen Frau in *The House* (2002) oder der Schizophrenie des jungen Mannes aus *Anne, Aki & God* (1998). *The House* präsentiert Ahtila auch zusammen mit vier Skulpturen – Architekturmodelle, die wie Auskoppelungen, wie typisierende Deutungen und abstrahierende Zuspitzungen des mysteriösen Filmhauses wirken. Auch sie sind Projektionsflächen des introvertierten Subjekts. Ahtila zeigt in Filmen, Fotos und Skulpturen mal tastende, mal selbstbewusste, auch in sich selbst versinkende Entwürfe eines Ich, die sie in Fiktionen bannt und ihnen in traumgleicher Bildhaftigkeit eine Sprache erschafft. Dafür findet sie verblüffende Formen diskontinuierlichen Erzählens, vermischt die Identitäten ihrer Figuren, lässt etwa einzelne Personen mit verschiedenen Stimmen und mehrere mit einer sprechen. Sie demonstriert persönliche Identität als fragiles Konstrukt mit stets fließenden Übergängen zum „Anderen".

Eija-Liisa Ahtila a décrit ses films comme des «drames humains». Ils traitent de situations limites, décrivent des phases de transition et la recherche de soi, qui est celle des protagonistes. Pour cela, Ahtila développe différentes formes de représentation, empruntant aux genres cinématographique et documentaire, au clip vidéo et au spot publicitaire, sans que ses propres films relèvent en fait d'un genre défini. Cette utilisation de plusieurs médiums ne procède jamais de l'autoréférence, mais est entièrement placée sous le signe du récit filmé : les images, le langage et la logique dramatique s'y condensent en une réalité propre. Il en émane une fascination et un mystère très caractéristiques. Ses films traitent presque toujours d'émotions fortes : les personnages mettent à nu leur sensibilité et leur vulnérabilité, qu'ils expriment parfois sous forme de bouleversement ou d'effondrement, comme le montrent les états psychotiques de la jeune femme de *The House* (2002) ou la schizophrénie du jeune homme de *Anne, Aki & God* (1998). Dans *The House*, on peut aussi voir Ahtila avec quatre de ses sculptures, des maquettes d'architecture qui se présentent comme des parenthèses, des interprétations typifiées, des exacerbations abstraites de la mystérieuse «maison-film». Elles font aussi office d'écrans de projection du sujet introverti. Dans ses films, ses photos et ses sculptures, Ahtila présente les projets tantôt tâtonnants, tantôt résolument affirmés d'elle-même, projets qui plongent au cœur d'un moi fixé dans des fictions, et pour lequel elle élabore un langage symbolique qui tient du rêve. Elle invente pour cela des formes surprenantes de narration discontinue, mélangeant les identités des personnages, en faisant parler certains avec plusieurs voix différentes et plusieurs autres avec la même voix. Ahtila présente l'identité personnelle comme un construct fragile qui ménage toujours aussi des transitions fluides vers «l'autre». J. A.

SELECTED EXHIBITIONS →
2005 *Me/We, Okay, Gray*, Kovács Gábor Art Foundation, Budapest; 51. Biennale di Venezia, Venice; *The World Is a Stage – Stories Behind Pictures*, Mori Art Museum, Tokyo **2004** *Le cinéma est un trésor – Rétrospective Eija-Liisa Ahtila*, Institut Finlandais, Paris; *Berlin North*, Hamburger Bahnhof, Berlin; 4. Busan Biennale; 14. Biennale of Sydney **2003** De Appel, Amsterdam **2002** Kunsthalle Zürich; Museum of Contemporary Art Kiasma, Helsinki; *Real Characters, Invented Worlds*, Tate Modern, London

SELECTED PUBLICATIONS →
2003 *The Cinematic Works*, Helsinki; *Eija-Liisa Ahtila*, Museion, Bolzano **2002** *Fantasized Persons and Taped Conversations*, Museum of Contemporary Art Kiasma, Helsinki and Tate Modern, London

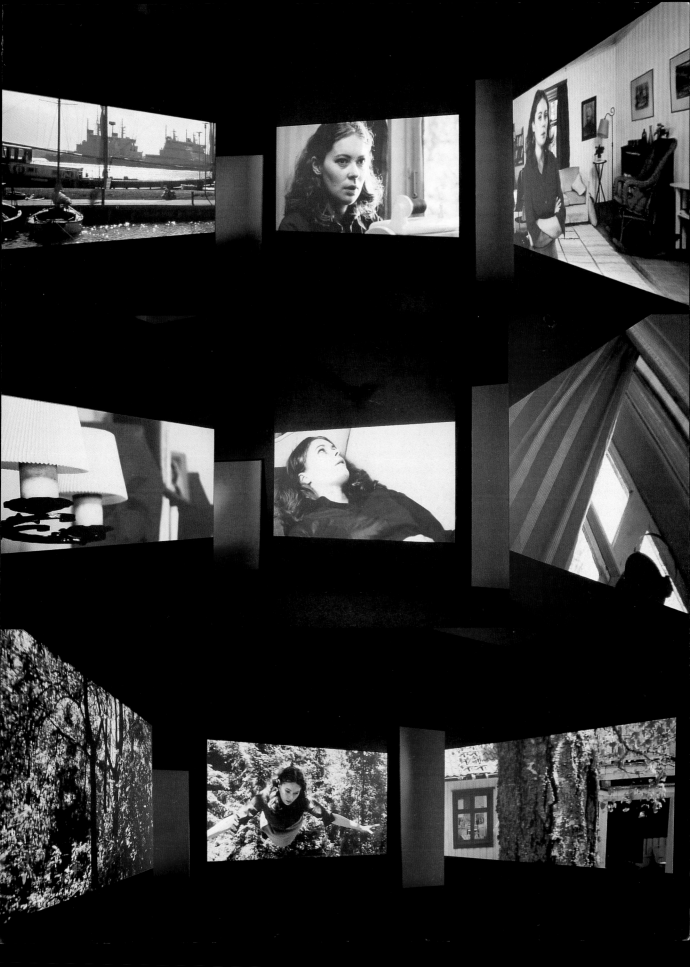

18

1 **Talo/The House,** 2002, 14 min., 3-screen DVD installation with sound
2 **Casting Portraits,** 1995–1997, b/w photographs, each frame 39 x 78 cm

3 **Scenographer's Mind,** 2002, colour prints, mounted, framed as a set, with hand coloured matte, each frame 118 x 180 cm

„Obgleich es meine Absicht ist, die Linearität einer Geschichte aufzubrechen, und zwar mithilfe der Ausdruckskraft von bewegten Bildern, will ich die zentrale Bedeutung der Erzählung aufrechterhalten.
Mich interessiert die Struktur der Geschichte, die Erzählung, das Hervorbringen von Bedeutung mittels bewegter Bilder sowie das Verhältnis Erzählung – Raum."

« Bien que mon intention soit bien de fragmenter la linéarité d'une histoire – en l'occurrence en me servant d'éléments qui ressortent de la création au moyen d'images animées, je tiens à conserver le rôle central de la narration. Je m'intéresse à la structure narrative, au récit, à la production de sens par le truchement d'images animées ainsi qu'au rapport récit/espace. »

**"Although my intention is to break up the linearity of a story, namely by using elements of the expressiveness produced by motion pictures, I want to preserve the narrative's central meaning.
I am interested in the structure of the story, the narrative, the generation of meaning by means of motion pictures, and the relationship between narration and space."**

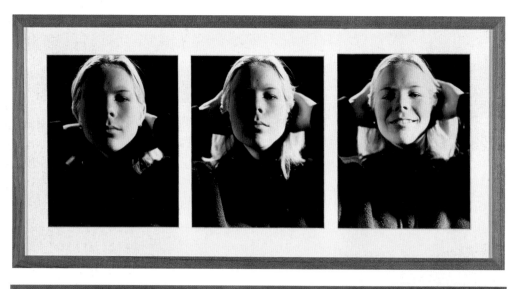

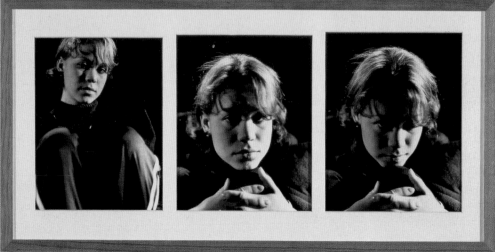

2

3

Doug Aitken

1968 born in Redondo Beach (CA), lives and works in Los Angeles (CA), USA

Doug Aitken's video projections develop within complex pictorial spaces, which viewers must wander through or walk around. As in a cabinet of curiosities one feels surrounded by several projection surfaces, or else one must move alongside the screens arranged freely in the room. There is no linear narrative in Aitken's videos; the story line is disjointed both in terms of the films' structure and sequence of images, as well as in their prism-like projection. The floods of images run parallel in some of his videos, and sometimes they are staggered over time. Completely dissimilar sequences are projected simultaneously in many of his works. Aitken's pictorial universes have very diverse sources. They may be based on documentary photos of urban or natural panoramas, for which Aitken seeks history-laden locations in which human dramas or natural catastrophes have taken place. Aitken's oeuvre also includes staged productions, however, in which he has his protagonists live out dramatic events or life phases. In *Electric Earth* (1999) the camera follows a man during a ramble through Los Angeles at night. *New Skin* (2002) shows a young woman who, in danger of losing her sight, attempts to impress upon her memory the images and objects of her surroundings. With all their expressive power, Aitken's films also always reflect upon their medium and upon how it is perceived. Besides the video installations, he also makes photographs that seem like stills from epic road movies, as well as computer-manipulated photographs that kaleidoscopically fragment their motifs, thus attempting to translate the principle of his video projections into a single flat surface.

Die Videoprojektionen von Doug Aitken entfalten sich in komplexen Bildräumen, die der Betrachter durch- oder umwandern muss. Wie in einem Panoptikum sieht man sich von mehreren Projektionsflächen umgeben, oder man muss sich entlang frei im Raum arrangierter Bildschirme bewegen. In Aitkens Videos gibt es keine lineare Erzählung, die Narration ist aufgebrochen, sowohl in Struktur und Bilderfolge des Films als auch in dessen prismenartiger Projektion: In manchen Videos laufen die Bilderfluten parallel, manchmal sind sie zeitversetzt. In vielen Werken von Aitken werden gänzlich verschiedene Sequenzen gleichzeitig projiziert. Aitkens Bilderkosmen haben sehr verschiedene Quellen. Sie können auf dokumentarischen Aufnahmen von Stadt- und Naturpanoramen beruhen, für die Aitken Orte aufsucht, die mit Geschichte beladen sind, an denen sich menschliche Dramen oder Naturkatastrophen abgespielt haben. Zu Aitkens Œuvre gehören aber auch Inszenierungen, in denen er seine Protagonisten dramatische Ereignisse oder Lebensabschnitte durchmachen lässt. In *Electric Earth* (1999) folgt die Kamera einem Mann bei seinem Streifzug durch das nächtliche Los Angeles. *New Skin* (2002) beobachtet eine junge Frau, die ihr Sehvermögen zu verlieren droht, bei ihrem Versuch, sich die Bilder und Objekte ihrer Umgebung einzuprägen. Mit all ihrer Bildgewalt sind Aitkens Filme immer auch Reflexion über ihr Medium und dessen Wahrnehmung. Neben den Videoinstallationen entstehen Fotografien, die wie Stills aus epischen Roadmovies scheinen, sowie computermanipulierte Fotografien, die ihr Motiv kaleidoskopartig aufsplittern und so versuchen, das Prinzip der Videoprojektion in die Fläche zu übersetzen.

Les projections vidéo de Doug Aitken se déploient dans des espaces visuels complexes que le spectateur doit traverser ou contourner. Comme dans un cabinet de curiosités, l'on y est entouré de plusieurs surfaces de projection ou bien l'on doit déambuler le long d'écrans de projection librement disposés dans l'espace. Dans les vidéos d'Aitken, on ne trouve pas de récits linéaires, la narration est fragmentée au niveau de la structure et de la séquence des images comme au niveau d'un mode de projection prismatique : dans certaines vidéos, des flots d'images se déversent en parallèle, dans d'autres, les images sont décalées dans le temps. Dans bien des œuvres, on assiste à la projection simultanée de séquences totalement hétéroclites. Les univers visuels d'Aitken puisent à des sources très diverses et s'appuient par exemple sur des prises de vue documentaires de panoramas urbains ou naturels pour lesquels Aitken recherche des lieux chargés d'histoire où se sont déroulés des drames humains ou des catastrophes naturelles. Mais l'œuvre d'Aitken propose aussi des mises en scène dans lesquelles l'artiste fait traverser aux protagonistes des événements ou des tranches de vie dramatiques. Dans *Electric Earth* (1999), la caméra suit un homme dans son errance nocturne à travers la ville de Los Angeles. *New Skin* (2002) observe une jeune femme en passe de perdre la vue dans ses efforts pour graver les images et les objets de son environnement dans sa mémoire. Malgré toute leur puissance visuelle, les films d'Aitken sont aussi et toujours une réflexion sur leur médium et sa perception. A côté des installations vidéo, il réalise des photographies qui se présentent comme des photos de plateau de *roadmovies* épiques, mais aussi des photographies retouchées par ordinateur, aux motifs éclatés de manière kaléidoscopique, et qui tentent ainsi de transposer le principe de la projection vidéo dans la surface.

A.M.

SELECTED EXHIBITIONS →
2005 Musée d'Art Moderne de la Ville de Paris **2004** *We're Safe As Long As Everything Is Moving*, "la caixa" Forum, Barcelona, Sala Rekalde, Bilbao **2003** Kunsthalle Zürich **2002** *Speed of Vision*, Aldrich Museum of Contemporary Art, Ridgefield; *Interiors*, The Fabric Workshop and Museum, Philadelphia; *Rise*, Louisiana Museum for Moderne Kunst, Humlebæk **2001–2003** *New Ocean*, Serpentine Gallery, London, Tokyo Opera City Gallery, Kunsthaus Bregenz, Fondazione Sandretto Re Rebaudengo, Turin

SELECTED PUBLICATIONS →
2004 *Doug Aitken. We're Safe As Long As Everything Is Moving*, Fundació "la Caixa", Barcelona **2002** *Doug Aitken A–Z Book (Fractals)*, The Fabric Workshop and Museum, Ostfildern-Ruit **2001** *Doug Aitken*, Amanda Sharp, Daniel Birnbaum, Jörg Heiser, London, New York

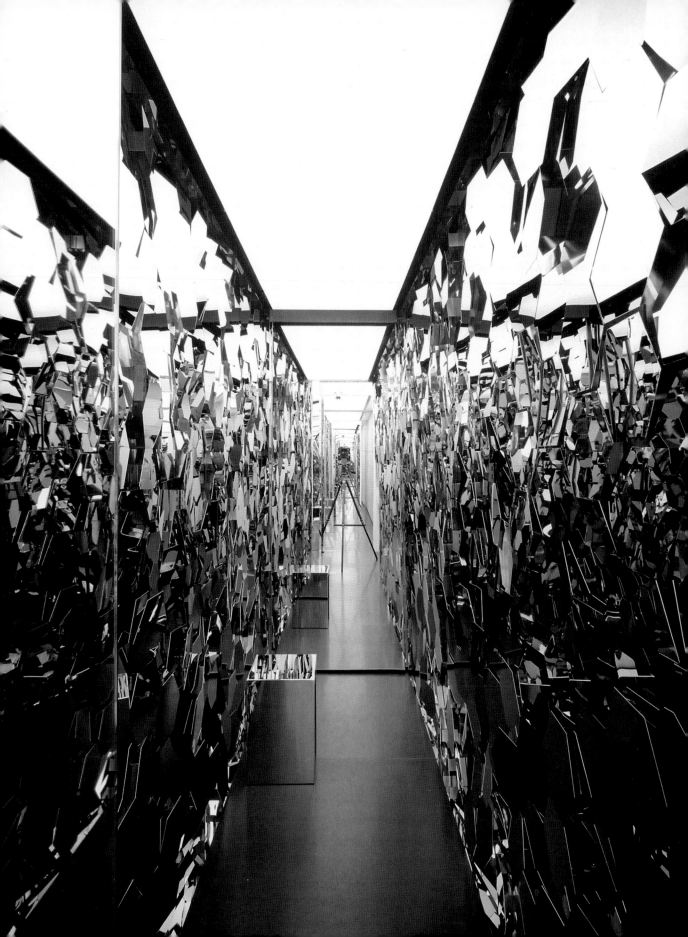

1 **This Moment is the Moment**, 2004, automated mirror sculpture, 195 x 105 x 200 cm

2 **The Moment**, 2005, 11-channel video installation with mirrors, 23 x 15 x 6 m
3 **Interiors**, 2002, 3-channel video installation, 11 x 11 m

„Jede meiner Arbeiten ist ein Experiment. Es interessiert mich nicht, Projekte zu schaffen, die illustrieren und definieren; vielmehr möchte ich Ausgangspunkte schaffen, Anreize für Fragen, Provokation."

« Chacune de mes œuvres est une expérience. La réalisation de projets qui illustrent et définissent ne m'intéresse pas ; je préfère créer des points de départ, des incitations au questionnement, des provocations. »

"Each work I make is an experiment. I'm not interested in creating projects that illustrate and define; I would rather make departure points, stimuli for questions, provocation."

2

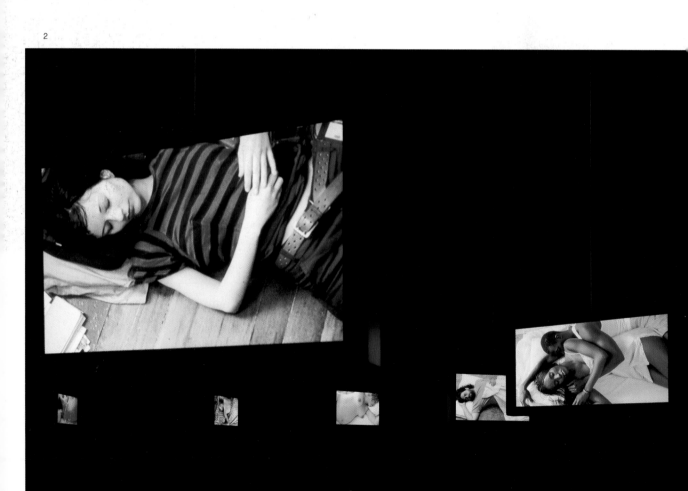

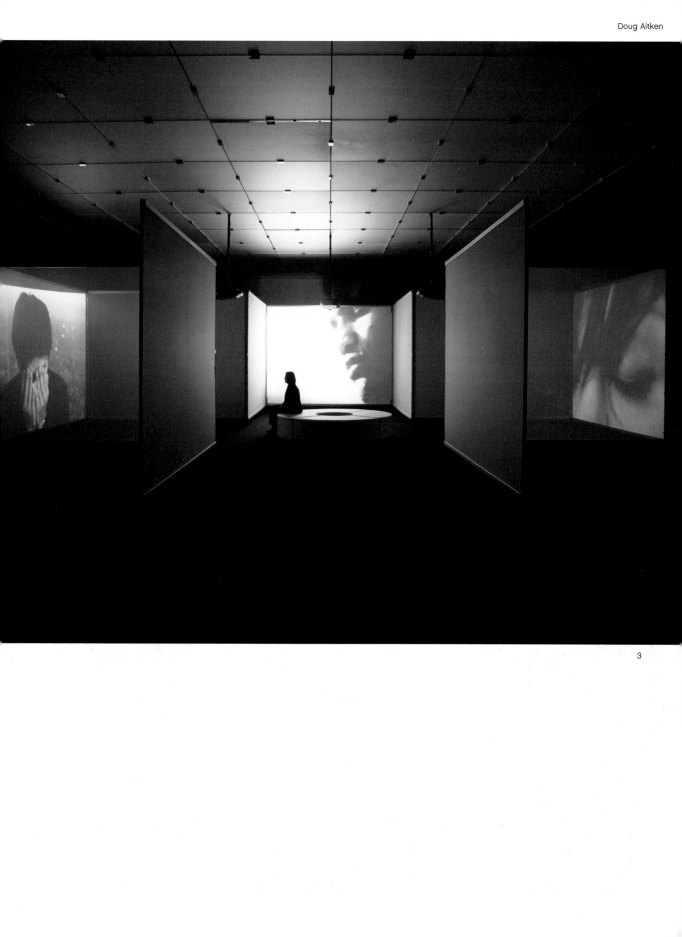

Darren Almond

1971 born in Wigan, lives and works in London, UK

How can you comprehend the perception of time? The attempt to investigate the subjective observation of objectively measurable systems plays a central role in Darren Almond's work. The installation *Live Sentence* (2004), which had ties with earlier works, used a live video feed to connect the exhibition room with the deserted rooms of a correctional institution. An oversized clock with digital numbers, just as real for the exhibition visitors as it is for the imagined prison inmates, let the passing of time be experienced as an existential quality. The same type of clock also appears in *Mean Time* (2000). For this work, on a voyage across the Atlantic the British artist accompanied an orange digital clock the size of a shipping container. Despite time travel and time zone changes it persistently remained on "Greenwich Mean Time", and with the click of its monotonously changing numbers it warned viewers of the inadequacy both of their subjective time sense and of objective measurability. Time that seems to stretch out or to stand still: these phenomena become most distinct at the limits of perceptibility. This is true for example at the geographical "end of the world", the South Pole, to which Almond travelled for his film *A* (2002). Time as contorted space, where memories can accumulate in the wrinkles: in the four-part video installation *If I had you* (2003), memories of Almond's grandmother are combined with a shot of an old dance hall in the English seaside resort of Blackpool, a shot of a garden, and one of a windmill covered with colourful little lights in a pleasure grounds. The separation from a past that seems so close can be understood spatially in the video images' juxtaposition.

Wie ist die Wahrnehmung von Zeit fassbar? Der Versuch, der subjektiven Betrachtung eines objektiv messbaren Systems nachzuspüren, steht im Zentrum der Arbeiten von Darren Almond. Die an frühere Arbeiten anschließende Installation *Live Sentence* (2004) verband mittels einer Live-Videoschaltung den Ausstellungsraum mit den menschenleeren Räumen einer Strafanstalt. Eine übergroße Uhr mit Digitalziffern, gültig für die Ausstellungsbesucher ebenso wie für die imaginierten Gefängnisinsassen, ließ die zeitliche Erfahrung als existenzielle Qualität erfahrbar werden. Derselbe Typus Uhr tauchte auch in *Mean Time* (2000) auf: Für diese Arbeit hatte der britische Künstler eine orangefarbene Digitaluhr in der Größe eines Schiffscontainers über den Atlantik begleitet. Der Zeitreise und der Zeitverschiebung zum Trotz, hielt sie beharrlich an der Greenwich Mean Time fest und gemahnte die Betrachter mit monoton klackenden Ziffernwechseln an die Unzulänglichkeit ihres subjektiven Zeitempfindens, aber auch objektiver Messbarkeit. Zeit, die sich zu dehnen oder still zu stehen scheint: An den Grenzen der Erfahrbarkeit werden diese Phänomene am deutlichsten. Dies gilt etwa für das geografische „Ende der Welt", den Südpol, den Almond für seinen Film *A* (2002) bereiste. Zeit als gekrümmter Raum, in dessen Falten sich Erinnerung akkumuliert: Die vierteilige Videoinstallation *If I had you* (2003) verbindet Erinnerungen von Almonds Großmutter mit Aufnahmen eines alten Tanzsalons des englischen Badeorts Blackpool, eines Gartens sowie einer Windmühle mit bunten Glühlämpchen in einem Vergnügungspark. Die Trennung von der so nahe scheinenden Vergangenheit wird im Nebeneinander der Videobilder räumlich fassbar.

Comment rendre tangible la perception du temps ? La tentative de suivre la trace de la contemplation subjective d'un système objectivement mesurable se trouve au centre du travail de Darren Almond. Par le truchement d'une liaison vidéo en direct, l'installation *Live Sentence* (2004), qui s'inscrit dans le sillage d'œuvres antérieures, reliait l'espace de l'exposition aux salles et aux cellules d'un établissement pénitentiaire désaffecté. Une horloge surdimensionnée à affichage digital, valide autant pour les visiteurs de l'exposition que pour les détenus imaginaires, faisait vivre l'expérience temporelle comme une qualité existentielle. Le même type d'horloge apparaît aussi dans *Mean Time* (2000). Pour cette œuvre, l'artiste britannique avait accompagné une horloge digitale orange de la taille d'un conteneur maritime pendant sa traversée de l'Atlantique. En dépit de la durée du voyage et du décalage horaire, l'horloge respectait obstinément l'heure du Greenwich Mean Time, et le claquement monotone des changements de chiffres rappelait aux spectateurs les limites de la perception subjective du temps mais aussi de l'objectivité de toute mesure. Un temps qui s'étire ou qui semble se figer : c'est aux limites de la perceptibilité que ces phénomènes se manifestent le plus clairement. Ceci vaut notamment pour la « fin du monde » géographique, le pôle Sud, où Almond s'est rendu dans le cadre de son film *A* (2002). Le temps comme espace courbe dans les plis duquel s'accumule la mémoire : l'installation vidéo en quatre parties *If I had you* (2003) réunit les souvenirs de la grand-mère de l'artiste, les photographies d'une ancienne salle de bal de la station balnéaire de Blackpool, d'un jardin et d'un moulin à vent dans un parc de loisirs, orné de lampions multicolores : l'adieu à un passé qui semble encore si proche devient saisissable spatialement dans la juxtaposition des images vidéo.

E. K.

SELECTED EXHIBITIONS →
2005 K21 – Kunstsammlung Nordrhein-Westfalen, Düsseldorf
2004 *Live Sentence*, Lentos Kunstmuseum, Linz **2003/04** *Witness*,
Barbican, London, Museum of Contemporary Art, Sydney
2001/02 *Night as Day*, Tate Britain, London **2001** De Appel, Amsterdam; 2. berlin biennale; Kunsthalle Zürich **1999** The Renaissance
Society, Chicago **1997–1999** *Sensation: Young British Artists from
the Saatchi Collection*, Royal Academy of Arts, London, Hamburger
Bahnhof, Berlin, Brooklyn Museum of Art, New York

SELECTED PUBLICATIONS →
2003 *Cream 3: Contemporary Art in Culture*, London; *Darren
Almond: Eleven Miles… from Safety*, White Cube, London
2002 *Zusammenhänge herstellen*, Kunstverein in Hamburg
2001 *Darren Almond*, Kunsthalle Zürich **2000** *Making Time:
Considering Time as a Material in Contemporary Video & Film*,
Palm Beach Institute of Contemporary Art, Lake Worth

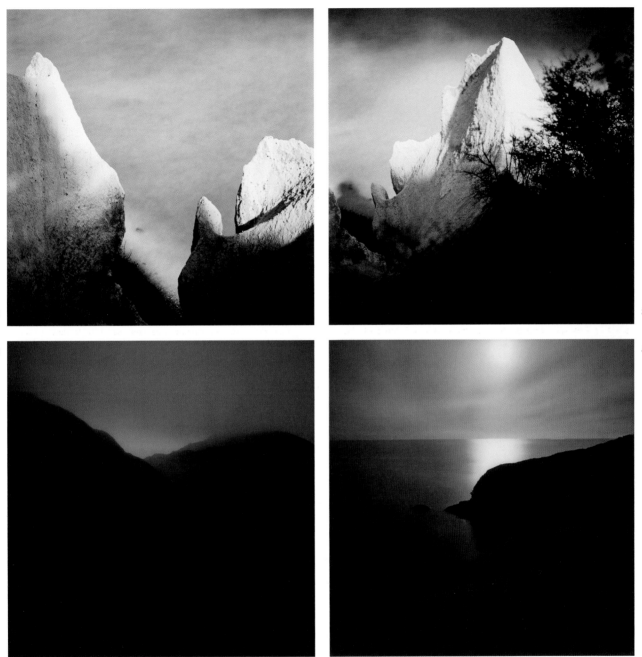

1 2 3 4

1 **Fullmoon@Rügen**, 2004, C-print, 126 x 126 cm (framed)
2 **Fullmoon@Rügen**, 2004, C-print, 126 x 126 cm (framed)
3 **Fullmoon@Highland**, 2004, C-print, 126 x 126 cm (framed)

4 **Fullmoon@Channel**, 2004, C-print, 126 x 126 cm (framed)
5 **2002**, 2002, aluminium, steel, electronic mechanics, 200 x 200 x 360 cm, exhibition view, "at speed", Galerie Max Hetzler, Berlin

„Man kann das Geräusch seines Herzschlags ebenso wenig loswerden wie das Geräusch seines zentralen Nervensystems. Selbst in totaler Isolation bleiben einem diese beiden Signaturen."

«On ne peut perdre le son de son propre cœur ni de son propre système nerveux central. Même en cas d'isolement, ces deux signatures demeurent.»

"You can't lose the sound of your own heart and you can't lose the sound of your central nervous system. Put yourself in isolation and you're still left with those two signatures."

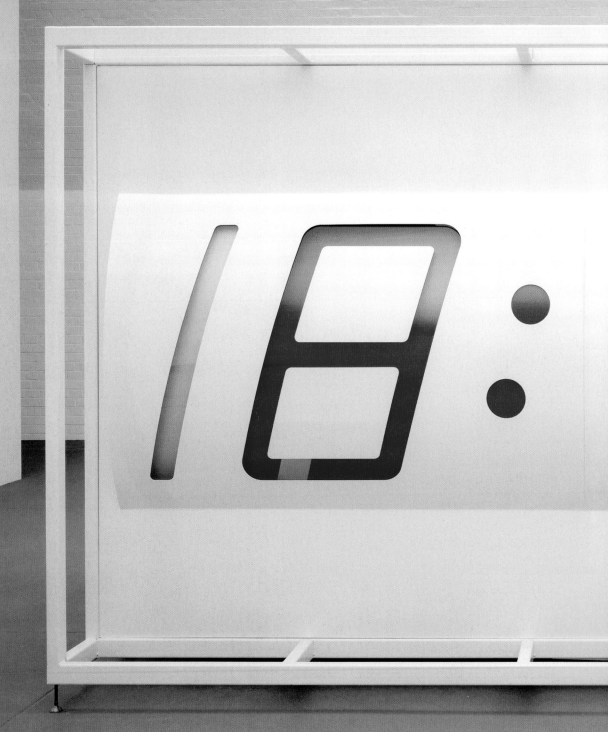

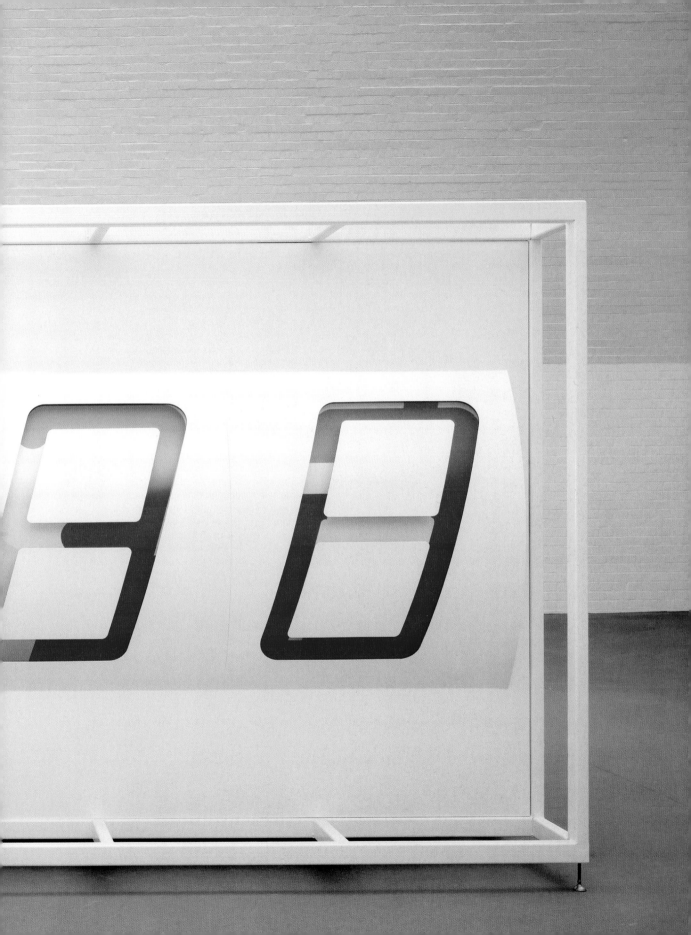

Francis Alÿs

1959 born in Antwerp, Belgium, lives and works in Mexico City, Mexico

In 1997, Francis Alÿs pushed a large block of ice through the streets of Mexico City until it was reduced to a puddle of melted water. This action, titled *Paradox of Praxis*, illustrated the futility of the sculptural endeavour and the conceptual double-bind of artistic production, but its very absurdity guaranteed its continued existence through word-of-mouth anecdote. This was one of several "paseos" (strolls) that Alÿs began in 1991 with *The Collector*, where he walked through the city pulling behind him a magnetic model dog on wheels which gradually grew a barnacled coat of metal detritus: nails, coins, scraps: an exercise in passive accumulation, in contrast to the dissolution of the ice block. Many of Alÿs' works have the quality of a fable, such as his faux-naif painting series, where an original painting is given to various sign painters who make copies which he then, in turn, copies. Like a game of Chinese-whispers, the original painting, populated by characters named "The Prophet" or "The Liar" engaged in obscurely metaphorical activities, is subtly modified and reinterpreted: shades of meaning accumulate or disintegrate. In the video work *Rehearsal 1* (1999–2004) a red VW Beetle, that most anthropomorphically endearing of cars, struggles to drive up a dusty hill in Tijuana. Its progress is synchronized with, indeed dictated by, the soundtrack of a band rehearsing a danzón: as the music falters and stops, the Beetle rolls back down the hill. A continuous inconclusive journey, it is a metaphor for progress on an individual as well as a societal level.

Im Jahr 1997 schob Francis Alÿs einen großen Eisblock so lange durch die Straßen von Mexico City, bis schließlich nur eine Pfütze aus geschmolzenem Wasser von ihm übrig war. Diese Aktion mit dem Titel *Paradox of Praxis* veranschaulichte die Nichtigkeit der bildhauerischen Anstrengung sowie die konzeptuelle Doppelbindung der künstlerischen Produktion, während die komplette Absurdität der Aktion sie als Anekdote lebendig erhielt. Es handelte sich hierbei um einen von mehreren „Paseos" (Spaziergängen), die Alÿs 1991 mit der Aktion *The Collector* begann, bei der er durch die Stadt lief und einen magnetischen Spielzeughund auf Rädern hinter sich herzog. Dieser sammelte nach und nach eine bremsende Schicht aus Metallteilen zusammen: Nägel, Münzen, Abfall – eine Übung in passiver Akkumulation, die im Gegensatz zur Auflösung des Eisblocks stand. Viele der Arbeiten von Alÿs verfügen über buchstäblich fabelhafte Qualitäten, so etwa seine pseudonaive Gemäldeserie, bei der mehrere Schildermaler ein Originalgemälde erhielten, um Kopien desselben anzufertigen, die Alÿs seinerseits kopierte. Wie beim Stille-Post-Spiel wurde das Original, ein Gemälde voller Figuren wie dem „Propheten" oder dem „Lügner", die mit obskur-metaphorischen Handlungen beschäftigt sind, subtil modifiziert und neu interpretiert: Bedeutungsspuren verdichteten sich oder lösten sich auf. In der Videoarbeit *Rehearsal 1* (1999–2004) quält sich ein roter VW Käfer, jenes wohl beliebteste vermenschlichte Auto, damit ab, einen staubigen Hügel in Tijuana hinaufzufahren. Dieser Vorgang wird mit der Tonaufnahme einer einen „Danzón" probenden Band synchronisiert, ja, von ihr diktiert. Sobald die Musik schwankt beziehungsweise aussetzt, rollt der Käfer wieder rückwärts bergab. Diese fortdauernde ergebnislose Reise ist eine Metapher für den Fortschritt auf individueller wie auf gesellschaftlicher Ebene.

En 1997, Francis Alÿs poussait un gros bloc de glace à travers les rues de Mexico jusqu'à ce qu'il eût été réduit à une flaque d'eau. Cette action intitulée *Paradox of Praxis* illustrait l'inanité de toute tentative sculpturale et la double corvée conceptuelle de la production artistique, mais c'est son absurdité même qui garantissait sa pérennité par le truchement de l'anecdote et du bouche à oreille. Ce fut là l'un de sept « paseos » (promenades) commencés en 1991 avec *The Collector*, une action pendant laquelle l'artiste parcourait la ville en tirant derrière lui un chien artificiel en matériau magnétique, monté sur roues, et qui s'agrandissait progressivement d'un manteau de déchets métalliques – clous, pièces de monnaie, bouts de ferraille – par un exercice d'accumulation passive qui contrastait avec la dissolution du bloc de glace. Nombre d'œuvres d'Alÿs ont les qualités d'une fable, comme sa série de peintures faux-naïves, dans laquelle un original était donné à plusieurs peintres d'enseignes qui en réalisaient des copies que l'artiste recopiait ensuite à son tour. Comme dans un jeu de « téléphone arabe », la peinture originale peuplée de personnages appelés « The Prophet » ou « The Liar » et investis dans des activités obscurément métaphoriques, se voyait subtilement modifiée et réinterprétée : des nuances de sens s'accumulaient ou se désintégraient. Dans l'œuvre vidéo *Rehearsal 1* (1999–2004), une Coccinelle Volkswagen rouge – la voiture la plus attachante en termes d'anthropomorphisme – lutte pour franchir une côte poussiéreuse de Tijuana. Sa progression est synchronisée et, de fait, dictée par la bande son d'un groupe de musique qui répète un « danzón » : quand la musique hésite et s'arrête, la Coccinelle redescend la colline en marche arrière. Voyage perpétuel et sans conclusion, il s'agit d'une métaphore du progrès, tant au niveau individuel que social.

K. B.

SELECTED EXHIBITIONS →
2004/05 *Walking Distance from the Studio*, Kunstmuseum Wolfsburg, Musée des Beaux Arts, Nantes; Museu d'Art Contemporani de Barcelona, San Idelfonso, Mexico City **2004** 54. Carnegie International, Carnegie Museum of Art, Pittsburgh; 14. Biennale of Sydney **2002/03** Centro Nazionale per le Arti Contemporanee, Rome, Kunsthaus Zürich, Museo Nacional Centro de Arte Reina Sofia, Madrid, Lambert Collection, Avignon **2002** *Projects 76: Francis Alÿs*, The Museum of Modern Art, New York

SELECTED PUBLICATIONS →
2005 *The Modern Procession*, Public Art Fund, New York
2004 *Walking Distance from the Studio*, Kunstmuseum Wolfsburg; *Francis Alÿs Blue Orange Prize*, Martin-Gropius-Bau, Berlin
2001 *Francis Alÿs*, Musée Picasso, Antibes

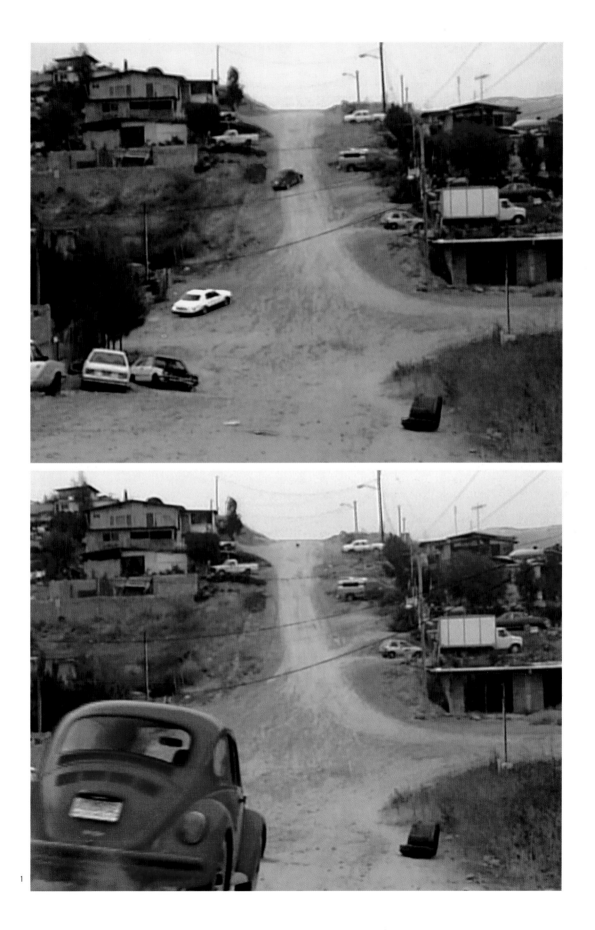

1 **Rehearsal II**, 1999–2004, video installation
2 **The Jungle**, 2003, oil and encaustic on canvas on wood, triptych (detail)

3 **Bolero**, 2004, video installation, 14. Biennale of Sydney

„Manchmal bedeutet etwas zu machen tatsächlich, nichts zu machen, während nichts zu machen paradoxerweise manchmal bedeutet, etwas zu machen."

« Parfois, faire quelque chose, c'est en fait ne rien faire ; et paradoxalement, parfois, ne rien faire, c'est faire quelque chose. »

"Sometimes, to make something is really to make nothing; and paradoxically, sometimes to make nothing is to make something."

2

Ghada Amer

1963 born in Cairo, Egypt, lives and works in New York (NY), USA

Ghada Amer meticulously embroiders the surfaces of her installations, sculptures and paintings. Sewing (a metaphor for women's work and an act eternally connected to notions of domesticity and femininity) representations of women in the liberating act of pleasuring themselves or each other, Amer addresses the woman's role in society and seeks to dispel socially imposed stereotypes. At the outset of her career, Amer reacted to the Islamic fundamentalism she was exposed to growing up in Cairo, later expanding her scope to address the objectification of women throughout the world. The source material for her heady imagery comes from pornography, but Amer uses the male gaze as a form of female empowerment, presenting a world where women embrace their sexual potential. In *Colored Drips/Figures en Zigzag*, a painting from 2000, drips of red and gold echo the knotted tangles of red and yellow thread that connect female couples to one another, caught in a web of desire and delight. Amer has also incorporated text into her pieces. For *Private Rooms* (1998/99), Amer sewed excerpted verses from the Qur'an onto shimmery hanging satin garment bags. She selected specific passages referencing women from a French translation of the original Arabic. With this action, Amer problematized both the sacredness and the literal meaning of the words chosen while testing boundaries between East and West.

Ghada Amer versieht die Oberflächen ihrer Installationen, Skulpturen und Gemälde mit akribischen Stickereien. Indem sie Darstellungen von Frauen während des befreienden Aktes der (Selbst-)Befriedigung stickt (und Sticken ist hier eine Metapher für Frauenarbeit sowie eine Tätigkeit, die stets mit Begriffen wie Häuslichkeit und Weiblichkeit in Verbindung gebracht wird), thematisiert Amer die soziale Rolle der Frau und strebt die Aufhebung gesellschaftlich festgelegter Stereotypen an. Zu Beginn ihrer künstlerischen Laufbahn reagierte Amer auf jenen islamischen Fundamentalismus, dem sie während ihrer Jugend in Kairo ausgesetzt war, später beschäftigte sie sich darüber hinaus mit der Verdinglichung von Frauen auf der ganzen Welt. Als Vorlagen für ihre berauschenden Bilder dient die Pornografie, wobei Amer den männlichen Blick als Form weiblicher Ermächtigung nutzt und eine Welt zeigt, in der sich Frauen zu ihrem sexuellen Potenzial bekennen. In *Colored Drips/Figures en Zigzag*, einem Bild von 2000, wiederholen Tropfen in Rot und Gold das verknotete Gewirr aus roten und gelben Fäden, mit denen die weiblichen Paare miteinander verbunden und in einem Netz aus Begehren und Genuss gefangen sind. Amer integriert in ihre Arbeiten auch Texte. In *Private Rooms* (1998/99) stickte Amer Koranverse auf hängende Kleiderbeutel aus glänzendem Satin. Dabei wählte sie solche Passagen einer französischen Übersetzung des arabischen Originals aus, die sich speziell auf Frauen beziehen. Mit dieser Aktion problematisierte Amer sowohl das Sakrale als auch die buchstäbliche Bedeutung der ausgewählten Wörter und überprüfte gleichzeitig die Grenzen zwischen Ost und West.

Ghada Amer brode avec une grande minutie les surfaces de ses installations, sculptures et peintures. Métaphore du travail féminin, activité associée depuis toujours aux notions de domesticité et de féminité, la couture – en l'occurrence de représentations féminines investies dans l'acte libérateur de l'autosatisfaction ou de la jouissance partagée – lui permet d'aborder le rôle social de la femme et de dissoudre les stéréotypes imposés par la société. Le début de sa carrière a été marqué par la réaction au fondamentalisme islamique auquel elle fut exposée durant sa jeunesse au Caire. Amer a ensuite étendu son champ d'intérêt à l'avilissement de la femme au rang d'objet de par le monde. Si elle puise le matériau de son imagerie troublante dans la pornographie, l'artiste utilise aussi le regard masculin comme une forme de prise de pouvoir de la femme en présentant un univers où les femmes prennent conscience de leur potentiel sexuel. Dans *Colored Drips/Figures en Zigzag*, une peinture de 2000, des coulures de peinture rouge et or font écho aux entrelacs de fils rouges et jaunes qui relient entre eux des couples de femmes s'abandonnant à une toile de désir et de volupté. Amer a aussi intégré des textes dans ses œuvres. Pour *Private Rooms* (1998/99), elle a cousu des versets du Coran sur un accrochage de housses à vêtements en satin, sélectionnant dans une traduction française de l'original arabe des passages concernant plus particulièrement la femme. Amer soulevait ainsi les problèmes à la fois du caractère sacré et du sens littéral des passages choisis, tout en mettant à l'épreuve les liens entre les mondes occidental et oriental. A.S.-S.

1

SELECTED EXHIBITIONS →
2005 *Perspectives @ 25: A Quarter Century of New Art in Houston*, Contemporary Arts Museum, Houston; *Beyond East and West: Seven Transitional Artists*, Williams College Museum of Art, Williamstown **2004** *Monument to Now*, Deste Foundation, Athens; *Artists' Favourites (Act 2)*, Institute of Contemporary Arts, London **2000** *Intimate Confessions*, Tel Aviv Museum of Art; Whitney Biennial, Whitney Museum of American Art, New York **2001** *Pleasure*, Contemporary Arts Museum, Houston; *The Short Century*, Martin-Gropius-Bau, Berlin, Museum Villa Stuck, Munich, Museum of Contemporary Arts, Chicago, P.S.1, New York **1999** 48. Biennale di Venezia, Venice

SELECTED PUBLICATIONS →
2004 *Ghada Amer*, Gagosian Gallery, New York
2002 *Correspondence between Andrew Renton and Ghada Amer*, Gagosian Gallery, New York **1997** *Ghada Amer: Pleasure*, Contemporary Arts Museum, Houston

1 **The Dance**, 2004, acrylic, gel medium, embroidery on canvas, 213.4 x 193 cm

2 **Les Poufs**, 2002, polyurethane, acrylic, 119.7 x 119.7 x 39.4 cm

3 **Love Park**, 1999, installation view, 3. International Biennial, Santa Fe

„Was politisch gerade passiert, ist wie ein Spiegelbild dessen, was in mir selbst schon immer vor sich geht, denn ich bin ein Bastard des Westens und des Ostens. Es ist ein Zusammenstoß von Kulturen, die einander natürlich nicht verstehen. Ich lebe schon mein ganzes Leben mit diesen Widersprüchen."

« Ce qui se passe actuellement en politique est comme un miroir de ce qui a toujours eu lieu en moi, parce que je suis un hybride entre l'Occident et l'Orient. C'est un choc entre des civilisations qui manifestement ne se comprennent pas. J'ai vécu toute ma vie avec ces contradictions. »

"What is going on now politically is like a mirror of what has always gone on in myself, because I am a hybrid of the West and the East. It's a clash between civilizations that of course don't understand each other. I've lived with these contradictions all my life."

2

Experience shows us that love does not consist in gazing at each other but looking at the same direction.

If you tame me, we will need each other. You will be for me someone unique and I will be someone unique for you.

assume vivid astro focus

born anytime between the 20th and 21st century in various parts of the world, nomads

The creative activities of assume vivid astro focus turn out to be just as eclectic and florid as the pseudonym behind which its bearer hides. Not only does the artist wish to remain unnamed, but most projects are created collectively in cooperation with friends and other artists from all fields. This consciously undermines the idea of the individual artist genius, and makes questions about authorship and the ascription of single works invalid. assume vivid astro focus eagerly gulps down props and motifs from art history and popular culture, seasons them with kitsch and psychedelia, and spits them back in an eruption of colours and forms. The installations are stupefying Gesamtkunstwerks: interiors in which every available surface is covered with lavish decoration. Photographs of scintillating candelabras hang on florally patterned wallpapers, stickers inspired by the Far East cover the floor, videos flicker, and sensuous drawings and prints try to draw the viewer under their spell. *Looking for Xanadu* (2002) is the title of one digital print, in which a fireworks of red and yellow tones glows against a black background. The title of this work appears to reveal assume vivid astro focus' dream – to create a psychedelic wonderland. The video *Freebird* (2002) also attempts to lure us off to this land. It reveals a phantasmagoria inspired as much by early Beatles' films as by Tibetan religious symbols. Another work, *Make Out with You: A Slow Dance Club* (2004), a collaboration with Los Super Elegantes, is a temporary disco in the smallest format. In a cosy atmosphere and very limited space, it invites visitors to grow peacefully and lovingly closer.

So eklektisch und blumig, wie sich das Pseudonym des Künstlers präsentiert, so stellen sich auch dessen kreative Aktivitäten dar. Nicht nur will der Künstler ungenannt bleiben – die meisten Projekte entstehen kollektiv in Kooperation mit Freunden und anderen Künstlern aller Sparten, womit bewusst die Vorstellung vom individuellen Künstlergenie untergraben und Fragen nach Autorenschaft und Zuschreibung einzelner Werke hinfällig werden. assume vivid astro focus verschlingt Versatzstücke und Motive aus Kunstgeschichte und Populärkultur, würzt diese mit Kitsch und Psychedelischem, um eine Eruption an Farben und Formen wieder auszuspeien: Die Installationen sind sinnenbetäubende Gesamtkunstwerke, Interieurs, in denen jede sich bietende Fläche mit üppigem Dekor überzogen wird. Fotografien von funkelnden Kandelabern hängen auf floral gemusterten Tapeten, fernöstlich inspirierte Sticker bedecken den Boden, Videos flimmern und sinnenfrohe Zeichnungen und Drucke versuchen, den Betrachter in ihren Bann zu ziehen. *Looking for Xanadu* (2002) ist der Titel eines Digitalprints, auf dem ein Feuerwerk aus Rot- und Gelbtönen vor einem schwarzen Hintergrund glüht. Der Titel dieser Arbeit scheint den Traum von assume vivid astro focus zu offenbaren – ein psychedelisches Wunderland zu erschaffen. In dieses will auch das Video *Freebird* (2002) entführen, das eine Fantasmagorie entfaltet, die von frühen Beatles-Filmen ebenso inspiriert ist wie von tibetanischen Kultbildern. Eine weitere Arbeit, *Make Out with You: A Slow Dance Club* (2004), in Zusammenarbeit mit Los Super Elegantes entstanden, ist eine temporäre Disco in kleinstem Format. Sie lädt ihre Besucher dazu ein, sich in kuscheliger Atmosphäre auf engem Raum friedlich und liebevoll näher zu kommen.

La fraîcheur et l'éclectisme du pseudonyme derrière lequel se cache son propriétaire caractérisent tout aussi bien ses activités créatrices. L'artiste n'entend pas seulement rester anonyme – la plupart de ses projets voient le jour dans une démarche collective, en collaboration avec des amis et d'autres artistes de tous horizons, ce qui rend délibérément caduque toute idée de génie artistique individuel et toute question de paternité et d'attribution des œuvres. assume vivid astro focus engloutit des éléments de décor et des motifs issus de l'histoire de l'art et de la culture populaire ; il les pimente de kitsch et d'éléments psychédéliques pour recracher une éruption de formes et de couleurs : ses installations sont des œuvres d'art totales déconcertantes, des intérieurs dans lesquels toutes les surfaces s'offrant au traitement sont couvertes d'un décor foisonnant. Des photographies de candélabres étincelants sont accrochées à des papiers peints à motifs floraux, des autocollants d'inspiration extrême-orientale jonchent le sol, des vidéos papillotent, et des dessins et des estampes multicolores et gaies tentent de soumettre le spectateur à leur fascination. *Looking for Xanadu* (2002) est le titre d'un tirage numérique dans lequel un feu d'artifice de tons rouges et jaunes flamboie sur un fond noir. Le titre de cette œuvre semble révéler le rêve d'assume vivid astro focus – créer un pays des merveilles psychédélique. C'est dans ce même pays qu'entend nous entraîner la vidéo *Freebird* (2002), qui déploie une fantasmagorie inspirée des premiers films des Beatles aussi bien que d'images cultuelles tibétaines. Une autre œuvre, *Make Out with You: A Slow Dance Club* (2004), une collaboration avec Los Super Elegantes, une discothèque éphémère en format miniature. Elle invite ses visiteurs à se rapprocher pacifiquement et amoureusement dans l'atmosphère moelleuse d'un espace confiné.

A. M.

SELECTED EXHIBITIONS →
2005 *Off the Wall: assume vivid astro focus,* Indianapolis Museum of Art; *assume vivid astro focus XII,* Tate Liverpool; *Baroque and Neo-Baroque/The Hell of the Beautiful),* Centro de Arte de Salamanca; *Ecstasy: In and About Altered States,* The Geffen Contemporary at MOCA, Los Angeles; *Tropicália,* Bronx Museum of the Arts, New York, Museum of Contemporary Art, Chicago; *Seeing Double: Encounters with Warhol,* Andy Warhol Museum of Art, Pittsburgh **2004** Whitney Biennial, Whitney Museum of American Art, New York; *assume vivid astro focus XI,* Rosa and Carlos de la Cruz Private Collection, Key Biscayne

SELECTED PUBLICATIONS →
2004 *Whitney Biennial 2004,* Whitney Museum of American Art, New York

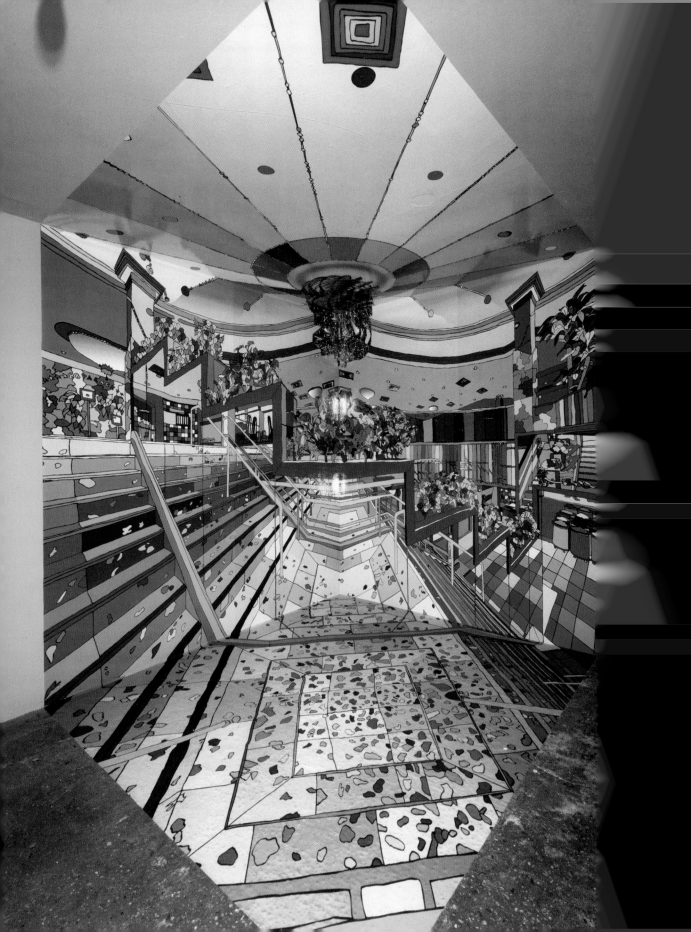

38

38

1 With Gerard Maynard, **Garden IX**, 2003, mixed media installation,
Deitch Projects, New York
2 **Butch Queen III**, 2004, wall decall, dimensions variable
3 With Los Super Elegantes, **Make Out with You: A Slow Dance Club**, 2004,
mixed media installation, Frieze Art Fair, London
4 **assume vivid astro focus VII**, 2004, mixed media, installation view,
Whitney Biennial, Whitney Museum of American Art, New York
5 With Natalja Kent, **Pomlady**, 2004, newsprint, CD, dimensions variable

6 DJ Booth with Rama Chorpash and opening performance by Los Super
Elegantes, **assume vivid astro focus IX**, 2004, mixed media installation,
Public Art Fund's programme "In the Public Realm"
(in collaboration with the Whitney Biennial), Central Park, New York
7 **assume vivid astro focus IX**, 2003, mixed media installation, private
collection. Michael Lazarus, **Move on**, 2003, painting; Justin Samson,
The Magical Mystery Mountain Man, 2004, sculpture; General Idea, **AIDS**,
1989, wallpaper

„Menschen Vergnügen zu bereiten und ihr Bewusstsein dafür zu schärfen,
was ihnen Vergnügen bereitet, ist äußerst politisch."

«Donner du plaisir aux gens et leur faire prendre conscience de ce qui leur
donne du plaisir est un acte éminemment politique.»

"Giving people pleasure and making them conscientious of what gives them pleasure is extremely political."

2

3

4

5

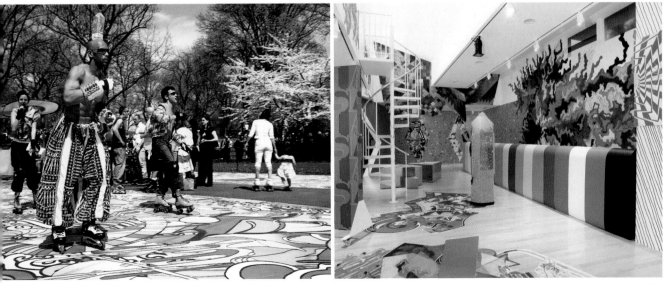

6

7

Kutlug Ataman

1961 born in Istanbul, lives and works in Buenos Aires, Argentinia, London, UK, and Istanbul, Turkey

Kutlug Ataman's film *Never My Soul* (2001) plunges the viewer into a state of continual bewilderment. Is this a true story or is it just being acted out? Is this a glamorous star speaking, or a seriously ill prostitute? Or is it really a man? The Turkish-born transsexual Ceyhan Firat, who is now living in Switzerland, alternately plays her own "role" and at other times slips into the role of the actress Turkan Soray, while telling stories that reveal the artificiality of identities and particularly the myth of femininity. Ataman became known as the director of the feature film *Lola and Bilidikid* (1998) before he moved into the art context with his first video installation *semiha b unplugged* (1997). This nearly eight-hour long interview with an 87-year-old Turkish opera star went far beyond the scope of a documentary film. While Semiha Berksoy slipped into a costume from her past and reinvented herself again and again in autobiographical fictions, the boundaries between reality and imagination became blurred. With subtle cinematic interventions Ataman showed the instability of one's own consciousness, and the constant alteration of the personality. The double projection *1+1=1* (2004) demonstrated the inadequacy of projections of national identity. In this work, filmed at the two heads of a table, a young Turkish Cypriot relates to herself the remembered events of her childhood, which were marked by the divided island's conflicts. The installation's spatial layout allows the island's partitioning to be understood as a division into two identity models. Once again Ataman refrains from any commentary within the film. The societal conditions that unite his figures are not explicitly criticized, but are always subliminally present in the stories.

Der Film *Never My Soul* (2001) von Kutlug Ataman stürzt die Betrachter in nachhaltige Verwirrung: Ist dies eine wahre Geschichte oder wird hier geschauspielert? Spricht hier eine glamouröse Diva oder eine schwerkranke Prostituierte? Oder handelt es sich doch um einen Mann? Die Erzählungen der türkischstämmigen, in der Schweiz lebenden Transsexuellen Ceyhan Firat, die abwechselnd ihre eigene „Rolle" spielt und in diejenige der Schauspielerin Turkan Soray schlüpft, machen das Konstruiertheit von Identitäten, insbesondere des Mythos der Weiblichkeit, deutlich. Ataman wurde als Regisseur des Spielfilms *Lola and Bilidikid* (1998) bekannt, bevor er mit seiner ersten Videoinstallation *semiha b unplugged* (1997) in den Kunstkontext wechselte. Dieses fast achtstündige Interview mit einer 87-jährigen türkischen Operndiva sprengte den Rahmen des Dokumentarfilms: Während Semiha Berksoy in Kostüme aus ihrer Vergangenheit schlüpfte und sich in autobiografischen Fiktionen immer wieder neu erfand, verwischten sich die Grenzen zwischen Realität und Fantasie. Mit subtilen filmischen Eingriffen zeigt Ataman die Instabilität von eigenem Bewusstsein und den steten Wandel der Persönlichkeit. Die Unzulänglichkeit nationaler Identitätsbilder führt die Doppelprojektion *1+1=1* (2004) vor: Gefilmt an den zwei Kopfenden eines Tisches, erzählt eine junge türkische Zypriotin sich selbst Erinnerungen aus ihrer Kindheit, die von den Konflikten der geteilten Insel geprägt war. Die räumliche Anordnung der Installation macht die Teilung der Insel als Spaltung in zwei Identitätsmodelle greifbar. Wieder verzichtet Ataman auf jeglichen Kommentar innerhalb des Films: Die gesellschaftlichen Bedingungen, die seine Figuren einengen, werden nicht explizit kritisiert, sind jedoch stets unterschwellig in den Erzählungen präsent.

Le film de Kutlug Ataman *Never My Soul* (2001) plonge les spectateurs dans une confusion durable : s'agit-il d'une histoire vraie ou d'un jeu d'acteur? La personne qui parle est-elle une diva glamoureuse ou une prostituée atteinte d'une maladie grave? Ou n'est-ce pas après tout un homme? Les récits du transsexuel d'origine turque Ceyhan Firat, qui vit en Suisse et se glisse tour à tour dans son propre « rôle » et dans celui de l'actrice Turkan Soray, mettent en évidence le caractère construit des identités, en particulier du mythe de la féminité. Ataman s'est fait connaître en qualité de metteur en scène du film *Lola and Bilidikid* (1998) avant de passer dans le contexte de l'art avec sa première installation vidéo *semiha b unplugged* (1997). Cette interview de presque huit heures d'une diva turque de 87 ans faisait éclater le cadre du film documentaire : à mesure que Semiha Berksoy endossait à nouveau les costumes de son propre passé et qu'elle se réinventait constamment à travers des fictions autobiographiques, la frontière entre réalité et imaginaire s'estompait. Par de subtiles interventions cinématographiques, Ataman montre le caractère instable de la conscience personnelle et le changement continuel de la personnalité. La double projection *1+1=1* (2004) présente les carences des images identitaires nationales : une jeune Chypriote turque filmée à partir des deux extrémités d'une table se raconte à elle-même des souvenirs de son enfance, qui fut marquée par les conflits liés à la partition de l'île. L'organisation spatiale de l'installation rend perceptible la division de l'île à travers la scission en deux modèles identitaires. Une fois de plus, Ataman renonce à tout commentaire à l'intérieur du film : les conditions sociales qui restreignent ses personnages ne sont pas critiquées explicitement, mais affleurent à tout moment dans ces récits.

E. K.

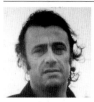

SELECTED EXHIBITIONS →
2005 *Perfect Strangers*, Museum of Contemporary Art, Sydney **2004/05** Carnegie Museum of Art, Pittsburgh **2004** *Kuba*, Artangel, London, Thyssen-Bornemisza Art Contemporary, Vienna; *Turner Prize Exhibition*, Tate Britain, London; Serpentine Gallery, London **2003/04** *Witness*, Barbican, London, Museum of Contemporary Art, Sydney **2003** Tate Triennial of Contemporary British Art, Tate Britain, London **2002** documenta 11, Kassel; *A Rose Blooms in the Garden of Sorrows*, Bawag Foundation, Vienna **2001** 2. berlin biennale

SELECTED PUBLICATIONS →
2005 *Perfect Strangers*, Museum of Contemporary Art, Sydney **2004** *Kuba*, Artangel, London **2003** *Days Like These*, Tate Britain, London; *fast forward: Media Art Sammlung Goetz*, Sammlung Goetz, Munich, Zentrum für Kunst und Medientechnologie, Karlsruhe **2002** *Kutlug Ataman: A Rose Blooms in the Garden of Sorrows*, Bawag Foundation, Vienna; *Kutlug Ataman: Long Streams*, Nikolaj Copenhagen Contemporary Art Center, GEM museum voor actuele kunst, The Hague **2001** *documenta 11*, Kassel

1 **The Four Seasons of Veronica Read**, 2002, 4 DVDs, c. 1 h each
2 **Stefan's Room**, 2004, 5 exhibition DVDs, 5 Digibeta cams, installation view, Lehmann Maupin Gallery, New York

3 **Stefan's Room**, 2004, video stills
4 **Küba**, 2002, video stills
5 **kutlug ataman's semiha b. unplugged**, 1997, video stills

„Identität ist ein Kleid, das Andere dir überstreifen, damit du es trägst – das Sprechen aber ist eine Form des Aufbegehrens, weil du gegen diese Vorstellungen angehen kannst."

« L'identité est un costume dont on vous affuble et qu'on vous force à porter – mais la parole est une forme de rébellion parce qu'elle permet d'œuvrer contre ce type de perceptions. »

"Identity is a dress that other people put on you and make you wear – but then talking is a form of rebellion because you can work against those perceptions."

3

4

2

5

The Atlas Group

Walid Ra'ad, 1967 born in Chbanieh, Lebanon, lives and works in New York (NY), USA

In 1999 in New York the Lebanese artist Walid Ra'ad founded "The Atlas Group", an imaginary foundation for researching and documenting contemporary Lebanese history. Its central topic is the 15-year civil war that shook Lebanon between 1975 and 1990. The Atlas Group's "archive" includes a broad spectrum of notebooks, drawings, collages, videos and photographs. Ra'ad additionally appears in lecture performances as a researcher of Lebanese history. The Atlas Group's fictional character questions very fundamental concepts of truth and objectivity in the writing of history. This does not detract, however, from the documents' corroboration in a subjective historical experience. The archive contains, for example, notebooks and films from the fictitious historian Fadl Fakhouri. *Notebook Volume 38: Already Been in a Lake of Fire* (1998) contains a documentation of the models of automobiles that were used in 145 assassinations with car bombs during the Lebanese civil war. In addition to photographs of each car – including exact details about manufacturer, model and colour – the extent of the damage they caused is also related, as if in a macabre competition. Two short films, *Miraculous Beginnings* and *No, Illness Is Neither Here Nor There*, both 1999, make up a further document from Fakhouri's "estate". The first contains a series of shots taken by the fictional Fakhouri "every time he thought the wars had come to an end". The second film shows a series of doctor's signs. The cascade of images of hope, which lead to absurdity just through their great number, is presented with equal weighting beside an arbitrarily selected chain of the occurrences of a random event, illustrating the juxtaposition of violence and everyday life during the civil war.

Der libanesische Künstler Walid Ra'ad gründete 1999 in New York „The Atlas Group", eine imaginäre Stiftung zur Erforschung und Dokumentation der libanesischen Zeitgeschichte. Ihr inhaltliches Zentrum bildet der 15-jährige Bürgerkrieg, der den Libanon zwischen 1975 und 1990 erschütterte. Das „Archiv" der Atlas Group umfasst ein weites Spektrum an Notizbüchern, Zeichnungen, Collagen, Videos und Fotografien. Zudem tritt Ra'ad in Vortragsperformances als Forscher der libanesischen Geschichte auf. Der fiktionale Charakter der Atlas Group hinterfragt ganz grundlegend Konzepte von Wahrheit und Objektivität in der Geschichtsschreibung. Der Wahrhaftigkeit der Dokumente im Sinne subjektiver historischer Erfahrung tut dies jedoch keinen Abbruch. Das Archiv enthält etwa Notizbücher und Filme des fiktiven Historikers Fadl Fakhouri. *Notebook Volume 38: Already Been in a Lake of Fire* (1998) enthält eine Dokumentation der Automodelle, die bei 145 Attentaten mit Autobomben im libanesischen Bürgerkrieg verwendet wurden: Wie in einem makabren Wettstreit ist neben Fotografien der Autos – mit genauen Angaben zu Marken, Modell und Farbe – jeweils das Ausmaß der von ihnen verursachten Schäden dargestellt. Ein weiteres Dokument aus Fakhouris „Nachlass" bilden zwei kurze Filme (*Miraculous Beginnings* und *No, Illness Is Neither Here Nor There*, beide 1999). Der erste enthält eine Reihe von Aufnahmen, die der erfundene Fakhouri „jedes Mal machte, wenn er dachte, der Krieg sei zu Ende". Der zweite Film zeigt eine Serie von Arztschildern. Die Kaskade an Bildern der Hoffnung, die sich selbst schon durch ihre Vielzahl ad absurdum führen, steht gleichberechtigt neben einer willkürlich gewählten Reihung eines zufälligen Ereignisses und macht das Nebeneinander von Alltag und Gewalt im Bürgerkrieg deutlich.

En 1999, l'artiste libanais Walid Ra'ad fondait à New York «The Atlas Group», une institution fictive dédiée à la documentation et à la recherche sur l'histoire contemporaine du Liban. Le contenu central en sont les quinze années de guerre civile qui ont ébranlé le pays entre 1975 et 1990. Les «archives» de l'Atlas Group comprennent un vaste éventail de carnets de notes, de dessins, de collages, de vidéos et de photographies. Ra'ad se produit en outre dans des conférences-performances en qualité de chercheur sur l'histoire du Liban. Le caractère fictionnel de l'Atlas Group interroge de manière tout à fait fondamentale les concepts de vérité et d'objectivité historiques, ce qui n'empêche d'ailleurs nullement le témoignage documentaire au sens d'une expérience historique subjective. Les archives contiennent ainsi des carnets de notes et des films de l'historien fictif Fadl Fakhouri. *Notebook Volume 38: Already Been in a Lake of Fire* (1998) contient toute une documentation sur les véhicules qui furent utilisés dans les 145 attentats à la voiture piégée commis pendant la guerre civile du Liban : comme dans un jeu de surenchère macabre, les photographies des voitures – avec mention exacte des marque, modèle et couleur – s'accompagnent de l'évaluation des dommages provoqués par les attentats auxquels elles ont servi. Un autre pan de la «succession» de Fakhouri est constitué de deux films *Miraculous Beginnings* et *No, Illness Is Neither Here Nor There* (tous deux 1999). Le premier contient une série de photographies réalisées par l'historien fictif Fakhouri «chaque fois qu'il a cru que la guerre était finie». Le second montre une série de plaques de médecins. La cascade d'images de l'espoir, que leur nombre suffit déjà à invalider, occupe un même rang à côté d'un choix arbitraire d'événements fortuits, et éclaire ainsi la coexistence de la vie quotidienne et de la violence pendant la guerre civile.

E. K.

SELECTED EXHIBITIONS →
2004 *I Was Overcome By A Momentary Panic At The Thought That They Might Be Right: Documents From The Nassar Files in The Atlas Group Archive*, Art Gallery of York University, Toronto
2003/04 *Witness*, Barbican, London, Museum of Contemporary Art, Sydney; *Die Sehnsucht des Kartografen*, Kunstverein Hannover
2003 50. Biennale di Venezia, Venice **2002–2004** *Mapping Sitting*, SK Stiftung Kultur, Cologne; Musée Nicéphore Niépce, Chalon sur Saône, Centre pour l'image contemporaine, Geneva

2002 documenta 11, Kassel; Whitney Biennial, Whitney Museum of American Art, New York **2000** *Stand der Dinge*, KW Institute for Contemporary Art, Berlin

SELECTED PUBLICATIONS →
2004 *Atlas Group*, Cologne **2003** *Die Sehnsucht des Kartografen*, Kunstverein Hannover **2002** Walid Ra'ad and Akram Zaatari (ed.), *Mapping Sitting*, The Arab Image Foundation, Mind The Gap Publications, Beirut **2002** documenta 11, Kassel

blue just like the Mediterranean.

The previous video segment was
two minutes and twelve seconds long.

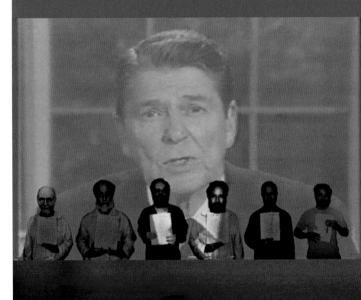

1 **Hostage**, 2001, DVD stills
2 **My Neck Is Thinner Than a Hair** (details), 2000–2003, 100 digital prints
3 **Secrets in the Open Sea**, 2004, 110 x 180 cm (detail)

4 **Already Been in a Lake of Fire**, 2002, installation view, documenta 11, Kassel

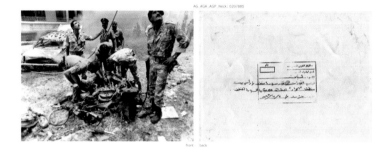

AG .AGA .AGP .Neck: 020788S

front back

Date: 2 July 1988
Archive: As-Safir (Beirut) / The Atlas Group | Photographer: Unknown
Notes: Lebanon - Crimes and Criminals - Explosions - 1988 - Beirut

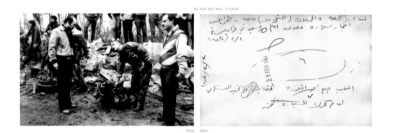

AG .AGA .AGP .Neck: 010285N

front back

Date : 1 February 1985
Archive: Annahar (Beirut) / The Atlas Group | Photographer: Unknown
Notes: Lebanon - Crimes and Criminals - Explosions - 1985 - North

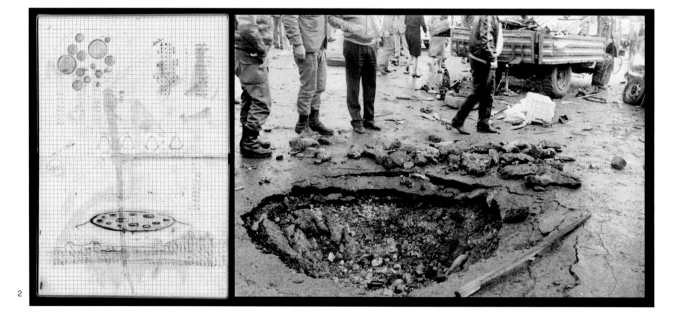

S19B

S19L

3

4

Matthew Barney

1967 born in San Francisco (CA), lives and works in New York (NY), USA

The completion of the fifth and final instalment of the 300-minute-long *Cremaster Cycle* (1994–2002) not only marked the end of a project that consumed almost ten years of Matthew Barney's life but left contemporary culture with one of the most complex, expansive and yet hermetically-sealed works of art produced anywhere during the last decade. These five feature-length films were entirely shot on, or transferred to, high-definition 35mm stock and introduced cinematic budgets, special effects, technologies and costumes that have forever reconfigured the genre of video art. Appropriating the gonadal muscle for its title, the *Cremaster* series needs to be broken down into cellular divisions to reveal its meanings because, as in a James Joyce novel, there is no linear narrative structure to the whole surreal dance. In a similarly Joycean manner, Barney mutates visual language to create his own encyclopaedic world of self-referentiality that creates the strong links between films. However, the many and varied themes of gender, sexual reproduction, Celtic mythology, opera and sporting endeavour, as well as the inclusion of cult figures Richard Serra and Ursula Andress as actors or notorious characters such as murderer Gary Gilmore and escapologist Harry Houdini, perhaps reveal more about Barney's formative concerns as a performance artist than any secrets that might unlock the mystery of the stories. Apart from further meditations on his magnum opus in the form of interrelated but residual sculptures, drawings and photographs, only Barney himself knows what feats he can possibly conjure up to follow this multimedia monolith.

Die Fertigstellung des fünften und letzten Teils des 300-minütigen *Cremaster*-Zyklus (1994–2002) markierte nicht nur das Ende eines Projekts, dem Matthew Barney sich nahezu ein Jahrzehnt seines Lebens verschrieben hatte, sie bescherte der zeitgenössischen Kultur auch eines der komplexesten, am weitesten ausholenden und doch hermetisch verschlossensten Kunstwerke, die während dieser Dekade entstanden. Diese fünf abendfüllenden Filme wurden komplett auf hoch auflösendem 35-mm-Film aufgenommen oder auf ihn übertragen und nutzten erstmals Kinobudgets, Spezialeffekte, Techniken und Kostüme. Mit ihnen hat Barney das Genre Videokunst ein für alle Mal neu erfunden. Die *Cremaster*-Serie, deren Titel den Hodenhebermuskel bezeichnet, muss in Zellabschnitte unterteilt werden, um ihre Bedeutung zu enthüllen, da in diesem surrealen Tanz wie in einem Roman von James Joyce keine lineare Erzählstruktur vorliegt. In ähnlicher Joyce-Manier betreibt Barney eine Mutation der Bildsprache, um eine eigene enzyklopädische Welt der Selbstreferenzialität zu schaffen, über die die Filme miteinander verknüpft sind. Allerdings offenbaren die so zahlreichen wie verschiedenen Themen Gender, geschlechtliche Fortpflanzung, keltische Mythologie, Oper und sportliche Betätigung ebenso wie die Einbeziehung der Kultfiguren Richard Serra und Ursula Andress als Schauspieler sowie berüchtigter Figuren wie dem Mörder Gary Gilmore und dem Entfesselungskünstler Harry Houdini vielleicht mehr über Barneys entscheidende Anliegen als Performance-Künstler als jedes Geheimnis, das die Rätselhaftigkeit der Geschichten aufheben könnte. Mit welchen Großtaten Barney neben den Reflexionen über sein Opus magnum in Form damit verbundener, aber übrig gebliebener Skulpturen, Zeichnungen und Fotos nach diesem Multimedia-Monolithen noch aufwarten kann, weiß wohl nur er selbst.

La réalisation du cinquième et dernier épisode du cycle *Cremaster* de 300 minutes (1994–2002) n'a pas seulement marqué l'achèvement d'un projet qui a consumé dix années de la vie de Matthew Barney, mais donné à la culture contemporaine l'une des œuvres les plus complexes, les plus vastes et néanmoins hermétiques produites de par le monde au cours des dix dernières années. Ces cinq long métrages ont été entièrement tournés ou convertis en 35 mm haute définition, ils ont nécessité des budgets, des effets spéciaux, des technologies et des costumes qui ont à jamais redéfini le genre de l'art vidéo. En s'appropriant le muscle crémaster pour son titre, le cycle *Cremaster* doit être décomposé en ses divisions cellulaires pour révéler ses significations. Comme dans un roman de Joyce, on ne relève en effet aucune trame narrative linéaire dans toute cette danse surréaliste. D'une manière tout aussi joycienne, Barney détourne ou opère une mutation du langage visuel pour créer l'univers encyclopédique d'auto-citations qui lui est propre et qui assure la puissante cohésion entre chaque film. Reste que les thèmes divers et variés du sexe, de la reproduction, de la mythologie celtique, de l'opéra et de la performance sportive, mais aussi la participation de figures culte comme Richard Serra et Ursula Andress comme acteurs, ou de personnages célèbres comme le meurtrier Gary Gilmore et l'escapologiste Harry Houdini, en disent peut-être plus long sur le propos formel de Barney comme performer que tous les secrets qui permettraient de décrypter le mystère de ces histoires. Au-delà des nouvelles méditations sur son magnum opus données par les sculptures, les dessins et les photographies liées à cette œuvre, mais qui n'en représentent pas moins un travail parallèle, seul Barney lui-même sait quelles prouesses il pourrait encore accomplir pour donner une suite à son monolithe multimédia.

O. W.

1

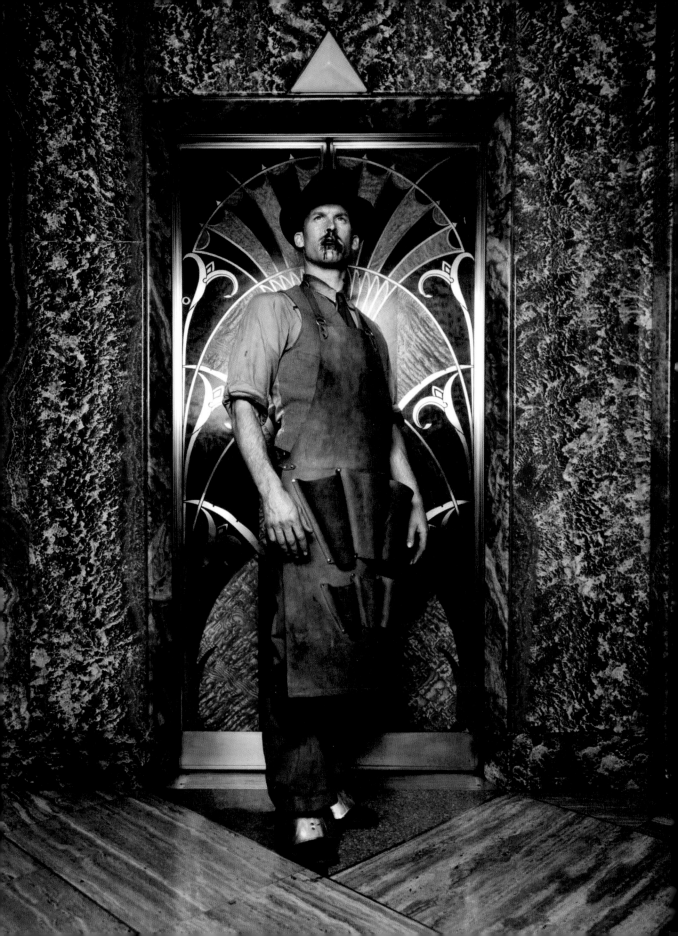

50

„Es ist, als öffnete man ein Ventil in einem geschlossenen System und benutzte entweder extreme Körperlichkeit, Gewalt oder Humor, um Druck abzulassen."

«C'est comme ouvrir une soupape quand on est dans un système clos et faire appel soit à des moyens physiques extrêmes ou à la violence, soit à l'humour pour relâcher la pression.»

"It's like opening a valve, being inside a closed system and using either extreme physicality or violence or humour to release pressure."

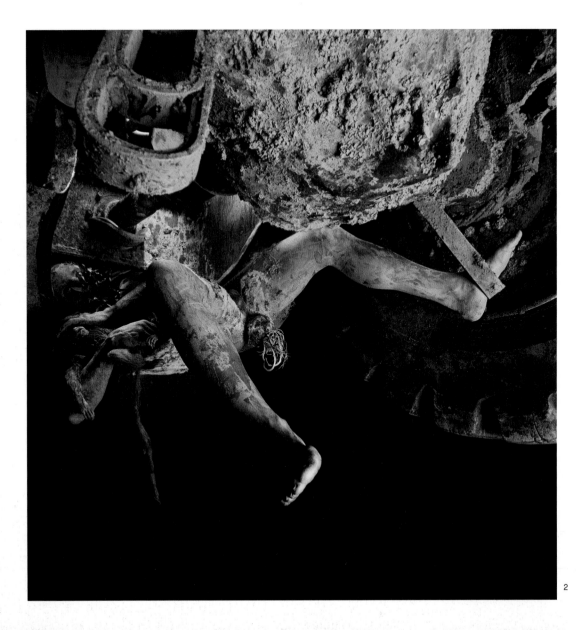

2

4

3

Vanessa Beecroft

1969 born in Genoa, Italy, lives and works in New York (NY), USA

Vanessa Beecroft originally trained as a painter, but in the early nineties she began appropriating subject matter as material, recruiting the models from her life drawing classes to appear as part of the work itself. In early works she dressed the girls in her own clothes and schoolgirl wigs and left them to hang around casually in gallery spaces, but her performances have since become increasingly stylized and rigorous, staged in ever more opulent settings. Series of large format glossy cibachromes and well-polished videos are produced as by-products of the performances. A turning point in scale of production came in 1998 with *Show*, where fifteen skinny models wearing Gucci bikinis and rhinestone high-heels (and five wearing nothing but heels), stood in military configuration in the atrium of Frank Lloyd Wright's spiraling Guggenheim Museum. Beecroft has said she thinks of the women like 'architecture', arranging them formally like human colonnades, their high heels acting like 'pedestals'. The results are glamorous, confrontational spectacles which provoke an array of unsettling questions about voyeurism, sexuality, repression, physical beauty and alienation. In recent pieces, Beecroft has delved into the territory of (racial) identity, exhibiting ensembles of strangely pale, thoroughly depilated women wearing egg-like masks over their heads (*VB47*, 2001), or Afro-American models in afro wigs, their skin made uniformly black with body make-up, bound together with silver shackles around their ankles (*VB54*, 2004). These highly controlled scenarios could be read as social allegories.

Vanessa Beecroft studierte ursprünglich Malerei und begann in den frühen neunziger Jahren, sich den Gegenstand als Material anzueignen, indem sie die Modelle aus ihren Anatomiekursen als Teil ihres Werks selbst auftreten ließ. In frühen Arbeiten verpasste sie den Mädchen ihre Kleider sowie Schulmädchen-Perücken und veranlasste sie, zwanglos in Galerieräumen herumzulungern. Aber ihre Performances wurden zunehmend stilisierter und strenger und ihre Inszenierung immer opulenter. Als Nebenprodukte ihrer Performances entstehen großformatige Hochglanz-Cibachromes und glatte Videos. Die Performance *Show* von 1998, bei der fünfzehn dürre Models in Gucci-Bikinis und hochhackigen Strasspumps (beziehungsweise fünf in nichts als Stöckelschuhen) in militärischer Formation im Atrium des spiralförmigen Guggenheim-Museums von Frank Lloyd Wright standen, markierte einen Wendepunkt im Hinblick auf den Produktionsmaßstab. Beecroft betrachtet Frauen nach eigener Aussage als „Architektur" und arrangiert sie formal im Sinne menschlicher Säulengänge, wobei ihre Pumps als „Basis" fungieren. Das Ergebnis sind glamouröse Konfrontationsschauspiele, die eine Reihe beunruhigender Fragen bezüglich Voyeurismus, Sexualität, Unterdrückung, physischer Schönheit und Entfremdung aufwerfen. In ihren jüngsten Arbeiten hat sich Beecroft in den Bereich der (Rassen-)Identität vertieft und Gruppen seltsam blasser, gründlich enthaarter Frauen mit eiförmigen Masken ausgestellt (*VB47*, 2001), außerdem mit Afro-Perücken ausgestattete afroamerikanische Modelle, deren Haut mit Körper-Makeup gleichmäßig schwarz gefärbt wurde und die mit silbernen Fußschellen aneinander gefesselt waren (*VB54*, 2004). Diese äußerst kontrollierten Szenarien lassen sich als Sozialallegorien verstehen.

Au début des années quatre-vingt-dix, après des études de peinture, Vanessa Beecroft a commencé à s'approprier comme matériau le sujet lui-même, recrutant les modèles de sa classe de nu pour les faire apparaître elles-mêmes comme l'œuvre. Dans ses premières œuvres, elle faisait porter aux filles ses propres vêtements et perruques d'écolière et les faisait déambuler dans les espaces d'exposition des galeries, mais au fil du temps, ses performances se sont stylisées, ont gagné en rigueur et ont été mises en scène dans des décors de plus en plus opulents. Des séries de grands cibachromes ultra-brillants et de vidéos minutieusement lissées sont réalisées comme des produits dérivés de ses performances. Un tournant dans l'échelle de production a été pris en 1998 avec *Show*, une performance au cours de laquelle quinze mannequins maigres portant des bikinis de chez Gucci et des chaussures fantaisie à talons hauts (cinq étant seulement vêtues de chaussures à talons) se tenaient debout en formation militaire dans l'atrium du bâtiment en spirale du Musée Guggenheim de Frank Lloyd Wright. Beecroft a pu dire qu'elle concevait les femmes comme de « l'architecture », les arrangeant formellement comme des colonnades humaines, les talons hauts fonctionnant comme des « piédestaux ». Les spectacles à la fois glamour et provocateurs qui résultent de cette démarche soulèvent des séries de questions troublantes autour du voyeurisme, de la sexualité, de la répression, de la beauté physique et de l'aliénation de l'individu. Dans ses œuvres récentes, Beecroft explore le domaine problématique de l'identité (raciale), exposant des groupes de femmes singulièrement pâles, entièrement épilées, portant sur leur tête des masques mous apparentés à des œufs (*VB47*, 2001), ou encore des modèles afro-américaines portant des perruques afro, la peau rendue uniformément noire par un make-up corporel, attachées les unes aux autres par des chaînes d'argent entourant les chevilles (*VB54*, 2004). Ces scénarios hautement contrôlés peuvent se lire comme des allégories sociales. K. B.

SELECTED EXHIBITIONS →
2004 *Power by Emotions*, Frankfurter Kunstverein; Tirana Biennial
2003 *Retrospective*, Castello di Rivoli, Turin **2002** *VB51*, Schlosspark Vinsebeck; *VB50*, 25. Bienal de São Paulo **2001** *VB48*, Palazzo Ducale, Genoa; *VB47*, Peggy Guggenheim Collection, Venice; Museet for samtidskunst, Oslo **2001** 49. Biennale di Venezia, Venice

SELECTED PUBLICATIONS →
2003 *Retrospective*, Castello di Rivoli, Turin **2000** *VB08–36: Vanessa Beecroft Performances*, Ostfildern-Ruit **1997** *Future, Present, Past*, 47. Biennale di Venezia, Venice

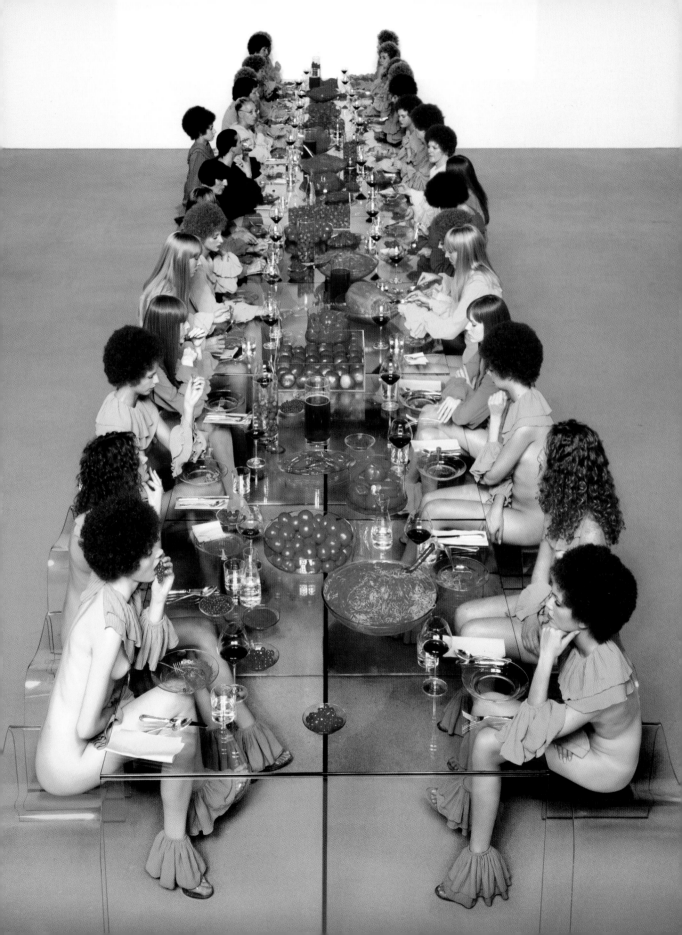

1 **VB52**, 2003, Castello di Rivoli, Turin
2 **VB50**, 2002, 25. Bienal de São Paulo
3 **VB46**, 2001, Gagosian Gallery, Los Angeles

„Ich versuche, jede meiner Performances abstrakter, schwieriger, künstlicher und unkonkreter zu gestalten als die vorherige."

«J'essaie de rendre chacune de mes performances plus abstraite, plus dure, plus artificielle, moins incarnée que la précédente.»

"I try to make each of my performances more abstract, harder, more artificial, less embodied than the one before."

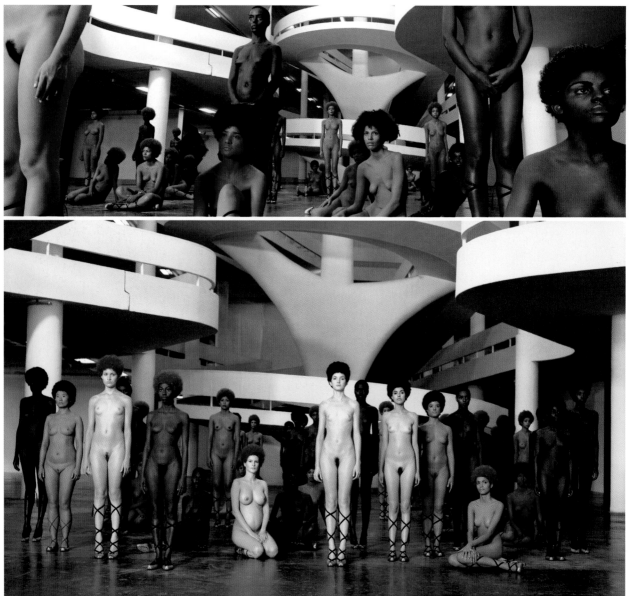

2

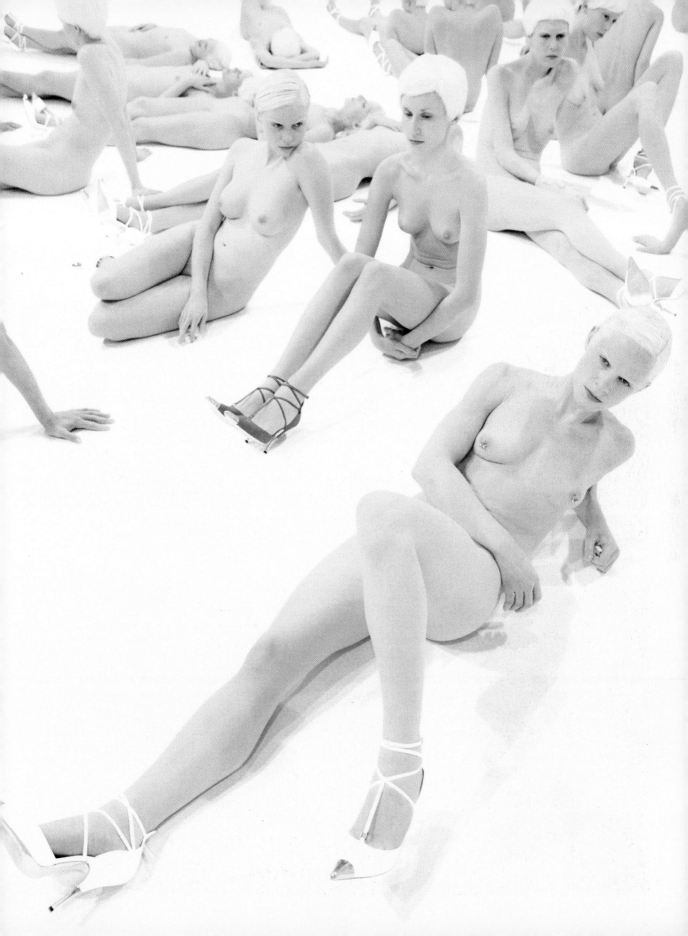

John Bock

1965 born in Gribbohm, lives and works in Berlin, Germany

Building upon his first lecture performances in the early nineties, John Bock has woven his work into a complex cosmos which seems in the meantime to have become fully individualized. For all of its clear links to the traditions of the absurd, to Dada, to Happenings and Fluxus, and to Viennese Actionism and Beuysian shamanism, its multilayered theatricality is characterized by a vocabulary all its own, which can be traced back to his early work. In performances like *Kunstwohlfahrtsmaschine* (1992) or *Der große und der kleine Rezipient* (1993), for example, Bock used only a few props and improvised a torrent of words interspersed with pseudo-scientific jargon. He has used overhead projectors, flipcharts, and blackboards to graphically supplement these performances. Thereby he refers specifically to aspects of the artistic context, taken to the point of absurdity in his explanations. Bock has widened this basic framework into a freer performance practice driving towards psychophysical absurdity, which has ties to folk theatre, cabaret, and slapstick, as well as to expressionist theatre and the other artistic contexts already mentioned. He has engineered his deliberately amateurish props made of highly diverse and usually cheap materials into complexly representational objects, bodily extensions, and costumes, and has developed multilayered spatial and staging concepts for them. Video and film, initially used only for documentation, became independent visual material, as in *Porzellan Isoschizo...* (2001) and *Meechfieber* (2004). The way Bock artistically deals with objects thus promotes the interpenetration of performance, film, theatre, and video media.

Ausgehend von ersten Vortragsperformances Anfang der neunziger Jahre hat John Bock sein Werk zu einem komplexen und mittlerweile völlig individualisierten Kosmos verwoben. Dessen vielschichtige Theatralität ist bei allen offenbaren Anknüpfungen an Traditionen des Absurden, an Dada, Happening und Fluxus, an Wiener Aktionismus und Beuys'sches Schamanentum, von einer ganz eigenen Diktion geprägt, die sich bis in die frühen Arbeiten zurückverfolgen lässt. Bei Performances wie *Kunstwohlfahrtsmaschine* (1992) oder *Der große und der kleine Rezipient* (1993) etwa hatte Bock noch anhand weniger Requisiten einen mit pseudowissenschaftlichem Vokabular durchsetzten Redefluss improvisiert, den er mittels Overheadprojektor, Flipchart oder Schultafel auch grafisch flankierte. Dabei bezog er sich im engeren Sinn auf Aspekte des Kunstkontexts, die er erläuternd ad absurdum führte. Diesen Rahmen hat Bock dann zu einer freieren, in psychophysische Absurdität hinein treibenden Aufführungspraxis erweitert, die ebenso an Volkstheater, Kabarett und Slapstick wie an expressionistisches Theater und genannte Kunstkontexte anknüpft. Dabei hat er die betont laienhaft gebastelten Requisiten aus breit gefächertem, meist billigem Material zu komplexen Handlungsträgern, Körpererweiterungen und Kostümierungen weiterentwickelt und dafür vielschichtige Raum- und Bühnenkonzepte entwickelt. Video und Film, zuerst bloß zur Dokumentation eingesetzt, wurden zu eigenständigen Bildmitteln, etwa in *Porzellan Isoschizo...* (2001) oder *Meechfieber* (2004). So hat Bock im bildnerischen Umgang mit Objekten die wechselseitige Durchdringung von Performance, Film, Theater, Video vorangetrieben.

Depuis ses premières conférences-performances présentées au début des années quatre-vingt-dix, John Bock a tissé son œuvre de manière à la transformer en un cosmos complexe qui se présente aujourd'hui comme un tout entièrement individualisé. Malgré les multiples références explicites à certaines traditions de l'absurde, au dadaïsme, au happening et à Fluxus, à l'actionnisme viennois et au chamanisme beuyssien, la théâtralité polysémique de cet univers dénote un ton résolument personnel dont on peut relever les traces dès ses toutes premières œuvres : pour des performances comme *Kunstwohlfahrtsmaschine* (1992) ou *Der große und der kleine Rezipient* (1993), Bock, qui ne faisait encore qu'un usage parcimonieux des accessoires, improvisait alors des logorrhées émaillées de termes pseudoscientifiques, complétées graphiquement par un rétroprojecteur, un tableau de conférence ou un tableau noir. Il s'y référait plus particulièrement à certains aspects du contexte artistique, que ses explications poussaient jusqu'à l'absurde. Par la suite, Bock a développé ce cadre à travers une pratique du spectacle plus libre et plus fortement teintée d'absurdité pathologique, qui se rattache au théâtre populaire, au cabaret et au comique aussi bien qu'au théâtre expressionniste et aux contextes artistiques déjà cités. Ses accessoires manifestement bricolés ont été développés à partir d'un vaste éventail de matériaux généralement bon marché qui deviennent des supports d'action complexes, des prolongements corporels et des costumes, et Bock a élaboré pour cela des concepts spatiaux et scénographiques à multiples niveaux de sens. La vidéo et le film, qui servaient initialement un propos purement documentaire, sont devenus des moyens plastiques à part entière, comme le montrent notamment *Porzellan Isoschizo...* (2001) et *Meechfieber* (2004). Dans son rapport plastique avec les objets, Bock a ainsi fait progresser l'interaction des médiums comme la performance, le film, le théâtre et la vidéo.

J. A.

1

SELECTED EXHIBITIONS →
2005 51. Biennale di Venezia, Venice **2004** Fondazione Nicola Trussardi, Stazione Centrale, Milan; *Klütterkammer*, Institute of Contemporary Arts, London; *Der Gast*, Sprengel Museum Hannover; Manifesta 4, San Sebastián **2003** Museum Boijmans Van Beuningen, Rotterdam; Arken Museum of Modern Art, Ishøj

SELECTED PUBLICATIONS →
2004 *Koppel*, Cologne, Arken Museum of Modern Art, Ishøj; *Klütterkammer*, Frankfurt/Main, Institute of Contemporary Arts, London **2001** *Gribbohm*, Gesellschaft für Aktuelle Kunst, Bremen

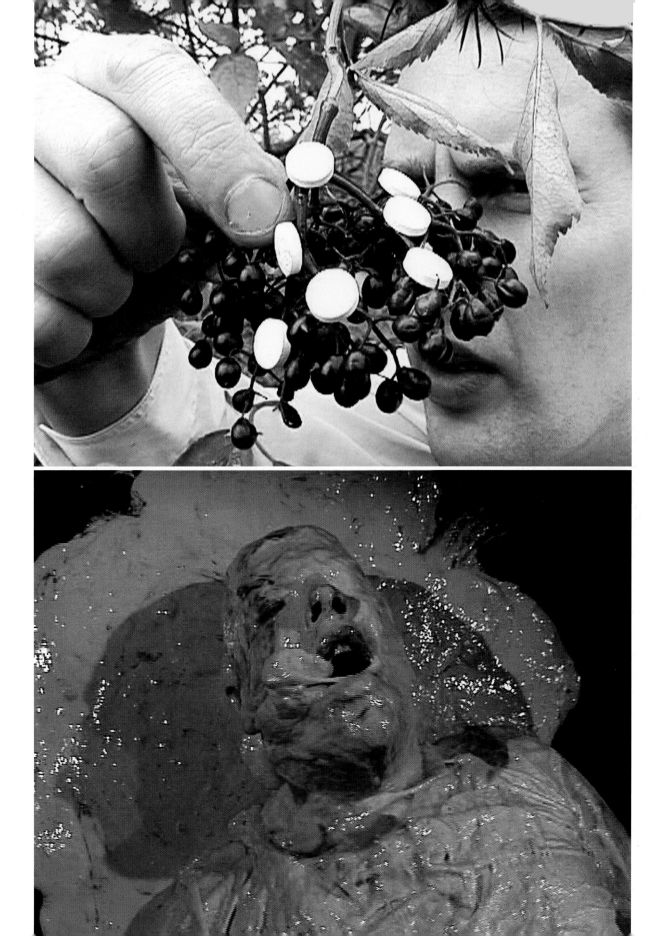

1 **Astronaut**, 2003, video stills
2 **Meechfieber (Meechfever)**, 2004/05, video stills, co-commissioned by

Carnegie International, Carnegie Museum of Art, Pittsburgh, and Fondazione Nicola Trussardi, Milan

„... die von mir verwendete Sprache setzt sich nicht aus Wörtern, sondern aus Kunst zusammen. Man kann auch mit Objekten, Aktionen und Gemälden etwas erzählen."

«... le langage dont je me sers n'est pas constitué de mots, mais d'art. L'art est un langage. On peut raconter quelque chose avec des objets, des actions et des peintures.»

"... the language I'm using is not made of words but art. Art is a language. You can tell something with objects, actions and paintings."

2

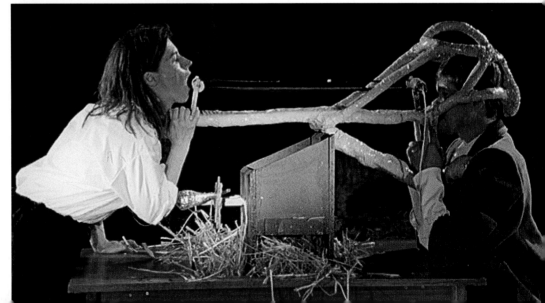

Cosima von Bonin

1962 born in Mombasa, Kenya, lives and works in Cologne, Germany

Objects and activities are presented in such a playful manner in Cosima von Bonin's exhibitions that they seem like magical places. A boat sheathed in colourful fabric could be stranded beside a pair of giant mushrooms, or the empty textile covering of something indefinable could hang limply from the ceiling. It is difficult to determine the origin of these objects, and the context does not make their symbolism completely clear, for the artist always holds something back, which infiltrates the individual objects' presence. Thus the performance video in the exhibition "2 Positionen auf einmal", shows exactly that which is absent – namely events before the exhibition opened – and contrasts it with that which is physically present. Her production's preconditions appear more important than its results, which after all only depict an event frozen into an object. This assumption is supported by the fact that von Bonin always integrates a whole circle of people she knows into her pieces, and makes reference to other artists' works. This method reflects the context in which her own activities can be located. While this qualifies the status of the artistic personality's autonomy, it simultaneously provides von Bonin with support for her own actions. Besides the metaphors that cloth objects such as mushrooms or fences embody, the very use of textiles is also crucial. Irrespective of feminist appropriation, carefully selected designer materials play a role here. Notable too is the contrast to room-filling works, like the monumental gesture of the boat in the installation *Bruder Poul sticht in See* (2001), particularly when the dreamy atmosphere is then destroyed by catapulting balls of material through the exhibition.

In den Ausstellungen von Cosima von Bonin sind Objekte und Handlungen so verspielt inszeniert, dass sie wie magische Orte wirken. Ein mit buntem Stoff überzogenes Boot scheint neben einem Paar riesiger Pilze gestrandet zu sein, oder die textile Hülle von etwas Unbestimmbarem hängt schlaff von der Decke. Es ist schwer zu erkennen, woher die Gegenstände kommen, deren Symbolik aus dem Zusammenhang nicht vollends klar wird. Denn die Künstlerin hält immer etwas zurück, das die Präsenz der einzelnen Objekte unterläuft. So zeigt das Performance-Video in der Ausstellung „2 Positionen auf einmal" gerade das Abwesende – nämlich die Geschehnisse vor der Eröffnung – und stellt es dem gegenüber, was physisch anwesend ist. Die Voraussetzungen ihrer Produktion scheinen entscheidender als das Resultat, das letztlich nur eine zum Objekt eingefrorene Handlung darstellt. Diese Annahme wird durch die Tatsache gestützt, dass von Bonin immer einen ganzen Kreis befreundeter Personen in ihre Arbeit einbezieht und auf Werke anderer Künstler verweist. Diese Vorgehensweise reflektiert den Zusammenhang, in dem ihre eigenen Aktivitäten verortet sind. Der Status der autonomen Künstlerpersönlichkeit wird zwar relativiert, gleichzeitig aber gewinnt von Bonin dabei Unterstützung für ihr eigenes Tun. Neben den Metaphern, die Stofffiguren wie Pilz oder Gatter verkörpern, ist der Einsatz des textilen Materials entscheidend. Abgesehen von feministischer Aneignung spielen dabei ausgesuchte Designerstoffe eine Rolle. Bemerkenswert ist auch der Kontrast zu raumgreifenden Arbeiten wie dem Boot in der Installation *Bruder Poul sticht in See* (2001) in ihrer monumentalen Geste, vor allem wenn die verträumte Atmosphäre durch das Katapultieren von Stoffballen durch die Ausstellung jäh gestört wird.

Dans les expositions de Cosima von Bonin, les objets et les actions sont mis en scène de manière si ludique qu'ils font l'effet de lieux magiques. Une barque tendue de tissu bigarré peut s'être échouée à côté de champignons géants, ou l'enveloppe textile d'un objet indéfini pendre mollement du plafond. La provenance des objets est difficilement identifiable et le contexte n'éclaire qu'incomplètement leur symbolique. Car l'artiste retient toujours quelque chose qui mine la présence des différents objets. Ainsi, la performance vidéo de l'exposition « 2 Positionen auf einmal » montre précisément ce qui est absent – les événements qui ont précédé l'exposition – et le confronte à ce qui est physiquement présent dans l'exposition. Les conditions de sa production semblent plus significatives que le résultat, qui ne représente en définitive qu'une action coagulée dans un objet. Cette hypothèse est étayée par le fait que von Bonin intègre tout un cercle d'amis dans son travail et qu'elle fait aussi référence aux œuvres d'autres artistes. Une telle démarche reflète le contexte dans lequel s'inscrivent ses propres activités. Si le statut de la personnalité artistique autonome s'en trouve relativisé, von Bonin y puise en même temps un soutien pour sa propre activité. Au-delà des métaphores incarnées par les figures de tissus comme les champignons ou les clôtures, l'emploi de matériaux textiles constitue un aspect significatif. Indépendamment de l'appropriation féministe, la sélection de tissus de designers joue un rôle important. Un aspect remarquable est aussi le contraste avec les œuvres qui investissent l'espace, comme la barque de l'installation *Bruder Poul sticht in See* (2001), avec son attitude monumentale – surtout quand l'atmosphère onirique est détruite par le catapultage de ballots de tissu à travers l'exposition.

C. E.

1

SELECTED EXHIBITIONS →
2005 *Exit_Ausstieg aus dem Bild*, Zentrum für Kunst und Medientechnologie, Karlsruhe **2004** *Born to be a star – Sound Video, Installationen, Performances*, Künstlerhaus Wien, Vienna; *2 Positionen auf einmal*, Kölnischer Kunstverein, Cologne; *Rhinegold: Art from Cologne*, Tate Liverpool **2002** *Fondorientierte Ausstattung*, Neue Galerie am Landesmuseum Joanneum, Graz **2001** *Bruder Poul sticht in See*, Kunstverein Hamburg

SELECTED PUBLICATIONS →
2004 *2 Positionen auf einmal*, Kölnischer Kunstverein, Cologne **2003** *Die bessere Hälfte – Künstlerinnen des 20. und 21. Jahrhunderts*, Cologne **2001** *Bruder Poul sticht in See*, Kunstverein Hamburg, Hamburg

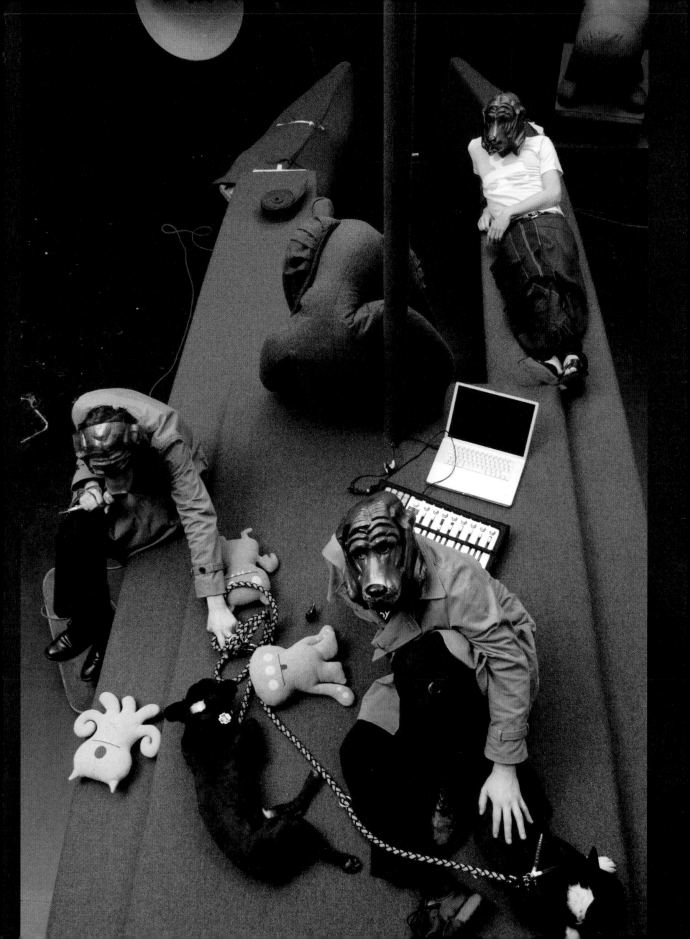

62

2

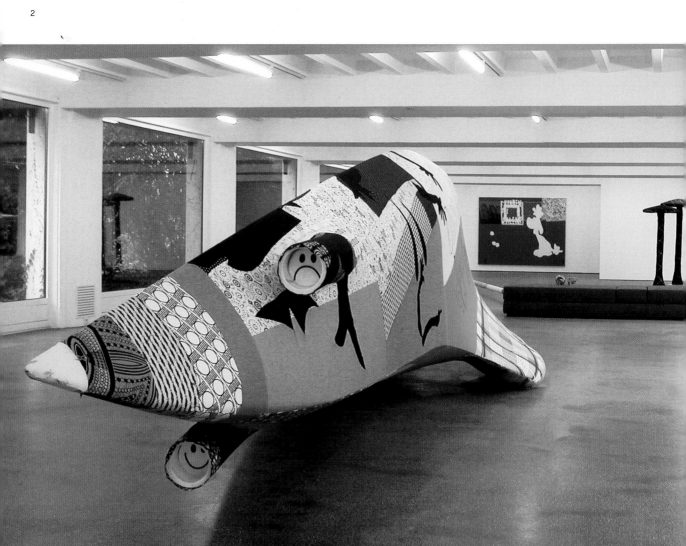

3

4

Monica Bonvicini

1965 born in Venice, Italy, lives and works in Berlin, Germany

Architecture is built upon the sweat of men: that of its theorists, planners, and builders. This is the male bulwark against which Monica Bonvicini has been protesting for years – rattling its foundations, smashing its windows, spraying it with obscene graffiti, and converting its chambers into SM clubs. *Black* (2002) is a construction of steel tubes transformed by a leather meshwork into room dividers. A leather swing hangs amidst heavy chains within this boundary. The floor is clad in black linoleum, and dramatic spotlights pierce the gloom. Bonvicini unmasks architecture as a playground for men's erotically charged dreams. She also does this in a softer version of an interior, *Eternmale* (2000). In this ensemble of Willy Guhl Eternit furniture, artificial turf, videos, and CDs, carnal desires reveal themselves in the plumply rounded shapes of the chairs. The contradictory roles of the construction worker – both as a bastion of true manliness and as a stereotype upon which homoerotic fantasies are projected – are weighed against each other in *These Days only a Few Men Know What Work Really Means* (1999). These large-format photographs are based on gay pornography combined with text fragments from chatrooms – two forms of expression for aggressive male sexuality. For Bonvicini the materials represent different spheres – that of rational thought, as it is ostensibly expressed in the architecture of modernism, and the world of the Freudian unconscious. In *Caged Tool 1– 4* (2004) She transformed tools into fetishes. Encased in a skin of black leather, heavy hammers and saws hang in metal cages. Overblown into erotic objects, they are simultaneously trophies afflicted by a sticky substance that robs them of their potency.

Architektur basiert auf Männerschweiß, dem ihrer Theoretiker, Planer und Erbauer. Gegen dieses Bollwerk läuft Monica Bonvicini seit Jahren Sturm, rüttelt an seinen Fundamenten, schlägt seine Scheiben ein, besprüht es mit obszönen Graffiti und verwandelt seine Kammern in SM-Clubs. *Black* (2002) ist eine Konstruktion aus Stahlrohren, die durch Ledergeflecht in Raumteiler verwandelt werden. Inmitten dieser Abgrenzung hängt eine Schaukel aus Leder zwischen schweren Ketten, der Boden ist mit schwarzem Linoleum überzogen, dramatische Spots durchbrechen die Düsternis. Bonvicini demaskiert Architektur als Spielwiese erotisch aufgeladener Männerträume, so auch in der softeren Version eines Interieurs, *Eternmale* (2000), ein Ensemble aus Willy-Guhl-Eternitmöbeln, Kunstrasen, Videos und CDs, in dem sich – im Entwurf des rundlich geformten Stuhls – die Begierden offenbaren. Die widersprüchlichen Rollen des Bauarbeiters als Sinnbild wahrer Männlichkeit und Projektionsfläche homoerotischer Fantasien werden in *These Days only a Few Men Know What Work Really Means* (1999) gegeneinander austariert: Die großformatigen Fotografien basieren auf Schwulenpornos, die mit Textfragmenten aus Chatrooms kombiniert sind – beides Ausdrucksformen aggressiver männlicher Sexualität. Die Materialien repräsentieren bei Bonvicini verschiedene Sphären – die des rationalen Denkens, wie sie sich vorgeblich in der Architektur der Moderne ausdrückt, und die Welt des Freud'schen Unbewussten. In *Caged Tool 1– 4* (2004) hat sie Werkzeuge in Fetische verwandelt: Mit einer schwarzen Lederhaut überzogen, hängen schwere Hämmer und Sägen in Metallkäfigen. Sie sind zu erotischen Objekten übersteigert, gleichzeitig aber mit einer klebrigen Substanz behaftete Trophäen, die ihnen ihre Potenz raubt.

L'architecture repose sur la sueur des hommes, celle de ses théoriciens, concepteurs et constructeurs. Depuis des années, Monica Bonvicini fulmine contre cette forteresse, secouant ses fondations, brisant ses vitres, la couvrant de graffitis obscènes et transformant ses chambres en clubs sadomaso. *Black* (2002) est une construction de tubes en acier transformés en cloisons par des entrelacs de lanières de cuir. Au milieu de ces délimitations, une balançoire en cuir est accrochée entre de lourdes chaînes, le sol est couvert de linoléum noir, des spots dramatiques transpercent l'obscurité lugubre. Bonvicini démasque l'architecture comme un terrain de jeu de rêves masculins chargés d'érotisme, notamment avec *Eternmale* (2000), version plus soft d'un intérieur composé de meubles en Eternit signés Willy Guhl, de gazon artificiel, de vidéos et de CDs, et dans lequel – avec la conception de la chaise aux formes arrondies – se manifestent les désirs masculins. Les rôles contradictoires de l'ouvrier de chantier comme bastion de l'authentique virilité et surface de projection des fantasmes homoérotiques, sont pondérés dans *These Days only a Few Men Know What Work Really Means* (1999) : ces photographies grand format reposent sur des revues porno gay associées à des fragments de texte tirés de *chatrooms* – les deux étant l'expression d'une sexualité masculine agressive. Chez Bonvicini, les matériaux renvoient à des sphères distinctes – celle de la pensée rationnelle, telle qu'elle s'exprime prétendument dans l'architecture de la modernité, et celle de l'inconscient freudien. Dans *Caged Tool 1– 4* (2004), elle a transformé des outils en fétiches : tendus d'une peau en cuir, de lourds marteaux et des scies sont suspendus dans des cages métalliques. Exacerbés jusqu'à l'objet érotique, ils sont en même temps des trophées enduits d'une substance gluante qui leur ôte toute puissance.

A. M.

SELECTED EXHIBITIONS →
2005 51. Biennale di Venezia, Venice **2004/05** *Monica Bonvicini, Elmgreen & Dragset,* Sprengel Museum Hannover **2004** 3. berlin biennale **2003** *Anxiety Attack,* Modern Art Oxford; *Poetic Justice,* 8. Istanbul Biennial **2002** *What does your wife/girlfriend think of your rough and dry hands?,* Palais de Tokyo, Paris; *Urban Creation,* 4. Shanghai Biennale

SELECTED PUBLICATIONS →
2003 *Monica Bonvicini: Anxiety Attack,* Modern Art Oxford and Tramway, Glasgow; *Monica Bonvicini/Sam Durant: Break it/Fix it,* Secession, Vienna **2001** *Monica Bonvicini: Scream & Shake,* Le Magasin, Grenoble

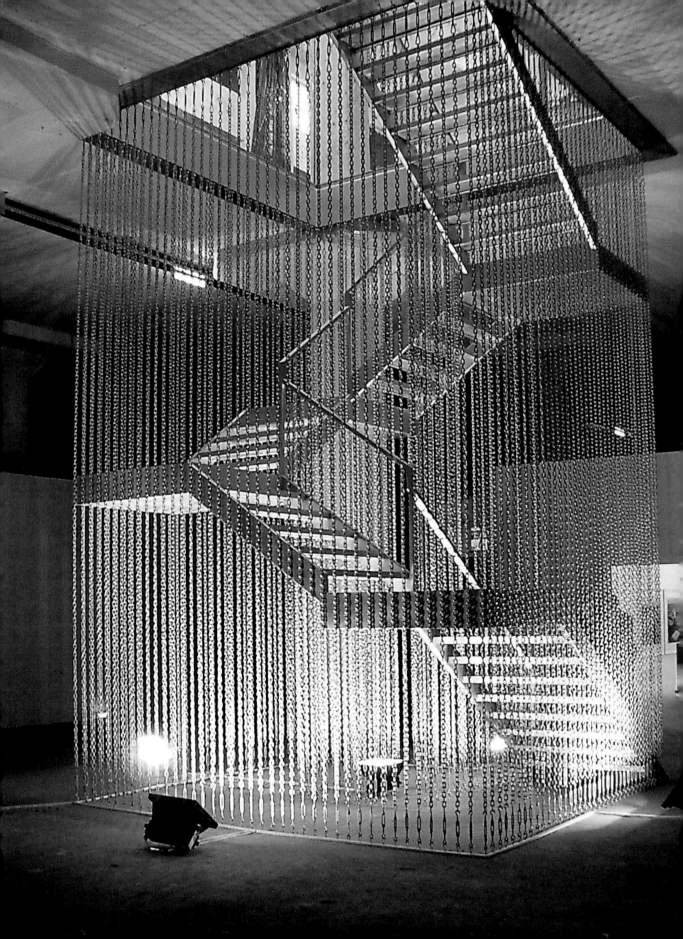

1 **Stairway to Hell**, 2003, steel structure, chains, broken safety glass, dimensions variable, installation view, 8. Istanbul Biennial
2 **Black**, 2002, steel, leather, swing, chains, black walls, black linoleum, adaptable dimensions

3 **Add Elegance to Your Poverty**, 1999, graffiti on wall
4 **Stonewall 3**, 2002, galvanized steel, chains, broken safety glass, 200 x 1230 x 100 cm, installation view, migros museum für gegenwartskunst, Zurich

„Ich möchte die Aura entmystifizieren, die noch immer um die Kunst herum schwebt, trotz aller Versuche, die unternommen wurden, um sie aufzubrechen."

«Je veux démystifier l'aura qui continue d'entourer l'art malgré toutes les tentatives entreprises pour la détruire.»

"I want to demystify the aura that is still around art, despite all the attempts that have been made to break it."

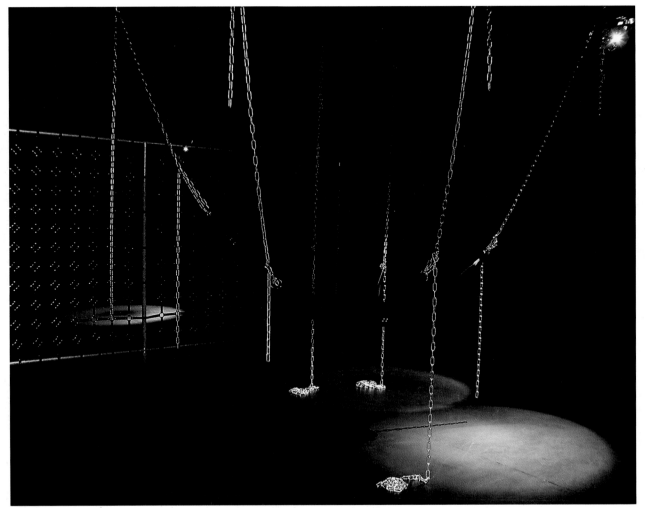

2

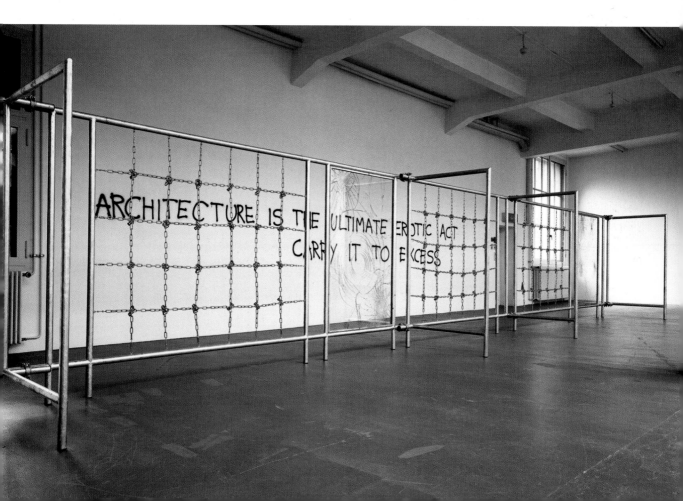

3

Candice Breitz

1972 born in Johannesburg, South Africa, lives and works in Berlin, Germany

How does one become Cameron Diaz or Jennifer Lopez? In her video work *Becoming...* (2004), named after the similarly titled MTV show, Candice Breitz recreates scenes from Hollywood romances. Breitz imitates the facial expressions and gestures used by the actresses to express a standard repertoire of emotional sentiment, and exposes the formulaic nature of globally present identification figures. *Becoming...* follows up on earlier works in which Breitz investigates the fiction, as conveyed by popular culture and the mass media, of universality in language and identity. The video installation *Four Duets* (1999/2000), reduces love songs from Annie Lennox and Whitney Houston to their basic pattern, the relationship between "I" and "you". Thus the singers are trapped in a seemingly absurd search for interaction in such text fragments as "You you you" or "Me My I". Breitz, who is a white South African, became known through her earlier collages such as the *Rainbow Series* (1996). The arbitrary and grotesque formations, which she created from image fragments of the bodies of white and black women cut from pornographic and ethnographic illustrations, refer to the deep rifts in South African society after the end of Apartheid. In stressing the restrictions inherent in formulas of cultural identification, Breitz begins with the idea of language's function as something regulative and a means of domination: In *Alien – Ten Songs from Beyond* (2002), she implants immigrants in Berlin with the language of their new homeland: the ten people sing German hymns and folksongs, but it is not their voices you hear as they try out the unfamiliar melodies and texts. Instead, recordings of native Germans have been superimposed over the immigrants' sound tracks.

Wie wird man zu Cameron Diaz oder Jennifer Lopez? In der Videoarbeit *Becoming...* (2004), benannt nach der MTV-Show, spielt Candice Breitz Szenen aus Hollywood-Romanzen nach. Breitz imitiert die Mimik und Gestik, mit der die Schauspielerinnen ein Standardrepertoire an emotionaler Bewegtheit ausdrücken, und legt die Formelhaftigkeit global verbreiteter Identitätsmodelle bloß. *Becoming ...* schließt an frühere Arbeiten an, in denen Breitz die Fiktion einer Universalität von Sprache und Identität problematisiert, wie sie über Populärkultur und Massenmedien transportiert wird. Die Videoinstallation *Four Duets* (1999/2000) reduziert Liebeslieder von Annie Lennox oder Whitney Houston auf ihr Grundmuster, die Beziehung zwischen dem „Ich" und dem „Du", so dass die Sängerinnen in einer absurd anmutenden Suche nach Interaktion in den Textfragmenten „You you you" oder „Me My I" gefangen sind. Bekannt wurde die weiße Südafrikanerin Breitz mit ihren frühen Collagen, etwa *Rainbow Series* (1996). Die willkürlichen und grotesken Formationen, zu denen sie Körperfragmente weißer und schwarzer Frauen aus pornografischen und ethnografischen Abbildungen zusammensetzte, wiesen auf die tiefen Brüche der südafrikanischen Gesellschaft auch nach dem Ende der Apartheid hin. In ihrer Betonung der Einengung durch kulturelle Identitätsformeln geht Breitz von der Funktion von Sprache als Regulativ, als Mittel zur Dominanz aus: In *Alien – Ten Songs from Beyond* (2002) pflanzte sie Immigranten in Berlin die Sprache ihrer neuen Heimat ein: Die zehn Personen singen deutsche Hymnen und Volkslieder, doch man hört nicht ihre Stimmen, die sich den ungewohnten Melodien und Texten nähern, stattdessen sind Aufnahmen einheimischer Deutscher über die Tonspuren der Immigranten gelegt.

Comment devient-on Cameron Diaz ou Jennifer Lopez? Dans la vidéo *Becoming...* (2004), intitulée d'après l'émission homonyme diffusée par MTV, Candice Breitz rejoue les scènes de certaines comédies sentimentales hollywoodiennes. Elle imite la mimique et la gestuelle avec lesquelles les actrices expriment un répertoire d'émotions figé et met ainsi en évidence les stéréotypes des modèles identitaires mondiaux. *Becoming...* se rattache à des œuvres antérieures dans lesquelles Breitz posait le problème de la fiction d'un langage et d'une identité universels, telle qu'elle est diffusée par la culture populaire et les mass media. L'installation vidéo *Four Duets* (1999/2000) ramène des chansons d'amour d'Annie Lennox ou de Whitney Houston à leurs schémas de base, à savoir le rapport entre «moi» et «toi». A travers les fragments de texte «You you you» ou «Me My I», les chanteuses apparaissent dès lors prisonnières d'une recherche d'interaction confinant à l'absurde. La Sud-Africaine blanche Breitz s'est fait connaître par ses premiers collages, comme on peut les voir dans ses *Rainbow Series* (1996). Les formations arbitraires et grotesques constituées de fragments corporels de femmes blanches et noires issus de représentations pornographiques et ethnographiques, renvoient aux profondes fractures de la société sud-africaine et à la fin de l'apartheid. Pour faire apparaître le caractère réducteur des formules culturelles et identitaires, Breitz part de la fonction du langage comme outil régulateur et moyen de domination. Dans *Alien – Ten Songs from Beyond* (2002), elle implantait à des immigrants berlinois le langage de leur nouvelle patrie: dix personnes y chantent l'hymne allemand et des chansons populaires allemandes. En fait, les voix qui tentent de maîtriser ces textes et ces mélodies inhabituels ne sont pas les leurs, mais des enregistrements d'Allemands de souche superposés sur les bandes son des immigrants. E. K.

SELECTED EXHIBITIONS →
2004 *Becoming*, Moderna Museet, Stockholm; *Mother + Father*, Castello di Rivoli, Turin **2003** *Re-Animations*, Modern Art Oxford **2002** *Alien (Ten Songs from Beyond)*, Künstlerhaus Bethanien, Berlin **2001** *Cuttings*, O.K Centrum für Gegenwartskunst, Linz, Kunstverein Sankt Gallen, New Museum of Contemporary Art, New York, Centre d'Art Contemporain Genève, Geneva; De Appel, Amsterdam

SELECTED PUBLICATIONS →
2003 *Candice Breitz: Re-Animations*, Modern Art Oxford
2001 *Candice Breitz: Cuttings*, O.K Centrum für Gegenwartskunst, Linz

1 **Mother**, 2005, 6-channel installation
2 **Diorama (Texas Version)**, 2002, DVD installation

3 **Becoming**, 2003, stills, 14-channel installation consisting
of 7 dual-channel installations

„Wenn es die Aufgabe des globalen Berufspendlers ist, den Mythos globaler Vernetzung zu verbreiten, dann liegt die Aufgabe des Künstlers [...] darin, diesem und anderen Mythen entgegenzutreten."

«Si la tâche du travailleur pendulaire de la globalisation consiste à répandre le mythe de la connectivité globale, celle de l'artiste [...] consiste à contrecarrer ce genre de mythes.»

"If the work of the global business commuter is to spread the myth of global connectivity, then the work of the artist [...] is to counter this and similar myths."

2

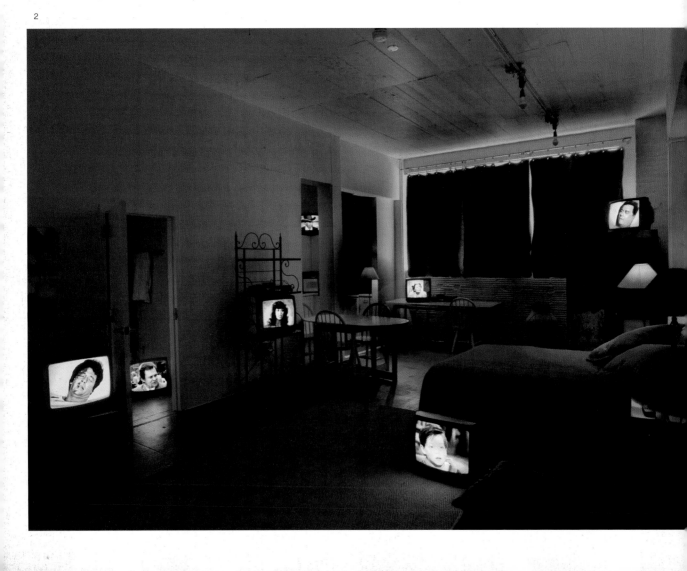

Cecily Brown

1969 born in London, UK, lives and works in New York (NY), USA

Cecily Brown's works have an element of the obsessively tasteful. This is perhaps their greatest provocation. Executed in the very traditional medium of oil on canvas, the generally large-format paintings represent a balancing act, newly defined in every painting, between figuration and an abstract-gestural style. Brown takes her motifs predominantly from porn magazines. In Brown's pictures one sees men and women, couples and groups, sexual acts sometimes from afar, and sometimes close up, all in various degrees of revelation and concealment. Thereby Brown, with great refinement, takes the visual unambiguousness clamoured for by the obscene to the most diverse degree of painterly dissolution. The vagueness and the blurring of the bodies forces a searching gaze. Abstracting omissions demand interpretation and reposition the viewer in the role of voyeur, while the erotic charge flows back into the painting itself in an open display of delicacy and opulence. This is even stronger in newer works, in which Brown concretely connects the views of "figurative landscapes" with real landscape portrayals. Painting such as *Couple* and *Teenage Wildlife* (both 2003), for example, play out clichés of secluded revelry in untouched nature in an almost rococo manner. The protagonists, enraptured in the undergrowth, are hardly more than spots of colour and therefore left all the more to the imagination. The natural setting is also conducive to the enhanced freedom of painting in a gestural, floral, all-over style, and paintings such as *Ambush Makeover* and *Landscape*, or *Canopy* and *Looby Loo* doubly so (all 2003), are almost only connected with the representational in their titles, and then diffusely. Thereby the painting style, however, represents itself all the more.

Die Bilder von Cecily Brown haben etwas obsessiv Geschmackvolles. Darin liegt ihre vielleicht größte Provokation. Die meist großformatige Malerei, formal durchaus traditionell in Öl auf Leinwand ausgeführt, ist eine mit jedem Bild aufs Neue austarierte Gratwanderung zwischen Figuration und abstrakt-gestischer Malweise. Ihre Motive entnimmt Brown überwiegend aus Pornomagazinen. In unterschiedlichen Graden von Entblößung und Verschleierung schaut man in Browns Bildern auf Männer und Frauen, Paare und Gruppen, sieht sexuelle Akte mal in der Totale und mal en détail. Die visuelle Eindeutigkeit, auf die das Obszöne drängt, treibt Brown dabei mit großem Raffinement in verschiedenste Grade malerischer Auflösung hinein. Die Vagheit, das Verschwimmen der Körper forciert den suchenden Blick, abstrahierende Auslassungen fordern zur Ausdeutung auf und positionieren den Betrachter einmal mehr als Voyeur, während die erotische Aufladung in offen inszenierter Delikatesse und Opulenz auch an die Malerei selbst zurückgegeben wird. Das gilt verstärkt für jüngere Arbeiten, in denen Brown den Blick auf „Körperlandschaften" de facto mit Landschaftsdarstellung verknüpft: Bilder wie *Couple* und *Teenage Wildlife* (beide 2003) etwa spielen in beinahe rokokohafter Manier Klischees von abgeschiedener Lustbarkeit in unberührter Natur aus. Die Akteure, ins Dickicht entrückt, sind kaum mehr als Farbflecken und desto mehr der Ahnung überlassen. Doch der naturhafte szenische Hintergrund ist eben auch Anlass zu gesteigerter gestischer Freisetzung der Malerei, die bei Arbeiten wie *Ambush Makeover* und *Landscape*, erst recht aber in *Canopy* oder *Looby Loo* (alle 2003) fast nur noch im Titel und diffus mit Gegenständlichem verbunden ist. Umso stärker aber steht diese Malerei für sich.

Les tableaux de Cecily Brown dénotent une élégance obsessionnelle, et c'est peut-être en cela que réside leur plus grande provocation. Cette peinture, le plus souvent de grand format et d'une facture résolument traditionnelle à l'huile sur toile, se présente comme un numéro d'équilibriste réitéré à chaque tableau, entre figuration et peinture abstraite et gestuelle. Brown emprunte l'essentiel de ses motifs à des revues pornographiques. A des degrés divers de nudité et de voilement, l'on y distingue des hommes et des femmes, des couples et des groupes, on assiste à des actes sexuels, en totalité ou en détail. La lisibilité visuelle vers laquelle nous pousse l'obscénité est pratiquée avec un grand raffinement et à tous les degrés de dissolution picturale. Le flou et le brouillage des corps défient le regard scrutateur, des épargnes abstraites forcent l'interprétation et placent le spectateur une fois de plus dans une posture de voyeur, cependant que la tension érotique se communique aussi à la peinture elle-même par le truchement d'une mise en scène résolument délicate et opulente. Ceci vaut plus encore pour les œuvres récentes, dans lesquelles Brown associe le regard porté sur ces «paysages corporels» à des représentations paysagères : des tableaux comme *Couple* et *Teenage Wildlife* (tous deux de 2003) développent d'une manière quasi rococo les clichés de la volupté dans le cadre d'une nature intacte. Les acteurs isolés dans les fourrés ne sont plus guère que des taches de couleur et sont ainsi livrés encore plus fortement à l'intuition. Mais le décor naturel fournit aussi le prétexte d'une picturalité accrue au sein de cet all-over gestuel et floral que seul le titre relie encore à la figuration dans des œuvres comme *Ambush Makeover* et *Landscape*, mais plus encore dans *Canopy* ou *Looby Loo* (tous de 2003). Cette peinture n'en tire cependant qu'un surcroît d'autonomie. J. A.

SELECTED EXHIBITIONS →
2005 *Paintings*, Modern Art Oxford; *The Triumph of Painting (Part 2)*, The Saatchi Gallery, London **2004** Museo Nacional Centro de Arte Reina Sofia, Madrid; Whitney Biennial, Whitney Museum of American Art, New York **2003** Museo d'Arte Contemporanea Roma, Rome **2002** Hirshhorn Museum, Washington D.C.

SELECTED PUBLICATIONS →
2005 *The Triumph of Painting*, The Saatchi Gallery, London **2004** *Cecily Brown*, Museo Nacional Centro de Arte Reina Sofia, Madrid **2003** *Cecily Brown*, Museo d'Arte Contemporanea Roma, Rome **2001** *Days of Heaven*, Contemporary Fine Arts, Berlin **2000** *Cecily Brown*, Gagosian Gallery, New York

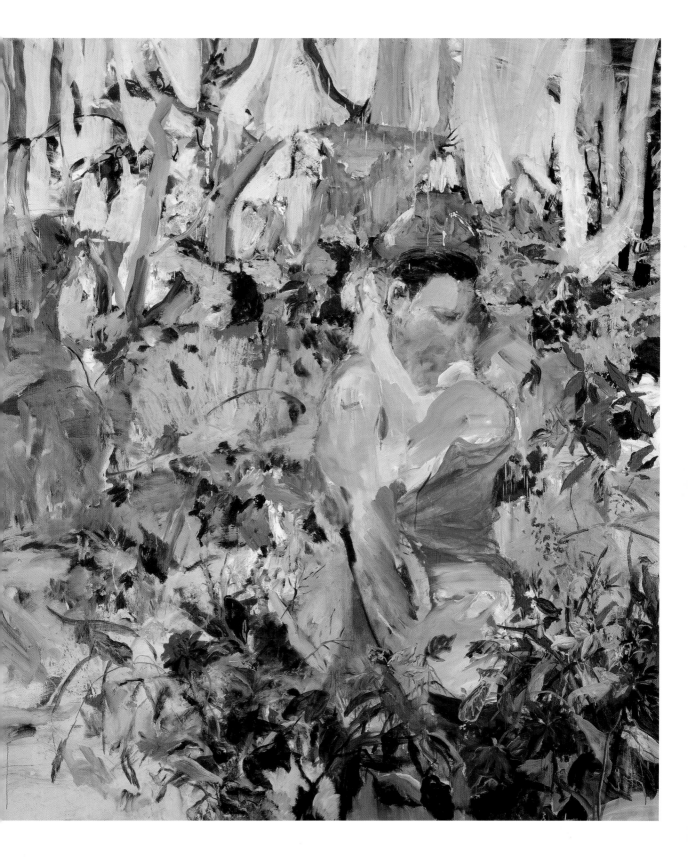

1 **Couple**, 2003/04, oil on canvas, 228.4 x 203.2 cm
2 **Landscape**, 2002/03, oil on canvas, 198.1 x 228.6 cm

3 **Justify My Love**, 2003/04, oil on canvas, 228.6 x 198.1 cm

„Das einzige, was ich je gemalt habe, sind Figuren.
Mich interessiert das menschliche Bedürfnis oder der Wunsch, sich selbst
zu repräsentieren. Mich fasziniert der menschliche Narzismus und das
Besessensein von Körpern. [...] Und ich liebe den Trick der Malerei. Es
kann Bewegung innerhalb dieses unbewegten Dings geben, und trotzdem
ist es völlig starr. Und diese Illusion ist immer wieder aufregend."

« Je n'ai jamais peint autre chose que des figures.
Je suis intéressée par le besoin ou le désir de l'homme de se représenter
lui-même. Je suis fascinée par le narcissisme humain et les obsessions liées
au corps. [...] Et j'aime le caractère astucieux de la peinture. On peut avoir
le mouvement au beau milieu de la tranquillité, mais il est complètement
fixé. Et cette illusion est toujours excitante. »

"Figures are the only thing that I've ever painted.
I'm interested in the human need or desire to represent itself. I'm fascinated
with human narcissism and obsessions with bodies. [...] And I love the trick
of painting. You can have the movement within the still thing,
but it is completely fixed. And that illusion is constantly exciting."

2

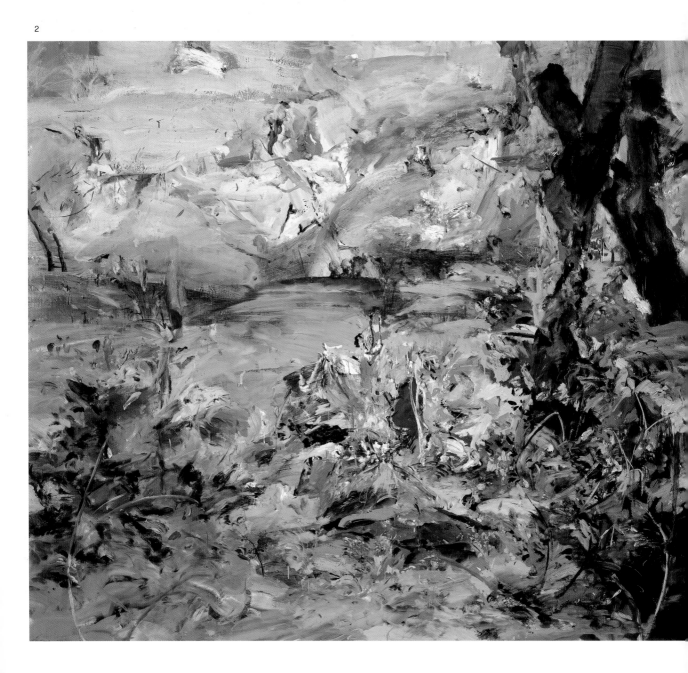

Glenn Brown

1966 born in Hexham, lives and works in London, UK

For an artist whose main weapon is misrepresentation, Glenn Brown has himself been grossly misrepresented as a painter and creator. Denounced as a plagiarist during his Turner Prize exhibition in 2000 for the work *The Loves of Shepherds* that took a 1974 science-fiction book jacket illustration as its starting point, Brown was accused of the diametric opposite of his artistic intention. His appropriation of other paintings, whether by artists such as Rembrandt, Dalí or Baselitz, or by lesser-known sci-fi illustrators such as Anthony Roberts (who actually took Brown to court over this copyright issue), are not meant as mere likenesses, but as tools in his own painterly game of hide, seek, build and destroy. Samplings of "low" or "high" art (always from postcards rather than the originals), are scaled up, skewed, distorted and, in the end, equalized – or literally flattened in the case of images borrowed from impasto painter Frank Auerbach – by Brown's precise, hyper-real brush-strokes. In *America* (2004), a symphony of red, white and blue, he subverts a Fragonard figure by applying a sickly blue complexion and El Greco-like proportions to the face, drawing the character's gaze up to heaven perhaps in mocking reference to the US government's arrogant stance on foreign policy. Brown's seemingly contrasting amorphous, lumpen sculptures built from thick swaths of oil paint are an extension of his ability to introduce play and humour into his work, as he does with all his titles from *Dirty*, taken from a Christina Aguilera pop song, to *The Loves of Shepherds*, a term describing 19th-century pastoral idylls, which Brown applies to outer space.

Für einen Künstler, dessen wichtigste Waffe die Entstellung ist, wird Glenn Brown als Maler und Bildhauer selbst gerne verzerrt dargestellt. Man unterstellte Brown das diametrale Gegenteil seiner tatsächlichen künstlerischen Absicht, als man ihn während der Ausstellung zum Turner-Preis 2000 wegen seiner Arbeit *The Loves of Shepherds*, für die er ein Science-Fiction-Buchcover aus dem Jahr 1974 als Vorlage benutzt hatte, als Plagiator denunzierte. Seine Aneignung existenter Gemälde von Künstlern wie Rembrandt, Dalí und Baselitz oder von Science-Fiction-Illustratoren wie Anthony Roberts (der Brown schließlich wegen Verletzung seiner Urheberrechte verklagte) geschieht nicht aus Gründen bloßer Ähnlichkeit, sondern als Instrument innerhalb seines eigenen malerischen Versteck-, Such-, Aufbau- und Zerstörungsspiels. Samples aus „niedriger" und „hoher" Kunst (stets auf der Grundlage von Postkarten statt der Originale) werden vergrößert, verzerrt und schließlich in Browns präzisen, hyperrealen Pinselstrichen wieder homogenisiert – oder buchstäblich plattgebügelt, wie im Falle der pastosen Bilder, die dem Maler Frank Auerbach entlehnt wurden. In *America* (2004), einer Sinfonie in Rot, Weiß und Blau, unterminiert er eine Fragonard-Figur, indem er dem Gesicht einen ungesund-blauen Teint und eine Physiognomie à la El Greco verleiht und ihren Blick womöglich in höhnischer Anspielung auf die arrogante außenpolitische Haltung der US-Regierung gen Himmel lenkt. Browns scheinbar gegensätzliche amorphe Klumpenskulpturen, aufgebaut aus dicken Ölfarbbrocken, bilden eine Erweiterung seiner Fähigkeit, das Spielerische und den Humor in seine Arbeit einfließen zu lassen, wie in all seinen Titeln abzulesen ist, von *Dirty*, dem entlehnten Titel eines Songs von Christina Aguilera, bis hin zu *The Loves of Shepherds*, einem Ausdruck zur Beschreibung pastoraler Idyllen des 19. Jahrhunderts, den Brown auf den Weltraum überträgt.

Pour un artiste dont l'arme principale est la déformation, Glenn Brown a lui-même été grossièrement déformé en tant que peintre et créateur. Dénoncé pour plagiat pour son œuvre *The Loves of Shepherds* exposée dans le cadre du Prix Turner 2000, et qui partait de l'illustration de titre d'un livre de science-fiction, Brown s'est vu accuser du contraire absolu de ses intentions artistiques. Son appropriation d'autres peintures, qu'il s'agisse d'artistes comme Rembrandt, Dalí ou Baselitz, ou d'illustrateurs de science-fiction moins célèbres comme Anthony Roberts (lequel est allé jusqu'à intenter un procès à l'artiste à propos des droits d'auteur), ne doit pas être comprise comme une simple imitation, mais comme l'outil de son propre jeu pictural de cache-cache, de construction et de destruction. Toujours réalisés à partir de cartes postales, et non de l'original, des échantillons d'art « noble » ou « trivial » y sont agrandis, déformés, étirés et en définitive nivelés – voire littéralement aplatis dans le cas d'images dérivées de la peinture empâtée de Frank Auerbach – par la facture précise et hyperréaliste de Brown. Dans *America* (2004), une symphonie de rouge, de blanc et de bleu, Brown subvertit une figure de Fragonard en conférant une complexion bleuâtre et des proportions à la Greco au visage, dont le regard a été délibérément tourné vers le ciel, peut-être en guise d'allusion moqueuse à l'arrogance de la politique étrangère américaine. Les sculptures négligées de Brown sont constituées de grosses bandes de peinture à l'huile et ont en commun avec ces tableaux leur programme alternatif d'enlaidissement artistique. Cette subversion est un prolongement de l'aptitude de Brown à introduire le jeu et l'humour dans son œuvre, comme le font aussi ses titres – de *Dirty*, emprunté à une chanson de Christina Aguilera, jusqu'à *The Loves of Shepherds*, terme qui évoque les idylles pastorales du XIXᵉ siècle et que Brown applique à la conquête spatiale. O. W.

SELECTED EXHIBITIONS →
2004 Serpentine Gallery, London **2003** *Ice Hot – Recent Painting from the Scharpff Collection*, Hamburger Kunsthalle; *Pittura/Painting – From Rauschenberg to Murakami 1964–2003*, 50. Biennale di Venezia, Venice; *M_ARS, Art and War*, Neue Galerie am Landesmuseum Joanneum, Graz; *Dear Painter...*, Kunsthalle Wien, Vienna, Schirn Kunsthalle, Frankfurt/Main, Centre Pompidou, Paris

SELECTED PUBLICATIONS →
2004 *Glenn Brown*, Gagosian Gallery, London **2004** *Glenn Brown*, Serpentine Gallery, London **2002** *Cher peintre... Lieber Maler ... Dear painter...*, Schirn Kunsthalle, Frankfurt/Main, Kunsthalle Wien, Vienna, Centre Pompidou, Paris **2001** *Azerty*, Centre Pompidou, Paris

1 **Sex**, 2003, oil on panel, 126 x 85.1 cm
2 **The Osmond Family**, 2003, oil on panel, 142.6 x 100.6 cm
3 **America**, 2003, oil on panel, 140 x 93.3 cm

4 **On Hearing of the Death of My Mother**, 2002, oil on board, 119 x 88 cm
5 **The Aesthetic Poor (for Tom Buckley) after John Martin**, 2002,
 oil on canvas, 220.5 x 333 cm

„Ich bin mir des Widerspruchs zwischen dem Schönen und dem Hässlichen
völlig bewusst. Ich mag es, wenn etwas gleichzeitig gegenständlich
und abstrakt ist, wenn etwas tot aussieht und doch noch lebt und wenn
sein Geschlecht nicht eindeutig ist."

«Je suis pleinement conscient de la contradiction entre le beau et le laid.
J'aime que quelque chose soit à la fois figuratif et abstrait, apparemment mort
mais encore vivant, et de sexe ambigu.»

"I am fully aware of the contradiction between the beautiful and the ugly. I like something to be both figurative and abstract, looking dead but still being alive, being of ambiguous sex."

2

3

4

5

Tania Bruguera

1968 born in Havana, lives and works in Havana, Cuba, and Chicago (IL), USA

Extreme physical experiences characterize Tania Bruguera's work – experiences that she exposes herself to in her performances, but increasingly exposes her viewers to as well. In her early performances, which were often inspired by archaic rituals and cults, she made her body her means of expression and the bearer of historical and political burdens. Recently she has created situations in which the viewer can understand the effects of observation and oppression first-hand. Thus upon entering the installation she contributed to documenta 11, *Untitled* (2002), visitors were exposed to a short, glaring flash of light, which regularly followed a sound sequence of the tramping of feet and the rattle of guns. Bruguera allows force as an expression of political power and oppression to be physically experienced by the individual. The emphasis of her work lies on the history of her native country Cuba, whereby she covers the entire time span from its colonial period right up to the present-day revolution as it really exists. In *Autobiografía* (2003), for example, the observer can experience the effects of being permanently bombarded by political propaganda. In this sound installation a microphone invites you to send your own message out into the exhibition room. These messages, however, are constantly interrupted and drowned out by quotations from speeches by Fidel Castro – the individual is silenced. For her work *Poetic Justice* (2002/03) Bruguera covered the walls of a narrow passageway with hundreds of thousands of used tea bags – a tangible metaphor for the circulation and alienation of goods and culture as a consequence of colonization and world trade.

Extreme körperliche Erfahrungen prägen das Werk von Tania Bruguera – Erfahrungen, denen sie sich in ihren Performances selber, in zunehmendem Maß aber auch den Betrachter ausliefert. In ihren frühen, oftmals an archaischen Ritualen und Kulten inspirierten Performances macht sie ihren Körper zum Ausdrucksmittel und Träger historischer und politischer Lasten. In jüngster Zeit schafft sie Situationen, in denen der Betrachter am eigenen Leib die Auswirkungen von Observation und Oppression nachvollziehen kann. So wurde der Besucher in ihrem Beitrag zur documenta 11, *Untitled* (2002), beim Betreten ihrer Installation einem kurzen, grellen Blitzlicht ausgesetzt, das regelmäßig auf eine Geräuschsequenz von stampfenden Füßen und rasselnden Gewehren folgte. Bruguera macht Gewalt als Ausdruck politischer Macht und Unterdrückung für den Einzelnen physisch erlebbar. Der Schwerpunkt ihres Werkes liegt dabei auf der Geschichte ihres Heimatlandes Kuba, wobei sie den Bogen von der Kolonialgeschichte bis in die Gegenwart der real existierenden Revolution spannt. In *Autobiografía* (2003) etwa kann der Betrachter die Auswirkungen ständiger Beschallung durch Politpropaganda erfahren: In der Klanginstallation lädt ein Mikrofon dazu ein, eigene Botschaften in den Ausstellungsraum zu transportieren, jedoch werden diese beständig durch Zitate aus Reden Fidel Castros unterbrochen und übertönt – das Individuum wird mundtot gemacht. Für ihr Werk *Poetic Justice* (2002/03) überzieht Bruguera die Wände eines schmalen Ganges mit Hunderttausenden gebrauchter Teebeutel – eine sinnliche Metapher für die Zirkulation und Entfremdung von Ware und Kultur im Gefolge von Kolonisation und Welthandel.

L'œuvre de Tania Bruguera est marquée par des expériences corporelles extrêmes auxquelles elle se soumet elle-même dans ses performances, mais auxquelles elle soumet aussi, de plus en plus souvent, le spectateur. Dans ses premières performances, qui étaient souvent inspirées de cultes et de rituels archaïques, elle fait de son corps le moyen d'expression et le support de fardeaux historiques et politiques. Récemment, elle a créé des situations dans lesquelles le spectateur peut éprouver les effets de l'observation et de l'oppression dans sa propre chair. Dans *Untitled* (2002), sa contribution à la documenta 11, le spectateur était exposé à un flash aveuglant au moment d'entrer dans l'installation, flash qui suivait régulièrement une séquence sonore de bruits de bottes et de cliquetis de fusils. Bruguera fait percevoir physiquement à l'individu la violence en tant que manifestation du pouvoir et de l'oppression politiques. L'accent principal de son œuvre porte sur l'histoire de son pays natal, Cuba, sachant que le regard de Bruguera s'étend aussi bien à l'histoire coloniale qu'à l'actualité de la révolution réelle aujourd'hui en place. Dans *Autobiografía* (2003), le spectateur peut éprouver les effets de la présence sonore continuelle de la propagande politique : dans cette installation acoustique, un microphone invite le spectateur à transporter ses propres messages dans l'espace d'exposition, mais ceux-ci sont sans cesse interrompus et couverts par des citations des discours de Fidel Castro – l'individu est muselé. Pour son œuvre *Poetic Justice* (2002/03), Bruguera a couvert les murs d'un couloir étroit de dizaines de milliers de sachets de thé usagés – une métaphore très sensorielle de la circulation et du détournement des biens et de la culture dans le sillage de la colonisation et du commerce mondial.

A.M.

SELECTED EXHIBITIONS →
2005 51. Biennale di Venezia, Venice **2003** *Autobiografia*, Museo Nacional de Bellas Artes, Havana; *El real viaje Real/The Real Royal Trip*, P.S.1, New York, Palacio del Patio Herreriano, Valladolid; *The Living Museum*, Museum für Moderne Kunst, Frankfurt/Main **2002** documenta 11, Kassel; *Fusion Cuisine*, Deste Foundation, Athens **2001** *La isla en peso*, Casa de las Americas, Havana; *A Little Bit of History Repeated*, KW Institute of Contemporary Arts, Berlin; *Plateau of Humankind*, 49. Biennale di Venezia, Venice

SELECTED PUBLICATIONS →
2003 *Autobiografia*, Museo Nacional de Bellas Artes, Havana **2002** *documenta 11*, Kassel **2001** *49. Biennale di Venezia*, Venice

1 **Poetic Justice**, 2002/03, used teabags, 8 one-second selections from several international historic newsreels, 8 LCD screens, 8 DVDs, 8 DVD players, installation view, 8. Istanbul Biennial, 2003
2 **Dated Flesh I**, 2003, hanging dress and veil made of cow cuts and stones, 147.3 x 60.9 x 60.9 cm

3 **Destierro**, 1998, Nkisi Nkonde sculptural suit made of mud and protruding nails, 198.1 x 81.2 x 70.3 cm
4 **Destierro in Performance**, 1998, 2. Bienal Barro de América, Caracas
5 **Sin Titulo**, 2000, 3.96 x 12 x 51.5 m, video performance installation, milled sugar cane, black and white monitor, DVD, DVD player, 7. Bienal de la Habana, Havana

„Kunst zu machen ist für mich ein Weg, Wissen zu erlangen und zu verarbeiten. Unterschiedliche Standpunkte auf ein Thema anzuwenden – sei es ein künstlerisches, soziales oder politisches."

«Pour moi, faire de l'art est une manière d'acquérir et de traiter la connaissance. Essayer différents points de vue sur un même sujet – qu'il soit artistique, politique ou social.»

"For me, making art is a way of acquiring and processing knowledge. Trying different points of view on a subject, whether artistic, social or political."

5

2

3

4

André Butzer

1973 born in Stuttgart, lives and works in Berlin, Germany

The *Wanderer*, a deformed, skull-faced and droopy-eared figure, equipped with his phallic staff extending upwards, laced boots, and shiny gold buttons on his jacket, wanders through André Butzer's paintings in continually new variations. Thereby he stares strangely hollowly at us out of dead eyes. This wanderer belongs to an allusive series of figures that populates Butzer's pictorial world. A preoccupation with the works of Asger Jorn, Edvard Munch and Philip Guston is clearly recognisable in Butzer's intensely coloured, large-format paintings. Influenced not least of all by the exchange within his self-organised teaching institute, Hamburg's "Akademie Isotrop", today André Butzer describes in his expressive manner a contradictory world: as cheerful as Disneyland and as gloomy as an air-raid shelter. He calls his wanderers' fictitious goal "Annaheim" (*Wanderung nach Annaheim*, 2001), a germanised version of the Californian town of Anaheim, where the first Disneyland was founded. In this artificial universe Butzer allows good and evil, comic figures, poets, war criminals and capitalists to appear as equals (*Porträt Josef Blösche*, 2004). In a final touch, the absurd word creations of the picture titles intensify the viewer's confusion and reveal the ambivalence of Butzer's brand of mythology. Thus in the words that make up their name the *Friedens-Siemense* – figures with white-grey heads, wide-open Mickey Mouse eyes and an eternal smile – bear both the desire for an ideal world, and the name of a German company once associated with the arms industry and forced labour. The uneasiness provoked by Butzer's worryingly piteous, yet nonetheless lovable, cheerful creatures, has a long-lasting effect.

Der *Wanderer*, eine deformierte Gestalt mit Totenschädel und Schlappohren, ausgerüstet mit einem nach oben gereckten, phallusartigen Stab, geschnürten Stiefeln und glänzenden Goldknöpfen am Jackett, durchstreift in immer wieder neuen Variationen die Gemälde von André Butzer. Dabei starrt er den Betrachter aus toten Augen seltsam hohl an. Dieser Wanderer gehört zu einer suggestiven Reihe von Figuren, die Butzers Bildwelt bevölkern. Die Auseinandersetzung mit den Arbeiten von Asger Jorn, Edvard Munch oder Philip Guston ist in den farbintensiven, großformatigen Gemälden Butzers deutlich zu erkennen. Nicht zuletzt aber auch geprägt vom Austausch innerhalb des selbst organisierten Lehrinstituts, der Hamburger "Akademie Isotrop", beschreibt Butzer heute in expressivem Gestus eine zwiespältige Welt: so heiter wie Disneyland und so finster wie ein Luftschutzbunker. Er nennt das fiktive Ziel seiner Wanderer "Annaheim" (*Wanderung nach Annaheim*, 2001), eine eingedeutschte Version für den kalifornischen Ort Anaheim, wo das erste Disneyland gegründet wurde. In diesem künstlichen Universum lässt Butzer gleichwertig Gut und Böse, Comicfiguren, Dichter, Kriegsverbrecher und Kapitalisten auftreten (*Porträt Josef Blösche*, 2004). Die absurden Wortschöpfungen der Bildtitel verstärken letztlich die Verwirrung des Betrachters und offenbaren die Ambivalenz der Butzer'schen Mythologien. So tragen die *Friedens-Siemense* – weiß-graue Kopfmenschen mit aufgerissenen Micky-Maus-Augen und ewigem Lächeln – in ihrem Namen sowohl den Wunsch nach einer heilen Welt wie auch die Erinnerung an Rüstungsindustrie und Zwangsarbeit. Das von Butzers Gestalten, zugleich beunruhigend erbärmliche und doch liebenswerte, fröhliche Wesen, ausgelöste Unbehagen wirkt lange nach.

Le *Wanderer* [promeneur], figure difforme à tête de mort, aux oreilles pendantes, équipé d'un bâton dressé apparenté à un phallus, de bottes à lacets et d'une veste à boutons, traverse dans des variantes sans cesse nouvelles les peintures d'André Butzer, tout en nous regardant de ses yeux morts étrangement vides. Ce promeneur fait partie d'une série de personnages suggestifs qui peuplent l'univers iconique de Butzer. Si l'assimilation des œuvres d'Asger Jorn, d'Edvard Munch ou de Philip Guston ressort clairement de l'intensité chromatique et des grands formats de ses peintures, les échanges au sein de l'« Akademie Isotrop » à Hambourg, une institution d'enseignement auto-organisée par André Butzer, ont également exercé sur lui une influence de premier plan. L'artiste décrit aujourd'hui dans une facture expressive un monde pétri de contradictions : aussi joyeux que Disneyland, aussi sombre qu'un abri antiaérien. Le but fictif désigné de ses promeneurs est « Annaheim » (*Wanderung nach Annaheim*, 2001), version germanisée de la petite ville californienne d'Anaheim, où fut fondé le premier parc Disneyland. Dans cet univers artificiel, la peinture de Butzer fait apparaître sans distinction le bien et le mal, les personnages de bandes dessinées, les poètes, les criminels de guerre et les capitalistes (*Porträt Josef Blösche*, 2004). Pour finir, les créations lexicographiques absurdes des titres renforcent le désarroi du spectateur et révèlent l'ambivalence des mythologies butzériennes. Ainsi, les *Friedens-Siemense* – bonshommes gris-blancs réduits à des têtes arborant des yeux écarquillés et un sempiternel sourire de Mickey – portent aussi bien dans leur nom le désir d'un monde préservé que les souvenirs de l'industrie d'armement et des travaux forcés. Le malaise que suscitent les personnages aussi tristement inquiétants qu'aimables et gais de Butzer, laisse sur le spectateur un effet durable.

C. R.

SELECTED EXHIBITIONS →
2005 *Munch Revisited*, Museum am Ostwall, Dortmund
2004 *Das Ende vom Friedens-Siemens Menschentraum*, Kunstverein Heilbronn; *Heimweh*, Haunch of Venison, London
2003 *deutschemalereizweitausenddrei*, Frankfurter Kunstverein
2001 *The Ölwechsel*, Transmission Gallery, Glasgow **1999** *Akademie Isotrop, die Abstimmung*, Kunstverein Graz **1998** *Junge Szene*, Secession, Vienna **1997** *Akademie Isotrop*, Künstlerhaus Stuttgart

SELECTED PUBLICATIONS →
2004 *Frau vor dem N-Haus*, Maschenmode, Galerie Guido W. Baudach, Berlin; *Massenfrieden*, Patrick Painter Inc., Santa Monica; *Das Ende vom Friedens-Siemens Menschentraum*, Kunstverein Heilbronn, Heilbronn **2003** *Chips, Pepsi und Medizin*, Galerie Max Hetzler, Berlin **2002** *Wanderung nach Annaheim*, Maschenmode, Galerie Guido W. Baudach, Berlin

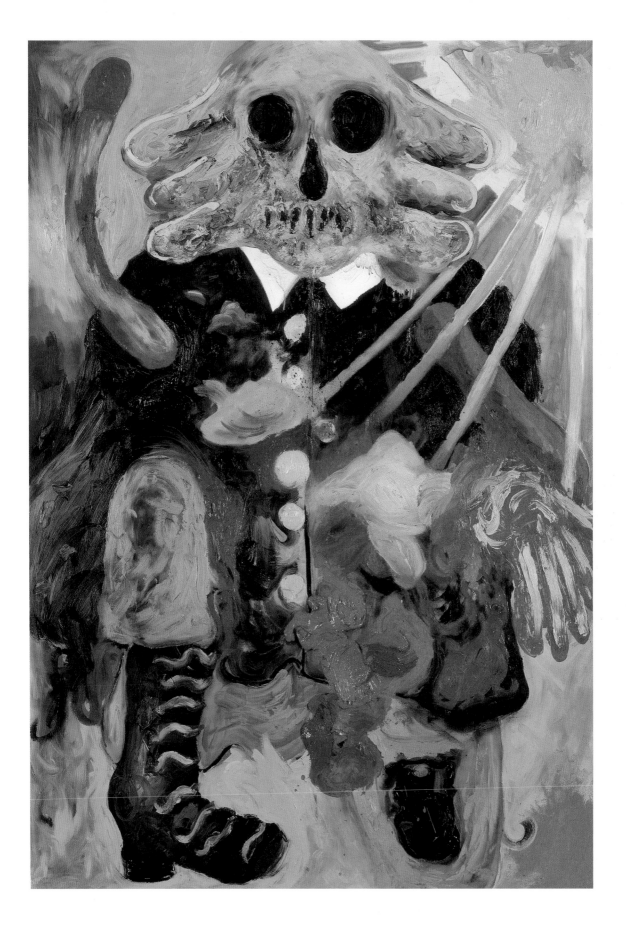

1 **Wanderer**, 2001, oil on canvas, 200 x 140 cm
2 **Hemmleben (Teil 2)**, 2003, oil on canvas, 220 x 280 cm
3 **Hemmleben (Teil 3)**, 2003, oil on canvas, 214.5 x 392 cm
4 **Auf der kleinen Wiese**, 2003, oil on canvas, 210 x 351 cm

„Ich bin der Rausch der Herzen und der Uhren auf beiden Seiten." «Je suis l'ivresse des cœurs et des montres des deux côtés.»

"I am the exhilaration of hearts and clocks on both sides."

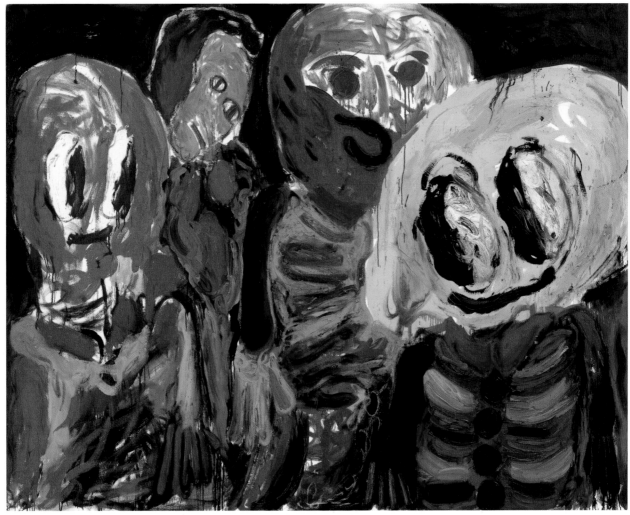

2

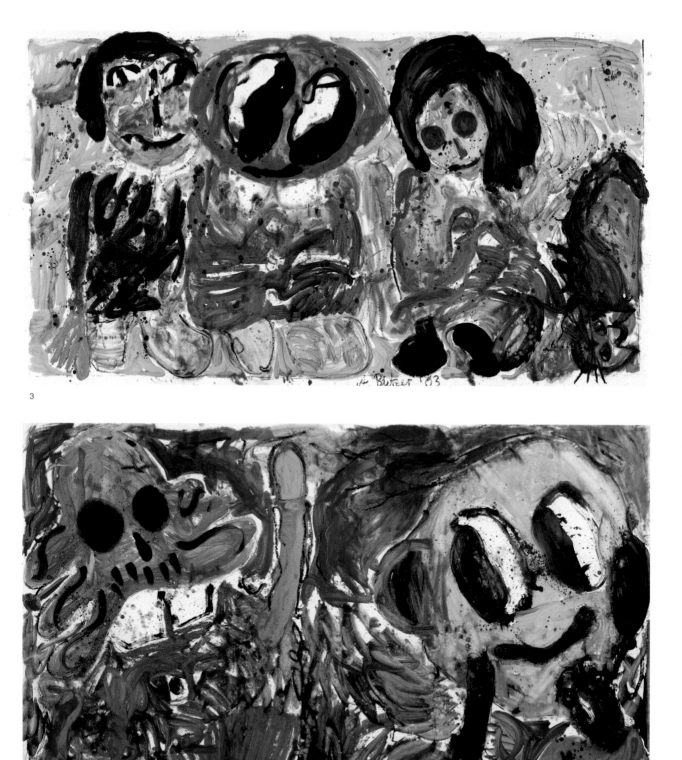

3

4

Miguel Calderón

1971 born in Mexico City, lives and works in Mexico City, Mexico

Miguel Calderón's work is very diverse and is sometimes reminiscent of amusement-park aesthetics. With youthfully aggressive irony, the artist often oversteps stylistic boundaries to undermine clichés about "Mexican art". This also affects the diversity of his means of expression. Calderón works with painting, photography, video, and sculpture. He has founded punk bands and an off-gallery, and he recently developed a soap opera. "I don't see my pieces as endings of something," says Calderón, "rather as a way of interacting with the world." *Bar Rústico Montañoso* (2003) is a perfect example of "typical" Mexican Art. An absurd imitation of a wooden bar, it is made of solid concrete and weights a full three tons even without the accompanying bar equipment. With *A Propósito* (1998) he overdoes another cliché in an exemplary manner. This video, shot together with Yoshua Okón, shows the artists during nightly thefts of car radios. As if to prove that this actually is non-fiction, the showing is embellished with a 120-piece pile of "stolen goods". Observers could ask themselves how much truthfulness they are willing to credit these artists with. The photo works show a reality that is often shifted disconcertingly. For *Chapultepec* (2003), for example, Calderón asked families assembled for a picnic in the park to play dead for the camera. The result produced strange pictures that are something between a B-movie and *Le Déjeuner sur l'herbe*. His painting is confusing in another way. For works such as *Bad Route* or *Attack* (both 1998) he initially staged the motif – a grotesquely masked gang – for a photo, but then had the final paintings created by a portrait painter: an intentional avoidance of style or, as Calderón says, "I wanted something camp."

Das Werk von Miguel Calderón ist sehr verschiedenartig, erinnert bisweilen an die Ästhetik von Vergnügungsparks, und oft geht der Künstler im Überschreiten stilistischer Kodes mit jugendlich-aggressiver Ironie zu Werke, um Klischees von „mexikanischer Kunst" zu unterminieren. Das schlägt auch auf die Vielfalt seiner Ausdrucksmittel durch: Calderón arbeitet mit Malerei, Fotografie, Video, Skulptur, gründete Punk-Bands und eine Off-Galerie, neuerdings entwickelt er eine Soap-Opera. „Ich betrachte Werke nie als Endpunkte", so Calderón, „sondern sehe sie als Interaktion mit der Welt." Ein Musterfall von „typisch" mexikanischer Kunst ist *Bar Rústico Montañoso* (2003): ein absurdes Holzbar-Imitat aus Vollbeton, das bereits ohne die zugehörige Getränke-Ausstattung satte drei Tonnen Gewicht aufweist. Mit *A Propósito* (1998) wird ein anderes Klischee exemplarisch übererfüllt: Das zusammen mit Yoshua Okón gedrehte Video zeigt die Künstler beim nächtlichen Klau von Autoradios, und wie zum Beleg, dass es sich tatsächlich um Non-Fiction handelt, wird die Vorführung mit 120 Stück gestapelter „Hehlerware" garniert. Betrachter dürfen sich fragen, wie viel Wahrhaftigkeit sie diesen Künstlern denn nun zugestehen mögen. Die Fotoarbeiten zeigen eine oft befremdlich verschobene Realität: Für *Chapultepec* (2003) etwa bat Calderón zum Picknick im Park versammelte Familien, sich fürs Foto tot zu stellen. Das Ergebnis zeigt merkwürdige Bilder zwischen B-Movie und *Le Déjeuner sur l'herbe*. Seine Malerei irritiert auf andere Weise: Für Arbeiten wie *Bad Route* oder *Attack* (beide 1998) hat er die Motive – eine grotesk maskierte Gang – zunächst fürs Foto inszeniert, um die eigentlichen Bilder dann von einem Porträtmaler ausführen zu lassen: gezielte Stilvermeidung oder, so Calderón: „I wanted something camp."

L'œuvre de Miguel Calderón est très diverse et rappelle parfois l'esthétique des parcs d'attraction. Pour transgresser les codes stylistiques, l'artiste met souvent en œuvre une ironie juvénile et agressive qui sape les clichés de « l'art mexicain ». Cette démarche se traduit aussi par la diversité des moyens d'expression : Calderón réalise des peintures, des photographies, des vidéos, des sculptures, il a fondé des groupes punk et une galerie « off ». Récemment, il travaillait sur un *soap opera*. « Je ne vois pas mes œuvres comme des produits finis », déclare l'artiste, « mais comme une manière d'interaction avec le monde. » *Bar Rústico Montañoso* (2003) se présente comme le cas d'école d'un art « typiquement » mexicain : il s'agit de l'imitation absurde d'un bar en bois exécuté en béton massif et pesant déjà trois bonnes tonnes sans ses équipements et ses boissons. *A Propósito* (1998) exauce à satiété un autre cliché : dans cette vidéo tournée en collaboration avec Yoshua Okón, on voit l'artiste volant des autoradios la nuit, et comme pour attester qu'il ne s'agit pas d'une fiction, la vidéo est accompagnée d'un empilement de 120 pièces de « recel ». Le spectateur peut dès lors s'interroger sur la dose de véracité qu'il juge acceptable de la part des artistes. Les œuvres photographiques montrent une réalité souvent singulièrement décalée : pour *Chapultepec* (2003), Calderón a demandé à des familles pique-niquant dans un parc de faire les morts pour la photo. Le résultat produit des images étranges entre film de série B et *Le Déjeuner sur l'herbe*. La peinture de Calderón est autrement troublante : pour des œuvres comme *Bad Route* ou *Attack* (toutes deux de 1998), l'artiste a d'abord mis en scène et photographié ses motifs – un gang affublé de masques grotesques – avant de faire reproduire ces images par un peintre de portraits, dans une négation délibérée de tout style. Ou encore, comme le dit Calderón : « I wanted something camp. » J. A.

SELECTED EXHIBITIONS →
2005 *In the Air: Projections of Mexico*, Solomon R. Guggenheim Museum, New York; *Prometer no empobrece: Arte Contemporáneo Mexicano*, Museo Nacional Centro de Arte Reina Sofía, Madrid **2004** 26. Bienal de São Paulo **2003** *Only Skin Deep: Changing Visions of the American Self*, International Center of Photography, New York **2002** *An Exhibition about the Exchange Rates of Bodies and Values*, P.S.1, New York **2001** *Tele[visions]*, Kunsthalle Wien, Vienna **2000** *Ultra Baroque*, Museum of Contemporary Art, San Diego

SELECTED PUBLICATIONS →
2004 *Mexico vs. Brasil*, Instituto Nacional de Bellas Artes, Mexico City **2003** *Only Skin Deep*, International Center of Photography, New York **2001** *Tele[visions]*, Kunsthalle Wien, Vienna

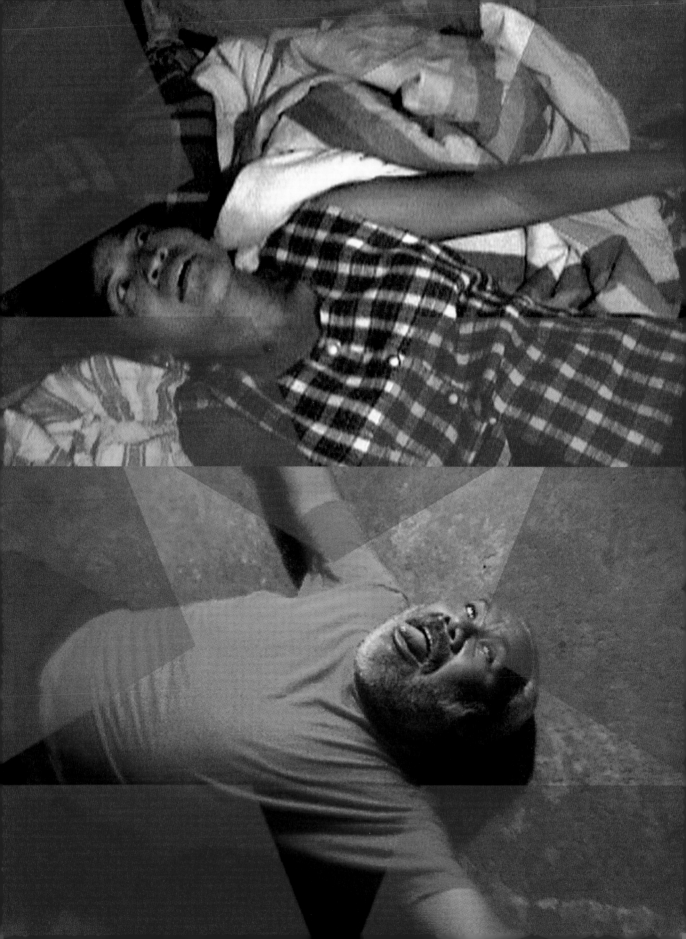

1 **Inverted Star**, 1999, video stills
2 **Mexico vs. Brazil**, 2004, video stills

„Für mich reflektiert Kunst das Chaos. Klar, man kann politisch sein, aber es offensichtlich zu sein, liegt mir nicht. […] Kunst kennt keine Regeln […], man kann grundsätzlich tun, was man will, und das gefällt mir gut."

«Pour moi, l'art reflète le chaos. Bien sûr, on peut être politique, mais l'être explicitement n'est pas ma tasse de thé. […] L'art connait pas de règles […] fondamentalement, on peut faire tout ce qu'on veut et cela me convient tout à fait.»

"To me, art reflects chaos. Sure you can be political, but being obviously so is not my cup of tea. […] Making art has no rules […], you can basically do anything you want and that is something that works for me."

2

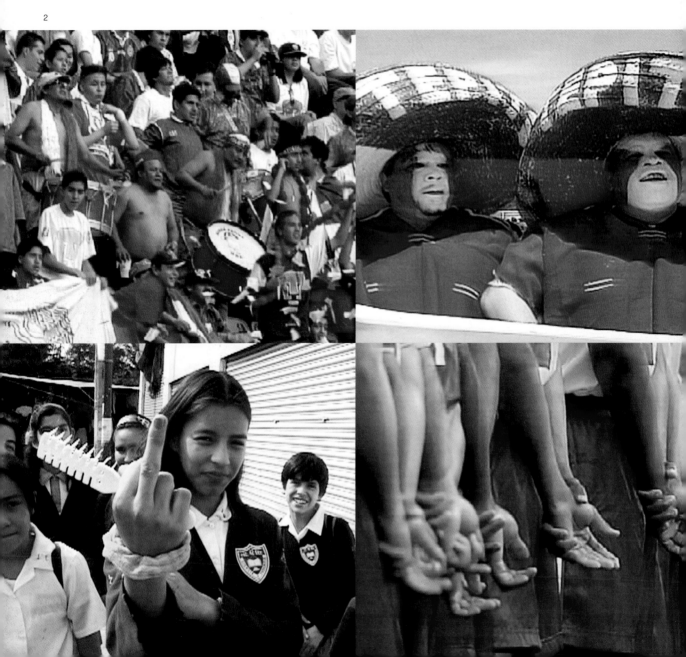

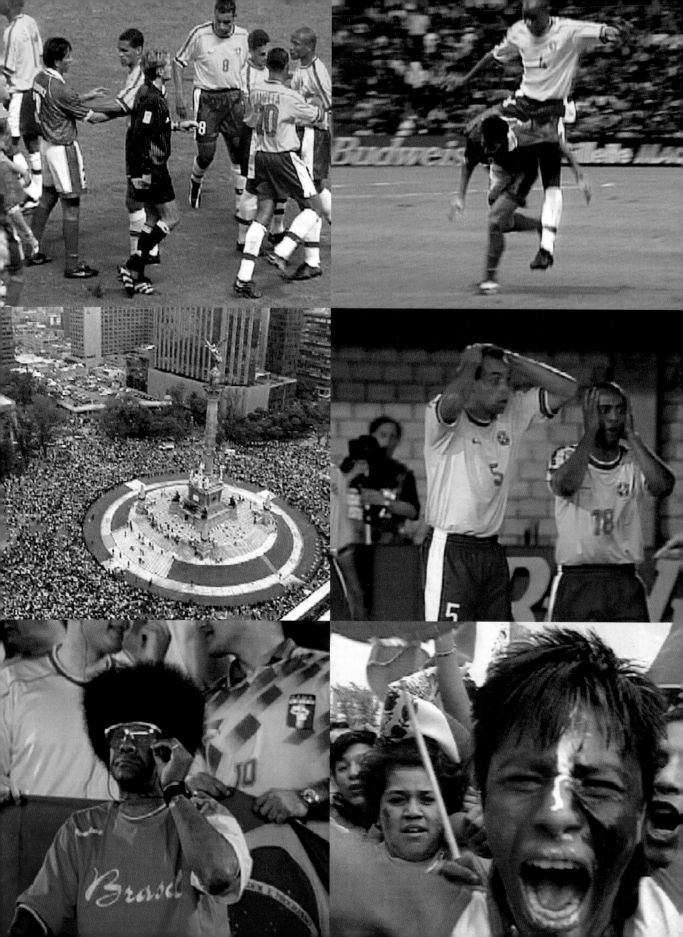

Merlin Carpenter

1967 born in Pembury, lives and works in London, UK

For Merlin Carpenter, painting is a perpetual problem to be constantly readdressed and never solved. There is an implicit tension in his work between what he sees as the intrinsic conservatism of his medium and his own explicitly stated politically left leanings. He employs techniques of appropriation as a key tool, allowing questions of content and meaning to be discussed at arms length. A series of paintings from 1999/2000 depict sexy women lifted from glossy magazines and juxtaposed with outlined cars, detailed views of leafy suburbs or roughly rendered abstract fragments. Exhibited together with a speedboat moored in the gallery, they suggest a critique of consumerism and superficiality, although their clumsy technique renders this ambivalent. In works from the following year, super-model Milla Jovovich is framed against jagged cubist backgrounds: *Girl, Interrupted* (2001) is steeped in irony, referring to the Hollywood blockbuster of that name about an attractive young mentally disturbed woman, while suggesting a simplistic psychological reading of Cubism. More recent paintings include homages to Malevich and Hirst, nodding to a lineage of painterly styles while simultaneously denying the notion of development and value. The 2003 exhibition "Children of the Projects" confronted issues of taste and prejudice head on with a group of neo-expressionistic paintings of underprivileged children amongst clichéd symbols of their plight: menacing tower blocks, oversized sneakers, guns and knives. But his works remain cloaked in an ambivalence about their allegiances and political meaning.

Für Merlin Carpenter bedeutet die Malerei ein unablässig neu zu behandelndes und nie gelöstes Problem. Sein Werk impliziert eine Spannung zwischen dem, was er für einen charakteristischen Konservatismus seines Mediums hält, und seiner eigenen, ausdrücklich formulierten, politisch linken Haltung. Als zentrales Mittel nutzt er Aneignungstechniken, die eine Erörterung von Fragen nach Inhalt beziehungsweise Bedeutung ermöglichen. In einer Gemäldeserie von 1999 bis 2000 sind sexy wirkende Frauen dargestellt, die Hochglanzmagazinen entnommen sind und sich mit Umrissbildern von Autos, Detailansichten von begrünten Vororten oder abstrakten Fragmenten abwechseln. Zusammen mit einem im Ausstellungsraum vertäuten Schnellboot präsentiert, suggerieren diese Bilder eine Kritik an Konsum und Verflachung, auch wenn diese aufgrund der hier vorherrschenden unbeholfenen Malweise nicht eindeutig wird. Arbeiten aus dem darauf folgenden Jahr zeigen das Supermodel Milla Jovovich vor kantigen kubistischen Hintergründen: Das ironieträchtige *Girl, Interrupted* (2001) verweist auf den gleichnamigen Hollywoodfilm über eine attraktive, junge, geistig verwirrte Frau und suggeriert eine vereinfachende psychologische Auslegung des Kubismus. Unter den jüngeren Arbeiten Carpenters finden sich Hommagen an Malewitsch und Hirst, die auf eine gemeinsame Abstammung malerischer Stile hinweisen und gleichzeitig Vorstellungen wie Entwicklung oder Wert negieren. In der Ausstellung „Children of the Projects" von 2003 wurden Fragen nach Geschmack und Vorurteil mit einer Gruppe von neoexpressionistischen Bildern konfrontiert, die unterprivilegierte Kinder inmitten klischeehafter Symbole ihres Elends zeigten: bedrohliche Hochhaustürme, überdimensionierte Sneakers, Schusswaffen und Messer. Und doch sind seine Arbeiten von einer gewissen Ambivalenz hinsichtlich ihrer eigenen Loyalität und politischen Bedeutung geprägt.

Pour Merlin Carpenter, la peinture est un problème perpétuel qui doit être constamment redéfini sans être jamais résolu. Son œuvre dénote une tension implicite entre ce que l'artiste considère comme le conservatisme intrinsèque du médium pictural et une tendance explicitement gauchisante. Carpenter se sert de techniques d'appropriation comme d'un outil majeur qui permet d'aborder des problèmes de contenu et de sens de manière distante. Une série de peintures de 1999/2000 décrit des femmes sexy tirées de revues de luxe et juxtaposées à des ébauches de voitures, à des vues détaillées de banlieues verdoyantes ou à des fragments abstraits peints dans une facture rugueuse. Exposées avec un hors-bord amarré dans la galerie, les peintures de cette série suggèrent une critique du consumérisme et de la superficialité, bien que leur maladresse technique rende le propos ambigu. Dans des œuvres de l'année suivante, la top-modèle Milla Jovovich est cadrée de manière à se détacher sur des fonds cubistes dentelés : *Girl, Interrupted* (2001) est fortement empreint d'ironie et se réfère à la superproduction hollywoodienne homonyme traitant d'une jeune et séduisante aliénée – tout en suggérant une lecture psychologique réductrice du cubisme. Les peintures plus récentes incluent des hommages à Malevitch et à Hirst et font de l'œil à une lignée de styles picturaux tout en niant les notions de valeur et d'évolution. L'exposition «Children of the Projects» (2003) confrontait directement les thèmes du goût et des préjugés à des séries de peintures néo-expressionnistes d'enfants défavorisés représentés parmi les signes et les clichés de leur détresse : tours d'habitations, baskets surdimensionnés, couteaux et fusils. Les œuvres de Carpenter n'en restent pas moins drapées dans l'ambiguïté de leurs allégeances et de leur signification politique.

K. B.

SELECTED EXHIBITIONS →
2004 *Nueva Generación*, Distrito 4, Madrid; *Take it Easy Default*, M-Project, Paris; *Edge of the Real*, Whitechapel Art Gallery, London **2001** *My Father, the Castaway*, White Cube, Kunstakademi Bergen **2000** *As a Painter I Call Myself the Estate of*, Secession, Vienna; *Girlfriend*, Galerie für Zeitgenössische Kunst, Leipzig; *It May be a Year of Thirteen Moons but it's Still the Year of Culture*, Transmission Gallery, Glasgow

SELECTED PUBLICATIONS →
2002 *Militant*, Galerie Christian Nagel, Cologne **2001** *Jewels-in-Art*, Galerie Bleich-Rossi, Graz **2000** *As a Painter I Call Myself the Estate of*, Secession, Vienna **1995** *Voluntary Effort*, Tom Solomon's Garage, Los Angeles

1 **40**, 2004, oil on canvas, 205.7 x 152.4 cm
2 Installation view, 2005, Galerie Christian Nagel, Cologne

3 **It Takes a Shallow Memory to Forget Me**, 2002, acrylic on canvas, 121.9 x 91.4 cm
4 **Baby Boy**, 2002, oil on canvas, 182.9 x 121.9 cm

„Die Malerei ist eine schwächliche, erfolglose Tätigkeit."

« La peinture est une activité médiocre et futile. »

"Painting is a feeble, unsuccessful activity."

2

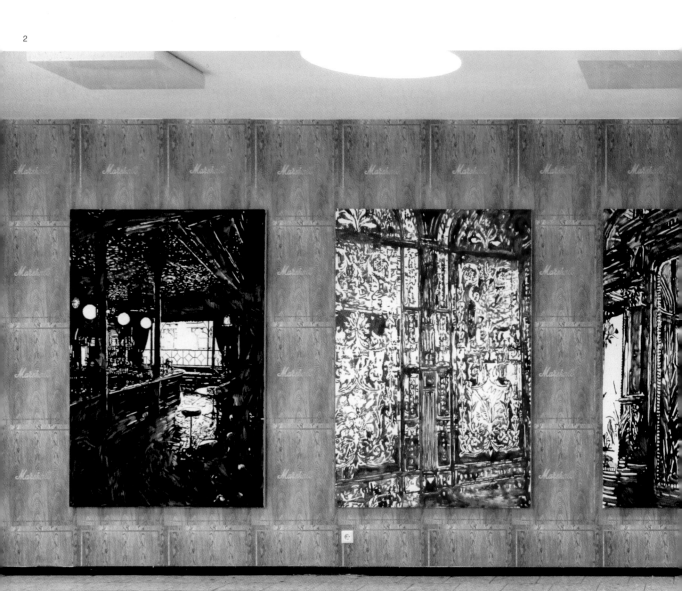

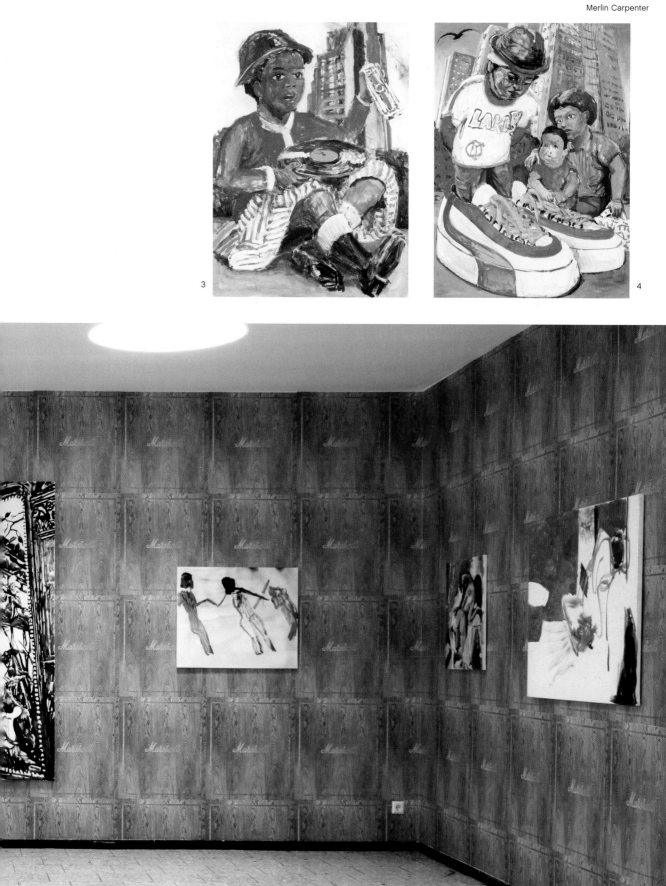

3

4

Maurizio Cattelan

1960 born in Padua, Italy, lives and works in New York (NY), USA

The contemporary art world's whistleblower, Maurizio Cattelan mines the system he inhabits in order to reveal its inner workings. His projects invariably begin with an idea, an image or a conversation. Some remain at that stage and many, such as proposals for a neo-Nazi rally or an attack dog stationed in a gallery space, have been censored. However, many of these insouciant thoughts – ritual humiliation of his dealers and art works as moneymaking scams included – become politically charged, shocking affronts to art, common decency and the art market. None of this seemingly self-defeating activism has stopped him from becoming one of the most successful and sought-after artists of his generation. Lifelike wax and resin dummies of animals and humans have been used to devastating effect, most famously for *La nona ora* (1999), an effigy of the Pope crushed by a meteorite, and more recently for *Untitled* (2004), an installation of three children hanged from a tree in a central Milan plaza that also provoked vandalism – to which Cattelan would reply "I'd rather be attacked than ignored". Less brazen are the artist's parodic self-portraits, which burrow into a museum or ride a remote-controlled tricycle. Cattelan's subterfuge is to reflect and warp the twin codes of Minimalism and Conceptual art by his practice of "working without working", hence curatorial projects such as the Wrong Gallery in New York (just a doorway) or the non-existent art at his Caribbean Biennial of 1999, effectively a holiday on St Kitts for the invited artists.

Maurizio Cattelan, Nestbeschmutzer der zeitgenössischen Kunstszene, untergräbt das System, das ihn selbst beherbergt, um so dessen innere Mechanismen zu entlarven. Seine Projekte nehmen ihren Anfang ausnahmslos in einer Idee, einem Bild oder einem Gespräch. Einige bleiben auf dieser Ebene, die meisten, beispielsweise sein Vorschlag für eine Neonazi-Kundgebung oder sein in einer Galerie postierter Kampfhund, wurden zensiert. Trotzdem werden viele dieser unbekümmerten Gedanken – einschließlich der rituellen Demütigung seiner Galeristen und der Kunstwerke als der Geldmacherei dienend – politisch aufgeladen und so zu schockierenden Angriffen auf Kunst, Anstand und Kunstmarkt. Keine dieser scheinbar sich selbst widerlegenden Aktionen konnte verhindern, dass Cattelan zu einem der erfolgreichsten und begehrtesten Künstler seiner Generation wurde. Seine lebensechten Attrappen von Tieren und Menschen aus Wachs und Kunstharz hatten überwältigende Auswirkungen; das bekannteste Beispiel dafür ist wohl *La nona ora* (1999), ein Bildnis des von einem Meteoriten erschlagenen Papstes, oder kürzlich die Installation *Untitled* (2004), drei an einem Baum auf einem Platz in der Innenstadt von Mailand aufgehängte Kinder, die zu vandalistischen Reaktionen führte – auf welche Cattelan entgegnete: „Ich lasse mich lieber angreifen als ignorieren." Weniger dreist sind die parodistischen Selbstbildnisse des Künstlers, die sich in ein Museum graben oder auf einem ferngesteuerten Dreirad fahren. Cattelans Trick besteht in einer Reflexion und Verzerrung der beiden Kodes von Minimalismus und Konzeptkunst in seiner Praxis der „Arbeit ohne Arbeit", aus der sich Ausstellungsprojekte wie die Wrong Gallery in New York (die lediglich aus einem Eingang bestand) oder die nichtexistente Kunst im Rahmen seiner Caribbean Biennial von 1999 ergaben, die letztlich nur eine Urlaubsreise der eingeladenen Künstler nach St. Kitts war.

Maurizio Cattelan, le trouble-fête du monde de l'art contemporain, sape le système dans lequel il vit lui-même pour en révéler les rouages. Ses projets partent invariablement d'une idée, d'une image ou d'une conversation. Certains en restent à ce stade, et beaucoup ont été censurés, comme ses propositions pour un meeting néonazi ou un chien de combat stationné dans l'espace d'une galerie. Quoi qu'il en soit, nombre de ces idées insouciantes – y compris les humiliations rituelles de ses marchands et de ses œuvres d'art en tant qu'escroqueries financières – sont politiquement chargées, deviennent de choquantes insultes à l'art, à la bienséance et au marché de l'art. Tous ces activismes apparemment autodestructeurs n'ont pas empêché Cattelan de devenir l'un des artistes les plus célèbres et les plus recherchés de sa génération. Des mannequins d'hommes et d'animaux en cire et en résine à l'aspect plus vivant que nature ont été utilisés pour des effets dévastateurs, l'un des plus célèbres étant celui de *La nona ora* (1999), une effigie du pape écrasé par un météorite, et, plus récemment, *Untitled* (2004), une installation de trois enfants pendus à un arbre au centre de Milan, qui a également déclenché des actes de vandalisme – auxquels Cattelan répond : « Je préfère être attaqué qu'ignoré. » Moins outranciers sont les autoportraits parodiques de l'artiste qui se terrent dans un musée ou qui chevauchent un tricycle téléguidé. Les manipulations de Cattelan consistent en une réflexion et un détournement des codes jumeaux du minimalisme et de l'Art conceptuel par la pratique de « l'œuvre sans œuvre », et donc de projets d'exposition comme la Wrong Gallery de New York (une simple entrée d'immeuble) ou l'art absent de sa Biennale des Caraïbes (1999) – en fait un jour férié à Saint-Kitts pour les artistes invités.

O. W.

SELECTED EXHIBITIONS →
2004/05 54. Carnegie International, Carnegie Museum of Art, Pittsburgh **2004** Galleria Civica di Arte Contemporanea, Trento; *Now*, Musée d'Art moderne de la Ville de Paris; *Untitled*, Fondazione Nicola Trussardi, Milan; 1. Bienal Internacional de Arte Contemporáneo de Sevilla; Whitney Biennial, Whitney Museum of American Art, New York **2003** Museum of Contemporary Art, Los Angeles; *2.0.0.2.*, Deste Foundation, Athens, Museum Ludwig, Cologne; *Delays and Revolutions*, 50. Biennale di Venezia, Venice **2002** *Charley*, P.S.1, New York

SELECTED PUBLICATIONS →
2003 *Maurizio Cattelan*, London; *Maurizio Cattelan*, Los Angeles **2001** *6. Caribbean Biennial*, Les Presses du réel, Dijon **2000** *Maurizio Cattelan*, Castello di Rivoli, Turin **1999** *Maurizio Cattelan*, Kunsthalle Basel, Basle

1 **Untitled**, 2003, body in resin, synthetic hair, clothes, electronic device, bronze drum, 80 x 85 x 56 cm, installation view, Museum Ludwig, Cologne
2 **Untitled**, 2004, mixed media, lifesize donkey

3+4 **Now**, 2004, polyester resin, wax, human hair, clothes, 85 x 225 x 78 cm

„Alles, was nach Fertigstellung deiner Arbeit geschieht, gehört dir nicht mehr. Es lässt sich nicht steuern. Die Arbeit muss für sich selbst kämpfen und sich selbst definieren."

«Quoi qu'il se passe une fois l'œuvre terminée, elle ne vous appartient plus. On ne peut la contrôler. L'œuvre doit se battre par elle-même et se définir elle-même.»

"Whatever comes after you've done your work, it doesn't belong to you. You can't control it. The work has to fight for itself and define itself."

2

3

Jake & Dinos Chapman

Jake Chapman, 1966 born in Cheltenham, and Dinos Chapman, 1962 born in London; live and work in London, UK

The surrealist poet André Breton insisted that beauty be compulsive and the Chapman brothers demand the same of their work. Ten years after they first refashioned Goya's *Desastres de la guerra* (Disasters of War) in three-dimensional, miniature form, Jake and Dinos Chapman revisited and physically defaced a set of eighty original etchings to produce *Insult to Injury* (2003). In each print, the heads of soldiers and mutilated corpses have been painted over with grinning clowns and deformed puppy dog faces, simultaneously lightening and darkening the barbarous mood of torture and death. Despite losing their most formidable work *Hell* (2000), nine vitrine-encased mountains of bloodied model figurines, in the apocalyptic YBA warehouse fire of 2004, their monastic dedication to similar labour-intensive projects has not ceased. The ingenious *Works from the Chapman Family Collection* (2003) appeared to be the sort of early 20th-century display of "primitive" art that was so revered by Picasso and cohorts, except that the hand-carved idols were infused with subliminal McDonald's iconography. After every jolting encounter with a sculptural installation or suite of drawings by the Chapmans, there comes a readjustment of belief systems, an acceptance of whatever atrocities they have depicted, which encompass such irreconcilable combinations as: childhood with sexuality, fascism with avant-garde art, craft with concept and religion with apathy. While their shock value decreases, their aesthetic debauchment gains credence. So the brothers' corruptive influence is spreading, just like that of the global corporations they lampoon.

Der surrealistische Dichter André Breton beharrte darauf, dass die Schönheit triebhaft sein müsse; dasselbe fordern auch die Chapman-Brüder von ihrer Arbeit. Zehn Jahre nach ihrer dreidimensionalen Umgestaltung von Goyas *Desastres de la guerra* (Schrecken des Krieges) haben Jake und Dinos Chapman sich einer Reihe von 80 Originalradierungen zugewandt und diese physisch geschändet. Das Ergebnis ist *Insult to Injury* (2003). In jedem Druck sind die Köpfe der Soldaten und verstümmelten Leichen mit den Fratzen grinsender Clowns und deformierten Welpengesichtern übermalt worden, so dass die barbarische Stimmung aus Folter und Tod sich gleichzeitig aufhellt und verdüstert. Auch der Verlust ihrer gewaltigsten Arbeit, *Hell* (2000), neun in Vitrinen gefasste Berge aus blutigen Modellbaufiguren, durch den apokalyptischen Lagerhausbrand von 2004, bei dem viele Werke der Young British Art zerstört wurden, hat ihrer mönchischen Hingabe an ähnlich arbeitsaufwändige Projekte keinen Abbruch getan. So wirkten die raffinierten *Works from the Chapman Family Collection* (2003) wie jene Art der Präsentation „primitiver" Kunst, die Picasso und Konsorten zu Beginn des 20. Jahrhunderts so verehrten, wobei allerdings diese handgeschnitzten Idole von einer unterschwelligen McDonald's-Ikonografie erfüllt waren. Jeder erschütternden Begegnung mit einer Skulpturinstallation oder Zeichnungsserie der Chapmans folgt eine Korrektur des eigenen Glaubenssystems, ein Annehmen aller durch sie dargestellten Abscheulichkeiten, unter die so unvereinbare Verbindungen wie Kindheit und Sexualität, Faschismus und Avantgarde-Kunst, Kunsthandwerk und Konzept oder Religion und Apathie fallen. In dem Maß, in dem ihr Schockwert abnimmt, gewinnen ihre ästhetischen Ausschweifungen an Glaubwürdigkeit. Damit verbreitet sich der verderbliche Einfluss der Brüder ebenso wie der jener globalen Unternehmen, die sie verunglimpfen.

Le poète surréaliste André Breton a prôné que la beauté devait être compulsive, et c'est cette même exigence que les Chapman posent à leur œuvre. Dix ans après avoir refondu les *Desastres de la guerra* (Désastres de la guerre) de Goya dans une forme miniature tridimensionnelle, Jake et Dinos Chapman ont revisité et physiquement défiguré une série de 80 gravures originales pour produire *Insult to Injury* (2003). Dans chacun des tirages, les têtes des soldats et des cadavres mutilés ont subi des repeints de clowns grimaçants et de têtes de chiots déformées dont les assombrissements « éclairent » la barbarie de la torture et de la mort. Bien qu'ils aient perdu leur œuvre la plus extraordinaire, *Hell* (2000), neuf amas de figurines ensanglantées enchâssées dans des vitrines, dans l'incendie apocalyptique qui a ravagé un entrepôt de Young British Art en 2004, l'attention toute monastique qu'ils portent à des projets tout aussi exigeants n'a en rien décru. Les ingénieux *Works from the Chapman Family Collection* (2003) sont apparus comme une sorte d'étalage de l'art « premier » du début du XXe siècle tant révéré par Picasso et consorts, sauf que les idoles taillées à la main ont été affublées d'iconographies subliminales se référant à McDonald's. Chaque découverte frappante d'une installation sculpturale ou d'une série de dessins des Chapman impose une relecture des schémas de croyance établis, une acceptation de toutes les atrocités qui y sont décrites et qui englobent des associations aussi inconciliables qu'enfance et sexualité, fascisme et avant-garde artistique, artisanat et conceptualisme, religion et apathie. A mesure que la valeur de leurs effets de choc décroît, leur dépravation esthétique gagne en crédibilité. L'influence subversive des deux frères s'étend ainsi dans la mesure même où s'étend celle des entreprises mondiales qu'ils malmènent.

O. W.

SELECTED EXHIBITIONS →
2004 *The New and Improved Andrex Works*, Thomas Olbricht Collection, Essen; *Insult to Injury*, Kunstsammlungen der Veste, Coburg; *The Marriage of Reason and Squalor*, Centro de Arte Contemporáneo de Málaga, Dunkers Kulturhus, Helsingborg **2003** *Hell*, The Saatchi Gallery, London; *Turner Prize Exhibition*, Tate Britain, London; *The Rape of Creativity*, Modern Art Oxford; *Jake & Dinos Chapman*, museum kunst palast, Düsseldorf **2002** *Jake and Dinos Chapman*, Groninger Museum

SELECTED PUBLICATIONS →
2004 *The Marriage of Reason and Squalor*, Centro de Arte Contemporáneo de Málaga, Dunkers Kulturhus, Helsingborg **2003** *Meatphysics*, Creation Books, London; *Insult to Injury*, London; *Hell*, The Saatchi Gallery, London **2002** *Disasters of War*, Chapman Publishing; *Enjoy More*, museum kunst palast, Düsseldorf, Groningen Museum, Groningen

1

2

1+2 **Insult to Injury**, 2003, Francisco de Goya "Disasters of War", portfolio of 80 etchings reworked and improved, each 37 x 47 cm (framed)
3 **Unholy McTrinity.1**, 2003, painted bronze, 180 x 210 x 60 cm
4 **CFC 76249559.1**, 2002, painted bronze, 92 x 41 x 9 cm

5 **CFC 76311561**, 2002, wood, paint, 92 x 58 x 49 cm
6 "Works from the Chapman Family Collection", exhibition view, White Cube, London 2002
7+8 **Rape of Creativity**, 2003, mixed media, dimensions variable

„Die Kunst leidet an ihrer Verantwortung, etwas Idealistisches über die Welt sagen zu müssen. Wir sind äußerst pessimistisch hinsichtlich des Künstlerberufs und hinsichtlich dessen, was die Kunst gesellschaftlich leistet."

« L'art souffre la responsabilité de devoir dire des choses idéalistes sur le monde. Nous sommes foncièrement pessimistes quant au métier d'artiste et l'action sociale de l'art. »

"Art suffers the responsibility of having to have idealistic things to say about the world. We are intensely pessimistic about the job of being an artist and about what art does socially."

3

5

7

8

John Currin

1962 born in Boulder (CO), lives and works in New York (NY), USA

John Currin's figurative paintings appeared in the art world at the end of the eighties. His perverse paintings of expressionless young female students are unsettling, and must therefore be ranked amongst "great painting" all the same. His meticulous, exaggerated and frightening paintings, with a distinctive sense for the abnormal, adopt their format and themes from middle-class easel painting, in order to present a strange and moralistic portrait of contemporary society. Currin is convinced that most emotions which we connect with religion, such as feelings of guilt, sin and redemption, have been changed by modern life, and he paints the various present-day ills. Although he prefers to relate himself to Pablo Picasso, Max Beckmann, and even Willem de Kooning, his characteristically illusionistic work is more closely related to the paintings of Francis Picabia, enriched with images from popular films and nude magazine illustrations. The figures are reduced to caricatures, to archetypes, the models for which seem far away, or even lost. He equips them with the faces of actresses from old magazines or theatre books, and the world in which they live is completely artificial. He has therefore also been described as a "post-postmodern Balthus". Regarding his project to create a picture in which all the figures are dressed up in "some sort of outlandish costume", Currin says it is: "Just to be honest about how fake and anachronistic the entire thing is." Far from orienting himself on tradition, he easily admits, "I really don't make a distinction between art and art history." He brings the past and the future together on a single plane of time and draws a relation with the metaphysical painting of Giorgio de Chirico: simultaneously "nostalgic and futuristic".

Ende der achtziger Jahre tauchten die figurativen Gemälde von John Currin in der Kunstwelt auf: Seine perversen Malereien ausdrucksloser Schülerinnen verstören, sind aber gleichwohl der "großen Malerei" zuzuordnen. Seine minuziösen, übertriebenen und Furcht erregenden, mit einem ausgeprägten Sinn für Anomalie gemalten Bilder übernehmen von der bürgerlichen Staffeleimalerei Format und Themen, um ein seltsames, moralisches Porträt der heutigen Gesellschaft zu zeichnen. Currin ist überzeugt davon, dass die meisten Emotionen, die wir mit der Religion verbinden, wie Schuldgefühle, Sünden und die Erlösung, durch das moderne Leben verändert wurden, und malt die Widrigkeiten der heutigen Zeit. Obwohl er sich lieber auf Pablo Picasso, Max Beckmann, ja sogar Willem de Kooning bezieht, steht sein von Illusionismus geprägtes Werk in der Folge der Malerei von Francis Picabia, angereichert mit Abbildungen beliebter Filme und Aktdarstellungen in Magazinen. Die Figuren sind auf Karikaturen reduziert, auf Archetypen, deren Vorbilder weit weg, ja verloren scheinen. Er stattet sie mit Gesichtern von Schauspielerinnen aus alten Zeitschriften oder Theaterheften aus, und die Welt, in der sie leben, ist vollkommen künstlich. Daher wurde er auch als „post-postmoderner Balthus" bezeichnet. Über sein Projekt, ein Bild zu realisieren, auf dem alle Figuren mit einer Art exotischem Kostüm bekleidet sind, sagt Currin: „Nur um deutlich darzulegen, wie falsch und anachronistisch dies alles ist." Weit davon entfernt, sich an der Tradition zu orientieren, gibt er freiwillig zu, „überhaupt keinen Unterschied zwischen Kunst und Kunstgeschichte zu machen", er bringt Vergangenheit und Zukunft auf einer Zeitebene zusammen und nimmt für sich die metaphysische Malerei Giorgio de Chiricos in Anspruch, gleichzeitig „nostalgisch und futuristisch".

Lorsqu'elle paraît, à la fin des années quatre-vingt, la peinture figurative de John Currin dénote : ses perverses peintures d'écolières dénuées d'expression n'en rappellent pas moins la «grande peinture». Minutieusement brossés avec excès, monstruosité, et un sens aigu de l'anomalie, ses tableaux empruntent à la tradition bourgeoise de la peinture de chevalet format et sujets pour dresser un curieux portrait moral de la société d'aujourd'hui. Convaincu que la plupart des émotions que nous associons avec la religion, comme la culpabilité, le péché et la rédemption, ont été transformées par la vie moderne, Currin en peint les avatars contemporains. Alors qu'il réfère plus volontiers à Pablo Picasso, Max Beckmann voire même Willem de Kooning, c'est bien dans la lignée des peintures de Francis Picabia, nourries d'images de magazines de cinéma populaire et de naturisme, que cette œuvre pétrie d'illusionnisme se place. Les figures, en effet, y sont clairement réifiées, réduites à des caricatures, des archetypes dont le modèle serait lointain, voire perdu. Il dote ses personnages de visages d'actrices issus de vieux magazines ou livres de théâtre, et l'univers même dans lequel ils évoluent est clairement anti-naturel. On a ainsi pu le qualifier de «Balthus post-postmoderne». A propos de son projet de réaliser une peinture où tout le monde soit vêtu d'une sorte de costume exotique, Currin précise : « Juste pour être honnête à propos de combien tout cela est faux et anachronique. » Loin d'être passéiste, il avoue simplement ne faire «aucune différence entre l'art et l'histoire de l'art», confondant passé et futur dans un même temps, en se revendiquant de la peinture métaphysique de Giorgio de Chirico, à la fois «nostalgique et futuriste».

S. C.

SELECTED EXHIBITIONS →
2004 Whitney Museum of American Art, New York; Museum of Contemporary Art, Chicago; Serpentine Gallery, London **2003** Museum of Fine Arts, Boston; Des Moines Art Center; Aspen Art Museum

SELECTED PUBLICATIONS →
2005 *John Currin, Catalogue raisonné*, Milan **2003** *John Currin Selects*, Museum of Fine Arts, Boston; *John Currin*, Museum of Contemporary Art, Chicago, Serpentine Gallery, London; *Dreams and Conflicts: The Dictatorship of the Viewer*, 50. Biennale di Venezia, Venice

1 **Fishermen**, 2002, oil on canvas, 127 x 104.1 cm
2 **Thanksgiving**, 2003, oil on canvas, 172.7 x 132.1 cm
3 **Rachel in Fur**, 2002, oil on canvas, 50.8 x 40.6 cm

4 **The Producer**, 2002, oil on canvas, 121.9 x 81.3 cm
5 **Bent Lady**, 2003, oil on canvas, 121.9 x 96.5 cm
6 **Anna**, 2004, oil on canvas, 61 x 45.7 cm

„Das Subjekt eines Bildes ist immer der Autor, der Künstler.
Man kann nur die Illusion vermitteln, dass es sich um etwas anderes handelt.
Ich glaube, dies ist die Funktion der Darstellung: einem Bild die Illusion
eines Subjekts zu verleihen."

« Le sujet d'un tableau c'est toujours l'auteur, l'artiste. Vous pouvez juste
donner l'illusion que ça parle d'autre chose. Je crois que c'est ça la fonction
de la représentation : doter un tableau de l'illusion d'un sujet. »

"The subject of a painting is always the author, the artist.
You can only make an illusion that it's about something other than that.
I think that's what the function of representation is: to give a painting
the illusion of a subject."

2

3

4

5

6

Jeremy Deller

1966 born in London, lives and works in London, UK

In 2004 Jeremy Deller received the renowned Turner Prize. In the run-up to the competition, he once flaunted his "inadequate technical skills", saying he could not draw, paint, or sculpt. Many media commentators were happy to tout this ironic twist on the traditional image of artists. This might have pleased Deller, as his "craft" lies precisely in brushing socially established conventions the wrong way: sometimes casually, and sometimes on a grand scale. Thereby he doesn't care about genres, but about themes. Deller questions those characteristics which lend identity to societies, and he addresses inconspicuous historical and (pop) cultural contexts, usually developing these themes in collaboration with others, such as with other artists, brass musicians, or workers from dockyards or mines. For example, the idea for *Acid Brass* (beginning in 1997) came from Deller's realization that House Music is the working classes' first really original music since the emergence of brass music 150 years ago. Thus he had Acid House tracks performed by a brass band. The spectacular *Battle of Orgreave* (2001) is also a type of re-performance. In this piece Deller recreated the events around the miner strike of 1984/85, in which bloody clashes with the police had taken place in Orgreave. He re-staged the events as a massive performance for which he was able to attract strike veterans and mounted police. With these types of projects, however, he is less interested in journalistic counter-propaganda than in performance. This is because fiction allows history to be literally resurrected here. In the concrete activity a playful distance combines with traumatic memory, and results in an ultimately incalculable intensity that can lead to something new. Art then convincingly becomes a political issue.

Im Jahr 2004 erhielt Jeremy Deller den renommierten Turner-Preis. Im Vorfeld kokettierte er einmal mit seinen „mangelhaften handwerklichen Fähigkeiten": Er könne weder zeichnen noch malen noch mit Skulptur umgehen. Viele Medien haben die ironische Spitze gegen das traditionelle Künstlerbild gerne kolportiert. Was Deller gefallen haben dürfte, liegt sein „Handwerk" doch gerade darin, mal beiläufig, mal im großen Format gesellschaftliche Konventionen gegen den Strich zu bürsten. Und dabei schert er sich nicht um Gattungen, sondern um Themen: Deller fragt nach identitätsstiftenden Merkmalen von Gesellschaften, greift ungesehene historische und (pop)kulturelle Zusammenhänge auf, die er meist in Kooperation erschließt: mit Künstlern, Blechbläsern, Hafen- oder Bergarbeitern. Anlass für *Acid Brass* (ab 1997) etwa war die Erkenntnis, dass House Music die erste wirklich originäre Musik der Arbeiterklasse seit Aufkommen der Blasmusik vor 150 Jahren sei. Und so ließ er eine Brass Band Acid-House-Tracks aufführen. Auch beim spektakulären *Battle of Orgreave* (2001) handelte es sich um eine Art Wiederaufführung: Deller stellte das Geschehen um die Bergarbeiterstreiks von 1984/85 nach, bei denen es in Orgreave zu blutigen Zusammenstößen mit der Polizei gekommen war. Er re-inszenierte die Ereignisse als Massenperformance, für die er Streikveteranen und berittene Polizei gewinnen konnte. Mit solchen Projekten geht es ihm jedoch weniger um journalistische Gegenaufklärung als um das Performative: Denn die Fiktion lässt Geschichte hier wortwörtlich wieder auferstehen, im konkreten Agieren verbinden sich spielerische Distanz und traumatische Erinnerung zu letztlich nicht kalkulierbarer Intensität, die zu etwas Neuem führen kann. Dann aber wird Kunst überzeugend zum Politikum.

En 2004, Jeremy Deller recevait le célèbre Prix Turner. Quelques temps avant l'annonce des résultats, il s'était flatté de son «manque de métier», déclarant qu'il ne savait ni dessiner, ni peindre, ni travailler la sculpture. Cette pique ironique à l'adresse de l'image traditionnelle de l'artiste avait été amplement colportée par les médias, ce qui n'a sans doute pas été pour déplaire à Deller, dont le «métier» consiste justement à prendre les conventions sociales admises à rebrousse-poil, parfois incidemment, parfois en grand format. Cela dit, Deller ne s'intéresse aux genres, mais plutôt à des thèmes : il interroge les signes identitaires des sociétés, relève des correspondances historiques et culturelles (pop) restées ignorées et les aborde le plus souvent à travers une démarche collective : avec des artistes, des musiciens de fanfares, des dockers ou des mineurs. *Acid Brass* (à partir de 1997) est né du constat que la *house music* était la première musique réellement issue de la classe ouvrière depuis l'apparition des fanfares voici quelque 150 ans, et c'est ce qui a conduit Deller à faire jouer des morceaux d'*acid house* par une fanfare. Dans le cas de la spectaculaire *Battle of Orgreave* (2001), il s'agissait d'une sorte de reprise : Deller a reconstitué les événements qui se sont déroulés lors des grèves de mineurs de 1984/85, qui ont été le théâtre d'accrochages sanglants avec la police à Orgreave. Deller a remis ces événements en scène comme une performance de masse, pour laquelle il a pu gagner le concours de vétérans grévistes et de policiers montés. Dans ce type de projets, Deller s'attache moins à donner un éclairage journalistique alternatif qu'à l'aspect performatif : la fiction ressuscite littéralement l'histoire, l'action concrète associe distance ludique et mémoire traumatique pour produire une intensité qui ne peut être programmée, mais qui est à même de conduire à quelque chose de nouveau. L'art devient alors un fait politique convaincant.　　　　　　J. A.

SELECTED EXHIBITIONS →
2005 Kunsthalle Basel, Basle; Kunstverein München, Munich; *Populism*, Frankfurter Kunstverein; Stedelijk Museum, Amsterdam; Museet for samtidskunst, Oslo; Contemporary Art Centre, Vilnius **2004** *Turner Prize Exhibition*, Tate Britain, London; 54. Carnegie International, Carnegie Museum of Art, Pittsburgh; Manifesta 4, San Sebastian; 4. Taipei Biennial; *This Is Us – Music from Appenzell*, Kunsthalle Sankt Gallen **2000** *Intelligence*, Tate Triennial, London

SELECTED PUBLICATIONS →
2005 *Folk Archive – Contemporary Popular Art from the UK (Opus Projects S.)*, Book Works, London **2004** *Turner Prize*, Tate Britain, London **2003** *This Is Us*, Red Hook, New York **2002** *The English Civil War Part II: Personal accounts of the 1984–85 miners' strike*, Artangel, London; *After The Goldrush*, CCA Wattis Institute for Contemporary Arts, San Francisco

The World of GAZZA!!

In Association with Mel Stein Enterprises
The Museum of Mankind.
Burlington Gardens London W1.
Kickoff February 21st Full Time May 10th
Mon-Fri 10.00-18.00 Sun 12.00-17.30
(Closed Easter Day and Easter Monday)
Admission Free.

1 **The World of Gazza**, 1995, silkscreen on paper, 70 x 50 cm
2 **The Battle of Orgreave**, 2004, video still

„Warhol sagte, bei der Pop Art ginge es darum, Dinge zu mögen, während es bei der populären Kunst [folk art] meines Erachtens darum geht, Dinge zu lieben."

«Warhol a dit que le Pop Art consiste à apprécier les choses, alors que pour moi, l'art populaire [folk art] consiste à aimer les choses.»

"Warhol said that pop art was about liking things, whereas for me folk art is about loving things."

Thomas Demand

1964 born in Munich, lives and works in Berlin, Germany

The chilling blankness and eerie evenness of Thomas Demand's immaculate photographs of otherwise unremarkable settings are clues to the two-pronged problem they bring up: how the resonance of history, narrative or memory can spawn meaning in a neutral environment; and the explicitly constructed nature of the photographic image. Although often taking a well-known media image as a starting point, Demand transposes it through a mind-bogglingly minute process. First he rebuilds it as a large scale sculptural replica in cardboard and paper, then he lights it precisely and finally photographs it. The model is discarded and the large scale glossy image is exhibited alone. This has the dual effect of creating an image drained of the messy details of reality while freed up for an audience's own associative interplay or paranoid readings. Demand's taut, crisp photographs hum with a suspense that defies their formal blandness. *Gate* (2004), picturing an airport baggage checkpoint, is all sharp angles and clear surfaces, but is thick with associations of airborne terrorism and undetected shoe-bombers. The endlessly curving underpass in the animated film-loop *Tunnel* (1999) has a disturbing emptiness whether or not one recognizes it as the Pont de l'Alma where Princess Diana's car crashed. Though the substantiality of these innocuous crime scenes is intrinsically questionable, and the protagonists are long-gone, they nonetheless tap directly into the most susceptible areas of contemporary cultural anxiety.

Die frostige Leere und gespenstische Geradheit in den makellosen Fotografien eher unauffälliger Kulissen von Thomas Demand weisen auf das zweischneidige Problem hin, das sie aufwerfen: einerseits die Frage, wie durch den Widerhall der Geschichte, Erzählung oder Erinnerung in einer neutralen Umgebung Bedeutung erzeugt werden kann, andererseits das Problem des ausdrücklich konstruierten Wesens des fotografischen Bildes. Demand wählt häufig ein bekanntes Bild aus den Medien als Ansatzpunkt und transponiert dieses vermittels eines unglaublich minuziösen Prozesses. Zunächst baut er es als großformatige dreidimensionale Nachbildung aus Pappe und Papier auf, dann beleuchtet er es präzise, und schließlich fotografiert er es. Während das Modell anschließend zerstört wird, wird nur das großformatige Hochglanzfoto ausgestellt. Dies führt dazu, dass ein von den schmutzigen Details der Realität befreites Bild entsteht, welches sich andererseits für ein assoziatives Wechselspiel mit dem Betrachter beziehungsweise für dessen paranoide Deutungen eignet. Demands glatte Fotografien sind von einer Spannung erfüllt, die sich ihrer formalen Milde widersetzt. *Gate* (2004), die Darstellung einer Flughafen-Gepäckkontrollstelle, besteht nur aus spitzen Winkeln und klaren Flächen, lässt jedoch unweigerlich an Luftpiraten und unerkannte Schuhsohlenbomber denken. Die endlos sich windende Unterführung aus dem animierten Filmloop *Tunnel* (1999) vermittelt eine verstörende Leere, egal ob man in ihr den Pont de l'Alma wiedererkennt, in dem Prinzessin Dianas Auto verunglückte. Obgleich die Bedeutung dieser harmlosen Tatorte fragwürdig ist und ihre Protagonisten längst verschwunden sind, wagen sie sich doch unmittelbar in die empfindlichsten Bereiche heutiger kultureller Angst vor.

L'effrayante vacuité, l'angoissante uniformité et la mise en scène apparemment anodine des photographies immaculées de Thomas Demand sont les indices de la double problématique qu'elles soulèvent – touchant d'une part la manière dont la résonance de l'Histoire, du récit ou de la mémoire peut être génératrice de sens dans un environnement neutre, et d'autre part la nature explicitement construite de l'image photographique. Bien qu'il parte le plus souvent d'une image bien connue des médias, Demand la transpose au moyen d'un processus tout à fait remarquable. Il commence par en construire une réplique sculpturale en carton et en papier, puis la soumet à un éclairage précis avant de la photographier. La maquette est ensuite mise au rebut et l'image lissée exposée seule. Ceci a pour double effet de créer une image expurgée de tous les détails gênants de la réalité, mais aussi libérée de manière à laisser libre cours aux jeux d'associations ou aux lectures paranoïaques du spectateur. Les photographies tendues et nettes de Demand distillent un suspense qui défie leur platitude formelle. Le point de contrôle de bagages de *Gate* (2004) est entièrement composé d'angles aigus et de surfaces vides, mais est lourd d'allusions au terrorisme aérien et aux poseurs de bombes non détectés. Passé en boucle, le souterrain indéfiniment courbe du film *Tunnel* (1999) dénote une troublante vacuité – indépendamment du fait que le spectateur y reconnaisse ou non le pont de l'Alma où s'est produit l'accident de voiture qui a coûté la vie à la princesse Diana. Bien que leur substantialité pose intrinsèquement question et que les protagonistes en aient depuis longtemps disparu, ces scènes de crime anodines ne s'adressent pas moins très directement aux zones les plus sensibles de l'angoisse culturelle contemporaine.

K. B.

SELECTED EXHIBITIONS →
2005 The Museum of Modern Art, New York **2004** 26. Bienal de São Paulo **2003** Dundee Contemporary Arts; 50. Biennale di Venezia, Venice; *Phototrophy*, Kunsthaus Bregenz **2002** Städtische Galerie Lenbachhaus, Munich; Louisiana Museum for Moderne Kunst, Humlebæk; Site Santa Fe; 3. Taipei Biennial **2001** Aspen Art Museum; De Appel, Amsterdam

SELECTED PUBLICATIONS →
2004 *Thomas Demand*, 26. Bienal de São Paulo, Cologne; *Thomas Demand: Phototrophy*, Kunsthaus Bregenz **2002** *Thomas Demand*, Städtische Galerie im Lenbachhaus, Munich, Louisiana Museum for Moderne Kunst, Humlebæk

1 **Clearing**, 2003, offset print on affiche paper, 326 x 920 cm,
 50. Biennale di Venezia, Venice
2 **Fence**, 2004, C-print/Diasec, 180 x 230 cm

3 **Gate**, 2004, C-print/Diasec, 180 x 238 cm
4 **Kitchen**, 2004, C-print/Diasec, 133 x 165 cm

„Die von mir dargestellten Umgebungen sind für mich etwas Unberührtes, eine utopische Konstruktion. Auf ihrer Oberfläche finden sich keine Gebrauchsspuren, die Zeit scheint in ihnen still zu stehen."

« Les environnements que je dépeins sont pour moi quelque chose d'intact, une construction utopique. Aucune trace d'utilisation n'est visible à leur surface, et le temps semble s'être arrêté. »

"The surroundings that I portray are for me something untouched, a utopic construction. No traces of use are visible on their surfaces, and time seems to have come to a stop."

2

3

4

Rineke Dijkstra

1959 born in Sittard, lives and works in Amsterdam, The Netherlands

Rineke Dijkstra portrays young people on the threshold of adulthood because she concentrates on moments of transition: the Bosnian girl Almerisa in a home for refugees in Holland, dancing youths in a disco, mothers after giving birth, or young Israelis beginning their military service. Generally in large-format colour photographs, she depicts them frontally as full-length or bust portraits in their customary surroundings. Capturing the transition from child to adult seems just as important as documenting certain stages of their biographies. Youth is a phase of life characterized just as much by uncertainty as by openness and the urge for something new. It is a time in which much is still undetermined and unpredictable. These photos therefore also contain a certain amount of imagination. To be sure, the portraits reveal fragments of their subjects' experience until now – in their physiognomy and gestures, in their clothing, and in the background interiors or landscapes. They say nothing, however, about the future of those portrayed, or about further developments in the course of their lives. The aspect of time plays a decisive role throughout Dijkstra's work. For every portrait fundamentally represents a single captured moment. However, by revisiting some of her subjects and re-photographing them over the course of time, Dijkstra creates open series of people growing older. Re-photographing the motif makes the advance of time apparent. The changes express growth, growing older, and maturing. This produces an intensity and immediacy in the depiction, due to both the artist and we as viewers being subject to the same chronological alteration.

Rineke Dijkstra porträtiert junge Menschen auf der Schwelle zum Erwachsensein, weil sie sich auf Übergangsmomente konzentriert: das bosnische Mädchen Almerisa im Flüchtlingsheim in den Niederlanden, tanzende Jugendliche in einer Disco, Mütter nach der Geburt oder junge Israelis zu Beginn des Militärdienstes. In meist großformatigen Farbfotografien sind sie frontal als ganze Figuren oder Brustbildnisse in ihrer gewohnten Umgebung dargestellt. Den Übergang vom Kind zum Erwachsenen festzuhalten scheint genauso wichtig, wie bestimmte Schritte in ihrer Biografie zu dokumentieren. Die Jugend ist als Lebensabschnitt sowohl von Unsicherheit als auch von Offenheit und Drang nach Neuem geprägt. Es ist eine Zeit, in der vieles noch unbestimmt und unvorhersehbar ist. Deshalb enthalten diese Fotos auch einen Anteil an Imagination. Die Porträts offenbaren zwar Bruchstücke des bisher Erlebten in der Physiognomie und der Gestik der Porträtierten, in deren Kleidung, im Interieur oder der Landschaft des Hintergrundes. Sie sagen jedoch nichts aus über die Zukunft der Abgebildeten oder über die Fortsetzung ihres Lebenslaufs. Der Aspekt der Zeit spielt in Dijkstras Werk allgemein eine entscheidende Rolle. Denn grundsätzlich ist jedes Porträt eine einzelne Momentaufnahme. Indem Dijkstra aber einige Porträtierte im Lauf der Zeit wieder besucht und neu fotografiert, entstehen offene Folgen heranwachsender Personen. Mit der Wiederaufnahme des Motivs wird das Fortschreiten der Zeit offensichtlich. Das Wachsen, Älterwerden und Reifen drückt sich in der Veränderung aus. Da die Künstlerin und wir als Betrachtende derselben zeitlichen Veränderung unterworfen sind, ergibt sich eine Intensität und Unmittelbarkeit der Darstellung.

Rineke Dijkstra fait le portrait de jeunes au seuil de l'âge adulte parce qu'elle concentre son intérêt sur les moments transitoires : Almerisa, la jeune Bosniaque d'un centre de réfugiés hollandais, des jeunes dansant dans une discothèque, des mères après l'accouchement ou de jeunes Israéliens commençant leur service militaire. Dans ses photographies en couleurs, le plus souvent des grands formats, ces jeunes sont représentés frontalement, en pied ou en buste, dans leur cadre familier. Pour Dijkstra, fixer le passage de l'enfance à l'âge adulte semble aussi important que la documentation de certaines étapes de sa propre biographie. En tant que phase de la vie, la jeunesse est caractérisée par le manque d'assurance, mais aussi par l'ouverture d'esprit et la recherche de la nouveauté. C'est un âge où bien des choses sont encore indéfinies ou imprévisibles. C'est pourquoi ces photos contiennent aussi une part d'imaginaire. Si la physionomie et la gestuelle des personnes représentées dans les portraits de Dijkstra, ou encore leurs vêtements, les intérieurs ou les paysages à l'arrière-plan, révèlent sans doute des fragments de ce qu'elles ont vécu jusqu'au moment de la prise de vue, elles ne disent rien sur leur avenir ou la poursuite de leur carrière. L'aspect temporel joue un rôle crucial dans toute l'œuvre de Dijkstra. Fondamentalement, chaque portrait est en effet un instantané individuel. Mais du fait que l'artiste revoit les personnes qu'elle a photographiées pour les photographier à nouveau, des séquences inachevées de personnes grandissantes voient le jour. La reprise des motifs fait apparaître l'œuvre du temps. La croissance, l'adolescence et la maturation s'expriment à travers les changements. Dans la mesure où l'artiste et nous-mêmes en tant que spectateurs sommes soumis aux mêmes altérations du temps, il en résulte une intensité et une immédiateté particulières de la représentation. C. E.

SELECTED EXHIBITIONS →
2005 *Portraits*, Fotomuseum Winterthur **2004** Jeu de paume, Paris **2002** *Moving Pictures*, Solomon R. Guggenheim Museum, New York; *Focus: Rineke Dijkstra*, The Art Institute of Chicago **2001** 49. Biennale di Venezia, Venice **2000** Tate Modern, London

SELECTED PUBLICATIONS →
2004 *Rineke Dijkstra: Portraits*, Munich **2001** *Rineke Dijkstra: Portraits*, Institute of Contemporary Art, Boston; *Israel Portraits – Rineke Dijkstra*, Herzliya Museum of Art, Sommer Contemporary Art Gallery, Tel Aviv **2000** *Die Berliner Zeit. Rineke Dijkstra, Bart Domburg*, Deutscher Akademischer Austauschdienst, Berlin

1 **Stephanie, Saint Joseph Ballet School, Santa Ana, CA, USA, March 22,** 2003, C-print, 126 x 107 cm (framed)

2 **Shany, Palmahim Israeli Air Force Base, Israel, October 8,** 2002, C-print, 126 x 107 cm (framed)

3 **Shany, Herzliya, Israel, August 1,** 2003, C-print, 126 x 107 cm (framed)

„Für mich ist es eine wesentliche Erkenntnis, dass jeder Mensch allein ist. Nicht im Sinne von Einsamkeit, sondern eher in dem Sinne, dass niemand den anderen vollständig verstehen kann. [...] Ich möchte bestimmte Sympathien für die von mir fotografierte Person erwecken."

« Pour moi, il est essentiel de comprendre que tout le monde est seul. Pas au sens de la solitude, mais plutôt en ce sens que personne ne peut entièrement comprendre quelqu'un d'autre. [...] Je veux susciter de franches sympathies pour les personnes que j'ai photographiées. »

"For me it is essential to understand that everyone is alone. Not in the sense of loneliness, but rather in the sense that no one can completely understand someone else. [...] I want to awaken definite sympathies for the person I have photographed."

2

120

Peter Doig

1959 born in Edinburgh, UK, lives and works in Port of Spain, Trinidad

The paintings of Peter Doig depict lone men engulfed by space, humanity dwarfed by landscape. His trademark misty surfaces and collaging of sources – holiday snaps, magazines and newspapers that are then photocopied, rephotographed and manipulated – create an indefinable place and time in which his subject matter floats, a sort of anti-history painting. Now an influential statesmen of contemporary figurative painting, Doig has recently returned to his childhood beginnings and moved to Trinidad, further complicating his private mythology that comprises teenage memories of Canadian wilderness with northern European Romanticism and Hollywood portrayals of backwater America. In contrast to earlier, heavily congealed canvases, Doig has begun to empty out his picture plane, thinning his washes and allowing liquid paint to drip and striate the surface vertically, but he retains the horizontal structuring, snow-blinded haze and acid-burn colouration of old. An often-reworked image of two figures standing in front of a multicoloured dry stone wall leading to a guesthouse in *Gasthof zur Muldentalsperre* (2001/02) dirties the magical atmosphere of an early Wassily Kandinsky or the work of Finnish painter Akseli Gallen-Kallela with the frontality of a 1970s psychedelic album cover. While his work runs the gamut of styles from Bonnard's post-impressionism to Thomas Kinkade's gaudy, hotel room painting, Doig is just as likely to turn his back on all this ironic, painterly signposting by jettisoning information from his pictures, as in the seaside vista of *Driftwood* (2001/02), and consequently heightening the feeling of alienation.

Die Gemälde von Peter Doig stellen vereinzelte, vom Raum überwältigte Menschen dar, die Menschheit wirkt zwergenhaft vor der Landschaft. Seine Markenzeichen, verschwommene Oberflächen und unterschiedliche Herkunft seiner Bilder – fotokopierte und dann erneut abfotografierte und bearbeitete Urlaubsschnappschüsse, Zeitschriften- und Zeitungsabbildungen – erzeugen einen undefinierbaren Zeit-Raum-Zusammenhang, in dem sein jeweiliger Gegenstand schwebt, und somit eine Art Anti-Historienmalerei. Doig, heute ein einflussreicher Vertreter der zeitgenössischen figurativen Malerei, ist vor einiger Zeit zu seinen Kindheitsursprüngen zurückgekehrt und nach Trinidad gezogen. Dies macht seine Privatmythologie aus Jugenderinnerungen an die kanadische Wildnis, nordeuropäischer Romantik und Hollywood-Darstellungen des rückständigen Amerika noch komplizierter. Im Gegensatz zu seinen früheren Gemälden mit schwerer geronnener Farbe ist Doig dazu übergegangen, die Bildfläche zu entleeren, seine Lasuren zu verdünnen und flüssige Farbe vertikal über die Oberfläche tropfen und fließen zu lassen, allerdings hat er die horizontale Struktur, jene schneeblinde Trübung und das säurebrandige Kolorit beibehalten. Durch das häufige Überarbeiten des Bildes zweier stehender Figuren vor einer bunten Trockenmauer, die zum *Gasthof zur Muldentalsperre* (2001/02) führt, vermischt sich die magische Atmosphäre eines frühen Wassily Kandinsky oder eines Werks des finnischen Malers Akseli Gallen-Kallela mit der Frontalität eines psychedelischen Plattencovers aus den Siebzigern. Während sein Werk die stilistische Skala zwischen Bonnards Postimpressionismus und Thomas Kinkades grellen Hotelzimmerbildchen abdeckt, kann sich Doig ebenso gut durch Zurückhalten von Informationen in seinen Bildern all dieser ironischen malerischen Hinweise enthalten und stattdessen wie im Seestück *Driftwood* (2001/02) konsequent das Gefühl der Entfremdung steigern.

Les peintures de Peter Doig montrent des hommes solitaires environnés par l'espace, une humanité nanifiée par le paysage. Les surfaces embrumées et le collage des sources – instantanés de vacances, photocopies de revues et de journaux rephotographiées et manipulées après coup – qui sont sa marque personnelle, génèrent des lieux et des temps indéfinis au sein desquels ses sujets semblent flotter comme dans une sorte d'anti-peinture d'histoire. Récemment, Doig est retourné sur les lieux de son enfance pour s'installer à Trinidad, complexifiant encore sa mythologie privée – qui comprend notamment des souvenirs d'adolescence des terres sauvages du Canada – en y ajoutant un romantisme nord-européen et des interprétations hollywoodiennes de l'Amérique profonde. Par contraste avec ses toiles plus anciennes, pesamment figées, Doig a commencé à vider sa surface picturale, diluant ses lavis et laissant la couleur liquide former des coulures et des striures verticales à la surface, tout en conservant la structure horizontale, les embus neigeux et les teintes acides de ses peintures antérieures. Une image souvent retravaillée de deux figures debout devant un mur multicolore en pierre sèche qui conduit à l'auberge *Gasthof zur Muldentalsperre* (2001/02), souille la magie d'un Vassily Kandinsky de la première époque ou de l'œuvre du peintre finlandais Akseli Gallen-Kallela par la frontalité d'une couverture de disque psychédélique des années soixante-dix. Cependant que son travail décline toute la gamme des styles du post-impressionnisme de Bonnard à la peinture d'hôtel criarde de Thomas Kinkade, Doig peut tout aussi bien tourner le dos à toute cette signalétique ironique et picturale en expurgeant ses tableaux de toute information, comme le montre la vue marine de *Driftwood* (2001/02), intensifiant ainsi le sentiment d'aliénation.

O. W.

SELECTED EXHIBITIONS →
2004/05 54. Carnegie International, Carnegie Museum of Art, Pittsburgh **2004** Pinakothek der Moderne, Munich **2003** *Charley's Space*, Bonnefanten Museum, Maastricht; Carré d'art, Nîmes; *Pittura/Painting – From Rauschenberg to Murakami 1964–2003*, 50. Biennale di Venezia, Venice; *Days Like These*, Tate Triennial, Tate Britain, London; *Dear Painter... Painting the Figure after Picabia*, Kunsthalle Wien, Vienna, Schirn Kunsthalle, Frankfurt/Main, Centre Pompidou, Paris

SELECTED PUBLICATIONS →
2004 *Metropolitain*, Pinakothek der Moderne, Munich, kestnergesellschaft, Hanover **2003** *Peter Doig*, Arts Club of Chicago, Chicago; *Charley's Space*, Ostfildern-Ruit **2002** *100 Years Ago*, Victoria Miro Gallery, London; *Cavepainting*, Santa Monica Museum of Art, Santa Monica **2001** *Peter Doig*, The Morris and Helen Belkin Art Gallery, University of British Columbia, Vancouver

1 **Gasthof**, 2004, oil on canvas, 275 x 200 cm
2 **Red Boat (Imaginary Boys)**, 2004, oil on canvas, 200 x 186 cm
3 **Paragon**, 2004, oil on canvas, 200 x 250 cm
4 **Lapeyrouse Wall**, 2004, oil on canvas, 200 x 250 cm

„Du kannst mich fragen, worum es in den Bildern geht, aber ich kann es dir wirklich nicht sagen. Sie sind einfach Chiffren für deine eigene Vorstellung."

« Tu peux me demander de quoi traitent les peintures, mais je ne saurais te le dire. Ce ne sont que des chiffres pour ta propre imagination. »

"You can ask what the paintings are about but I can't really tell you. They're really just ciphers for your own imagination."

2

3

4

Stan Douglas

1960 born in Vancouver, lives and works in Vancouver, Canada

Stan Douglas investigates history, leading us with his films and photographs to places where the collapse of political and social systems is manifested in small biotopes, which he interweaves with references from film history and from literature. Douglas breaks with the conventional narrative form of cinema. His films have no conclusion, they are looped, and the picture is released from the soundtrack. Within the camera's infinite number of points of view the projection is generally broken into two images, a then/now, and either/or. In *Der Sandmann* (1995) Douglas focuses on motifs from E. T. A. Hoffmann's story of the same name, and on the economic and social consequences of German reunification. The story is centred on the history of allotment gardens in Potsdam. The film splits into two parallel time lines, both of which take place in the same location. The black-and-white film *Le Détroit* (1999/2000) is a document about the decline of the city, of its economic foundation, and of its social cohesion. Captured in an endless loop, the camera follows an Afro-American woman as she moves through, and then suddenly flees out of, a deserted building. *Journey into Fear* (2001) reflects upon the driving forces and rules of the game in the global marketplace. The film shows a 15-minute sequence of conversations staged on a container ship. The action is divided into four scenes for which there are five different, deliberately poorly synchronized dialogues. A computer system creates a total of 625 different combinations of sound and image. The ability to ever comprehend the action is therefore denied to the viewer – Douglas merely offers an insight into the artificiality of the viewing material.

Stan Douglas spürt Geschichte nach, führt mit seinen Filmen und Fotografien an Orte, an denen sich die Zusammenbrüche politischer und sozialer Systeme in kleinen Biotopen manifestieren, und überblendet diese mit filmhistorischen und literarischen Referenzen. Douglas bricht mit der herkömmlichen Erzählform des Kinos, seine Filme haben keine Conclusio, sie drehen sich in einer Schleife, Bild- und Tonspur voneinander gelöst, die Projektion ist zumeist bifokal aufgebrochen, in ein Damals/Heute, Entweder/Oder, in die unendlich vielen Standpunkte der Kamera. In *Der Sandmann* (1995) fokussiert Douglas vor Motiven aus E. T. A. Hoffmanns gleichnamiger Erzählung auf die wirtschaftlichen und sozialen Folgen der deutschen Wiedervereinigung, mit der Geschichte Potsdamer Schrebergärten im Brennpunkt. Der Film splittet sich in zwei parallel verlaufende Zeitlinien auf, die am gleichen Ort spielen. Der Schwarzweißfilm *Le Détroit* (1999/2000) ist ein Dokument über den Niedergang der Stadt, ihrer wirtschaftlichen Basis und ihres sozialen Zusammenhalts. Die Kamera folgt einer Frau, einer Afro-Amerikanerin, bei ihrem Gang durch ein verlassenes Haus und ihrer plötzlichen Flucht daraus, gefangen in einer unendlichen Schleife. *Journey into Fear* (2001) reflektiert die Triebkräfte und Spielregeln im globalen Markt. Der Film besteht aus einer fünfzehnminütigen Sequenz an Gesprächen, inszeniert auf einem Containerschiff. Die Handlung ist in vier Szenen aufgegliedert, für die es fünf verschiedene, absichtlich schlecht synchronisierte Dialoge gibt. Ein Computersystem kreiert insgesamt 625 verschiedene Kombinationen von Ton und Bild. Dem Betrachter wird es somit verwehrt, jemals die Handlung zu erfassen – Douglas bietet ihm lediglich die Einsicht in die Konstruiertheit des zu Sehenden.

Stan Douglas remonte les traces de l'histoire. Ses films et ses photographies conduisent le spectateur dans des lieux où l'effondrement des systèmes politiques et sociaux se manifeste au sein de petits biotopes parsemés de références littéraires et cinématographiques à l'histoire. Douglas rompt avec la forme narrative traditionnelle du cinéma ; ses films ne présentent aucune conclusion, ils sont passés en boucle, la bande son et les images sont dissociées, la projection est généralement fragmentée en deux perspectives – passé/présent ou « de deux choses l'une » – par les points de vue infiniment nombreux de la caméra. Dans *Der Sandmann* (1995), devant des motifs tirés du récit homonyme d'E. T. A. Hoffmann, Douglas se concentrait sur les conséquences économiques et sociales de la réunification allemande, l'histoire des jardins ouvriers de Potsdam occupant une place centrale. Le film se scinde en deux fils temporels parallèles se déroulant sur un même lieu. Le film en noir et blanc *Le Détroit* (1999/2000) est un document sur le déclin de la ville, de ses bases économiques et de sa cohésion sociale. La caméra y suit une Afro-Américaine dans ses déambulations à travers les couloirs d'un immeuble abandonné et dans sa fuite soudaine hors de l'immeuble, emprisonnée dans une boucle sans fin. *Journey into Fear* (2001) évoque les forces pulsionnelles et les règles du jeu au sein du marché global. Le film est constitué d'une séquence de 15 minutes de conversations mises en scène sur un porte-conteneurs. L'action est découpée en quatre scènes composées chacune de cinq dialogues délibérément mal synchronisés. Un système informatique génère un total de 625 combinaisons différentes entre l'image et le son. Le spectateur se voit ainsi dans l'impossibilité de jamais saisir l'action – tout au plus Douglas lui propose-t-il un aperçu du caractère construit de ce qu'il y a à voir.

A. M.

SELECTED EXHIBITIONS →
2005 51. Biennale di Venezia, Venice **2003** *Stan Douglas: Film-Installationen und Fotografien*, kestnergesellschaft, Hanover **2002** *Journey into Fear*, Serpentine Gallery, London; documenta 11, Kassel **2001** 49. Biennale di Venezia, Venice **2000** *Hugo Boss Prize*, Solomon R. Guggenheim Museum, New York; *Between Cinema and a Hard Place*, Tate Modern, London

SELECTED PUBLICATIONS →
2003 *Stan Douglas: Film-Installationen und Fotografien*, kestnergesellschaft, Hanover **2002** *Stan Douglas: Journey into Fear*, Serpentine Gallery, London **1998** *Stan Douglas*, Scott Watson, Diana Thater, Carol J. Clover (ed.), London

1 **Susperia**, 2002, installation view, documenta 11, Kassel
2 **Paseo/Street Market, Nuevo Vedado**, 2005, C-print mounted on 0.65 cm honeycomb aluminium, 78.7 x 98.4 cm
3 **Rooftops, Habana Vieja**, 2004, C-print mounted on 0.65 cm honeycomb aluminium, 78.7 x 98.4 cm
4 **Print Shop/Auto Shop, Habana Vieja**, 2004, C-print mounted on 0.65 cm honeycomb aluminium, 78.7 x 98.4 cm
5 **Girón Building, Vedado**, 2004, C-print mounted on 0.65 cm honeycomb aluminium, 78.7 x 98.4 cm

6 **Bank/Cafeteria, Habana Vieja**, 2004, C-print mounted on 0.65 cm honeycomb aluminium, 101.6 x 81.3 cm
7 **"La Inalámbrica" Building/Metropolitan Building, Habana Vieja**, 2004, C-print mounted on 0.65 cm honeycomb aluminium, 101.6 x 81.3 cm
8 **Liberty City, Buenavista**, 2005, C-print mounted on 0.65 cm honeycomb aluminium, 148 x 125.1 x 5.7 cm (framed)
9 **Cine Majestic/Carpentry Shop, Habana Vieja**, 2004, C-print mounted on 0.65 cm honeycomb aluminium, 101.6 x 81.3 cm

„Die Arbeit hat eine permanente ethische und politische Aufgabe, deren Lösung fraglich ist. Doch diese Strategie eröffnet einen Denkraum zum zukünftigen Sozialen und Politischen."

« L'œuvre a toujours une fonction éthique et politique, et il est douteux qu'elle puisse déboucher sur une solution. Mais cette stratégie ouvre un espace de réflexion sur le social et le politique. »

"The work has an ethical, political task, which is ongoing and it is doubtful that it will be resolved. But that strategy opens the space for thought about the social and political to take place."

2

3

4

5

7

9

Marlene Dumas

1953 born in Cape Town, South Africa, lives and works in Amsterdam, The Netherlands

Marlene Dumas' paintings and drawings take the human body as a starting point to explore issues of race, identity, sexuality and mortality. She works quickly with a palette of starkly contrasting dark, bruised colours and bleached out whites, obscuring features with thin, liquid washes of oil paint on canvas or blooms of ink spreading on thick, water-saturated paper. Although usually based on photographic sources, whether found or taken herself, their relation to these origins is distant: background details are blanked out and the figures are isolated, close cropped and thickly outlined. As Dumas puts it, her work plays on the tension between "technological source material and the meta-physical imagination". Known for sexually explicit paintings based on pornographic images that emphasize the vulnerability of the naked body, recent paintings have ventured into a new unsettling territory: death. The women in a series of paintings from 2004 could be sleeping or perhaps caught in a moment of ecstasy, but they are full of a creeping anxiety that evokes death while never stating it directly. *Lucy* was inspired by Caravaggio's painting of the martyred Santa Lucia, while *Stern* takes its title from the German magazine which first published the image of the dead Ulrike Meinhof, from which photograph this painting, as well as that in Gerhard Richter's *18. Oktober 1988*, was taken. Mortality is described not only as an unavoidable fact of life, but also a tragic result of current political upheavals, ever more present and explicitly pictured in the daily media, as well as a subject constantly revisited in the history of art.

Die Gemälde und Zeichnungen von Marlene Dumas nutzen den menschlichen Körper als Ausgangspunkt für die Untersuchung von Themen wie Rasse, Identität, Sexualität und Sterblichkeit. Sie arbeitet schnell, ihre Palette ist bestimmt von kontrastierenden dunklen, bedrückenden Farben und ausgeblichenen Weißtönen, durch die die Bildbestandteile in dünnen, verwaschenen Lasuren aus Ölfarben auf Leinwand oder in verlaufenden Tuscheflecken auf dickem, wassergesättigtem Papier aufgelöst werden. Obwohl in der Regel auf gefundenen oder selbst produzierten Fotografien basierend, besteht ein distanziertes Verhältnis zu diesen Vorlagen: Hintergrunddetails werden ausgeblendet, und die Figuren erscheinen isoliert, angeschnitten und grob konturiert. Wie Dumas es ausdrückt, spielt ihre Arbeit mit dem Spannungsverhältnis zwischen „technischem Ausgangsmaterial und metaphysischer Vorstellung". Ihre neueren, sexuell eindeutigen, auf der Grundlage von Pornobildern entstandenen Gemälde heben die Verletzlichkeit des nackten Körpers hervor und stoßen in ein neues, beunruhigendes Terrain vor: den Tod. Die in einer Bildserie von 2004 dargestellten Frauen könnten im Schlaf, vielleicht aber auch in einem Augenblick der Ekstase festgehalten sein, allerdings sind sie von einer schleichenden Angst erfüllt, die den Tod heraufbeschwört, ohne ihn direkt zu formulieren. *Lucy* wurde angeregt durch Caravaggios Darstellung der heiligen Lucia, während sich der Titel *Stern* der gleichnamigen deutschen Zeitschrift verdankt, die als Erste das Foto der toten Ulrike Meinhof veröffentlichte, nach dem das Gemälde, ebenso wie jenes in Gerhard Richters Zyklus *18. Oktober 1988*, entstand. Sterblichkeit wird hier nicht lediglich als unausweichlicher Lebensumstand beschrieben, sondern auch als tragisches Resultat aktueller politischer Umbrüche, das in den Medien immer präsenter ist und deutlicher bebildert wird und ebenso ein ständig behandeltes Thema der Kunstgeschichte ist.

Les peintures et les dessins de Marlene Dumas partent du corps humain pour explorer des sujets comme le racisme, l'identité, la sexualité et la mortalité. Dumas travaille rapidement avec une palette de couleurs sombres, exsangues, fortement contrastées, et de blancs délavés, assombrissant ses touches par des lavis fins et liquides de peinture à l'huile sur toile ou des efflorescences d'encre répandues sur du papier épais saturé d'eau. Bien qu'elle s'appuie ordinairement sur des sources photographiques empruntées ou réalisées par elle-même, le lien avec l'original demeure distant : les détails de l'arrière-plan sont effacés, les figures isolées, rognées et grossièrement ébauchées. Comme le dit Dumas, son œuvre joue sur la tension entre « un matériau de sources technologiques et une imagination métaphysique ». Célèbres pour leur sexualité explicite, qui s'appuie sur des images pornographiques soulignant la vulnérabilité du corps nu, ses œuvres récentes ont abordé un nouveau territoire troublant : la mort. Les femmes d'une série de peintures de 2004 pourraient aussi bien être ensommeillées que captées dans un moment d'extase, mais elles sont emplies d'une angoisse rampante qui rappelle la mort sans jamais l'évoquer directement. *Lucy*, s'inspire d'une peinture du Caravage représentant le martyre de Sainte Lucie, tandis que *Stern* tire son titre du premier magazine allemand à avoir publié l'image d'Ulrike Meinhof morte, auquel cette peinture emprunte également la photographie, tout comme l'avait fait *18. Oktober 1988* de Gerhard Richter. La mortalité n'est pas seulement décrite comme un fait inéluctable de la vie, mais aussi comme le résultat tragique des bouleversements politiques contemporains, plus présents et représentés plus explicitement que jamais dans les médias – et comme un sujet sans cesse revisité par l'histoire de l'art.

K. B.

SELECTED EXHIBITIONS →
2005 *Black & White and a little bit of colour*, Museum voor Moderne Kunst Arnhem; *The Triumph of Painting*, The Saatchi Gallery, London **2004** *L'Air du Temps*, migros museum für gegenwartskunst, Zurich **2003** *Wet Dreams*, Städtische Galerie Ravensburg; *Suspect*, Fondazione Bevilacqua La Masa, Venice; *Focus: Marlene Dumas*, The Art Institute of Chicago **2001** *Stop Press: Beautiful Productions*, Whitechapel Art Gallery, London

SELECTED PUBLICATIONS →
2004 *Marlene Dumas. Wet Dreams: Watercolors*, Ostfildern-Ruit **2003** *Marlene Dumas: Suspect*, Skira, Milan **1999** *Marlene Dumas*, London

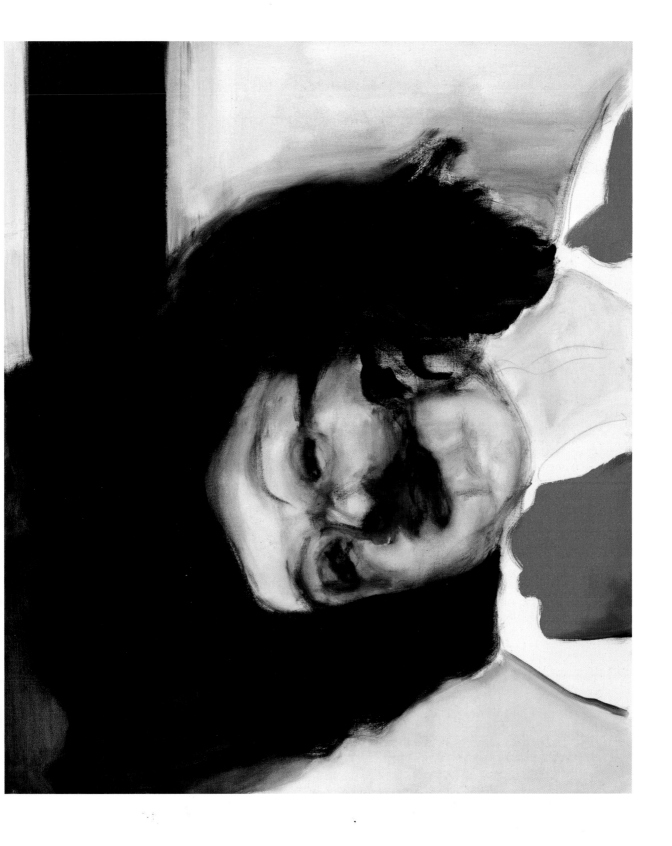

1 **Dead Girl**, 2002, oil on canvas, 130 x 110 cm
2 Exhibition view, "Con vista al celestiale" (with Marijke van Warmerdam), 2004, Montevergini – Galleria Civica d'Arte Contemporanea di Siracusa,

Syracuse, from left to right: **Lucy**, **Stern** and **Alfa**, each 2004, each oil on canvas, 110 x 130 cm

„Malerei ist kein Massenmedium für einen Massenmarkt. Man muss Bilder einzeln und Auge in Auge betrachten."

«La peinture n'est pas un médium de masse fait pour la diffusion de masse. Les peintures doivent être regardées, une par une, les yeux dans les yeux.»

"Painting is not a mass medium made for mass distribution. Paintings need to be seen, one by one, eye to eye."

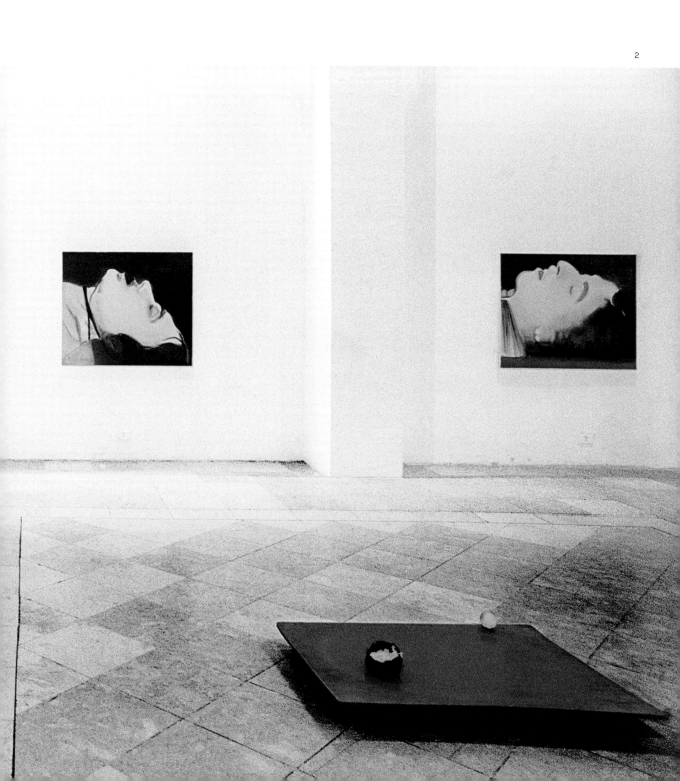

Martin Eder

1968 born in Augsburg, lives and works in Berlin, Germany

The universe that Martin Eder allows to appear before us in his pictures is not quite tangible. In his figurative paintings he makes liberal use of the standard repertoire of kitsch, combining these elements into pictures, in pallid but also in shrill colours, to reflect a closed, inscrutable and dreamlike reality. Essentially recruiting from amongst lascivious female nudes, cute animals, and children – in approximately this order and importance – Eder consistently keeps his arsenal of motifs narrow. This allows him to stage and reconfigure such "clichés incarnate" in an even more refined manner. He presents bare-breasted, big-eyed women, massively furry Persian cats, absurd Standard Poodles, birds or rabbits; sometimes individually, sometimes as an ensemble, and in ever new and more highly polished variations. This practice feeds on animal post-card kitsch, soft-core pornography, and that brand of flea-market verisimilitude that one associates with hot-blooded gypsy women and faithful-eyed puppy dogs, but Eder's paintings are not about kitsch and cliché, instead, these are his visual tools. He uses the familiar visual paradigms as elements of his own visual language, which appeals with unchecked strength to our unsophisticated instincts on one hand, while it can also always be recognized, particularly in such intensified form, as highly socially encoded and restricted emotion. This type of lush ambiguity can be used very effectively and Eder, who once fittingly described his own paintings as "cute, but also a little brutal", does so very consistently. From his bewildering orchestration of strictly conventional charms he manages to extract reflected images of a mask-like and threatening rigidity.

Es ist ein nicht recht greifbares Universum, das Martin Eder in seinen Bildern vor uns aufscheinen lässt. In der figürlichen Malerei bedient er sich ausgiebig aus dem Standardrepertoire des Kitschs und verquickt diese Elemente zu Bildern, die in fahler und doch auch schriller Farbigkeit eine geschlossene, abgründig traumgleiche Wirklichkeit spiegeln. Das motivische Arsenal hält Eder konsequent klein, rekrutiert es im Wesentlichen aus lasziven Frauenakten, niedlichen Tieren und Kindern – ungefähr in dieser Reihenfolge und Gewichtung. Umso raffinierter kann er dann die Inszenierung und Rekonfiguration solcher Gestalt gewordenen Klischees betreiben. In immer neuen, ausgefeilten Variationen werden barbusige, großäugige Frauen, massig-pelzige Perserkatzen, absurde Königspudel, Vögel oder Kaninchen in Aufstellung gebracht, mal einzeln, mal im Ensemble. Das nährt sich von Tierpostkartenkitsch, Softpornografie und jenem Flohmarktverismus, den man mit heißblütigen Zigeunerinnen und treuäugigen Hundebabys verbindet, doch Kitsch und Klischee sind nicht der Gegenstand von Eders Bildern, sie sind deren visuelles Werkzeug. Er nutzt die bekannten visuellen Schemata als Elemente einer eigenen Bildsprache, die einerseits in ungebremster Wirkungsmacht an jene biederen Instinkte appelliert, während sie doch auch, zumal in derart zugespitzter Inszenierung, jederzeit als hochgradig sozial kodierte, kontrollierte Emotion durchschaubar ist. Mit derart satter Zweideutigkeit lässt sich vortrefflich operieren, und Eder, der seine Bilder selbst einmal passend als „niedlich, aber auch ein wenig brutal" bezeichnet hat, leistet dies in aller Konsequenz. Der verblüffenden Orchestrierung streng konventionalisierter Reize gewinnt er Spiegelbilder von maskenhafter und bedrohlicher Erstarrung ab.

L'univers que déploient les tableaux de Martin Eder n'est pas bien cernable. Pour sa peinture figurative, l'artiste puise abondamment dans le répertoire standard du kitsch, dont il combine les éléments pour créer des tableaux au chromatisme blafard, mais néanmoins criard, créant ainsi des œuvres qui reflètent une réalité fermée sur elle-même et abyssalement onirique. L'arsenal de motifs d'Eder, qui se compose essentiellement – cités par ordre d'importance et d'accent – de nus féminins lascifs, d'animaux et d'enfants mièvres, reste soumis à une réduction cohérente, ce qui permet à l'artiste de travailler sur une mise en scène et une reconfiguration d'autant plus subtile de ces clichés figuraux. Femmes torse nu aux yeux écarquillés, chats persans massifs et poilus, caniches royaux absurdes, oiseaux ou lapins sont dès lors présentés dans des variantes sans cesse nouvelles et raffinées, tantôt isolément, tantôt en groupes. Cette démarche se nourrit du kitsch des cartes postales, de la pornographie «soft» et du vérisme de brocante auquel on associe le sang chaud des bohémiennes et les yeux mièvres des bébés chiens, mais le kitsch et le cliché ne sont pas le propos des tableaux d'Eder, il n'en sont que l'outillage iconique. L'artiste se sert des schémas visuels connus comme d'éléments de son propre langage pictural, dont la suggestivité effrénée fait appel aux instincts bourgeois tout en restant à tout moment lisible – notamment par l'exacerbation de la mise en scène – comme une émotion réductrice au plus haut point codifiée socialement. Cette saturation de l'ambiguïté permet de réaliser d'excellentes manipulations qu'Eder, qui a lui-même qualifié pertinemment ses tableaux de «mignons, mais aussi un peu brutaux», pratique avec une indéfectible cohérence pour tirer de la stupéfiante orchestration des stimuli rigoureusement conventionnalisés les images d'une pétrification menaçante qui relève du masque. J. A.

SELECTED EXHIBITIONS →
2004 *Die kalte Kraft*, Kunstverein Lingen **2003** Brandenburgischer Kunstverein Potsdam; *Adieu Avantgarde. Willkommen zu Haus*, Ludwig Forum für Internationale Kunst, Aachen **2001** *Something Slightly Different/From the Beginning After the End*, HfBK Dresden; *Forever Isn't Very Long*, Städtische Kunstsammlung Augsburg **2000** *P. P.. Pipi-Paradiso*, *My Favourite Rooms*, Galerie für Zeitgenössische Kunst, Leipzig; *I love you too, but...*, Galerie für Zeitgenössische Kunst, Leipzig

SELECTED PUBLICATIONS →
2004 *Die kalte Kraft*, Kunstverein Lingen **2003** *Memoirs of My Nervous Illness*, Brandenburgischer Kunstverein Potsdam; *Kunstpreis der Böttcherstraße in Bremen 2003*, Bremen **2001** *The Undead*, HfBK Dresden; *Something Slightly Different/From the Beginning After the End*, New York; *The Return of the Anti-Soft*, Städtische Kunstsammlung Augsburg

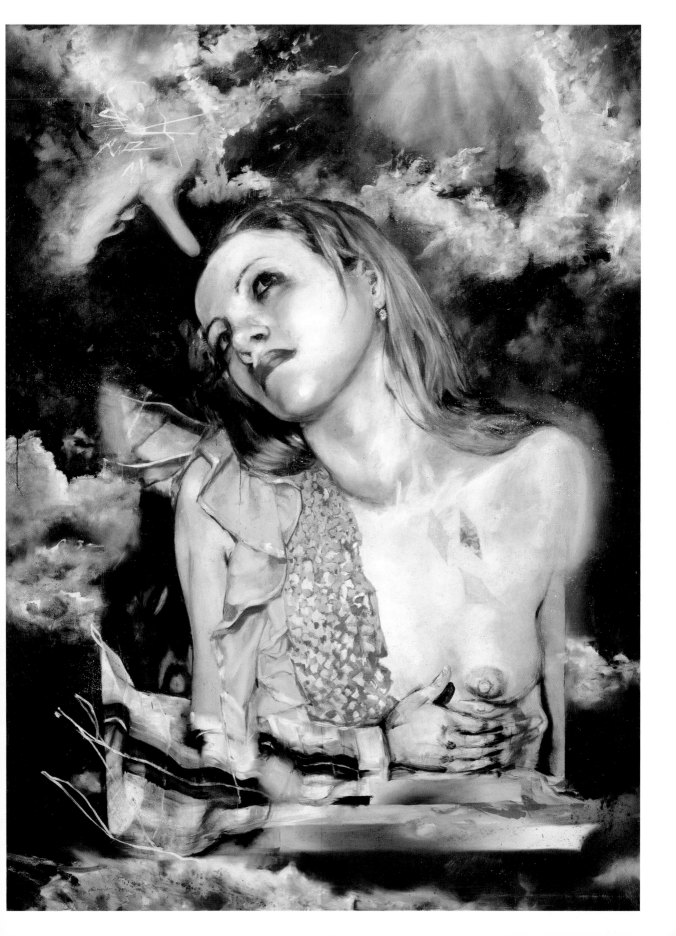

1 **Die Braut des Pierrot**, 2004, oil on canvas, 250 x 200 cm
2 **Die Phantasie wird siegen – nicht siegen**, 2004, installation view,
 "Die kalte Kraft", Kunstverein Lingen Kunsthalle

3 **Der Schritt – The Step**, 2005, oil on canvas, 100 x 80 cm
4 **Solitude**, 2003, oil on canvas, 150 x 170 cm

„Ich spiele gerne. Ich liebe es, mich mit Klischees zu umgeben.
Ein Pornoheft funktioniert wie die niedlichen Tiere nach einem einfachen
kodierten System. Alle Posen sind sofort verständlich. Das zeigt auf, mit
welcher Denkweise wir leben und wie schnell alles in Schubladen landet."

« J'aime jouer. J'adore m'entourer de clichés. Comme les animaux mignons,
une revue porno fonctionne selon un système de codes simples. Toutes les
poses sont immédiatement compréhensibles. Cela montre le mode de
pensée avec lequel nous vivons et à quelle vitesse tout finit dans des cases. »

**"I like to play. I like to surround myself with clichés. A porn magazine
functions like the cute little animals, according to a simply coded system.
All of the poses can be understood right away. That points
up the way we think and how quickly everything is pigeonholed."**

2

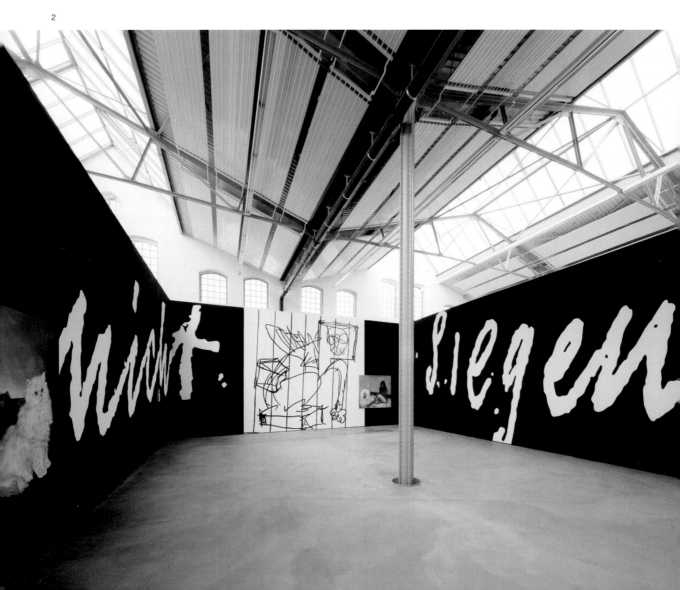

3

4

Tim Eitel

1971 born in Leonberg, lives and works in Berlin, Germany

In his figurative painting Tim Eitel strikes a distinctive note. With thoroughly new objectivity Eitel populates his specific brand of place-lessness with predominantly young characters. His settings are characterized by architecture and lately also by landscape, and are populated throughout by characters approximately thirty years of age. The men and women have individual features, but this almost never approaches portraiture. They are prototypes; personified representatives of an individual here and now. They flaunt the signs of the times with absolutely no intrusive commercial branding. The figures cultivate an indistinct ennui as they stroll, walk on the beach and visit museums. They are depicted alone or in small groups, sometimes even just sitting, standing or lying in a compositionally planned and simplified environment, clearly arranged in terms of colour. Much like a stage set, this is aimed at recognizability. It is sometimes unspecific and atmospheric, perhaps with typical features of urban or natural scenery, but is occasionally concrete as well, and particularly in earlier works. Thus in some of his paintings Eitel employs the characteristic architecture of the MMK Frankfurt or the GfZK Leipzig, while elsewhere he may use works from artists ranging from Mondrian to Murakami as compositional elements – thus also baiting his hook with references. Eitel often depicts his figures as seen from the rear. This is a device connecting him to such prominent precursors as Caspar David Friedrich or Richard Oelze, and one that he continu-ously replays in many different combinations, so that within the silently smouldering web of relationships between the figures, he may also be able to integrate the viewer.

Tim Eitel trifft in seiner figurativen Malerei einen eigentümlichen Ton. In durchaus neuer Sachlichkeit verknüpft Eitel das spezifisch ein-gefärbte Ortlose mit dem Auftritt überwiegend jungen Personals. Seine architektonisch und neuerdings verstärkt auch landschaftlich gepräg-ten Settings werden durchweg von etwa Dreißigjährigen bevölkert. Die Männer und Frauen tragen individuelle Züge, doch reicht das so gut wie nie ans Porträt. Es sind Referenzfiguren, personifizierte Stellvertreter eines individuellen Hier und Heute. Ganz ohne aufdringliches Branding tragen sie Zeichen der Zeit zur Schau. Die Figuren pflegen unbestimmtes Ennui: Spaziergänge, Strandwanderungen, Museumsbesuche, allein oder in kleinen Gruppen, mal auch bloßes Sitzen, Stehen, Liegen in reduzierter, auf Komposition bedachter, farblich klar gegliederter Um-gebung. Und die ist in aller Kulissenhaftigkeit aufs Wiedererkennbare gerichtet. Entweder unspezifisch, atmosphärisch – etwa in typischen Ausprägungen von Stadt- oder Naturraum –, bisweilen und insbesondere in frühen Arbeiten aber auch konkret. So hat Eitel in einigen seiner Bilder die charakteristische Architektur des MMK Frankfurt oder der GfZK Leipzig, teils auch Werke von Mondrian bis Murakami als kompositio-nelle Elemente eingesetzt – und so zugleich den Köder Referenz ausgelegt. Vielfach setzt Eitel seine Figuren als Rückenansicht ins Bild. Ein Verfahren, mit dem er an so prominente Vorläufer wie Caspar David Friedrich oder Richard Oelze anknüpft und das er in vielfältigen Kombina-tionen durchspielt, um ins sprachlos latente Beziehungsgeflecht der Figuren potenziell auch den Betrachter einzubinden.

Dans sa peinture figurative, Tim Eitel adopte un ton très particulier. Dans une forme qui se rapproche fortement de la Nouvelle Objec-tivité, Eitel montre des personnages – essentiellement des jeunes – dans des lieux indéfinissables baignant dans des couleurs spécifiques. Les décors caractérisés par des architectures, mais aussi, de plus en plus souvent, par des paysages, sont uniment peuplés de trentenaires qui présentent des traits individuels sans qu'on puisse généralement parler de portraits. Il s'agit de figures de référence, de personnifications d'un ici et maintenant individuel. Sans ostentation de marques commerciales, ils arborent néanmoins certains signes du temps. Les figures cul-tivent un ennui indéfinissable : promenades, flâneries, visites de musées, seules ou en petits groupes, parfois aussi, de simples poses assises, en pied, allongées, le tout dans des cadres restreints, soucieux de la composition et d'une répartition lisible des couleurs. Malgré son carac-tère de pur décor, cet environnement est orienté avant tout vers l'identifiabilité : généraliste, atmosphérique – notamment avec l'emploi de schémas paradigmatiques des espaces urbain ou naturel –, parfois aussi concret, en particulier dans les œuvres les plus anciennes. Dans certaines de ses compositions, Eitel a fait entrer des éléments empruntés à l'architecture caractéristique du MMK de Francfort ou de la GfZK de Leipzig, mais aussi des œuvres d'artistes – de Mondrian à Murakami –, ce qui lui permet de jouer en même temps sur la notion de réfé-rence. Les figures d'Eitel sont souvent présentées de dos, un procédé qui rattache l'artiste à des modèles aussi célèbres que Caspar David Friedrich ou Richard Oelze et qu'il décline dans toutes sortes de combinaisons pour faire entrer le spectateur dans la trame d'interactions latentes et muettes tissée par ses personnages.

J. A.

SELECTED EXHIBITIONS →
2004 CRAC Alsace, Altkirch; *Funny Cuts*, Staatsgalerie Stuttgart
2004/05 *Terrain*, Museum zu Allerheiligen, Schaffhausen, Galerie der Stadt Backnang **2003** *sieben mal malerei*, Museum der Bildenden Künste Leipzig; *deutschemalereizweitausenddrei*, Frankfurter Kunstverein **2002** Künstlerhaus Bethanien, Berlin **2000** *Frühjahrs-kollektion*, Künstlergilde Ulm

SELECTED PUBLICATIONS →
2004 *Terrain*, Berlin **2003** *Drei Positionen zur Malerei – Tim Eitel, Cornelius Völker, Matthias Weischer*, Kunstallianz Berlin, Berlin; *sieben mal malerei*, Museum der Bildenden Künste, Leipzig, Bielefeld; *Aussicht*, Künstlerhaus Bethanien, Berlin; *deutsche-malereizweitausenddrei*, Frankfurter Kunstverein, New York, Berlin

1 **Boygroup**, 2003, oil on canvas, 260 x 190 cm
2 **Boot**, 2004, oil on canvas, 250 x 210 cm

3 **Küste**, 2004, oil on canvas, 30 x 30 cm
4 **Arken**, 2003, oil, acrylic on canvas, 25 x 25 cm

„Für mich ist ein Foto nichts anderes als eine Skizze [...].
Ich reflektiere keine Fotografie. Ich versuche, Bilder zu konstruieren,
die [...] keine bloße Abbildung darstellen. Es sind innere Bilder,
die ich mir mithilfe der Fotografie zusammensetze."

«Pour moi, une photo n'est rien d'autre qu'une esquisse [...]. Je ne reflète
pas des photographies. J'essaie de construire des images qui [...] ne soient
pas de simples illustrations. Il s'agit d'images intérieures que je compile à
l'aide de photographies.»

"For me a photo is nothing more than a sketch [...]. I don't mirror photographs.
I try to design pictures that [...] are not mere illustrations.
These are inner pictures, which I compile with the help of photographs."

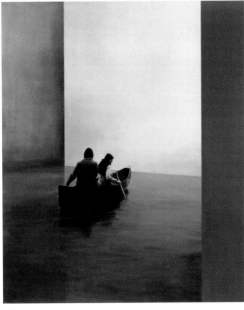

2

3

Olafur Eliasson

1967 born in Copenhagen, Denmark, lives and works in Berlin, Germany

An unexpected effect of Olafur Eliasson's 2003 commission *The Weather Project* was that it transformed Tate Modern's cavernous Turbine Hall space into a giant mock solarium, attracting thousands of artificial sun worshippers. Viewers – actually participants – staring up at the mirrored ceiling saw a reflection that completed the half-circle of strip lamps as well as a ghostly double of themselves through a cloud of water vapour. This technique of bringing the outside in, be it a waterfall (*Wasserfall*, 1998), ice rink (*The Very Large Ice Floor*, 1998) a woodland (*The Forked Forest Path*, 1998) or a rainbow (*Beauty*, 1994), as a critique of, or a device to rupture, the institutionalized gaze of gallerygoers is still undoubtedly a concern for Eliasson. However, international projects and biennial exhibitions often take him outside the museum, where he is freer to pursue his phenomenological engagement with the act of seeing and experiencing art, by pouring gallons of green dye into a river or leaving a tap running for the water to infiltrate hidden corners of a city. The spectacular results of a quasi-scientific collaboration or investigation such as his kaleidoscopic, kinaesthetic funhouse, *Blind Pavilion* at the 2003 Venice Biennale, can also be achieved given simpler means, by playing perceptual games with light projections for example, switching from red to green to yellow for *Your Colour Memory* (2004). Eliasson envisages a situation and creates a machine or a means to that end, but clearly without our involvement the machine ceases to function.

Ein unerwarteter Effekt der Auftragsarbeit *The Weather Project* (2003) von Olafur Eliasson war die Verwandlung der leer stehenden Turbinenhalle der Tate Modern in eine riesige Solariumattrappe, die Tausende von Kunstsonnenanbetern anzog. Die Betrachter – eher die Mitwirkenden –, die zur verspiegelten Decke aufblickten, sahen eine Reflexion, die einen aus Leuchtröhren gebildeten Halbkreis verdoppelte, ebenso wie eine geisterhafte Spiegelung ihrer selbst durch eine Wolke aus Wasserdampf. Diese Methode, das Außen nach innen zu tragen – beispielsweise einen Wasserfall (*Wasserfall*, 1998), eine Eisbahn (*The Very Large Ice Floor*, 1998), einen Wald (*The Forked Forest Path*, 1998) oder einen Regenbogen (*Beauty*, 1994) – wird von Eliasson unablässig verfolgt, und zwar als Kritik oder als Mittel zur Brechung des institutionalisierten Blicks von Galeriebesuchern. Allerdings führen ihn internationale Projekte und Biennalen immer häufiger aus den Museen hinaus und erlauben ihm eine freiere Umsetzung seiner phänomenologischen Untersuchung des Sehakts und der Kunstwahrnehmung, wenn er etwa fässerweise grünen Farbstoff in einen Fluss leitet oder aus einem Reservoir abgepumptes Wasser in die verborgenen Winkel einer Stadt fließen lässt. Die spektakulären Ergebnisse seiner pseudowissenschaftlichen Gemeinschaftsarbeiten und Untersuchungen, darunter seine kaleidoskopische, kinästhetische Wunderkammer *Blind Pavilion* auf der Biennale 2003 in Venedig, lassen sich auf einfachere Weise realisieren, so zum Beispiel, indem er mithilfe von Lichtprojektionen, die von rot zu grün und gelb wechseln (*Your Colour Memory*, 2004), ein Spiel mit der Wahrnehmung treibt. Eliasson entwirft eine Situation, für die er zunächst eine Maschine oder ein Instrument konstruiert, das erst im Wechselspiel mit dem Rezipienten funktioniert.

Un des effets inattendus du *Weather Project* commandé à Olafur Eliasson en 2003 a été de transformer le Turbine Hall de la Tate Modern en un immense pseudo-solarium attirant des milliers d'adeptes du bronzage artificiel. Les spectateurs, mieux, les participants qui levaient les yeux vers le plafond couvert de miroirs pouvaient y voir complété le demi-cercle de tubes d'éclairage, et à travers un nuage de vapeur d'eau, le double fantomatique d'eux-mêmes. Si cette technique consistant à faire entrer l'extérieur dans un espace clos, que ce soit sous la forme d'une chute d'eau (*Wasserfall*, 1998), d'une patinoire (*The Very Large Ice Floor*, 1998), d'une forêt (*The Forked Forest Path*, 1998) ou d'un arc-en-ciel (*Beauty*, 1994), se présente comme une critique de la rupture un dispositif qui la met en évidence, l'institutionnalisation du regard des visiteurs d'exposition n'en reste pas moins le propos invariable d'Eliasson. Reste que les projets internationaux et les expositions réalisées pour des biennales conduisent souvent l'artiste hors de l'espace muséal, où il se sent plus libre pour se consacrer à son implication phénoménologique dans l'acte visuel et dans l'expérience artistique, qui lui fait déverser des litres de teinture verte dans une rivière ou laisser couler un robinet d'eau pour infiltrer les coins cachés d'une ville. Les résultats spectaculaires d'une collaboration ou d'une investigation quasi scientifique, telle qu'elle se présente par exemple dans son *Blind Pavilion*, galerie des glaces kaléidoscopique et cénesthésique qu'il présenta à la Biennale de Venise de 2003, peuvent aussi être réalisés à l'aide de moyens plus simples, par exemple en jouant sur la perception à l'aide de projections lumineuses passant du rouge au vert et à l'orangé dans *Your Colour Memory* (2004). Eliasson conçoit une situation et crée une machine ou un moyen à cette fin, mais il apparaît que cette machine cesse de fonctionner sans notre participation. O. W.

SELECTED EXHIBITIONS →
2004/05 *Minding the World*, Aarhus Kunstmuseum **2004** Aspen Art Museum; *Photographs*, The Menil Collection, Houston; *Your Lighthouse*, Kunstmuseum Wolfsburg; Reykjavik Art Museum **2003** *Colour memory and other informal shadows*, Astrup Fearnley Museet for Moderne Kunst, Oslo; 50. Biennale di Venezia, Venice; *The Weather Project*, Tate Modern, London; *Funcionamiento Silencioso*, Museo Nacional Centro de Arte Reina Sofía, Madrid

SELECTED PUBLICATIONS →
2004 *Minding the World*, Aarhus Kunstmuseum, Aarhus; *Photographs*, The Menil Collection, Houston; *Olafur Eliasson: Your Lighthouse*, Ostfildern-Ruit **2003** *The Weather Project, The Unilever Series*, Tate Publishing, London; *The Blind Pavilion*, Ostfildern-Ruit; *Olafur Eliasson*, London; *Olafur Eliasson – Colour memory and other informal shadows*, Astrup Fearnley Museet for Moderne Kunst, Oslo **2002** *Chaque matin je me sens différent – Chaque soir je me sens le même*, Musée d'Art Moderne de la Ville de Paris

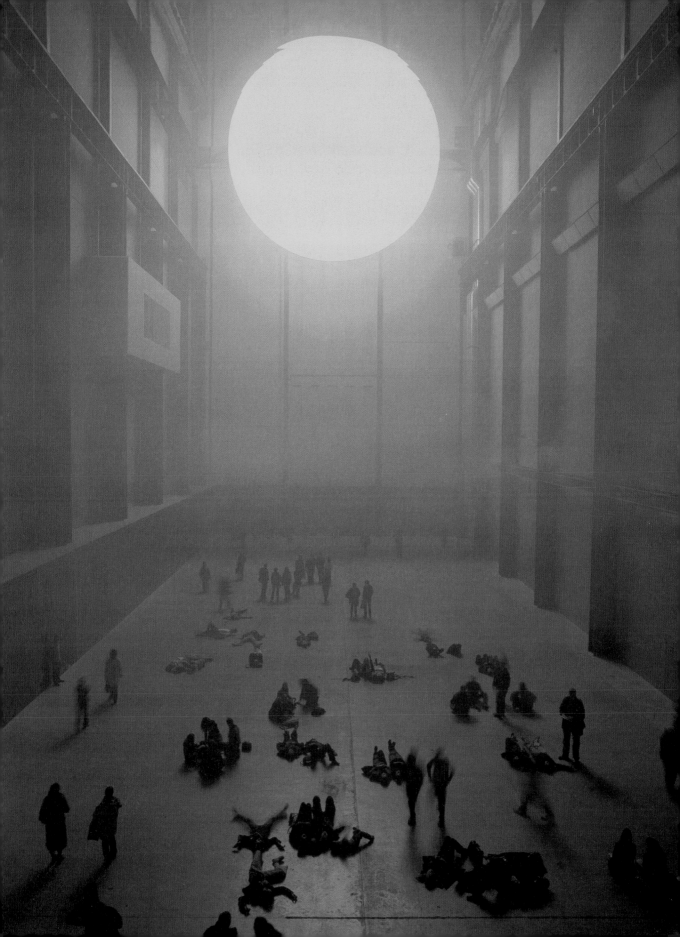

1 **The Weather Project,** 2003, mono-frequency light, foil, haze machine, mirror foil, scaffold, c. Ø 15 m, installation view, Turbine Hall, Tate Modern, London

2 **Funcionamiento silencioso,** 2003, installation view, Palacio de Cristal, Parque del Retiro, Museo Nacional Centro de Arte Reina Sofía, Madrid
3+4 **The Blind Pavilion,** 2003, steel construction, black and transparent glass, outer ring: 2.5 m, Ø 7.5 m, inner ring: 2.2 m, Ø 5 m

„Man steht in einer Beziehung zum Raum; man sieht ihn, man bewegt sich in ihm oder tut irgend etwas in ihm, und der Raum verfügt aufgrund seiner offenen Ideologie über die Fähigkeit, einem zu zeigen, dass man sich in ihm befindet."

«Vous entrez en relation avec l'espace, vous le voyez, vous y marchez ou vous y faites quelque chose, et l'espace, du fait de son idéologie révélatrice, est à même de vous montrer que vous êtes à l'intérieur de lui.»

"You relate to space; you see it, you walk in it, or you do something in it, and the space, due to its disclosed ideology, has the ability to show you that you are in it."

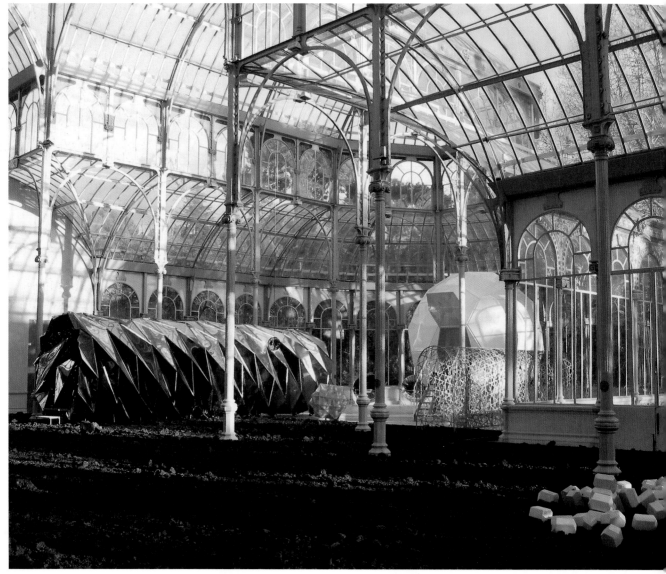

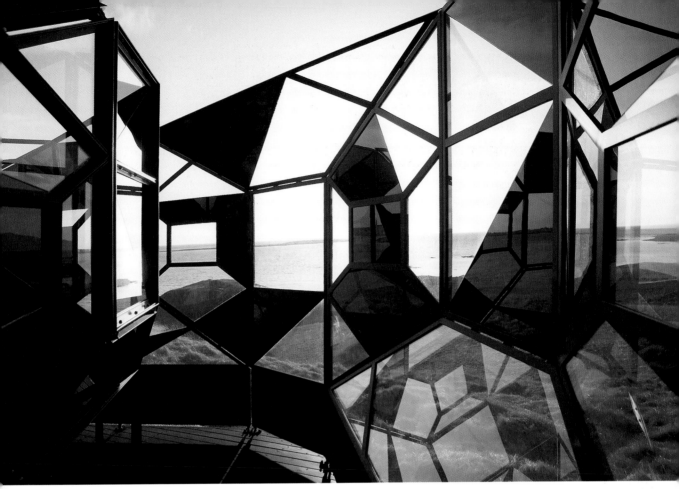

3

4

Elmgreen & Dragset

Michael Elmgreen, 1961 born in Copenhagen, Denmark, and
Ingar Dragset, 1969 born in Trondheim, Norway; live and work in Berlin, Germany

The work of collaborative duo Elmgreen and Dragset presents a systematic overturning of conventions, be they architectural, institutional, sexual or societal. An ongoing investigation into the porousness of the art world staple, the white cube, sees generically spotless gallery units suspended from the ceiling of museum spaces, sunk into public gardens, or equipped with glory holes and mirrors to imply clandestine sexual couplings. With the common title *Powerless Structures*, they not only question the already much discussed neutrality of the white cube, but fundamentally rupture its conventional function. Recent works extend the investigation of accepted conventions within the art institution to examine taboo subjects of sickness, death and abandonment. *Please, Keep Quiet!* (2003) transposes into the commercial gallery space another room with equally specific aesthetic conventions: the hospital ward. Equipped with hospital beds, patients and visitors, the gallery's cool white walls take on a literal clinicality while the hush expected of an art-viewing audience assumes a morbid tone as sickness and death infiltrate. In an empty museum space, a tiny sparrow is trapped between the two panes of a plate glass window, its wing fluttering with its last suffocating breath. Titled *Somewhere in the World it's 4 O'clock* (2004), this work confronts the audience with a spectacle of cruelty and helplessness, testing their behaviour in response to the scene. Elmgreen and Dragset go out of their way to prevent passivity in their audience, provoking instead a direct response whether through humour, fear or embarrassment.

Die Gemeinschaftsarbeiten von Elmgreen und Dragset präsentieren einen systematischen Konventionsbruch auf architektonischer, institutioneller, sexueller oder gesellschaftlicher Ebene. In ihren fortdauernden Untersuchungen der Durchlässigkeit jener die Kunstwelt zusammenhaltenden Klammer namens White Cube werden die im Allgemeinen makellosen Galerieräume an Museumsdecken aufgehängt, in öffentlichen Parks versenkt oder zur Andeutung geheimer sexueller Verbindungen mit Gucklöchern und Spiegeln versehen. Mit dem gewöhnlichen Titel *Powerless Structures* stellen sie nicht nur die bereits häufig diskutierte Neutralität des White Cube in Frage, sondern verletzen auf grundsätzliche Weise seine traditionelle Funktion. In jüngeren Arbeiten werden die Untersuchungen akzeptierter Konventionen innerhalb von Kunstinstitutionen auf Tabuthemen wie Krankheit, Tod und Verlassensein ausgedehnt. In *Please, Keep Quiet!* (2003) wird ein anderer Raum mit ebenso spezifischen ästhetischen Funktionen in den kommerziellen Galerieraum transponiert: die Krankenstation. Ausgestattet mit Krankenhausbetten, Patienten und Besuchern, erhalten die kühl-weißen Wände der Galerie etwas buchstäblich Klinisches, während die vom Kunstbetrachter geforderte Stille angesichts der Vermischung mit Krankheit und Tod einen morbiden Eindruck hinterlässt. In einem leeren Museumsraum befindet sich ein kleiner Spatz, gefangen zwischen zwei Scheiben eines Glasfensters, der mit letztem Atem herumflattert. Diese Arbeit von 2004 mit dem Titel *Somewhere in the World it's 4 O'clock* konfrontiert den Betrachter mit einem Schauspiel aus Grausamkeit und Hilflosigkeit und stellt dessen Verhalten gegenüber dieser Szene auf die Probe. Elmgreen und Dragset bemühen sich, Passivität aufseiten des Publikums zu verhindern und fordern statt dessen eine unmittelbare Reaktion heraus, sei es durch Lachen, Furcht oder Betretensein.

Le travail du duo collaboratif Elmgreen et Dragset propose un renversement systématique des conventions, qu'elles soient architecturales, institutionnelles, sexuelles ou sociales. Une recherche continue sur la porosité du *white cube*, marque principale du monde de l'art, présente des éléments génériques immaculés appartenant à l'univers des galeries et suspendus aux plafonds des salles de musées, enfoncés dans des jardins publics ou affublés de *glory holes* et de miroirs pour suggérer un accouplement clandestin. Sous le titre général *Powerless Structures*, les artistes n'interrogent pas seulement la neutralité largement discutée du *white cube*, mais rompent fondamentalement avec sa fonction conventionnelle. Des œuvres récentes étendent la recherche sur les conventions admises au sein de l'institution artistique à des sujets tabous comme la maladie, la mort et l'abandon. *Please, Keep Quiet!* (2003) transpose dans l'espace commercial de la galerie un second espace dénotant des conventions tout aussi esthétiques : la salle d'hôpital. Equipés de lits d'hôpital, de patients et de visiteurs, les murs blancs et froids de la galerie prennent une connotation littéralement clinique, cependant que le silence attendu de la part du public de l'art prend des tonalités morbides avec l'insinuation de la maladie et de la mort. Dans un espace muséal vide, un minuscule moineau est pris au piège entre les deux vitres d'un double vitrage, les ailes battant dans la suffocation de l'agonie. Intitulée *Somewhere in the World it's 4 O'clock* (2004), cette œuvre confronte le spectateur au spectacle de la cruauté et de l'impuissance et teste ses réactions face à la scène. Elmgreen et Dragset sortent des sentiers battus pour empêcher la passivité de leur public et provoquer au lieu de cela une réponse directe, que ce soit par l'humour, l'angoisse ou la gêne. K. B.

SELECTED EXHIBITIONS →
2004 *Somewhere in the World it's 4 O'clock*, Tate Modern, London **2004** *Everything is Connected, he, he, he*, Astrup Fearnley Museet for Moderne Kunst, Oslo **2003** *Spaced Out/Powerless Structures, Fig. 211*, Portikus, Frankfurt/Main; *Short Cut*, Fondazione Nicola Trussardi, Milan; *Utopia Station*, 50. Biennale di Venezia, Venice; *Happiness*, Mori Art Museum, Tokyo; *Living Inside the Grid*, New Museum of Contemporary Art, New York **2002** *Preis der Nationalgalerie für junge Kunst*, Hamburger Bahnhof, Berlin

SELECTED PUBLICATIONS →
2003 *Spaced Out. Elmgreen & Dragset*, Portikus, Frankfurt/Main **2002** *Taking Place: The Works of Michael Elmgreen & Ingar Dragset*, Kunsthalle Zürich, Ostfildern-Ruit

1 **Spelling U-T-O-P-I-A**, 2003, performing chimpanzee, wood, paint, perspex, 320 x 320 x 320 cm (glass box), installation view, 50. Biennale di Venezia, Venice

2 **Short Cut**, 2003, mixed media, 250 x 850 x 300 cm, installation view, Galleria Vittorio Emanuele, Milan

3 **Please, Keep Quiet!**, 2003, mixed media, 4 beds, 3 wax figures, installation view, Galleri Nicolai Wallner, Copenhagen

„Indem wir scheinbar autoritäre, statische Strukturen herausfordern, wollen wir zeigen, wie fragil diese Strukturen – sowohl innerhalb des urbanen Raums als auch innerhalb des Systems der Kunstinstitutionen – tatsächlich sind."

«En défiant des structures apparement très autoritaires et statiques, nous voulons en fait souligner la fragilité de ces structures – au sein du paysage urbain comme du système institutionnel de l'art.»

"By challenging what might seem to be very authoritarian and static structures, we want to underline these structures' actual fragility – within both the cityscape and the art institutional system."

2

Tracey Emin

1963 born in London, lives and works in London, UK

Tracey Emin's degree of fame stands out even among the Young British Artists: her installation *My Bed* that she exhibited in 1999 when she was nominated for the Turner Prize doubtless remains that competition's best-known work – though she didn't even win the prize. Exhibiting her bed, which was marked by signs of use including condoms, bottles, packs of cigarettes, books, Kleenexes and bloodstains, provoked a scandal nonetheless. Emin repeatedly shocks her audience with her unsparing openness, which now and again borders on thoroughly enthusiastic-narcissistic exhibitionism. The installation *Everyone I Have Ever Slept With 1963–1995* consisted of a dome tent with, on its inner wall, a sewn collage of letters and anecdotes revealing the names of the people with whom she has "slept" – including the name of her twin brother. When she showed this work in 1995 Emin had to pacify the infuriated press by assuring them that she intended the work's title to be taken very literally. Emin's autobiographical revelations and sometimes embarrassing confessions are characterized by an energetic directness that does not stop at societal taboos. Their expressiveness and her belief that emotions and subjectivity can be depicted allow her a strong voice, which traces the system's boundaries and simultaneously provides opposition to male formulas of universalism. The photographic series *I've Got It All* (2000) is a pointed attack on depictions of sexuality and femininity as a suprahistorical phenomenon where, in an arrangement reminiscent of Gustave Courbet's oil painting *L'Origine du monde* (1866) she scoops a pile of banknotes between her opened legs, onto her "femininity".

Selbst unter den Young British Artists sticht der Bekanntheitsgrad von Tracey Emin noch heraus: Ihre Installation *My Bed*, die sie 1999 anlässlich ihrer Nominierung für den Turner-Preis zeigte, ist wohl nach wie vor die bekannteste Arbeit dieses Wettbewerbs – dabei ging der Preis nicht einmal an sie. Doch die Ausstellung ihres von Gebrauchsspuren gezeichneten Betts – darunter Kondome, Flaschen, Zigarettenpackungen, Bücher, Taschentücher und Blutflecke – provozierte einen Skandal. Mit ihrer schonungslosen Offenheit, die zuweilen an durchaus lustvoll-narzisstischen Exhibitionismus grenzt, schockierte Emin wiederholt ihr Publikum. Als sie 1995 die Installation *Everyone I Have Ever Slept With 1963–1995* zeigte, ein Kuppelzelt, an dessen Innenseite eine genähte Collage aus Buchstaben und Anekdoten die Namen der Menschen verriet, mit denen sie „geschlafen" hatte – darunter den ihres Zwillingsbruders – musste Emin die aufgebrachte Presse damit beruhigen, dass sie den Titel der Arbeit ganz wörtlich verstanden wissen wollte. Emins autobiografische Enthüllungen und mitunter peinliche Bekenntnisse sind von einer energischen Direktheit geprägt, die keinen Halt vor gesellschaftlichen Tabus macht. Ihre Expressivität und ihr Glaube an die Darstellbarkeit von Emotionen und Subjektivität ermöglichen eine starke Stimme, die die Grenzen des Systems nachzeichnet und zugleich einen Widerpart gegen männliche Universalismusformeln bildet. Einen pointierten Angriff gegen die Abbildung von Sexualität und Weiblichkeit als überhistorische Phänomene stellt die fotografische Serie *I've Got It All* (2000) dar, in der sie in einer Anordnung, die an Gustave Courbets Gemälde *L'Origine du monde* (1866) erinnert, einen Haufen Geldscheine zwischen ihre geöffneten Beine, an ihre „Weiblichkeit", rafft.

Même parmi les représentants des Young British Artists, le degré de célébrité de Tracey Emin occupe une place à part : l'installation *My Bed*, présentée en 1999 à l'occasion de la nomination de l'artiste au Prix Turner, reste à ce jour l'œuvre la plus connue du concours – même si le prix ne lui fut finalement pas attribué. L'exposition de son lit présentant toutes sortes de signes d'utilisation – préservatifs, bouteilles, paquets de cigarettes, livres, mouchoirs et taches de sang – a fait scandale. Avec une franchise dont l'implacabilité relève parfois d'un exhibitionnisme résolument voluptueux et narcissique, Emin a maintes fois choqué son public. En 1995, dans le cadre de la présentation de l'installation *Everyone I Have Ever Slept With 1963–1995*, une tente en forme de dôme sur la face intérieure de laquelle un collage de lettres et d'anecdotes révélait le nom de tous les hommes et femmes avec qui elle avait « dormi » – parmi eux celui de son frère jumeau –, Emin dut apaiser les foudres de la presse en déclarant que le titre de l'œuvre devait être compris à la lettre. Les dévoilements autobiographiques et les révélations parfois embarrassantes d'Emin sont empreints d'une énergique immédiateté qui ne recule devant la transgression d'aucun tabou social. Son expressivité et sa foi en la représentabilité des émotions et de la subjectivité permettent une voix forte qui consigne les limites du système, et qui se présente en même temps comme une réponse aux formules figées de l'universalisme masculin. Avec la série photographique *I've Got It All* (2000), une composition qui évoque *L'Origine du monde* (1866) de Gustave Courbet, et dans laquelle l'artiste presse un tas de billets entre ses jambes écartées, contre sa « féminité », Emin procède à une attaque ciblée contre la représentation de la sexualité et de la féminité conçues comme des phénomènes supra-historiques.

E. K.

SELECTED EXHIBITIONS →
2004 1. International Biennal of Contemporary Art, Seville; *Tracey Istanbukda – Tracey Emin*, Platform Garanti, Istanbul **2003** *Social Strategies: Redefining Social Realism*, University Art Museum Santa Barbara **2002** *This Is Another Place*, Modern Art Oxford; *Ten Years Tracey Emin*, Stedelijk Museum, Amsterdam; *Tracey Emin*, Haus der Kunst, Munich **2001** *Century City*, Tate Modern, London **2000** *The British Art Show 5*, Hayward Gallery, London **1999** *Turner Prize Exhibition*, Tate Britain, London

SELECTED PUBLICATIONS →
2003 *fast forward: Media Art Sammlung Goetz*, Munich; Zentrum für Kunst und Medientechnologie, Karlsruhe **2002** *The Art of Tracey Emin*, London, New York; *Ten Years: Tracey Emin*, Stedelijk Museum Amsterdam, Amsterdam **2002** *Tracey Emin: This Is Another Place*, Modern Art Oxford, Oxford

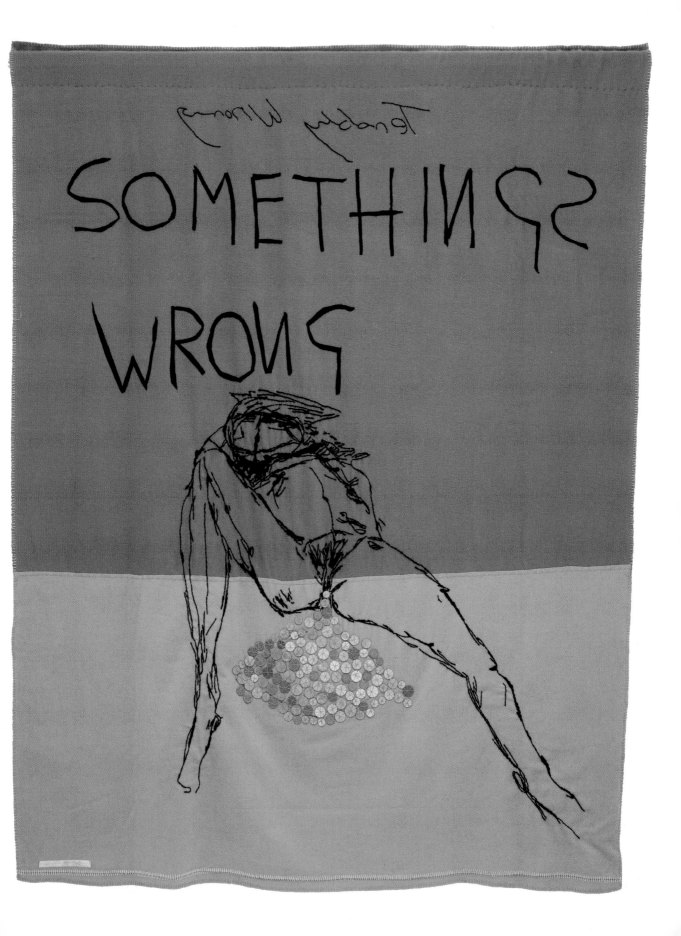

1 **Something's Wrong**, 2002, appliqué blanket with embroidery, 200 x 154 cm
2 **Big Dick Small Girl**, 1994, monoprint, 12.2 x 10.1 cm
3 **Mother**, 1994, monoprint, 12.2 x 10.1 cm

4 **It Doesn't Matter – My Friend It Does Not Matter to Cry Is Beautiful**, 2004, blue neon, 110.9 x 178.3 cm
5 **And That's How I Feel**, 2004, appliqué blanket, 203 x 183 cm

„Ich stehe am Rand eines Abgrunds, doch die Aussicht von hier ist grandios." «Je me tiens au bord d'un précipice, mais la vue est merveilleuse.»

"I'm standing at the edge of a precipice, but it's a wonderful view."

2

3

4

YOU ARE PLAGUED
BY HATE
THE HATE AND
UNHAPPYNESS
THAT YOU HAVE GIVEN
TO OTHERS
THATS ALL I WISH

UGLY
BITCH

Elger Esser

1967 born in Stuttgart, lives and works in Düsseldorf, Germany

Elger Esser's large-format colour photographs of landscapes and city panoramas, empty of human presence almost without exception, initially irritate in their spareness. Esser, who completed his studies in 1997 as a student in the master class of Bernd Becher, makes pictures that only slowly develop a strange fascination. This comes from their aura of quiet and concentration, and is more reminiscent of old-master works from landscape painting than of contemporary photography. Here, just as there, you can find strange depths and horizon lines as straight as a ruler; and here, just as there, a similarly uniform, diffused light lies over the landscapes, in which every detail, no matter how small, seem precisely and clearly recognizable. A further pictorial tradition to which Esser's work is connected is 19th-century travel photography. Not bound by the genre's former task of documentation, Esser turns instead to rather unspectacular motifs. On extended journeys through Europe over the past years he has thus created photographic series that merge into a concise body of work, in terms of both form and content. These images all share an extremely narrow colour spectrum, although astonishing nuances within this spectrum can be made out. Esser's work has little in common with the sober and factual approach to photography that often characterizes the Becher school. Time stands still in his works, and they express a conception of nature whose roots are most likely to be found in Romantic paintings. When viewing *Beauduc* (2000) or *Ameland Pier X* (2000), who doesn't feel reminded of something which Edmund Burke and Immanuel Kant once described with the concept of the sublime?

Fast ausnahmslos menschenleer zeigen die großformatigen Farbaufnahmen von Elger Esser Landschaften oder Städtepanoramen, die in ihrer Reduziertheit zunächst irritieren und erst langsam eine eigentümliche Faszination entfalten. Denn die Bilder Essers, der 1997 sein Studium bei Bernd Becher als Meisterschüler abschloss, verfügen über eine Aura der Ruhe und Konzentration, die eher an altmeisterliche Gemälde der niederländischen Landschaftsmalerei denn an zeitgenössische Fotografie denken lässt. Hier wie dort finden sich seltsam tiefe und wie mit dem Lineal gezogene Horizontlinien und hier wie dort legt sich ein gleichmäßig diffuses Licht über die Landschaften, in welchem jedes noch so kleine Detail präzise und klar erkennbar erscheint. In der Reisefotografie des 19. Jahrhunderts findet sich eine weitere Bildtradition, an die das Werk Essers anschließt. Von dem vormals dokumentarischen Auftrag des Genres entbunden, wendet sich Esser allerdings meist eher unspektakulären Motiven zu. Auf ausgedehnten Reisen durch Europa sind so in den vergangenen Jahren Bildserien entstanden, die sich inhaltlich und formal zu einem konzisen Werkkörper zusammenfügen. Diesen Aufnahmen ist ein extrem verengtes Farbspektrum eigen, innerhalb dessen sich erstaunliche Nuancierungen ausmachen lassen. Mit dem nüchtern-sachlichen Zugang zur Fotografie, der die Becher-Schule häufig kennzeichnet, hat das Werk Essers wenig gemein. In seinen Werken steht die Zeit still, und es drückt sich in ihnen eine Naturauffassung aus, deren Wurzeln sich am ehesten in romantischen Bildern finden lassen. Wer fühlte sich beim Anblick von *Beauduc* (2000) oder *Ameland Pier X* (2000) nicht an das erinnert, was die Philosophen Edmund Burke und Immanuel Kant mit dem Begriff des Erhabenen beschrieben haben?

Presque uniment dépeuplées, les grandes photographies en couleurs d'Elger Esser montrent des paysages ou des panoramas urbains dont la réduction d'abord irritante ne déploie que progressivement sa fascination particulière. Car les images d'Esser, qui a terminé ses études en 1997 en qualité de maître-assistant de Bernd Becher, répandent une aura de calme et de concentration, qui rappelle moins la photographie contemporaine que les grands paysagistes hollandais. Chez ceux-ci comme chez Esser, on trouve des lignes d'horizon singulièrement profondes, tirées comme à la règle, et les paysages y baignent dans une lumière homogène et diffuse qui fait ressortir le moindre détail avec une grande précision et une grande clarté. L'œuvre d'Esser se rattache encore à une autre tradition iconique : la photographie de voyage du XIXᵉ siècle. Libéré de la fonction naguère documentaire du genre, Esser se consacre toutefois le plus souvent à des motifs peu spectaculaires. Pendant les longs voyages qui lui ont fait parcourir l'Europe au cours des dernières années, l'artiste a ainsi réalisé des séries qui composent un corpus concis tant sur le plan formel que sémantique. Ces photographies présentent une palette de couleurs réduite à l'extrême, au sein de laquelle le regard approfondi relève toutefois de surprenantes nuances. L'œuvre d'Esser a peu de choses en commun avec l'approche sobre et objective de la photographie qui caractérise habituellement l'école des Becher. Dans ses photographies, le temps semble arrêté, et il s'y exprime une conception de la nature qu'on peut rattacher le plus clairement à la peinture romantique. A la vue de *Beauduc* (2000) ou de *Ameland Pier X* (2000), qui ne sentirait l'évocation de quelque chose qu'Edmund Burke et Immanuel Kant ont tenté de cerner par le concept du sublime ?

D. M.

SELECTED EXHIBITIONS →
2004 *Zur Bedeutung der Farbe in der Photographie. Elger Esser, Felice Beato*, Fondation Herzog – Ein Laboratorium für Photographie, Basle **2003** Kunsthalle Rostock; *Cap d'Antifer-Etretat*, Schirmer/Mosel Showroom, Munich; *Moving Pictures, Contemporary Photography and Video from the Guggenheim Museum Collections*, Guggenheim Museum Bilbao **2002** *Zwischen Konstruktion und Wirklichkeit. Landschaft in der zeitgenössischen deutschen Fotografie*, Suermondt-Ludwig-Museum, Aachen

SELECTED PUBLICATIONS →
2002 *Elger Esser, Peter Foos. Cap d'Antifer-Etretat*, Munich; *In Szene gesetzt*, Götz Adriani (ed.), Ostfildern-Ruit; *heute bis jetzt, Zeitgenössische Fotografie aus Düsseldorf, Teil II*, Munich **2000** *Elger Esser. Veduten und Landschaften*, Munich; *Manfred & Elger Esser. Nach Italien*, Heidelberg

„Ama et fac quod vis – liebe und tu was du willst."

«Ama et fac quod vis – aime et fais ce que tu veux.»

"Ama et fac quod vis – love, and do what you want."

3

4

5

Yang Fudong

1971 born in Beijing, lives and works in Shanghai, China

Yang Fudong's work exposes the conflict between traditional and modern ways of living in China's newly oriented society. Falling back on clichés, the artist conveys as a reciprocal projection not only the image of the traditional world, but also that of the consumption-driven one. As demonstrated by the colourful and provocative video *Honey* (2003) desire is becoming the foundation of the vibrantly modernized city, where one can only be satisfied by overindulgence: gambling or cigarette-smoking men and women in luxurious clothing wait suspiciously coolly for something. People going in and out are observed in mysterious activities. The account follows the pattern of classic film narratives, but the story line remains unclear and distorted. Fudong's early photographic work *The First Intellectual* (2000) reflects on the difficulty of being rebellious and critical towards a society experiencing incisive changes so quickly. Yang Fudong develops this theme in the as yet unfinished five-part film series *The Seven Intellectuals*, in which he relates contemporary China to its own history: this series tells the ancient tale of seven wise men who have withdrawn from social life out of protest. In a harmonious rhythm of intermingling black and white images, the first episode (2003) shows seven people in a dreamlike mountain world. The beauty of nature is connected in the film with the protagonists' psychology – its dazed spirit seems to find alleviation here. Through this poetic approach, Yang Fudong appeals stylistically to 1930s and 40s films from Shanghai, thereby arousing an ambiguous nostalgia.

Das Werk von Yang Fudong enthüllt den Konflikt zwischen der traditionellen und der modernen Lebensweise der neu orientierten chinesischen Gesellschaft. Auf Klischees zurückgreifend, vermittelt der Künstler nicht nur das Bild des Althergebrachten, sondern auch das der konsumgeleiteten Welt als wechselseitige Projektion. Wie das bunte und provokative Video *Honey* (2003) vorführt, wird Lust zur Basis der vibrierenden modernisierten Stadt, wo man einzig durch Übersättigung befriedigt wird: verdächtig gelassen warten spielende oder Zigaretten rauchende Männer und Frauen in luxuriöser Kleidung. Ein- und ausgehende Personen werden bei geheimnisvollen Handlungen beobachtet. Die Schilderung folgt dem Muster klassischer Filmerzählungen, aber der narrative Strang bleibt unklar und verzerrt. Fudongs frühe Fotoarbeit *The First Intellectual* (2000) reflektiert die Schwierigkeit, rebellisch und kritisch gegenüber einer Gesellschaft zu sein, die so schnell einschneidende Veränderungen erlebt. Fudong vertieft dieses Thema in der noch nicht abgeschlossenen fünfteiligen Filmreihe *The Seven Intellectuals*, in welcher er das gegenwärtige China in Bezug zu seiner eigenen Geschichte setzt: Darin wird die alte Überlieferung der sieben Weisen erzählt, die sich aus Protest aus dem gesellschaftlichen Leben zurückgezogen haben. Im harmonischen Rhythmus ineinanderfließender schwarzweißer Bilder zeigt die erste Episode (2003) sieben Menschen in einer traumhaften Bergwelt. Die Schönheit der Natur ist filmisch mit der Psychologie der Protagonisten verknüpft – ihr verwirrter Geist scheint dort Erholung zu finden. Durch diese poetische Herangehensweise spielt er stilistisch auf Filme aus dem Schanghai der dreißiger und vierziger Jahre an und ruft damit eine doppeldeutige Nostalgie wach.

L'œuvre de Yang Fudong met en évidence le conflit entre les modes de vie traditionnel et moderne des évolutions récentes de la société chinoise. L'artiste s'appuie sur des clichés pour transmettre sous forme de projection réciproque non seulement l'image de la tradition, mais aussi celle d'un monde guidé par le consumérisme. Comme le montre la provocante vidéo *Honey* (2000), le plaisir devient le fondement de la ville vibrante et modernisée, où seule la satiété apporte la satisfaction : avec une tranquillité suspecte, des hommes et des femmes luxueusement vêtus attendent en jouant ou en fumant des cigarettes. Des personnes au comportement mystérieux sont observées dans leurs allées et venues. La description suit le schéma classique du récit filmique, mais la composante narrative demeure confuse et déformée. *The First Intellectual* (2000), un travail photographique ancien, se présente comme une réflexion sur la difficulté d'adopter une position contestataire et critique à l'égard d'une société soumise à des évolutions aussi rapides que profondes. Yang Fudong développe aujourd'hui ce thème dans une série encore inachevée de cinq films, *The Seven Intellectuals*, dans lesquels la Chine d'aujourd'hui est confrontée à sa propre histoire. Il s'appuie pour cela sur la vieille tradition des sept sages qui se retirèrent de la vie publique pour protester contre l'état de la société. Avec des images en noir et blanc s'écoulant les unes dans les autres à un rythme harmonieux, le premier épisode (2003) nous montre sept hommes dans une idylle montagneuse. La beauté de la nature est mêlée cinématographiquement à la psychologie des protagonistes – leur esprit troublé semble y trouver un certain réconfort. Stylistiquement, cette approche poétique fait appel aux films du Shanghai des années trente et quarante et éveille ainsi une nostalgie à double fond.

C. E.

SELECTED EXHIBITIONS →
2005 *Don't worry, it will be better...*, Kunsthalle Wien, Vienna
2004 The Renaissance Society, Chicago; *Time Zones*, Tate Modern, London **2003** 50. Biennale di Venezia, Venice **2002** *Urban Creation*, 4. Shanghai Biennale; documenta 11, Kassel **2001** *Living in Time*, *29 zeitgenössische Künstler aus China*, Hamburger Bahnhof, Berlin; 1. Yokohama Triennale **2000** Multimedia Art Asia Pacific Festival, Brisbane

SELECTED PUBLICATIONS →
2003 *Camera*, Musée d'Art Moderne de la Ville de Paris; *Yang Fudong: "S10"*, Siemens Arts Program **2002** *documenta 11*, Kassel **2001** *Living in Time*, Hamburger Bahnhof, Berlin **2000** *Useful Life* (with Yang Zhenzhong and Xu Zhen), Shanghai

1 **Seven Intellectuals in Bamboo Forest**, 2003/04, 35mm b/w film, 46 min.
2 **Moon Tonight**, 2000, video installation, Shanghai
3 **The Evergreen Nature at Romantic Stories**, 1999, photograph, 78 x 110 cm

4 **Honey**, 2003, photograph, 50 x 70 cm
5 **Flutter Flutter Jasmine Jasmine**, 2002, 3-channel video installation, 17 min. 40 sec., video still

„Das ist eine Vorstellung, die mich nach wie vor beschäftigt: Man will Großes erreichen, und am Ende gelingt es einem doch nicht. Jeder gebildete Chinese ist ehrgeizig, stößt aber auf Hindernisse – ‚äußere', das heißt gesellschaftliche oder historische Hindernisse, oder ‚innere' Hindernisse, die man sich selbst in den Weg legt."

«Un concept qui continue de me préoccuper: on veut accomplir de grandes choses, mais au bout du compte, on n'y arrive pas. Tout Chinois éduqué est très ambitieux, et il y a manifestement des obstacles – des obstacles qui viennent soit de ‹l'extérieur›, à savoir de la société ou de l'histoire soit de ‹l'intérieur› de soi.»

"A concept that still preoccupies me: One wants to accomplish big things, but in the end it doesn't happen. Every educated Chinese person is very ambitious, and obviously there are obstacles – obstacles coming either from 'out there', meaning society or history, or from 'inside', from within oneself."

2

3

4

5

Ellen Gallagher

1965 born in Providence (RI), lives and works in New York (NY), USA

Ellen Gallagher exploded onto the New York art scene in the mid-1990s with beautiful medium- to large-scale paintings that infused the formal vocabulary of high-modernist abstraction with the exaggerated physical traits typical of racist caricature. Lurking at the edges and in the seams of her elegant grids and minimalist compositions were the disembodied eyes and lips of blackface minstrelsy, a return of the repressed that has become more prominent in recent paintings that place Afro-centric advertisements lifted from magazines like "Ebony" and "Our World" in large, austere grids. Yet Gallagher invariably complicates a straight reading of her work along racial lines. Parallel to her use of these archival materials to examine class connotations, the changing definition of beauty, and how our bodies represent socio-cultural predicaments, Gallagher has created fantastic imaginary realms wherein these issues are (literally) submerged in an ocean of history, ritual, and myth. The heads, which often have their eyes removed and always feature yellow (blond) Plasticine wigs, are here writ small and set loose on blank expanses of paper or interwoven with the gills, tentacles, and fins of oceanic monsters. These two recent bodies of work are united by Gallagher's exquisite crafts-manship: the large paintings, built up with collaged elements, are densely mapped; the smaller works on paper – incised with an X-acto knife – are diaphanous. Both suture together the form-and-content divide, pairing oblique social commentary with elegant compositions and seductive surfaces.

Ellen Gallagher platzte Mitte der neunziger Jahre in die New Yorker Kunstszene mit ihren hübschen, mittel- bis großformatigen Gemäl-den, die das Formvokabular der abstrakten Moderne mit jenen für die rassistische Karikatur typischen überzogenen physischen Merkmalen durchtränkten. An den Rändern ihrer eleganten Gitterbilder und minimalistischen Kompositionen lauerten Glupschaugen und grotesk über-zeichnete Lippen wie in der Minstrel-Show. Das Verdrängte, das noch exponierter in neueren Gemälden zutage tritt, in denen afrozentrische Werbeanzeigen aus Zeitschriften wie „Ebony" oder „Our World" in große, strenge Rasterstrukturen übertragen wurden, kehrt zurück. Und doch erschwert Gallagher unweigerlich eine direkte Auslegung ihrer Arbeit im Hinblick auf die Rassenthematik. Neben der Verwendung des erwähn-ten Archivmaterials zur Untersuchung von Klassenassoziationen, sich wandelnden Definitionen von Schönheit und der Repräsentation sozio-kultureller Dilemmata durch unseren Körper entwirft Gallagher fantastische Traumreiche, in denen diese Themen buchstäblich in einem Meer aus Geschichte, Ritual und Mythos untergehen. Die Köpfe, deren Augen häufig fehlen und die stets gelbe Plastilinperücken tragen, sind hier winzig klein und lose auf leere Papierflächen gesetzt beziehungsweise mit den Kiemen, Tentakeln und Flossen von Meeresungeheuern ver-woben. Diese neueren Werkkomplexe sind verbunden durch Gallaghers perfekte Beherrschung ihres Handwerks: Die großen, aus collagierten Elementen zusammengesetzten Gemälde sind dicht ausgearbeitet, während die kleineren, mit einem Grafikskalpell ausgeschnittenen Papier-arbeiten transparent wirken. Gemeinsam ist ihnen die Aufhebung der Trennung zwischen Form und Inhalt sowie die Kombination von indirek-tem gesellschaftlichem Kommentar mit eleganten Kompositionen und verführerischen Oberflächen.

Au milieu des années quatre-vingt-dix, Ellen Gallagher investissait la scène artistique new-yorkaise avec des peintures de moyen et grand format mêlant le vocabulaire formel de l'abstraction ultramoderne et l'exagération des particularités physiques qui caractérise la carica-ture raciste. Des yeux exorbités et des lèvres grossièrement exagérées comme dans un «Minstrel show» guettaient dans les ourlets et bor-dures de ses trames élégantes et de ses compositions minimalistes, un retour de l'interdit qui prédomine encore plus fortement dans ses pein-tures récentes, où des publicités afro-centrées tirées de magazines comme «Ebony» et «Our World» sont présentées dans des trames amples et austères. Gallagher complique néanmoins systématiquement toute interprétation réductrice de son travail s'appuyant sur des grilles de lec-ture purement raciales. Parallèlement à une utilisation de ce matériau d'archives dédiée à l'analyse des connotations de classe, de l'instabili-té de la notion de beauté et de la manière dont nos corps incarnent des situations socioculturelles, Gallagher a créé des univers fantastiques imaginaires dans lesquels les mêmes sujets sont (littéralement) submergés par un océan d'histoire, de rituel et de mythe. Ici, les têtes dépour-vues d'yeux, toujours coiffées de perruques jaunes (blondes) en pâte à modeler, sont réduites à des miniatures et disséminées sur des sur-faces de papier vides ou enchevêtrées avec des lamelles, des tentacules et des nageoires de monstres marins. Ces deux pans de son travail récent sont liés par l'époustouflante technique artistique de Gallagher : les peintures grand format, constituées de collages d'éléments, ont une facture dense, tandis qu'avec leurs incisions au cutter, les œuvres sur papier de moindre format sont diaphanes. Tous deux abolissent la divi-sion forme/contenu et associent le commentaire social transversal à des compositions élégantes aux surfaces séduisantes. B. S.

SELECTED EXHIBITIONS →
2005 *DeLuxe*, Whitney Museum of American Art, New York; *Ichthyosaurus*, Freud Museum, London **2004** *Orbus*, Fruitmarket Gallery, Edinburgh; *Disparities and Deformations: Our Grotesque*, 5. International Biennial, Santa Fe; *Here Is Elsewhere*, Museum of Modern Art, New York **2003** *POMP-BANG*, Saint Louis Art Museum; 50. Biennale di Venezia, Venice, **2001/02** *Watery Ecstatic*, Institute of Contemporary Art, Boston, Museum of Contemporary Art, Sydney **2001** *The Americans*, Barbican, London

SELECTED PUBLICATIONS →
2005 Ellen Gallagher: *eXelento*, Gagosian Gallery, New York; *Orbus*, Caoimhin MacGiolla Leith (ed.), Fruitmarket Gallery, Edinburgh **2004** *Disparities and Deformations: Our Grotesque*, Robert Storr (ed.), Santa Fe **2003** *Vitamin P*, London **2001** *Watery Ecstatic*, Institute of Contemporary Art, Boston, New York

1 **Lustrasilk** (from **DeLuxe**), 2004/05, photogravure, aquatint, silkscreen, laser-cutting, oil, plasticine, 33 x 24.8 cm

2 **DeLuxe**, 2004/05, portfolio of 60 etchings with photogravure, spitbite, collage, laser cutting, silkscreen, offset lithography, hand painting, plasticine sculptural editions, each 33 x 26.7 cm

„Die körperlosen Augen und Lippen verweisen auf ein Schauspiel, auf unsichtbare Körper, die vor dem elektrischen Schwarz der Varietébühne schweben. Bei den Perücken geht es ebenfalls darum, auch wenn das Plastilin ihnen eine Struktur oder Präsenz verleiht."

«Les yeux et les lèvres désincarnées se réfèrent à la performance, à des corps qu'on ne peut voir, otage en suspension dans le noir électrique de la scène du ménestrel. Les perruques évoquent la même chose, même si la pate à modeler leur confère une texture ou une présence.»

"The disembodied eyes and lips refer to performance, to bodies you cannot see, floating hostage in the electric black of the minstrel stage. The wigs are also about that even though the plasticine gives them a texture, or presence."

Anna Gaskell

1969 born in Des Moines (IA), lives and works in New York (NY), USA

Anna Gaskell's photographic work and videos are highly artificial and staged. Using actresses she creates tableaux in which young girls perform in enchanted and gloomy landscapes, gaze into dramatic skies, or stare at the viewer out of haunting portraits. The female protagonists in her images often seem like the heroines of storybooks or thrillers, from which she borrows liberally. In the series *Untitled (Resemblance)* (2001) a group of young women re-enacts the creation of an artificial person. The artist does not have them give birth to a Shelleyesque monster, however, but to a mother figure. Gaskell's oeuvre seems like an illustration of the uncanny. She defamiliarizes the familiar, reverses roles, undermines expectations, and plays with motifs and concepts from psychoanalysis. Her figures are ambivalent, being threatening and threatened simultaneously. The photograph *Untitled 107* (2004) shows a group of young girls in front of a gloomy, snow-covered landscape. The black-clad figures are cut off by the frame at the lower edge of the picture, and are shown from the back. Their facelessness greatly increases the uneasy atmosphere. The photograph remains insistently tense, and doesn't resolve its story. Gaskell undermines the idea of domesticated, asexual girls, and her models are erotic objects and subjects equally. The series *Untitled (Hide)* (1998) reduces the childlike female body to single body parts frozen as machines or dolls. Gaskell applies related strategies in her drawings. In *At Sixes and Sevens* (2003) she covers many sheets of paper with an anatomical network of linearly outlined, distorted, and deformed bodies – the grotesque version of a childlike ring-a-ring-a-roses.

Die fotografischen Arbeiten und Videos von Anna Gaskell sind hoch artifiziell und inszeniert. Mithilfe von Schauspielerinnen kreiert sie Tableaus, in denen junge Mädchen in verwunschenen und düsteren Landschaften agieren, in dramatische Himmel blicken oder den Betrachter aus eindringlichen Porträts ansehen. Oftmals wirken die Protagonistinnen ihrer Bilder wie Heldinnen aus Märchenbüchern oder Schauerromanen, bei denen sie starke Anleihen macht: In der Serie *Untitled (Resemblance)* (2001) stellt eine Gruppe junger Frauen die Schöpfung eines künstlichen Menschen nach, doch lässt die Künstlerin sie kein Shelley'sches Monster, sondern eine Mutterfigur gebären. Gaskells Œuvre erscheint als Illustration des Unheimlichen, sie verfremdet das Vertraute, verkehrt Rollen und untergräbt Erwartungen, spielt mit Motiven und Konzepten aus der Psychoanalyse. Ihre Figuren sind ambivalent, sind Bedrohung und Bedrohte zugleich: Die Fotografie *Untitled 107* (2004) zeigt eine Gruppe junger Mädchen vor einer düsteren, verschneiten Landschaft. Die schwarz bekleideten Figuren sind am unteren Bildrand angeschnitten und in Rückenansicht abgebildet, durch die Gesichtslosigkeit wird das Beunruhigende übersteigert. Die Fotografie verharrt in ihrer Spannung, sie löst die Geschichte nicht auf. Gaskell untergräbt die Vorstellung vom domestizierten, geschlechtslosen Mädchen, ihre Modelle sind erotisches Objekt und Subjekt gleichermaßen – die Serie *Untitled (Hide)* (1998) reduziert den kindlich-weiblichen Körper auf einzelne Körperteile, erstarrt zu Automaten und Puppen. In ihren Zeichnungen wendet Gaskell verwandte Strategien an. In *At Sixes and Sevens* (2003) erstreckt sich ein anatomisches Geflecht aus linear umrissenen, verzerrten und deformierten Körpern über eine Vielzahl von Blättern – die groteske Version eines kindlichen Ringelreihens.

Les œuvres photographiques et les vidéos d'Anna Gaskell sont hautement artificielles et mises en scène. Gaskell utilise des actrices professionnelles pour créer des «tableaux» dans lesquels des jeunes filles évoluent dans des paysages lugubres et envoûtés, regardent des ciels dramatiques ou contemplent le spectateur depuis des portraits pénétrants. Les protagonistes de ses images font l'effet d'héroïnes de recueils de contes ou de romans d'horreur, auxquels l'artiste fait des emprunts notoires: dans la série *Untitled (Resemblance)* (2001), un groupe de jeunes femmes rejoue la création d'un homme artificiel. Toutefois, l'artiste ne leur fait pas créer un monstre à la Shelley, mais une figure mère. L'œuvre de Gaskell se présente comme une illustration de l'étrange, elle détourne le familier, inverse les rôles, déjoue les attentes, joue sur des motifs et des notions psychanalytiques. Ses personnages ambigus sont à la fois menaçants et menacés: la photographie *Untitled 107* (2004) montre un groupe de jeunes filles devant un paysage lugubre et enneigé. Les figures vêtues en noir et coupées au bord inférieur sont représentées de dos, et l'absence de visage exacerbe l'inquiétude. La photographie demeure dans sa tension, elle ne résout pas l'histoire. Gaskell sape l'idée de la jeune fille domestiquée et asexuée, ses modèles sont à la fois objet et sujet érotique – la série *Untitled (Hide)* (1998) réduit le corps enfantin et féminin à des parties corporelles isolées, figées en automates et en poupées. Dans ses dessins, Gaskell se sert de stratégies similaires. *At Sixes and Sevens* (2003), qui montre un enchevêtrement anatomique de corps aux contours linéaires déformés, s'étend sur un grand nombre de feuilles – comme la version grotesque d'une ronde enfantine.

A. M

SELECTED EXHIBITIONS →
2005 *Works from the Magasin 3 Stockholm Konsthall Collection*, Magasin 3, Stockholm; *Out There: Landscape in the New Millennium*, Museum of Contemporary Art Cleveland **2004** *Monument To Now*, The Dakis Joannou Collection, Athens; *Stalemate*, Museum of Contemporary Art, Chicago **2002** *half life*, The Menil Collection, Houston; *Moving Pictures. Contemporary Photography and Video from the Guggenheim Museum Collections*, Solomon R. Guggenheim Museum, New York, Guggenheim Museum Bilbao; *Visions from America*, Whitney Museum of American Art, New York; *Stories. Erzählstrukturen in der zeitgenössischen Kunst*, Haus der Kunst, Munich

SELECTED PUBLICATIONS →
2003 *Anna Gaskell: half life*, The Menil Foundation, Houston **2002** *Moving Pictures. Contemporary Photography and Video from the Guggenheim Museum Collections*, Solomon R. Guggenheim Museum, New York; *Resemblance: Photographs by Anna Gaskell*, Addison Gallery of American Art, Andover

166

„Die Entwicklung des (eines) Märchens, vom Fakt zur Fiktion (und von der Fiktion zur Mythologie), und die verschiedenen Interpretationsmöglichkeiten, bieten eine wunderbare Gelegenheit, die Geschichte einer bestimmten Erzählung nachzuvollziehen."

« L'évolution d'un (du) conte de fées, du fait à la fiction (et de la fiction à la mythologie), et les différentes interprétations possibles sont une belle manière de regarder se développer l'histoire d'un récit particulier. »

"The evolution of (a) fairytale, from fact to fiction, (and fiction to mythology), and the different ways it can be interpreted, is a beautiful way to watch the history of a particular story unfold."

2

3

4

5

Robert Gober

1954 born in Wallingford (CT), lives and works in New York (NY), USA

At first glance some of Robert Gober's sculptural objects seem like ready-mades: a sink (*Sinks* series), a drain (*Drain* series), an empty wedding dress (*Wedding Gown*, 1989), or two doors leaning up against the wall (*Two Doors*, 1989). In fact all of these objects are handmade recreations, the surfaces of which exhibit a delicate, lifelike materiality. The borderline between things and people is blurred. In addition to its drain a sink may have two, four, or six eye-like openings, or none at all. A human leg, complete with shoe, sock, and hairs on its waxy skin, projects from the wall. A pillow becomes a half female, half male human chest. And reappearing everywhere is the drain, which can open up in the floor, a wall, a sink, and finally even in the skin. The objects' simple literalness begins to waver and to open up chasms of horror in the familiar. The wallpaper *Hanging Man/Sleeping Man* (1989) is a good example of this: its pattern alternates between depictions of a sleeping white man and a hanged black man. The lynching, a historical symbol of violence against minorities in the USA, appears as a 'sleep of reason', an endless nightmare (or pipe dream?) decorating a peaceful home. Gober uses his site-specific installation in the US pavilion at the 2001 Venice Biennial for criticism that is more explicit. The mirror-image arrangement of the individual exhibits in the symmetrical building radically questions the individual sculptures' status as original objects. Making thematic reference to contemporary crimes of violence against homosexuals, the installation contradicts the apparently harmonic, egalitarian arrangement of the neopalladian building, symbol of the United States Constitution and Western values.

Manche der skulpturalen Objekte von Robert Gober erscheinen auf den ersten Blick wie Ready-mades: ein Waschbecken (Serie *Sinks*), ein Abflussloch (Serie *Drains*), ein leeres Brautkleid (*Wedding Gown*, 1989), zwei an die Wand gelehnte Türen (*Two Doors*, 1989). Tatsächlich sind all diese Objekte handgemachte Nachbildungen, deren Oberflächen eine zarte, lebensähnliche Materialität aufweisen. Die Grenze zwischen den Dingen und den Menschen ist fließend: Ein Waschbecken kann über dem Abfluss zwei, vier, sechs oder gar keine augenähnliche Öffnungen haben. Ein menschliches Bein ragt, komplett mit Schuh, Socken und Härchen auf der wächsernen Haut, aus der Wand. Ein Kopfpolster wird zu einer halb weiblichen, halb männlichen menschlichen Brust. Und allgegenwärtig kehrt das Abflussloch wieder, das sich im Boden, in der Wand, im Waschbecken und schließlich in der Haut auftun kann. Die einfache Buchstäblichkeit der Dinge gerät ins Wanken und eröffnet Abgründe des Grauens im Vertrauten. Die Tapete *Hanging Man/Sleeping Man* (1989) führt dies exemplarisch vor: Ihr Muster zeigt abwechselnd einen schlafenden weißen Mann und einen gehängten schwarzen Mann. Der Lynchmord, historisches Symbol der Gewalt gegen Minderheiten in den USA, erscheint als ein Schlaf der Vernunft, ein endloser Alp- (oder Wunsch-?)traum schmückt das friedliche Heim. Zu einer expliziteren Kritik nutzte Gober seine ortsspezifische Installation im US-amerikanischen Pavillon der Biennale Venedig 2001. Die spiegelbildliche Anordnung der einzelnen Exponate in dem symmetrischen Gebäude hinterfragte radikal den Objektstatus der Einzelskulpturen. Thematisch Bezug nehmend auf aktuelle Gewaltverbrechen gegen Homosexuelle, konterkarierte die Installation die anscheinend harmonische, gleichberechtigte Ordnung des neopalladianischen Gebäudes, Sinnbild der US-amerikanischen Verfassung und westlicher Werte.

A première vue, certains des objets sculpturaux de Robert Gober se présentent comme des ready-mades: un lavabo (série *Sinks*), une bonde (série *Drains*), une robe de mariée vide (*Wedding Gown*, 1989), deux portes appuyées contre un mur (*Two Doors*, 1989). En fait, tous ces objets sont entièrement réalisés à la main et leur surface dénote une matérialité délicate, proche de l'aspect naturel. La frontière entre les hommes et les objets est perméable: au-dessus de sa bonde, un lavabo peut présenter deux, quatre, six ou aucune ouverture apparentée à des yeux; une jambe humaine sort d'un mur, complète et vêtue d'une chaussure, d'une chaussette, la peau cireuse couverte de tous ses poils; un oreiller devient une poitrine mi-masculine, mi-féminine. Partout on voit réapparaître la bonde, qui peut s'ouvrir dans le sol, dans un mur, dans un lavabo, mais aussi dans la peau. La simple littéralité des objets en est ébranlée et ouvre des abîmes d'horreur dans l'univers le plus familier, comme l'illustre de manière exemplaire le papier peint *Hanging Man/Sleeping Man* (1989), dont les motifs présentent alternativement un homme blanc dormant et un homme noir pendu. Le lynchage, symbole historique des violences perpétrées à l'encontre des minorités américaines, apparaît comme un sommeil de la raison – un cauchemar ou un fantasme interminable orne la paix du foyer. Gober a utilisé l'installation spécialement réalisée pour le pavillon américain de la Biennale de Venise 2001 pour formuler une critique encore plus explicite. La disposition en miroir des objets exposés en différents endroits de l'édifice symétrique constituait une remise en cause radicale du statut d'objet revendiqué par la sculpture unique. Se référant thématiquement aux crimes commis à l'encontre des homosexuels, l'installation contredisait l'ordre apparemment harmonieux et équilibré de l'architecture néo-palladienne, symbole de la constitution américaine et des valeurs occidentales. E. K.

SELECTED EXHIBITIONS →
2004 *Robert Gober/Mike Kelley/Christopher Wool*, Pinakothek der Moderne, Munich **2003** *Displacements*, Astrup Fearnley Museet for Moderne Kunst, Oslo **2001** *Katharina Fritsch/Robert Gober*, Museum für Moderne Kunst, Frankfurt/Main; 49. Biennale di Venezia, Venice **1999/2000** *Robert Gober: Sculpture + Drawing*, Walker Art Center, Minneapolis, Rooseum Center for Contemporary Art, Malmö, Smithsonian Institution, Washington D.C., San Francisco Museum of Modern Art

SELECTED PUBLICATIONS →
2003 *Robert Gober, Werke von 1978 bis heute*, Nuremberg; *Robert Gober: Displacements*, Astrup Fearnley Museet for Moderne Kunst, Oslo **2001** *Katharina Fritsch/Robert Gober*, Museum für Moderne Kunst, Frankfurt/Main; *Robert Gober: The United States Pavilion*, 49. Biennale di Venezia, Venice **1999** *Robert Gober: Sculpture + Drawing*, Walker Art Center, Minneapolis, Rooseum Center for Contemporary Art, Malmö, Smithsonian Institution, Washington D.C., San Francisco Museum of Modern Art, San Francisco

1 **Untitled** (detail), 2004/05, bronze, cement, feather re-creation of American
Robin, water, 174.6 x 100.3 x 104.1 cm
2 **Untitled**, 2005, pastel and graphite on paper, 55.9 x 67.3 cm
3 **Untitled**, 2004/05, bronze, beeswax, lead crystal, oil paint,
52.1 x 118.1 x 64.1 cm

4 **Untitled**, 2004/05, Fibreglass, beeswax, human hair, nickel-plated bronze,
wood, semi-gloss enamel paint, graphite on paper, water,
c. 244 x 357 x 159 cm

„Ich versuche immer, die Leute dazu zu bringen, sich nicht so sehr oder
wenigstens am Anfang nicht darauf zu konzentrieren, in der Arbeit eine
‚Bedeutung' oder ein ‚Thema' zu suchen, sondern darauf, worum es sich bei
der Arbeit konkret handelt. Woraus sie physisch besteht und wie sie
gemacht ist. Sehr häufig finden sich Metaphern fast im Medium selbst."

« J'essaie toujours d'amener les gens à se poser moins de questions –
du moins au debut – sur la ‹ signification › ou le ‹ thème › de l'œuvre, mais
à se concentrer sur ce que c'est exactement. Sur ce dont elle est faite et
comment elle est faite. Très souvent, des métaphores sont quasiment intrin-
sèques au médium. »

"I always try to get people to focus less, or at least not first, on finding 'meaning', or 'theme' in the work, but to focus on what it is exactly. What is it physically made of and how it is made. A lot of times metaphors are almost embedded in the medium."

3

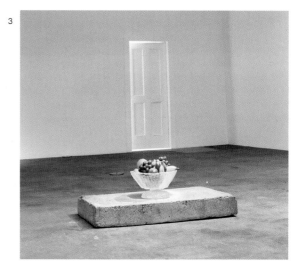

4

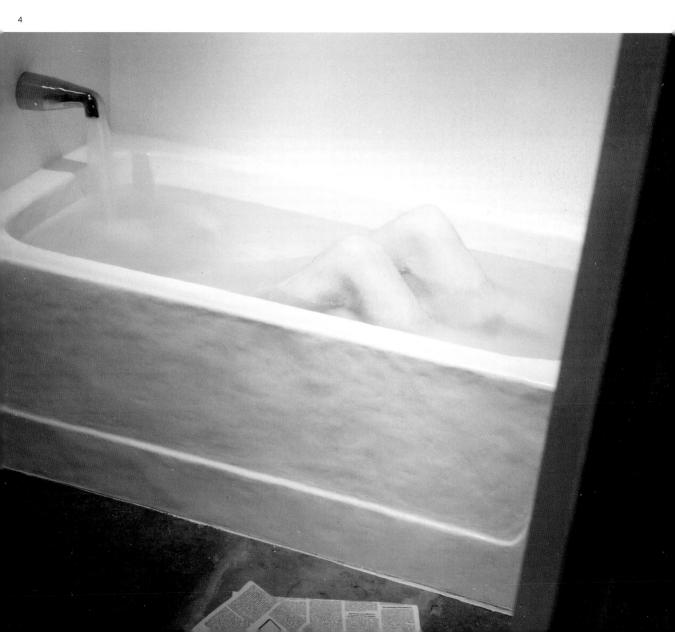

Anthony Goicolea

1971 born in Atlanta (GA), lives and works in New York (NY), USA

The Photoshop generation of digital artists and photographers has no better pin-up boy than the ever-youthful Anthony Goicolea, protagonist (always many times over) of his own photographic and video work. Traditional self-portraiture tends to idealise or reinforce the role of the artist, whereas Goicolea presents himself as hapless victim of adolescent pranks and hormonal fantasies, dressed in wigs, school uniforms or perhaps caught in a state of embarrassment, trussed up or undressed. A feverish *Last Supper* (1999) shows eight deranged clones of the artist stuffing themselves with bread, while the adolescent abuse of *Spit or Swallow* (1999) hints at the homoerotic overtones in later work such as *Midnight Kiss* or *Lake* from the *Kidnap Series* (2004). Goicolea owes the seed of his technique of panoramically exaggerating visual truth to the German photographer Andreas Gursky, who is also reliant on computers and digital manipulation to achieve the unreal. However, no one does narcissistic self-multiplication more convincingly than Goicolea and complex videos featuring his duplicate personalities falling down stairs, in *Tickle (Triptych II)* of 2003, and installations involving stuffed animals in a landscape (*Snowscape*, 2003) are the natural progression of the photographic dioramas. The playacting of other identity-hopping artists such as Jeff Koons and Cindy Sherman comes to mind, especially in the context of the *Fairytale* series (1996) in which Goicolea assumes the roles of The Little Prince or the Mad Hatter, but the volatility of selfhood has been a constant theme in photography since 19th-century sitters were first startled by their own photographic likenesses.

Für die digitalen Künstler und Fotografen der Generation Photoshop gibt es wohl kein größeres Idol als den ewig jugendlichen Anthony Goicolea, der selbst als (stets mehrfacher) Protagonist in seinen Foto- und Videoarbeiten auftritt. Das traditionelle Selbstporträt neigt dazu, die Rolle des Künstlers zu idealisieren oder überzubetonen, Goicolea hingegen präsentiert sich als unglückseliges Opfer halbwüchsiger Witzbolde und hormoneller Fantasien – Perücken und Schuluniformen tragend, in peinlichen Situationen, gefesselt oder ausgezogen. Ein fiebriges *Last Supper* (1999) zeigt acht gestörte Klone des Künstlers, die Brot in sich hineinstopfen, während der pubertäre Missbrauch in *Spit or Swallow* (1999) auf die homoerotischen Zwischentöne in späteren Arbeiten wie *Midnight Kiss* oder *Lake* aus der *Kidnap Series* (2004) verweist. Goicolea verdankt seine Technik der panoramahaft übersteigerten visuellen Wahrheit dem deutschen Fotografen Andreas Gursky, der zur Erzeugung des Unwirklichen ebenfalls Computer und digitale Bearbeitung nutzt. Dennoch betreibt niemand die narzisstische Selbstvervielfältigung überzeugender als Goicolea, und so sind jene komplizierten Videos, in denen seine duplizierten Figuren eine Treppe herabstürzen, wie in *Tickle (Triptych II)* von 2003, und Installationen mit ausgestopften Tieren in einer Landschaft (*Snowscape*, 2003) nur die natürliche Weiterentwicklung seiner fotografischen Dioramen. Man muss unweigerlich an das In-fremde-Rollen-Schlüpfen anderer ihre Identität wechselnder Künstler wie Jeff Koons und Cindy Sherman denken, insbesondere im Fall der *Fairytale*-Serie (1996), in der Goicolea die Rollen des „kleinen Prinzen" oder des verrückten Hutmachers aus „Alice im Wunderland" spielt, aber die Unbeständigkeit des Selbst war schließlich schon immer ein Thema der Fotografie, seit im 19. Jahrhundert die Abgelichteten erstmals über ihre eigene fotografische Ähnlichkeit erschraken.

La génération Photoshop de photographes et d'artistes numériques n'a pas de meilleure vedette masculine que l'éternel jeune homme Anthony Goicolea, protagoniste (toujours très abondamment) de son propre travail photographique et vidéo. Alors que l'autoportrait traditionnel tend à idéaliser ou à souligner le rôle de l'artiste, Goicolea se présente lui-même comme la victime de frasques d'adolescence ou de fantasmes hormonaux : vêtu de perruques, d'uniformes d'écolier ou dans quelque posture embarrassante, ligoté ou dévêtu. Dans *Last Supper* (1999), une fébrile dernière cène montre huit clones dérangés de l'artiste en train de se bourrer de pain, tandis que le viol sur mineur de *Spit or Swallow* (1999) annonce les connotations homosexuelles d'œuvres ultérieures comme *Midnight Kiss* ou *Lake* des *Kidnap Series* (2004). Goicolea doit sa technique d'exagération panoramique de la vérité visuelle au photographe allemand Andreas Gursky, lui aussi tributaire de l'informatique et des manipulations numériques pour réaliser l'irréel. Reste que personne ne pratique l'auto-multiplication narcissique de manière plus convaincante que Goicolea, et les vidéos complexes qui présentent ses personnalités dupliquées tombant dans des escaliers comme dans *Tickle (Triptych II)* de 2003, et les installations montrant des animaux empaillés dans un paysage (*Snowscape*, 2003) sont le prolongement naturel de ses dioramas photographiques. L'on songe immanquablement au jeu de rôles pratiqué par d'autres virtuoses du changement d'identité comme Jeff Koons et Cindy Sherman, en particulier dans le contexte de la série *Fairytale* (1996), dans laquelle Goicolea endosse le rôle du Petit Prince ou de Mad Hatter, le Chapelier Fou d'« Alice au pays des merveilles ». Quoi qu'il en soit, la volatilité de l'individualité est un thème récurrent de la photographie depuis que les modèles du XIXe siècle ont commencé d'être fascinés par la ressemblance de leur double photographique. O. W.

SELECTED EXHIBITIONS →
2005 *Anthony Goicolea: Photographs, Drawings and Video*, Arizona State University Art Museum, Tempe **2004** *Nocturnal Emissions*, Groninger Museum; *The Amazing and the Immutable*, University of South Florida Contemporary Art Museum, Tampa; *Out of Place: Part II*, Indianapolis Museum of Contemporary Art; *Open House: Working in Brooklyn*, Brooklyn Museum, New York, *Boys Behaving Badly*, Contemporary Arts Museum Houston; *Only Skin Deep: Changing Visions of the American Self*, International Center of Photography, New York **2003** *Art Unlimited*, Art Basel, Basle; Contemporary Center of Photography, Melbourne; *Comic Release: Negotiating Identity for a New Generation*, Carnegie Mellon University, Pittsburgh **2002** Artspace, Auckland; Museum of Contemporary Photography, Chicago

SELECTED PUBLICATIONS →
2003 *Anthony Goicolea*, San Francisco **2001** *Anthony Goicolea*, RareArt Properties, New York

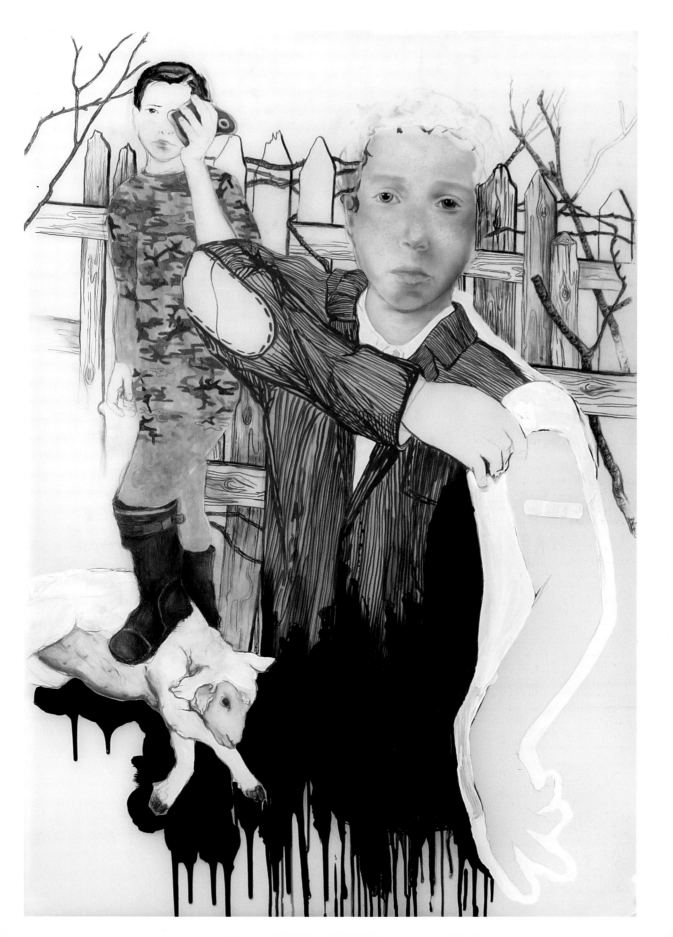

1 **Mama's Boy**, 2004, graphite, ink, acrylic on Mylar, 106.7 x 76.2 cm
2 **Bell Jar**, 2003, graphite, ink, acrylic on Mylar, 30.5 x 22.9 cm
3 **Red Sky**, 2004, graphite, ink, acrylic on Mylar, 218 x 159 cm

4 **Poolpushers**, 2001, colourprint on Forex, laminated, 180 x 275 cm
5 **After Dusk**, 2001, colourprint on Forex, laminated, 101.6 x 256.5 cm

„Durch die digitale Manipulation bin ich in der Lage, mich selbst zu klonen und Szenarien zu erschaffen, in denen ich Kindheitserlebnisse wie Kampfszenen, erste Küsse und verrückte Kindergeburtstage inszenieren kann."

«Par le truchement de la manipulation numérique, je suis en mesure de me cloner et de créer des scénarios dans lesquels je rejoue certains incidents de l'enfance comme des scènes de ménage, les premiers baisers et les rendez-vous manqués.»

"Through digital manipulation, I am able to clone myself and create scenarios in which I act out childhood incidents such as fight scenes, first kisses, and deranged play dates."

2

3

4

5

Dominique Gonzalez-Foerster

1965 born in Strasbourg, lives and works in Paris, France

Dominique Gonzalez-Foerster is a media artist in a very specific, while also very comprehensive sense of the word. Her works function like media because viewers must virtually adapt the works to suit themselves, inevitably supplementing them with their own emotions and ideas when approaching them. In these works, Gonzalez-Foerster formulates and tests various vocabularies of the imagination and memory. In her atmospheric environments she creates links to real or invented life-stories, often those of figures from literature and film. Thereby her works speak of the relationship of individuals to their environment, and of the fluidity of this relationship in impressions, memories, projections, and dreams. The works are laid out as readings. They are fragmentary narratives created from colour, from literary and personal references, and from precisely composed passages of emptiness. Gonzalez-Foerster is interested in the way in which spaces reflect people's stories, obsessions and wishes, how they reflect their relationships to objects, pictures, and daily life. The works thus become transitory places that oscillate between inner "intellectual" spaces, and those outside: beyond our body and outside of the building. In the work *Park – A Plan for Escape* (2002), created for documenta 11, Gonzalez-Foerster related this to the outdoors. She combined elements having various historical, cultural and geographical associations into a hybrid, modernist "locus amoenus", which included palms and agaves, a light blue Brazilian telephone booth, a blossoming rose bush from Le Corbusier's garden, and a seven-ton chunk of lava from Mexico, among other things. This resulted in the superimposition of an atmospheric picture upon a discursive system, and was an invitation for the viewer to embark upon journeys of the imagination.

Dominique Gonzalez-Foerster ist Medienkünstlerin in einem ganz spezifischen und dann auch wieder sehr umfassenden Sinn des Worts: Ihre Werke funktionieren „medial", da man sich ihnen als Betrachter quasi anverwandeln muss, sie in der Annäherung unweigerlich mit eigenen Emotionen und Vorstellungen auffüllt. Gonzalez-Foerster formuliert und erprobt darin unterschiedliche Sprachen von Imagination und Erinnerung. Mit ihren atmosphärischen Environments knüpft sie an wahre oder erfundene Lebensgeschichten an, oft solche von Personen aus Literatur und Film. Ihre Werke sprechen dabei vom Verhältnis des Individuums zu seiner Umgebung, von dessen Verflüssigung in Prägungen, Erinnerungen, Projektionen und Träumen. Die Arbeiten sind als Lektüre angelegt: fragmentarische Erzählungen aus Farbe, literarischen und persönlichen Verweisen sowie präzis gefassten Leerstellen. Gonzalez-Foerster interessiert sich für die Art, wie Räume die Geschichten, Obsessionen und Wünsche der Leute, ihre Beziehungen zu Gegenständen, Bildern und dem täglichen Leben reflektieren. So werden die Werke zu transitorischen Orten, die zwischen inneren „geistigen" Räumen und dem Draußen, außerhalb unseres Körpers und außerhalb des Hauses changieren. Mit dem zur documenta 11 entstandenen *Park – A Plan for Escape* (2002) bezog Gonzalez-Foerster dies auf den Außenraum. Sie verknüpfte historisch, kulturell und geografisch unterschiedlich kodierte Elemente zu einem modernistisch-hybriden „Locus Amoenus", der unter anderem Palmen und Agaven, eine hellblaue brasilianische Telefonzelle, einen blühenden Rosenbusch aus dem Garten Le Corbusiers und einen sieben Tonnen schweren Lavabrocken aus Mexiko enthielt: eine Überlagerung aus atmosphärischem Bild und diskursiv komponiertem System, die zu imaginären Reisen einlud.

Dominique Gonzalez-Foerster travaille sur le médium dans un sens bien particulier, mais aussi très général : ses œuvres fonctionnent de manière «médiale» dans la mesure où le spectateur est pour ainsi dire obligé de se transformer en elles, et donc de les investir inévitablement de ses propres émotions et conceptions. Gonzalez-Foerster y formule et expérimente différents langages de l'imaginaire et de la mémoire. Dans ses environnements atmosphériques, elle aborde des biographies vécues ou fictives, souvent empruntées à la littérature ou au cinéma, et part pour cela du rapport de l'individu à son entourage, de sa dissolution dans les influences, les souvenirs, les projections et les rêves. Ses œuvres s'organisent comme une lecture : récits fragmentaires faits de couleurs, de références littéraires et personnelles ainsi que de blancs soigneusement définis. Gonzalez-Foerster s'intéresse à la manière dont les espaces reflètent l'histoire des gens, leurs obsessions et leurs désirs, leurs rapports aux objets et aux images ou à leur vie quotidienne. Ses œuvres deviennent alors des lieux transitoires oscillant entre espaces intérieurs «spirituels» et monde extérieur – hors du corps et de l'habitat. Avec le *Park – A Plan for Escape* (2002) réalisé pour la documenta 11, Gonzalez-Foerster reliait tous ces aspects à la sphère publique. Elle y combinait des éléments codés par l'histoire, la culture et la géographie pour créer un *locus amoenus* mi-moderniste, mi-hybride – avec ses palmiers et ses agaves, sa cabine téléphonique brésilienne bleu clair, son rosier fleuri du jardin de Le Corbusier et son bloc de sept tonnes de lave du Mexique –, dans lequel la superposition d'une ambiance imagée et d'un système discursif invitait au voyage imaginaire.

J. A.

SELECTED EXHIBITIONS →
2005 *Tropicalia*, Museum of Contemporary Art, Chicago; *e-flux Video Rental*, KW Institute for Contemporary Art, Berlin **2004** *Multiverse*, Kunsthalle Zürich; *Alphavilles?*, deSingel, Antwerp; *Moment Dream House* (House for Daisuke Miyatsu), Tokyo **2003** *Cosmodrome*, 7. Biennale de Lyon (with Jay Jay Johanson); *Artist in Focus*, Museum Boijmans Van Beuningen, Rotterdam; Rotterdam International Film Festival **2002** documenta 11, Kassel; *Exotourisme*, Centre Pompidou, Paris (Prix Marcel Duchamp)

SELECTED PUBLICATIONS →
2004 *Alphavilles?*, Zurich, Amsterdam **2003** *Films. Dominique Gonzalez-Foerster*, Dijon, Frankfurt/Main; *Moment Dream House*, Mori Art Museum, Tokyo **2002** *Exotourisme*, Centre Pompidou, Paris; *Park – Plan d'évasion*, Imschoot, uitgevers, Ghent; *Néo-Horizon*, The Centre, Glasgow

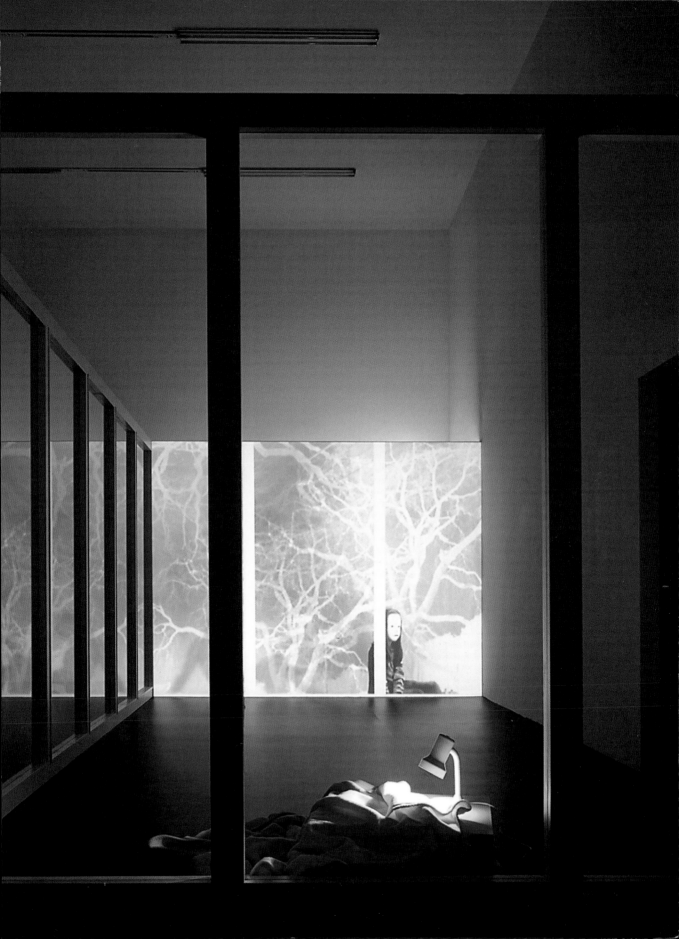

1 **Petite**, 2001, installation view, "Multiverse", Kunsthalle Zürich, 2004
2 **Trous Noirs**, 2004, installation view, "Multiverse", Kunsthalle Zürich
3 **Exotourisme**, 2002, installation view, "Exotourisme", Prix Marcel Duchamp, Centre Pompidou, Paris

4 **Plages**, 2001, still, 35mm film transferred to DVD
5 **Alphaville?**, 2005, exhibition view, "Dominique Gonzalez-Foerster. Alphavilles?", deSingel, Antwerp

„Ich möchte den Betrachter in einen Detektiv verwandeln, einen Forschergeist, eine Neugier auf andere Geschichten als die eigene erzeugen. Ich möchte die Wichtigkeit aller möglichen Geschichten als Selbst-Sprachen und den Wert sämtlicher Indizien und Wortschätze hervorheben."

« Je veux transformer le spectateur en détective, susciter un esprit de chercheur pour une investigation, une curiosité pour d'autres histoires, à moins que ce ne soit la nôtre : souligner l'importance de toutes sortes de récits comme auto-langages et la valeur de chaque indice ou vocabulaire. »

"I want to transform the viewer into a detective, generate a seeking spirit for a research, a curiosity for other stories unless it is one's own: to stress the importance of all kinds of narratives as self-languages, and the value of all clues or vocabularies."

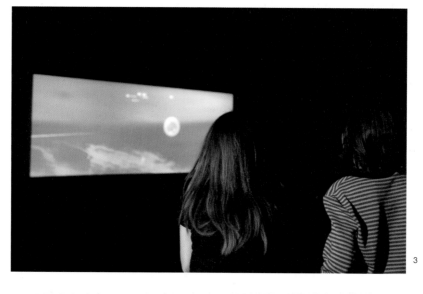

3

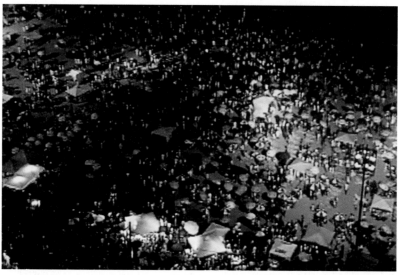

4

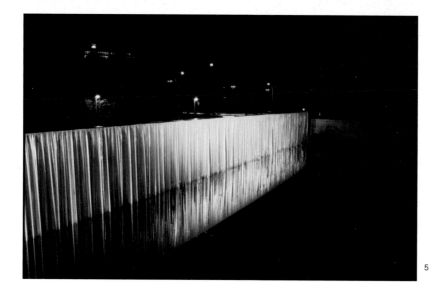

5

Douglas Gordon

1966 born in Glasgow, lives and works in Glasgow, UK, and New York (NY), USA

In *24 Hour Psycho* (1993), Douglas Gordon's best known work, he thwarted the linear narrative time-sequence we take for granted in cinema through the simple strategy of radically slowing down Hitchcock's notorious film. A constant, elastic present is created, where the past retreats reluctantly and the climax remains frustratingly far off. Whether isolating a scene and repeating it in an endless loop; splitting a film into three side-by-side projections, each running at a slightly different speed; or projecting two films simultaneously on opposing sides of one screen: Gordon teases the formal and narrative structures of the films he borrows. But his interest in film has just as much to do with its social function and entanglement with personal memory. He chooses films equipped with their own mythology ("Psycho", "Taxi Driver", "The Exorcist") to let loose a roll of associations: those of his audience are as important as his own. The film installation *Play Dead; Real Time* (2003), shows a shift of focus from time to scale: On two huge free-standing screens and a small adjacent monitor show we see an elephant lumbering around, lying down, rolling over and heaving herself back up onto her feet, all set in a vast, majestic prime white gallery. The unlikely combination of this huge creature in the chic exhibition space is an unexpectedly moving sight, whose meaning is open-ended and fluid: is this a metaphor for the struggles of the artist, or a sly reference to the role of scale in art (Richard Serra himself exhibited huge steel sculptures in this same space)?

In seiner bekanntesten Arbeit *24 Hour Psycho* (1993) durchkreuzt Douglas Gordon die für das Kino selbstverständliche linear-narrative Zeitabfolge mittels der einfachen Strategie einer radikalen Verlangsamung von Hitchcocks berühmtem Film. Es entsteht eine dehnbare Gegenwart, in der die Vergangenheit widerwillig zurückweicht und der Höhepunkt in frustrierender Ferne verharrt. Egal ob er eine Szene isoliert und sie in einer endlosen Schleife wiederholt, ob er einen Film in drei nebeneinander projizierte Teile aufspaltet, die in leicht unterschiedlicher Geschwindigkeit abgespielt werden, oder ob er zwei Filme gleichzeitig auf die beiden Seiten einer Leinwand projiziert: Gordon treibt seinen Spaß mit den formalen und narrativen Strukturen des von ihm entlehnten Films. Doch sein Interesse am Film hat auch mit dessen gesellschaftlicher Funktion und Verbindung zu persönlichen Erinnerungen zu tun. Er greift auf Filme mit einer eigenen Mythologie zurück („Psycho", „Taxi Driver", „Der Exorzist"), um eine ganze Reihe von Assoziationen auszulösen, wobei diejenigen des Publikums von ebenso großer Bedeutung sind wie seine eigenen. Seine Film-Installation *Play Dead; Real Time* (2003) zeigt eine Fokusverschiebung von der Zeit hin zum Maßstab: Auf zwei großen frei stehenden Leinwänden und einem kleinen benachbarten Monitor sieht man einen Elefanten umhertrampeln, sich niederlegen, herumwälzen und schließlich wieder auf die Füße kommen, all dies in einer hoheitsvollen, blütenweiß gestrichenen Galerie. Die ungewöhnliche Kombination dieses riesigen Geschöpfs mit dem schicken Ausstellungsraum bietet einen unerwartet rührenden Anblick, dessen Bedeutung offen und fließend ist: Handelt es sich hier um eine Metapher für die Mühen des Künstlers oder um einen schlauen Verweis auf die Bedeutung von physischer Größe in der Kunst (schließlich stellte Richard Serra im selben Raum seine großen Stahlskulpturen aus)?

Dans *24 Hour Psycho* (1993), l'œuvre la plus connue de Douglas Gordon, l'artiste contrecarrait la séquence narrative temporelle et linéaire, couramment considérée comme admise au cinéma, au moyen d'une stratégie très simple consistant à ralentir radicalement le célèbre film d'Hitchcock. Un présent continu et élastique est ainsi créé dont le passé ne se retire qu'à contrecœur, et le paroxysme reste confiné dans un frustrant éloignement. Qu'il isole une scène par sa mise en boucle incessante, qu'il éclate un film en trois projections juxtaposées – chacune se déroulant à une vitesse légèrement différente – ou qu'il projette deux films simultanément sur les faces opposées d'un même écran, Gordon malmène les structures formelles et narratives des films qu'il utilise. Reste que son intérêt pour le cinéma a tout autant à voir avec sa fonction sociale et son enracinement dans la mémoire personnelle. Gordon choisit des films chargés de leur propre mythologie (« Psychose », « Taxi Driver », « L'Exorciste ») pour libérer toute une série d'associations – celles du public étant tout aussi importantes que les siennes. L'installation cinématographique *Play Dead; Real Time* (2003) présente un déplacement d'accent du temps vers des préoccupations d'échelle : Sur deux immenses écrans portatifs et de petits moniteurs attenants, nous voyons un éléphant déambulant lourdement, s'allongeant, se roulant par terre ou se relevant sur ses pattes, le tout dans l'espace d'une vaste galerie à la blancheur majestueuse et immaculée. Contre toute attente, l'association inhabituelle entre l'énorme créature et le chic de l'espace d'exposition est une vision touchante dont la signification demeure ouverte et fluide : s'agit-il d'une métaphore des luttes de l'artiste ou d'une référence subtile au rôle de l'échelle dans l'art (Richard Serra a lui aussi exposé d'immenses sculptures en acier dans le même espace) ?

K. B.

SELECTED EXHIBITIONS →
2005 *Vanity of Allegory*, Deutsche Guggenheim, Berlin; *Bidibido-bidiboo*, Fondazione Sandretto Re Rebaudengo, Turin **2003** *Point of View: Anthology of the Moving Image*, New Museum of Contemporary Art, New York **2002/03** *What Have I Done*, Hayward Gallery, London **2001** The Museum of Contemporary Art, Los Angeles; Solomon R. Guggenheim Museum, New York; Hirshhorn Museum, Washington D.C.

SELECTED PUBLICATIONS →
2004 *Douglas Gordon*, Katrina M. Brown (ed.), London **2003** *Double-Cross: The Hollywood Films of Douglas Gordon*, Philip Monk (ed.), The Power Plant, Toronto **2001** *Douglas Gordon*, The Museum of Contemporary Art, Los Angeles

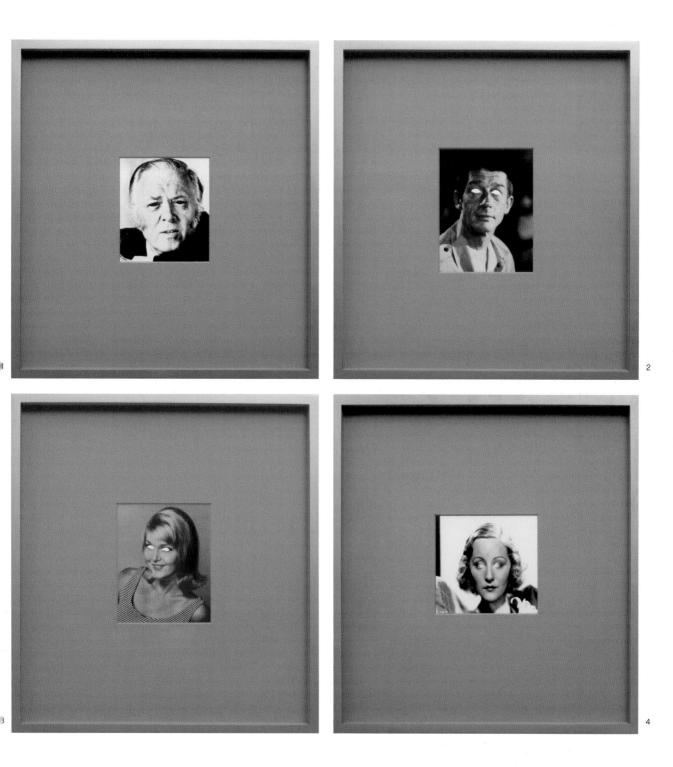

1 **Blind Richard Attenborough (Black Eyes)**, 2004, framed archival board and photograph, 65.5 x 61 x 6.3 cm
2 **Blind John Hurt (White Eyes)**, 2004, framed archival board and photograph, 65.5 x 61 x 6.3 cm
3 **Blind Carol Linley (White Eyes)**, 2004, framed archival board and photograph, 65.5 x 61 x 6.3 cm

4 **Blind Tallulah Bankhead (Silver Eyes)**, 2004, framed archival board and photograph, 65.5 x 61 x 6.3 cm
5 **Pretty much every video and film work from about 1992 until now. To be seen on monitors, some with sound, others run silently and all simultaneously**, 2002, installation view, Galerie Yvon Lambert, Paris
6 **Play Dead; Real Time**, 2003, installation view, Gagosian Gallery, New York

„Man weiß, dass es auf der anderen Seite der Filmleinwand etwas gibt, egal ob Fiktion oder Realität."

« Fiction ou réalité, vous savez qu'il y a quelque chose de l'autre côté de l'écran. »

"You know there's something on the other side of the screen, whether it's fiction or reality."

5

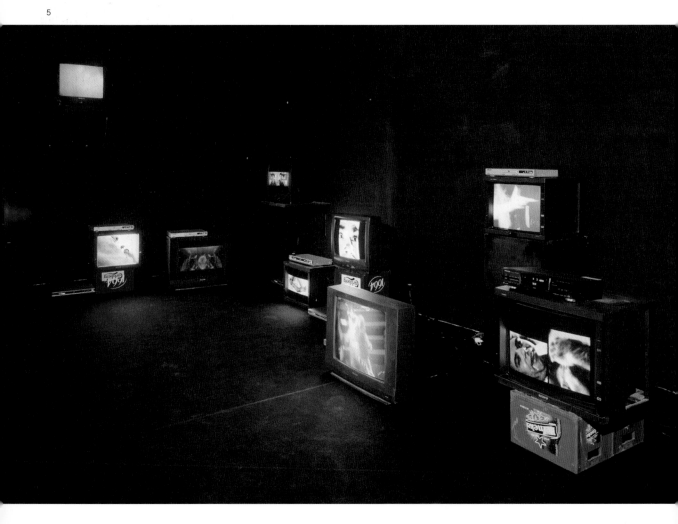

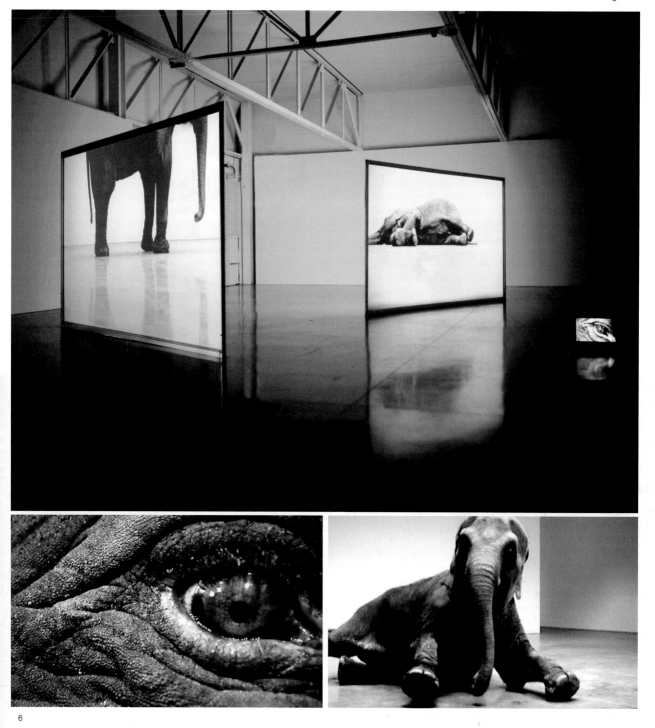

Mark Grotjahn

1968 born in Pasadena (CA), lives and works in Los Angeles (CA), USA

At first glance, Mark Grotjahn's work seems quite disparate. There are caricature-like depictions of anthropomorphic plants with grotesque blossom faces, such as *Angry Flower/Cactus* (2000). There are seemingly atavistic masks (*Mask*, 2004) and pictures of masks (*Face 2*, 2004). There are also abstract, colourful drawings done with crayons or ballpoint pens, like *Untitled/Double Butterfly* (2004), in which he presents a similar repertoire of forms to that used in his painting. A more conceptual body of work consists of notes written on matchbooks by casino visitors and found by Grotjahn, himself a passionate poker player, who compiled them in a notebook. Another body of work, *Sign Exchange* (1998), pertains to handmade restaurant signs that Grotjahn faithfully copied, traded with the owners for the original signs, and then showed as "acquired" ready-mades in exhibitions. It is not surprising that the artist is alternately associated with such diverse names as Duchamp and Warhol, or even Alfred Jensen and Stuart Davis. Since he began producing monochrome paintings in 1997 he has also been associated with op art and colourfield painting. Grotjahn, however, cannot be relegated to any "school". His colour-intensive panels (e.g. *Untitled/Orange Butterfly*, 2003) tend towards meditative formalism, and have a very unique character. The thickly applied paint gives them a crystalline brilliance and simultaneously a quality of being impenetrable and immediate, which makes the paintings seem like a veritable celebration of colour. Grotjahn celebrates a glowing minimalism here: splendid, opulent and on the brink of the mystical.

Die Arbeit von Mark Grotjahn erscheint auf Anhieb ziemlich divergent. Da gibt es karikaturhaft vermenschlichte Pflanzendarstellungen wie *Angry Flower/Cactus* (2000) mit grotesken Blütengesichtern, es gibt atavistisch anmutende Masken (*Mask*, 2004) beziehungsweise Maskenbilder (*Face 2*, 2004), außerdem abstrakte farbige Zeichnungen mit Wachskreide oder Kugelschreiber, etwa *Untitled/Double Butterfly* (2004), in denen er ein ähnliches Formenrepertoire durchspielt wie in seiner Malerei. Ein eher konzeptueller Werkkomplex besteht aus Notizen, die Grotjahn auf Streichholzschachteln von Kasinobesuchern fand (er ist leidenschaftlicher Pokerspieler), kopierte und in einem Notizbuch zusammenstellte. Eine andere Werkgruppe, *Sign Exchange* (1998), bezieht sich auf handgefertigte Beschilderungen von Restaurants, die Grotjahn originalgetreu abmalte, bei den Besitzern gegen die ursprünglichen Schilder eintauschte und diese als „akquirierte" Ready-mades in Ausstellungen zeigt. Es verwundert nicht, wenn der Künstler nacheinander mit so unterschiedlichen Namen wie Duchamp und Warhol, aber auch mit Alfred Jensen oder Stuart Davis in Verbindung gebracht wurde. Seit seiner ab 1997 entstehenden monochromen Malerei kommt noch die Zuordnung zu Op Art und Colourfield-Painting hinzu. Doch Grotjahn lässt sich wohl in keiner „Schule" unterbringen. Seine farbintensiven Tafeln (zum Beispiel *Untitled/Orange Butterfly*, 2003) gehorchen eher einem meditativen Formalismus und bleiben ganz bei sich. Der dichte Farbauftrag verleiht ihnen kristalline Brillanz und zugleich etwas Undurchdringliches, Gegenwärtiges, wodurch die Bilder Farbe regelrecht zu zelebrieren scheinen. Grotjahn feiert hier einen glühenden Minimalismus, prächtig, opulent und nahe am Mystischen.

Au premier abord, le travail de Mark Grotjahn semble passablement hétéroclite. On y trouve des représentations de plantes caricaturalement humanisées comme *Angry Flower/Cactus* (2000), avec des fleurs-visages grotesques, des masques (*Mask*, 2004) aux connotations ataviques ou des tableaux en forme de masques (*Face 2*, 2004), ainsi que des dessins de couleur abstraits réalisés au pastel ou au stylo à bille, par exemple *Untitled/Double Butterfly* (2004), dans lesquels Grotjahn décline tout un répertoire formel proche de sa peinture. Un groupe d'œuvres plutôt conceptuel est constitué de notes que l'artiste a trouvées sur des boîtes d'allumettes de joueurs de casino (lui-même est féru de poker), et qu'il a ensuite copiées et regroupées dans un carnet. Un autre groupe d'œuvres, *Sign Exchange* (1998), se réfère à des enseignes de restaurants peintes à la main dont Grotjahn a réalisé des copies fidèles qu'il a échangées contre les originaux avant d'exposer ces derniers dans des expositions sous forme de ready-mades « acquis ». L'on n'est donc pas surpris que Grotjahn ait été rapproché de noms d'artistes aussi différents que Duchamp et Warhol, mais aussi d'Alfred Jensen ou de Stuart Davis. Depuis les peintures monochromes qu'il réalise à partir de 1997, il faut encore y ajouter ses accointances avec l'Op Art et la Colourfield Painting. Mais Grotjahn ne saurait être classé dans une « école » particulière. Ses peintures de panneau d'une grande intensité chromatique (p. ex. *Untitled/Orange Butterfly*, 2003) relèvent plutôt d'un formalisme méditatif et ont leur personnalité propre. Leur facture épaisse leur confère une brillance cristalline et en même temps quelque chose d'impénétrable, une présence qui transforme manifestement ces tableaux en une célébration de la couleur. Grotjahn célèbre ici un minimalisme ardent, somptuaire, opulent et proche du mysticisme.

J. A.

SELECTED EXHIBITIONS →
2005 *The Altoids Curiously Strong Collection*, Center of Contemporary Art, Seattle **2004** *54. Carnegie International*, Carnegie Museum of Art, Pittsburgh **2002** *Play As It Lays*, London Institute Gallery, London **2001** *Sharing Sunsets*, The Museum of Contemporary Art, Los Angeles; *Superman in Bed. Kunst der Gegenwart und Fotografie. Sammlung Schürmann*, Museum am Ostwall, Dortmund **2000** *Young and Dumb*, Acme, Los Angeles **1999** *After the Gold Rush*, Thread Waxing Space, New York

SELECTED PUBLICATIONS →
2004 *54. Carnegie International*, Carnegie Museum of Art, Pittsburgh

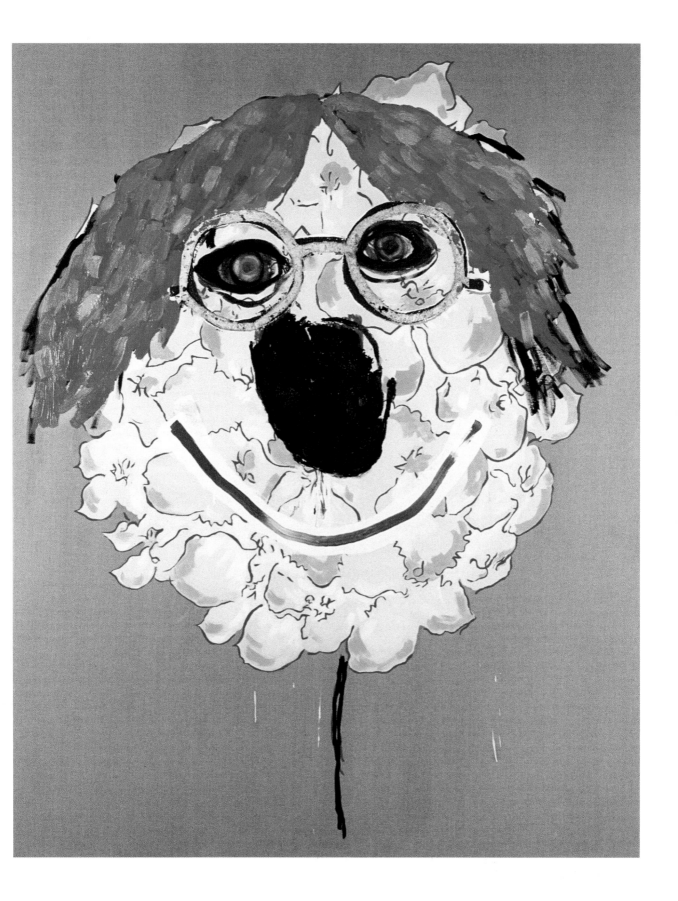

1 **Flower with Glasses**, 2000, oil paint on paper, 27.9 x 21.6 cm
2 **Untitled (Color Butterfly White Background 6 Wings Large)**, 2004, crayon, mixed media on cardboard, 169.5 x 119.4 cm
3 **Tequila Sunrise**, 2003, oil on linen, 152.4 x 127 cm

4 **Untitled (Green Butterfly Yellow MG)**, 2003, oil on linen, 185.4 x 124.5 cm
5 **Untitled (Black Butterfly MG)**, 2004, pastel on paper, 55.9 x 45.7 cm
6 **Untitled (Yellow Butterfly Orange Mark Grotjahn 2004)**, 2004, oil on linen, 152.4 x 127 cm

„Ich wollte eine bestimmte Art der Abstraktion entwickeln, so wie eine feste grafische Form, an die ich mich halten könnte, um herauszufinden, wie weit sie sich innerhalb dieses Systems treiben ließe. Ich habe eine ganze Menge Abstraktionen ausprobiert, aber diese Form fand ich am interessantesten, so dass ich versuchte, sie weiter zu entwickeln."

« Je voulais trouver une abstraction sûre, comme une forme graphique à laquelle je pourrais rester fidèle, et voir jusqu'où je pourrais pousser le système. J'ai pratiqué toutes sortes d'abstractions différentes, et c'est celle-ci qui m'a semblé la plus intéressante et que j'ai tenté de dévelop per au maximum. »

"I wanted to come up with some certain abstraction, like a certain graphic form that I could stick with and see how far within that system I could push it. I did a whole bunch of different abstractions and this is the one that for me just felt the most interesting and is the one I tried to push."

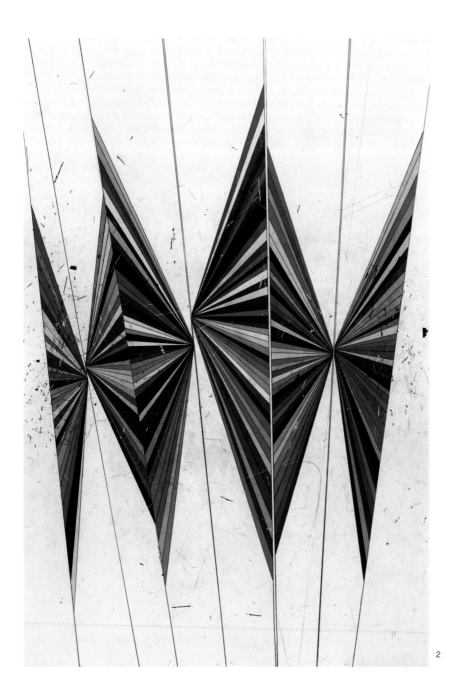

2

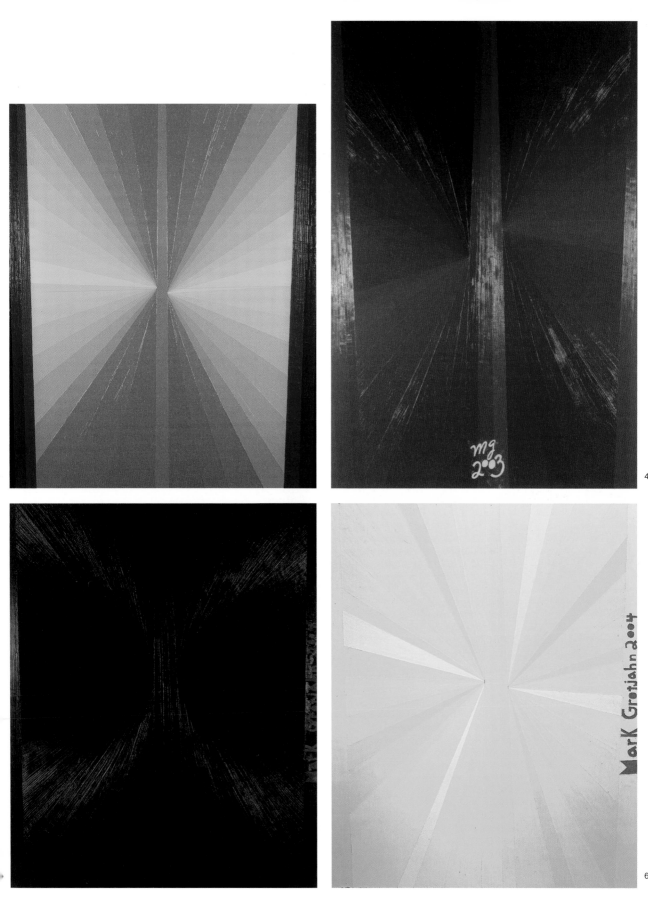

Andreas Gursky

1955 born in Leipzig, lives and works in Düsseldorf, Germany

One of most important photo artists of our time, Andreas Gursky ranks as an aloof chronicler of modern venues. In fascinating photographs he captures representative scenes of contemporary life: depicting the relationship between people and space has interested him right from the beginning. Gursky has been working concurrently on the most diverse subjects to create his large-format colour photographs of building façades, interior spaces, masses of people, etc. Unlike his teachers Bernd and Hilla Becher, Gursky does not work strictly in series, although many photographs can be organized into groups by motif. For about ten years the artist has made very deliberate use of digital image editing techniques – but not like Jeff Wall, for example, to freely invent his motifs, but simply to strengthen the intended visual effect. Many of Gursky's pictures achieve their tension and astounding impact from the simultaneous visibility of each motif's structure as well as its details. This can be seen with particular clarity in his architectural photographs such as *Paris, Montparnasse* (1993) which shows almost the complete grid-like, horizontally extended façade of a large building, yet still allows voyeuristic views into every uncurtained window. After having thoroughly preoccupied himself with the luxurious outgrowths of consumer society, Gursky set his sights in newer works on the darker side of globalisation, approaching this theme in his customarily aloof manner. The gulf between poverty and riches, between staged emptiness and overflowing abundance within an increasingly homogeneous world culture, can hardly be more fittingly symbolized than in the juxtaposition of the photographs *Prada II* (1997) and *Untitled XIII (Mexico)* (2003).

Unter den bedeutenden Fotografiekünstlern unserer Zeit nimmt Andreas Gursky den Rang eines distanzierten Chronisten moderner Schauplätze ein. In faszinierenden Aufnahmen bannt er exemplarische Orte des zeitgenössischen Lebens auf die Bildfläche, wobei ihn von Beginn an die Darstellung des Verhältnisses von Mensch und Raum interessiert hat. Großformatige Farbfotografien von Architekturfassaden, Innenräumen, Menschenmassen etc. entstehen jeweils parallel zueinander. Anders als seine Lehrer Bernd und Hilla Becher arbeitet Gursky nicht strikt seriell, wenngleich sich zahlreiche Aufnahmen motivisch in Gruppen gliedern lassen. Seit etwa zehn Jahren nutzt der Künstler ganz bewusst die Möglichkeiten der digitalen Bildbearbeitung – allerdings nicht um, wie beispielsweise Jeff Wall, seine Motive vollkommen frei zu erfinden, sondern lediglich um intendierte Bildwirkungen zu verstärken. Die Spannung und verblüffende Wirkung vieler Bilder Gurskys beruht auf der gleichzeitigen Sichtbarmachung von Struktur und Detail des Motivs. Dies zeigt sich besonders deutlich in den Architekturaufnahmen wie *Paris, Montparnasse* (1993), das die lang gezogene Rasterfassade eines großen Baukörpers fast in Gänze zeigt und dennoch voyeuristische Einblicke in jedes unverhängte Fenster ermöglicht. Nachdem sich Gursky ausgiebig mit den luxuriösen Auswüchsen der Konsumgesellschaft auseinander gesetzt hat, nimmt er in seinen neueren Arbeiten auch die Schattenseiten der Globalisierung in gewohnt distanzierter Weise ins Visier. Die Kluft zwischen Arm und Reich, inszenierter Leere und überbordender Fülle innerhalb einer zunehmend vereinheitlichten Weltkultur ließe sich kaum treffender versinnbildlichen als in der Gegenüberstellung der Aufnahmen *Prada II* (1997) und *Untitled XIII (Mexico)* (2003).

Parmi les grands artistes photographes de notre époque, Andreas Gursky occupe une place de chroniqueur distant des sites de la modernité. Dans ses photographies fascinantes, il sait comprimer des lieux exemplaires de la vie contemporaine tout en s'attachant depuis toujours à représenter le rapport entre l'homme et l'espace. S'il réalise ses photographies en couleurs de façades d'architectures, d'espaces intérieurs, de masses humaines etc. en parallèle, on ne peut dire qu'il travaille de manière sérielle – contrairement à ses professeurs Bernd et Hilla Becher – même si nombre de ses œuvres peuvent être classées en groupes. Depuis une dizaine d'années, l'artiste met sciemment à profit les possibilités offertes par le traitement numérique de l'image, non pas pour inventer ses motifs en toute liberté comme le fait un Jeff Wall, mais seulement pour souligner les effets visuels qu'il recherche. La tension et l'effet très frappant de nombreuses photographies de Gursky reposent sur la visualisation simultanée de la structure et du détail des différents motifs. Ceci est particulièrement manifeste dans une photo d'architecture comme *Paris, Montparnasse* (1993), qui nous montre dans presque toute sa hauteur la façade tramée d'un corps architectural, tout en nous donnant des aperçus voyeuristes dans chaque fenêtre non voilée. Après s'être abondamment penché sur la débauche de luxe de la société de consommation, Gursky se concentre aujourd'hui sur les faces cachées de la mondialisation, toujours avec le même point de vue distant. Le fossé entre la pauvreté et la richesse, la mise en regard du dénuement et de la surabondance au sein d'une culture mondiale de plus en plus globalisée ne sauraient guère être symbolisés de manière plus frappante que par la confrontation entre les photographies *Prada II* (1997) et *Untitled XIII (Mexico)* (2003).

D. M.

SELECTED EXHIBITIONS →
2004 *The Explosive Photography*, Nassau County Museum of Art, Roslyn Harbor; *The Human Condition. The Dream of a Shadow*, Forum Universal de las Culturas Barcelona **2003** *Cruel + Tender*, Tate Modern, London; *Made in Mexico*, Institute of Contemporary Art, Boston **2001** The Museum of Modern Art, New York **1998** *Fotografien 1994–1998*, Kunstmuseum Wolfsburg; *Photographs from 1984 to the Present*, Kunsthalle Düsseldorf

SELECTED PUBLICATIONS →
2002 *Andreas Gursky*, Centre Pompidou, Paris **2001** *Andreas Gursky*, The Museum of Modern Art, New York **1998** *Andreas Gursky: Fotografien 1994–1998*, Kunstmuseum Wolfsburg, Ostfildern-Ruit; *Andreas Gursky, Photographs from 1984 to the Present*, Kunsthalle Düsseldorf

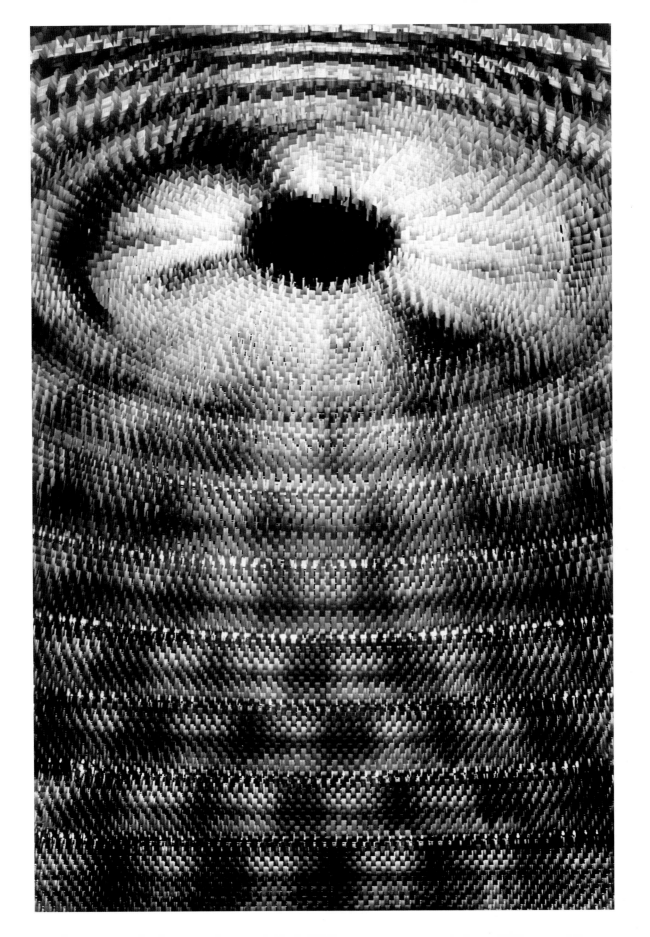

1 **PCF**, 2004, colour print, 293.5 x 207 cm
2 Exhibition view, Monika Sprüth Galerie, Cologne, 2004
3 **Nha Trang**, 2004, colour print, 295.5 x 207 cm

„In der Tat ist mein Zugriff auf die Welt phänomenologischer Natur. Ich bin an dem äußeren Erscheinungsbild der Welt interessiert, an ihrer haptischen Oberfläche, und behalte eine genaue Schilderung der Welt im Auge."

«Mon approche du monde est effectivement de nature phénoménologique. Je m'intéresse à l'aspect extérieur du monde, à sa surface tactile, et je garde à l'esprit une description exacte du monde.»

"In fact, my grasp of the world is phenomenological in nature. I am interested in the world's external appearance, in its tactile surface, and I keep an exact portrayal of the world in mind."

Jeppe Hein

1974 born in Copenhagen, Denmark, lives and works in Berlin, Germany

Upon entering the exhibition room a large steel sphere lying on the ground sets itself into motion. Slowly it rolls away in the opposite direction, so that the changing environment is smoothly reflected on its polished surface. Drawn by the object's activity the visitors follow it, to soon understand the chain of reactions. The ball reacts to movement with the help of sensors that steer it. Its mobility is consequently dependent on the movement of the person facing it. This is less concerned with interactivity as it is with loosening up institutional structures, and making visible the freedoms gained thereby. As with many of Jeppe Hein's works, *The Big Mirror Ball* (2003) also plays with particular expectations about architecture and the business of exhibitions, and about the corresponding behavioural patterns of viewers within this system. Formally, the artist always uses basic geometrical forms such as cubes or spheres. In regard to his materials (i. e. steel in *360° Presence*, 2002, or neon light in *Moving Neon Cube*, 2004), and to finishing his works into products that seem industrially produced, he also refers to the Minimal Art of the 1960s. Whether in refashioning a room minimally but effectively by, for example, adding a moving wall (*Invisible Moving Wall*, 2002) or bench (*Moving Bench*, 2000), or by placing a single object in an empty room, Hein's discreet interventions ensure surprises. The kinetic effects give the abstract objects a playful lightness. With the displacement of perspective comes a change in perception – both of the architecture as well as of the institution or public space – thereby proving that the artist predetermines everything only to a certain point.

Beim Betreten des Ausstellungsraumes setzt sich eine große, auf dem Boden liegende Stahlkugel in Bewegung. Langsam rollt sie in entgegengesetzter Richtung weg, so dass sich die verändernde Umgebung fließend auf ihrer polierten Oberfläche spiegelt. Durch die Aktivität des Objektes angezogen folgen ihr die Besucher, um bald die Kette der Reaktionen zu begreifen. Die Kugel reagiert mithilfe eines Sensors auf Bewegungen, die sie steuern. Ihre Mobilität ist folglich abhängig von der ihres Gegenübers. Dabei geht es weniger um Interaktivität als darum, institutionelle Strukturen aufzulockern und die dadurch gewonnenen Spielräume sichtbar zu machen. Wie viele Arbeiten von Jeppe Hein spielt auch *The Big Mirror Ball* (2003) mit bestimmten Erwartungen an die Architektur und den Ausstellungsbetrieb sowie den entsprechenden Verhaltensmustern der Betrachtenden innerhalb dieses Systems. Formal hält sich der Künstler dabei stets an geometrische Grundformen wie Würfel oder Kugel. Auch in Bezug auf das Material (zum Beispiel Stahl bei *360° Presence*, 2002, oder Neonlicht bei *Moving Neon Cube*, 2004) und die Ausarbeitung zu einem vermeintlich industriellen Produkt bezieht er sich auf die Minimal Art der sechziger Jahre. Ob er nun einen Raum auf minimale, aber wirkungsvolle Art umgestaltet, indem er beispielsweise eine sich bewegende Wand (*Invisible Moving Wall*, 2002) oder eine Sitzbank (*Moving Bench*, 2000) hinzufügt oder einen einzelnen Gegenstand im leeren Raum platziert: Heins diskrete Eingriffe sorgen für Überraschungen. Durch den kinetischen Effekt erhalten die abstrakten Objekte eine verspielte Leichtigkeit. Mit Verlagerung der Perspektive ändert sich die Wahrnehmung – sowohl der Architektur als auch der Institution oder des öffentlichen Raumes – und beweist somit, dass alles vom Künstler nur bis zu einem bestimmten Punkt vorgegeben ist.

Au moment où le spectateur entre dans la salle d'exposition, une grande boule d'acier posée au sol se met en mouvement, roule doucement en sens opposé, de sorte que les changements de l'environnement se réfléchissent de manière fluide sur sa surface polie. Attiré par son activité, le spectateur la suit et ne tarde pas à en comprendre le mécanisme. Par le truchement d'un détecteur de mouvement, la boule réagit aux déplacements qui la guident, et sa mobilité est donc fonction de son vis-à-vis. En l'occurrence, le propos vise moins l'interactivité que l'assouplissement des structures institutionnelles et la visualisation des possibilités qui en découlent. Comme beaucoup d'œuvres de Jeppe Hein, *The Big Mirror Ball* (2003) joue sur certaines attentes posées à l'architecture et au fonctionnement des expositions, mais aussi sur les schémas comportementaux du spectateur au sein de ce système. Sur le plan formel, l'artiste s'en tient pour cela toujours à des formes géométriques fondamentales comme le cube ou la sphère. Concernant le matériau (p. ex. l'acier dans *360° Presence*, 2002, le néon dans *Moving Neon Cube*, 2004) et l'élaboration d'un produit soi-disant industriel, il se réfère au minimalisme des années soixante. Que Hein transforme une salle par une intervention minimale, mais non moins efficiente, en y ajoutant par exemple une cloison mobile (*Invisible Moving Wall*, 2002) ou un banc (*Moving Bench*, 2000), ou qu'il place un objet isolé dans la salle vide, ses interventions discrètes ménagent des surprises. Leur effet cinétique confère aux objets abstraits une légèreté ludique, le déplacement de la perspective agit sur la perception de l'architecture comme de l'institution ou de l'espace public, démontrant ainsi que toutes choses ne sont posées par l'artiste que jusqu'à un certain point.

C. E.

SELECTED EXHIBITIONS →
2005 The Museum of Contemporary Art, Los Angeles
2004 *Anziehung/Abstoßung*, Galerie für Zeitgenössische Kunst, Leipzig; *Flying Cube*, P.S.1, New York; *Moving Parts*, Kunsthaus Graz, Museum Tinguely, Basle **2003** *Take a Walk in the Forest at Sunlight*, Kunstverein Heilbronn; *Utopia Station*, 50. Biennale di Venezia, Venice **2002** *Take a Walk in the Forest at Moonlight*, capcMusée d'art contemporain, Bordeaux; *I Promise it's Political*, Museum Ludwig, Cologne **2001** *Neue Welt*, Frankfurter Kunstverein

SELECTED PUBLICATIONS →
2004 *Performative Installation*, Siemens Arts Program **2003** *Jeppe Hein. Take a Walk in the Forest at Sunlight*, Kunstverein Heilbronn **2001** *Neue Welt*, Frankfurter Kunstverein, Frankfurt/Main

1 **Discovering Your Own Wall**, 2001, water, gravels, grating, pumps, iron, sensors, dimensions variable, installation view, Kokerei Zollverein, Essen
2 **360° Presence**, 2002, steel, motor, sensor, Ø 70 cm, installation views, Johann König, Berlin
3 **Space in Action/Action in Space**, 2002, water, wood, pumps, iron, sensors, 500 x 500 x 350 cm, installation view, 50. Bienniale di Venezia, Venice 2003
4 **Distance**, 2004, metal, motor, PVC balls, sensors, 400 m length, all other dimensions variable, installation view, Ludwig Forum für Internationale Kunst, Aachen

„Ich versuche zu zeigen, dass das Werk nicht aus sich selbst heraus besteht, sondern aus dem, was der Betrachter in das Werk hineinlegt."

« Je veux montrer que l'œuvre n'est pas un fait autonome, mais seulement l'information que le public y investit. »

"I want to show that the work isn't anything on its own, it's only what the public informs it with."

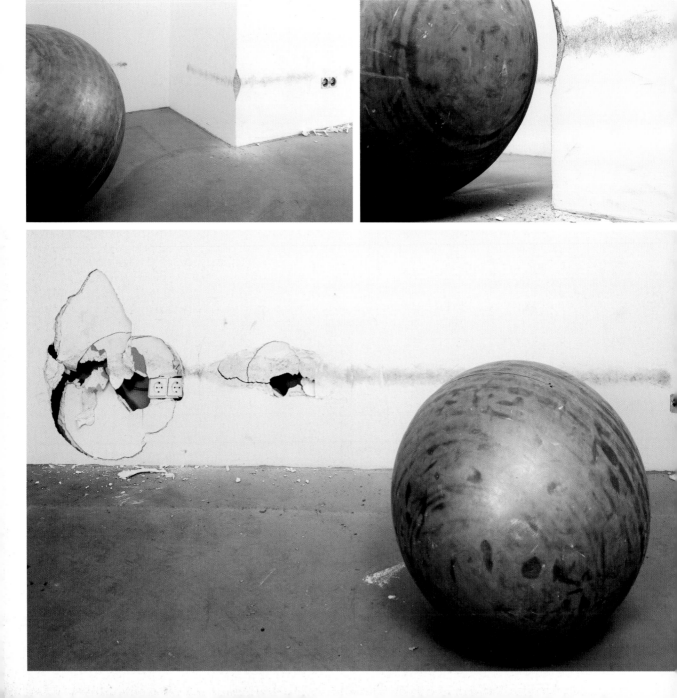

3

4

Jonathan Hernández

1972 born in Mexico City, lives and works in Mexico City, Mexico

Jonathan Hernández is an exemplary tourist. In photo series, installations, videos, and actions he examines travelling as a mass phenomenon forged by the tourism industry. Thereby he also focuses on this industry's links with the art system: museums founded today are set up to be tourist spectacles; artists travel worldwide, disseminating their trademarks throughout the global village. Hernández sees this from the point of view of a visual taxonomist. *Travelling Without Moving* (1998–2003), for example, is a type of photo album, which he implements as a touristic metadiscourse. Over the years he has documented the experiences of mass-produced travel, showing himself and others in the well-known transitional areas of waiting rooms and airports, as well as at those destinations which, touristically mythologized, await travellers with all the exoticism of catalogue-influenced desires. This is precisely the reason that Hernández chose this form, and of all places he exhibited his travel photos, inevitably clichés incarnate, at the Mexico City airport. Another exhibition, "Bon Voyage", took place in the Spanish town of Málaga – *the* tourist gateway to the Costa del Sol. Here, in addition to similar work intended to reverse-translate prefabricated travel experiences (*Marruecos No*, 2002/03) he also showed a work with local relevance, in which he revealed the interconnections between tourism, economics, and art. *Cocha-Bomba* (2003) consisted of a provisional circle of yellow-painted wooden panels, within which he presented a red Citroën Xsara Picasso. Hernández ironically added Spain's national colours to the picture here, in a metropolis that lures tourists with a new Picasso museum, while the name of that famous son of the city adorns the Spaniards' most popular family car.

Jonathan Hernández ist ein exemplarischer Tourist. Mit Fotoserien, Installationen, Videos und Aktionen macht er das Massenphänomen eines von der Tourismusindustrie geprägten Reisens zum Thema. Dabei geraten auch Verflechtungen mit dem Kunstsystem in den Blick: Museumsgründungen sind heute als touristische Spektakel angelegt; Künstler, weltweit unterwegs, verbreiten ihre Trademarks im globalen Dorf. Hernández sieht das als visueller Systematiker. *Travelling Without Moving* (1998–2003) zum Beispiel ist eine Art Fotoalbum, das er wie einen touristischen Metadiskurs praktiziert. Er dokumentierte über Jahre konfektioniertes Unterwegssein, zeigt sich selbst und andere in notorischen Übergangsräumen der Wartehallen und Flughäfen sowie an Zielorten, die, touristisch mythologisiert, mit der Exotik kataloggeprägter Sehnsüchte aufwarten. Hernández hat daher gerade diese Form gewählt, und seine Reisebilder, unweigerlich geronnene Klischees, stellte er ausgerechnet am Flughafen von Mexico City aus. In der Ausstellung „Bon Voyage" im spanischen Málaga – *dem* touristischen Einfallstor zur Costa del Sol – zeigte er neben ähnlichen Arbeiten zur Rückübersetzung vorgefertigter Reiseerfahrung (*Marruecos No*, 2002/03) auch ein Werk mit lokalem Bezug, in dem er die Verflechtung von Tourismus, Wirtschaft und Kunst dekuvriert: *Cocha-Bomba* (2003) besteht aus einem provisorischen Rund gelbgestrichener Holzpaneele, in dem ein roter Citroën Xsara Picasso präsentiert wird. Ironisch setzt Hernández hier die spanischen Nationalfarben ins Bild, in einer Metropole, die mit einem neuen Picasso-Museum Touristen lockt, während der Name des berühmten Sohns der Stadt das beliebteste Familienauto der Spanier ziert.

Jonathan Hernández est un touriste exemplaire : ses séries photographiques, ses installations, vidéos et actions portent sur le phénomène de masse de voyages modelés par l'industrie du tourisme. En même temps, son travail aborde les multiples correspondances que ce système entretient avec celui de l'art : la fondation de nouveaux musées est aujourd'hui organisée comme une attraction touristique, et les artistes qui parcourent le monde répandent leurs marques déposées dans le village global. Hernández soumet tout ceci au regard du systématicien. *Travelling Without Moving* (1998–2003) est une sorte d'album photo fonctionnant comme un métalangage touristique. L'artiste y a documenté un mode de voyage élaboré au fil des années : il se montre lui-même et d'autres personnes dans les espaces transitoires célèbres des salles d'attente et des aéroports et sur des lieux de destination mythifiés par le tourisme, où s'étale l'exotisme des désirs de catalogue. C'est précisément ce qui a fait choisir cette forme à Hernández, et ce n'est pas un hasard si l'artiste a exposé les clichés inéluctablement figés de ses photos de voyage dans l'aéroport de Mexico. A côté d'autres œuvres tournant autour de la retraduction d'expériences de voyage préfabriquées (*Marruecos No*, 2002/03), Hernández a aussi montré dans l'exposition « Bon Voyage » présentée à Málaga – *le* portail par excellence de l'invasion touristique de la Costa del Sol – une œuvre à connotation régionale, dans laquelle il met en lumière les liens entre le tourisme, l'économie et l'art : *Cocha-Bomba* (2003) est constitué d'une palissade éphémère circulaire en bois peint en jaune, dans laquelle est exposée une Citroën Xsara Picasso rouge. Hernández y met ironiquement en scène les couleurs nationales espagnoles dans une métropole qui attire les touristes avec un nouveau Musée Picasso, tandis que le nom du plus illustre fils de la ville orne la voiture familiale préférée des Espagnols. J. A.

SELECTED EXHIBITIONS →
2005 *Juego Doble*, Centro Cultural de España en Mexico, Mexico City; *Universal Experience: Art, Life, and the Tourist's Eye*, Museum of Contemporary Art, Chicago; *Farsites: Urban Crisis and Domestic Symptoms in Recent Contemporary Art*, San Diego Museum of Art, Centro Cultural Tijuana **2004** *Music/Video*, The Bronx Museum of the Arts, New York **2003** *Bon Voyage*, Centro de Arte Contemporáneo de Málaga **2002** *Travelling Without Moving*, Mexico City International Airport; *Everything Is O.K.*, Project Room, ARCO, Madrid; *An Exhibition About the Exchange Rates of Bodies and Values*, P.S.1, New York, KW Institute for Contemporary Art, Berlin **2000** *Arte de América*, *F(r)icciones*, Museo Nacional Centro de Arte Reina Sofía, Madrid

SELECTED PUBLICATIONS →
2005 *Vulnerabilia*, La Caja Negra, Madrid **2003** *Bon Voyage*, Centro de Arte Contemporáneo de Málaga; *You Are Under Arrest*, La Caja Negra, Madrid **2002** *Se Busca Recompensa*, Stedelijk Museum voor Actuele Kunst, Ghent

1 **rongwrong**, 2004/05, collage, 149 x 99 cm
2 **Everything Is OK**, 2002, mirror, acrylic, red carpet, dimensions variable

3 **Bon voyage**, 2003, wooden pylon, dimensions variable

„Im Raum zwischen zwei Arbeiten liegt das Wesen des Gesamtwerks. Normalerweise sind das Wichtige zwischen zwei oder mehreren Inseln die imaginären Brücken, die sie verbinden."

«Dans l'espace entre une pièce et une autre repose l'essence de l'œuvre. Généralement, ce qu'il y a de plus important entre deux ou plusieurs îles, ce sont les ponts imaginaires qui les relient.»

"In the space between one piece and another lies the essence of the body of work. Usually what is important between two or many more islands are the imaginary bridges that link them."

2

José Antonio Hernández-Díez

1964 born in Caracas, lives and works in Barcelona, Spain, and Caracas, Venezuela

In the last decade, José Antonio Hernández-Díez has become one of the most important artists of South America's young generation. His photo and video work, sculptures and multimedia installations principally deal with the relationship between consumer society and globalization. He invents bizarre versions of everything that Venezuela's Americanized young generation dreams of, such as skateboards, plastic toys, sneakers, video games, and fast food. As a comment on the paradoxes of globalization, he transforms these into poetic and often ironic works that are grounded in the local culture. Hernández-Díez has developed a distinctive pictorial language for his graphic and striking criticism of the links between culture and economics. Hernández-Díez creates contemporary icons that reflect thought and identity in the age of globalised consumer societies. His photo works showing stacks of Nike sneakers are an example of this. This brand of shoe, produced cheaply in third world countries, is a ubiquitous part of global culture today. Hernández-Díez uses such shoes to signify the interrelation between style and economy, when he smugly crosses them with the names of some great minds from "old Europe". For example the images (2000–2003) may be named *Kant* or *Hegel*, *Marx* or *Hume* – names that the artist spells out from the logos applied to the shoes, simply by arranging the piles so that the letters form words. In an ironic comparison, Hernández-Díez raises the question of whether social cohabitation defines itself today through common ideas and values, or whether it is based on labels and worldwide McDonaldisation instead.

José Antonio Hernández-Díez ist im vergangenen Jahrzehnt zu einem der wichtigsten Künstler der jungen Generation in Südamerika geworden. Seine Foto- und Videoarbeiten, Skulpturen sowie Multimedia-Installationen thematisieren das Verhältnis von Konsumgesellschaft und Globalisierung. Er erfindet bizarre Versionen von all dem, wovon die amerikanisierte junge Generation Venezuelas träumt: Skateboards, Plastikspielzeug, Sneaker, Videospiele, Fastfood – und transformiert dies in poetische, oft auch ironische Werke, die in lokaler Kultur gründen, um von dort aus Paradoxien der Globalisierung zu kommentieren. Hernández-Díez hat für seine bildhaft-eindrückliche Kritik an kulturellen und ökonomischen Verflechtungen eine charakteristische Bildsprache entwickelt. Hernández-Díez errichtet zeitgenössische Ikonen, die Denken und Identität im Zeitalter globalisierter Konsumgesellschaften reflektieren. Ein Beispiel dafür sind Fotoarbeiten, die übereinander gestapelte Nike-Sneaker zeigen. Schuhe dieses Labels, in Drittweltländern billig produziert, sind heute allgegenwärtiger Teil von Globalkultur. Hernández-Díez nutzt sie als signifikante Schnittstelle von Stil und Ökonomie, wenn er sie fürs Foto süffisant mit den Namen einiger Geistesgrößen aus dem „alten Europa" kreuzt: Solche Bilder (2000–2003) heißen dann zum Beispiel *Kant* oder *Hegel*, *Marx* oder *Hume* – Namen, die der Künstler anhand der auf den Schuhen angebrachten Logos und schlicht durchs buchstabierende Stapeln zusammengefügt hat. Im ironischen Abgleich wirft Hernández-Díez die Frage auf, ob sich gesellschaftliches Zusammenleben heute durch gemeinsame Ideen und Werte definiert oder eher auf Labels und weltweiter McDonaldisierung beruht.

Au cours de la dernière décennie, José Antonio Hernández-Díez est devenu un des artistes majeurs de la jeune génération latino-américaine. Ses œuvres photographiques, ses vidéos, sculptures et installations multimédia mettent en évidence le rapport entre la société de consommation et la globalisation. Hernández-Díez invente des versions bizarres de tout ce qui nourrit les rêves de la jeunesse vénézuélienne américanisée – skate-boards, jouets en plastique, sneakers, jeux vidéo, fast-foods – et transforme tout cela en œuvres poétiques souvent empreintes d'ironie et enracinées dans la culture locale, pour commenter les paradoxes de la globalisation à partir de ce point de vue. Pour sa frappante critique imagée des interconnexions culturelles et économiques, Hernández-Díez a développé un langage visuel tout à fait personnel. Hernández-Díez élabore des icônes contemporaines qui reflètent la pensée et l'identité à l'ère des sociétés de consommation globalisées. Un exemple en sont ses œuvres photographiques qui présentent des baskets Nike empilés les uns sur les autres. Fabriqués à bas coût dans les pays du tiers-monde, les baskets de cette marque sont aujourd'hui un élément omniprésent de la culture globale. Hernández-Díez s'en sert comme d'interfaces significatives entre le style et l'économie quand il les associe de manière suffisante aux noms de quelques pointures culturelles de la « vieille Europe » : ces photos (2000–2003) ont pour titre *Kant* ou *Hegel*, *Marx* ou *Hume*, dont les noms sont composés à partir des logos appliqués sur les chaussures et grâce à leur mode d'empilement. A travers ses détournements ironiques, Hernández-Díez soulève la question de savoir si la coexistence sociale se définit aujourd'hui sur la base d'idées et de valeurs communes, ou si elle ne repose pas plutôt sur les marques et la McDonaldisation croissante du monde.

J. A.

1 **JUNG**, 2000, C-print, 210 x 160 cm
2 **Indy**, 1995, wood, tables, videos, skate wheels, television sets, 4 pieces, each 145 x 70 x 46 cm
3 **Cuidados 1**, 2004, giclee print on cotton paper, 110 x 185 cm

4 **Cuidados 6**, 2004, giclee print on cotton paper, 140 x 110 cm
5 **Gulliver**, 2004, wood, aluminium, rubber, 62 x 216 x 205 cm, installation view, Galeria Fortes Vilaça, São Paulo

„Ich möchte Bedeutungen nicht überschreiten. Ich möchte sie nur aufzeigen. Sie offensichtlich machen, als trüge man ein T-Shirt falschherum, so dass man die Pflegehinhweise lesen kann."

«Je n'ai pas l'intention de transgresser les significations. Juste de les révéler. De les rendre évidentes, comme les instructions de lavage d'un t-shirt, que l'on découvre lorsqu'on le retourne.»

"I don't want to transgress meanings. Just reveal them. Just make them evident, like the washing instructions of a t-shirt which you can see when you turn it inside out."

2

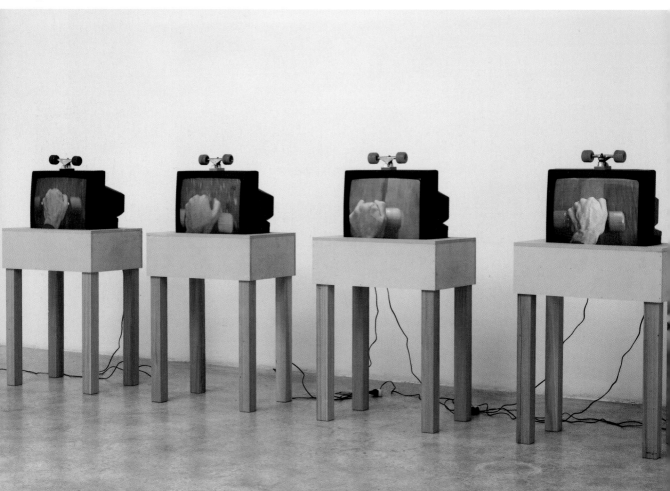

3

4

5

Thomas Hirschhorn

1957 born in Bern, Switzerland, lives and works in Paris, France

Thomas Hirschhorn's artworks hover between categories: sculpture and architecture, art and non-art, inside and outside; for the past decade he has combined deliberately ramshackle materials (cardboard, packing tape, aluminium foil, nylon, and wood scraps) with a delicately calibrated non-stance toward the political material and consumer goods included in his "displays". Everything is painstakingly handmade, so that the radical juxtapositions between dissimilar objects – photocopies of texts from Arendt to Zizek, oversized tinfoil-and-cardboard Rolex watches and Mercedes hood ornaments, pictures and statistics of worldwide atrocities clipped from magazines – are laid out on a level playing field: Hirschhorn's indiscriminate associations mimic the slide of object value into the more nebulous realm of sign-exchange. Yet his non-ideological, intentionally simplistic approach also places responsibility on the viewer to become active participants and to ascribe value where there is none. Recently Hirschhorn has leveraged his name recognition into opportunities to place his monuments, altars, kiosks, and pavilions in public spaces: at documenta 11 in Kassel, he built a monument to Georges Bataille in a low-income immigrant neighbourhood; he erected a *Musée Précaire Albinet*, replete with treasures from the Centre Pompidou, in the suburbs of Paris; he presented a kiosk devoted to Robert Walser and an altar to Raymond Carver in public spaces in Zurich; and he constructed a monument to Spinoza in Amsterdam. All were attempts to encourage collective perception, the first step toward autonomy, to which Hirschhorn ascribes the greatest value of all.

Die Arbeiten von Thomas Hirschhorn schweben irgendwo zwischen den Kategorien Skulptur und Architektur, Kunst und Nichtkunst, Innen und Außen. Seit etwa einem Jahrzehnt verbindet er bewusst ramschige Materialien (Pappe, Paketband, Alufolie, Nylon und Holzabfälle) mit einer fein kalkulierten Positionslosigkeit gegenüber dem in seinen „Displays" enthaltenen politischen Material oder Konsumgut. Alles ist sorgfältig von Hand gemacht, so dass die radikalen Gegenüberstellungen von ungleichartigen Objekten – fotokopierte Texte von Arendt bis Zizek, überdimensionierte Rolex-Uhren und Mercedes-Sterne aus Pappe und Alufolie, aus Zeitschriften ausgeschnittene Bilder und Statistiken von weltweiten Grausamkeiten – doch gleichen Rahmenbedingungen folgen: Hirschhorns wahllose Assoziationen ahmen den Eingriff des Objektwerts im eher nebulösen Bereich des Zeichenaustauschs nach. Trotzdem kommt dem Betrachter durch den nicht-ideologischen, bewusst vereinfachenden Ansatz aber auch die Verantwortung einer aktiven Mitwirkung und die Zuschreibung von Wert trotz Wertlosigkeit zu. In jüngster Zeit hat Hirschhorn seinen Bekanntheitsgrad genutzt, um seine Monumente, Altäre, Kioske und Pavillons im öffentlichen Raum zu platzieren: Anlässlich der documenta 11 erbaute er in einem von Immigranten mit geringem Einkommen bewohnten Viertel in Kassel ein Denkmal für Georges Bataille, in einem Pariser Vorort errichtete er ein mit Schätzen des Centre Pompidou bestücktes *Musée Précaire Albinet*, auf öffentlichen Plätzen in Zürich präsentierte er einen Robert Walser gewidmeten Kiosk sowie einen Altar für Raymond Carver, und in Amsterdam stellte er ein Monument für Spinoza auf. All dies waren Versuche der Anregung einer kollektiven Wahrnehmung, der erste Schritt zur Autonomie, für Hirschhorn der größte Wert überhaupt.

Les réalisations de Thomas Hirschhorn oscillent entre les genres : sculpture et architecture, art et anti-art, intérieur et extérieur. Au cours de la dernière décennie, il a su combiner des matériaux délibérément éphémères (carton, bande adhésive, papier d'aluminium, nylon, copeaux de bois) avec une non-position subtilement calibrée à l'égard du matériau politique et des biens de consommation intégrés dans ses «présentoirs». Tout y est minutieusement fait main, de sorte que les juxtapositions radicales d'objets hétéroclites – photocopies de textes d'Arendt à Zizek, Rolex surdimensionnées en papier d'aluminium et en carton, enjoliveurs de capots de Mercedes, images et statistiques tirées de revues et montrant les atrocités commises de par le monde – s'étalent sur un champ de présentation nivelé : les associations sans discernement de Hirschhorn reproduisent le glissement de la valeur de l'objet vers le domaine plus nébuleux du dialogue de signes. Reste que son approche non idéologique et délibérément simpliste responsabilise le spectateur en faisant de lui un participant actif qui attribue de la valeur là où il n'y en a pas. Récemment, Hirschhorn a usé de sa notoriété pour placer ses monuments, autels, kiosques et pavillons dans des espaces publics : il a ainsi dressé un monument à Georges Bataille dans un quartier d'immigrés pour la documenta 11 à Kassel, présenté un *Musée Précaire Albinet* rempli de trésors du Centre Pompidou dans la banlieue parisienne, installé un kiosque consacré à Robert Walser et un autel dédié à Raymond Carver dans l'espace public de Zurich et construit un monument à Spinoza à Amsterdam. Toutes ces actions on été réalisées pour favoriser la perception collective, premier pas vers cette autonomie à laquelle Hirschhorn attribue la valeur suprême entre toutes. B. S.

SELECTED EXHIBITIONS →
2004 Les Laboratoires d'Aubervilliers; *The Beauty of Failure/The Failure of Beauty*, Fundació Miró, Barcelona **2003** *Doppelgarage in der Schirn*, Schirn Kunsthalle, Frankfurt/Main; *Utopia Station*, 50. Biennale di Venezia, Venice **2002** *Liubov Popova-Kiosk, n°7/Otto Freundlich-Kiosk, n°8*, Université de Zurich-Irchel; documenta 11, Kassel **2001** *Wirtschaftslandschaft Davos*, Kunsthaus Zürich; *Skulptur Sortier Station*, Stalingrad, Paris (Collection Centre Pompidou); *Archeology of Engagement*, Museu d'Art Contemporani de Barcelona

SELECTED PUBLICATIONS →
2003 *Thomas Hirschhorn: Bataille Maschine*, Berlin; *Doppelgarage*, Schirn Kunsthalle, Frankfurt/Main **2002** *Short Guide*, Barbara Gladstone Gallery, New York **2001** *Material: Public Works – The Bridge 2000*, Whitechapel Art Gallery, London

1 **Unfinished Walls**, 2004, installation view, Stephen Friedman Gallery, London
2 **Stand-In**, 2004, installation view, "The Beauty of Failure/The Failure of Beauty", Fundació Miró, Barcelona
3 **Chalet Lost History**, 2003, installation view, Galerie Chantal Crousel, Paris
4 **U-Lounge**, 2003, installation view, "Common Wealth", Tate Modern, London
5 Thomas Hirschhorn in front of **Musée Précaire Albinet**, Aubervilliers, 2004

„Ich habe mein bildhauerisches Vokabular dergestalt gewählt, dass Menschen nicht ausgeschlossen, sondern in meine Arbeit – oder besser, in die Welt – einbezogen werden. Das ist mein Anliegen. Aus diesem Grund arbeite ich. Das ist meine politische Aussage."

«Mon vocabulaire sculptural est choisi de manière à ne pas exclure, mais à impliquer les gens dans mon œuvre – ou plutôt, à les impliquer dans le monde. C'est ce que je tente de faire. C'est la raison d'être de mon travail. C'est ma profession de foi politique.»

"My sculptural vocabulary is chosen so as not to exclude people, but instead to implicate them in my work – or rather, implicate them in the world. That's what I try to do. That is why I work. That's my political statement."

déjà fait
Rommel Tartare

4

5

Jim Hodges

1957 born in Spokane (WA), lives and works in New York (NY), USA

Jim Hodges came to prominence in the early 1990s by presenting elegant arrangements of commonplace materials – napkins, silk flowers, silver chain – in sculptures and installations that broached universal themes like love, loss, and the interplay of private remembrance and public consciousness. Trained as a painter, the artist has applied the painterly concerns with light, colour, and patterning to an ever-widening array of found objects; recent artworks incorporate shards of mirror, sheet music, camouflage patterning, and even other people's handwriting (for a recent project, Hodges made a large mural that presented approximately seventy UN delegates writing "don't be afraid" in their own handwriting and native tongue). A sense of wonderment at the world, the interconnectedness of its citizens, and a belief in the transformative power of beauty (what Elaine Scarry has identified as beauty's ability to assist us in our attention to justice) connect these disparate activities. Hodges' formal strategies bolster the content of his works, as do carefully planned titles (a lifelike glass sculpture of a bird's nest resting on a tree branch that extends from the gallery wall is called *a view from in here*, 2003). Hodges' art, as a subjective response to the cascade of fleeting moments that make up life, is deeply personal, yet his reticence to include direct references to himself keeps his works from lapsing into sentimentality. What results are visually poetic distillations of big subjects in which the viewer is always capable of locating himself; Hodges' artworks are prisms through which we find our place in the world.

Bekannt wurde Jim Hodges in den frühen neunziger Jahren mit seinen eleganten Arrangements aus banalen Materialien – Servietten, Seidenblumen, Silberketten – in Form von Skulpturen und Installationen, die so universale Themen wie Liebe, Verlust und das Wechselspiel zwischen privater Erinnerung und öffentlichem Bewusstsein behandelten. Der ausgebildete Maler überträgt die bildnerische Beschäftigung mit Licht, Farbe und Mustern auf ein sich ständig erweiterndes Gebiet vorgefundener Objekte. So enthalten seine neueren Arbeiten Spiegelscherben, Notenblätter, Tarnmuster und fremde Handschriften (für ein kürzlich realisiertes Projekt fertigte Hodges eine große Wandarbeit an, die aus den Worten „don't be afraid" bestand, handgeschrieben von annähernd siebzig UN-Delegierten in ihrer jeweiligen Muttersprache). Ein Gefühl des Erstaunens angesichts der Welt, die gegenseitige Verbundenheit ihrer Bewohner und der Glaube an die transformative Macht der Schönheit (oder, wie Elaine Scarry es nannte, die Fähigkeit der Schönheit, uns bei der Achtung der Gerechtigkeit zu helfen) verbindet diese verschiedenen Aktivitäten. Dabei wird der Inhalt von Hodges' Arbeiten durch seine formalen Strategien ebenso wie durch die sorgfältig geplanten Titel gestützt (eine naturgetreue Glasskulptur eines Vogelnests auf einem Ast, der aus der Galeriewand zu wachsen scheint, trägt den Titel *a view from in here*, 2003). Hodges' Kunst ist in ihrer subjektiven Reaktion auf die Flut vergänglicher Augenblicke, aus denen das Leben besteht, äußerst persönlich, und doch verhindert seine Zurückhaltung gegenüber direkten biografischen Verweisen, dass seine Arbeiten in bloße Sentimentalität abgleiten. Das Ergebnis sind vielmehr visuell-poetische Destillate großer Themen, in denen der Betrachter sich immer selbst wiederfinden kann. Hodges' Arbeiten sind Prismen, durch die wir unseren Platz in der Welt erkennen können.

Jim Hodges s'est fait connaître au début des années quatre-vingt-dix en présentant d'élégants arrangements de matériaux ordinaires – serviettes de table, fleurs de soie, chaînes d'argent – dans des sculptures et des installations qui traitaient de thèmes universels comme l'amour, la perte et l'interaction entre mémoire privée et conscience publique. Après ses études de peinture, l'artiste a appliqué les moyens de la peinture – lumière, couleur, motifs – à une panoplie sans cesse croissante d'objets trouvés. Ses œuvres récentes contiennent des tessons de miroir, des partitions musicales, des éléments de camouflage, et même des écritures d'autres personnes (pour un projet récent, Hodges a réalisé un vaste mur présentant quelque soixante-dix délégués des Nations Unies écrivant « don't be afraid » dans leurs propres langue et écriture). Un sens de l'émerveillement face au monde et aux liens qui en unissent les citoyens, une foi dans le pouvoir transformateur de la beauté (dans laquelle Elaine Scarry a vu l'aptitude à nous soutenir dans notre attention à la justice) relient ces différentes activités. Les stratégies formelles de Hodges viennent soutenir le contenu de ses œuvres, de même que les titres soigneusement élaborés (la sculpture grandeur nature en verre d'un nid d'oiseau posé sur une branche sortant du mur de la galerie est intitulée *a view from in here*, 2003). Réponse subjective au flot d'instants éphémères qui constituent la vie, l'art de Hodges se veut profondément personnel, mais la réticence de l'artiste à y faire entrer des références explicitement autobiographiques empêche ses œuvres de sombrer dans le sentimentalisme. Il en résulte des distillations visuelles poétiques de sujets importants, dans lesquelles le spectateur conserve toujours la possibilité de se situer lui-même. Les œuvres de Hodges fonctionnent comme des prismes qui nous permettent de trouver notre place dans le monde. B. S.

SELECTED EXHIBITIONS →
2005 *Heaven and Earth*, Centro Galego de Arte Contemporánea, Santiago de Compostela **2004** *Don't Be Afraid*, Worcester Art Museum; Whitney Biennial, Whitney Museum of American Art, New York **2003–2005** The Tang Teaching Museum and Art Gallery at Skidmore College, Saratoga Springs; Austin Museum of Art; Weatherspoon Art Museum, Greensboro; Museum of Contemporary Art Cleveland **2003** *colorsound*, Addison Gallery of American Art, Andover; *Returning*, Artpace, San Antonio; *Tracing the Sublime*, Addison Gallery of American Art, Andover **2002** *Life Death Love Hate Pleasure Pain*, Museum of Contemporary Art, Chicago; *Mirror Mirror*, Massachusetts Museum of Contemporary Art, North Adams

SELECTED PUBLICATIONS →
2004 *Jim Hodges*, The Tang Teaching Museum and Art Gallery at Skidmore College, Saratoga Springs, Weatherspoon Art Museum, Greensboro **2002** *Arte Povera American Style: Funk, Play, Poetry & Labor*, The Cleveland Institute of Art

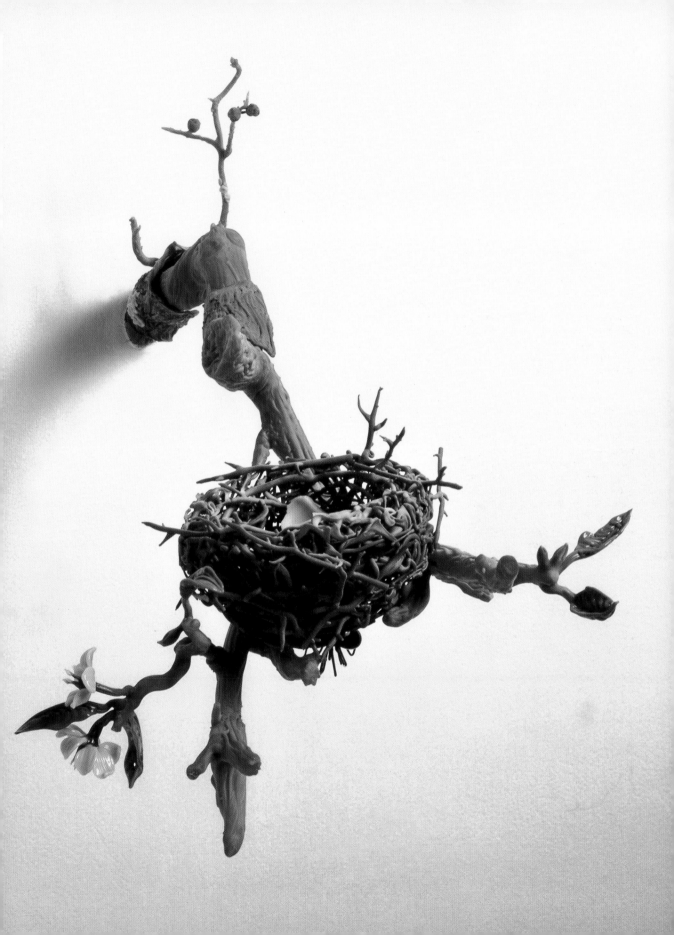

1 **a view from in here**, 2003, glass, 17.8 x 14 x 64.8 cm
2 **Light I**, 2004, mirror on canvas, Ø 182 cm
3 **look and see**, 2004, enamel on stainless steel, 335 x 762 x 366 cm, installation view, Ritz Carlton, Battery Park, New York

4 **along the great curve**, 2004, prismacolour pencil on wall, dimensions variable, installation view, Weatherspoon Art Museum, Greensboro

„In all diesen Arbeiten versuche ich, einfach und direkt vorzugehen. Ich versuche, an einen Punkt zu gelangen, an dem ich ein bestimmtes Material so wenden kann, dass etwas anderes zum Vorschein kommt; es geht also um ein Entfalten des Materials, um herauszufinden, womit man es zu tun hat. Es geht um eine Aufdeckung."

« Dans toutes ces œuvres, j'essaie d'être simple et direct. J'essaie d'arriver à un point où je transforme un matériau de manière qu'on puisse y voir autre chose, un déploiement du matériau pour voir ce qui est là. Tout tourne autour de la découverte. »

"In all these works I try to be simple and direct. I try to get to a point where I am turning a material in a way so that something else is seen, an unfolding of the material to see what's there. It's about discovery."

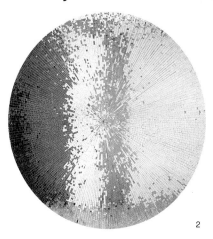

2

3

Candida Höfer

1944 born in Eberswalde, lives and works in Cologne, Germany

After initial, more sociologically oriented photo series dedicated for example to Liverpool's urban structure (1968), or the living conditions of Turkish immigrants in major German cities (1972–1979), the artistic theme of space made its appearance in Candida Höfer's later work. Continually becoming less disguised and more central to her work, this remains her primary artistic theme to this day. After completing her studies with Bernd and Hilla Becher, her photographic gaze focused on depicting public interior spaces, which she approached in a distanced manner. Often created over a longer time span, the many photo series of this world's deserted archives, museums, libraries, and reading rooms provide us with a clear view of spaces whose beauty or absurdity generally remains hidden from everyday view due to their transitory character. Höfer, you see, is less interested in spectacular views of famous architecture, but much more in the spaces of the visual subconscious. Her precise, masterful handling of light can be viewed as a distinguishing characteristic of almost all of her photographs. Often the pictorial spaces seem strangely bewildering and timeless due to their complex lighting, an example being the photograph *Banco de España Madrid 2000*, where the floor of a space is transformed into a sea of blazing light. Thus despite her rather sober, factual view of the world of objects, Höfer succeeds in capturing the specific atmosphere of each space. Overall, Höfer's work cannot therefore be classified within the genre of classical architectural photography. Her images can more easily be understood as sensitive portraits of rooms in which people, although always absent, are finally always present in the traces they have left and the structures they have created.

Nach anfänglich eher soziologisch orientierten Bildserien, die sich etwa der urbanen Struktur Liverpools (1968) oder der Lebenswelt türkischer Einwanderer in deutschen Großstädten (1972–1979) widmeten, tritt in den späteren Bildern das bis heute zentrale künstlerische Thema von Candida Höfer immer unverstellter in den Mittelpunkt ihrer Arbeit: der Raum. Nach Beendigung ihres Studiums bei Bernd und Hilla Becher fokussierte sich ihr fotografischer Blick auf die Darstellung öffentlicher Innenräume, denen sie sich distanziert annähert. Die oft über längere Zeitspannen entstandenen Serien der menschenleeren Archive, Museen, Bibliotheken und Lesesäle dieser Welt geben uns den Blick frei auf Räume, deren Schönheit oder Absurdität aufgrund ihres transitorischen Charakters der alltäglichen Wahrnehmung zumeist entzogen bleibt. Denn es sind weniger die spektakulären Ansichten berühmter Architektur, sondern vielmehr die Räume des optisch Unbewussten, die Höfer interessieren. Als ein fast alle Aufnahmen Höfers auszeichnendes Merkmal kann ihr präziser, meisterhafter Umgang mit Licht gelten. Oftmals wirken die Bildräume aufgrund der komplexen Lichtführung seltsam verunklärt und zeitlos, wenn sich beispielsweise wie in der Aufnahme *Banco de España Madrid 2000* der Boden einer Halle in einen See gleißenden Lichtes verwandelt. So gelingt es Höfer, trotz ihrer eher nüchternen, sachlichen Sicht auf die Objektwelt, die spezifische Atmosphäre der jeweiligen Räume einzufangen. Insgesamt lässt sich Höfers Werk daher nicht dem Genre der klassischen Architekturfotografie zuordnen. Eher kann man ihre Bilder als sensible Raumporträts begreifen, in denen der Mensch, obgleich stets abwesend, in den festgehaltenen Spuren und von ihm geschaffenen Strukturen letztlich immer präsent bleibt.

Après des séries de photographies de tendance sociologique consacrées notamment à la structure urbaine de Liverpool (1968) ou à l'univers des immigrés turcs dans les grandes métropoles allemandes (1972–1979), l'espace, thème central de Candida Höfer, occupe de manière de plus en plus directe le centre de son travail. Après des études chez Bernd et Hilla Becher, son regard photographique s'est concentré sur la représentation des espaces intérieurs publics, qu'elle cerne par une approche distante. Souvent réalisées sur des périodes de temps assez longues, ses séries sur les archives, les musées, les bibliothèques et les salles de lecture déserts de ce monde nous donnent accès à des espaces dont la beauté ou l'absurdité restent le plus souvent cachées en raison du caractère transitoire de la perception quotidienne. L'intérêt de Höfer porte en effet moins sur les vues spectaculaires des architectures célèbres que sur les espaces de l'inconscient visuel. La mise en scène magistrale de la lumière peut être considérée comme une caractéristique de presque toutes les photographies de Höfer. Du fait d'un traitement complexe de la lumière, ses espaces iconiques nous apparaissent souvent étrangement indéfinis et intemporels, comme dans la photo *Banco de España Madrid 2000*, dans laquelle le sol fraîchement astiqué d'une salle se transforme en un lac de lumière aveuglante. Malgré le regard plutôt froid et objectif qu'elle porte sur le monde des objets, Höfer parvient ainsi à capter l'atmosphère spécifique des différents espaces. Très généralement, ses œuvres ne peuvent en fait être classées dans le genre de la photographie d'architecture classique, elles doivent plutôt être comprises comme des portraits sensibles des espaces dans lesquels l'homme, bien que toujours absent, demeure finalement toujours présent à travers les traces qu'il laisse et les structures qu'il a créées.

D. M.

SELECTED EXHIBITIONS →
2004 *In ethnographischen Sammlungen*, Völkerkundemuseum der Universität Zürich **2003** 50. Biennale di Venezia, Venice; *Leseräume II*, Kaiser Wilhelm Museum, Krefeld **2002** documenta 11, Kassel **2001** Musée des Beaux-Arts et de la Dentelle, Calais **2000** *Orte Jahre. Photographien 1968–1999*, Kunsthalle Nürnberg; *Ansicht Aussicht Einsicht Architekturphotographie*, Galerie für Zeitgenössische Kunst, Leipzig

SELECTED PUBLICATIONS →
2004 *Candida Höfer: In ethnographischen Sammlungen*, Cologne **2003** *Candida Höfer: Monographie*, Munich **2002** *Zwölf – Twelve*, Munich **1999** *Orte Jahre. Photographien 1968–1999*, Munich, Paris; *Leseräume*, Basle

214

1 **Van Abbemuseum Eindhoven V 2003**, C-print, 101 x 85 cm
2 **Kunstraum Innsbruck II 2004**, C-print, 68 x 85 cm, exhibition architecture:
Kühn Malvezzi Berlin

3 **Palais Garnier III 2004**, C-print, 220 x 180 cm

„Anhand des Abzuges mache ich mir dann noch mal meinen eigenen Raum. Es kommt mir nicht darauf an, den Raum möglichst nah an der Wirklichkeit zu zeigen."

« J'élabore alors mon propre espace à partir du tirage. Mon propos n'est pas de montrer les espaces sous une forme qui se rapproche le plus possible de la réalité. »

"By means of the print I then create my own space once again. It is not my intention to show the space in a manner as realistic as possible."

Gary Hume

1962 born in Kent, lives and works in London, UK

Gary Hume's paintings fascinate through their shining surfaces and cool elegance. Hume uses commonly available enamel paint, which he applies to aluminium. Thus monochrome planes and lines converge completely without brush marks. Room and viewer are reflected in these pictures, which shimmer as if the paint was still wet. The artist became known at the end of the 1980s with the *Doors* painting series, in which he painted swinging doors, like those common in British hospitals, with a few geometric forms. Despite their stylisation approaching abstraction, the motifs reawaken collective memories. Hume followed these early works with the *Window* paintings series, in which a pink grid on an opaque black ground invokes window structures, such as in *Small Disappointment* (2003). The artist breaks up this minimalist composition with a drop of bright paint, which he places in the middle of one of the black squares. Hume happily refers to himself as a "beauty terrorist" and intentionally works irregularities into his paintings. For example, he reduces his figurative depictions of plants, animals and portraits so radically that the outlines and forms must be completed by the viewer's memory. Thus he painted the portrait of Nicola, the artist's girlfriend, as a black oval with the suggestion of two yellow strands of hair on aluminium (*Nicola as an Orchid*, 2004). In the variations of *Snowman*, the artist is ultimately toying with the utopia of the perfect sculpture: thus *Back of a Snowman*, 2002, consists of two balls painted with white enamel. Here, although the coal eyes and carrot nose are missing, he is again playing with nostalgic perceptions. At the same time the figure can be viewed from all sides, and is perfect from every perspective.

Die Gemälde von Gary Hume faszinieren durch ihre glänzenden Oberflächen und ihre kühle Eleganz. Hume benutzt handelsüblichen Lack, den er auf Aluminium aufträgt. Ganz ohne Pinselspuren treffen so monochrome Farbflächen und Linien aufeinander. Raum und Betrachter spiegeln sich in diesen Bildern, die schillern, als wäre die Farbe noch feucht. Bekannt wurde Hume Ende der achtziger Jahre mit der Serie *Doors*: lebensgroße Gemälde von Schwingtüren, wie sie in englischen Krankenhäusern üblich sind, mit wenigen geometrischen Formen. Trotz ihrer Stilisierung bis hin zur Abstraktion rufen die Motive kollektive Erinnerungen wach. Mit der Serie der *Windows* schließt Hume an diese frühen Arbeiten an: Ein pinkfarbenes Raster auf einem opaken schwarzen Grund weist in *Small Disappointment* (2003) auf die Fensterstruktur hin. Diese minimalistische Komposition bricht der Künstler mit einem hellen Lacktropfen, den er mitten in eines der schwarzen Quadrate setzt. Gerne bezeichnet sich Hume als „beauty terrorist" und arbeitet gezielt Unregelmäßigkeiten in seine Gemälde ein. Seine figürlichen Darstellungen von Pflanzen, Tieren und Porträts etwa reduziert er so radikal, dass die Umrisse und Formen beim Betrachten aus dem Gedächtnis vervollständigt werden müssen. So beschreibt er das Porträt der Künstlerfreundin Nicola als ein schwarzes Oval mit zwei angedeuteten gelben Haarsträhnen auf Aluminium (*Nicola as an Orchid*, 2004). In den Variationen von *Snowman* schließlich spielt der Künstler mit der Utopie der perfekten Skulptur: *Back of a Snowman* (2002) besteht aus zwei weiß lackierten Kugeln. Obwohl Kohleaugen und Rübennase fehlen, spielt Hume hierbei wiederum mit nostalgischen Vorstellungen. Gleichzeitig kann die Figur von allen Seiten betrachtet werden und ist aus jeder Perspektive vollkommen.

Les peintures de Gary Hume exercent une forte fascination par leurs surfaces brillantes et leur froide élégance. Hume se sert d'une laque ordinaire appliquée sur de l'aluminium. Sans la moindre trace de pinceau, des surfaces de couleur monochromes s'y entrechoquent avec des lignes. L'espace d'exposition et le spectateur se reflètent dans ces tableaux qui brillent comme si la peinture en était encore humide. Hume s'est fait connaître à la fin des années quatre-vingt par sa série *Doors*, des peintures de portes battantes grandeur nature, avec quelques formes géométriques, telles qu'on les trouve couramment dans les hôpitaux anglais. Malgré leur stylisation confinant à l'abstraction, ces motifs éveillent des souvenirs collectifs. Avec la série des *Windows*, Hume s'inscrit dans le prolongement de ces œuvres anciennes : dans *Small Disappointment* (2003) une trame rose sur un fond noir opaque renvoie à la structure d'une fenêtre. L'artiste rompt cette composition minimaliste par une goutte de laque claire déposée dans un des carrés noirs. Hume aime à se définir comme un « beauty terrorist » et introduit délibérément des irrégularités dans ses peintures. Ses représentations figuratives de plantes, d'animaux et de portraits sont réduites de manière si radicale que les silhouettes et les formes doivent en être complétées de mémoire par le spectateur. Le portrait de son amie artiste Nicola est constitué d'un ovale noir accompagné de l'indication de deux mèches de cheveux jaunes sur aluminium (*Nicola as an Orchid*, 2004). Enfin, dans les variations de *Snowman*, l'artiste joue sur l'utopie de la sculpture parfaite : *Back of a Snowman* (2002) est constitué de deux boules laquées de blanc. Bien qu'il y manque les charbons et la carotte figurant les yeux et le nez, Hume joue ici encore sur des conceptions nostalgiques. En même temps, cette figure peut être abordée par tous les côtés et s'avère parfaite quel que soit le point de vue adopté. C. R.

SELECTED EXHIBITIONS →
2004 *Carnival*, kestnergesellschaft, Hanover; *The Bird Has a Yellow Beak*, Kunsthaus Bregenz; *The Flower as Image: From Monet to Jeff Koons*, Louisiana Museum for Moderne Kunst, Humlebæk **2003** Irish Museum of Modern Art, Dublin **2002** *Painting on the Move*, Kunsthalle Basel, Basle **2001** *Public Offerings*, The Geffen Contemporary at MOCA, Los Angeles **2000** Fundació "la Caixa", Barcelona; *Sincerely Yours*, Astrup Fearnly Museet for Moderne Kunst, Oslo

SELECTED PUBLICATIONS →
2004 *Gary Hume: Carnival*, kestnergesellschaft, Hanover; *Gary Hume*, Royal Jelly Factory, London; *The Bird Has a Yellow Beak*, Kunsthaus Bregenz, Bregenz **2003** *Gary Hume*, Irish Museum of Modern Art, Dublin **2000** *Gary Hume*, Fundació "la Caixa", Barcelona

218

1 **Hermaphrodite Polar Bear**, 2003, enamel on aluminium, 198 x 150 cm
2 **Dead Head**, 2003, enamel on aluminium, 95 x 68 cm
3 **Granny Had a Bird**, 2003, enamel on aluminium, 176 x 122 cm
4 **Green, Black, Pink and Green**, 2004, enamel on aluminum, 234 x 163 cm

„Es sind Bilder, aber ich weiß nicht, was sie sind. Ich versuche, an sie zu glauben, ich glaube, sie verfügen über eine Wahrheit.“

«Ce sont des tableaux, mais je ne sais pas ce qu'ils sont. Je tente de croire en eux; je pense qu'ils recèlent une vérité.»

"They are pictures and I don't know what they are. Doing my best, I believe in them, I believe that they have got a truth in them."

2

3

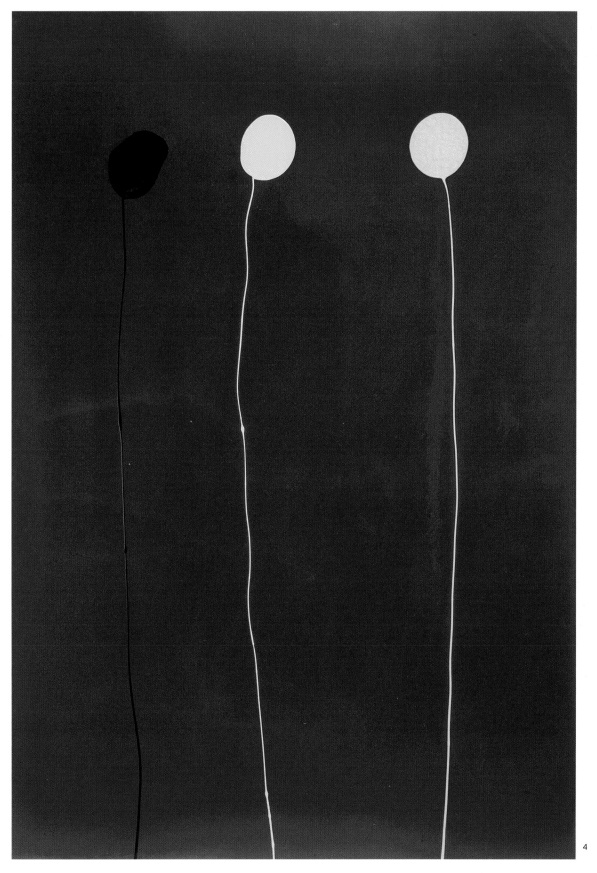

Pierre Huyghe

1962 born in Paris, lives and works in Paris, France

Since 1990 Pierre Huyghe's projects have included posters, pamphlets, billboards, public interventions, objects, architecture, film and photography. Huyghe's interest is in the coefficient of fictional content that exists in every situation; and that supplement to reality has remained a starting point for Huyghe's work. Since founding the Association of Freed Times in 1995, Huyghe has sought to introduce new paradigms to the art exhibition by extending its temporal mode. In *Streamside Day* (2003) – which consisted of a public celebration, a film and an exhibition – Huyghe invented a new tradition for a burgeoning community at Streamside Knolls, a new housing development in the Hudson Valley, New York. For *This is not a Time for Dreaming* (2004), Huyghe worked in collaboration with the curatorial, design and architectural faculties of Harvard University to create a marionette opera tracing the story of Le Corbusier's architectural commission and Huyghe's own work at Harvard. An architectural extension to the Carpenter Center transformed an unfinished terrace into a temporary puppet theatre where scenes were performed to the public, and filmed in situ – thereby incorporating the fictionalised and the real into the resulting film. Huyghe has often collaborated with other artists. His collaborative projects have included a television station *Mobil TV* (1995), a collective architectural scenario *House or Home* (1995) and *No Ghost Just a Shell* (1999–2002) – for which Huyghe and Philippe Parreno invited artists to create scenarios with Annlee, the Japanese anime character that they bought the rights to in 1999.

Seit 1990 sind Plakate, Pamphlete, Werbetafeln, öffentliche Interventionen, Objekte, Architektur, Film und Fotografie die Arbeiten von Pierre Huyghe. Huyghe interessiert sich für den Koeffizienten fiktionalen Inhalts, der jeder Situation innewohnt; dieser Zusatz zur Realität ist ein steter Ausgangspunkt seiner Arbeiten. Seit der Gründung der Association of Freed Times 1995 versucht Huyghe neue Paradigmen in Kunstausstellungen einzuführen, indem er ihren zeitlichen Verlauf ausdehnt. In *Streamside Day* (2003) – das aus einer öffentlichen Feier, einem Film und einer Ausstellung bestand – erfand Huyghe ein neues Brauchtum für die Bewohner von Streamside Knolls, einem modernen Häuserkomplex im Hudson Valley, New York. Für *This is not a Time for Dreaming* (2004) arbeitete er mit den Fachbereichen für kuratorische Studien, Design und Architektur der Harvard University zusammen und inszenierte eine Marionetten-Oper, die die Geschichte von Le Corbusiers architektonischen Auftragsarbeiten und Huyghes eigenen Arbeiten in Harvard erzählt. Ein Anbau an das Carpenter Center verwandelte eine unfertige Terrasse in ein temporäres Puppentheater, auf dem das Stück dem Publikum vorgeführt und aufgezeichnet wurde – wodurch Fiktion und Realität in den so entstandenen Film einbezogen wurden. Huyghe hat oftmals mit anderen Künstlern zusammengearbeitet. Zu seinen kollektiven Projekten gehörten ein Fernsehsender, *Mobil TV* (1995), ein Architektur-Szenario, *House or Home* (1995), und *No Ghost Just a Shell* (1999–2002), für das Huyghe und Philippe Parreno andere Künstler dazu einluden, Szenen mit Annlee zu erfinden, jener japanischen Anime-Figur, an der sie 1999 die Rechte erworben hatten.

Depuis 1990, les projets de Pierre Huyghe comprennent affiches, pamphlets, panneaux publicitaires, interventions publiques, objets, architecture, film et photographie. Huyghe s'intéresse au coefficient fictionnel contenu dans chaque situation ; c'est en effet ce supplément à la réalité qui est devenu le point de départ de ses différents travaux. Ayant fondé l'Association of Freed Times en 1995, Huyghe a tenté d'introduire de nouveaux paradigmes dans les expositions d'art en étendant leurs contextes temporels. Pour *Streamside Day* (2003), qui consistait en une célébration publique, un film et une exposition, Huyghe inventa une nouvelle tradition pour une communauté en plein essor à Streamside Knolls, un nouveau lotissement en développement dans la Hudson Valley, à New York. Pour *This is not a Time for Dreaming* (2004), Huyghe collabora avec les départements d'études curatoriales, de design et d'architecture de l'Université Harvard pour créer un opéra de marionnettes retraçant l'histoire des commandes architecturales de Le Corbusier et le travail de Huyghe à Harvard. Une extension architecturale du Carpenter Center transformait une terrasse inachevée en théâtre de marionnettes où l'on jouait les scènes au public tout en les enregistrant in situ, le résultat étant un film qui incorpore fiction et réalité. Huyghe a souvent collaboré avec d'autres artistes. Ses projets en collaboration comportent une station de télévision, *Mobil TV* (1995), un scénario architectural collectif, *House or Home* (1995), et *No Ghost Just a Shell* (1999–2002), pour lequel Huyghe et Philippe Parreno ont invité d'autres artistes à créer des scénarios autour d'Annlee, le caractère de dessin animé japonais dont ils avaient acquis les droits en 1999.

S.C.

SELECTED EXHIBITIONS →
2005 Moderna Museet, Stockholm; Los Angeles Museum of Contemporary Art, Los Angeles **2004** *This Is Not a Time for Dreaming*, Carpenter Center, Harvard University, Cambridge; Castello di Rivoli Museo d'Arte Contemporanea, Turin **2003** *Streamside Day*, Dia Center for the Arts, New York; *The Hugo Boss Prize 2002*, Solomon R. Guggenheim, New York **2002** *L'Expédition scintillante, a musical*, Kunsthaus Bregenz, Bregenz **2001** French Pavilion, Biennale di Venezia, Venice

SELECTED PUBLICATIONS →
2004 *Pierre Huyghe: Float*, Milan **2003** *Pierre Huyghe: Le Château de Turing*, Van Abbemuseum, Eindhoven; *No Ghost Just a Shell*, Pierre Huyghe and Philippe Parreno (ed.), Cologne **2000** *Pierre Huyghe: The Trial*, Kunstverein München, Munich, Kunsthalle Zürich, Secession, Vienna, Le Consortium, Dijon

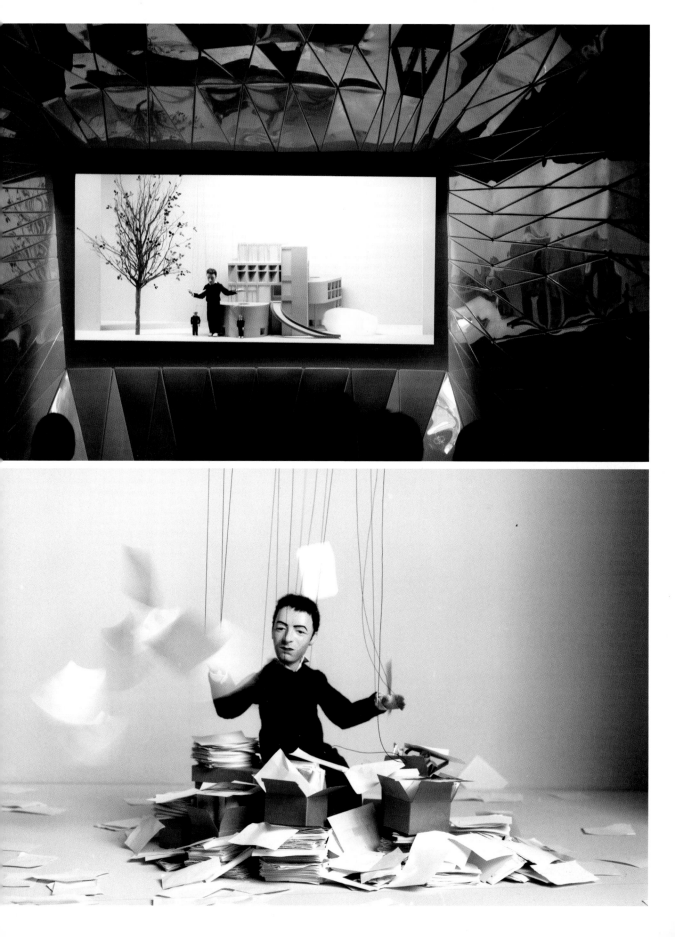

1 **This Is Not a Time for Dreaming**, 2004, live puppet play, super 16mm film, transferred to DigiBeta, colour, sound, 24 min.

2+5 **Streamside Day**, 2003, S-16mm film and video transferred to DigiBeta, colour, sound, 26 min.

3 **L'Expédition scintillante, Acte 2 (light show)**, 2002, light show, fog, mixed media, exhibition view, "L'Expédition scintillante, a musical", Kunsthaus Bregenz

4 **L'Expédition scintillante (a musical)**, 2002, light show, fog, mixed media, exhibition view, "L'Expédition scintillante, a musical", Kunsthaus Bregenz

„Der Koeffizient von Fiktion, der in einer realen Situation enthalten ist, kann multipliziert ein Zusatz zur Realität werden."

«Le coefficient de fiction qui est compris dans une situation existante peut être intensifié pour devenir un supplément de la réalité.»

"The coefficient of fiction contained in an existing situation can be intensified to become a supplement of reality."

2

4

Emily Jacir

1970 born in Riyadh, Saudi Arabia, lives and works in Ramallah, West Bank, and New York (NY), USA

Emily Jacir's work visualizes the consequences that political, religious, ideological, economic, and cultural lines of demarcation have on the lives of individuals. As a Palestinian born in Saudi Arabia, the artist has increasingly turned her attention to the Middle East conflict and its consequences for the Palestinian people. Jacir makes use of documentary structures; she works with photography, video, texts, recordings, newspaper articles, and found materials. She charts situations and events that come directly from her own life, or from other such worlds personally conceived and created by her. The secretly filmed video *Crossing Surda (A Record of Going to and from Work)* (2002/03) shows the harassment that Palestinians are subject to when crossing a checkpoint in the West Bank. In the work *Sexy Semite* (2000–2002), the Palestinians' legal position is manifested by means of fake marriage ads placed by Jacir, in which Palestinian women seek Jewish mates in order to get a residency permit for Israel. Jacir functions as a service provider and mediator in her sensational project *Where We Come From* (2001–2003), in which she, privileged by her US passport, fulfilled the wishes and requests of Palestinians who were denied access to family, friends, and places due to the political situation. Life in various countries and cultures is accompanied by frictional losses: In *Change/Exchange (3 Days)* (1998) Jacir exchanged 100 Dollars into French francs and back, until the money was completely gone due to fees and exchange-rate fluctuations. In Jacir's work the existential conditions of a life behind and between borders materializes within familiar actions and images.

Das Werk von Emily Jacir visualisiert die Auswirkungen, die politische, religiöse, ideologische, wirtschaftliche und kulturelle Demarkationslinien auf das Leben des Einzelnen haben. Als in Saudi-Arabien geborene Palästinenserin richtet die Künstlerin ihr Augenmerk verstärkt auf den Nahostkonflikt und dessen Folgen für das palästinensische Volk. Jacir bedient sich dokumentarischer Strukturen – sie arbeitet mit Fotografie, Video, Text, Aufzeichnungen, Zeitungsartikeln und Fundstücken. Sie kartografiert Situationen und Begebenheiten, die sowohl ihrer Lebenswelt direkt entnommen als auch von ihr konzipiert und herbeigeführt worden sind. Das heimlich gefilmte Video *Crossing Surda (A Record of Going to and from Work)* (2002/03) zeigt die Schikanen, denen Palästinenser an einem Checkpoint in der West Bank ausgesetzt sind. In der von schwarzem Humor durchdrungenen Arbeit *Sexy Semite* (2000–2002) manifestiert sich die Rechtslage der Palästinenser anhand falscher, von Jacir aufgegebener Heiratsanzeigen, in denen palästinensische Frauen heiratswillige jüdische Männer suchen, um eine Aufenthaltsgenehmigung in Israel zu bekommen. Als Dienstleisterin und Mittlerin fungierte Jacir in ihrem Aufsehen erregenden Projekt *Where We Come From* (2001–2003), bei dem sie, privilegiert durch ihren US-amerikanischen Pass, die Wünsche und Bitten von Palästinensern erfüllte, denen der Zugang zu Familie, Freunden und Orten aufgrund der politischen Lage versperrt blieb. Das Leben in verschiedenen Ländern und Kulturen geht einher mit Reibungsverlusten: In *Change/Exchange (3 Days)* (1998) tauschte Jacir 100 Dollar so lange in französische Francs und zurück um, bis das Geld durch Gebühren und Kursschwankungen aufgezehrt worden war. Bei Jacir materialisiert sich an vertrauten Handlungen und Bildern die existenzielle conditio eines Lebens hinter und zwischen Grenzen.

L'œuvre d'Emily Jacir visualise les effets exercés sur la vie de l'individu par les lignes de démarcation politiques, religieuses, idéologiques, économiques et culturelles. Palestinienne née en Arabie Saoudite, l'artiste porte plus particulièrement son attention sur le conflit du Moyen-Orient et ses conséquences sur le peuple palestinien. Jacir se sert de structures documentaires – elle travaille avec la photographie et la vidéo, des textes et des notes, des articles de journaux et des objets trouvés, cartographiant pour cela des faits et des situations tirés de sa propre vie ou encore conçus ou suscités par elle-même. Tournée en caméra cachée, la vidéo *Crossing Surda (A Record of Going to and from Work)* (2002/03) montre les tracasseries auxquelles les Palestiniens sont exposés au passage d'un point de contrôle de la West Bank. Dans l'œuvre *Sexy Semite* (2000–2002), la situation légale des Palestiniens est mise en lumière au moyen de faux faire-part de mariage publiés par l'artiste, et dans lesquels des femmes palestiniennes recherchent des hommes juifs disposés au mariage pour obtenir une carte de séjour en Israël. Dans son projet très remarqué *Where We Come From* (2001–2003), pour lequel son passeport américain a permis à Jacir d'exaucer les désirs et les demandes de Palestiniens à qui l'accès à leur famille, à leurs amis et à des lieux familiers demeurait interdit en raison de la situation politique, l'artiste agissait en qualité d'intermédiaire et prestataire de service. La vie dans différents pays et cultures est jalonnée de pertes d'énergie frictionnelles : dans *Change/Exchange (3 Days)* (1998), Jacir changeait un billet de 100 dollars en francs français et vice versa jusqu'à ce que la somme ait été consumée par les frais de change et les fluctuations des cours. Chez Jacir, des actes et des images familiers mettent en évidence les conditions d'existence d'une vie derrière et entre les frontières.

A. M.

SELECTED EXHIBITIONS →
2005 51. Biennale di Venezia, Venice; 7. Sharjah International Biennial; *Where We Come From*, Ulrich Museum of Art, Wichita State University **2004** *Non Toccare La Donna Bianca*, Fondazione Sandretto Re Rebaudengo, Turin, Castel dell'Ovo, Naples; *Wherever I Am*, Modern Art Oxford; Whitney Biennial, Whitney Museum of American Art, New York; *Transcultures*, National Museum of Contemporary Art, Athens; 5. Gwangju Biennale **2003** 8. Istanbul Biennial

SELECTED PUBLICATIONS →
2004 *Transcultures*, National Museum of Contemporary Art, Athens; *Non Toccare La Donna Bianca*, Fondazione Sandretto Re Rebaudengo, Turin; *Emily Jacir: belongings*, Vienna

1 **Sexy Semite** (detail), 2000–2002, documentation of an intervention, personal ads placed in the "Village Voice"
2 **Memorial to 418 Palestinian Villages Destroyed, Depopulated and Occupied by Israel in 1948**, 2001, refugee tent, embroidery thread, mixed media, 244 x 305 x 366 cm

3 **Ramallah/New York**, 2004/05, 2-channel video installation on DVD, video stills, dimensions variable

„Bewegung (sowohl erzwungene als auch freiwillige), Zerrüttung, radikale Abweichung und Widerstand sind wiederkehrende Themen meiner künstlerischen Praxis. Viele meiner Arbeiten behandeln unbewusste Grenzmarkierungen (sowohl reale als auch imaginäre) zwischen Territorien, Orten, Ländern und Staaten. Dabei geht es zuweilen um die direkte, physische Existenz politischer Landaufteilungen, das Ineinanderverschlungensein sozioökonomischer Strukturen sowie die Unterteilungen zwischen Kulturen, die jenseits des markierten Raums existieren."

« Dans ma pratique [de l'art], les thèmes récurrents concernent des problèmes de mouvement (à la fois forcé et volontaire), de délocalisation, de déplacement radical et de résistance. Une part importante de mon œuvre tourne autour des marqueurs inconscients de limites (à la fois réelles et imaginées) entre des territoires, des lieux, des pays et des Etats. Il s'agit parfois de l'existence directe et physique de partitions territoriales politiques, ou bien de l'interaction entre des structures socio-économiques, ou encore de divisions entre des cultures existant au-delà des espaces physiquement définis. »

"Recurrent themes in my practice are issues of movement (both forced and voluntary), dislocation, radical displacement, and resistance. Much of my work addresses the unconscious markers of borders (both real and imagined) between territories, places, countries and states. These are at times the direct, physical existence of political land divisions, the intertwining of socio-economic structures, and the divisions between cultures which exist beyond marked space."

2

Mike Kelley

1954 born in Detroit (MI), lives and works in Los Angeles (CA), USA

The artist who has contributed the most to revitalizing the Los Angeles artistic scene was born and raised in Detroit, Michigan: Mike Kelley. By his own statements, that was also where he got his first aesthetic jolt while leafing through comics. This position of "reversal" characterizes very clearly, with absolutely no irony, Kelley's art and way of thinking. His fascination with Robert Crumb soon awoke his interest in the painting of Peter Saul and led him to question the impermeability of the boundary between "high" and "low" art. In order to denounce the power structures behind these cultural stereotypes, Kelley began with works in the field of performance at the end of the 1970s, and branched out into drawing, painting, sculpture, installation, music, video and books, following the example of Martin Kippenberger, to whom he felt very related. Art, politics, sex and morals – Kelley throws everything into a mixing bowl of "good" and "bad" taste, with the aim of showing the repressed side of the modernity and subconscious of America, which Henry Miller described as the "air-conditioned nightmare". Kelley's unusual installations testify to a black humour, which can go to the point of cruelty. He makes use alternately and sometimes simultaneously of material taken from post hippies, heavy metal, punk and grunge, as well as the sub- and counter-cultures. The installation he created in 1988, *Pay for Your Pleasure*, is intended to investigate the relationship between creativity and crime in this way. In his latest installation *The Uncanny* (2004) at the Tate Liverpool Kelley explores memory, recollection, horror and anxiety through the juxtaposition of a highly personal collection of objects with realist figurative sculpture.

Der Künstler, der am meisten zum Wiederaufleben der künstlerischen Szene in Los Angeles beigetragen hat, ist in Detroit, Michigan, geboren und aufgewachsen: Mike Kelley. Nach eigenem Bekunden erlebte er dort beim Durchblättern von Comics seinen ersten ästhetischen Schock. Diese Position der „Umkehrung" charakterisiert ohne jegliche Ironie sehr deutlich Kunst und Denkweise Kelleys. Seine Faszination für Robert Crumb, den Meister des Underground-Comics, führte ihn bald dazu, sich für die Malerei von Peter Saul zu interessieren und die Undurchlässigkeit der Grenzen zwischen der „hohen" und „niedrigen" Kunst zu hinterfragen. Um die Machtgefüge, die hinter diesen kulturellen Stereotypen stehen, anzuprangern, begann Kelley mit Arbeiten, die sich, Ende der siebziger Jahre auf dem Gebiet der Performance begonnen, um Zeichnungen, Malerei, Skulptur, Installation, Musik, Video und das Buch erweiterten, nach dem Vorbild eines Martin Kippenberger, dem er sich sehr verwandt fühlte. Kunst, Politik, Sex, Moral – Kelley wirft alles in eine Mischmaschine des „guten" und „schlechten" Geschmacks, mit dem Ziel, das Verdrängte in der Modernität und das Unbewusste Amerikas, das Henry Miller als den „klimatisierten Alptraum" bezeichnete, zu zeigen. Die außergewöhnlichen Installationen von Kelley zeugen von einem schwarzen Humor, der bis zur Grausamkeit gehen kann. Er bedient sich abwechselnd und manchmal gleichzeitig des Registers der Post-Hippies, des Heavy Metal, Punk und Grunge, der Sub- wie der Gegenkultur. Seine 1988 geschaffene Installation *Pay for Your Pleasure* will auf diese Weise die Beziehungen zwischen Kreativität und Kriminalität erforschen. In seiner neuesten Installation *The Uncanny* (2004) in der Tate Liverpool ergründet Kelley das menschliche Gedächtnis, Erinnerung, Horror und Angst durch die Gegenüberstellung einer sehr persönlichen Sammlung von Gegenständen mit realistisch-figurativen Skulpturen.

Ainsi l'artiste qui a le plus œuvré à la reconnaissance de la scène artistique de Los Angeles est né et a grandi dans le Michigan, à Detroit, où il avoue avoir connu ses premiers chocs esthétiques en feuilletant des bandes dessinées : Mike Kelley. Loin d'être ironique, cette posture de « retournement » caractérise tout l'art et la pensée de Kelley. Sa fascination pour Robert Crumb l'amène rapidement à s'intéresser à la peinture de Peter Saul, et le conduit à s'interroger sur l'étanchéité de la frontière entre la « haute » et la « basse » culture. Pour dénoncer les rapports de pouvoirs qui sont à l'origine de ces stéréotypes culturels, Kelley initie un travail qui, commencé dès la fin des années soixante-dix dans le domaine de la performance, contaminera par la suite le dessin, la peinture, la sculpture, l'installation, la musique, la vidéo et le livre, à l'image d'un Martin Kippenberger dont il se sentait d'ailleurs proche. Art, politique, sexe, morale – Kelley passe tout à la moulinette du « bon » et du « mauvais » goût en vue d'exposer le refoulé de la modernité et l'inconscient de cette Amérique dont Henry Miller dénonçait le « cauchemar climatisé ». Piochant tour à tour, et parfois simultanément, dans les répertoires du post-hippie, du heavy metal, du punk et du grunge, de la subculture comme de la contreculture, les installations déjantées de Kelley témoignent d'un humour noir qui peut aller jusqu'à la cruauté. Créée en 1988, son installation *Pay for Your Pleasure* entend ainsi explorer les liens entre créativité et criminalité. Dans sa récente installation à la Tate Liverpool, intitulée *The Uncanny* (2004), Kelley analyse la mémoire, le souvenir, l'horreur et l'anxiété humains par le biais d'une juxtaposition d'un ensemble d'objets très personnel et de sculptures figuratives réalistes.

S.C.

SELECTED EXHIBITIONS →
2005 *Funny Cuts – Cartoons und Comics in der zeitgenössischen Kunst*, Staatsgalerie Stuttgart **2004** *Das Unheimliche*, Museum Moderner Kunst Stiftung Ludwig Wien, Vienna; *The Uncanny*, Tate Liverpool; *Robert Gober/Mike Kelley/Christopher Wool*, Pinakothek der Moderne, Munich **2003** *The Poetics Project 1977–1997: Mike Kelley/Tony Oursler*, Barbican, London **1999** *Le Magasin*, Grenoble

SELECTED PUBLICATIONS →
2004 *The Uncanny*, Liverpool, Vienna **1999** *Mike Kelley*, London; *Mike Kelley*, Grenoble

1 **A Continuous Screening of Bob Clark's Film "Porky's" (1981), the Soundtrack of which has been replaced with Morton Subotnik's Electronic Composition "The Wild Bull", and Presented in the Secret Sub-Basement of the Gymnasium Locker Room (Office Cubicles)**, 2002, detail: interior office cubicle, pencil, pen, grease pencil, marker, collage on photocopies glued to rag paper and mounted wood panels, Plexiglass, hardware, chairs, light fixtures, intercom system, 185 x 833 x 366 cm

2 **John Glenn Memorial Detroit River Reclamation Project**, 2002, installation view, "Black Out", Patrick Painter Inc., Santa Monica

3 Drawing for **Repressed Spatial Relationships Rendered as Fluid, No. 5: John Glenn High School with White Panther Satellite**, 2002, mixed media on butcher paper mounted on rag paper, 85.7 x 157.5 cm

4 **Repressed Spatial Relationships Rendered as Fluid, No. 5: John Glenn High School with White Panther Satellite**, 2002, steel, Plexiglass, 106.7 x 162.6 x 162.6 cm

„Bevor ich die Underground-Comics entdeckte, war ich nie mit ‚radikaler' oder mit Avantgarde-Kunst in Berührung gekommen."

« Je n'avais jamais été confronté à l'art ‹radical› ou d'avant-garde avant de découvrir la bande dessinée underground. »

"I had never been confronted with 'radical' or avant-garde before seeing underground comic books."

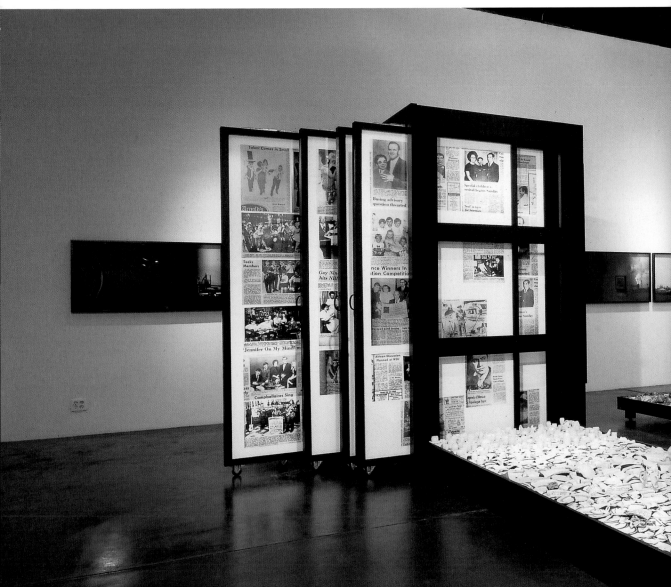

3

4

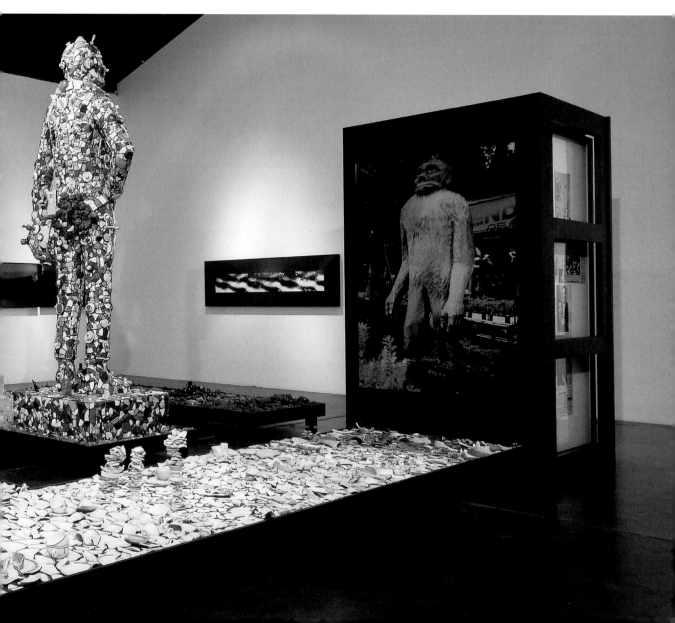

Hassan Khan

1975 born in London, UK, lives and works in Cairo, Egypt

Hassan Khan works in diverse forms of multimedia. His work includes video, video installation, performance, and text. He also writes soundtracks for films, compositions for theatre and dance, and he combines screenings with music in live performances. "My experiences with various media", says Khan, "are born of the effort to define a theoretical position and the impulse to follow an undefined instinct." With the openness of this systematically intuitive strategy, Khan is examining the points at which traditional Egyptian society and Western modernism meet, and he is focusing on highly varied forms of an identity stamped by cultural break-up and integration. Cairo often provides the framework for Khan's decidedly anti-exotic view. He is interested in the metropolis of 16 million as the site of the most varied cultural influences and rivalling philosophies of life. *17 and in AUC* (2003) focuses upon this as a self-experiment. For two weeks Khan sat alone for four hours daily in a cubicle mirrored on the inside, but which could be seen into from the outside. Sitting there drinking beer, smoking cigarettes, and being observed by an audience invisible to him, he spoke about his studies at the American University of Cairo. Khan taped this subjective reconstruction of a piece of his own identity, and presented the 52-hour video in real time in the AUC gallery. In another way the installation *Re/lapse* (2000) is also very personal. Khan showed four projections of sleeping people. If viewers approached close to the screens, they heard people talking about their (very diverse) habits and rituals after getting up, and here Khan broke the images' erratic generality into the banal and complex.

Hassan Khan arbeitet auf vielfältige Weise multimedial. Sein Werk umfasst Video und Videoinstallation, Performance und Text, er schreibt Soundtracks für Filme, Kompositionen für Sprech- und Tanztheater und verbindet Screenings und Musik in Live-Aufführungen. „Meine Erfahrungen mit verschiedenen Medien", so Khan, „kennzeichnet eine beständige Spannung zwischen dem Versuch, eine theoretische Position zu formulieren und dem Impuls, einem unbestimmten Instinkt zu folgen." Mit der Offenheit solch planvoll-intuitiver Strategie geht Khan den Berührungspunkten zwischen traditioneller ägyptischer Gesellschaft und westlicher Moderne nach und nimmt ganz unterschiedliche Formen einer von kulturellen Brüchen und Mischungen geprägten Identität in den Blick. Oft bietet Kairo den Rahmen für Khans entschieden anti-exotischen Blick: Ihn interessiert die Sechzehn-Millionen-Metropole als Schauplatz verschiedenster kultureller Einflüsse und rivalisierender Lebenseinstellungen. *17 and in AUC* (2003) fokussiert dies als Selbstexperiment: Zwei Wochen lang setzte sich Khan täglich vier Stunden allein in eine von innen verspiegelte, von außen einsehbare Zelle und redete allein bei Bier, Zigaretten und unter für ihn unsichtbarer Publikumsbeobachtung über sein Studium an der American University of Cairo. Die subjektive Rekonstruktion eines Stücks eigener Identität hat Khan aufgezeichnet, die zweiundfünfzig Stunden Video in Echtzeit dann in der AUC-Galerie präsentiert. Auf andere Weise ist auch die Installation *Re/lapse* (2000) sehr persönlich: In vier Projektionen zeigt Khan schlafende Menschen. Tritt der Betrachter nahe an die Screens heran, hört man Personen über ihre (sehr verschiedenen) Gewohnheiten und Rituale nach dem Aufstehen sprechen, und hier bricht Khan das erratisch Allgemeine des Bildes ins Banale und Komplexe auf.

Hassan Khan travaille de manière très diversement multimédiale. Son œuvre intègre la vidéo et l'installation vidéo, la performance et le texte ; Khan écrit des musiques de films, des compositions pour le théâtre parlé ou dansé et combine projections et musique dans des shows live. « Mes expériences dans différents médiums sont nées de la double tendance de définir une position théorique et de suivre un instinct indéfinissable. » C'est avec cette stratégie ouverte, aussi planifiée qu'intuitive, que Khan soumet à son regard les points de contact entre la société égyptienne traditionnelle, la modernité occidentale et les différentes formes d'une identité marquée par les ruptures et les mélanges culturels. La ville du Caire fournit souvent le cadre de son approche résolument anti-exotique : Khan aborde la métropole de 16 millions d'habitants comme une scène où se jouent les influences culturelles rivales et les conceptions de vie les plus diverses. *17 and in AUC* (2003) condense ceci sous forme d'expérience autobiographique : pendant deux semaines, Khan s'est installé quatre heures par jour dans une cellule à miroirs sans tain, parlant seul avec bière et cigarettes, sous les yeux d'un public pour lui invisible, de ses études à l'American University of Cairo. L'artiste a ainsi enregistré la reconstitution subjective d'un bout d'identité personnelle, présentant ensuite à la galerie de l'AUC ces 52 heures de vidéo en temps réel. L'installation *Re/lapse* (2000) est elle aussi très personnelle d'une autre manière : sur quatre écrans, Khan y montre des personnes pendant leur sommeil. Quand on se rapproche des écrans, on entend les personnes parler de leur habitudes et rituels (très divers) au moment du lever. Khan fait ainsi éclater le cadre général et erratique de l'image vers la banalité et la complexité. J. A.

SELECTED EXHIBITIONS →
2005 ursula blickle videolounge, Kunsthalle Wien, Vienna **2004** *Naher Osten Näher*, Schirn Kunsthalle, Frankfurt/Main; *Inauguration*, Jeu de Paume, Paris **2003** 8. Istanbul Biennial; 50. Biennale di Venezia, Venice; *Contemporary Arab Representations: Cairo*, Fundació Antoni Tàpies, Barcelona, Witte de With, Rotterdam **2001** *Reading the Surface: 100 Portraits, 6 Locations and 25 Questions*, Townhouse Gallery, Cairo; *Re/lapse*, Square Circle, Daraj El Fann, Beirut **2000** *Re/lapse*, L'Art dans le monde, Paris

SELECTED PUBLICATIONS →
2004 *17 and in AUC*, ASSN (ed.), Chantal Crousel, Paris **2001** *Transit Visa – On Video and Cities*, Akram Zaatari, Mahmoud Hojeij (ed.), Beirut Press, Beirut

1 **sometime, somewhere else**, 2001, video still, colour video with sound, 1 min. 45 sec.
2 **Transmission**, 2002, 3-channel video installation, video stills
3 **Untitled**, 2002, image for public buses, exhibition "Naher Osten Näher", Schirn Kunsthalle, Frankfurt/Main
4 **Reading the Surface: 100 Portraits, 6 Locations and 25 Questions**, 2001, 8-channel video installation, surveillance camera, microphones, audio channel, Townhouse Gallery, Cairo
5 **tabla dubb n° 9**, 2002, colour video, sound, DVD, 3 min. 40 sec., video stills
6 **The Hidden Location**, 2004, 4-channel video installation, 52 min., video stills

„Das, was ich zu tun versuche, hat mit dem, was mich umgibt, zu tun; es geht mir darum, ein Gleichgewicht zwischen unmittelbar identifizierbaren visuellen Realitäten und, auf formeller Ebene, ihrem unüblichen Gebrauch herzustellen."

«Ce que je veux faire est lié à mon environnement. En fait, il s'agit pour moi d'atteindre un équilibre entre des réalités visuelles immédiatement identifiables et – au niveau de la forme – leur utilisation insolite.»

"That which I am trying to do is related to that which surrounds me; for me it's about reaching equilibrium between immediately identifiable visual realities and, at the level of form, their use in an unfamiliar way."

2

4

5

6

Jeff Koons

1955 born in York (PA), lives and works in New York (NY), USA

Jeff Koons is generally considered one of the most significant artists of the late 20th century. In his works from the 80s, Koons raised the legacy of Duchamp's ready-made to a new level, yoking it with pop principles of mass consumerism and strategies of display. With a Warholian flourish, Koons took everyday objects of the most banal nature and transformed them through a quasi-alchemical process, requiring the technical proficiency of only the best craftsmen, into monumental elegies on taste and elitism. *Rabbit* (1986) an inflatable bunny holding a carrot, re-cast in highly polished stainless steel, is now an iconic work of that time. An almost impossibly seductive object, it swarms with questions of consumerism, taste, value, innocence, corruption and desire. As Arthur C. Danto put it, Koons found a way of making high art out of low art. His most recent series of works, *Popeye* (2003), marks a return to the trashy vocabulary of inflatable pool toys, this time cast in aluminium and repainted to resemble the originals, but suspended from chains or displayed in ambiguous combinations together with real objects, a sense of unease and tarnished associations thereby underlying their childlike simplicity. The accompanying collage-based paintings present similarly troublesome combinations of children's toys, foodstuffs and sexualized body parts, so tightly cropped together as to produce an effect of all-over surface, a riot of superficial information that denies depth and prevents visual coherence while implying absence, invisibility; a society's lack of soul.

Jeff Koons gilt allgemein als einer der bedeutendsten Künstler des späten 20. Jahrhunderts. Mit seinen Arbeiten aus den achtziger Jahren hat Koons das Erbe von Duchamps Ready-made auf eine gänzlich neue Ebene gehoben, indem er es mit den Pop-Prinzipien von Massenware und Präsentationsstrategien verband. In Warhol'scher Blumigkeit griff Koons die banalsten Alltagsgegenstände auf und verwandelte sie in einem fast alchemistischen Prozess, der das technische Geschick der besten Kunsthandwerker erforderte, in monumentale Elegien auf Geschmack und Elitarismus. *Rabbit* (1986), ein aufblasbares Kaninchen mit Karotte in der Pfote, in polierten Edelstahl gegossen, gilt inzwischen als Ikone jener Epoche. Dieses auf kaum fassbare Weise verführerische Objekt wirft eine Unzahl von Fragen zu Konsum, Geschmack, Wert, Unschuld, Korruption und Begehren auf. In Arthur C. Dantos Worten gelang es Koons, „aus niedriger Kunst hohe Kunst zu machen". Seine jüngste Werkserie, *Popeye* (2003), markiert die Rückkehr zum trashigen Vokabular aufblasbaren Kinderspielzeugs, diesmal aus Aluminium und in Imitation der Originale nachträglich bemalt, allerdings entweder an Ketten hängend oder in mehrdeutigen Kombinationen mit realen Gegenständen, wodurch ihrer kindlichen Einfachheit ein Gefühl der Beklommenheit und getrübter Assoziationen unterlegt wird. Die zugehörigen, nach Collagen entstandenen Gemälde sind ebenfalls verwirrende Synthesen aus Kinderspielzeug, Nahrungsmitteln und sexualisierten Körperteilen, die so eng aneinander gefügt wurden, dass der Effekt eines Allover der Bildteile entsteht, ein Tohuwabohu aus oberflächlichen Informationen, das jede Tiefe negiert, jede visuelle Kohärenz vermeidet und eine Form der Abwesenheit, Unsichtbarkeit, eine Gesellschaft ohne Seele andeutet.

Jeff Koons est généralement considéré comme un des artistes les plus importants de la fin du XXᵉ siècle. Dans son œuvre des années quatre-vingt, il a haussé l'héritage du ready-made de Duchamp sur un nouveau plan en y appliquant les principes pop du consumérisme de masse et des stratégies de présentation. Avec une attitude proprement warholienne, Koons prenait les objets quotidiens les plus banals et les transformait en élégies monumentales du goût et de l'élitisme – dans une sorte de processus alchimique ne faisant appel qu'aux meilleurs artisans. *Rabbit* (1986), un lapin gonflable tenant une carotte, refondu en acier inoxydable ultra-poli, est aujourd'hui une icône de l'époque. Cet objet presque contraire à toute séduction soulève une multitude de questions sur le consumérisme, le goût, la valeur, l'innocence, la corruption et le désir. Comme l'a très bien formulé Arthur C. Danto, Koons a su trouver une manière de faire de l'art «noble» à partir de l'art «trivial». *Popeye* (2003), sa série la plus récente, renoue avec le vocabulaire trivial des jouets de piscine gonflables, coulés ici en aluminium et repeints de manière à ressembler à l'original, mais suspendus à des chaînes ou présentés dans des combinaisons ambiguës d'objets réels, un sens du malaise et des associations glauques sous-tendant leur simplicité enfantine. Les peintures proches du collage qui accompagnent ces objets présentent des combinaisons tout aussi désagréables de jouets d'enfants, de denrées alimentaires et de parties corporelles sexualisées, si étroitement liées qu'elles produisent un effet d'all-over, une profusion d'informations superficielles qui nie toute profondeur et empêche toute cohérence visuelle, tout en produisant un sentiment d'absence et d'invisibilité : un manque d'âme de la société. K. B.

1 **Elvis**, 2003, oil on canvas, 274.3 x 236.2 cm
2 **Bagel**, 2002, oil on canvas 274.3 x 213.4 cm
3 **Elephant**, 2000–2004, high chromium stainless steel, mirror polish finish with transparent colour coating, 92.7 x 73.7 x 48.3 cm
4 **Monkeys (Chair)**, 2003, polychromed aluminium, wood, straw, 284.5 x 58.4 x 73.7 cm

5 **Caterpillar Ladder**, 2003, polychromed aluminium, aluminium, plastic, 218.4 x 111.8 x 193 cm
6 **Dolphin**, 2002, polychromed aluminium, stainless steel, rubber coated steel, 127 x 200 x 97.2 cm

„Kunst ist eine Form der Selbsthilfe, die im Betrachter ein Gefühl der Zuversicht erwecken kann."

«L'art est une manière de s'aider soi-même qui peut instiller au spectateur un sentiment de confiance.»

"Art is a form of self-help that can instill a sense of confidence in the viewer."

2

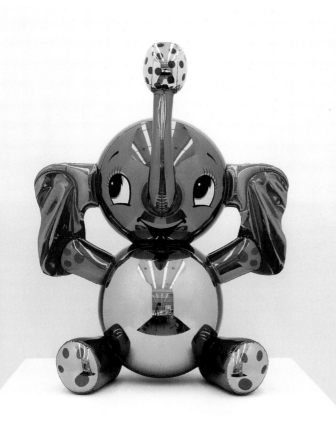

4

6

Jim Lambie

1964 born in Glasgow, lives and works in Glasgow, UK

It is a more glamorous, psychedelically radiating minimalism that Jim Lambie presents in his installations – or which, one could almost say, he allows to perform. Also taking place on this stage is an encounter between such genres as painting, sculpture, object and ready-made, all thoroughly drenched in pop art and nonchalantly loaded with op art's effectiveness. Using such "staging" Lambie transform the exhibition room into a traversable painting. Since 1999 he has also been integrating the floor in this by covering its entire surface with a linear structure made of tape, sometimes gaudily coloured (most of the *Zobop* variants, 1999–2002), and sometimes black-and-white (*Male Stripper*, 2003). What may sound simple produces visually amazing results. Through his concentrically progressing method, the room's outline is repeated from the outside inwards, and is thus increasingly abbreviated. Every irregularity, such as an angle or pillar, asserts itself more and more. Thus Lambie creates a progressive rendition of the room upon its surface, and ensnares it at the same time. This goes beyond the appreciable psychedelic effect, and for all its supposed affiliation with painting is also a satisfyingly sculptural way of dealing with space, therefore being perhaps closer to Carl Andre than to Bridget Riley. Lambie then introduces further exhibits with distinctively independent existences into this type of parallel universe. Much is connected with musical pop culture in this. Work and installations are named after bands or song titles, and objects are made from records (*Funkadelic*, 2002), record covers (*Karma Man*, 2000), or record players covered with glitter (*Graffiti*, 1999). This also harbours an ironic nostalgia: Lambie demonstrates out-dated technology as a fetichized artefact.

Es ist ein glamouröser, psychedelisch ausstrahlender Minimalismus, den Jim Lambie in seinen Installationen vorführt – fast möchte man sagen: zur Aufführung bringt. Auf dieser Bühne wird auch eine Begegnung von Gattungen wie Malerei, Skulptur, Objekt und Ready-made inszeniert, die dabei durchweg popgetränkt und ziemlich lässig mit der Wirksamkeit von Op Art aufgeladen ist. Durchs „Staging" verwandelt Lambie den Ausstellungsraum in ein begehbares Bild. Seit 1999 bezieht er dafür auch den Boden ein, indem er ihn flächendeckend mit einem linearen Gefüge aus mal grellbuntem (die meisten *Zobop*-Varianten, 1999–2002), mal auch schwarzweißem Klebeband versieht (*Male Stripper*, 2003). Was simpel klingt, zeigt visuell verblüffende Ergebnisse: Durch die konzentrische Vorgehensweise pflanzt sich der Grundriss des Raums nach hinten hin fort und unterliegt dabei fortschreitender Verkürzung. Jede Unregelmäßigkeit, Winkel oder Pfeiler etwa, macht sich dabei zunehmend geltend. So bildet Lambie den Raum in progressiver Übersetzung auf die Fläche hin ab und bindet ihn zugleich: Das ist über spürbar psychedelische Effekte hinaus und bei aller vermeintlichen Nähe zur Malerei auch ein überzeugend skulpturaler Umgang mit Raum und damit vielleicht näher an Carl Andre als an Bridget Riley. In ein solches Paralleluniversum führt Lambie dann weitere Exponate mit ausgeprägtem Eigenleben ein. Vieles ist dabei mit musikalischer Popkultur verknüpft: Arbeiten und Installationen werden nach Bands oder Songtiteln benannt, Objekte aus Schallplatten (*Funkadelic*, 2002), Covern (*Karma Man*, 2000) oder mit Glitterstaub besetzten Plattenspielern (*Graffiti*, 1999) gefertigt. Darin liegt auch ironische Nostalgie: Lambie demonstriert überholte Technik als fetischisiertes Artefakt.

Dans ses installations, Jim Lambie présente – on devrait presque dire met en scène – un minimalisme glamour et psychédélique. Sur ce plateau de présentation, Lambie met aussi en scène la rencontre de différents genres artistiques tels que la peinture, la sculpture, l'objet et le ready-made, une rencontre entièrement imprégnée de Pop Art et intégrant de manière assez distante les effets de l'Op Art. Grâce à ce *staging*, Lambie transforme l'espace d'exposition en tableau pénétrable. Depuis 1999, cette démarche inclut aussi le sol, dont la surface est intégralement recouverte d'une trame linéaire faite de rubans adhésifs – tantôt de couleurs criardes (la plupart des variantes *Zobop*, 1999–2002), tantôt noir et blanc (*Male Stripper*, 2003). Ce qui peut paraître banal présente des effets visuels époustouflants : la démarche concentrique perpétue le plan de la salle vers le centre et lui fait ainsi subir un raccourcissement graduel. Par une transposition progressive, Lambie reproduit ainsi l'espace vers la surface tout en le fixant, ce qui, indépendamment des effets nettement psychédéliques et en dépit des connotations picturales, représente aussi un traitement sculptural convainquant de l'espace et rapproche l'artiste d'un Carl Andre plutôt que d'une Bridget Riley. Dans cet univers parallèle, Lambie présente alors des objets d'exposition dénotant une vie propre très affirmée. Nombre d'éléments sont associés à la culture musicale pop. Les titres des œuvres et des installations sont empruntés à des groupes musicaux ou reprennent des titres de chansons, les objets sont réalisés à partir de disques (*Funkadelic*, 2002), de pochettes de disques (*Karma Man*, 2000) ou encore de tournedisques recouverts de poussière de strass (*Graffiti*, 1999). Tout cela dénote aussi une nostalgie ironique : Lambie présente la technique obsolète sous forme d'artefact fétichisé.

J. A.

SELECTED EXHIBITIONS →
2005 Dallas Museum of Art **2004** *Boros Collection*, Zentrum für Kunst und Medientechnologie, Karlsruhe; *Stalemate*, Museum of Contemporary Art, Chicago **2003** *Male Stripper*, Modern Art Oxford; *Paradise Garage*, The Moore Space, Miami; *Zenomap*, 50. Biennale di Venezia, Venice; Tate Triennial, Tate Britain, London **2002** *Early One Morning*, Whitechapel Art Gallery, London; *Hello My Name Is...*, Carnegie Museum of Art, Pittsburgh

SELECTED PUBLICATIONS →
2004 *Voidoid*, Cologne; *Boros Collection*, Zentrum für Kunst und Medientechnologie, Karlsruhe

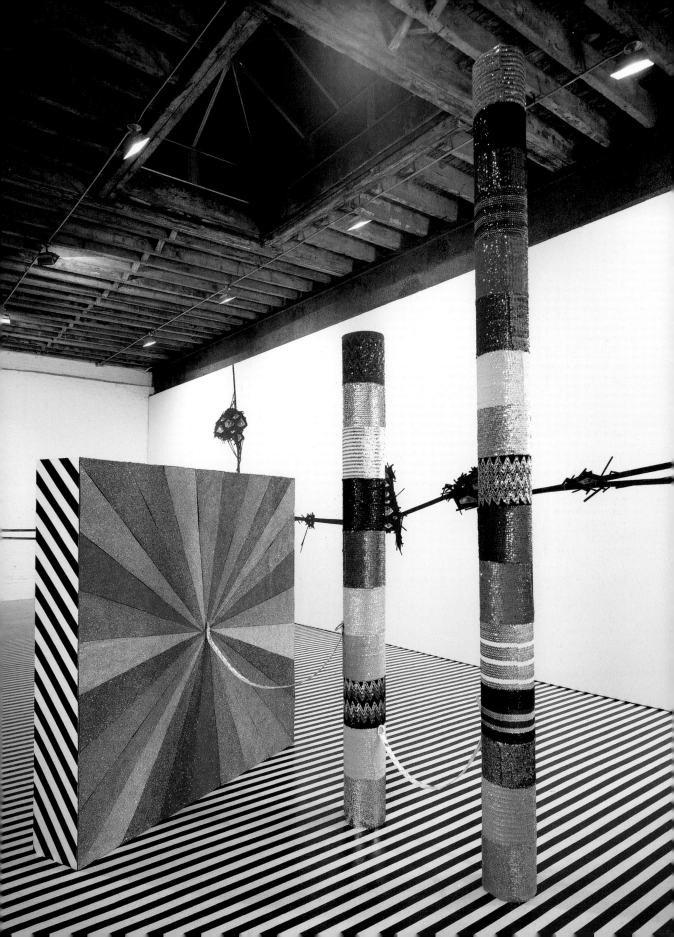

1 **Mental Oyster**, 2004, installation view, Anton Kern Gallery, New York
2 **The Jesus and Mary Chain**, 2004, metal, wood, handbags, concrete base, installation view, Carnegie International, Carnegie Museum of Art, Pittsburgh

3 **Ska's Not Dead**, 2001, turntable, glitter, glove, mixed media, 36 x 36 x 72 cm
4 **Master Blaster**, 2001, poster eye collage, dimensions variable

„Jetzt möchte ich mich weiter ins Innere bewegen, ins tiefe Innere. Und ich nehme das Äußere mit, ich nehme alles mit … alle Titel, alle eure Handschuhe, alle eure Spiegel, alle eure Plattensammlungen, alles. Und wenn es zurückkehrt in die wirkliche Welt, wird es euch vertraut scheinen, aber das wird es nicht sein."

«En ce moment, je veux m'avancer plus profondément vers l'intérieur. Et j'y emporte l'extérieur, je prends tout avec moi… tous les titres, tous vos gants, tous vos miroirs, toutes vos collections de disques, tout. Et quand cela revient dans le monde réel, votre monde, ça vous semblera familier, mais ça ne le sera pas.»

"Right now I want to go further inside, deep inside. And I'm taking the outside with me, I'm taking it all with me … all the titles, all your gloves, all your mirrors, all your record collections, the lot. And when it comes back out into the real world, your world, it'll feel familiar, but it won't be."

2

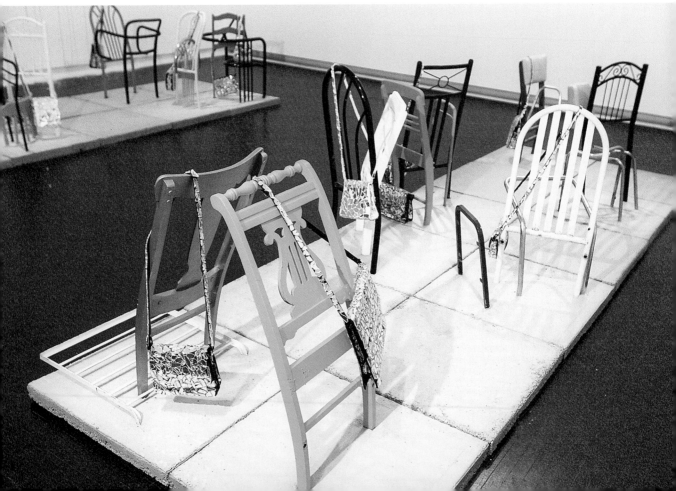

3

4

Ulrich Lamsfuß

1971 born in Bonn, lives and works in Berlin, Germany

One could refer to Ulrich Lamsfuß' studio as an "image factory". Here the artist paints everything he gets his eyes on and that in some way interests him, apparently without restriction. He takes the images for his photo-realistic paintings just as much from lifestyle magazines and natural science periodicals as from advertising or art history. With the care and technical expertise of a copyist, the painter then translates the media flood of images from contemporary life into apparently traditional oil painting: He places a precisely reproduced close-up of a bathing hippopotamus (*Nilpferd. Frans Lanting, National Geographic*, 2004) beside the depiction of a starving Somalian mother with her child (*Mutter und Kind im Krankenhaus, Somalia 1992. Chris Steele-Perkins, Magnum*, 2004). The question of content is invalid here – instead, the motif and the possibilities of transposing it as a reproduction are the theme of Lamsfuß' pictures. Thereby he adopts classical painting compositions from art history again and again. Detached from its original context, the painted image is simultaneously a copy and an original. Lamsfuß multiplies this perception in series such as *Untitled (Indian Girl)* (2001), in which he reproduced, six times and with only minor differences, the photo of the half-naked model Natasha Prince decked out in Indian feathers. In *Thomas Struth, Paradies #7. Daintree/Australia, 1998, New Pictures from Paradise* (2004), Lamsfuß uses painterly techniques to realize Thomas Struth's photograph *Paradies #7*, 1998, as a painting. As with all of Lamsfuß' works, the new piece created in this way also explores, not least, the limits of the innumerable images which inundate us daily.

Das Atelier von Ulrich Lamsfuß kann man als eine Art „Image factory" bezeichnen. Hier malt Lamsfuß scheinbar ohne Einschränkung alles, was ihm vor die Augen kommt und ihn auf irgendeine Weise interessiert. Die Vorlagen für seine fotorealistischen Gemälde findet er genauso in Lifestyle-Magazinen und naturwissenschaftlichen Zeitschriften wie in der Werbung oder der Kunst(geschichte). Mit der Sorgfalt und dem handwerklichen Können eines Kopisten überträgt der Maler dann die mediale Bilderflut unserer Gegenwart in scheinbar traditionelle Ölmalerei: Eine präzise nachempfundene Nahaufnahme eines badenden Nilpferdes (*Nilpferd. Frans Lanting, National Geographic*, 2004) stellt er neben die Darstellung einer hungernden somalischen Mutter mit ihrem Kind (*Mutter und Kind im Krankenhaus, Somalia 1992. Chris Steele-Perkins, Magnum*, 2004). Die Frage nach dem Inhalt ist hier hinfällig – das Motiv und die Möglichkeiten seiner reproduzierten Umsetzung sind stattdessen das Thema der Bilder von Lamsfuß. Dabei greift er immer wieder klassische Bildkompositionen der Kunstgeschichte auf. Ihrem ursprünglichen Kontext entrissen, ist die gemalte Abbildung Kopie und Original zugleich. Diese Wahrnehmung vervielfacht Lamsfuß in Serien wie *Untitled (Indian Girl)* (2001): Sechsmal hat er das Foto des halbnackten, mit Indianerfedern geschmückten Models Natasha Prince mit nur geringen Abweichungen vervielfältigt. In *Thomas Struth, Paradies #7. Daintree/Australia, 1998, New Pictures from Paradise* (2004) setzt Lamsfuß die Fotografie *Paradies #7* (1998) von Thomas Struth mit den Mitteln der Malerei in ein Gemälde um. Das so entstandene neue Werk lotet, wie alle Arbeiten von Lamsfuß, nicht zuletzt auch die Grenzen der unzähligen Bilder aus, die täglich auf uns einströmen.

L'on peut décrire l'atelier d'Ulrich Lamsfuß à bon droit comme une sorte d'«image factory». Lamsfuß y peint sans restriction visible tout ce qui passe à portée de son regard et l'intéresse pour une raison ou pour une autre. Les modèles de ses peintures photoréalistes sont tout aussi bien tirés de magazines de style de vie et de revues scientifiques que de la publicité ou de (l'histoire de) l'art. Avec la méticulosité et le métier accompli du copiste, le peintre transpose ensuite le déluge d'images de l'époque contemporaine dans une peinture à l'huile d'apparence traditionnelle : la reproduction précise du gros plan d'un hippopotame (*Nilpferd. Frans Lanting, National Geographic*, 2004) est placée à côté de la représentation d'une mère somalienne famélique et de son enfant (*Mutter und Kind im Krankenhaus, Somalia 1992. Chris Steele-Perkins, Magnum*, 2004). La question du contenu est ici caduque – le motif et les possibilités offertes par sa transposition et sa reproduction en tiennent lieu et constituent le thème des tableaux de Lamsfuß. L'artiste fait régulièrement appel pour cela à des compositions classiques de l'histoire de l'art. Arrachée à son contexte initial, la reproduction peinte est à la fois copie et original. Cette perception, Lamsfuß la multiplie dans des séries comme *Untitled (Indian Girl)* (2001) : l'artiste a reproduit six fois, avec de légères variations, la photo de la top-modèle Natasha Prince torse nu, affublée de plumes d'Indien. Dans *Thomas Struth, Paradies #7. Daintree/Australia, 1998, New Pictures from Paradise* (2004), Lamsfuß transpose la photographie *Paradies #7* (Thomas Struth, 1998) dans les moyens de sa peinture. Comme toutes les œuvres de Lamsfuß, celle-ci sonde elle aussi les limites des images innombrables qui nous assaillent quotidiennement. C.R.

SELECTED EXHIBITIONS →
2003 Prague Biennale 1 **2001** *Offensive Malerei. Malerei im Spannungsfeld neuer Medien*, Lothringer 13/Halle, Munich; *Beaucoup de plaisir*, Espace Paul Ricard, Paris

SELECTED PUBLICATIONS →
2001 *Offensive Malerei. Malerei im Spannungsfeld neuer Medien*, Lothringer 13/Halle, Munich

„Ich mag das Alte, Klassische, ‚Erhabene' als klar erkennbares Werkzeug der Fiktion."

« J'aime l'ancien, le classique, le ‹ sublime › en tant qu'outil clairement reconnaissable de la fiction. »

"I like the old, classical, 'sublime' as a clearly recognizable tool of fiction."

3

Zoe Leonard

1961 born in New York (NY), lives and works in New York (NY), USA

Since several lengthy trips to Alaska during the mid-1990s, Zoe Leonard has subtly altered the content of her art practice, turning away from earlier inquiries into gender and sexuality toward extended meditations on how the effects of time can manifest themselves in objects and on the relationship between the man-made and the natural. Her poetic photographs, sculptures, and installations, all of which work with found objects, possess a sly political edge that lends weight to her documentation of the fleetingly beautiful. One of the largest individual artworks to date is *Tree* (1997), for which she disassembled a twenty-one-foot tall tree and reconstructed it – with the aid of steel supports, cables, and joints – inside the Paula Cooper Gallery. The denuded limbs, sutured together and set against the white walls of the gallery, spoke of the havoc mankind has visited upon nature; an ongoing series of photographs depicting "survivalist" trees growing over and around fences, wooden boxes, and through cracks in concrete complicates an essentialist reading of the sculpture. *Analog*, an ongoing archive currently comprising several thousand photographs that is equal parts artistic venture and documentary undertaking, catalogues the disappearance of handmade signage (and with it, small businesses) on the Lower East Side of Manhattan, where she lived for over twenty years, as well as cities around the world. Never didactic – she shows rather than tells – Leonard consistently extrapolates larger lessons from her heightened attention to the tiny details comprising everyday life.

Nach mehreren längeren Reisen, die sie Mitte der neunziger Jahre nach Alaska unternahm, hat sich die künstlerische Praxis von Zoe Leonard inhaltlich subtil gewandelt und sich von früheren gender- und sexualitätsspezifischen Untersuchungen wegbewegt, um sich allgemeineren Betrachtungen über die Auswirkung der Zeit auf Objekte und das Verhältnis zwischen Menschengemachtem und Natürlichem zuzuwenden. Ihre poetischen Fotos, Skulpturen und Installationen, die sämtlich unter Verwendung gefundener Objekte entstehen, verfügen über einen verstohlenen politischen Aspekt, der ihrer Dokumentation des vergänglichen Schönen Gewicht verleiht. Eine ihrer bislang größten Einzelarbeiten ist *Tree* (1997), für die sie einen mehr als sechs Meter hohen Baum zertrennte, um ihn anschließend – mithilfe von Stahlstützen, Kabeln und Klemmen – in den Räumen der Paula Cooper Gallery wieder zusammenzusetzen. Die entblößten Glieder des Baums, miteinander verbunden und den weißen Wänden der Galerie gegenübergestellt, gaben Aufschluss über die Verwüstung, mit der der Mensch der Natur begegnet. In einer fortlaufenden Serie von Fotografien, die über und um Drahtzäune, Holzkisten und durch Risse im Asphalt wachsende, „überlebende" Bäume zeigen, wird eine wesensmäßige Auslegung von Skulptur erschwert. In *Analog*, einem ebenfalls fortlaufenden Archiv, das bislang aus einigen tausend Fotografien besteht, ein gleichermaßen künstlerisches wie dokumentarisches Unterfangen, wird das Verschwinden handgemachter Schilder (und, damit einhergehend, des Kleingewerbes) in Manhattans Lower East Side, wo die Künstlerin seit mehr als zwanzig Jahren lebt, wie auch in anderen Städten weltweit aufgezeichnet. Niemals didaktisch – das Zeigen wird dem Mitteilen vorgezogen –, zieht Leonard konsequent allgemeinere Schlussfolgerungen aus ihrer geschärften Beobachtung jener winzigen Details, die den Alltag ausmachen.

Depuis ses longs voyages en Alaska au milieu des années quatre-vingt-dix, Zoe Leonard a subtilement modifié le contenu de sa pratique artistique, délaissant ses premières explorations du genre sexuel et de la sexualité au profit de vastes méditations sur la manière dont les effets du temps se manifestent sur certains objets et sur le rapport entre la nature et les réalisations humaines. Ses photographies, sculptures et installations poétiques, toutes réalisées à partir d'objets trouvés, dénotent une tendance sournoisement politique qui confère un poids supplémentaire à sa documentation de la beauté éphémère. *Tree* (1997), une œuvre pour laquelle Leonard a découpé un arbre de sept mètres de haut pour le reconstituer à l'intérieur de la Paula Cooper Gallery à l'aide d'étais en acier, de câbles et de raccords, est l'une de ses plus grandes réalisations individuelles à ce jour. Les branches dénudées, leur raccordement et la manière dont elles se détachaient sur les murs blancs de la galerie, évoquaient les dégâts naturels causés par l'humanité. Une série encore inachevée de photographies montrant des «forcenés de la survie», c'est-à-dire des arbres poussant par-dessus et autour de clôtures, de caisses en bois ou à travers des bétons fissurés, complique la lecture essentialiste de la sculpture. *Analog*, un flot d'archives inachevé comprenant plusieurs milliers de photographies et relevant de la démarche artistique autant que du propos documentaire, dresse un catalogue de la disparition des enseignes réalisées à la main (et donc du petit commerce) dans Lower East Side, à Manhattan, où l'artiste a vécu pendant plus de vingt ans, et dans d'autres villes de par le monde. Jamais didactique – elle montre plus qu'elle ne raconte –, Leonard extrapole systématiquement des leçons plus vastes à partir de l'attention accrue qu'elle porte aux petits détails qui font la vie quotidienne.

B. S.

SELECTED EXHIBITIONS →
2004 Triennale Kleinplastik Fellbach **2003** *A Clear Vision – Photographien aus der Sammlung F. C. Gundlach*, Deichtorhallen Hamburg; *Phantom der Lust – Visionen des Masochismus in der Kunst*, Neue Galerie am Landesmuseum Joanneum, Graz; *Mouth Open, Teeth Showing*, Museum für Gegenwartskunst, Siegen; *Eric Hattan Zoe Leonard Michel François Eddie Chu*, Swiss Institute, New York

SELECTED PUBLICATIONS →
2001 *Double Life: Identity and Transformation in Contemporary Art*, Cologne

1 **Yellow, Pink, and Blue Bundle**, 2001, detail from work in progress, C-print/workprint

2 **For Which It Stands**, 2003, 32 postcards (multiples), steel postcard rack, Plexiglass and wood money box, dimensions variable, installation view, Massachusetts Museum of Modern Art, North Adams

3 **Shoes**, 2000/01, detail from work in progress, C-print/workprint

4 **House**, 2001/02, dye transfer print, 36 x 55.6 cm

2

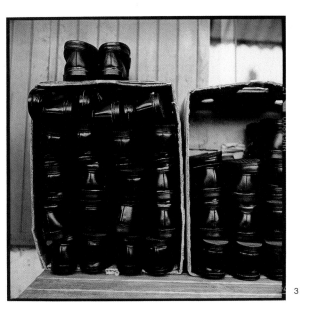

3

4

Won Ju Lim

1968 born in Gwangju, South Korea, lives and works in Los Angeles (CA), USA

Won Ju Lim's sculptures explore the transformations that our comprehension of architecture, city and landscape undergo as they shift from our daily surroundings, to cinematic representation, utopian construct, contemporary reportage or historical documentation. With *California Dreamin'* (2002), she built a multi-dimensional vision of the myth-laden state: a Lilliputian cityscape where modernistic buildings modelled in foamcore and Plexiglass formed the centre within a kaleidoscopic field of overlapping illuminations and projections of towering palm trees and modernistic skylines. Lim's dramatic use of lighting and sensitive combinations of materials, exploiting the properties of transparency and opacity to considerable pictorial effect, are also present in her recent works titled *Memory Palace*. Referring to the teachings of 16th-century Jesuit Matteo Ricci about a palace of the mind furnished with mnemonic devices, Lim examines the interlocking of real with imaginary spaces in wall-based lightboxes which splice together elements of baroque architecture with details from ancient Asian landscape traditions, set design and shadow puppetry. Whereas the question of scale was central to her previous room-size installations, these light/ shadow-boxes present an enclosed space lit with either warm orange-hued or cool blue light that seems laden with mystery and tricky multiple perspectives that imply the illusionary haze of overlapping memories.

Won Ju Lim untersucht in ihren Skulpturen die Transformationen, die unser Verständnis von Architektur, Stadt und Landschaft erfährt, wenn sich diese Elemente von der alltäglichen Umwelt zur filmischen Darstellung, utopischen Konstruktion, zeitgenössischen Reportage oder historischen Dokumentation wandeln. Für ihre Installation *California Dreamin'* (2002) schuf sie eine mehrdimensionale Vision jenes von Mythen befrachteten amerikanischen Staates: eine Lilliput-Stadtlandschaft, in der aus Schaumpappe und Acrylglas modellierte modernistische Bauten das Zentrum eines kaleidoskopischen Feldes aus sich überschneidenden Lichteffekten und Projektionen von aufragenden Palmen und modernistischen Skylines bilden. Die dramatische Beleuchtung sowie feinsinnige Kombinationen von Materialien, deren Eigenschaften wie Transparenz und Undurchsichtigkeit für erstaunliche Bildeffekte genutzt werden, finden sich auch in Lims neueren Arbeiten mit dem Titel *Memory Palace*. Unter Bezugnahme auf die im 16. Jahrhundert verfassten Lehren des Jesuiten Matteo Ricci über einen mit mnemonischen Instrumenten ausgestatteten Gedächtnispalast untersucht Lim die Verschachtelung von realen und imaginären Räumen. In an Wänden angebrachten Leuchtkästen sind Elemente barocker Architektur mit Details asiatischer Landschaftstraditionen, Bühnenbild und Schattenspiel miteinander verbunden. Während in ihren früheren raumgreifenden Installationen die Frage des Maßstabs von zentraler Bedeutung war, präsentieren diese Licht/Schattenkästen einen entweder in warmes orangefarbenes oder kühles blaues Licht getauchten, eingegrenzten Raum, der von Mysterien und vertrackten Mehrfachperspektiven beherrscht ist, die den illusionären Dunst sich überlagernder Erinnerungen andeuten.

Les sculptures de Won Ju Lim explorent les transformations subies par notre compréhension de l'architecture, de la ville et du paysage lorsque ceux-ci passent de notre environnement quotidien dans les domaines de la représentation cinématographique, du concept utopique, du reportage contemporain ou du document historique. Avec *California Dreamin'* (2002), elle a élaboré une vision multidimensionnelle de l'Etat et de ses mythes : un paysage urbain lilliputien dont les immeubles modernes réalisés en carton plume et en plexiglas constituaient le centre dans un espace kaléidoscopique de superpositions d'illuminations et de projections de hauts palmiers et de skylines modernistes. L'utilisation spectaculaire des éclairages et les sensibles combinaisons de matériaux, dont Lim exploite les propriétés de transparence et d'opacité pour créer des effets puissamment picturaux, sont également présentes dans une œuvre récente comme *Memory Palace*. Se référant aux enseignements du jésuite Matteo Ricci au XVIe siècle concernant un palais de l'esprit entièrement meublé d'éléments mnémoniques, Lim étudie l'enchevêtrement d'espaces réels et imaginaires dans des caissons lumineux fixés au mur et combinant éléments de l'architecture baroque, détails d'anciennes traditions paysagères asiatiques, décoration intérieure et théâtre d'ombres. Alors que les problèmes d'échelle étaient au centre de ses installations antérieures, qui investissaient l'espace d'exposition, ces caissons d'ombres et de lumières proposent un espace clos éclairé par une lumière chaude, teintée d'orangé, ou froide, d'un bleu mystérieux, qui semble chargé d'habiles perspectives multiples impliquant le regard trompeur des mémoires qui se chevauchent.

K. B.

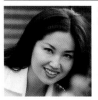

SELECTED EXHIBITIONS →
2004 *Zwischenwelten*, Museum Haus Esters, Krefeld **2003** *Elysian Field North*, Vancouver Art Gallery **2002** *There: Sites of Korean Diaspora*, 4. Gwangju Biennale **2001** *Longing for Wilmington*, Museum für Gegenwartskunst, Siegen; *Snapshot: New Art from Los Angeles*, Museum of Contemporary Art, North Miami; The Hammer Museum, Los Angeles

SELECTED PUBLICATIONS →
2002 *There: Sites of Korean Diaspora*, Gwangju **2001** *Skulptur-Biennale Münsterland*, Kreis Steinfurt; *Snapshot: New Art from Los Angeles*, Museum of Contemporary Art, North Miami **2000** *Won Ju Lim*, Künstlerhaus Bethanien, Berlin

1 **Memory Palace (Terrace 49 #2)**, 2003, mixed media, 106.7 x 106.7 cm
2 **Memory Palace (Baroque #4)**, 2004, lightbox, frosted Mylar, containing sculpture out of mixed media, 107.1 x 178.3 x 50.5 cm
3 Installation view, **Memory Palace**, 2004, Galerie Max Hetzler, Berlin

4 **Abazzaba**, 2004, Plexiglass, acrylic platform, fluorescent lights, dimensions variable
5 **California Dreamin'**, Plexiglass, foam core board, DVD projections, lamps, dimensions variable

„Ich benutze meine Erinnerungen und meine Vorstellungskraft, um fantastische Interieurs zu erschaffen, die nicht an einen Punkt oder einen tatsächlich existierenden Ort gebunden sein müssen."

«J'utilise mes souvenirs et mon imagination pour créer des intérieurs fantastiques, qui ne se rattachent pas nécessairement à un point ou un lieu réel.»

"I am using my recollections and imagination to create fantastic interiors that are not necessarily attached to a point or a real place."

2

3

4

5

Sharon Lockhart

1964 born in Norwood (MA), lives and works in Los Angeles (CA), USA

The works of the filmmaker and photographer Sharon Lockhart move within a dynamic area between artistic production and that free region which is beyond all control. Her conceptualism is influenced by the tradition of structuralist film just as much as by the experimental set-ups of medical and anthropological photography. *Interview Locations* (1999), was created during a journey through Brazil's Amazon region in the company of two female anthropologists. After the researchers scientifically questioned Brazilian women, Lockhart photographed the location in which the interviews had just taken place. She exhibited the sober black and white photographs beside photos from the questioned persons' family albums. Individuality also disturbs the abstraction in Lockhart's photographic portraits. The intensity of these close-up individual portraits or staged "snapshots" is augmented through small deviations or asymmetries within the staged settings. Despite all his reserved solemnity the photograph of a young man, hands on hips and gazing past the viewer, achieves atmospheric drama in *Untitled* (1996). An avant-garde variation of the Ikebana tradition, the practice of Nô-no-ikebana in which fruit and vegetables are placed in arrangements, served as the inspiration for the film *Nô* (2003). Shot in one single 30-minute take it shows the "creation of a landscape painting" (Lockhart). Working their way slowly to the foreground of the picture, a farm couple pile haystacks on a field. The shot is choreographed, the softly shimmering colour spectrum precisely arranged: the art of Ikebana characterizes not only the activity of the field labourers, but also that of the artist.

Die Arbeiten der Filmemacherin und Fotografin Sharon Lockhart bewegen sich im Spannungsfeld zwischen künstlerischer Inszenierung und dem sich jeglicher Kontrolle entziehenden freien Raum. Ihr Konzeptualismus ist von der strukturalistischen Filmtradition ebenso beeinflusst wie von den Versuchsanordnungen medizinischer oder anthropologischer Fotografie. Während einer Reise durch das brasilianische Amazonas gebiet in Begleitung zweier Anthropologinnen entstand *Interview Locations* (1999). Nach den wissenschaftlichen Befragungen brasilianischer Frauen durch die Forscherinnen fotografierte Lockhart den Ort, an dem zuvor die Interviews stattgefunden hatten. Die nüchternen Schwarz weißaufnahmen stellte sie neben Fotografien aus den Familienalben der Befragten. Auch in Lockharts fotografischen Porträts bricht Individu alität die Abstraktion: Die Intensität der nahsichtigen Einzelporträts oder gestellten „Momentaufnahmen" wird durch kleine Abweichungen oder Asymmetrien innerhalb der Inszenierungen verstärkt. Aller distanzierten Rigidität zum Trotz erscheint die Aufnahme eines jungen Mannes, der die Hände in die Hüften gestützt, am Betrachter vorbei blickt, voll atmosphärischer Dichte (*Untitled*, 1996). Eine avantgardistische Variante der Ikebana-Tradition, die Praxis des Nô-no-ikebana, bei dem Obst und Gemüse zu Arrangements gesteckt werden, diente als Inspiration für den Film *Nô* (2003). Gedreht in einer einzigen dreißigminütigen Einstellung zeigt *Nô* die „Entstehung eines Landschaftsbildes" (Lockhart): Ein Bauern paar schichtet, sich langsam zum Bildvordergrund arbeitend, Heuhaufen auf einem Feld auf. Die Aufnahme ist choreografiert, das sanft schimmernde Farbspektrum genau arrangiert: Die Kunst des Ikebana kennzeichnet nicht nur die Tätigkeit der Feldarbeiter, sondern auch die der Künstlerin.

Les œuvres de la photographe et réalisatrice Sharon Lockhart s'inscrivent dans un champ de tension qui se situe entre la mise en scène artistique et un espace libre échappant à tout contrôle. Le conceptualisme de Lockhart est influencé par la tradition cinématographique struc turaliste autant que par les approches expérimentales de la photographie médicale et anthropologique. *Interview Locations* (1999) a vu le jour avec le concours de deux femmes anthropologues, pendant un voyage à travers la forêt amazonienne du Brésil. Après les enquêtes scienti fiques réalisées par les chercheuses auprès de femmes brésiliennes, Lockhart a photographié les lieux où s'étaient déroulées les interviews. Les sobres photographies en noir et blanc ont été placées en regard de photos tirées des albums de famille des personnes interrogées. Dans les portraits photographiques de Lockhart aussi, l'individualité vient rompre l'abstraction : l'intensité des portraits individuels présentés en plan rapproché ou des « instantanés » posés est encore renforcée par de petits écarts ou asymétries dans la mise en scène. Malgré toute la rigueur distante de cette œuvre, la photographie d'un jeune homme aux mains campées sur les hanches, et dont le regard passe à côté du specta teur, présente une densité toute atmosphérique (*Untitled*, 1996). Une variante avant-gardiste de la tradition de l'ikebana, la pratique du Nô-no ikebana, dans laquelle des fruits et des légumes sont disposés sous forme d'arrangements, a servi d'inspiration au film *Nô* (2003). Tourné en plan fixe de 30 minutes, *Nô* montre la « genèse d'une image du paysage » (Lockhart) : au fil de son travail, un couple de paysans se rapproche du premier plan en entassant des meules de foin dans un champ. La prise de vue est chorégraphiée, le spectre chromatique aux doux chatoiements méticuleusement arrangé : l'art de l'ikebana ne caractérise pas seulement l'activité des agriculteurs, mais aussi l'artiste elle-même.

E. K

SELECTED EXHIBITIONS →
2004 Whitney Biennial, Whitney Museum of American Art, New York
2003/04 *Strange Days*, Museum of Contemporary Art, Chicago
2003 *Conceptualismus*, Akademie der Künste, Berlin **2002** 2. Triennale der Fotografie, Kunstverein Hamburg **2001** Museum of Contemporary Art San Diego; Museum of Contemporary Art, Chicago; *Public Offerings*, The Geffen Contemporary at MOCA, Los Angeles

SELECTED PUBLICATIONS →
2003 *fast forward: Media Art Sammlung Goetz*, Sammlung Goetz, Munich, Zentrum für Kunst und Medientechnologie, Karlsruhe
2002 *Triennale der Fotografie*, Kunstverein Hamburg, Hamburg; *Mask or Mirror? A Play of Portraits*, Worcester Art Museum, Worcester
2001 *Sharon Lockhart*, Museum of Contemporary Art San Diego; San Diego; Museum of Contemporary Art, Chicago; *Public Offerings*, The Museum of Contemporary Art, Los Angeles

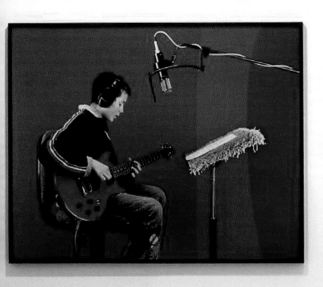

STUFF J Litt

1 Installation view, Galleria Giò Marconi, Milan; back: **Untitled (Boy with Guitar)**, 2005, chromogenic print, 124.5 x 157.5 cm, front: **Balam Garcia, Stuff I Like**, 2005, recordplayer, record

2 **Nô-no-Ikebana**, arranged by Haruko Takeichi, 1 December 2002 (December 2–3), 3 chromogenic prints, each 57.2 x 71.1 cm

3 **Untitled (Zadka)**, 2005, chromogenic print, 91.5 x 115.5 cm

„Ich entwickle häufig Strukturen, in denen etwas passiert, auf das ich keinen Einfluss habe."

« J'élabore souvent une structure à l'intérieur de laquelle se produisent des choses qui échappent à mon contrôle. »

"I often set up a structure in which things happen that are uncontrolled by me."

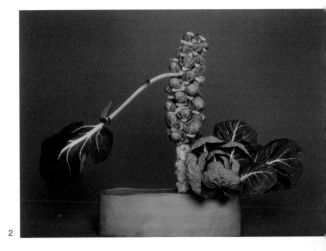

2

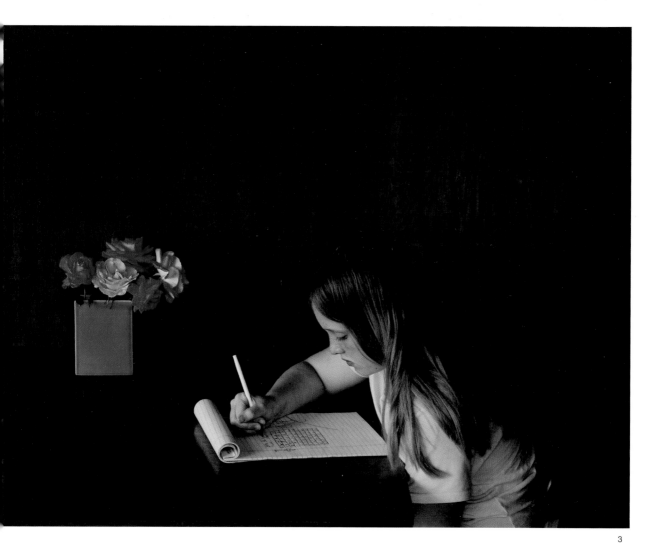

3

Sarah Lucas

1962 born in London, lives and works in London, UK

Together with Tracey Emin, Sarah Lucas is one of the best-known protagonists of the YBA (Young British Artists) phenomenon. In 1993 the two artists opened their "shop" in London, which was both a sales and exhibition room, and a meeting-place for the young art scene. This deliberate appropriation of avant-garde practices, fully conscious of the already legendary status of Andy Warhol's Factory or Vivienne Westwood's World's End, was simultaneously a skilful gesture of self-empowerment within the London art system. Lucas became known through a series of photographic self-portraits created during the 1990s. In often seemingly coarse visual language she presents herself as a pimp for sexual stereotypes and resorts to moments of aggressiveness in dealing with femininity and sexuality in daily culture. In *Eating a Banana* (1990), wearing a leather jacket and unisex haircut and in a manner denying any lasciviousness, she stuffs a banana into her mouth on the street. This aggressive reductionism also marks Lucas' material assemblages, the titles of which linger around them like offensive remarks: for instance *Christ, You Know It Ain't Easy* (2003), a depiction of the crucified Christ made up of Marlboro Light cigarettes, which blasphemously immortalizes the suffering of nicotine withdrawal. There was some protest against this, but incomparably fiercer were the reactions to a work that struck a sore spot with the British public: *All We Are Saying Is Give Pizza a Chance* (2003) a bomb built out of pizza delivery brochures, was a little too reminiscent of the "advertising campaign" for the war against Iraq that Great Britain was pursuing.

Gemeinsam mit Tracey Emin zählt Sarah Lucas zu den bekanntesten Protagonistinnen des Phänomens YBA (Young British Artists). 1993 eröffneten die beiden Künstlerinnen in London ihren „Shop", zugleich Verkaufs- und Ausstellungsraum und Treffpunkt der jungen Kunstszene. Diese gezielte Aneignung avantgardistischer Praktiken, im Bewusstsein des mittlerweile legendären Status von Andy Warhols Factory oder Vivienne Westwoods Laden World's End, war zugleich eine geschickte Geste der Selbstermächtigung innerhalb des Londoner Kunstsystems. Lucas wurde mit einer Serie fotografischer Selbstporträts bekannt, die im Lauf der neunziger Jahre entstanden. In einer oft grobschlächtig anmutenden Bildsprache inszeniert sie sich als Erfüllungsgehilfin sexistischer Stereotypen und greift Momente der Aggressivität im Umgang mit Weiblichkeit und Sexualität in der Alltagskultur auf. In *Eating a Banana* (1990) stopft sie sich, in einem jegliche Laszivität verweigerndem Gestus, mit Lederjacke und Unisex-Haarschnitt, auf der Straße eine Banane in den Mund. Dieser angriffslustige Reduktionismus kennzeichnet auch Lucas' Materialassemblagen, deren Titel wie anzügliche Bemerkungen an ihnen hängen bleiben: etwa *Christ, You Know It Ain't Easy* (2003), eine Darstellung des gekreuzigten Christus aus Marlboro-Light-Zigaretten, die blasphemisch die Leiden der Nikotinentwöhnung verewigt. Die Proteste blieben nicht aus, doch ungleich heftiger waren die Reaktionen auf eine Arbeit, die die britische Öffentlichkeit an einem wunden Punkt traf: *All We Are Saying Is Give Pizza a Chance* (2003), eine aus Pizzaservice-Prospekten gefertigte Bombe, erinnerte wohl zu sehr an die „Werbekampagne" für den Krieg gegen den Irak, der Großbritannien gefolgt war.

Avec Tracey Emin, Sarah Lucas compte parmi les protagonistes les plus célèbres du phénomène YBA (Young British Artists). En 1993, les deux artistes ouvraient à Londres leur «shop», un lieu servant à la fois d'espace de vente et de lieu d'exposition et de rencontre pour la jeune scène artistique. Placée sous le signe du statut désormais légendaire de la Factory d'Andy Warhol ou du magasin World's End de Vivienne Westwood, cette appropriation ciblée des pratiques avant-gardistes était en même temps une habile posture d'auto-légitimation au sein de la scène artistique londonienne. Lucas s'est fait connaître par une série de portraits photographiques qui ont vu le jour au fil des années quatre-vingt-dix. Dans un langage iconique souvent marqué par la trivialité, elle s'y met en scène comme une assistante de la réalisation de stéréotypes sexistes pour concrétiser des moments d'agressivité dans l'approche ordinaire de la féminité et de la sexualité qui est celle de la culture quotidienne. Dans *Eating a Banana* (1990), l'artiste en blouson de cuir, coupe de cheveux unisexe, s'enfonce une banane dans la bouche en pleine rue en arborant une pose refusant toute lascivité. Ce réductionnisme belliqueux caractérise aussi ses assemblages de matériaux, auxquels le titre s'attache comme une remarque malveillante. *Christ, You Know It Ain't Easy* (2003), une représentation du Christ crucifié réalisée à partir de cigarettes Marlboro Light, qui immortalise les affres de la désaccoutumance à la nicotine, en est un bon exemple. Si les protestations ne se sont pas fait attendre, aucune n'a égalé le scandale déclenché par une œuvre qui atteignait le public britannique à un endroit sensible : *All We Are Saying Is Give Pizza a Chance* (2003), une bombe confectionnée à partir de prospectus de livraison de pizzas et qui rappelait sans doute de trop près la vaste « campagne publicitaire » en faveur de la guerre d'Irak, à laquelle la Grande-Bretagne avait emboîté le pas.

E. K

SELECTED EXHIBITIONS →
2004 *In-A-Gadda-Da-Vida: AngusFairhurstDamianHirstSarahLucas*, Tate Britain, London; *Atomkrieg*, Kunsthaus Dresden **2003** 50. Biennale di Venezia, Venice **2001** *Public Offerings*, The Geffen Contemporary at MOCA, Los Angeles **2000** *Beyond the Pleasure Principle*, Freud Museum, London; *Self-Portraits and More Sex*, Centro Cultural Tecla Sala, Barcelona

SELECTED PUBLICATIONS →
2004 *In-A-Gadda-Da-Vida: AngusFairhurstDamianHirstSarahLucas*, Tate Britain, London **2002** *Sarah Lucas*, Tate Publishing, London **2000** *Self-Portraits and More Sex*, Centro Cultural Tecla Sala, Barcelona

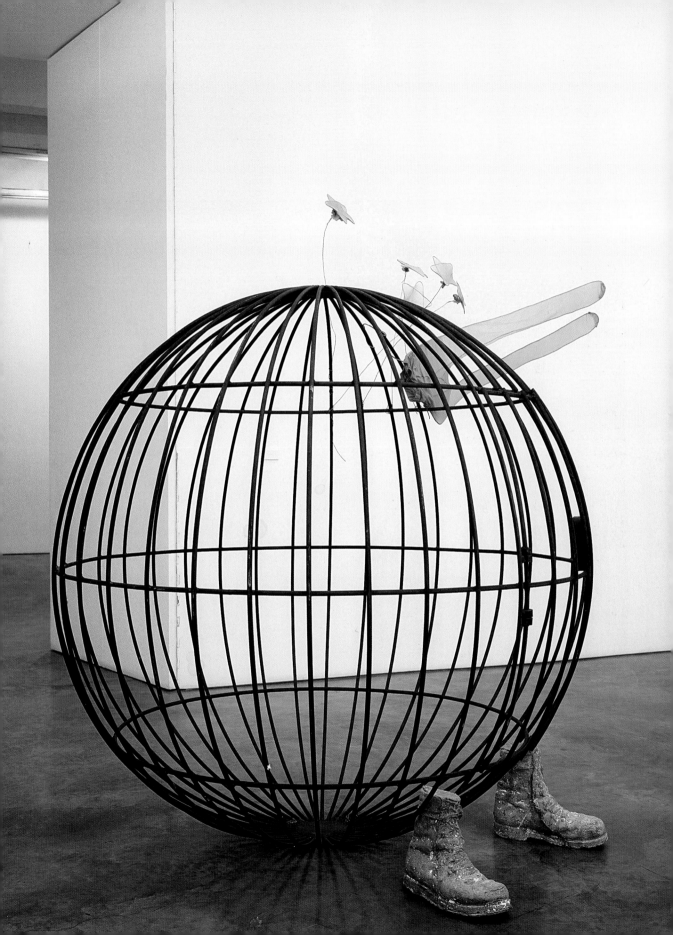

1 **Aunty Jam**, 2005, steel cage, wire, nylon tights, cast concrete, 203 x 160 x 239 cm
2 **Geezer**, 2002, paper collage, acrylic on wood, 82 x 76 cm

3 **Cnut**, 2004, jesmonite sandwich, concrete figure, cigarette, paint, stainless steel toilet, plastic seat, sandwich: 60 x 244 x 190 cm, figure: 87 x 102 x 43 cm

„Ich bevorzuge die Abwesenheit von Stil."

« J'ai une préférence pour l'absence de style. »

"I have a preference for a lack of style."

2

Vera Lutter

1960 born in Kaiserslautern, Germany, lives and works in New York, USA

Vera Lutter practises photography in its elementary form – and this in an extremely artificial manner. She works with the original principle of the light-drawn image, the Camera Obscura technique. The expression "dark room" can be taken very literally. She sets up large wooden boxes to capture the light or uses entire rooms, rented specifically to photograph particular motifs, as her cameras. She covers the windows with black plastic, cuts a tiny hole in the centre of this, and thus exposes photo paper hung on the opposite wall – sometimes for hours, and often for days or even weeks. The pictures are thus originals created directly and without a negative. There are no tricks, no retouching: they simply document the fall of light, which inscribes itself in the pictures as areas of darkness. The technique results in a reversal of dark and light, and a mirror-image reversal. Thus architectural structures – city views, airports, docks and factories – appear in Lutter's large-format, almost monumental photographs as a ghostly dark counter-world, impressively sharp and strangely empty. It is an uneasily silent world without people, leaving an impression of condensed, suspended time. In newer series, such as *Pepsi Cola Interieur* (2000–2003), Lutter explicitly uses the Camera Obscura to deconstruct the image. She photographs decrepit, visually complex industrial rooms, and then places the images back in these rooms to photograph room and image together. Thus Lutter initiates an interaction of image, photographic process and real space, from which all delimiting elements consistently withdraw.

Vera Lutter betreibt Fotografie in Elementarform – und dies in höchstem Maß artifiziell. Sie arbeitet nach dem Urprinzip des Lichtbilds, der Camera-Obscura-Technik. Den Ausdruck „dunkle Kammer" darf man wörtlich nehmen. Sie stellt große Holzboxen zum Einfangen des Lichtes auf oder nutzt ganze Räume als Fotoapparat, die sie auf bestimmte Motive hin eigens anmietet. Fenster verklebt sie mit schwarzer Folie, bohrt mittig ein winziges Loch hinein und belichtet so das auf der gegenüberliegenden Wand hängende Fotopapier – manchmal stunden-, oft aber tage- oder wochenlang. Die Bilder entstehen also ohne Negativ und unmittelbar als Original. Es gibt keine Tricks, keine Retusche: Sie dokumentieren bloß den Niederschlag von Licht, der sich im Bild als dunkle Fläche einschreibt. Die Technik führt zu Hell-Dunkel-Vertauschung und zu spiegelbildlicher Seitenumkehrung. Dadurch tauchen in Lutters großformatigen, fast monumentalen Fotos architektonische Strukturen – Stadtansichten, Flughäfen, Werften, Fabriken – als gespenstisch dunkle Gegenwelt auf, bestechend trennscharf und eigenartig leer. Es ist eine beunruhigend stille Welt ohne Menschen, die einen Eindruck von komprimierter, aufgehobener Zeit hinterlässt. In neueren Serien, etwa *Pepsi Cola Interieur* (2000–2003), nutzt Lutter die Camera Obscura explizit zur Dekonstruktion des Abbilds: Sie fotografierte marode, optisch komplexe Industrieräume und platzierte diese Bilder ebendort, um Raum und Abbild zusammen zu fotografieren. So initiiert Lutter ein Wechselspiel zwischen Bild, Abbildungsprozess und wirklichem Raum, in dem sich alle Elemente einer Verortung konsequent entziehen.

Vera Lutter pratique une forme élémentaire de la photographie – et ce d'une manière au plus haut point artificielle. Elle travaille selon le principe archétypal de la photographie, la technique de la camera obscura. L'expression « chambre obscure » doit en l'occurrence être prise à la lettre : Lutter utilise de grands caissons de bois pour capter la lumière ou se sert de pièces entières comme d'un appareil photo, pièces qu'elle loue pour fixer des motifs spécifiques. Elle en recouvre les fenêtres d'un film noir, y pratique une minuscule ouverture et impressionne ainsi le papier photographique fixé sur le mur opposé – parfois pendant des heures, mais souvent aussi pendant des journées ou des semaines. Ses images sont donc réalisées sans négatif et littéralement comme des originaux. Pas de trucages, pas de retouches : elles documentent simplement les effets de la lumière qui s'inscrit dans l'image sous forme de surface sombre. Cette technique conduit à des interversions de clair-obscur et à des inversions en miroir. Dans ses photographies grand format, presque monumentales, des structures architecturales – vues urbaines, aéroports, jetées, usines – se présentent dès lors comme des anti-mondes sombres et fantomatiques, séduisants par leur « piqué » et singulièrement vides, toute vie semble bannie de l'image, il s'agit d'un monde inquiétant de paix, vide de toute présence humaine, qui laisse le sentiment d'un temps à la fois comprimé et aboli. Dans des séries récentes comme *Pepsi Cola Interieur* (2000–2003), Lutter se sert explicitement de la camera obscura à des fins de déconstruction du modèle : elle y photographie des espaces industriels en décrépitude, visuellement complexes, et réutilise ses propres photographies de manière à fixer simultanément l'espace et la représentation. Lutter initie ainsi un jeu d'alternance entre l'image, le processus de représentation et l'espace réel, un jeu dans lequel les éléments échappent de manière cohérente à tout repérage.

J. A

1 **Battersea Power Station, IV: July 30**, 2004, unique silver gelatin print, 189.9 x 142.2 cm

2 **Berlin, Holzmarktstraße, II, B: August 23**, 2003, unique silver gelatin print, 4 panels, 200 x 569 cm overall

3 **Pepsi Cola Interior, XX: March 24 – April 24**, 2003, unique silver gelatin print, 229 x 426.7 cm

4 **Erie Basin, Red Hook, III: July 28**, 2003, unique silver gelatin print, 260.4 x 426.7 cm

„Das Dreieck aus Licht, Zeit und Bewegung in seiner Beziehung zur Camera erzeugt ein Bild. Ich lernte, und lerne noch immer, wie ich diese Kräfte am besten in einer Weise orchestrieren kann, die es mir erlaubt, die Ergebnisse zu erzielen, die ich möchte."

«Le triangle lumière-temps-mouvement et son rapport à l'objectif génèrent une image. J'ai appris et continue d'apprendre comment je peux orchestrer au mieux ces forces de manière à obtenir les résultats que je recherche.»

"The triangle between light, time, and motion in relation to the camera forms an image. I was, and still am, learning how best to orchestrate these forces in a fashion that will allow me to achieve the results I desire."

2

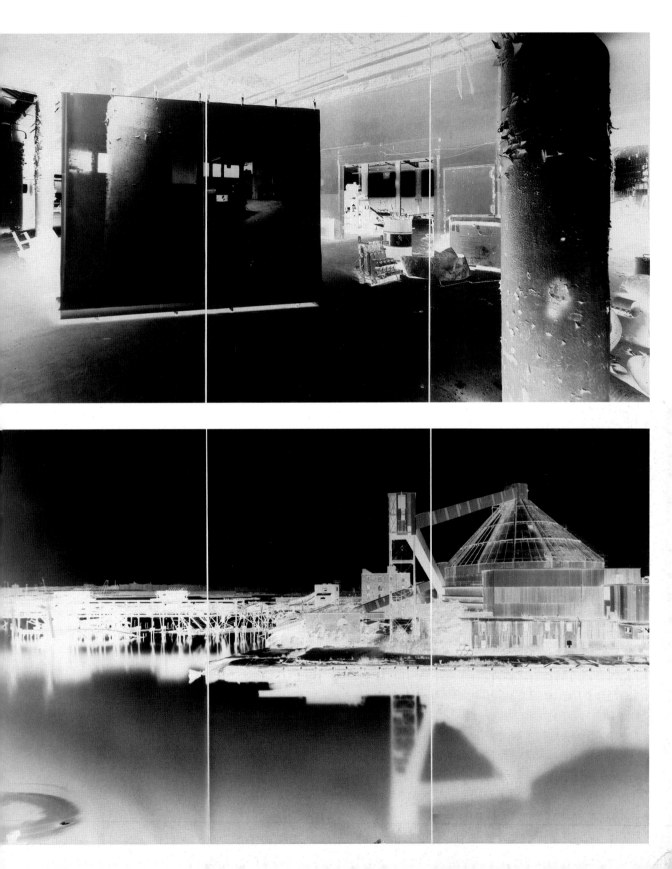

Jorge Macchi

1963 born in Buenos Aires, lives and works in Buenos Aires, Argentina

Jorge Macchi's works are poetic transformations that convert one medium into another, producing aesthetic systems from forms and structures created by chance. In *Buenos Aires Tour* (2003) Macchi exploits the potential of a pattern created by violence. Over a map of Buenos Aires he laid a cracked plate of glass, and used the cracks in the glass to plot a route through the metropolis. Photos, sound recordings, and found objects tell of the places this randomly chosen path led him to. Language is frequently his source material. *Speaker's Corner* (2002) is an arrangement of newspaper snippets, all of which are quotations with their text carefully cut away, leaving only the quotation marks and empty paper frames. The work's "speechlessness" stands in sharp contrast to the freedom of speech implied in the title. *Musica Incidental* (1998) consists of three large-sized collages depicting gigantic sheets of music, the lines of which are made up of newspaper cuttings that report on accidents and acts of violence. From a headphone come the sounds of piano music; the composition being played is based on the order of the texts. The interjacent blank spaces yield a visual structure that resembles musical notation. Language becomes a picture, and the picture in turn becomes music. In *Caja de Música* (2004) Macchi uses a similar strategy on structures that conform to their own inviolable system, converting this system into music. The video shows a multi-lane expressway. The soundtrack imitates – as the title suggests – the sound of a music box. An ordering principle completely foreign to the genre generates the sound here as well. Every note corresponds with the moment at which a car drives over the speed limit markers on the roadway.

Jorge Macchis Arbeiten sind poetische Transformationen, die ein Medium in ein anderes überführen und ästhetische Systeme mit vom Zufall geschaffenen Formen und Strukturen herstellen. In *Buenos Aires Tour* (2003) nutzt Macchi das Potenzial eines durch Gewalt entstandenen Musters: Er legte über den Stadtplan von Buenos Aires eine zerborstene Glasscheibe, deren Sprünge ihm den Weg durch die Metropole wiesen. Fotos, Tonaufnahmen, Fundstücke erzählen von den Orten, an die ihn diese zufällige Konstellation geführt hat. Sprache ist häufig Ausgangsmaterial. *Speaker's Corner* (2002) ist ein Arrangement aus Zeitungsschnipseln, Zitate allesamt, deren Text sorgsam weggeschnitten ist, nur die Anführungszeichen und leeren Papierrahmen wurden belassen. Die „Sprachlosigkeit" der Arbeit steht in starkem Kontrast zu der im Titel implizierten Redefreiheit. *Musica Incidental* (1998) besteht aus drei großformatigen Collagen, gigantische Notenblätter, deren Linien aus Zeitungsausschnitten gebildet werden, die von Gewalttaten und Unfällen berichten. Aus einem Kopfhörer tönt Klaviermusik, deren Komposition auf der Anordnung der Texte beruht: Die Leerräume dazwischen ergeben eine visuelle Struktur, die einer Notenschrift gleicht. Sprache wird zu Bild und das Bild wiederum zu Musik. Eine ähnliche Strategie, bei der Strukturen, die ihrem eigenen, undurchdringlichen System gehorchen, in das System Musik verwandelt werden, wendet Macchi in *Caja de Música* (2004) an. Das Video zeigt eine mehrspurige Schnellstraße. Die Tonspur imitiert – wie im Titel suggeriert – den Klang einer Musikbox. Auch hier generiert ein gänzlich artfremdes Ordnungsprinzip den Ton, jede Note korrespondiert mit dem Moment, in dem ein Auto die Geschwindigkeitsmarkierung auf der Fahrbahn überfährt.

Les œuvres de Jorge Macchi sont des transformations poétiques qui font évoluer un médium vers un autre, des formes et des structures fortuites vers des systèmes esthétiques. Dans *Buenos Aires Tour* (2003), Macchi s'est servi du potentiel d'un motif né de la violence : sur un plan de Buenos Aires, il a posé une vitre éclatée dont les lignes de fracture lui ont indiqué un itinéraire à travers la métropole. Les photographies, les prises de son, les objets trouvés évoquent les lieux où l'a conduit cette constellation fortuite. Le matériau de départ de ses œuvres est souvent donné par le langage. *Speaker's Corner* (2002) est un arrangement de coupures de journaux présentant toutes des citations dont le texte a été soigneusement découpé – seuls les guillemets et les cadres de papier vides ont été conservés. La « mutité » de ce travail forme un puissant contraste avec la liberté de parole évoquée par le titre. *Musica Incidental* (1998) est constitué de trois collages grand format, gigantesques papiers à musique dont les lignes sont formées de coupures de journaux relatant des violences et des accidents. Des écouteurs diffusent une musique de piano dont la composition s'appuie sur l'organisation du texte : les espaces vides produisent une structure visuelle apparentée à une écriture musicale. Le langage devient image, et l'image devient musique. Dans *Caja de Música* (2004), Macchi s'est servi d'une stratégie similaire, par laquelle des structures obéissant à leur propre et impénétrable système sont transformées en système musical. Cette vidéo montre une artère de circulation rapide à plusieurs voies. Comme le suggère le titre, la bande son imite une boîte à musique. Là encore, le son est généré par un principe totalement étranger au genre – chaque note correspond au moment où une voiture dépasse la limitation de vitesse.

A. M.

SELECTED EXHIBITIONS →
2005 *La Ascensión* (with Edgardo Rudnitzky), 51. Biennale di Venezia, Venice **2004** *Caja de Música*, 26. Bienal de São Paulo; *Réplica*, Museo Universitario de Ciencas y Arte Roma, Mexico City; *Treble*, SculptureCenter, New York **2003** 8. Istanbul Biennial **2001** *Jorge Macchi*, Le 10neuf, Centre Régional d'Art Contemporain, Montbéliard; *12 Views*, The Drawing Center, New York

SELECTED PUBLICATIONS →
2004 *Jorge Macchi: Buenos Aires Tour*, Turner/Musac, Buenos Aires
2002 *Fuegos de artificio*, Ruth Benzacar Gallery, Buenos Aires
1997 *Jorge Macchi: Incidental Music*, University Gallery, University of Essex, Colchester

1 **Speakers Corner** (detail), 2003, newspaper cuts, 130 x 180 cm
2 **Distrito**, 2003, installation view, Galeria Luisa Strina, São Paulo
3 **Blue Planet**, 2003, intervention on a map, Ø 15 cm
4 **Venecia**, 2003, cut Venice map, pins, 55 x 78 cm

„Ich frage mich, ob meine Arbeit mit Abfällen eine primitive und entartete Form der Fotografie ist; beide versuchen, den Zerfall und das Verschwinden fest zu halten oder zu verlangsamen."

« Je me demande si mon travail avec les déchets, mon œuvre n'est pas une forme primitive et dégénérée de la photographie ; tous deux tentent de suspendre ou de ralentir la détérioration et la disparition. »

"I wonder if my work with refuse is a primitive and degenerate form of photography; both try to stop or slow down deterioration and vanishing."

2

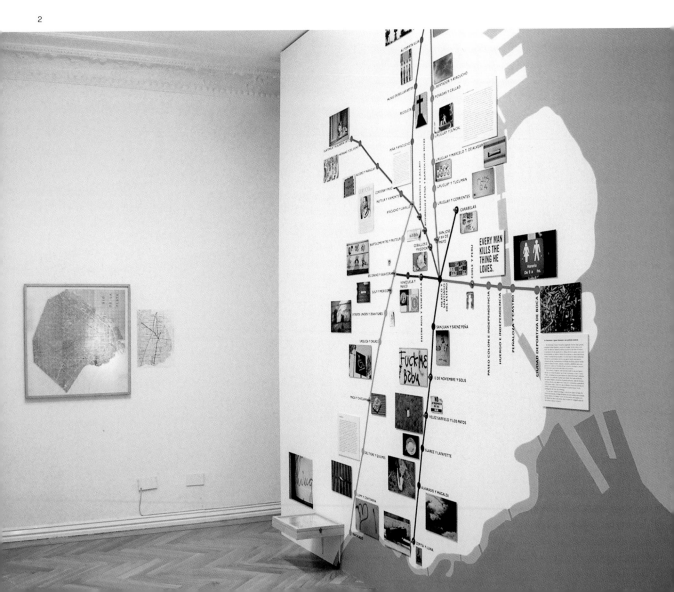

3

4

Marepe

1970 born as Marcos Reis Peixoto in Santo Antônio de Jesus, lives and works in Santo Antônio de Jesus, Brazil

In his exhibition at the Centre Pompidou in Paris, Marepe erects a monument to his grandfather whose nickname was Bubu. A portrait of this craftsman from Bahia hangs for some weeks next to the portrait of Georges Pompidou. Marepe's objects, installations, and actions celebrate the culture and handicrafts of his native region of Bahia, but simultaneously they are thoughtful, socially engaged, and poetic comments on the difficult conditions of life in his country, and on the consequences of colonialism. He frequently employs the strategy of the ready-made: not to transform everyday objects into art, however, but to make everyday objects visible in the art context as everyday objects with all their significance. Thus Marepe also eschews the term ready-made, and instead speaks of "nécessaires": Utensils necessary for sustaining life and for survival form the source material for his sculptures and installations. *Os Filtros* (*The Filters*, 1999) is based on commonly available water filters, which Marepe has distorted longitudinally. The sculptures are a monument to drinking water shortages, and simultaneously a symbolic work that conjures up ideas of spiritual cleansing. The carefully packaged and laconically arranged clay cubes made for *Presente para os Presentes* (*Present for the Presents*, 2001) have the potential to be cast in the mould of everyday objects or art objects, and they also allude to old cultural practices of barter and dispensation that have been replaced by the economic structures propagated by colonialism. Almost all of Marepe's works operate in a dynamic area between practical use and aesthetics.

In seiner Ausstellung im Pariser Centre Pompidou setzt Marepe seinem Großvater, dessen Spitzname Bubu war, ein Denkmal: Ein Porträt des Handwerkers aus Bahia hängt für einige Wochen neben dem Bildnis von Georges Pompidou. Marepes Objekte, Installationen und Aktionen feiern Kultur und Handwerk seiner Heimatregion Bahia, sind aber zugleich nachdenkliche, sozial engagierte und poetische Kommentare zu den schwierigen Lebensbedingungen in seinem Land und zu den Folgen des Kolonialismus. Er verwendet häufig die Strategie des Ready-made, jedoch nicht, um Alltagsobjekte in Kunst zu überführen, sondern um Alltagsobjekte im Kunstkontext als Alltagsobjekte mit all ihren Bedeutungen sichtbar zu machen. So vermeidet Marepe auch den Begriff des Ready-made und spricht stattdessen von „nécessaires": Das Ausgangsmaterial seiner Skulpturen und Installationen sind für den Lebensunterhalt und das Überleben notwendige Utensilien. *Os Filtros* (*The Filters*, 1999) beruht auf handelsüblichen Wasserfiltern, die Marepe länglich verformt hat. Die Skulpturen sind ein Mahnmal gegen Trinkwassermangel und ein symbolisches Werk zugleich, das Vorstellungen von spiritueller Reinigung heraufbeschwört. Die für *Presente para os Presentes* (*Present for the Presents*, 2001) lakonisch aufgestellten, sorgsam verpackten Kuben aus Ton besitzen nicht nur das Potenzial, zu Alltags- oder Kunstobjekten geformt zu werden, sondern spielen auch auf alte Kulturformen des Tauschens und Schenkens an, die durch die vom Kolonialismus verbreiteten Wirtschaftsstrukturen verdrängt worden sind. Fast alle Werke Marepes verharren in einem Spannungsfeld zwischen Gebrauch und Ästhetik.

Pour son exposition au Centre Beaubourg à Paris, Marepe se propose d'élever un monument à son grand-père, dont le surnom fut Bubu : un portrait de cet artisan de Bahia accroché pendant plusieurs semaines à côté d'un portrait de Georges Pompidou. Les objets de Marepe, ses installations et actions célèbrent la culture et l'artisanat de sa région natale Bahia, mais sont en même temps des commentaires méditatifs, engagés et poétiques sur les conditions de vie difficiles dans son pays comme sur les conséquences du colonialisme. L'artiste se sert souvent de la stratégie du ready-made – non pour faire passer des objets quotidiens dans le domaine de l'art, mais pour faire voir des objets quotidiens dans le contexte de l'art : en tant qu'objets quotidiens chargés de toutes leurs significations et implications. Marepe évite le terme de ready-made et parle plutôt de «nécessaires»: le matériau de départ de ses sculptures et installations est constitué d'ustensiles indispensables à la subsistance et à la survie. *Os Filtros* (*The Filters*, 1999) repose sur des filtres à eau disponibles dans le commerce et déformés en longueur. Ces sculptures sont un monument à la pénurie d'eau potable, mais aussi une œuvre symbolique évoquant des notions de purification spirituelle. Les cubes en terre cuite soigneusement emballés, laconiquement dressés de *Presente para os Presentes* (*Present for the Presents*, 2001), ne possèdent pas seulement le potentiel de devenir des objets quotidiens ou des objets d'art, ils sont aussi une allusion aux formes culturelles traditionnelles du troc et du cadeau qui ont été éradiquées par les structures économiques du colonialisme. Presque toutes les œuvres de Marepe demeurent dans un champ de tension entre utilisation et esthétique.

A.M.

SELECTED EXHIBITIONS →
2005 Centre Pompidou, Paris **2004** *450 Years*, Pinacoteca do Estado, São Paulo **2003** 8. Istanbul Biennial; 50. Biennale di Venezia, Venice; *How Latitudes Become Forms: Art in a Global Age*, Walker Art Center, Minneapolis, Fondazione Sandretto Re Rebaudengo, Turin, Contemporary Arts Museum, Houston, Museo de Arte Contemporáneo Internacional Rufino Tamayo, Mexico City

SELECTED PUBLICATIONS →
2003 *How Latitudes Become Forms: Art in a Global Age*, Walker Art Center, Minneapolis **2002** *Marepe*, Galeria Luisa Strina, São Paulo **2001/02** *O Fio da Trama/The Thread Unraveled: Contemporary Brazilian Art*, El Museo del Barrio, New York

1 **A Thread That Connects the Worlds**, 2002, wood, metallic paper, steel wool, cheese, needle, thread
2 **Deep River**, 2004, rubber inner tubes, wood tables, formic, glass bottles of "cachaça" Rio Fundo, dimensions variable

3 **A Mudança**, 2005, metal, wood, rubber, plastic, hinge, 210 x 360 x 140 cm
4 **Jelly Fish**, 2004, glass, silicone glue, 20 pieces, dimensions variable

„Ich glaube an eine Kunst ohne Grenzen, die sich in menschlichen Angelegenheiten engagiert."

«Je crois en un art ouvert et engagé dans des questions d'humanité.»

"I believe in an open art engaged in humanity matters."

2

3

Paul McCarthy

1945 born in Salt Lake City (UT), lives and works in Altadena (CA), USA

If Paul McCarthy sometimes seems to be a "survivor", this is due to his work frequently being misunderstood. At the beginning of the 1970s he organized performances in Los Angeles but unlike Chris Burden, for example, he didn't seem to take any risks. Even if his performances appeared to imitate the extreme violence of Viennese Actionism, the blood was nevertheless represented by ketchup and the excrement by chocolate. The parodistic dimension is ever-present in McCarthy's work, above all in regards to "great art", personified in the exceptionally funny video *Painter* (1995) by the figure of the bloated, Abstract-expressionist painter, who burps, gripes, and is at the edge of despair. *MJBH* (2002), an abbreviation of "Michael Jackson Big Head", is a recent work McCarthy has has made based on Jeff Koons' famous sculpture, *Michael Jackson and Bubbles* (1998). It describes both the subject and McCarthy's characteristic figurative exaggeration. With cartoonish feet, large heads and relatively small bodies, McCarthy's works seem like the chance encounter of childlike folk art with an "anti-morality" which combines "pornography, glorification of drugs, radical political speeches and recognition of the least 'integration-capable' minorities". The works take the body as a starting point for a metaphorical investigation of all of American society's taboos, and its hypocrisy. No mythology is left out: Pinocchio, Santa Claus, and even the family paradise as in *The Garden* (1991/92), where father and son mechanically copulate with a tree. Since the end of the 1980s McCarthy's work has concentrated primarily on monumental sculptures and arrangements. Clearly inspired by the aesthetics of the amusement park, these refer to the consequences of capitalistic mass culture.

Wenn Paul McCarthy wie ein „Überlebender" wirkt, dann, weil seine Arbeit häufig missverstanden wurde. Anfang der siebziger Jahre veranstaltete er Performances in Los Angeles, aber anders als zum Beispiel Chris Burden schien er kein Risiko einzugehen. Auch wenn seine Performances aussahen, als ahmten sie die extreme Gewalt des Wiener Aktionismus nach, wurde das Blut doch durch Ketchup dargestellt und die Exkremente durch Schokolade. Bei McCarthy ist die parodistische Dimension allgegenwärtig, vor allem im Hinblick auf die „große Kunst", personifiziert in der Figur des aufgedunsenen Malers des abstrakten Expressionismus im außerordentlich komischen Video *Painter* (1995), der aufstößt, meckert und am Rand der Verzweiflung steht. Als Grundlage für die Arbeit *MJBH* (2002), was als Abkürzung für „Michael Jackson Big Head" steht, hat McCarthy die berühmte Skulptur von Jeff Koons *Michael Jackson and Bubbles* (1998) benutzt. Sie beschreibt sowohl die Figuren als auch McCarthys typische Übersteigerung. Die Arbeiten von McCarthy wirken wie die zufällige Begegnung einer kindlichen Volkskunst mit einer „Anti-Moral", die „Pornografie, Verherrlichung von Drogen, radikale politische Reden und Anerkennung der am wenigsten ‚integrierfähigen' Minderheiten" verschmilzt. Sie nehmen den Körper als Ausgangspunkt für die metaphorische Erforschung aller Tabus der amerikanischen Gesellschaft und ihrer Scheinheiligkeit. Kein Mythos wird ausgelassen: Pinocchio, der Weihnachtsmann bis hin zum Familienparadies wie in *The Garden* (1991/92), wo Vater und Sohn mechanisch mit einem Baum kopulieren. Seit Ende der achtziger Jahre konzentriert sich McCarthys Werk vor allem auf monumentale Skulpturen und Arrangements, die deutlich von der Ästhetik der Vergnügungsparks inspiriert sind, um auf die Folgen der kapitalistischen Massenkultur hinzuweisen.

Si Paul McCarthy peut apparaître comme un « rescapé », c'est que son travail a souvent fait l'objet de malentendus. Certes il faisait des performances à Los Angeles au début des années soixante-dix, mais contrairement à Chris Burden, par exemple, elles ne supposaient aucune prise de risque. Si ses performances singeaient l'ultra-violence de l'actionnisme viennois, le sang y était figuré par du ketchup et les excréments par du chocolat. Chez McCarthy, la dimension parodique est omniprésente, à l'égard du « grand art », notamment, personnifié par la figure du peintre expressionniste abstrait boursouflé de la désopilante vidéo *Painter* (1995), qui éructe, râle, au bord du désespoir. *MJBH* (2002), abréviation de « Michael Jackson Big Head », est une œuvre récente de McCarthy, basée sur la fameuse sculpture *Michael Jackson and Bubbles* (1998) de Jeff Koons. Elle décrit à la fois le sujet et l'exagération figurative caractérisique pour McCarthy. Beau comme la rencontre fortuite d'une culture populaire infantilisée et d'une « morale contraire » qui mêle « pornographie, apologie des drogues, discours politiques radicaux, reconnaissance des minorités les moins ‹intégrables›, le travail de McCarthy prend le corps comme point de départ de son exploration métaphorique de tous les tabous de la société américaine et de son hypocrisie. Aucun mythe n'est épargné : Pinocchio, le Père Noël, jusqu'à ce jardin d'Eden familial comme *The Garden* (1991/92) où père et fils copulent mécaniquement avec un arbre. Depuis la fin des années quatre-vingt, son travail s'organise autour de sculptures et d'arrangements souvent monumentaux, empruntant ouvertement à l'esthétique des parcs d'attractions pour pointer l'horreur engendrée par l'intrusion de la culture capitalistique de masse dans le corps psychosociologique dès la petite enfance. S. C.

SELECTED EXHIBITIONS →
2005 *Lala Land – Parodie Paradies*, Haus der Kunst, Munich
2004/05 Centro de Arte Contemporáneo de Málaga **2004** *Brain Box Dream Box*, Van Abbemuseum, Eindhoven **2003** Tate Modern, London **2001** Tate Liverpool; New Museum of Contemporary Art, New York; Villa Arson, Nice

SELECTED PUBLICATIONS →
2004 *Paul McCarthy: Videos 1970–1997*, Cologne; *Brain Box Dream Box*, Van Abbemuseum, Eindhoven; *Tokyo Santa*, Cologne **2003** *Paul McCarthy at Tate Modern: Block Head and Daddies Big Head*, Tate Modern, London **2001** *Paul McCarthy*, Ostfildern-Ruit

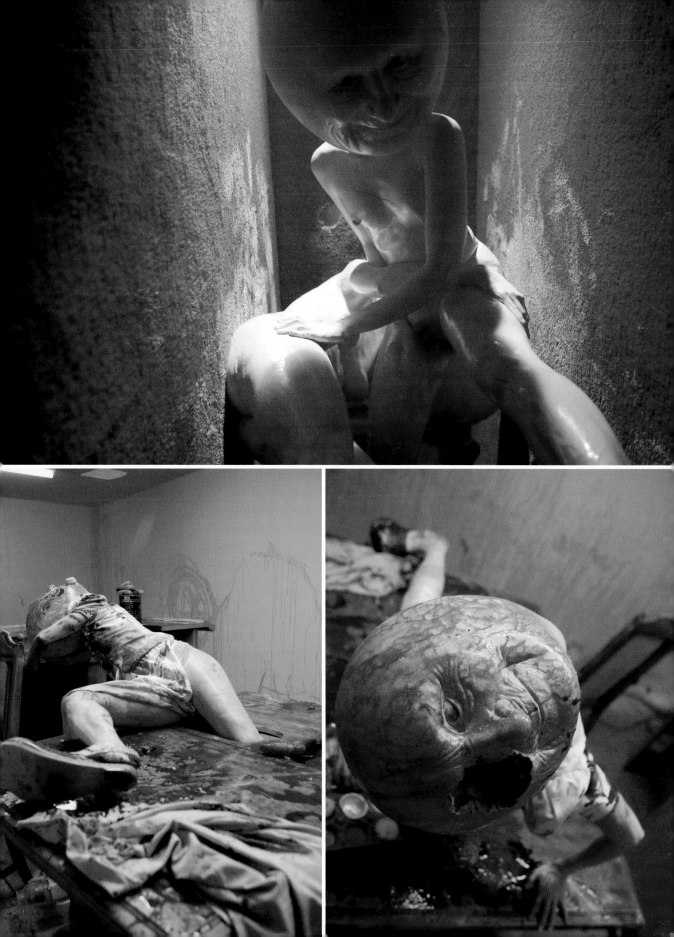

1 **Basement Bunker**, 2003, C-prints on aluminium, **Painting Queens in the Red Carpet Hall 1**, 122 x 183 cm, **A Queen in the Yellow Room on the Table 1 and 2**, each 183 x 122 cm
2 **Santa (with Butt Plug)**, 2004, bronze, height: c. 90 cm
3 **Jack**, 2002, silicon, dildo, wood, steel, 60 x 60 x 46 cm

4 **Piccadilly Circus**, 2003, mixed media installation with 6 projectors, installation view, Hauser & Wirth, London
5 **Bound to Fail – PM HM Sculpture on a Pedestal**, 2004, installation view, Whitney Museum of American Art, New York

„Es ist meine Überzeugung, dass unsere Kultur die wirkliche Wahrnehmung der Existenz verloren hat. Sie ist verschleiert. Wir taumeln allenfalls in dem herum, was wir als Wirklichkeit wahrnehmen. Meist wissen wir nicht, dass wir lebendig sind."

«Je suis d'avis que notre culture a perdu toute véritable perception de l'existence. Elle est voilée. Nous ne faisons qu'errer dans ce que nous percevons comme étant la réalité. La plupart du temps nous ne sommes même pas conscients d'être vivants.»

"It is my belief that our culture has lost a true perception of existence. It is veiled. We are only tumbling in what we perceive to be reality. For the most part we do not know we are alive."

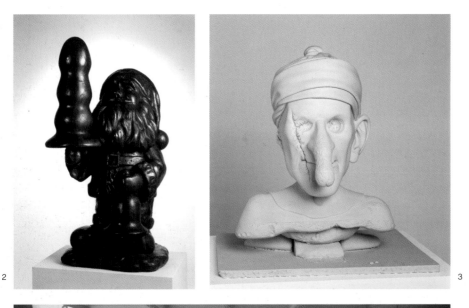

2

3

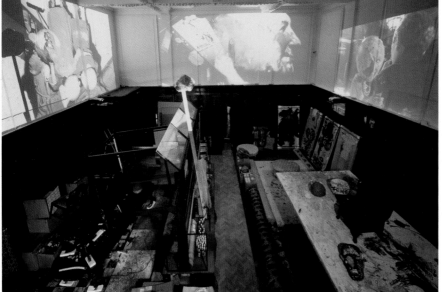

4

Lucy McKenzie

1977 born in Glasgow, lives and works in Glasgow, UK

It is often hard to tell where the boundaries of Lucy McKenzie's work lie. A huge mural in a Polish shipyard, for instance, painted together with friend and frequent collaborator, Polish artist Paulina Olowska, integrated existing graffiti and shipyard workers' strike posters into its design. Although it was clear that the stylized figures were the products of the artists, the provenance of the graffiti tags "Global Joy" or "Depeche Mode" were less easy to work out. Its title *Plastyczna Integracja* (Aesthetic Integration, 2001), is a useful key to McKenzie's approach, which is socially engaged and intent on rejecting the institutional conventions which keep art isolated in a specialist arena, cut off from everyday life. Her figurative paintings adopt the flat style of the social realist tradition to produce contemporary notions of individual or collective identity, or the intersection of art-history and advertising. A solo exhibition at the Tate in London became a platform to promote the activities of a Polish charity working against the exploitation of women, while her Glasgow studio was home to "Flourish Nights", a series of live music and art. In lieu of an exhibition in Warsaw, she and Olowska set up an illegal bar called *Nova Popularna*, designing the interior, staging special events, and running it themselves, in the self-conscious roles of highly aestheticised bohemian feminists. McKenzie highlights the similarities in urban-aesthetics between Glasgow and the former socialist territories in Eastern Europe, but also draws on the particular quality of these cities, located on the periphery of the art world.

Wo die Grenzen der Arbeiten von Lucy McKenzie liegen, lässt sich oft nur schwer sagen. So integrierte sie beispielsweise in Zusammenarbeit mit der befreundeten polnischen Künstlerin Paulina Olowska bereits vorhandene Graffitis und Streikplakate in ein riesiges Wandgemälde auf einer polnischen Werft. Obwohl deutlich war, dass es sich bei den stilisierten Figuren um das Werk der Künstlerinnen handelte, war die Herkunft der Tags von „Global Joy" oder „Depeche Mode" weniger leicht festzustellen. Der Titel der Arbeit, *Plastyczna Integracja* (Ästhetische Integration, 2001), stellt einen Schlüssel zu McKenzies Ansatz dar, der sich durch gesellschaftliches Engagement sowie die Entschlossenheit auszeichnet, auf institutionelle Konventionen zu verzichten, die Kunst in einem Spezialistenbiotop isolieren und vom Alltag fernhalten. In ihren figürlichen Bildern wird der flächige Stil der Tradition des Sozialistischen Realismus angewendet, um zeitgenössische Vorstellungen von individueller oder kollektiver Identität oder eine Überschneidung von Kunstgeschichte und Werbung herzustellen. Eine Einzelausstellung von McKenzie in der Tate Gallery in London wurde eine Plattform zur Förderung einer polnischen Wohlfahrtsorganisation, die gegen die Ausbeutung von Frauen kämpft, während in ihrem Atelier in Glasgow die „Flourish Nights" stattfanden, eine Reihe von Livemusik- und Kunstveranstaltungen. Statt einer Ausstellung in Warschau richteten McKenzie und Olowska eine illegale Bar namens *Nova Popularna* ein, gestalteten die Einrichtung, inszenierten spezielle Veranstaltungen und betrieben den Laden selbst in der Rolle selbstbewusster, äußerst ästhetisierter Boheme-Feministinnen. McKenzie weist auf die Ähnlichkeiten zwischen Glasgow und den ehemals sozialistischen Ländern Osteuropas bezüglich ihrer urbanen Ästhetik hin, behandelt jedoch auch die Besonderheiten dieser an der Peripherie der Kunstwelt angesiedelten Städte.

Il est souvent difficile de cerner les limites du travail de Lucy McKenzie. Dans un chantier naval polonais, une gigantesque peinture murale peinte avec la Polonaise Paulina Olowska – une amie artiste et fréquente collaboratrice de McKenzie – intégrait dans sa conception des graffitis existants et des affiches appelant à la grève. Si les figures stylisées se devaient manifestement aux deux artistes, l'origine des tags «Global Joy» ou «Depeche Mode» était déjà moins facile à déterminer. Le titre *Plastyczna Integracja* (Intégration esthétique, 2001) est une bonne clef pour décrire l'approche de McKenzie, qui tient de l'engagement social et du rejet des conventions sociales qui confinent l'art dans une arène de spécialistes isolée de la vie quotidienne. Les peintures figuratives de McKenzie adoptent le style plan de la tradition du réalisme socialiste pour écorcher les notions contemporaines d'identité individuelle ou collective, ou encore la collusion entre histoire de l'art et publicité. Une exposition personnelle à la Tate Gallery de Londres s'est transformée en plate-forme promotionnelle pour les activités d'une organisation caritative œuvrant contre l'exploitation de la femme, tandis que l'atelier de McKenzie à Glasgow abritait les «Flourish Nights», une série de spectacles musicaux et artistiques live. Au lieu d'une exposition à Varsovie, McKenzie et Olowska ont monté un bar illégal nommé *Nova Popularna*, dont elles ont conçu la décoration intérieure, où elles ont présenté différents événements et qu'elles ont fait tourner elles-mêmes, endossant fièrement le rôle de féministes bohèmes hautement esthétisées. McKenzie met en lumière les correspondances entre les esthétiques urbaines de Glasgow et des anciens pays socialistes d'Europe de l'Est, mais fait aussi appel aux qualités particulières de deux villes situées aux confins du monde de l'art.

K. B.

SELECTED EXHIBITIONS →
2004 Institute of Contemporary Art, Boston; *The Undiscovered Country*, The Hammer Museum, Los Angeles; *Deathwatch*, Van Abbemuseum, Eindhoven **2003** *MMIV*, Tate Britain, London; *Kontext, Form, Troja*, Secession, Vienna; *Brian Eno*, Neuer Aachener Kunstverein, Aachen **2002** *The Best Book About Pessimism I Ever Read*, Kunstverein Braunschweig; *Painting on the Move*, Kunsthalle Basel, Basle **2001** *Love by Women Loved by Henri de Toulouse-Lautrec*, Inverleith House, Royal Botanic Garden, Edinburgh

SELECTED PUBLICATIONS →
2004 *Global Joy. Lucy McKenzie*, Galerie Daniel Buchholz, Cologne **2003** *Brian Eno*, Neuer Aachener Kunstverein, Aachen **2002** *Lucy McKenzie: The Best Book About Pessimism I Ever Read*, Cologne

1 **Untitled**, 2005, oil on canvas, 243 x 183 cm
2 **IntegrityGap**, 2003, installation view, Neuer Aachener Kunstverein, Aachen

3 **Deathwatch**, 2004, mural, acrylic paint on wallpaper on wooden panels, 320 x 2400 cm, installation view, Van Abbemuseum, Eindhoven
4 **Nova Popularna**, 2003, installation view, Warsaw

„Das Herstellen von Querverweisen zwischen mehreren Personen zur Neuausrichtung ihrer Standpunkte ist eine Taktik, die sich auf künstlerische Entwürfe anwenden lässt. Ich arbeite allein, um kontemplative Vorzimmer zu schaffen, und ich arbeite mit anderen Künstlern zusammen und agiere dabei als Hüterin der Ideen anderer und als Urheberin eines gesellschaftlichen Experiments."

« Les renvois entre entités plurielles en vue de réorienter leur intelligibilité propre deviennent une tactique appliquée aux structures artistiques. Je travaille seule pour produire des antichambres contemplatives, et en collaboration comme conservatrice des idées des autres et productrice d'un champ d'expérimentation sociale. »

"Cross-referencing of plural entities to reorientate their point of understanding in itself becomes a tactic applied to artistic frameworks. I work alone to produce contemplative ante-chambers, and collaboratively; being the custodian of the ideas of others and the producer of social experiment."

2

3

Jonathan Meese

1971 born in Tokyo, Japan, lives and works in Berlin and Hamburg, Germany

Jonathan Meese's installations are like overloaded adolescent bedrooms where we can surmise wild fantasies from the cosmos of utensils, idols and scraps of pictures. Heroes from film and mythology, or sinister characters from history are presented. The artist sets himself in context with the prominent figures. In performances he transforms himself into these types of figures as he moves through the chaotic spaces, narrating or singing. Two-dimensionally, he transfers the expressive illustration of his fantasy world into the medium of painting, and loaded just as densely with information: warriors' heads, heavily armed figures and various types of crosses appear in dark, earthy tones. The problematic relationship to power seems significant. Hagen von Tronje, the dark figure of the Nibelung legend, becomes a primal guardian or state god here. Thus the recently created bronze sculptures are reminiscent of graven images. Fantastically shaped, the creations portray something between horror masks and icons. In formal terms, however, they form the greatest possible contrast to his previous actionist work in that the traditional bronze casting technique freezes all processes. As though the German language were no longer sufficient to describe his universe, Meese has invented his own words that appear in his work. For his invented words he combines vocabulary from heroic epics with Celtic or Greek forms – or combines these with contemporary expressions. Although their meaning is still generally unknown, certain references become obvious in context. As maniacal assemblages his installations, performances, paintings and sculptures become, as it were, visions of his imagination.

Die Installationen von Jonathan Meese gleichen überladenen Jugendzimmern, deren Kosmos aus Utensilien, Idolen und Bilderfetzen wilde Fantasien erahnen lassen. Helden des Films, der Mythologie oder historische Finsterlinge werden präsentiert. Der Künstler setzt sich selbst den prominenten Figuren gegenüber. In Performances verwandelt er sich in diese Figuren, wenn er erzählend oder singend durch die wirren Räumlichkeiten zieht. Auf zweidimensionaler Ebene überträgt er die expressive Darstellung seiner Fantasiewelt in das Medium der Malerei – ebenso dicht beladen mit Informationen: Köpfe von Kriegern, schwer bewaffnete Gestalten und verschiedenartige Kreuze erscheinen in dunklen, erdigen Tönen. Das problematische Verhältnis zur Macht scheint bedeutungsvoll. Hagen von Tronje, die düstere Gestalt der Nibelungensage, wird hier zum Erzwächter oder Staatsgott. So erinnern auch die jüngst entstandenen Bronzeplastiken an Götzenbilder. Fantastisch geformt stellen die Geschöpfe eine Mischung aus Horrormasken und Ikonen dar. In ihrer formalen Gestaltung aber bilden sie den größtmöglichen Kontrast zu seinem bisherigen, aktionistischen Werk, indem der traditionelle Bronzeguss alle Prozesse erstarren lässt. Als würde die deutsche Sprache für die Beschreibung seines Universums nicht mehr ausreichen, hat Meese eigene Wörter erfunden, die in seiner Arbeit erscheinen. Für seine Wortschöpfungen verknüpft er Vokabeln aus Heldenepen mit Formen des Keltischen oder Griechischen – oder verbindet diese mit zeitgenössischen Ausdrücken. Ihre Bedeutung ist bisher meist unbekannt, aber gewisse Referenzen werden im Zusammenhang offensichtlich. Als manische Assemblagen werden seine Installationen, Performances, Malereien oder Plastiken gleichsam zu Visionen seiner Imagination.

Les installations de Jonathan Meese s'apparentent à des chambres d'adolescents surchargées dont le cosmos d'ustensiles, d'idoles et de fragments d'images laisse deviner des fantasmes débridés. Héros du cinéma et de la mythologie ou figures historiques sombres y sont présentés. Tout un bric-à-brac de vieilleries s'y mêle à différentes déclinaisons du propre portrait de l'artiste, qui se confronte ainsi lui-même aux célébrités. Dans ses performances, Meese se transforme lui-même en ces figures quand il parcourt ses espaces fous en chantant ou en racontant des histoires. Dans le domaine bidimensionnel, Meese donne une représentation expressive de son univers fantasmatique à travers le médium pictural, qui est tout aussi chargé d'informations : têtes de guerriers, figures lourdement armées et croix en tous genres y apparaissent dans des couleurs sombres et terreuses. Le rapport problématique avec le pouvoir semble y jouer un rôle décisif. Hagen von Tronje, la sombre figure des Nibelungen, y devient un gardien du seuil ou un dieu national. De même, les sculptures en bronze réalisées récemment par l'artiste rappellent des idoles. Ces créatures aux formes fantastiques se présentent comme des hybridations à mi-chemin entre icônes et masques d'horreur. Par leur réalisation formelle, elles constituent néanmoins le contraste le plus extrême avec son œuvre antérieur, jusqu'ici actionniste, en ceci que le bronze traditionnel fige toute processualité. Comme si la langue allemande ne suffisait plus à décrire son univers, Meese a inventé ses propres mots, qui apparaissent dans son travail. Pour ses créations verbales, il combine des vocables tirés de poèmes épiques avec des formes empruntées au celte ou au grec – ou encore ces dernières avec des expressions contemporaines. A ce jour, leur signification est le plus souvent inconnue, mais certaines références s'éclairent à la vue du contexte. En tant qu'assemblages obsessionnels, les installations, performances, peintures ou sculptures de Meese se transforment en quelque sorte en visions de son imaginaire.　　C. E

SELECTED EXHIBITIONS →
2005 *Dionysiac*, Centre Pompidou, Paris **2004** *Képi blanc, nackt*, Schirn Kunsthalle, Frankfurt/Main; *Dr. Staatsall*, Dommuseum zu Salzburg **2002** *Revolution*, kestnergesellschaft, Hanover **2000** *Wounded Time*, Städtisches Museum Abteiberg, Mönchengladbach **1999** *German Open*, Kunstmuseum Wolfsburg; *Generation Z*, P.S.1, New York; *Mr. Deltoid's a.k.a. Urleandrusus – Sonnenallee – AHOI DE ANGST – FAIR WELL Good Bye*, Neuer Aachener Kunstverein, Aachen

SELECTED PUBLICATIONS →
2004 *Képi blanc, nackt,* Schirn Kunsthalle, Frankfurt/Main; *Das Bildnis des Dr. Fu Manchu*, Contemporary Fine Arts, Berlin; *Albert Oehlen, Jonathan Meese – Spezialbilder*, Cologne **2002** *Revolution*, kestnergesellschaft, Hanover **2000** *Stierhoden und Absinth – Erwin Meese*, Contemporary Fine Arts, Berlin **1999** *Gesinnungsbuch '99 – Jonathan Meese and Erwin Kneihsl*, Cologne

1 **Sankt Ich II**, 2002, photo, collage, 190 x 132 cm

2 Exhibition view "Képi blanc, nackt" Schirn Kunsthalle, Frankfurt/Main, 2004

„Kunst braucht keinen Kontext, keine Geschichte. Deswegen werde ich wütend, wenn mir jemand erzählen will, was Kunst ist. Das weiß doch keiner, und es ist nicht schlimm, dass wir es nicht wissen. Einer der wenigen geheimnisvollen Lebensbereiche!"

« L'art n'a pas besoin de contexte ou d'histoire. C'est pourquoi ça me rend furieux quand on veut m'expliquer ce qu'est l'art. Personne n'en sait rien et ce n'est pas grave de ne pas le savoir. Un des rares domaines mystérieux de la vie ! »

"Art needs no context, no history. That's why I become furious if somebody thinks they can tell me what art is. Nobody knows that, and it's not a bad thing that we don't know it. One of the few mysterious areas of life!"

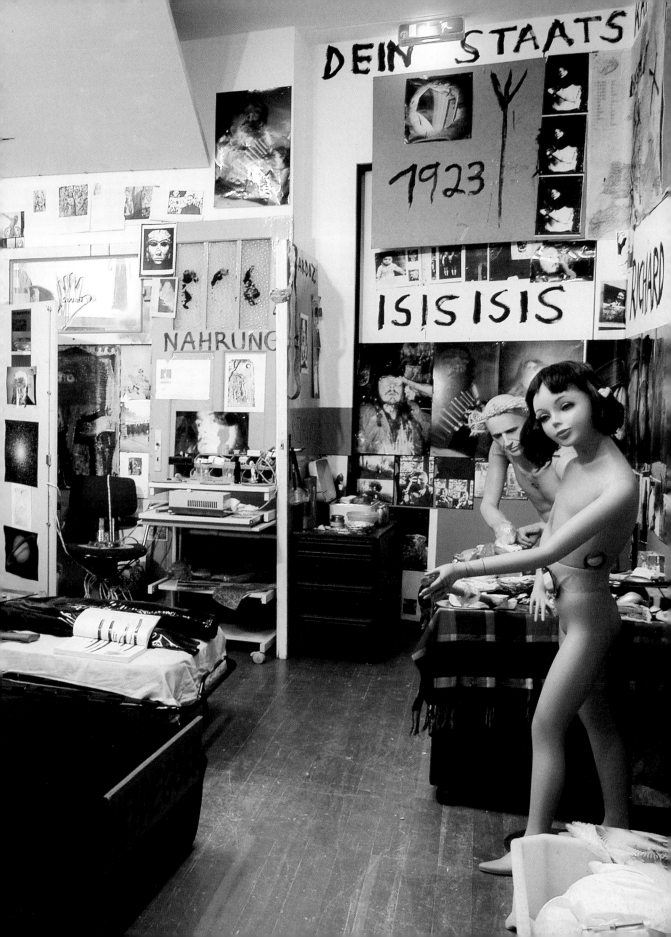

Julie Mehretu

1970 born in Addis Ababa, Ethiopia, lives and works in New York (NY), USA

In her work, Julie Mehretu has developed characteristic mixed and linked forms of painting and drawing – "drawing into painting" as she puts it. She has created a completely unique visual language for this, which she implements in large-sized wall drawings and highly complex easel paintings. In this artistic practice, drawing also always means "dealing with symbols". Mehretu builds her paintings up from several layers of milkily transparent paint, and draws into each of these layers. Her vocabulary is abstract in very diverse ways: It contains tags and graffiti as well as baroque ingredients, and uses elements of calligraphy, landscape painting, and comics. Mehretu blends asymmetrically unfurling planes of colour with dynamically colourful lines and curves, which with the appropriate focus allow fleeting tectonics and an ambiguous depth to appear in the picture. Her motifs generally depict public, socially prominent locations – government buildings, museums, stadiums schools or airports – which also allow the pictures to become abstract "cityscapes". Moreover, symbols such as flags, tattoo motifs, comic elements, or simple coloured dots can often be found in details of the work. Mehretu bundles these into groups or swarms. In this carefully balanced chaos, one's gaze constantly moves from the whole to the details and back, and yet the work's density and dynamics remain incomprehensible and nonhierarchical in the best sense. The visual language of these pictures, with their highly complex organization, is hardly unambiguous. For Mehretu they thus also become metaphors of the global socio-political conditions at the beginning of the 21st century.

Julie Mehretu hat in ihrer Arbeit charakteristische Misch- und Verknüpfungsformen von Malerei und Zeichnung entwickelt – sie selbst spricht von „drawing into painting" – und darüber eine ganz eigene Sprache geschaffen, die sie in großformatige Wandzeichnungen und hoch komplexe Tafelbilder umsetzt. In dieser Praxis heißt Zeichnen stets auch „mit Zeichen umgehen". Mehretu baut ihre Malerei in mehreren milchig-transparenten Farbschichten auf, die sie zeichnerisch bearbeitet. Ihr Vokabular ist auf ganz verschiedene Weise abstrakt: Es enthält Tags und Graffiti ebenso wie barocke Elemente, greift auf Kalligrafie ebenso wie auf Landschaftsmalerei oder Comic zurück. Mehretu verbindet asymmetrisch ausgreifende Farbfelder mit dynamisch-farbigen Linien und Kurven, die bei entsprechender Fokussierung eine flüchtige Tektonik und mehrdeutige Tiefe im Bild aufscheinen lassen: Motive, die zumeist öffentliche, gesellschaftlich herausgehobene Orte zeigen – Regierungsgebäude, Museen, Stadien, Schulen oder Flughäfen – und die Bilder auch zu abstrakten „Stadtlandschaften" werden lassen. Zudem finden sich of kleinteilige Symbole wie Flaggen, Tattoomotive, Comicelemente oder schlicht farbige Punkte, die Mehretu zu Gruppen oder Schwärmen bündelt Im sorgsam austarierten Chaos pendelt der Blick permanent vom Ganzen zum Detail und zurück, und doch bleiben Dichte und Dynamik im besten Sinne ungreifbar und a-hierarchisch. Die Bilder, hochkomplex organisiert, sind in ihrer visuellen Grammatik kaum durchschaubar – und werden für Mehretu damit auch zu Metaphern globalisierter gesellschaftspolitischer Verhältnisse zu Beginn des 21. Jahrhunderts.

Dans son œuvre, Julie Mehretu a développé des formes mixtes et combinatoires entre la peinture et le dessin – elle-même parle de « drawing into painting » – et a ainsi créé un langage tout à fait personnel qu'elle transpose dans des dessins muraux grand format et des peintures de panneau dénotant une haute complexité. Cette pratique du dessin relève aussi et toujours du « maniement des signes ». Mehretu élabore sa peinture en plusieurs couches de couleur laiteuses et transparentes dont chacune subit un traitement graphique. Son vocabulaire est abstrait aux titres les plus divers : il contient des tags et des graffitis aussi bien que des éléments baroques, fait appel à la calligraphie comme à la peinture de paysages ou à la bande dessinée. Mehretu combine des champs de couleur étendant asymétriquement des lignes et des courbes dynamiques et colorées, à travers lesquels la mise au point correspondante fait apparaître une tectonique éphémère et une profondeur ambivalente du tableau, avec des motifs qui montrent le plus souvent des lieux publics significatifs au plan social – bâtiments gouvernementaux, musées, stades, écoles ou aéroports – et qui transforment aussi les tableaux en « paysages urbains » abstraits. On relève en outre la présence de minuscules symboles comme des drapeaux, des tatouages, des éléments de bandes dessinées ou de simples points de couleu que Mehretu regroupe en grappes ou en essaims. Dans ce chaos soigneusement équilibré, le regard oscille constamment entre l'ensemble e le détail, et pourtant la densité et la dynamique en demeurent au meilleur sens insaisissables et non hiérarchiques. La grammaire visuelle de ces tableaux ne permet guère de les appréhender dans leur organisation hautement complexe – et ils deviennent ainsi pour Mehretu des métaphores de la globalisation des conditions sociopolitiques à l'aube du XXIe siècle.

J. A

SELECTED EXHIBITIONS →
2005/06 *Africa Remix: Contemporary Art of a Continent,* Hayward Gallery, London, Centre Pompidou, Paris, Mori Art Museum, Tokyo **2005** *Currents,* Saint Louis Art Museum **2004** *Matrix,* Berkeley Art Museum, University of California; Whitney Biennial, Whitney Museum of American Art, New York; 26. Bienal de São Paulo **2003** *Drawing into Painting,* Walker Art Center, Minneapolis; Albright-Knox Art Gallery, Buffalo **2002** *Drawing Now: Eight Propositions,* The Museum of Modern Art, New York; 3. Busan Biennale **2000** *Five Continents*

and One City, Museo de la Ciudad de México, Mexico City; *Greater New York,* P.S.1, New York

SELECTED PUBLICATIONS →
2004 *Whitney Biennale 2004,* Whitney Museum of American Art, New York **2003** *Cream 3,* London **2002** *Vitamin P,* London

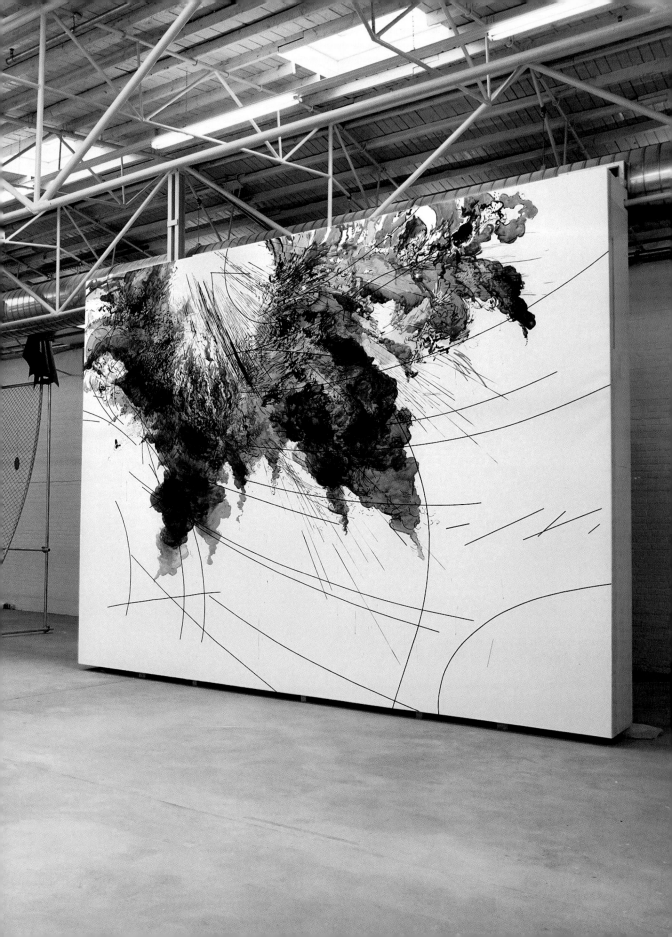

1 **The Eye of Ra**, 2004, ink on acrylic latex, wall drawing, 431 x 575 cm, installation view, Ausstellungshalle zeitgenössische Kunst Münster
2 **Congress**, 2003, ink, acrylic on canvas, painting, 180 x 245 cm

3 **Excerpt (Paradigm)**, 2003, ink, acrylic on canvas, 81.3 x 137.2 cm
4 **Excerpt (Suprematist Evasion)**, 2003, ink, acrylic on canvas, 81.3 x 137.2 cm

„Ich glaube, bei mir sind die Gemälde anfangs aus der Zeichnung hervorgegangen. Mein Ausgangsimpuls und meine Ausgangsuntersuchung bestanden im Versuch, mit Hilfe der Zeichnung eine Sprache zu entwickeln, die zwischen verschiedenen Erzählarten vermitteln und eine Stadtlandschaft erzeugen könnte, wobei jede Markierung über einen Charakter, einen Modus operandi des sozialen Verhaltens verfüge. Als sie in der Zeichnung weiter wuchsen und sich entwickelten, wollte ich, dass sie einander überlagerten, damit in den Erzählungen eine andere Art Raum- und Zeitmaß entstünde."

« Je pense qu'à l'origine, mes peintures sont nées du dessin. Mon impulsion et ma recherche initiales étaient de tenter de développer un langage graphique qui pourrait communiquer différents modes narratifs et de construire un paysage urbain, chaque marque ayant son caractère, un mode opératoire lié au comportement social. Au fil de leur croissance et de leur développement dans le dessin, j'ai voulu les voir stratifiés ; faire entrer dans les récits un autre genre de dimension de l'espace et du temps. »

"I think that for me the paintings grew out of the drawing in the beginning. My initial impulse and investigation was to try and develop, through drawing, a language that could communicate different types of narratives and build a cityscape, each mark having a character, a modus operandi of social behaviour. As they continued to grow and develop in the drawing I wanted to see them layered; to build a different kind of dimension of space and time into the narratives."

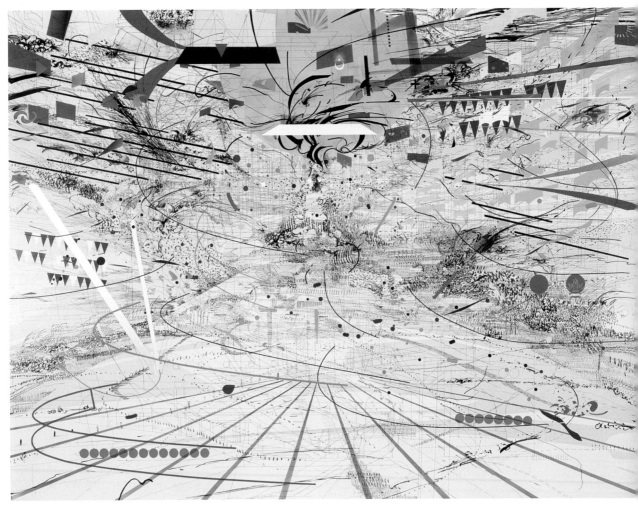

Aernout Mik

1962 born in Groningen, lives and works in Amsterdam, The Netherlands

In video and photo work Aernout Mik presents group behaviour in a disconcerting interplay between individuals and multitudes, thereby allowing events to become fully unconstrained situations. The carefully prepared scenarios are performed by amateur actors and documented on video. Mik stages the action without a strict story line and with finely gauged uncertainty. Cause, time and place can never be exactly determined, and the stage-like settings generally testify clearly to an exemplary artificiality. The soundless pictures let the observer's mood swing between amusement, sometimes absurd comedy, and apprehensiveness. *Middlemen* (2001), for example, has become a classic of this type of psychological experiment. This piece depicts brokers in a recreated stock exchange. Amidst heaps of papers, they sit, walk or stand around helplessly after an apparently devastating bear market, staring in disbelief at an (unseen) monitor. The protagonists act as if in a trance, while an evenly scanning camera presents the situation with complete objectivity. The newer video *Reversal Room* (2004) presents two dissimilar settings. In the first you see a conventional restaurant kitchen, which besides the staff is also haunted by peculiarly uninterested protagonists. A Chinese restaurant is the second setting, in which an intense brawl soon develops between two guests and the staff. While tables and fists are flying, however, the rest of the people take absolutely no notice of the occurrence, thus making it seem unreal and ghostly. Mik's films are experiments in the "human condition", and with their precise staging they lead us towards chaos and the indescribable.

In Video- und Fotoarbeiten inszeniert Aernout Mik Gruppenverhalten in befremdlichem Zusammenspiel von Einzelnem und Masse und lässt dabei Ereignisse in Situationen von Entgrenzung münden. Die sorgfältig vorbereiteten Szenarios werden mit Laiendarstellern aufgeführt und auf Video dokumentiert. Den Ablauf inszeniert Mik ohne strikte Storyline in fein justierter Unbestimmtheit: Anlass, Zeit und Ort sind nie genau ablesbar, und bühnenhaft konstruierte Settings zeugen zumeist deutlich von exemplarischer Künstlichkeit. Die ohne Ton gezeigten Bilder lassen den Betrachter zwischen Amüsement über teils absurde Komik und Beklemmung schwanken. Zum Klassiker solch psychologischen Modellversuchs ist etwa *Middlemen* (2001) geworden. Darin agieren Broker in einem nachgebauten Börsenraum. Sie sitzen, gehen oder stehen nach offenbar vernichtender Baisse inmitten von haufenweise hingeworfenen Papieren ratlos herum, starren ungläubig aufs (unsichtbare) Display. Die Akteure agieren wie in Trance, während eine gleichmäßig abtastende Kamera die Situation in aller Sachlichkeit vor Augen führt. Das jüngere Video *Reversal Room* (2004) führt zwei unterschiedliche Szenen vor: Im ersten Teil sieht man eine herkömmliche Restaurantküche, die neben dem Personal auch von eigenartig unbeteiligten Akteuren heimgesucht wird. Im zweiten Teil sieht man ein China-Restaurant, in dem sich zwischen zwei Gästen und dem Personal bald eine heftige Prügelei entwickelt. Während Tische und Fäuste fliegen, nehmen die übrigen Anwesenden aber keinerlei Notiz vom Geschehen, das dadurch irreal und geisterhaft erscheint. Miks Filme sind Experimente zur „Conditio humana", die präzise inszeniert ins Chaotische und Bodenlose führen.

Dans ses vidéos comme dans son œuvre photographique, Aernout Mik met en scène des comportements de groupe à travers l'interaction indéfinissable entre l'individu et la masse, et fait déboucher des événements dans des situations sans restriction. Ses scénarios soigneusement élaborés sont joués par des acteurs amateurs et documentés sur vidéo. Le déroulement en est mis en scène de manière subtilement vague, sans que la narration présente vraiment de fil conducteur : le prétexte, le moment et le lieu ne sont jamais clairement lisibles et les décors apparentés à une scène de théâtre témoignent le plus souvent d'une artificialité affichée. Les images présentées sans bande son font osciller le spectateur entre amusement – du fait d'un comique en partie absurde – et malaise. *Middlemen* (2001) est entre-temps devenu un classique de ce type d'expérience psychologique modélisée. On y voit des courtiers vaquer à leurs occupations dans un décor boursier après une chute des cours vertigineuse, assis ou debout ou marchant parmi des piles de papiers entassés, désorientés, les yeux rivés sur des moniteurs invisibles. Le jeu des acteurs s'apparente à une transe, tandis que le mouvement régulier de la caméra présente la situation en toute objectivité. La vidéo plus récente *Reversal Room* (2004) montre deux décors différents : dans la première partie, l'on voit une cuisine de restaurant ordinaire peuplée par son personnel, mais aussi par des acteurs singulièrement indifférents. Dans la seconde partie, on voit un restaurant chinois dans lequel une violente bagarre éclate bientôt entre le personnel et deux clients. Tandis que les tables volent et que fusent les coups de poings, les autres personnes présentes ne prêtent aucune attention à ces événements, qui apparaissent ainsi irréels et fantomatiques. Les films de Mik sont des expériences sur la « condition humaine » dont la mise en scène précise débouche sur le chaos et la perte de références. J. A.

SELECTED EXHIBITIONS →
2005 New Museum of Contemporary Art, New York; *Refraction*, Museum of Contemporary Art, Chicago **2004** Museum Ludwig, Cologne; *Dispersion*, Haus der Kunst, Munich; 26. Bienal de São Paulo **2003** The Cleveland Museum of Art; *Flock*, Magasin 3 Stockholm Konsthall; 8. Istanbul Biennial **2002** *Aernout Mik in The Living Art Museum*, The Living Art Museum, Reykjavik; Contemporary Art Centre, Vilnius

SELECTED PUBLICATIONS →
2004 AC: *Aernout Mik – Dispersion Room, Reversal Room*, Museum Ludwig, Cologne; *Dispersionen*, Haus der Kunst, Munich **2002** *Aernout Mik: Reversal Room*, Toronto

1 **Dispersion Room**, 2004, video installation, Museum Ludwig, Cologne
2 **Pulverous**, 2003, video installation, carlier I gebauer, Berlin

3 **Refraction**, 2004, video stills

„Wir erkennen im wirklich Seltsamen nicht etwas, das sich völlig von allem anderen unterscheidet. Es tritt genau an dem Punkt auf, wo die Dinge erkennbar und doch so anders sind, dass unser Sinn für das Vertraute ins Schlingern gerät."

« Nous n'identifions pas l'étrange comme quelque chose qui diffère totalement de tout le reste. Ceci se produit précisément là où les choses sont reconnaissables et néanmoins si différentes que le sens de ce qui nous est familier commence à se dérober. »

"We don't recognize the truly strange as something that differs totally from everything else. It occurs precisely at the point where things are recognizable and yet so different that our sense of familiarity slithers away."

2

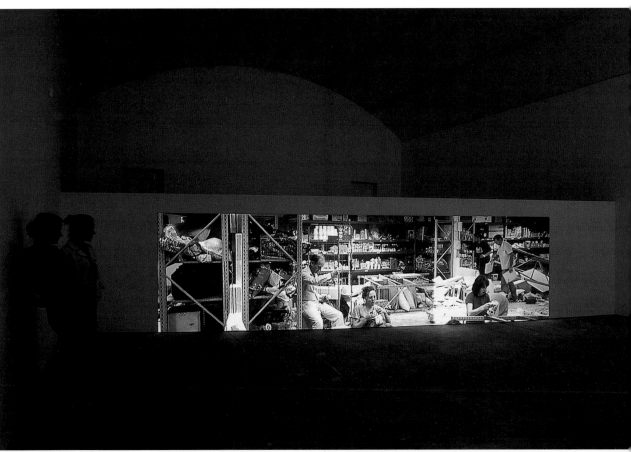

Beatriz Milhazes

1960 born in Rio de Janeiro, lives and works in Rio de Janeiro, Brazil

In her painting, Beatriz Milhazes combines the established vocabulary of abstraction and figuration in an unusual manner. With their intense colouration and extravagant abundance of motifs, her generally large-scale easel paintings develop a fascinating presence. Plant-like structures and especially blossoms make up the central motif and simultaneously form the hub through which a wide range of realistic, free and abstract illustrative styles are united. Milhazes' pictures are hybrid, hypnotically ornamental bouquets. Like Mandalas overflowing from sheer abundance they are interspersed with linear, dotted or flatly applied circular and spiral forms, and overgrown with dahlia and daisy blossoms, or fantasy flowers. Initially painting these elements on plastic, Milhazes transfers them like peel-off pictures only in a second step, and thus constructs the composition like a collage. The artist, who once referred to herself with ironic sincerity as a "conceptual carnavalesca" contemplates and combines highly diverse cultural and art-historical traditions in her strategy of amalgamation, which lends her works, particularly amid such luxurious delicacy, a provocative power. Unmistakably rooted in Brazilian modernism, Milhazes is also influenced by abstraction from other sources. Her paintings evoke Matisse or Bonnard, for example, but also the visual language of such dissimilar artists as Bridget Riley, Josef Albers, Piet Mondrian, or Kenneth Noland. Her work's decorative, filigree character additionally refers to traditional (generally with feminine connotations) forms of handicrafts: sewing, embroidery and appliqué. In this gesture of embellishment, Milhazes combines a Brazilian carnavalesque feeling for life with European modernism.

In ihrer Malerei verschmilzt Beatriz Milhazes auf ungewöhnliche Weise tradiertes Vokabular von Abstraktion und Figuration. Die zumeist großformatigen Tafelbilder entfalten mit ihrer intensiven Farbigkeit und ausschweifenden Motivfülle eine faszinierende Präsenz. Pflanzliche Strukturen, vor allem Blüten, bilden dabei das Kernmotiv und zugleich das Scharnier, über das eine große Bandbreite von gegenständlichen, freier und abstrakten Darstellungsarten verknüpft wird. Milhazes' Bilder sind hybride, hypnotisch ornamentale Bouquets. Wie vor Fülle überquellende Mandalas sind sie von linear, gepunktet oder flächig aufgetragenen Kreis- und Spiralformen durchsetzt, von Dahlien- und Margeritenblüten oder Fantasieblumen durchwuchert. Milhazes malt solche Elemente zunächst auf Folie und überträgt sie erst im zweiten Schritt wie Abziehbilder auf den späteren Bildgrund, baut die Komposition also wie eine Collage auf. Die Künstlerin, die sich selbst einmal in ironischer Aufrichtigkeit als „conceptual carnavalesca" bezeichnete, reflektiert und verbindet in ihrer Strategie der Mischungen ganz unterschiedliche kulturelle und kunsthistorische Traditionen – was ihren Werken gerade inmitten schwelgender Delikatesse auch provozierende Kraft verleiht. Unübersehbar in der brasilianischen Moderne verwurzelt, greift Milhazes auch auf andere Linien der Abstraktion zu: In ihrer Malerei evoziert sie etwa Matisse oder Bonnard, aber auch die Bildsprache so unterschiedlicher Künstler wie Bridget Riley, Josef Albers, Piet Mondrian oder Kenneth Noland. Der dekorativ-filigrane Charakter der Werke verweist zudem auf traditionelle (meist weiblich konnotierte) Formen von Handarbeit, auf Nähen, Sticken, Applizieren. In diesem Gestus des Schmückenden verbindet Milhazes brasilianisch-karnevaleskes Lebensgefühl mit europäischer Moderne.

Dans sa peinture, Beatriz Milhazes procède à une fusion inhabituelle entre les vocabulaires traditionnels de l'abstraction et de la figuration. Avec leurs couleurs vives et leurs motifs foisonnants, ses panneaux, le plus souvent des grands formats, déploient une fascinante présence. Les structures végétales, surtout des fleurs y constituent le motif central en même temps que la charnière où converge un large éventail de modes de représentation figuratifs, libres et abstraits. Les tableaux de Milhazes sont des bouquets ornementaux hybrides et hypnotiques. Tels des mandalas débordant de profusion, ils sont parsemés de formes circulaires ou de spirales linéaires peintes en pointillés ou en aplats où foisonnent des dahlias, des marguerites ou des fleurs inventées. Ces éléments sont peints sur un film avant d'être transposés sur le tableau comme des décalcomanies ; les compositions de Milhazes sont donc conçues à la manière d'un collage. L'artiste, qui définit elle-même son travail avec une franchise ironique comme une « conceptual carnavalesca », intègre dans sa stratégie une réflexion sur le mélange des traditions culturelles et artistiques de tous bords – ce qui, nonobstant leur festive délicatesse, leur confère aussi une charge provocatrice. Résolument enracinée dans la modernité brésilienne, Milhazes fait aussi appel à d'autres courants de l'abstraction : dans sa peinture, elle évoque Matisse ou Bonnard, mais aussi les langages d'artistes aussi divers que Bridget Riley, Josef Albers, Piet Mondrian ou Kenneth Noland. De plus, le caractère décoratif et filigrane de ses œuvres renvoie le plus souvent à des formes traditionnelles de l'artisanat (généralement à connotation féminine), à la couture, à la broderie, aux applications. Dans cette démarche ornementale et décorative, Milhazes parvient à opérer la fusion entre le sentiment de vie carnavalesque brésilien et la modernité européenne. J. A.

SELECTED EXHIBITIONS →
2004 26. Bienal de São Paulo **2003** 50. Biennale di Venezia, Venice **2002** *Beatriz Milhazes*, Centro Cultural Banco do Brasil, Rio de Janeiro; *Urgent Painting*, Musée d'Art Moderne de la Ville de Paris **2001** Birmingham Museum & Art Gallery; *Hybrids*, Tate Liverpool **2000** *Projects 70*, The Museum of Modern Art, New York

SELECTED PUBLICATIONS →
2003 *Mares do Sol – Beatriz Milhazes*, Centro Cultural Banco do Brasil, Rio de Janeiro **2002** *Urgent Painting*, Musée d'Art Moderne de la Ville de Paris, Paris **2001** *Beatriz Milhazes*, Ikon Gallery, Birmingham Museum & Art Gallery, Birmingham; *Hybrids*, Tate Liverpool, Liverpool

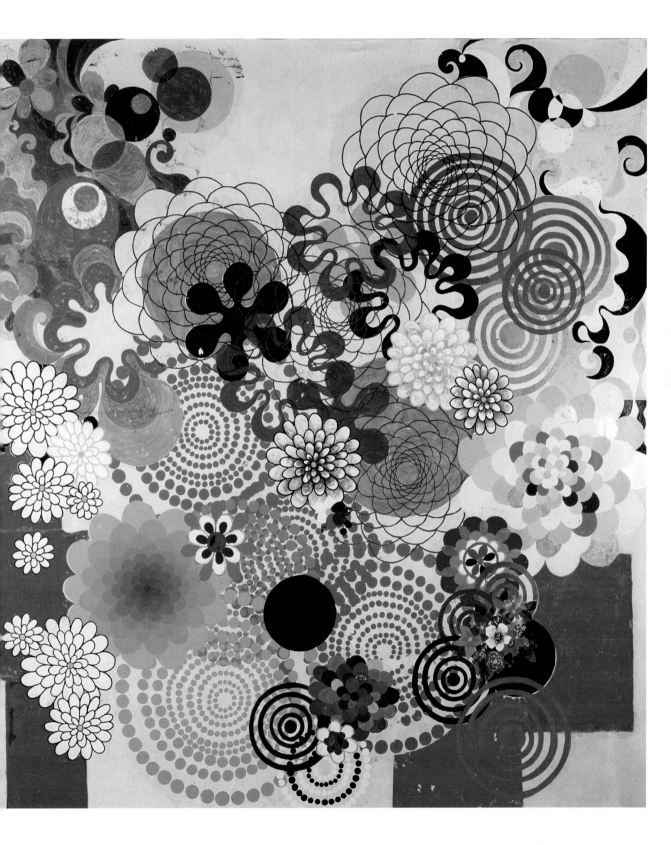

1 **Maresias**, 2002, acrylic on canvas, 300 x 266.5 cm
2 **O Sol de Londres**, 2003, acrylic on canvas, 250 x 230 cm

3 **Ovo de Páscoa**, 2003, acrylic on canvas, 299 x 189.5 cm

„Diese Bilder entstehen durch die Atmosphäre meiner Stadt –
durch das natürliche Licht, das Meer und den Karneval!"

«Ces peintures sont formées par l'ambiance de ma ville –
par la lumière naturelle, la mer et le carnaval!»

"These paintings are formed by the atmosphere of my city – by the natural light, the sea, and the Carnival!"

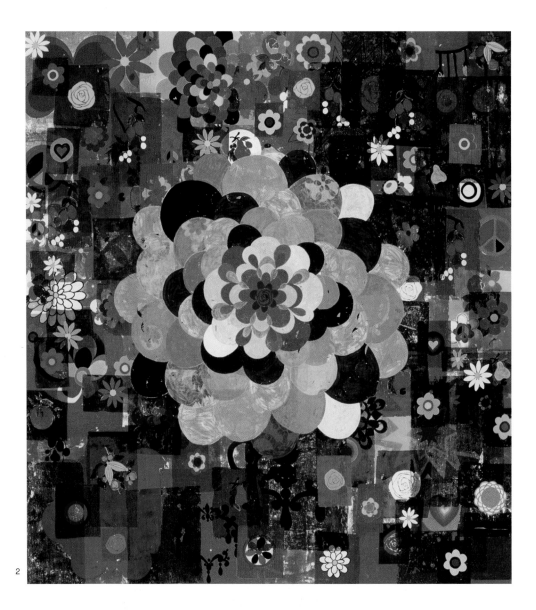

2

Shintaro Miyake

1970 born in Tokyo, lives and works in Tokyo, Japan

Shintaro Miyake's installations are populated by whole societies of cartoon figures, in coloured pencil drawings or plywood cutout figures, all with a recognizable silhouette of flattened oval heads, skinny bodies and long limp limbs. The figures are engaged in all manner of activities, presenting a complete graphic cosmos with their own internal logic. Miyake dramatizes the production of his work by appearing dressed in home-made costumes: an enormous red-headed octopus/alien, or a sky-blue cloud-covered bunny-like creature named Fluffy, and making drawings in situ. The audience is allowed a prolonged and close-up look at the creative act, itself dramatized in children's storybook terms. The products of this creativity appear not only once removed from the secrets of the artist's studio, but seem to belong to a parallel world. Certain characters such as Sweet san, a wide-eyed prepubescent girl, are recurrent favourites, while other themes are chosen to relate to the place of production: "The Fourth Planet Hour" exhibition was populated by dozens of tiny red jellyfish-like aliens, while "Minotauro contro Mostro Marino" in Milan presented a medieval-meets-manga dramaturgy of cartoon knights in armour, fortresses and bloody battle scenes. In Miyake's work, the artist is presented as outsider in the most extreme sense: his friendly, cuddly costumes on the one hand erasing the distance between audience and artist, while also denying the possibility of meaningful interaction. He appropriates a child's world-view; dramatizing the emergence of picture stories and integrating himself fully in their other-worldliness.

Die Installationen von Shintaro Miyake sind von ganzen Gesellschaften von Comicfiguren in Gestalt von Buntstiftzeichnungen oder ausgesägten Sperrholzfiguren bevölkert, stets erkennbar an ihren querovalen Köpfen, dürren Körpern und schlaffen langen Gliedern. Diese Figuren geben sich einer Vielzahl von Tätigkeiten hin und vertreten in ihrer charakteristischen Logik einen eigenen grafischen Kosmos. Miyake inszeniert die Entstehung seiner Werke, indem er in selbst gemachten Kostümen auftritt, in denen er die Zeichnungen vor Ort anfertigt: entweder als riesiger rotköpfiger Oktopus/Alien oder als mit himmelblauen Wolken bedecktes kaninchenhaftes Wesen namens Fluffy. Dem Betrachter wird so eine erweiterte Nahansicht auf den schöpferischen Akt gewährt, der eine kinderbuchartige Dramatik aufweist. Die Ergebnisse dieser Kreativität erscheinen nicht nur der Geheimnisse des Künstlerateliers enthoben, sie wirken wie Teile einer Parallelwelt. Bestimmte Figuren, so etwa die präpubertäre großäugige Sweet San, kehren häufig wieder, während andere Motive auf den Produktionsort verweisen. So traf man in der Berliner Ausstellung „The Fourth Planet Hour" auf Dutzende quallenartiger roter Aliens, wohingegen die Dramaturgie der Ausstellung „Minotauro contro Mostro Marino" in Mailand sich aus Mittelalter-/Manga-Comicrittern, Burgen und blutigen Schlachtenszenen zusammensetzte. Miyake präsentiert in seinen Arbeiten den Künstler auf extreme Weise als Außenseiter: Einerseits heben seine freundlichen, kuscheligen Kostüme die Distanz zwischen Betrachter und Künstler auf, andererseits negieren sie die Möglichkeit einer sinnvollen Interaktion beider. Dazu eignet er sich eine kindliche Weltsicht an und inszeniert die Entstehung von Bildgeschichten, in deren außerirdisches Ambiente er sich vollständig eingliedert.

Les installations de Shintaro Miyake sont peuplées de sociétés entières de personnages de dessins animés croqués au crayon de couleur ou réalisés en découpe de contreplaqué, reconnaissables à leurs silhouettes caractérisées par une large tête ovale, un corps famélique et de longs membres amollis. Les personnages sont occupés à toutes sortes d'activités et présentent un univers graphique complet ayant sa propre logique interne. Miyake met en scène la production de son œuvre en se présentant vêtu de déguisements confectionnés à la main – énorme poulpe extraterrestre à tête rouge, créature bleu ciel couverte de nuages apparentée à un lapin et surnommée Fluffy – et en réalisant des dessins *in situ*. Les spectateurs sont autorisés à assister de manière prolongée et de près à l'acte créateur, lui-même mis en scène comme un scénario de conte pour enfants. Les produits de cette forme de création ne sont pas seulement issus des secrets d'atelier de l'artiste, mais semblent aussi appartenir à un univers parallèle. Certains personnages comme Sweet san, une fillette prépubère aux yeux écarquillés, sont des favoris récurrents, tandis que d'autres thèmes sont choisis par référence au lieu de production : l'exposition « The Fourth Planet Hour » était peuplée de douzaines de petits extraterrestres rouges ressemblant à des méduses, tandis que « Minotauro contro Mostro Marino » à Milan présentait une mise en scène de type « rencontre entre le Moyen Age et les mangas », avec des chevaliers de dessin animé en armure, des châteaux-forts et des scènes de bataille. Dans l'œuvre de Miyake, l'artiste est présenté comme un outsider au sens le plus extrême : d'un côté, ses costumes attachants et potelés effacent la distance entre le spectateur et l'artiste, de l'autre, ils empêchent en même temps toute interaction significative. Miyake s'approprie le regard de l'enfant sur le monde et met en scène l'émergence d'histoires illustrées en s'intégrant lui-même entièrement dans leur altérité relevant d'un autre monde.

K. B.

SELECTED EXHIBITIONS →
2005 *Mixed-Up Childhood*, Auckland Art Gallery **2004** *The Japanese Experience – Inevitable*, Museum der Moderne Salzburg; *Officina Asia*, Galleria d'Arte Moderna di Bologna

PERFORMANCES →
2004 *Innocy's House*, Art Unlimited, Art Basel, Basle **2003** *Returning to the Memory of Your Home Town*, Laforet Museum, Tokyo **2002** *Live Wall Painting of Shulascaux*, Tokyo Tower Amusement Hall, Tokyo

1 Performance "Minotauro vs Kraken", "The Japanese Experience-Inevitable", Museum der Moderne, Salzburg
2 **Mars Dweller**, 2004, acrylic, colour pencil, pencil, glitter on cardboard on wood, 72 x 42 x 0.5 cm
3 **Mars Ride (Jellyfish Model)**, 2004, colour pencil, pencil on cardboard on wood, 76 x 54 x 0.5 cm

4 **Mars Dweller (Spacewalk)**, 2004, colour pencil, pencil on cardboard on wood, 50 x 51 x 0.5 cm
5 **The Third Planet (Lines)**, 2004, acrylic, colour pencil and pencil on paper, Ø 110 cm
6 **The Third Planet (Lines)**, 2004, acrylic, colour pencil and pencil on paper, 113.5 x 149 cm

„Ich bin beim Malen kostümiert, denn wenn ich nicht verkleidet bin, wird das Bewusstsein zu stark von der Tatsache geprägt, dass hier ein Künstler ein Werk erschuf."

« Quand je peins, je porte un costume ; si je ne suis pas déguisé, la conscience est trop fortement imprégnée du fait qu'il s'agit d'un artiste qui est en train de créer une œuvre. »

"I dress up while painting, because if I am not disguised, my consciousness is too strongly marked by the fact that here an artist has created a work."

2

3

4

5

6

Mariko Mori

1967 born in Tokyo, Japan, lives and works in New York (NY), USA

Since Mariko Mori's early self-portraits as a cyber-punk *manga otaku* (an addict of Japanese comic books) or a service droid in body-hugging armour, she has gradually incorporated more traditional Japanese culture into her work, including ritual tea ceremonies, supra-religious temples and Buddhist peace gardens, without sacrificing any of her acute visions of the future. Now an established artist in the West (Mori only had her first solo show in Tokyo in 2002), her numerous artistic personae of cyborgs and Bodhisattvas have given way to externalised expressions of how humans may evolve and what brave new world of technology awaits us. She has also progressed from photography, video and sculpture to ambitious installations such as the *Dream Temple* of 1999, an eight-sided structure of pearlescent glass and fibre optics floating above a white bed of salt that cocoons one visitor at a time in a spherical, multimedia environment of sound and imagery, relaying the artist's interpretation of the origins of life. Whereas *Dream Temple* is a 23rd-century reimagining of an existing building, the Yumedono, or "Dream hall" in Japan's ancient capital Nara, Mori's subsequent major architectural work, *Wave UFO* (2003) is fittingly unlike anything on Earth. This gleaming, interactive space pod landed first in Austria and then in central New York, inviting "travellers" to be connected to electrodes and have their brainwaves analyzed and visualized on screen. Beyond the glimpses of a technologically advanced civilisation, Mori hopes to put everyone onto a more humble path to spiritual enlightenment.

Seit ihren frühen Selbstporträts als Cyberpunk-*manga-otaku* (ein Fan japanischer Comics) oder als Reparaturdroide in figurbetontem Harnisch hat Mariko Mori zunehmend die traditionellere japanische Kultur in ihre Arbeiten einfließen lassen, beispielsweise rituelle Teezeremonien, religionsübergreifende Tempel und buddhistische Friedensgärten, ohne dafür auf ihre scharfsinnigen Zukunftsvisionen zu verzichten. Inzwischen im Westen eine etablierte Künstlerin (Mori hatte erst 2002 ihre erste Einzelausstellung in Tokio), sind ihre zahlreichen künstlerischen Identitäten als Cyborgs und Bodhisattvas eher äußerlichen Manifestationen der Entstehungsmöglichkeiten des Menschen sowie zu erwartender neuer technischer Wunderwelten gewichen. Dabei verlief ihre Entwicklung von Fotografie, Video und Skulptur zu anspruchsvollen Installationen. *Dream Temple* (1999), ein achteckiger Bau aus Acrylglas und Glasfaser, der über einem weißen Bett aus Salz schwebt und einen Besucher gleichzeitig kokonhaft in einem sphärischen Multimedia-Environment aus Klängen und Bildern umschließt, lenkt die künstlerische Interpretation auf die Ursprünge des Lebens. Während es sich bei *Dream Temple* um eine im 23. Jahrhundert anzusiedelnde Neuvorstellung eines bestehenden Baus handelt, nämlich der Yumedono oder „Halle der Träume" in Japans antiker Hauptstadt Nara, gleicht Moris darauffolgende größere architektonische Arbeit *Wave UFO* (2003) passenderweise nichts Irdischem. Diese schimmernde interaktive Raumkapsel, die zunächst in Österreich und dann im Zentrum von New York landete, lud die „Reisenden" ein, sich an Elektroden anzuschließen, um ihre Hirnströme auf einem Bildschirm analysieren und visualisieren zu lassen. Jenseits der Präsentation einer technisch fortschrittlicheren Zivilisation hofft Mori, dass es ihr gelingt, die Menschen auf einen demütigeren Pfad der spirituellen Erleuchtung zu führen.

Depuis ses premiers autoportraits en cyberpunk *manga otaku* (accro du manga japonais) ou en droïde domestique engoncée dans son armure moulante, Mariko Mori a peu à peu fait entrer dans son travail une part accrue de culture traditionnelle japonaise – notamment des cérémonies rituelles du thé, des temples suprareligieux et des jardins de la paix bouddhistes – sans rien sacrifier de ses perspicaces visions futuristes. Artiste aujourd'hui établie en Occident (sa première exposition personnelle à Tokyo ne date que de 2002), ses nombreux personnages artistiques de cyborgs et de bodhisattvas ont ouvert la voie à des expressions extraverties de la manière dont pourrait évoluer l'humanité et du genre de civilisation technologique exaltante qui nous attend. Dans le même temps, Mori est aussi passée de la photographie, de la vidéo et de la sculpture à d'ambitieuses installations comme le *Dream Temple* de 1999, une structure octogonale opalescente en verre et fibres optiques érigée sur un lit de sel de mer, qui baigne le spectateur – un seul à la fois – dans un environnement multimédia sphérique de sons et d'images relayant la vision de l'artiste sur les origines de la vie. Alors que le *Dream Temple* se présente comme la réinterprétation, au XXIIIe siècle, d'une architecture existante, le Yumedono ou «Salle du rêve» de Nara, l'ancienne capitale du Japon, *Wave UFO* (2003), l'œuvre architecturale majeure de Mori, est un objet authentiquement différent de tout ce qui existe sur terre. Ce module spatial interactif étincelant a d'abord atterri en Autriche, puis au centre de New York, invitant les «voyageurs» à se connecter à des électrodes et à contempler leurs ondes cérébrales analysées et visualisées sur un écran. Au-delà des aperçus d'une civilisation technologique avancée, Mori se propose de conduire chacun vers la voie plus humble de l'illumination spirituelle.

O. W.

SELECTED EXHIBITIONS →
2004 *Video – Die Bildsprache des 21. Jahrhunderts*, NRW-Forum, Düsseldorf **2003** *Wave UFO*, Public Art Fund, New York, Kunsthaus Bregenz **2002** *Pure Land*, Museum of Contemporary Art, Tokyo; 26. Bienal de São Paulo **2001** *Form Follows Fiction*, Castello di Rivoli, Turin **2000** *Dream Temple*, Rooseum Center for Contemporary Art, Malmö; *Link*, Centre Pompidou, Paris; *Beginning of the End*, Centre National de la Photographie, Paris

SELECTED PUBLICATIONS →
2003 *Wave UFO*, Kunsthaus Bregenz, Bregenz **2000** *Dream Temple*, Fondazione Prada, Milan **1999** *Mariko Mori*, The Museum of Contemporary Art, Chicago; *Esoteric Cosmos*, Kunstmuseum Wolfsburg, Ostfildern-Ruit

1 **Transcircle**, 2004, Corian, LED, real-time control system, pebbles, Ø 430 cm

2+3 **Wave UFO**, 1999–2002, brainwave interface, vision dome, projector, computer system, fibreglass, Technogel, acrylic carbon fiber, aluminium, magnesium, 493 x 1134 x 528 cm

„Ich suche stets nach den Beziehungen zwischen meiner Existenz und der totalen Existenz, nach den Verbindungen zwischen dem Hier und dem Anderswo."

« Je cherche toujours des rapports entre mon existence et l'existence globale, des liens entre l'ici et l'ailleurs. »

"I am always looking for relationships between my existence and total existence, connections between here and elsewhere."

2

Sarah Morris

1967 born in Kent, UK, lives and works in New York (NY), USA, and London, UK

Smoothly reflective surfaces, strictly laid-out grid structures, garishly elegant colour combinations – within her individual adaptation of the minimalist code Sarah Morris creates a pictorial space of seductive emptiness. Building upon her painting's thoroughly abstract qualities, however, she also makes very concrete references: the illusion that Morris distils from the interwoven grids and frameworks, lately of increasing complexity, coalesces into an impression of urban glass façades. In Morris' colourfield painting one inevitably reads the anonymous surfaces of office towers and bank buildings. Her painting's strength lies in its insistence on ambivalence, for between abstract and representational pictorial space Morris smuggles in contradictions. This results in uniquely interpenetrated surfaces and highly diverse ways of reading the work: characteristics that Morris has achieved with even greater intensity in newer works such as *Sony (Los Angeles)* or *People's Bank (Los Angeles)*, both from 2004. Morris has also developed the central motif of urbanity as a façade in the medium of film. After works about New York, Miami, Las Vegas and Washington her most recent film is *Los Angeles* (2004), which records the speed of the megacity – itself the capital city of image production – and mirrors its self-made myths. Morris captures moods and images all relating to the Oscar awards: stars, temples of consumerism, cryogenic laboratories, Botox injections, Mulholland Drive, the Wells Fargo building – everything tightly woven into a rhythmically pulsating flow of images, in which artificiality and authenticity merge inextricably with one another.

Glatte Hochglanzoberflächen, strikt konstruierte Rasterstrukturen, grell-elegantes Nebeneinander der Farben – in ihrer eigenwilligen Adaption minimalistischer Kodes kreiert Sarah Morris einen Bildraum von verführerischer Leere. Auf Basis durchweg abstrakter Qualitäten ihrer Malerei erschließt sie allerdings auch ganz reelle Referenzen: Die Illusion, die Morris aus den zuletzt zunehmend komplex verschachtelten Gittern und Rastern destilliert, bündelt sich zum Eindruck städtischer Glasfassaden. Unweigerlich liest man in Morris' Colourfield painting die anonymen Oberflächen von Bürotürmen und Bankgebäuden mit. Die Stärke ihrer Malerei liegt im Beharren auf Ambivalenz, denn zwischen abstraktem und repräsentativem Bildraum schleust Morris Widersprüche ein. Daraus resultiert eine eigenartige Durchdringung von Oberfläche und ganz unterschiedlichen Lesarten, die Morris in neueren Arbeiten wie *Sony (Los Angeles)* oder *People's Bank (Los Angeles)*, beide 2004, sogar in ungleich gesteigerter Form gelingt. Das Kernmotiv von Urbanität als Fassade entwickelt Morris auch im Medium Film – nach Werken über New York, Miami, Las Vegas und Washington entstand zuletzt *Los Angeles* (2004). Der Film nimmt die Geschwindigkeit der Megacity auf, ihrerseits Hauptstadt der Bildproduktion, und spiegelt deren selbst gemachte Mythen. Morris fängt Stimmungen und Bilder rund um die Oscar-Verleihung ein: Stars, Konsumtempel, Kryogenik-Labors, Botox-Injektionen, der Mulholland Drive, das Wells-Fargo-Gebäude – alles dicht gefügt zum rhythmisch pulsierenden Bilderstrom, in dem Kulissenhaftigkeit und Authentizität unlöslich miteinander verschmelzen.

Surfaces ultrabrillantes, structures tramées construites avec une extrême rigueur, juxtaposition élégante et bigarrée des couleurs – avec son adaptation très personnelle des codes minimalistes, Sarah Morris crée un espace pictural d'une séduisante vacuité. Sur la base des qualités uniment abstraites de sa peinture, il est vrai qu'elle intègre aussi dans ses tableaux des références tout à fait réelles : l'illusion qu'elle distille à travers ses grilles et ses trames, dont les imbrications n'ont cessé de se complexifier ces derniers temps, concourt à générer l'impression de façades vitrées. Immanquablement, on se prend à lire dans le Colourfield painting de Morris les surfaces anonymes des tours de bureaux et des édifices bancaires. La force de sa peinture réside dans le maintien opiniâtre de cette ambivalence, car entre les espaces picturaux abstrait et figuratif, elle instille en effet des contradictions. Il en résulte une interpénétration très particulière entre la surface picturale et les multiples lectures qu'on peut en faire, interpénétration à laquelle Morris a encore su donner une forme incomparablement potentialisée dans des œuvres récentes comme *Sony (Los Angeles)* ou *People's Bank (Los Angeles)*, deux œuvres de 2004. Pour développer son motif central de l'urbanité comme façade, Morris se sert aussi du médium cinématographique. Après des œuvres sur New York, Miami, Las Vegas et Washington, elle a tourné récemment *Los Angeles* (2004), un film qui s'attache à décrire le rythme trépidant de la mégapole américaine – elle-même capitale de la production d'images – et qui élabore une réflexion sur ses mythes auto-créés. Morris capte les images et les atmosphères autour de la remise des Oscars : stars, temples de la consommation, laboratoires de cryogénie, injections de Botox, Mulholland Drive, l'immeuble de la Wells Fargo Bank – le tout agencé dans un flux d'images rythmées où décor et authenticité sont inextricablement mêlés. J. A.

SELECTED EXHIBITIONS →
2005 *Populism*, Contemporary Art Centre, Vilnius, Museet for samtidskunst, Oslo; Stedelijk Museum, Amsterdam; *Bühne des Lebens – Rhetorik des Gefühls*, Städtische Galerie im Lenbachhaus, Munich **2004** *Treasure Island*, Kunstmuseum Wolfsburg; *Heißkalt – Aktuelle Malerei aus der Sammlung Scharpff*, Hamburger Kunsthalle, Staatsgalerie Stuttgart **2003** 2. Tate Triennial, Tate Britain, London; *Abstraction Now*, Künstlerhaus Wien, Vienna **2002** Palais de Tokyo, Paris; *Capital*, Site Santa Fe; *Cinecity: The Films of Sarah Morris*, Hirshhorn Museum, Washington D.C.; *Project 77*, The Museum of Modern Art, New York; *Sarah Morris: Miami*, Museum of Contemporary Art, North Miami

SELECTED PUBLICATIONS →
2004 *Bar Nothing*, Galerie Max Hetzler, Berlin **2001** *The Mystery of Painting*, Sammlung Goetz, Munich; *Capital*, Hamburger Bahnhof, Berlin; *Hybrids – International Contemporary Painting*, Tate Liverpool; *Playing Amongst the Ruins*, Royal College of Art, London; *Shopping*, Generali Foundation, Vienna

1 **Sony (Los Angeles)**, 2004, household gloss on canvas, 289 cm x 289 cm
2 Installation view, "Los Angeles", White Cube, London, 2004

3 **Los Angeles**, 2004, 35mm film transferred to DVD, 26 min. 12 sec., film stills

„Das Interessante sind all die Gespräche, die geführt werden, damit etwas passiert. Diese Gespräche üben eine transformative Kraft auf deine Meinung von einem Ort und deine Erfahrung mit ihm aus. Die Intelligenz einer Stadt, die einen kommerziellen Ruf hat, eine Industrie, die Bilder produziert und in die ganze Welt exportiert, die so unglaublich resistent dagegen ist, repräsentiert zu werden. Das ist eine faszinierende Idee, glaube ich."

« Ce qu'il y a d'intéressant, ce sont toutes les conversations qui ont lieu afin que quelque chose soit réalisé. Ces conversations sont en mesure de transformer votre opinion sur un lieu et votre expérience de ce lieu. L'intelligence impliquée dans une ville qui a une réputation commerciale, une industrie tellement impliquée dans le conditionnement et l'exportation d'images à travers le monde, et qui, en fait, est incroyablement résistante à être soi-même représentée. Je pense que c'est une idée fascinante. »

"What's interesting is all of the conversations that go on in order to make something happen. Those conversations have a transformative power in terms of your opinion of a place and your experience of it. The intelligence involved in a city that has a commercial reputation, an industry so involved in packaging and exporting images throughout the world, that is actually incredibly resistant to be being represented. I think that's a fascinating idea."

2

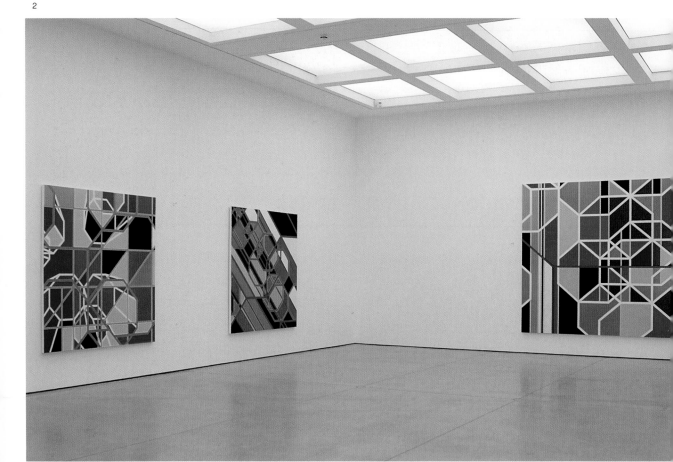

Ron Mueck

1958 born in Melbourne, Australia, lives and works in London, UK

Ron Mueck's hyper-realistic figures are marked by an astounding precision of detail, which tests sculpture's limits as a means of annexation of the human body. Mueck initially attracted attention with a sculpture that was striking in its literalness: no single hair or wrinkle seemed to be missing from *Dead Dad* (1996/97), a deceptively life-like reproduction of the body of his naked, dead father, shrunken to the smaller format of one metre long. A reduction to the empty shell of his own face with hairline was sufficient for the self-portrait *Mask II* (2001/02), which seemed to be asleep lying on its side. The exactness of detail in the fibreglass and silicone sculptures testifies to Mueck's experience as a professional puppet builder for animation films and special effects. However, the figures' inner sensitivity attracts just as much attention as does their outward perfection. The multi-layered nature of his portrayals is thus also due to their psychological dimension, the manipulation of relative sizes, and the site-specific installation. The depiction in *Ghost* (1998) of a gangling girl in a swimsuit who, slightly oversized, leans on a wall, expresses the awkwardness of an adolescent who would feel uneasy in any body. In the 2001 Venice Biennale Mueck exhibited *Boy* (1999), the figure of a youth almost five metres tall who cowered in the exhibition's entryway. The arms crossed in front of his face do not allow his facial expression to be immediately recognized: simultaneously menacing and in need of protection, despite his monumentality he appears to be fearfully hoping to remain undiscovered in his hiding place.

Die hyperrealistischen Figuren von Ron Mueck kennzeichnet eine erstaunliche Detailpräzision, die die Grenzen der Skulptur als Mittel zur Aneignung des menschlichen Körpers auslotet. Mueck machte zunächst mit einer Skulptur auf sich aufmerksam, die durch ihre Buchstäblichkeit bestach: An *Dead Dad* (1996/97), einer täuschend echten Nachbildung des Körpers seines nackten toten Vaters, geschrumpft auf ein Miniaturformat von knapp einem Meter Länge, schien kein Haar, keine Falte zu fehlen. Für das Selbstporträt *Mask II* (2001/02) war die Reduktion auf die leere Hülle des eigenen Gesichts mit Haaransatz ausreichend, das seitlich liegend zu schlafen schien. Muecks Erfahrung als professioneller Hersteller von Puppen für Animationsfilme und Spezialeffekte bezeugt die Detailgenauigkeit der Skulpturen aus Fiberglas und Silikon. Der inneren Befindlichkeit der Figuren kommt jedoch ebenso viel Aufmerksamkeit zu wie ihrer äußeren Perfektion. Dadurch entsteht eine Vielschichtigkeit der Darstellung mit einer psychologischen Dimension, der Verfremdung von Größenrelationen und der ortsspezifischen Installation. Die Darstellung eines schlaksigen Mädchens in einem Badeanzug (*Ghost*, 1998), das, leicht übergroß, an einer Wand lehnt, bringt die Befangenheit einer Heranwachsenden zum Ausdruck, die sich in jedem Körper unwohl fühlen würde. Auf der Biennale Venedig 2001 zeigte Mueck die fast fünf Meter hohe Figur eines Jungen (*Boy*, 1999), der im Eingangsbereich der Ausstellung hockte. Die vor dem Gesicht des Jungen verschränkten Arme ließen seinen Gesichtsausdruck nicht sofort erkennen: Zugleich bedrohlich und schutzbedürftig, schien er ungeachtet seiner Monumentalität ängstlich auf die Möglichkeit zu hoffen, in seinem Versteck unentdeckt zu bleiben.

Les figures hyperréalistes de Ron Mueck se caractérisent par une précision de détails stupéfiante qui sonde les limites de la sculpture comme moyen d'appropriation du corps humain. Mueck s'est d'abord fait connaître par une sculpture fascinante de littéralité : dans *Dead Dad* (1996/97), une reproduction extraordinairement réaliste du corps nu de son père mort ramené à un format miniaturisé d'à peine un mètre de long, il ne semblait manquer aucun poil ni aucune ride. Pour l'autoportrait *Mask II* (2001/02), la réduction du propre visage de l'artiste à son enveloppe vide, avec naissance du cuir chevelu, couché sur le côté et plongé dans le sommeil, semblait se suffire à elle-même. L'expérience de Mueck dans la réalisation professionnelle de personnages de films d'animation et d'effets spéciaux pour le cinéma explique la précision des détails de ses sculptures en fibre de verre et en silicone. Mais l'intériorité et l'état d'âme de ses figures reçoivent la même attention que la perfection extérieure de l'exécution. C'est à cette double focalisation que se doit aussi la polysémie psychologique de la représentation, du détournement des rapports de grandeur et de l'installation *in situ*. La représentation d'une jeune fille dégingandée en maillot de bain (*Ghost*, 1998), un peu plus grande que nature, qui s'appuie contre un mur, exprime l'embarras d'une adolescente qui se sentirait mal à l'aise dans n'importe quel corps. Pour la Biennale de Venise 2001, Mueck a présenté une figure de presque cinq mètres de haut, un garçon (*Boy*, 1999) accroupi dans la zone d'entrée de l'exposition. Les bras croisés devant le visage ne permettaient pas de reconnaître son expression au premier coup d'œil : à la fois menaçant et désireux de protection nonobstant sa monumentalité, il semblait compter sur une possibilité de rester inaperçu dans sa cachette.

E. K.

SELECTED EXHIBITIONS →
2003 Hamburger Bahnhof, Berlin; The National Gallery, London; Frans Hals Museum, Haarlem; *The Body Transformed*, National Gallery of Canada, Ottawa **2002/03** *Sculpture*, Museum of Contemporary Art, Sydney **2002** *Directions*, Hirshhorn Museum, Washington D.C. **2001** 49. Biennale di Venezia, Venice **2000** *Ant Noises*, The Saatchi Gallery, London

SELECTED PUBLICATIONS →
2003 *Ron Mueck*, Hamburger Bahnhof, Berlin; *Ron Mueck*, The National Gallery, London; *The Body Transformed*, National Gallery of Canada, Ottawa **2002** *Sammlung Ackermans*, K21 – Kunstsammlung Nordrhein-Westfalen, Düsseldorf **2001** *Boy by Ron Mueck*, Biennale di Venezia, Venice **2000** *Ant Noises*, The Saatchi Gallery, London

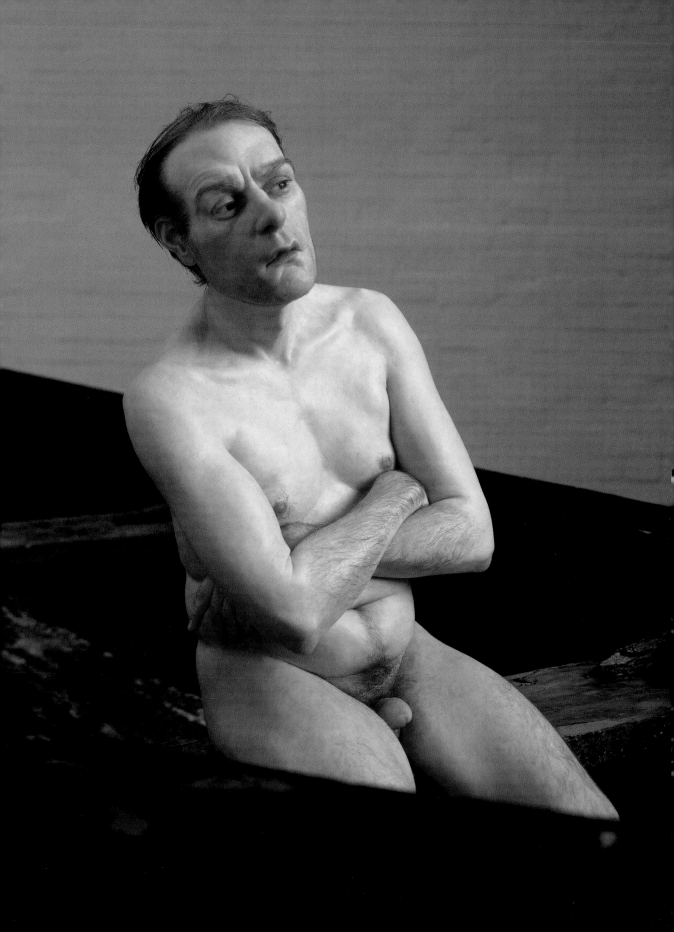

1 **Man in a Boat** (detail), 2002, mixed media, man height: 75 cm,
 boat length: 427 cm

2 **Mask II**, 2001/02, mixed media, 77 x 118 x 85 cm
3 **Pregnant Woman**, 2002, mixed media, height: 252 cm

„Einerseits versuche ich, in meinen Arbeiten eine glaubhafte Präsenz
zu schaffen, und andererseits müssen sie als Objekte funktionieren."

« D'un côté, mes travaux cherchent à créer une présence plausible,
mais de l'autre, ils doivent fonctionner en tant qu'objets. »

"On one hand, I try to create a believable presence; and, on the other hand, they [the works] have to work as objects."

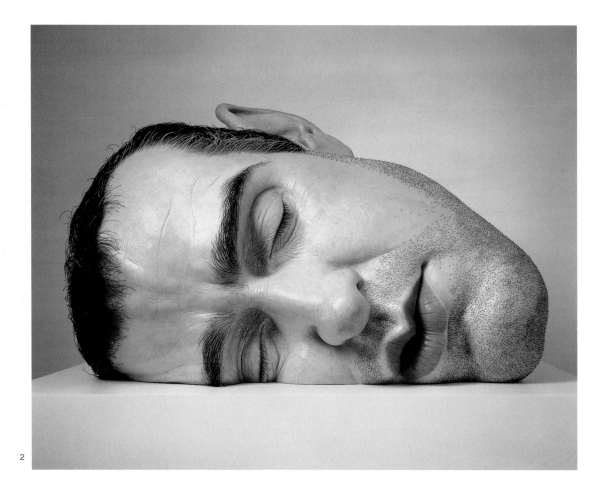

2

Vik Muniz

1961 born in São Paulo, Brazil, lives and works in New York (NY), USA

What actually is a picture? And how badly are we led astray by the daily flood of images? Vik Muniz asks these questions in a manner as witty as it is inventive. What we think we recognize at first glance as one of Théodore Géricault's legendary portraits, or as the well-known photo of Jackson Pollock "in action", can be seen on closer inspection to be a drawing done in chocolate syrup (*Mad Woman, After Géricault*, 2002; *Action Photo I [After Hans Namuth]*, 1997/98). The Brazilian artist constructs his reproductions of famous artworks from simple materials like sugar, dust, thread or plastic toys, and then photographs them. The fact that the painstaking act of picture composition is invisible in the ultimately presented photo links Muniz's working methods with the art of the 1960s and 1970s, with Land Art or Performance Art, in which the documenting photo was the only thing that remained of the work. As a "low-tech illusionist" as Muniz describes himself, he plays with and simultaneously analyses our perceptions and visual memory. His works are a kind of "picture-puzzle" in which not only the illustration, but often also the material used requires deciphering: For example in *Portrait of Alice Liddell, After Lewis Carroll* (2004) the artist uses small, coloured plastic toys to reconstruct the photo that writer Lewis Carroll took of the human model for his "Alice in Wonderland". Through his specific choice of materials, Muniz elucidates the ambivalent relationship between the author and the girl, which gave cause for rumours. By directly disrupting the recognition effect of his works and of the related everyday ingredients used, Muniz forces us to reconsider our usual ways of seeing.

Was eigentlich ist ein Bild? Und inwiefern werden wir von der täglichen Bilderflut in die Irre geleitet? Diese Fragen stellt Vik Muniz auf so geistreiche wie erfinderische Art. Was wir auf den ersten Blick als eines der legendären Bildnisse von Théodore Géricault oder als das bekannte Foto von Jackson Pollock „in Aktion" zu erkennen glauben, wird bei genauerer Betrachtung zu einer Zeichnung aus Schokoladensirup (*Mad Woman, After Géricault*, 2002; *Action Photo I [After Hans Namuth]*, 1997/98). Seine Reproduktionen berühmter Kunstwerke baut der brasilianische Künstler aus einfachen Materialien wie Zucker, Staub, Garn oder Plastikspielzeug und fotografiert sie. Dass der aufwändige Akt der Bildkomposition im schließlich präsentierten Foto unsichtbar ist, verbindet die Arbeitsweise von Muniz mit der Kunst der sechziger und siebziger Jahre, mit der Land Art oder der Performance-Kunst, bei der einzig das dokumentierende Foto vom Werk an sich übrig blieb. Als „Lowtech-Illusionist", wie Muniz sich selber bezeichnet, spielt er mit unserer Wahrnehmung und unserem Bildgedächtnis und hinterfragt sie gleichzeitig. Seine Arbeiten sind eine Art Bilderrätsel, bei dem nicht nur die Darstellung, sondern oft auch der Werkstoff der Entschlüsselung bedarf: In *Portrait of Alice Liddell, After Lewis Carroll* (2004) setzt der Künstler beispielsweise das Foto, das der Schriftsteller Lewis Carroll vom menschlichen Vorbild seiner „Alice im Wunderland" aufgenommen hat, aus kleinen, bunten Plastikspielsachen zusammen. Durch die spezifische Wahl des Materials verdeutlicht Muniz die Ambivalenz der Beziehung des Autors zu dem Mädchen, die zu Gerüchten Anlass gab. Indem er den Wiedererkennungseffekt seiner Arbeiten und der verwendeten profanen Zutaten unvermittelt stört, zwingt uns Muniz, unsere gewohnten Sehweisen zu überdenken.

Qu'est-ce véritablement qu'une image? Et jusqu'à quel point sommes-nous induits en erreur par le flot d'images quotidien? Telles sont les questions posées de manière aussi spirituelle qu'inventive par Vik Muniz. Ce qu'un premier regard nous fait apparaître comme un des légendaires portraits de Théodore Géricault ou comme la célèbre photographie de Jackson Pollock «en action», devient après plus ample examen un dessin exécuté au sirop de chocolat (*Mad Woman, After Géricault*, 2002; *Action Photo I [After Hans Namuth]*, 1997/98). Les reproductions d'œuvres d'art célèbres de Vik Muniz sont réalisées à partir de matériaux simples comme le sucre, la poussière, le fil de lin ou des jouets en plastique avant d'être photographiées. Le fait que l'acte laborieux de la composition devienne finalement invisible dans la photographie exposée rapproche la démarche de Muniz de l'art des années soixante et soixante-dix, du Land Art et de la performance, dans lesquels le document photographique est la seule trace qui reste de l'œuvre proprement dite. En tant qu'«illusioniste low-tech», comme Muniz se décrit lui-même, l'artiste joue sur notre perception et notre mémoire iconique tout en les interrogeant. Ses œuvres sont des sortes de rébus où la représentation, souvent aussi le matériau utilisé, requièrent un décryptage: dans *Portrait of Alice Liddell, After Lewis Carroll* (2004), l'artiste compose par exemple à partir de jouets en plastique coloré la photo que l'écrivain Lewis Carroll prit pour modèle de son «Alice au pays des merveilles». Le choix particulier du matériau éclaire les rapports ambigus de l'auteur avec la jeune fille, qui donnèrent lieu à des rumeurs dès son vivant. En perturbant très concrètement l'effet de reconnaissance induit par ses œuvres et les ajouts profanes utilisés, Muniz nous oblige à repenser nos modes de regard habituels.

C. R.

SELECTED EXHIBITIONS →
2005 *Prisons, After Piranesi*, National Academy of Sciences, Washington D.C. **2004** Irish Museum of Contemporary Art, Dublin; Fundación Telefónica, Madrid **2003** Museo d'Arte Contemporanea Roma, Rome **2002** *Model Pictures*, The Menil Collection, Houston **2001** 49. Biennale di Venezia, Venice; Museu de Arte Moderna de São Paulo; *The Things Themselves: Pictures of Dust*, Whitney Museum of American Art, New York **2000** Whitney Biennial, Whitney Museum of American Art, New York

SELECTED PUBLICATIONS →
2003 *Vik Muniz*, Fundación Telefónica, Madrid, Dublin; *Vik Muniz*, Museo d'Arte Contemporanea Roma, Rome **2001** *Vik Muniz/Ernesto Neto: Brasilconnects*, 49. Biennale di Venezia, Venice **1999** *Vik Muniz*, Centre national de la photographie, Paris **1998** *Seeing is Believing*, International Center of Photography, New York

1 **Irises, After Van Gogh**, 2004, from **Pictures of Magazines**, chromogenic print, 242.6 x 182.9 cm
2 **Sisyphus, After Tiziano**, 2005, from **Pictures of Junk**, C-print, 229 x 183 cm

3 **Medusa, After Bernini**, 2004, from **Pictures of Chocolate**, Cibachrome, 134.6 x 131.4 cm

„Zauberer und Künstler verdienen ihren Lebensunterhalt damit, Dinge zu manipulieren, die man gemeinhin als selbstverständlich betrachtet."

« Les magiciens et les artistes gagnent leur vie en manipulant des choses que l'on considère généralement comme des évidences. »

"The magician as well as the artist makes a living by manipulating stuff people generally take for granted."

2

Takashi Murakami

1962 born in Tokyo, lives and works in Tokyo, Japan, and New York (NY), USA

Previously considered as entertainment in Eastern culture, art has become big business in the West, yet both ways of thinking and both hemispheres are embraced by Takashi Murakami's art. From his Hiropon Factory near Tokyo and workshops in Brooklyn and Paris, an army of workers, accountants and managers oversee the mass-manufacture of Murakami t-shirts, toys, stickers and mouse pads that have joined the production line of paintings, sculptures, videos and installations. Unlike Warhol's creative, laidback Factory, Murakami's namesake is part of a real commercial enterprise, the Kaikai Kiki corporation, where Pop Art is being reinvented under the banner of the "Superflat". By incorporating traditional *nihon-ga* painting techniques into his cutesy computer-generated scenes that are subsequently hand painted by assistants, Murakami steamrollers over styles of high and low art as well as closing the gulf between techniques of craftsmanship and industry. His first trademarked character Mr DOB, a crazed, mutated version of Mickey Mouse, still appears alongside the rest of Murakami's anthropomorphic universe of smiling flowers and fungi, writ large in the mega-mall surroundings of New York's Rockefeller Plaza for his sculpture *Reversed Double Helix* (2003). In his continuing quest to "superflatten" the art world, he is bringing out artists, illustrators and designers from the Kaikai Kiki stable (including Chiho Aoshima and Mr.) as he would new action figures. Not only can we worship and covet Murakami's colourful, plastic deities as art works but we can now consume and collect the whole set.

Die früher in der fernöstlichen Kultur als Unterhaltung betrachtete Kunst ist im Westen zu einem großen Geschäft geworden. Dabei schließen die Arbeiten von Takashi Murakami beide Denkweisen und beide Hemisphären ein. Von seiner Hiropon Factory bei Tokio und seinen Betrieben in Brooklyn und Paris aus beaufsichtigt eine Armee aus Arbeitern, Buchhaltern und Managern die Massenproduktion von Murakami-T-Shirts, -Spielzeug, -Aufklebern und -Mousepads, die die Produktpalette aus Gemälden, Skulpturen, Videos und Installationen komplettieren. Anders als Warhols lässige Factory steht der Name Murakami für ein reelles Handelsunternehmen, die Firma Kaikai Kiki, in der die Pop Art unter dem Etikett der „Superflatness" neu erfunden wird. Durch Einbeziehung traditioneller *nihon-ga*-Maltechniken in seine niedlichen computergenerierten Szenen, die Assistenten anschließend eigenhändig malen, walzt Murakami Hoch- und Trivialkunststile glatt und schließt gleichzeitig die Lücke zwischen handwerklichen und industriellen Techniken. Seine erste zum Markenzeichen avancierte Figur, Mr DOB, eine wahnsinnige, mutierte Micky-Maus-Version, taucht noch immer neben dem restlichen anthropomorphen Murakami-Universum aus lächelnder Blumen und Pilzen auf, das für seine Skulptur *Reversed Double Helix* (2003) in der Mega-Shoppingmeile von New Yorks Rockefeller Plaza vergrößert wurde. In seinem fortdauernden Bestreben nach einem „Superflattening" der Kunstwelt bringt er Künstler, Illustratoren und Designer aus dem Kaikai-Kiki-Stall (wie Chiho Aoshima und Mr.) auf den Markt, als handelte es sich um neue Actionfiguren. Die bunten Plastikgottheiten Murakamis lassen sich nicht nur als Kunstwerke verehren und begehren, sondern nun auch als komplette Reihe konsumieren und sammeln.

Considéré naguère comme un divertissement par la culture orientale, l'art est devenu une affaire de gros sous en Occident, mais ces deux hémisphères et modes de pensée font aujourd'hui cause commune dans l'art de Takashi Murakami. De sa Hiropon Factory, située dans les environs de Tokyo, et de ses ateliers installés à Brooklyn et à Paris, une armée d'ouvriers, de comptables et de managers supervise la production de masse des t-shirts, jouets, autocollants et tapis de souris qui ont rejoint la ligne de production de peintures, de sculptures, de vidéos et d'installations de Murakami. A la différence de la Factory créative et bon enfant de Warhol, l'usine homonyme de Murakami fait partie d'une authentique entreprise commerciale, la Kaikai Kiki Corporation, dans laquelle le Pop Art est réinventé sous la bannière du « superflat ». En intégrant les techniques de peinture du traditionnel *nihon-ga* dans ses scènes mièvres générées par ordinateur puis peintes à la main par des assistants, Murakami passe au rouleau compresseur les styles artistiques nobles ou triviaux et comble le fossé qui sépare les techniques industrielle et artisanale. Version folle et mutée de Mickey Mouse, Mr DOB, son premier personnage déposé, continue de figurer au sein de l'univers anthropomorphique de fleurs et de champignons souriants, étalé dans le mégacentre commercial du Rockefeller Plaza de New York autour de sa sculpture *Reversed Double Helix* (2003). Dans sa quête incessante pour « superaplatir » le monde de l'art, Murakami présente aujourd'hui des artistes, des illustrateurs et des designers issus de l'écurie Kaikai Kiki (notamment Chiho Aoshima et Mr.) comme il produirait de nouvelles figurines d'action. Murakami ne nous invite pas seulement à adorer et à convoiter ses divinités en plastique bigarrées comme des œuvres d'art – nous pouvons désormais les consommer et en collectionner toute la gamme.

O. W

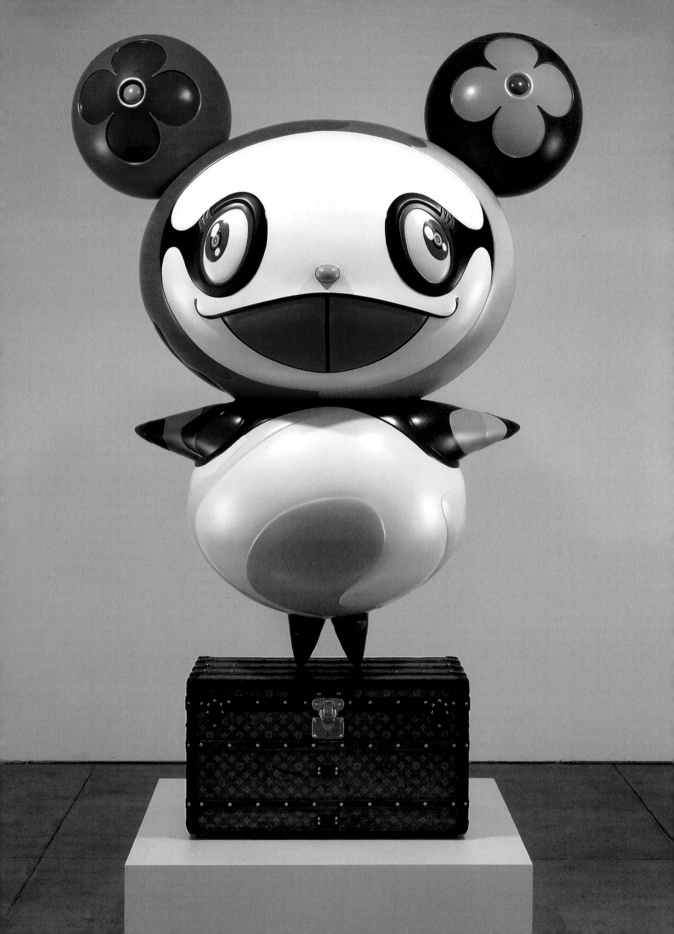

1 **Panda**, 2003, acrylic on fibreglass with antique Louis Vuitton trunk, 255 x 165 x 109 cm

2 **Tan Tan Bo Puking – a.k.a. Gero Tan**, 2002, acrylic on canvas, mounted on board, 360 x 720 x 6.7 cm

„Die Kluft zwischen Hoch- und Trivialkultur ist nahezu verschwunden. Stattdessen ist eine im wörtlichen Sinn ‚superflache' Kunst entstanden."

«Le fossé entre les cultures haute et basse a presque disparu. Dans un sens littéral, on a assisté à l'émergence d'une culture ‹superplate›.»

"The gap between high and low cultures is now almost gone. In a literal sense, a 'superflat' culture has emerged."

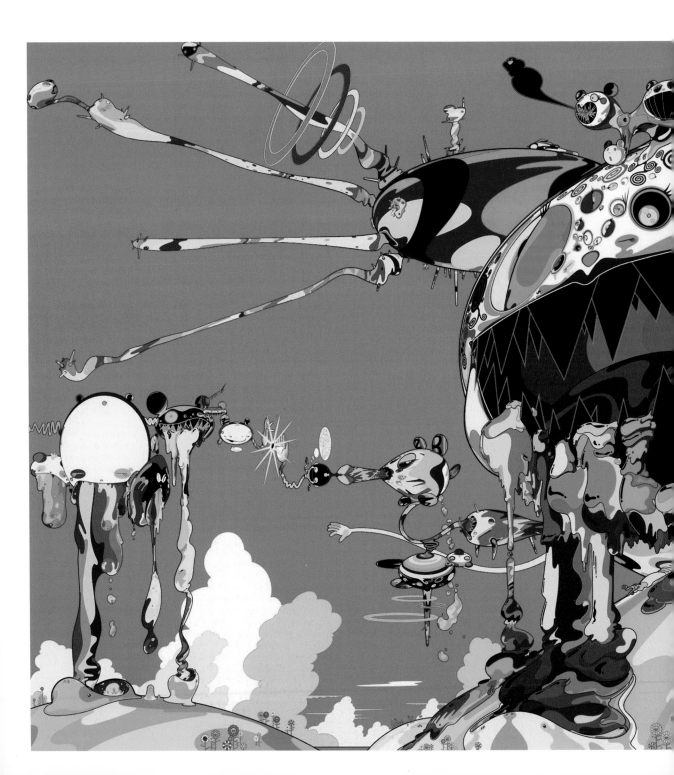

Yoshitomo Nara

1959 born in Hirosaki, lives and works in Tokyo, Japan

No They Didn't, claimed the title of a work and an exhibition by Yoshitomo Nara in 1999, but looking at the oval-faced, bug-eyed kiddie in question, it certainly seemed that they were up to no good. Nara's youngsters generally seem too small and angelic to inflict injury, but hi cartoon creations are anything but innocent, also pictured smoking cigarettes or setting dogs' tails on fire. Even at the height of play, dresse as bunnies, these toddlers look unhappy, but are they menacing or merely misunderstood? Nara taps into the awkwardness that plagues th developing minds of prepubescent children, who are stuck between the twilight of not yet knowing who they are and the dawn of teen sel confidence. This mid-childhood crisis of emotions is played out in his delicate and obsessively sculpted, painted or drawn characters, which now appear just as readily on plates, watches and ashtrays as on canvases or plinths. While Nara has joined fellow countryman Takash Murakami in the merchandising of his work, he retains a humble scale and handmade, rough-edge quality to the work, aligning himself firml with historical Japanese painters and printmakers, rather than the new breed of artists making hi-tech consumables. Mischievously, Nara toy with these boundaries and disguises his role as sentient artist behind the same youthful naiveté that suffuses the ambiguous texts in his work For instance, a speech bubble floats above a child's head wrapped in heavy bandages stating that "Nothing Ever Happens". But this doesn mean it couldn't or wouldn't.

No They Didn't wurde 1999 im Titel einer Arbeit und einer Ausstellung von Yoshitomo Nara behauptet, aber ein Blick auf jene eierköpf gen, glupschäugigen Kinder ließ ahnen, dass sie nichts Gutes im Schilde führten. Naras Geschöpfe wirken im Allgemeinen zu klein und engel haft, um Schaden anzurichten, aber seine rauchenden oder einen Hundeschwanz anzündenden Comic-Schöpfungen sind alles andere a unschuldig. Selbst mitten im Spiel, als Häschen verkleidet, erscheinen diese Kleinkinder unglücklich; aber sind sie wirklich bedrohlich, ode werden sie bloß missverstanden? Nara pocht auf jene Unbeholfenheit, die den sich entwickelnden Geist präpubertärer Kinder quält, die zwi schen der Dunkelzone des Noch-nicht-Wissens, wer sie sind, und dem Morgengrauen teenagerhaften Selbstbewusstseins gefangen sind. Dies emotionale Krise in der Mitte der Kindheit wird in seinen feinen, zwanghaft geformten, gemalten beziehungsweise gezeichneten Figuren aus geschöpft, denen man heute ebenso gut auf Tellern, Uhren und Aschenbechern begegnen kann wie auf Leinwand oder Sockel. Während Nar seinem Landsmann Takashi Murakami hinsichtlich der Vermarktung seines Werks in nichts nachsteht, ist er doch seinen bescheidenen Forma ten und der handgefertigten, ungeschliffenen Ausführung treu geblieben. Das stellt ihn in eine direkte Linie mit historischen japanische Malern und Holzschnittkünstlern und trennt ihn gleichzeitig von jener neuen Sorte Hightech-Konsumgüter produzierender Künstler. Verschmitz spielt Nara mit diesen Grenzen und verbirgt seine Rolle des empfindsamen Künstlers hinter derselben jugendlichen Naivität, die auch d mehrdeutigen Texte in seinen Arbeiten durchzieht. So verkündet beispielsweise eine über dem dick bandagierten Kopf eines Kindes schwe bende Sprechblase: „Nothing Ever Happens". Das soll allerdings nicht bedeuten, dass sich dies nicht ändern könnte.

No They Didn't, tel était le titre lancé par une œuvre et une exposition de Yoshitomo Nara en 1999. Mais en regardant les visages oval et les yeux écarquillés des bambins en question, on ne pouvait douter qu'ils étaient sur le point d'accomplir quelque méfait. Les enfants d Nara semblent généralement trop jeunes et trop angéliques pour commettre quelque acte malveillant, mais les personnages de ses dessin animés, que l'on voit fumant des cigarettes ou mettant le feu à des queues de chiens, sont tout sauf innocents. Même au plus fort de leur jeux, ces bébés vêtus en Jeannot Lapin ont l'air malheureux – mais sont-ils menaçants ou ne sont-ils qu'incompris? Nara met le doigt sur l maladresse qui harcèle l'esprit en formation d'enfants prépubères, pris en tenaille entre la pénombre de l'ignorance de leur identité et l'aub de l'assurance adolescente. C'est cette crise émotionnelle de l'enfance que développent ses personnages délicats, obsessionnellement sculp tés, peints ou dessinés, qui apparaissent aujourd'hui aussi indistinctement sur des assiettes, des montres et des cendriers que sur des toile et des socles. Même si Nara a rejoint son compatriote Takashi Murakami en ce qui concerne la commercialisation de son œuvre, il conserv une échelle plus modeste dans son travail, une qualité plus artisanale, moins lissée, et s'inscrit lui-même fermement dans la lignée des peintre et graveurs japonais historiques plutôt que dans la nouvelle génération d'artistes-fabriquants de produits de consommation high-tech. Na joue habilement de ces limites et déguise son rôle d'artiste sensible sous la même naïveté juvénile qui distille les textes ambigus de so œuvre. Ainsi, une bulle surplombant une tête d'enfant entourée d'épais bandages nous dit que « Nothing Ever Happens », ce qui ne veut pa dire que cela ne pourrait pas changer.

O. V

SELECTED EXHIBITIONS →
2004/05 *Over the Rainbow: Yoshitomo Nara and Hiroshi Sugito*, Pinakothek der Moderne, Munich; *Strips & Characters: Art under the Influence of Comics*, Kunstverein Wolfsburg **2003/04** *Nothing Ever Happens*, Museum of Contemporary Art Cleveland, Institute of Contemporary Art, Philadelphia, San Jose Museum of Art, Contemporary Art Museum Saint Louis, The Contemporary Museum, Honolulu; *Splat, Boom, Pow! The Influence of Comics in Contemporary Art*, Contemporary Arts Museum, Houston

SELECTED PUBLICATIONS →
2004 *The Little Star Dweller*, Rockin' On Inc., Tokyo **2003** *The Japanes Experience: Inevitable*, Ostfildern-Ruit; *Nothing Ever Happens*, Museum of Contemporary Art Cleveland, Cleveland **2002** *Nobody Knows: Drawings*, Little More Publishing, Tokyo; *Who Snatched the Babies?*, centre national de l'estampe et de l'art imprimé, Chatou

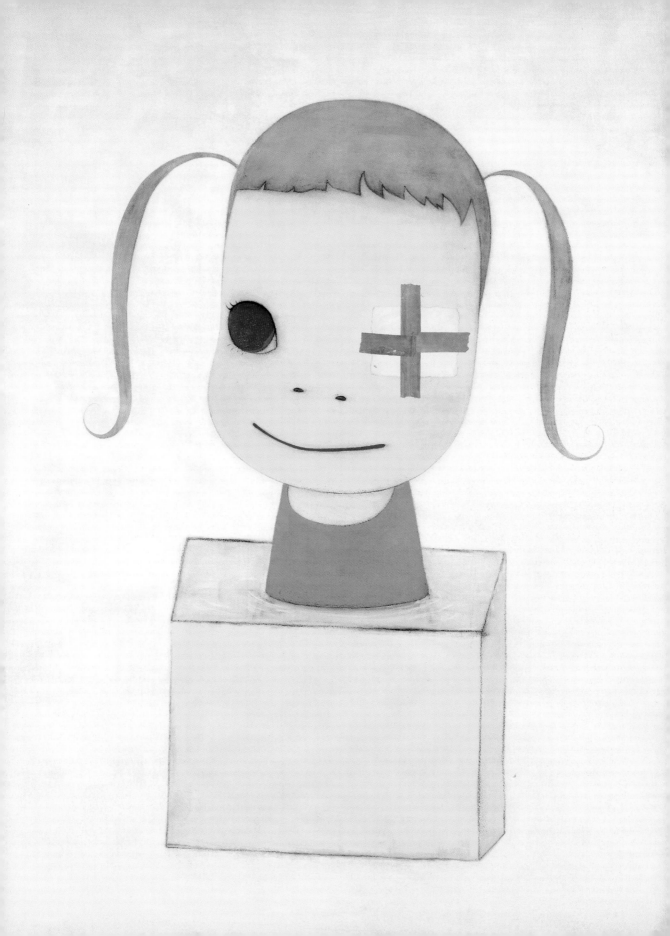

1 **sorry, couldn't draw left eye!**, 2003, acrylic on paper, 137 x 100 cm
2 Exhibition view, "Time of My Life: Art with Youthful Spirit", Tokyo Opera
 City Art Gallery, Tokyo, 2004

„Auch wenn ich versuche, etwas anderes zu zeichnen,
es kommt doch immer so etwas dabei heraus."

« Même quand j'essaie de dessiner autre chose,
c'est toujours cela qui en résulte. »

"Even if I try to draw something different, it always comes out this way."

Shirin Neshat

1957 born in Qazvin, Iran, lives and works in New York (NY), USA

Shirin Neshat became known through her photo series and video installations. They are based on extremely sharply contrasting visual and symbolical associations, such as in *Fervor* (2000), in which men appear in white on the left side, with veiled women dressed in black on the right. As an artist from an Islamic culture and in an art world anxious to be open to "minorities", Neshat nonetheless avoids expressing political or religious convictions. Her works point out clear fields of tension: men/women, orient/occident, pacifism/violence. Even if her titles sound like slogans, they still remain universal and unfathomable without a clearly recognizable message. Although this universe is forcefully depicted, it would be a mistake to assume that it is also one-sided and simple. Neshat left her country in 1974, four years before the Islamic revolution. Her first photographs, which are assembled under the generic heading *Women of Allah* (1993–1997), were created the first time she returned to Iran. Sometimes accentuated by calligraphy, these staged shots are frequently self-portraits in which Neshat poses stiffly, alone or with her young son. *Women of Allah* is a meditation on the social and political changes that the revolution triggered in the lives of women. She investigates how they have accepted this new ideology, and how they manage to survive these profound upheavals. The abyss of oppression which women suffer in a world ruled by men forms the centre of all of Neshat's work. Her latest project, *Women Without Men* (2004), is the cinematic adaptation of a novel by Shahrnush Parsipur.

Shirin Neshat wurde durch ihre Fotoserien und Video-Installationen bekannt. Sie sind auf visuell und symbolisch extrem stark kontrastierenden Verbindungen aufgebaut, wie zum Beispiel *Fervor* (2000), aufgeteilt zwischen Männern in weiß auf der linken Seite und schwarz gekleideten und verschleierten Frauen auf der rechten Seite. Als Künstlerin aus einer islamischen Kultur hütet sich Neshat jedoch davor, in einer Kunstwelt, die darauf bedacht ist, sich „Minderheiten" zu öffnen, politische oder religiöse Überzeugungen auszusprechen. Ihre Werke weisen auf deutliche Spannungsfelder hin: Männer/Frauen, Orient/Okzident, Pazifismus/Gewalt. Wenn auch ihre Titel wie Slogans klingen, so bleiben sie doch universell oder unergründlich ohne klar erkennbare Aussage. Obwohl dieses Universum eindringlich dargestellt wird, täuscht man sich in der Annahme, dass es auch einseitig und einfach ist. Neshat hat ihr Land 1974 verlassen, vier Jahre vor der islamischen Revolution. Ihre ersten Fotografien, die unter dem allgemeinen Oberbegriff *Women of Allah* (1993–1997) zusammengefasst sind, entstanden, als sie zum ersten Mal in den Iran zurückkreiste. Diese Inszenierungen, manchmal durch Kalligrafien hervorgehoben, sind häufig Selbstporträts, auf denen Neshat, allein oder mit ihrem kleinen Sohn, steif posiert. *Women of Allah* ist eine Meditation über die gesellschaftlichen und politischen Veränderungen, die die Revolution im Leben der Frauen ausgelöst hat, und sie erforscht, wie diese die neue Ideologie aufgenommen haben und wie es ihnen gelingt, diese tief greifenden Umwälzungen zu überleben. Die Abgründigkeit der Unterdrückung, die Frauen in einer von Männern bestimmten Welt erleiden, steht im Zentrum aller Arbeiten von Neshat. Das neueste Projekt, *Women Without Men* (2004), ist die filmische Adaption eines Romans von Scharnusch Parsipur.

Shirin Neshat s'est fait connaître par ses séries de photographies et installations vidéos fondées sur des rapports visuels et symboliques violemment contrastés, à l'image de l'écran de *Fervor* (2000), divisé entre, à gauche, des hommes en blanc et, à droite, des femmes vêtues et voilées de noir. Femme de culture musulmane dans un monde de l'art soucieux de s'ouvrir aux « minorités », Neshat se garde bien cependant d'affirmer des convictions politiques ou religieuses. Ses œuvres mettent en scène des oppositions nettes : hommes/femmes, Orient/Occident, pacifisme/violence. Même si leurs titres sonnent comme des slogans, ils demeurent universalistes ou énigmatiques, sans message univoque. On aurait tort de croire que, parce que cet univers est tranché, net, il serait simpliste ou réducteur. Neshat a quitté son pays en 1974, quatre ans avant la révolution islamique. Parmi ses premières photographies, regroupées sous le titre générique *Women of Allah* (1993–1997), quelques-unes ont été prises alors qu'elle revenait en Iran pour la première fois. Ces mises en scènes, parfois réhaussées de calligraphies, sont souvent des autoportraits où Neshat, seule ou avec son jeune fils, pose, hiératique. Méditation sur les changements sociaux et politiques causés par la Révolution dans la vie des femmes, *Women of Allah* explore comment celles-ci ont adapté cette nouvelle idéologie, et comment elles parviennent à survivre à ces bouleversements. La mise en abyme de cette oppression que subissent les femmes dans un monde par ailleurs dominé par les hommes est au cœur de tous les projets de Neshat, dont le dernier, *Women Without Men* (2004), est une adaptation pour le cinéma d'un roman de Shahrnoush Parsipur.

S. C.

SELECTED EXHIBITIONS →
2005 *Über Schönheit*, Haus der Kulturen der Welt, Berlin
2004 *Monument to Now*, Deste Foundation, Athens; *Entfernte Nähe – Neue Positionen iranischer Künstler*, Haus der Kulturen der Welt, Berlin **2003** Tensta Konsthall, Spanga, Sweden; Museo de Arte Moderno de México, Mexico City; Contemporary Arts Museum, Houston **2002** Walker Art Center, Minneapolis; Castello di Rivoli, Turin; Aarhus Kunstmuseum

SELECTED PUBLICATIONS →
2002 *Shirin Neshat*, Milan **2001** *Shirin Neshat*, Musée d'art contemporain de Montréal **2000** *Shirin Neshat: Two Installations*, Wexner Center for the Arts, Columbus

1 **Women Without Men (Untitled #2)**, 2004, C-print, 117.5 x 156.5 cm
2 **Women Without Men (Untitled #1)**, 2004, C-print, 102.9 x 165.1 cm
3 **Women Without Men (Woman Knitting)**, 2004, C-print, 91.4 x 234.3 cm
4 **Women Without Men (Untitled #3)**, 2004, C-print, 72.4 x 233.7 cm

„Ich bin eine Künstlerin, keine Aktivistin. Meine Arbeit verfolgt das Ziel, den Dialog zu fördern ... Ich stelle nur Fragen."

« Je suis une artiste, pas une activiste. Mon travail a juste pour but de favoriser un dialogue... Je ne fais que poser des questions. »

"I am an artist, not an activist. I am creating work simply to entice a dialogue... I am only asking questions."

2

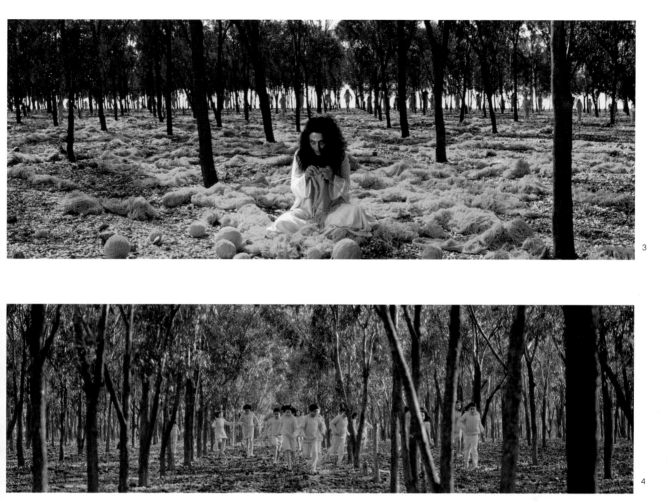

3

4

Ernesto Neto

1964 born in Rio de Janeiro, lives and works in Rio de Janeiro, Brazil

Ernesto Neto's works can be termed "experience sculptures", exploring bodily and sensorial effects and encouraging the viewer into active participation. He employs sensual fabrics like nylon, Styrofoam or lycra which ask to be touched while emphasizing the lightness and permeability of the structures they form. Tent-like constructs span the room from ceiling to floor, inviting spectators to enter through narrow orifices (*Nude Plasmic*, 1999); voluptuous corporeal sculptures filled with tiny styrofoam beads (*Humanoides*, 2001) are a cross between chairs and costumes which the viewer can either sit on or wear; cavernous environments of carved foam (*The House*, 2003) offer seclusion within tactile, undulating walls. The works, while formally minimal, are intimate meditations on the fine membranes which form the boundaries between an individual and his surroundings, while alluding to landscapes of an earthly, alien or even microbiological nature. They set up a system of polarities, both physically through their reliance on weight, mass, volume and tension, and conceptually through the dichotomies they propose of inside/outside, solid/fluid, transparency/opacity, nature/artifice. *The Slow Pace of the Body that Skin Is* (2004), a floor sculpture woven from strips of rubbery lycra, is either an island with hillocks or an amorphous beast expanding horizontally. It emanates a friendly, if curious, atmosphere, heightened by the scents of ginger, cumin and cloves hidden beneath the carpet-like structure, which infuses the room with a mystical aroma.

Die Arbeiten von Ernesto Neto lassen sich als „Erlebnisskulpturen" beschreiben, die körperlich-sinnliche Effekte untersuchen und den Betrachter zur aktiven Mitwirkung auffordern. Neto nutzt sinnliche Materialien wie Nylon, Styropor oder Lycra, die dazu einladen, angefasst zu werden, und gleichzeitig die Leichtigkeit und Durchlässigkeit der von ihnen gebildeten Strukturen betonen. Zeltartige Gebilde durchziehen den Raum von der Decke bis zum Fußboden und erlauben dem Betrachter, durch enge Öffnungen in sie einzutreten (*Nude Plasmic*, 1999); üppige, mit kleinen Styroporkugeln gefüllte körperhafte Skulpturen (*Humanoides*, 2001) bilden Zwitter aus Sesseln und Kostümen, in die man sich setzen oder die man anziehen kann; höhlenartige Environments aus geformtem Schaumstoff (*The House*, 2003) gewähren Unterschlupf innerhalb taktiler, wellenartiger Wände. Die formal betrachtet minimalistischen Arbeiten sind intime Betrachtungen über die feinen Membranen, die die Grenzen zwischen einem Individuum und seiner Umwelt bilden, und spielen gleichzeitig auf irdische, außerirdische und gar mikrobiologische Landschaften an. Sie errichten ein Polaritätensystem, sowohl physisch durch den Einsatz von Gewicht, Masse, Volumen und Spannung als auch konzeptuell durch die von ihnen angeregten Dichotomien innen/außen, fest/flüssig, transparent/opak, natürlich/künstlich. *The Slow Pace of the Body that Skin Is* (2004), eine aus Lycrastreifen gewobene Bodenskulptur, stellt entweder eine hügelig-bewachsene Insel oder ein sich horizontal ausdehnendes amorphes Wesen dar. Sie verströmt eine freundliche, wenn auch eigenartige Atmosphäre, verstärkt durch den Geruch, der von den unter dem teppichartigen Gebilde verborgenen Gewürzen Ingwer, Kumin und Nelken ausgeht, die den Raum mit einem mystischen Duft durchziehen.

Les œuvres d'Ernesto Neto peuvent être décrites comme des « sculptures à sensations » en ce qu'elles explorent les effets corporels et sensoriels et invitent le spectateur à la participation active. Neto se sert de tissus sensuels comme le nylon, le polystyrène ou le lycra, qui demandent à être touchés tout en soulignant la légèreté et la perméabilité des structures par eux formées. Des constructions apparentées à des tentes tendent l'espace du sol au plafond, invitant le spectateur à y entrer par des orifices étroits (*Nude Plasmic*, 1999); des sculptures corporelles voluptueuses emplies de minuscules perles en polystyrène (*Humanoides*, 2001) se situent au carrefour entre des chaises et des costumes dont le visiteur peut se vêtir ou se servir comme de sièges; des environnements caverneux réalisés en mousse taillée (*The House*, 2003) proposent un fort isolement entre des murs tactiles et ondulants. Bien que formellement minimalistes, les œuvres de Neto se présentent comme des méditations intimistes sur les fines membranes qui marquent les limites entre l'individu et son entourage, tout en évoquant des paysages d'une nature terrestre, extraterrestre, voire microbiologique. Elles mettent en œuvre un système de polarités : sur le plan physique de par leur rapport avec le poids, la masse, le volume et la tension, comme sur le plan conceptuel de par les dichotomies qu'elles proposent entre intérieur et extérieur, solide et fluide, transparence et opacité, nature et artifice. *The Slow Pace of the Body that Skin Is* (2004), une sculpture de sol tissée à partir de bandes de lycra caoutchouteux, est une île verdoyante avec des collines ou bien une bête amorphe étendue à l'horizontale. Cette œuvre répand une atmosphère chaleureuse, bien que singulière, soulignée par des senteurs de gingembre, de cumin, de girofle cachées sous une structure ressemblant à un tapis, et qui diffuse dans cet espace un arôme de mysticisme. K. B.

SELECTED EXHIBITIONS →
2005 *Tropicalia*, Museum of Contemporary Art, Chicago **2004** *Brasil: Body Nostalgia*, The National Museum of Modern Art, Tokyo; The National Museum of Modern Art, Kyoto **2003** Museu de Arte Moderna Aloísio Magalhães, Recife; The Museum of Contemporary Art, Los Angeles; The Fabric Workshop and Museum, Philadelphia **2002** Hirshhorn Museum, Washington D.C.; Kunsthalle Basel, Basle; Württembergischer Kunstverein, Stuttgart **2001** 49. Biennale di Venezia, Venice; Centro Galego de Arte Contemporánea, Santiago de Compostela

SELECTED PUBLICATIONS →
2002 *Genealogy of Live*, Württembergischer Kunstverein, Stuttgart; *Ernesto Neto*, Kunsthalle Basel, Basle **2001** *O Corpo, Nu Tempo*, Centro Galego de Arte Contemporánea, Santiago de Compostela **2000** *Ernesto Neto*, Institute of Contemporary Art, London, Dundee Contemporary Arts, Dundee

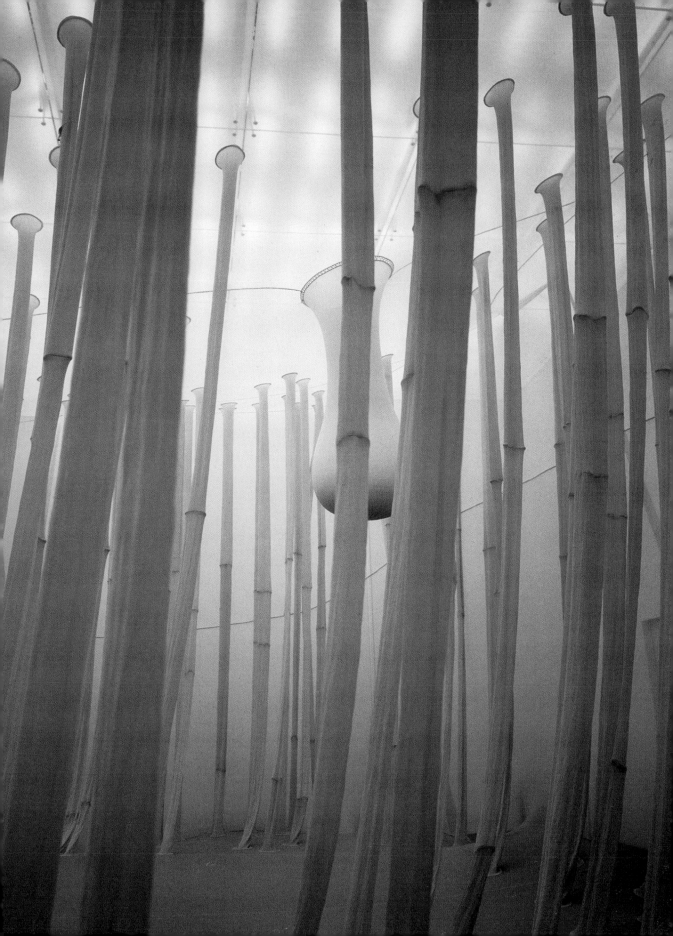

„Ich stelle mir den Körper gerne als Landschaft der Lust, als sinnliche Meditation vor."

«J'aime penser au corps comme à un paysage de plaisir, comme à une méditation sensorielle.»

"I like to think of the body as a landscape of pleasure, as a sensory meditation."

2

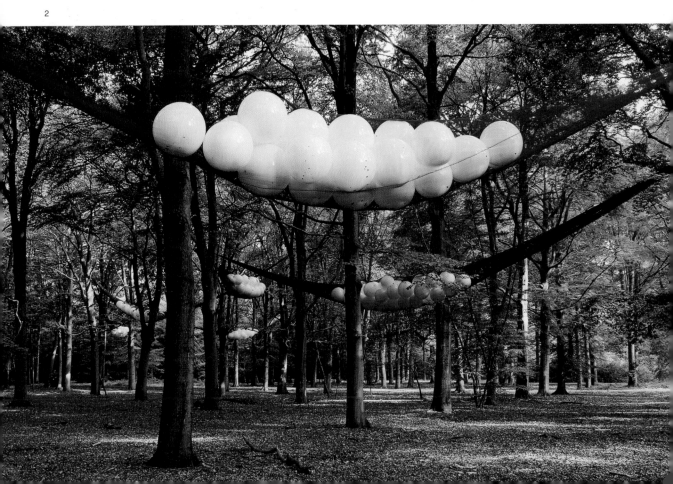

Jun Nguyen-Hatsushiba

1968 born in Tokyo, Japan, lives and works in Ho Chi Minh City, Vietnam

In his installations and his unusual videos staged on the ocean floor, Jun Nguyen-Hatsushiba plumbs the identity of his home country of Vietnam. Central to his first video are the cyclos, the bicycle taxis that the artist sees as a national institution, and which are particularly fitting symbols of Vietnam's social and economic development. Since the government forbids the deployment of new cyclos, Nguyen-Hatsushiba designed new models for his installation *Xich Lo 2001 – The Making of Alternative History* (2001). He presented them as if in a glitzy automobile showroom – in obstinate insistence on a cultural peculiarity, and as a memorial to those forgotten by the economic boom. In an oppressively beautiful way the video *Memorial Project Nha Trang, Vietnam: Toward the Complex – For the Courageous, the Curious and the Cowards* (2001) reminds viewers of the cyclo drivers' lot in life. This race between rickshaw drivers, filmed completely underwater, is a forceful metaphor of their struggle for existence. Their nightmarishly slow movements and their surfacing to draw breath become symbolic of the struggle just to survive. Since then, Nguyen-Hatsushiba has set all his videos in the ocean, selecting locations steeped many times over in history. *Ho! Ho! Ho! Merry Christmas: Battle of Easel Point – Memorial Project Okinawa* (2003) was filmed at Okinawa island in Japan, which was a battlefield during the Second World War, and a US base during the Vietnam War. The video observes a group of combat divers who set out to paint the star of the Vietnamese flag. Instead, however, the portraits of American film stars from Vietnamese films appear on the canvases – the country's image has been stamped by Hollywood's propaganda machine.

Die Installationen von Jun Nguyen-Hatsushiba und ungewöhnliche, am Meeresgrund inszenierte Videos loten die Identität seines Vaterlandes Vietnam aus. Im Mittelpunkt seines ersten Videos stehen die Cyclos, die Fahrradtaxis, die der Künstler als nationale Institution versteht, an der sich die sozialen und wirtschaftlichen Entwicklungen Vietnams prägnant abzeichnen. Da die Regierung den Einsatz neuer Cyclos verbietet, hat Nguyen-Hatsushiba für seine Installation *Xich Lo 2001 – The Making of Alternative History* (2001) neue Modelle entworfen, die er im Stil eines schillernden Autosalons präsentiert – ein störrisches Beharren auf einem Stück kultureller Eigenheit und Mahnmal für die vom ökonomischen Boom Vergessenen. Auf beklemmend schöne Weise erinnert das Video *Memorial Project Nha Trang, Vietnam: Toward the Complex – For the Courageous, the Curious and the Cowards* (2001) an das Los der Cyclofahrer: Das vollständig unter Wasser gefilmte Rennen zwischen Rikschafahrern ist eine eindringliche Metapher für ihren Existenzkampf, die alptraumhaft langsamen Bewegungen und das Auftauchen zum Luftholen werden zu Sinnbildern eines Mühens ums bloße Überleben. Nguyen-Hatsushiba inszeniert seither alle Videos an oftmals geschichtsträchtigen Orten im Meer. *Ho! Ho! Ho! Merry Christmas: Battle of Easel Point – Memorial Project Okinawa* (2003) wurde auf der japanischen Insel Okinawa gefilmt, Schlachtfeld im Zweiten Weltkrieg und US-Basis während des Vietnamkrieges. Das Video beobachtet eine Gruppe von Kampftauchern bei ihrem Vorhaben, den Stern der vietnamesischen Flagge zu malen. Doch stattdessen erscheinen auf den Leinwänden die Porträts von amerikanischen Filmstars aus Vietnamfilmen – das Image des Landes ist geprägt von der Propagandamaschinerie Hollywoods.

Les installations de Jun Nguyen-Hatsushiba et ses vidéos inhabituelles mises en scène au fond des mers sondent l'identité de sa patrie, le Vietnam. Au centre de sa première vidéo se trouvent les cyclopousses, les vélos-taxis que l'artiste considère comme une institution nationale qui illustre de manière particulièrement claire les évolutions sociales et économiques du Vietnam. Le gouvernement ayant interdit l'introduction de nouveaux cyclopousses, Nguyen-Hatsushiba a conçu pour son installation *Xich Lo 2001 – The Making of Alternative History* (2001) de nouveaux modèles qu'il présente dans le style d'un flamboyant salon automobile – acte de fidélité opiniâtre à un morceau d'identité culturelle et monument aux laissés-pour-compte du boom économique. D'une manière à la fois belle et oppressante, la vidéo *Memorial Project Nha Trang, Vietnam: Toward the Complex – For the Courageous, the Curious and the Cowards* (2001) rappelle le destin des conducteurs de cyclopousses : cette course de conducteurs de rickshaws filmée sous l'eau est une métaphore saisissante de la lutte pour la survie : les mouvements d'une lenteur cauchemardesque et les remontées à la surface pour reprendre de l'air deviennent l'image des efforts pour survivre. Depuis, Nguyen-Hatsushiba met toutes ses vidéos en scène dans la mer, sur des lieux souvent chargés historiquement. *Ho! Ho! Ho! Merry Christmas: Battle of Easel Point – Memorial Project Okinawa* (2003) a été tourné sur l'île d'Okinawa, au Japon, champ de bataille de la Seconde Guerre mondiale et base américaine durant la guerre du Vietnam. La vidéo observe un groupe de plongeurs de combat occupés à peindre l'étoile du drapeau vietnamien. Mais sur les toiles apparaissent peu à peu les portraits de stars américaines des films sur le Vietnam – l'image du pays est marquée par la machine propagandiste hollywoodienne.

A. M.

SELECTED EXHIBITIONS →
2005 Malmö Konsthall **2004** *MAM Project 002*, Mori Art Museum, Tokyo; *Encounters in the 21st Century*, 21st Century Museum of Contemporary Art, Kanazawa; *Material Witness*, Museum of Contemporary Art Cleveland **2003** Museo d'Arte Contemporanea Roma, Rome; *Memorial Project Nha Trang, Vietnam: Towards the Complex – For the Courageous, the Curious, and the Cowards*, Kunsthalle Wien, Vienna; 8. Istanbul Biennial; 50. Biennale di Venezia, Venice

SELECTED PUBLICATIONS →
2005 *Jun Nguyen-Hatsushiba*, Malmö Konsthall, Malmö **2004** *Material Witness*, Museum of Contemporary Art Cleveland, Cleveland; *MAM Project 002: Jun Nguyen-Hatsushiba*, Mori Art Museum, Tokyo

1 **Ho! Ho! Ho! Merry Christmas: Battle of Easel Point – Memorial Project Okinawa**, 2003, single-channel video, c. 15 min., video stills

2 **Memorial Project Minamata: Neither Either Nor Neither – A Love Story**, 2002/03, single-channel and 4-channel projection, installation view, 50. Biennale di Venezia, Venice

3 **Memorial Project Nha Trang, Vietnam: Towards the Complex – For the Courageous, the Curious and the Cowards**, 2001, single-channel video installation, c. 13 min., video stills

„Für mich bedeutet die Idee eines Denkmals nicht bloß den Versuch, sich an die Vergangenheit zu erinnern und sie zu würdigen, sondern etwas, das uns in die Gegenwart befördert und uns außerdem zwingt, die Zukunft in Frage zu stellen."

«Pour moi, l'idée de mémorial ne consiste pas seulement à tenter de rappeler et de reconnaître le passé, c'est quelque chose qui nous ramène au présent et nous incite à interroger l'avenir.»

"The idea of a memorial for me is not just trying to recall and acknowledge the past, but it is something that brings us to the present and also urges us to question the future."

2

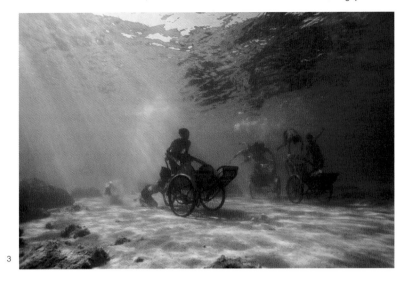

3

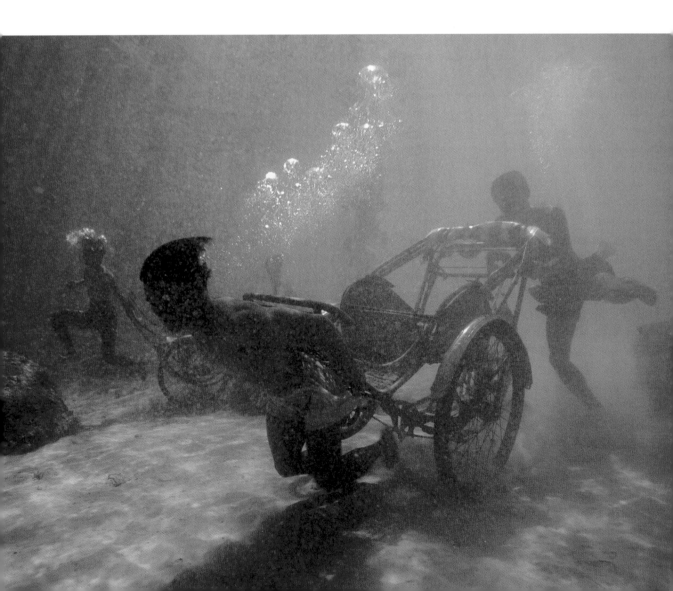

Frank Nitsche

1964 born in Görlitz, lives and works in Berlin, Germany

Frank Nitsche was a student at the Dresden Academy when the Berlin Wall came down. Nitsche favours a palette of alternating acrid greens, burnt reds, radiant yellows, greenish-greys, pale blues and fleshy pinks. His outsized geometric abstractions appear angular, flat and polished, but up close they reveal a dynamic surface of drips, marks and heavy strokes. His futuristic forms are defined by heavy outlines and cropped tight. With *MBC-14–2000* (2000), Nitsche merges what seems to be an aerial view of a racecar with a driver's helmet. These forms appear regularly in Nitsche's compositions and reveal the artist's attraction to high velocity and industrial design. In another work, *BDG-01–2002* (2002), dominated by pastel and royal blues with shades of gray, an image of a car driver outfitted with a racing helmet and goggles appears caught in a rearview mirror. In Nitsche's latest paintings angles and planes collide and lines intersect, creating a sensation of incredible depth that appears more indebted to architectonic sources than before. For example, in *GOF-08–2004* (2004), broad expanses of orange-red, mauve, pinks and greys are traversed by dozens of overlapping lines to produce a vibrant visual effect akin to a computer graphic. The source material for these paintings derives from an extensive picture archive the artist has been amassing diligently for years in ringed binders. Nitsche's distorted overlay of alternating perspectives creates both an illusion of depth and a tension between abstraction and representation.

Frank Nitsche war zur Zeit des Falls der Berliner Mauer Student an der Kunstakademie Dresden. Nitsche benutzt vorzugsweise eine Palette aus abwechselnd giftigem Grün, gebranntem Rot, strahlendem Gelb, grünlichem Grau, blassem Blau und fleischigem Pink. Seine übergroßen geometrischen Abstraktionen wirken kantig, flach und hochglanzpoliert, bei näherem Hinsehen allerdings offenbaren sie eine dynamische Oberfläche aus Tropfen, Markierungen und heftigen Pinselstrichen. Seine futuristischen Formen sind durch starke Konturen begrenzt und klar voneinander abgesetzt. In *MBC- 14–2000* (2000) scheint Nitsche die Draufsicht eines Rennwagens mit dem Helm seines Piloten verschmelzen zu lassen. Derartige Formen kehren in Nitsches Kompositionen regelmäßig wieder und verraten sein Interesse an Geschwindigkeit und Industriedesign. In einer anderen, von Pastell- und Königsblau sowie Grautönen beherrschten Arbeit mit dem Titel *BDG-01–2002* (2002) erscheint das Bild eines Autofahrers mit Helm und Schutzbrille wie in einem Rückspiegel gesehen. In Nitsches jüngsten Bildern treffen Winkel und Flächen aufeinander und überschneiden sich Konturen, so dass der Eindruck einer fantastischen Tiefe entsteht, der sich mehr als bisher architektonischen Quellen zu verdanken scheint. In *GOF-08–2004* (2004) beispielsweise werden breite orangerote, malvenfarbene, rosa und graue Flächen von Dutzenden sich überlagernder Linien durchzogen, die den vibrierenden optischen Effekt einer Computergrafik erzeugen. Die Vorlagen für diese Gemälde stammen aus dem umfangreichen Bildarchiv, das der Künstler seit Jahren emsig in Ringbüchern zusammenträgt. Nitsches verzerrte Überlagerungen wechselnder Perspektiven erzeugen sowohl die Illusion von Tiefe als auch ein Spannungsverhältnis zwischen Abstraktem und Gegenständlichem.

Frank Nitsche était étudiant à l'Académie de Dresde au moment de la chute du Mur de Berlin. Nitsche privilégie une palette alternant des verts acides, des rouges feu, des jaunes radioactifs, des gris glauques, des bleus pâles et des roses charnels. Ses abstractions géométriques démesurées présentent une apparence anguleuse, plane et polie, mais un examen rapproché révèle une surface dynamique de coulures, de taches et de touches pâteuses. Ses formes futuristes sont cernées de contours épais et serrés. Avec *MBC-14–2000* (2000), Nitsche fusionne avec un casque de pilote automobile ce qui s'avère être la vue aérienne d'une voiture de course. Ces formes apparaissent régulièrement dans ses compositions et évoquent la passion de l'artiste pour la vitesse et le design industriel. Dans une autre œuvre, *BDG-01-2002* (2002), où dominent les tons pastel et le bleu roi ombrés de gris, l'image d'un pilote automobile affublé d'un casque et de lunettes de course apparaît dans le cadre d'un rétroviseur. Dans les tableaux récents de Nitsche, angles et surfaces entrent en collision et les contours se croisent, créant l'illusion d'une profondeur fantastique, qui, plus que jamais, semble s'alimenter de sources architectoniques. Dans *GOF-08–2004* (2004), par exemple, des surfaces épaisses aux tons rouges-orangés, mauves, violets et gris sont striées par des douzaines de lignes imbriquées, produisant un effet optique semblable aux vibrations d'un graphique d'ordinateur. La source de ces peintures est une banque d'images extensive que l'artiste a diligemment réunie dans des classeurs depuis des années. La superposition déformatrice de perspectives alternantes réalisée par Nitsche crée à la fois une illusion de profondeur et une tension entre l'abstraction et la représentation. A.S.-S.

SELECTED EXHIBITIONS →
2005 *Do It Yourself – Positionen von den sechziger Jahren bis heute*, Sammlung Marx im Hamburger Bahnhof – Museum für Gegenwartskunst, Berlin **2004** *Art Contemporain de 1960 à nos jours*, Centre Pompidou, Paris **2003** *New Abstract Painting*, Museum Morsbroich Leverkusen; *deutschemalereizweitausenddrei*, Frankfurter Kunstverein

SELECTED PUBLICATIONS →
2003 *New Abstract Painting*, Museum Morsbroich Leverkusen
2002 *Standards, Frank Nitsche*, Leo Koenig, New York
2000 *Goldener, Der Springer, Das kalte Herz*, White Cube, London

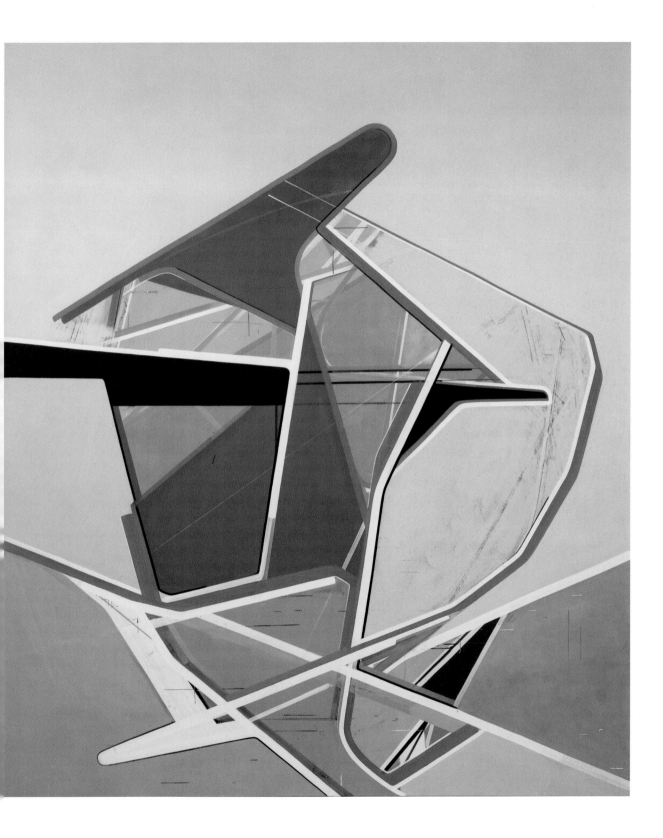

1 **POA-12–2002**, 2002, oil on canvas, 290 x 250 cm
2 **BAC-04–2003**, 2003, oil on canvas, 220 x 200 cm

3 **KOK-03–2005**, 2005, oil on canvas, 190 x 200 cm
4 **GOF-08–2004**, 2004, oil on canvas, 200 x 290 cm

„Meiner Ansicht nach sind alle Aspekte des gesellschaftlichen Lebens designt. Ich verstehe meine Arbeit sozusagen als Resümee und Essenz des gesamten Designs im Sinne des entstellten Zeitgeist-Designs, des Über-Designs und der Verzerrung des Über-Designs."

« De mon point de vue, tous les aspects de la vie sociale sont soumis au design. Je comprends mon œuvre comme un résumé et une essence de tout design, en d'autres termes, le design déformé du zeitgeist, le sur-design et la distorsion du sur-design. »

"In my view, all aspects of social life are designed. I understand my work as the résumé and essence of all design, so to say, the deformed design of the zeitgeist, the over-design and the distortion of the over-design."

2

3

4

Tim Noble and Sue Webster

**Tim Noble 1966 born in Stroud, and
Sue Webster 1967 born in Leicester, live and work in London, UK**

British artists Tim Noble and Sue Webster are partners in both life and art. Their body of work examines the infectious delirium of an all-consuming culture, often using self-portraiture to challenge the preeminence of the idea of artist as celebrity. Noble and Webster literally manipulate waste, debris, and detritus (the day-to-day by-products of our society) into remarkable silhouettes evoking Hallmark Card-style sanguinity. For example, *Dirty White Trash (with Gulls)* (1998) comprises six months' worth of the artists' collected garbage. A shadow is cast by a slide projector that lights the sculptural mass, forming a self-portrait of the artists, one of whom grasps a glass of wine as the other holds a cigarette. Inspired by a laborious play on chance, the works assume a state of beauty derived from the accumulation of trash. *British Wildlife* (2000) is a tangled-up pile of taxidermy. A blinding white light illuminates this mix of squirrels, birds and rabbits, forming a resultant shadow depicting the oddly romantic coupling of two lovers, another double self-portrait. Summoning up the gaudy glitz of Las Vegas, Noble and Webster's *Forever* (2001) comprises twenty feet of dazzling, coloured neon lights that flash the word "Forever". Likewise, *Dollar Sign* (2001) transforms a prime symbol of capitalist society into a glimmering outpouring of white light. Employing their own particular set of aesthetic mechanisms to make transformative processes, both physical and ideological, palpable to their audience, Noble and Webster urge us to consider a vast, colourful, and often overwhelming multitude of existing and possible cultural trajectories.

Tim Noble und Sue Webster sind sowohl privat als auch künstlerisch ein Paar. In ihren Arbeiten untersuchen sie den ansteckenden Wahnsinn einer alles verzehrenden Kultur, wobei sie häufig zum Selbstporträt greifen, um die Vorherrschaft der Vorstellung vom Künstler als Prominenten zu hinterfragen. Noble und Webster verwandeln buchstäblich Schrott, Schutt und Abfälle (die alltäglichen Nebenerzeugnisse unserer Gesellschaft) in bemerkenswerte Silhouetten, die die Zuversicht von Glückwunschkarten verströmen. So besteht *Dirty White Trash (with Gulls)* von 1998 aus dem kompletten Müll, den die beiden Künstler in sechs Monaten produzierten. Ein Diaprojektor beleuchtet die skulpturale Halde und erzeugt einen Schatten in Form eines Selbstporträts der beiden Künstler mit Weinglas beziehungsweise Zigarette in der Hand. Angeregt durch ein mühsames Spiel mit dem Zufall schaffen diese Arbeiten einen Zustand der Schönheit, der sich dem Aufeinandertürmen von Abfall verdankt. *British Wildlife* (2000) ist eine verschlungene Ansammlung ausgestopfter Exponate. Dieses Durcheinander aus Eichhörnchen, Vögeln und Kaninchen wird von einem blendend hellen Licht angestrahlt, während der an die Wand geworfene Schatten die Form eines weiteren Doppelselbstbildnisses des Paares bildet, das als eigenartig romantische Liebende dargestellt ist. Die Arbeit *Forever* (2001), die den grellen Pomp von Las Vegas ausstrahlt, besteht aus etwa sechs Metern blendend-bunter blinkender Neonlichter, die das Wort „Forever" bilden. Ganz ähnlich wird in *Dollar Sign* (2001) das zentrale Symbol des Kapitalismus in einen schimmernden Erguss weißen Lichts verwandelt. Mit ihren speziellen ästhetischen Mechanismen zur Schaffung von für den Betrachter erfahrbaren physischen und ideologischen Transformationsprozessen zwingen uns Noble und Webster zur Auseinandersetzung mit einer gewaltigen, bunten, häufig erschlagenden Vielfalt realer und möglicher kultureller Entwicklungen.

Les artistes britanniques Tim Noble et Sue Webster sont partenaires dans la vie comme dans l'art. Leur œuvre, qui analyse le délire infectieux d'une culture qui consume toute chose, se sert souvent de l'autoportrait pour défier la suprématie de l'idée de l'artiste comme célébrité. Noble et Webster manipulent au sens littéral des déchets, débris et ordures (les produits dérivés quotidiens de notre société) pour en faire de remarquables silhouettes qui évoquent un optimisme de carte de vœux. Ainsi, *Dirty White Trash (with Gulls)* (1998) est composé de six mois de déchets des artistes. Une ombre est jetée par un projecteur de diapositives qui éclaire la masse sculpturale, formant un autoportrait des artistes, l'un saisissant un verre de vin, l'autre tenant une cigarette. Inspirées par un laborieux jeu de hasard, les œuvres incarnent un état de la beauté dérivé de l'accumulation d'ordures. *British Wildlife* (2000) est un amas enchevêtré d'objets taxidermiques. Une lumière blanche éblouissante illumine ce mélange d'écureuils, d'oiseaux et de lapins, formant une ombre qui décrit l'accouplement singulièrement romantique de deux amants – encore un autoportrait. Evoquant le clinquant tape-à-l'œil de Las Vegas, *Forever* (2001) se compose de sept mètres de tubes de néon de couleur éblouissants qui clignotent le mot « Forever ». De même, *Dollar Sign* (2001) transforme un symbole primordial de la société capitaliste en un scintillant débordement de lumière blanche. Se servant de leur propre gamme particulière de mécanismes esthétiques pour élaborer des processus transformatifs à la fois physiques et idéologiques, palpables pour le spectateur, Noble et Webster nous pressent d'examiner une vaste multitude bigarrée et souvent écrasante de trajectoires culturelles existantes ou possibles. A. S.-S.

SELECTED EXHIBITIONS →
2004 Museum of Fine Arts, Boston; *Monument to Now*, Deste Foundation, Athens **2003** P.S.1, New York **2001** *Melodrama*, Tate Liverpool; *Magic, Loneliness & Trash*, Museum of Modern Art, Buenos Aires; *Form Follows Fiction*, Castello di Rivoli, Turin; *Casino 2001*, Stedelijk Museum voor Actuele Kunst, Ghent **2000** *Man, Body in Art from 1950–2000*, Arken Museum for Moderne Kunst; *Apocalypse: Beauty & Horror in Contemporary Art*, Royal Academy of Arts, London

SELECTED PUBLICATIONS →
2002 *Landscape*, The Saatchi Gallery, London **2001** *Form Follows Fiction*, Castello di Rivoli, Turin; *The Taste Makers*, London; *British Rubbish*, Independent Art Space, London; *The New Neurotic Realism*, The Saatchi Gallery, London; *Apocalypse*, Royal Academy of Arts, London **2000** *Moving Targets 2, A User's Guide to British Art Now*, Tate Gallery, London

1 **Kiss of Death**, 2003, 3 x juvenile brown rats, 3 x brown rats, 1 x mink (front and rear halves), 1 x full mounted carrion crow, 8 x rooks (head/neck), 11 x jackdaw (head/neck), 7 x carrion crow (head/neck), 8 x jackdaw (legs/feet), 12 x rook (legs/feet), 8 x carrion crow (legs/feet), 2 x carrion crow (wings), various bones, light projector, metal stand, 180 x 80 x 50 cm

2 **Puny Undernourished Kid & Girlfriend from Hell**, 2004, neon, 2 parts, 284 x 400 cm
3 **Sunset over Manhattan**, 2003, cigarette packets, tin cans, wooden bench, air gun pellets, light projector, 75 x 110 x 31 cm
4 **HE/SHE**, 2003, welded metal, light projector, HE: 185 x 96 x 148 cm, SHE: 114 x 100 x 186 cm

„In unseren Arbeiten geht es eindeutig nicht um guten Geschmack. Uns interessieren Aspekte der Kultur, die mit glamourösen, massenfabrizierten Oberflächen zu tun haben, beispielsweise Las Vegas."

«Notre travail ne tourne manifestement pas autour du bon goût. Ce qui nous intéresse, ce sont les aspects de la culture comme Las Vegas, qui ont affaire avec la surface clinquante de la production de masse.»

"Obviously our work's not about good taste. What we're drawn to are those aspects of culture like Vegas which are to do with a glitzy mass-produced surface."

2

3

4

Motohiko Odani

1972 born in Kyoto, lives and works in Matsudo City, Japan

Motohiko Odani studied sculpture at the Tokyo University of Fine Arts, but his body of work spans sculpture, video and photography. Odani merges tradition with high technology in order to investigate the evolving possibilities of the digital matrix. In doing so, Odani creates an alternative universe in which scientific discovery trumps our wildest fantasies. For example, in the video *Rompers*, presented in the Japanese pavilion at the Venice Biennial 2003, a young girl with pigtails and a floral frock sits playfully in a tree, humming. At first the scene seems that of an innocent, Eden-like wonderland, but a frog then hops along sprouting human ears, while the beatific girl reveals a yellow stare and a reptilian tongue poised to catch flies. Odani's seemingly saccharine scene turned sinister reveals the inconceivable mutations resulting from a harmful dose of genetic engineering. In the sculpture *Human Lesson* (1997), Odani creates a human-animal amalgamation. A life-sized female figure is clothed in fur with stiletto heels; her head is not human but is those of a pair of wolves. These works illustrate Odani's preoccupation with the ever-expanding possibilities of today's high-tech frontier. Odani creates hybrid worlds beyond the realms of human imagination where man-made mutants and otherworldly creatures fuel contemporary anxieties about science gone awry. His works can be interpreted as "Buddhist sculptures", which in our age question the disappearance of direct contacts.

Motohiko Odani hat in Tokio an der Universität der Schönen Künste Bildhauerei studiert, aber sein Werk umfasst Skulptur, Video und Fotografie. Odani verschmilzt zur Untersuchung der sich ergebenden Möglichkeiten der digitalen Matrix Traditionelles mit Hightech. Dabei schafft Odani ein Alternativuniversum, in dem wissenschaftliche Errungenschaften unsere kühnsten Fantasien übersteigen. So sitzt beispielsweise im Video *Rompers*, das auf der Biennale in Venedig 2003 im japanischen Pavillon gezeigt wurde, ein junges Mädchen mit Rattenschwänzen und Blümchenkleid verspielt auf einem Baum und summt vor sich hin. Zunächst wirkt dies wie eine Szene aus einem unschuldigen, paradiesischen Wunderland, doch dann hüpft ein Frosch mit menschlichen Ohren auf dem Rücken vorbei, während das glückselige Mädchen seine gelben Augen zeigt und seine Reptilienzunge hervorschnellen lässt, um Fliegen zu fangen. Odanis scheinbar süßliche Szene verfinstert sich und enthüllt die unvorstellbaren Mutationen als Folge einer Überdosis an Gentechnologie. In seiner Skulptur *Human Lesson* (1997) erschafft Odani ein Mischwesen aus Mensch und Tier. Die lebensgroße weibliche Figur, gehüllt in Pelz und mit hochhackigen Schuhen, trägt keinen menschlichen Kopf, sondern einen doppelten Wolfskopf. Diese Arbeiten zeigen Odanis Beschäftigung mit den unablässig wachsenden Möglichkeiten heutiger Hochtechnologie. Odani erzeugt hybride Welten jenseits des Bereichs menschlicher Vorstellung, in denen vom Menschen geschaffene Mutanten und Wesen aus einer anderen Welt die zeitgenössische Angst vor einer aus dem Ruder gelaufenen Wissenschaft anheizen. Seine Arbeiten können als „buddhistische Skulpturen" interpretiert werden, die in unserer Zeit das Verschwinden direkter Berührungen hinterfragen.

Motohiko Odani a fait des études de sculpture à l'Ecole des Beaux-Arts de Tokyo, mais au-delà de la sculpture, son œuvre s'étend aussi à la vidéo et à la photographie. Odani fait fusionner tradition et haute technologie en vue d'explorer les perspectives d'évolution offertes par l'univers numérique. Il crée ainsi un univers alternatif où les découvertes scientifiques dépassent nos rêves les plus fous. Dans la vidéo *Rompers* par exemple, qui fut présentée au pavillon japonais de la Biennale de Venise 2003, une jeune fille arborant des nattes et une robe à fleurs est assise ludiquement dans un arbre et fredonne un air. La scène se présente d'abord comme un pays de cocagne ingénu et paradisiaque, mais une grenouille s'en vient ensuite en sautillant, la tête affublée d'oreilles humaines, cependant que la jeune fille révèle un regard jaune et une langue reptilienne prête à gober des mouches. La scène apparemment édulcorée d'Odani vire au sinistre et révèle les mutations inconcevables résultant d'une dose malencontreuse de manipulation génétique. Dans la sculpture *Human Lesson* (1997), Odani réalise l'amalgame entre l'humain et l'animal. Une femme représentée grandeur nature est vêtue d'une fourrure et de chaussures à talons aiguilles ; sa tête n'est pas humaine, mais celle d'un couple de loups. Cette œuvre illustre les préoccupations de l'artiste, qui portent sur les possibilités croissantes d'une technologie d'avant-garde en constante expansion. Odani crée des mondes hybrides qui défient l'imagination, où des mutants créés par l'homme et des créatures venues d'autres mondes alimentent les angoisses contemporaines sur les dérives de la science. On peut interpréter ses travaux comme des « sculptures bouddhistes » mettant le doigt sur l'absence de contacts directs qui caractérise notre époque. A.S.-S.

SELECTED EXHIBITIONS →
2005 *Becoming Animal*, Massachusetts Museum of Modern Art, North Adams **2004** *Strategies of Desire*, Kunsthaus Baselland, Muttenz; *Roppongi Crossing*, Mori Art Museum, Tokyo; *Motohiko Odani*, Moderna Museet, Stockholm **2003** 50. Bienniale di Venezia, Venice **2001** 7. Istanbul Biennial

SELECTED PUBLICATIONS →
2004 *Can You See the Air*, Galeria Begoña Malone, Madrid **2003** *Cream 3*, London **2002** *Pause: Conception*, Gwangju Biennale Press, Gwangju

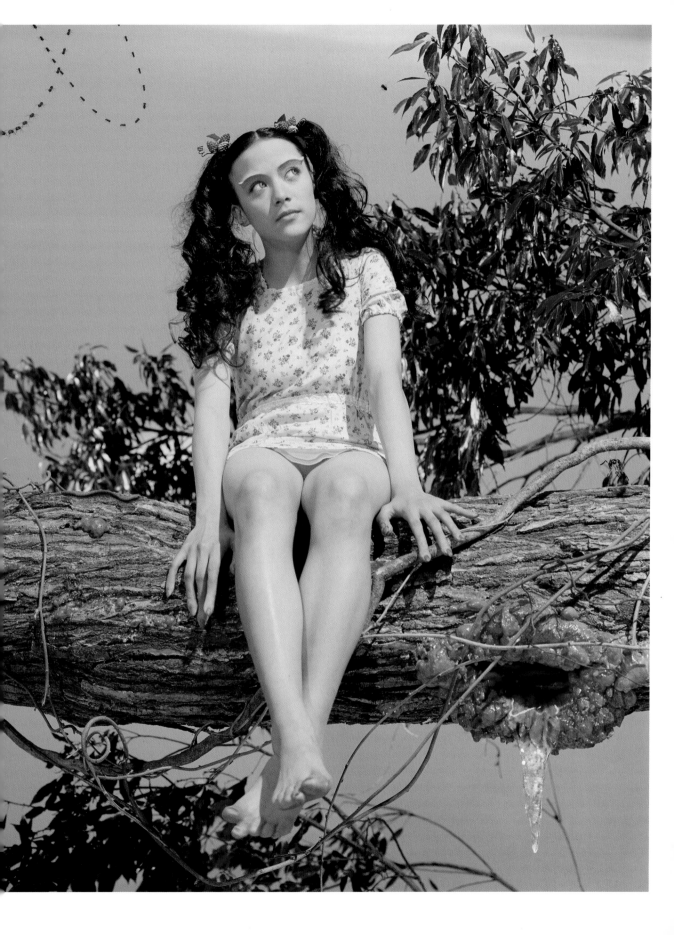

1 **Rompers**, 2003, digital effect, C-print mounted on aluminium, 80.5 x 66.7 cm
2 **ERECTRO (Bambi)**, 2003, stuffed Bambi, cast aluminium, other materials, 61 x 60 x 29 cm
3 **ERECTRO (Clara)**, 2004, fibre reinforced plastics, cast aluminium, other materials, 88 x 130 x 280 mm
4 **Berenice**, 2003, fibre reinforced plastics, steel, other materials, sphere c. Ø 300 cm

„Mir gefallen Exponate, die ein Gefühl von Spannung auf den Betrachter projizieren, besonders solche, denen dies gelingt, indem sie eine gewisse Distanz zwischen dem betrachteten Werk und dem Betrachter bewahren. Ich glaube, bei einer ausgestellten Arbeit ist es wichtig, dass sie eine dichte Atmosphäre erzeugt und sowohl transparent als auch unsichtbar-kalt gegenüber der Berührung ist, so wie ein Schaufenster für einen Blinden."

« J'aime les expositions qui dégagent un sentiment de tension en direction du spectateur, surtout celles qui arrivent à garder une certaine distance entre l'œuvre regardée et le spectateur qui la regarde. Je pense qu'il est important qu'une œuvre exposée crée une atmosphère tendue, tout en étant transparente et invisible-froide au toucher, comme une vitrine l'est pour un aveugle. »

"I like exhibits which project a sense of tension to the viewer, especially those that do so by maintaining a certain distance between the work being viewed and the person viewing it.
I think it's important for an exhibited work to create a tense atmosphere and be both transparent and invisible-cold to the touch, like a show window to a blind man."

2

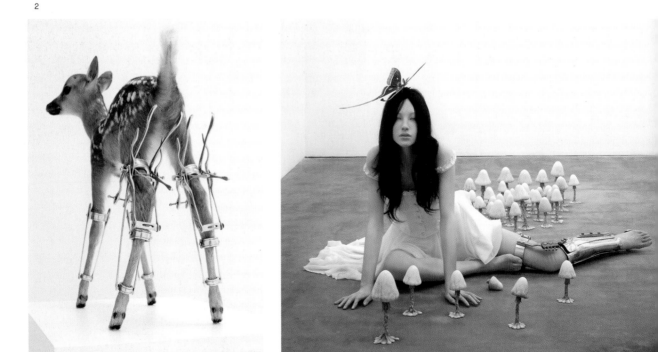

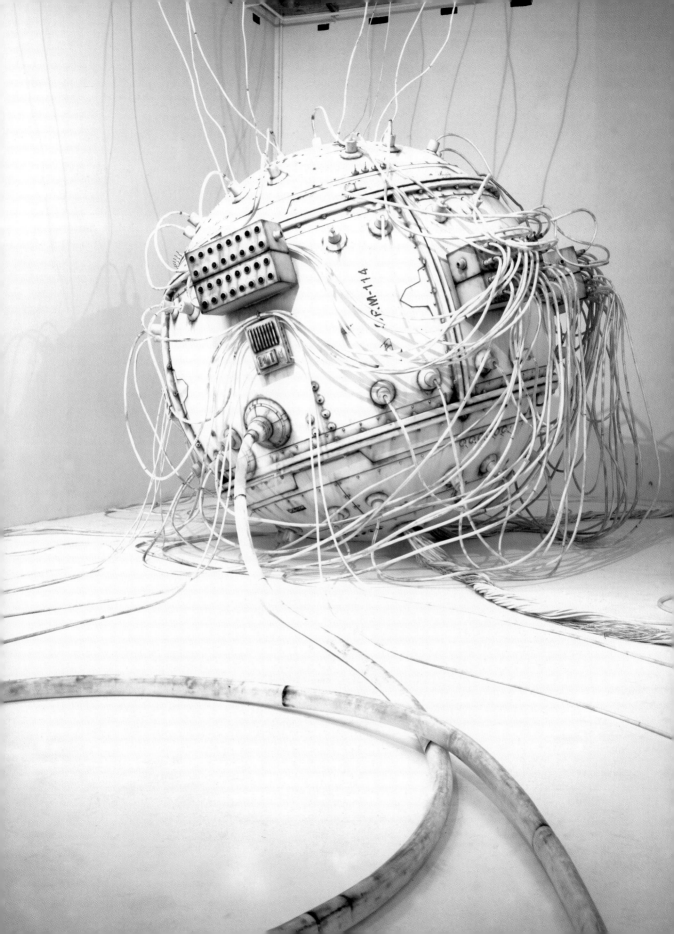

Albert Oehlen

1954 born in Krefeld, Germany, lives and works in Switzerland and Las Palmas, Spain

Since Albert Oehlen began exhibiting at the beginning of the 1980s, he has performed stylistic manoeuvres that defied the prevailing tastes of the respective times. Together with Martin Kippenberger, Werner Büttner and Georg Herold, he is one of the art scene's enfants terribles, considered even early on to be a painter and anti-painter in one. While this unbridled attitude also falls within the zeitgeist its rawness in Oehlen's works, unlike many neo-Fauves of the time, was less a question of subjective expression and much more one of intellectual attitude, loading provocative "bad painting" with terseness, cynicism and explosive topics. Right from the beginning this type of painting's rebellious spirit was articulated not so much through gestural intensity as through well-placed stylistic inconsistencies and unexpected content, to rely entirely on a strict avoidance of clarity. After initially creating paintings loaded with radical content he proclaimed a "post-non-representational" approach in 1987, producing abstract paintings composed of complex formal layers. They have a systematically cultivated ambivalence that can never be completely trusted. Is this contemporary painting – or perhaps simply its stereotype? That is a question Oehlen can confidently leave unanswered. Beginning in 1997 Oehlen returned to the use of content and figuration, grotesquely combining highly diverse elements from the animate and inanimate world, mixing these both with non-representational elements, and including the occasional self-reference. At the same time Oehlen's painting is also constantly directed against his own virtuosity. This can be seen recently, for example, in the *Spezialbilder* produced in collaboration with Jonathan Meese.

Seit Albert Oehlen Anfang der achtziger Jahre auszustellen begann, hat er stilistische Manöver gegen den jeweils geltenden Zeitgeschmack ausgeführt. Gemeinsam mit Martin Kippenberger, Werner Büttner und Georg Herold gehörte er zu den Enfants terribles der Kunstszene, schon früh galt er als Maler und Anti-Maler in einem. Zwar ist die rüde Attitüde auch vom Zeitgeist gedeckt, doch anders als bei vielen der damals „Jungen Wilden" war solche Rauheit bei Oehlen weniger eine Frage subjektiver Expression, dafür umso mehr eine der intellektuellen Haltung, die provozierendes „bad painting" mit Lakonie, Zynismus und brisanten Themen schärfte. Der Widerspruchsgeist solcher Malerei artikulierte sich von Beginn an weniger in gestischer Heftigkeit als in gut gesetzten Stilbrüchen und überraschenden Inhalten, um aufs Ganze in strikte Vermeidung von Eindeutigkeit zu münden. Nach der ersten Phase radikal inhaltlich aufgeladener Malerei proklamierte er 1987 einen „post-ungegenständlichen" Ansatz. Es entstanden abstrakte, in komplexen formalen Schichtungen aufgebaute Bilder, deren gezielt gestreuter Ambivalenz nie ganz zu trauen ist: Zeitgenössische Malerei – oder nicht vielleicht doch bloß das Klischee von ihr? Das kann Oehlen getrost offen lassen. Seit 1997 kommt Oehlen erneut auf Inhalt und Figuration zurück, lässt in seinen Bildern verschiedenste Elemente aus belebter und unbelebter Welt in grotesker Weise aufeinander treffen, mischt beides mit Ungegenständlichem, speist gelegentlich auch Selbstzitate ein. Dabei richtet sich Oehlens Malerei stets auch gegen die eigene Virtuosität. Das zeigte sich zuletzt etwa in gemeinsam mit Jonathan Meese erstellten *Spezialbildern*.

Depuis qu'Albert Oehlen a commencé à exposer au début des années quatre-vingt-dix, il n'a cessé d'utiliser des manœuvres stylistiques allant à contre-courant du goût en vigueur à chaque époque. Avec Martin Kippenberger, Werner Büttner et Georg Herold, il fait partie des enfants terribles de la scène artistique. Il a été considéré dès l'origine à la fois comme peintre et anti-peintre en un. Si ce type de posture correspondait sans doute aussi à l'esprit du temps, contrairement à bien de « Nouveaux fauves » de l'époque, la rudesse d'Oehlen relevait moins de l'expressivité subjective que d'une position intellectuelle qui s'entendait à aiguiser les provocations de sa « bad painting » à coups de laconisme, de cynisme et de sujets explosifs. Dès le début, l'esprit contestataire de sa peinture s'appuie moins sur la violence de la gestuelle que sur des ruptures stylistiques soigneusement calculées et des contenus inattendus, pour déboucher le plus souvent sur un évitement rigoureux de tout caractère univoque. Après une première phase de peinture chargée de contenu, Oehlen proclame en 1987 une démarche « post-non figurative » et réalise des tableaux abstraits construits en strates formelles complexes dont l'ambivalence volontairement diffuse n'est jamais tout à fait fiable : s'agit-il de peinture contemporaine ou peut-être seulement de son cliché ? L'artiste peut laisser planer le doute en toute quiétude. A partir de 1997, Oehlen revient au contenu et à la figuration. Dans ses tableaux, il organise la rencontre grotesque entre les éléments les plus hétéroclites issus des mondes animé et inanimé, mêlant aux deux univers des éléments non figuratifs et y introduisant parfois des autocitations. En cela, la peinture d'Oehlen est toujours dirigée aussi contre sa propre virtuosité, comme l'ont montré récemment les *Spezialbilder* réalisés en collaboration avec Jonathan Meese.

J. A.

SELECTED EXHIBITIONS →
2004 *Malerei 1980–2004, Selbstportrait mit 50millionenfacher Lichtgeschwindigkeit*, Musée cantonal des Beaux-Arts, Lausanne; *26. Bienal de São Paulo* **2003** *Painting Pictures, Malerei und Medien im digitalen Zeitalter*, Kunstmuseum Wolfsburg **2002** *Painting on the Move*, Kunstmuseum Basel, Basle **2001** *Terminale Erfrischung: Computercollagen und Malerei*, kestnergesellschaft, Hanover **2000** *Der Ritt der sieben Nutten – das war mein Jahrhundert*, Städtisches Museum Abteiberg, Mönchengladbach; *In Between*, Expo 2000, Hanover

SELECTED PUBLICATIONS →
2004 *Albert Oehlen, Jonathan Meese – Spezialbilder*, Berlin; *Albert Oehlen: Malerei 1980–2004. Selbstportrait mit 50millionenfacher Lichtgeschwindigkeit*, Musée cantonal des Beaux-Arts, Lausanne **2002** *Albert Oehlen: Gemälde/Paintings 1980–1982*, Galerie Max Hetzler, Berlin **2001** *Free Logo*, Galerie Bärbel Grässlin, Frankfurt/Main **2000** *Der Ritt der sieben Nutten – das war mein Jahrhundert* (mit Markus Oehlen), Städtisches Museum Abteiberg, Mönchengladbach; *Inhaltsangabe*, Galerie Max Hetzler, Berlin

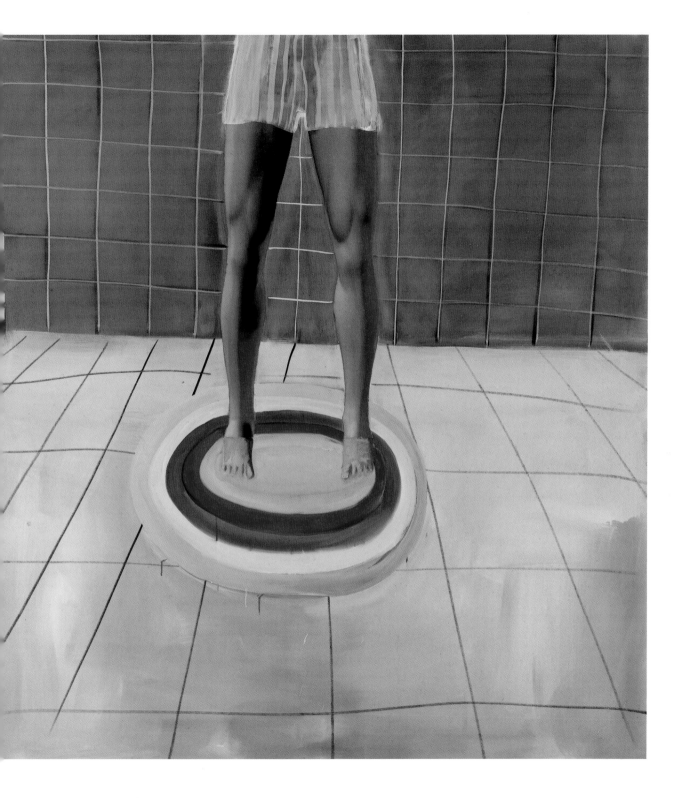

1 **Halbnackt**, 2004, oil and paper on canvas, 180 x 170 cm
2 **Frau im Stuhl**, 2004, oil and paper on canvas, 180 x 240 cm
3 **Chemical Schmutzli**, 2004, oil on canvas, 280 x 260 cm

4 **Selbstportrait mit 50 millionenfacher Lichtgeschwindigkeit**, 2004, oil on canvas, 350 x 870 cm

„Bei meiner Arbeit bin ich ständig umgeben von den scheusslichsten Bildern. Was ich sehe sind unerträglich hässliche Fetzen, die dann im letzten Moment wie durch Magie in etwas Wunderbares transformiert werden."

« Dans mon travail, je suis constamment entouré des images les plus affreuse. Ce que je vois, ce sont des lambeaux d'une insupportable laideur qui sont ensuite transformés au dernier moment, comme par magie, en quelque chose de merveilleux. »

"In my work, I'm surrounded by the most dreadful pictures. What I see are unbearably ugly tatters, which are then transformed at the last moment, as if by magic, into something beautiful."

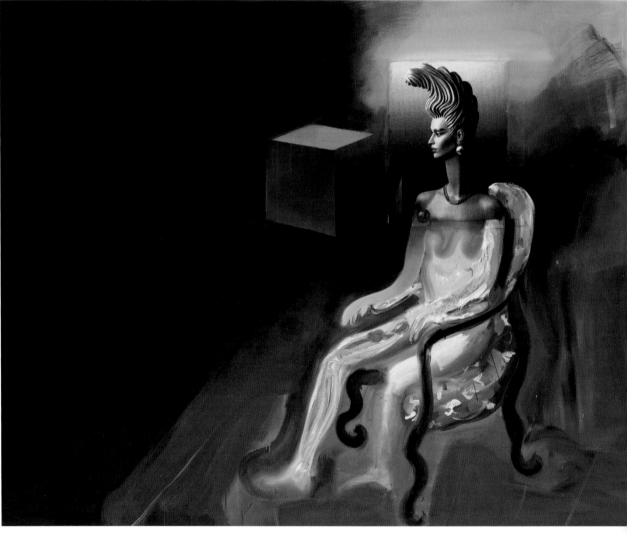

2

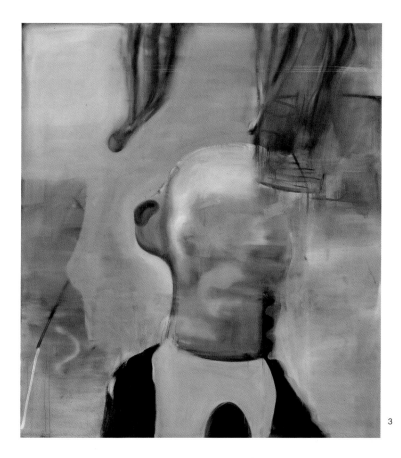

3

Chris Ofili

1968 born in Manchester, lives and works in London, UK

The many-layered work of Chris Ofili is a contemporary remix of his own culture with the traditional arts of Senegalese *souwère* glass painting or perhaps Russian devotional icon painting. His glittering canvases are built up from thousands of coloured spots, in the manner of aboriginal or Zimbabwean cave painting, usually with a central portrait of a black superhero or a Madonna figure, the most famous being *The Holy Virgin Mary* (1996), whose elephant-dung breast and surrounding collage of female genitals cut from porn magazines caused a scandal. Recently Ofili has begun to build environments to house his works, the first of which, titled *The Upper Room* (2002) after the room where Jesus ate the Last Supper, was nicknamed "the Ofili chapel". In collaboration with British architect David Adjaye, he installed his cycle of 13 monochromatic monkey paintings, one for each disciple plus the triumphant golden monkey, in a dramatically lit interior of walnut-veneered floors, walls benches and ceiling. That the colour-coded rhesus macaques were all derived from a Warhol drawing highlights that Ofili worships at the altar of the high priests of Pop Art as well as in the temple of art history. One overriding influence is music, and the sultry soul ballads of Teddy Pendergrass, the conscious lyricism of hip-hop and 1970s funk could all be seen in Ofili's next major installation, *Within Reach* (2003). Smiling lovers peered out from Afro-sheen paintings bathed in the red, black and green pigments that covered every surface of the jewel-like pavilion; the pinnacle of Ofili's statements on black pride so far.

Die mehrschichtigen Arbeiten von Chris Ofili sind ein zeitgenössischer Remix seiner eigenen Kultur mit der traditionellen Kunst senegalesischer *Souwère*-Glasmalerei und vielleicht russischer Ikonen. Seine glitzernden Gemälde, die sich in der Art der Aborigine- oder der Höhlenmalerei Simbabwes aus Tausenden farbiger Punkte zusammensetzen, zeigen häufig in ihrem Zentrum einen schwarzen Superhelden oder eine Madonnenfigur. Seine bekannteste Madonna, *The Holy Virgin Mary* (1996), sorgte mit ihren Brüsten aus Elefantendung und den weiblichen Genitalien aus collagierten Pornobildern für einen Skandal. Seit einiger Zeit baut Ofili Environments um seine Arbeiten herum. Das erste, *The Upper Room* (2002), entstand nach dem Vorbild des Raums, in dem das Letzte Abendmahl stattfand, und erhielt den Spitznamen „die Ofili-Kapelle". In Zusammenarbeit mit dem britischen Architekten David Adjaye gestaltete er seinen Zyklus in einem dramatisch beleuchteten Innenraum mit Böden, Wänden, Bänken und Decken aus Walnussfurnier, bestehend aus dreizehn monochromen Affenbildern, eins für jeden Jünger und den glorreichen goldenen Affen. Dass die farblich kodierten Rhesusaffen einer Warhol-Zeichnung entlehnt sind, bestätigt, dass Ofili seine Religion sowohl vor dem Altar der Hohepriester der Pop Art als auch im Tempel der Kunstgeschichte ausübt. Die Musik zählt zu seinen Haupteinflüssen, und so ließen sich in Ofilis großer Installation *Within Reach* (2003) die schwülen Soulballaden von Teddy Pendergrass ebenso wie die siegessicheren Texte von HipHop und Siebziger-Jahre-Funk ausmachen. Lächelnde Verliebte im Afrolook blicken aus den von roten, schwarzen und grünen Pigmenten beherrschten Gemälden in dem juwelengleichen Pavillon, der den bisherigen Höhepunkt von Ofilis künstlerischer Äußerungen über das schwarze Selbstbewusstsein bildet.

L'œuvre stratifiée de Chris Ofili est un remix contemporain de sa propre culture et de la peinture sénégalaise sur verre, dite *souwère* – et peut-être de la peinture d'icônes russe. Ses toiles rutilantes sont composées de milliers de taches de couleur à la manière des peintures rupestres aborigènes ou du Zimbabwe, le centre étant habituellement occupé par le portrait d'un super-héros noir ou d'une madone. L'exemple le plus célèbre en est *The Holy Virgin Mary* (1996), dont la poitrine en bouses d'éléphants et les collages d'organes génitaux féminins issus de magazines pornographiques qui l'entouraient ont déclenché un scandale. Récemment, Ofili a commencé à construire des environnements pour accueillir ses œuvres. Le premier du genre, intitulé *The Upper Room* (2002) d'après la salle où Jésus mangea sa dernière Cène, a été surnommé « la chapelle Ofili ». En collaboration avec l'architecte anglais David Adjaye, Ofili a installé son cycle de 13 peintures de singes monochromes, une pour chaque apôtre plus un singe doré triomphant, dans un intérieur à l'éclairage spectaculaire, dont le sol, les murs, les bancs et le plafond sont plaqués de bois de noyer. Le fait que les rhésus et leur codage chromatique soient tous dérivés d'un dessin de Warhol, souligne le fait que l'artiste sacrifie à l'autel du grand prêtre du Pop Art aussi bien qu'aux temples de l'histoire de l'art. Une influence majeure de son œuvre est la musique, et les voluptueuses ballades soul de Teddy Pendergrass, le lyrisme velléitaire du hip-hop et le funk des années soixante-dix étaient tous présents dans l'installation majeure qui suit, *Within Reach* (2003). Les amants souriants jetaient leurs regards hors des rutilantes peintures africaines baignées de pigments rouges, noirs et verts recouvrant toutes les surfaces du pavillon transformé en joya – constituant à ce jour le pinacle des déclarations d'Ofili sur la fierté noire.

O. W

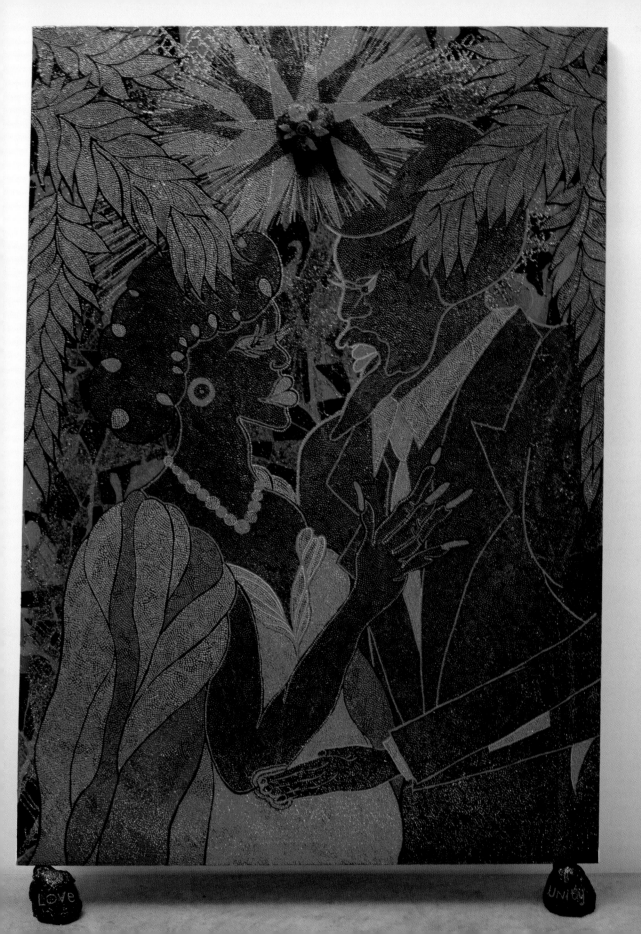

1 **Afro Love and Unity**, 2002, oil paint, acrylic paint, polyester resin, glitter, map pins and elephant dung on linen with two elephant dung supports, 213 x 152 cm

2 **Within Reach**, 2003, installation, British Pavilion, 50. Biennale di Venezia, Venice

„Mir gefällt die Cut-and-Paste-Haltung im HipHop. Man hört oft, wo ein Element endet und ein anderes anfängt, und genau das versuche ich auch in meinen Arbeiten offenzulegen, damit man sieht, wie sie entstanden sind."

« J'aime l'attitude couper/coller du hip-hop. On entend souvent le raccord entre la fin d'une partie et le début de la suivante. C'est ce que j'essaie de mettre en évidence dans mon œuvre en sorte qu'on puisse voir la manière dont les choses sont faites. »

"I like the cut-and-paste attitude of hip-hop. You can often hear where one joint ends and another begins, which is something I try to make apparent in my work so you can see how things are made."

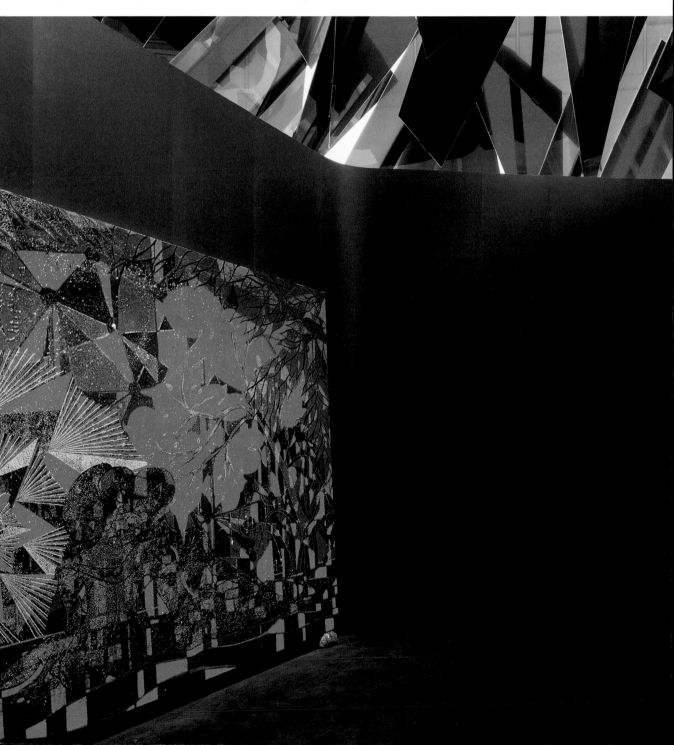

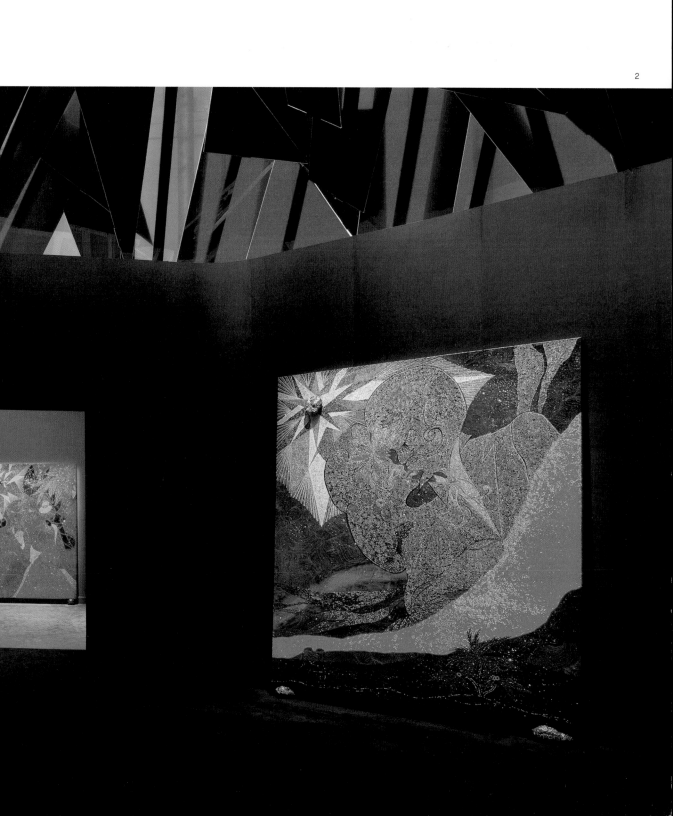

Mélik Ohanian

1969 born in Lyon, lives and works in Paris, France

In his work, Mélik Ohanian explores notions of territory and space. Using multi-media such as video, photography, installation, and text, he seems at first glance to employ a reportage style. Several layers of reality, however, are always superimposed in his images. Ohanian shows "other places", telling of a reality that is always already infused by the imaginary, and which also retains a touch of inaccessibility. Ohanian's attention is fixed upon this discrepancy, and he draws a prevailingly poetic mood from it. Some series reveal a distinct political subtext. *White Wall Travelling* (1997 and 2003), for example, is clearly linked to social reality. In the film and the subsequent poster version based on stills, Ohanian shows the now inoperative Liverpool Docks, which were the scene of the great strikes between 1995 and 1998. One sees the now empty streets – a gigantic stage empty of actors, in a decaying no man's land – which could be anywhere. In another type of work Ohanian takes a more contemplative approach. His photo series *Selected Recordings* gives you a feeling for the elementary diversity among which the things of this world coexist. It is a strangely serene glimpse of very different places, in which people are never completely absent. Ohanian's photos of apartment towers or municipal fringe areas generally exclude depictions of their residents, but this is precisely what makes the human presence in this series seem to resonate all the more strongly. Other photos show sheer distance: sea, sky, and open land. These are images of being in transit, and they retain within themselves that precise, quietly nebulous distance to the documentary: a distance that allows the fiction to widen out into an unobstructed view.

In seinem Werk erkundet Mélik Ohanian Vorstellungen von Territorium und Raum. Er arbeitet multimedial, verwendet etwa Video, Fotografie, Installation, sowie Text und scheint auf den ersten Blick reportageartig vorzugehen. Doch in seinen Bildern überlagern sich stets mehrere Schichten von Realität: Ohanian zeigt „andere Orte", erzählt von einer Wirklichkeit, die immer bereits vom Imaginären durchdrungen ist und die sich auch eine gewisse Unzugänglichkeit bewahrt. An dieser Differenz macht sich Ohanians Blick fest, bezieht daraus eine poetische Grundstimmung. Manche Werkgruppen offenbaren einen deutlich politischen Subtext. *White Wall Travelling* (1997 und 2003) etwa ist klar mit sozialer Wirklichkeit verknüpft. In diesem Film und der späteren, auf Standbildern beruhenden Plakatversion zeigt Ohanian die stillgelegten Liverpooler Docks, die von 1995 bis 1998 Schauplätze der großen Streiks gewesen sind. Man sieht die heute leeren Straßenzüge – eine riesige unbespielte Bühne, verfallendes Niemandsland, das überall sein könnte. Mit einem anderen Werktypus verfolgt Ohanian einen eher kontemplativen Ansatz: Seine Fotoreihe *Selected Recordings* weckt ein Gefühl für die elementare Vielfalt, in der die Dinge in der Welt koexistieren. Es ist ein eigenartig gleichmütiger Blick auf ganz unterschiedliche Orte, an denen Menschen nie völlig abwesend sind. Zwar kommen Ohanians Aufnahmen von Wohnsilos oder städtischen Randzonen meist ohne Darstellung der Bewohner aus, doch gerade dadurch scheint ihre Präsenz nur umso stärker nachzuhallen. Andere Fotos zeigen bloße Weite: Meer, Himmel, offenes Gelände. Es sind Bilder vom Unterwegssein und sie tragen jenen präzisen, leise nebelhaften Abstand zum Dokumentarischen in sich, an dem sich die Fiktion zum offenen Blick erweitert.

Dans son œuvre, Mélik Ohanian s'attache à décrire différentes conceptions du territoire et de l'espace. Il travaille dans plusieurs médiums – vidéo, photographie, installation, texte. Si sa démarche semble relever à première vue du reportage, ses images superposent toujours plusieurs niveaux de réalité : Ohanian montre des lieux « autres », la réalité qu'il évoque est toujours empreinte d'imaginaire, mais conserve toujours aussi une certaine inaccessibilité. C'est cet écart qu'Ohanian soumet à son regard et dont il tire une note fondamentalement poétique. Certains groupes d'œuvres dénotent un sous-texte nettement politique. *White Wall Travelling* (1997 et 2003) se réfère clairement à la réalité sociale. Dans ce film et dans les affiches de la version ultérieure réalisée à partir d'arrêts sur image, Ohanian présente les docks désaffectés de Liverpool, qui ont été le théâtre des grandes grèves de 1995 à 1998. Aujourd'hui, l'on voit de grandes rues désertes – une immense scène sans dramaturgie, un *no man's land* en voie de délabrement, qui pourrait être partout. Dans un autre groupe d'œuvres, Ohanian a une approche plus contemplative : sa série photographique *Selected Recordings* éveille le sentiment de l'élémentaire multiplicité dans laquelle coexistent les choses du monde. Il s'agit d'un regard singulièrement égal sur des lieux tout à fait différents et dont les hommes ne sont jamais tout à fait absents. Si les prises de vue de tours d'habitation ou de zones urbaines périphériques se passent le plus souvent de toute présence humaine, c'est précisément cette absence qui leur confère une résonance supplémentaire. D'autres photos montrent seulement la vastitude : la mer, le ciel, des terres à perte de vue. Ces images nomades portent en elles une distance aussi précise que légèrement nébuleuse par rapport au documentaire, distance dans laquelle la fiction s'élargit en un regard ouvert.

J. A

SELECTED EXHIBITIONS →
2005 *Documentary Creations*, Kunstmuseum Luzern; 1. Moscow Biennale **2004** 14. Biennale of Sydney; 3. berlin biennale; 26. Bienal de São Paulo **2003** *Sound Billboard*, museum in progress, Vienna; *No Ghost Just a Shell*, Van Abbemuseum, Eindhoven, Kunsthalle Zürich; Institute for Visual Culture, Cambridge, San Francisco Museum of Modern Art **2002** *Island of an Island* and *Peripherical Communities*, Palais de Tokyo, Paris **2001** *Traversées*, Musée d'Art Moderne de la Ville de Paris; *Soirée Nomade*, Fondation Cartier, Paris

SELECTED PUBLICATIONS →
2005 *Slowmotion – From Slave to Valse*, Center for Contemporary Art, Kitakyushu; *Documentary Creations*, Kunstmuseum Luzern, Luzern **2003** *Monografie*, Galerie Chantal Crousel, Frac Languedoc-Roussillon, HXY, Paris; *No Ghost Just a Shell*, Cologne, Van Abbemuseum, Eindhoven **2002** *Stories*, Haus der Kunst, Munich; *Centre of Attraction*, 8. Baltic Triennial of International Art, Contemporary Art Centre, Vilnius **2001** *Traversées*, Musée d'Art Moderne de la Ville de Paris, Paris

1 **The Patrol**, 2004, modified NYPD police car patroling around Chelsea, NYC, performance filmed by 4 synchronised video camera and soundtrack
2 **Island of an Island**, 2001, Surtsey Island, 63° 4' NORD 20° 3' WEST, video still
3 **Island of an Island**, 2001, 3 35mm films, silent, 18 min. 30 sec., 3 white wood screens, animated electric system with 900 bulbs, 5 hemispheric mirrors, books, installation view, Art Unlimited, Basle 2002
4 Slowmotion from **Slave to Valse**, 2003, 5 lightning boards, 150 electric circuits, keyboard, 750 x 550 cm, installation view, Center for Contemporary Art, Kitakyushu
5 **The Gear**, 2004, stainless steal revolving structure, exhibition view, „Revolving Analogia", Yvon Lambert Gallery, New York

„In ihrer Komposition wahren [die Bilder] die Spontaneität ihrer Akquisition. Ich zögere nicht: Es geht um das Davongetragene, das Aufgezeichnete. Wieso warten? Gleichzeitig spiele ich jedoch nicht mit dem Augenblick. Das Zeitmaß, in dem die Dinge stattfinden, ist nicht das der Fotografie."

«En leur composition, [les images] conservent la spontanéité de leur acquisition. Je n'hésite pas: il s'agit de ce qui a été emporté et enregistré. Pourquoi attendre? En même temps, je ne joue pas avec le moment présent. L'échelle de temps dans laquelle se déroulent les choses n'est pas celle de la photographie.»

"In their composition [the images] preserve the spontaneity of their acquisition. I don't hesitate: it's the thing carried off, recorded. Why wait? At the same time, I don't play with the moment. The time scale in which things take place is not that of photography."

2

3

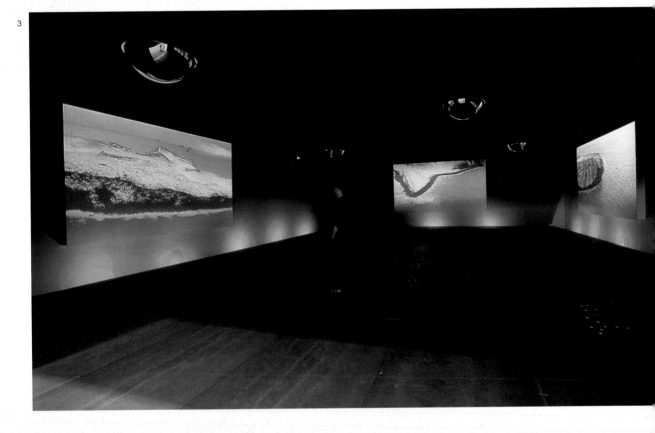

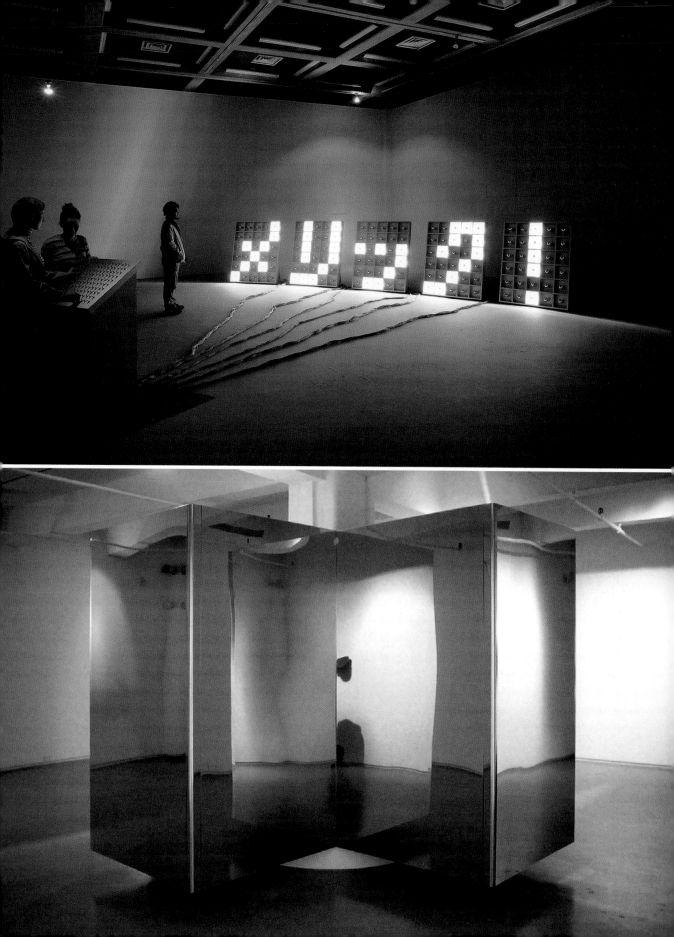

Henrik Olesen

1967 born in Esbjerg, Denmark, lives and works in Berlin, Germany

A crooked branch bound to long straight floorboards is emblematic of Henrik Olesen's investigations, which scrutinise authoritarian insistence on conformity to social, as well as sexual, norms. But his works rarely state their point so clearly and directly. Accumulations of facts pulled from the internet, print media or governmental legislation, often annotated or manipulated by the artist, provide a proliferation of versions of information. Olesen presents a decentralized view which takes into account the marginal, the overlooked, and the often sublimated processes of art (or any cultural) production. This may manifest itself architecturally, as he alters the spatial configuration of an exhibition space to draw attention to the empty, unofficial back rooms. Or through working notes displayed in vitrines or fixed on walls, which deprivilege the finished artwork in relation to its supplementary or preparatory material. In *Anthologie de l'amour sublime* (2003) surrealist collages by Max Ernst are reworked into gay sado-masochistic scenes, with Tom of Finland figures or references to repressive political legislation. The radical nature of the old avant-garde is questioned through this forced confrontation with homosexual motifs. Although homosexuality is a central and recurrent theme of Olesen's work, the maltreatment of other minorities and the distribution of power are also subjects through which he chooses to highlight the gaps, ambiguities and discrepancies of our social, as well as artistic, milieu.

Ein krummer Ast, befestigt auf langen, geraden Bodenplanken, ist geradezu emblematisch für Henrik Olesens Untersuchungen, in denen er das autoritäre Beharren auf Konformität im Hinblick auf gesellschaftliche und sexuelle Normen erforscht. Allerdings formulieren seine Arbeiten ihre Aussage selten derart klar und direkt wie in diesem Fall. Die Anhäufung von Fakten aus dem Internet, den Printmedien oder Gesetzestexten, häufig vom Künstler mit Anmerkungen versehen oder manipuliert, erzeugt ein Wuchern der verschiedenen Informationsversionen. Olesen präsentiert einen dezentralisierten Blick, der auch das Marginale, das Übersehene sowie die häufig sublimierten Vorgänge der künstlerischen (beziehungsweise jeder kulturellen) Produktion berücksichtigt. Dies kann sich in architektonischer Form manifestieren, wenn er die räumliche Gestalt des Ausstellungsraums verändert, um die Aufmerksamkeit auf die leeren, nichtöffentlichen Hinterzimmer zu lenken; oder aber in Form von Vitrinen oder an der Wand ausgestellten Arbeitsnotizen, welche das vollendete Kunstwerk seines Privilegs im Verhältnis zu ergänzendem oder vorbereitendem Material berauben. In *Anthologie de l'amour sublime* (2003) wurden surrealistische Collagen von Max Ernst in schwule SM-Szenen verwandelt, wobei Figuren von Tom of Finland auf repressive politische Gesetze verweisen. Durch die erzwungene Konfrontation mit homosexuellen Motiven wird die Radikalität der alten Avantgarde in Frage gestellt. Obgleich Homosexualität in Olesens Arbeiten ein zentrales, wiederkehrendes Thema darstellt, bilden die Misshandlung anderer Minderheiten und die Verteilung von Macht weitere Schwerpunkte, die er zur Hervorhebung der Risse, Mehrdeutigkeiten und Diskrepanzen im gesellschaftlichen wie auch im künstlerischen Umfeld wählt.

Une branche difforme fixée à une longueur de planches droites est emblématique des recherches de Henrik Olesen, qui scrutent l'insistance autoritaire sur la conformité aux normes sociales et sexuelles. Mais ses œuvres ne sont que rarement aussi directes et univoques. Souvent commentées ou manipulées par l'artiste, les accumulations de faits glanés sur Internet, dans la presse ou les législations gouvernementales, fournissent une foisonnante multitude de versions de l'information. Olesen propose une vue décentralisée qui tient compte des processus marginaux, ignorés et souvent sublimés de la production artistique ou culturelle. Ceci peut se manifester sur un plan architectural quand l'artiste transforme la disposition spatiale d'un espace d'exposition de manière à diriger l'attention du spectateur vers les pièces arrières vides, non officielles. Ou encore par des notes de travail présentées dans des vitrines ou fixées au mur, qui privent de son aura l'œuvre d'art achevée en la mettant en relation avec ses matériaux subsidiaires ou préparatoires. Dans *Anthologie de l'amour sublime* (2003), des collages surréalistes de Max Ernst sont transformés en scènes gay sado-masochistes, avec des personnages de Tom of Finland ou des références à des législations politiques répressives. La nature radicale de l'ancienne avant-garde est interrogée par le truchement de sa confrontation forcée avec des motifs homosexuels. Bien que l'homosexualité soit un thème central et récurrent dans l'œuvre d'Olesen, l'oppression d'autres minorités et la répartition du pouvoir sont aussi des sujets par lesquels l'artiste choisit de mettre en lumière les hiatus, les ambiguïtés et les divergences de notre milieu social aussi bien qu'artistique.

K. B.

SELECTED EXHIBITIONS →
2004/05 *Utopia Station*, Haus der Kunst, Munich **2004** Grafisches Kabinett, Secession, Vienna **2003** *1935 1922*, Sprengel Museum Hannover; *Contextualise*, Kunstverein Hamburg; *Handlungsräume/ Areas of Action*, Salzburger Kunstverein **2002** *Centre of Attraction*, 8. Baltic Triennial of International Art, Vilnius; *Okonomien der Zeit*, Museum Ludwig, Cologne, migros museum für gegenwartskunst, Zurich

SELECTED PUBLICATIONS →
2004 *Henrik Olesen*, Secession, Vienna **2003** *Henrik Olesen: Anthology de l'amour sublime*, Sprengel Museum Hannover, Hanover **2002** *Henrik Olesen: What is Authority?*, Pork Salad Press, Copenhagen

EIN KLEID IST KEINE HOSE
DER VATER IST NICHT DIE MUTTER
MEINE HERREN, SIE SIND VERHAFTET

1 **Ein Kleid ist keine Hose, Der Vater ist nicht die Mutter, Meine Herren, Sie sind verhaftet**, from Anthologie de l'amour sublime, 2004

2 **N. Andry: L'Orthopédie ou l'art de prévenir et de corriger dans les enfants, les difformités du corps 1749**, 2002, wood, rope, sticker, c. 260 x 30 cm

3 **Ohne Titel**, 2004, wall, door, clothes hanger, pants, wall: 248 x 380 cm, door: 85 x 205 cm, installation view, Secession, Vienna

2

Paulina Olowska

1976 born in Gdansk, lives and works in Warsaw, Poland

Does revolution still make sense? This question, raised programmatically by Paulina Olowska's installation *Metaloplastyka* (2005), forms a leitmotif in her work. Olowska conjures up the various forms of modernism, their utopian world views, and their attempts to interpenetrate art and life. Fascinated by the promise of a global village ahead of its time, she praises abstraction as a universal language of form just as she commends the attempt by Poland's Ludwig Zamenhof to overcome linguistic barriers by creating Esperanto. Completely in accord with the spirit of the historical avant-garde, Olowska integrates non-artistic teachings and practices – in which she has diagnosed similarities with concepts of modernism – into her installations, performances, drawings, and paintings. The performance *Bauhaus Yoga* (2001), for example, amalgamates these two schools on the basis of a common striving for improvement of the quality of life. However, it is particularly the role of women, upon which utopian social systems and the realization of these systems manifest themselves most clearly, that Olowska pursues throughout the history of modernism, and which she questions in terms of its relevance to contemporary structures. She finds a model in the salon culture of the 19th century which she revives in her own installations and actions. Together with the artist Lucy McKenzie, Olowska ran a bar called *Nova Popularna* (2003) in Warsaw for a few weeks. This bar was simultaneously a Gesamtkunstwerk, a drinking parlour, and an event platform. Another work, the interior designed by Olowska entitled *Sie musste die Idee eines Hauses als Metapher verwerfen* (2004), paid tribute to the heroines of art- and literature history, while also critically questioning the idea of genius.

Macht die Revolution noch Sinn? Diese Frage, die Paulina Olowska in ihrer Installation *Metaloplastyka* (2005) programmatisch aufwirft, bildet ein Leitmotiv in ihrem Werk. Olowska beschwört die unterschiedlichen Ausprägungen der Moderne, deren utopische Weltentwürfe und Versuche einer Durchdringung von Kunst und Leben. Fasziniert von der Verheißung eines globalen Dorfs vor der Zeit erweist sie der Abstraktion als universeller Formensprache ebenso Reverenz wie dem Versuch des Polen Ludwig Zamenhof, durch die Schöpfung des Esperanto linguistische Grenzen zu überwinden. Ganz im Sinne der historischen Avantgarde integriert Olowska in ihre Installationen, Performances, Zeichnungen und Gemälde nicht-künstlerische Lehren und Praktiken, bei denen sie Gemeinsamkeiten mit Konzepten der Moderne diagnostiziert – die Performance *Bauhaus Yoga* (2001) amalgamiert beide Schulen auf der Basis eines gemeinsamen Strebens nach Verbesserung der Lebensqualität. Besonders aber ist es die Rolle der Frau, an der sich utopische Gesellschaftsentwürfe und deren Umsetzung besonders deutlich manifestieren, die Olowska durch die Geschichte der Moderne verfolgt und auf ihre Relevanz für zeitgenössische Strukturen hin befragt. In der Salonkultur des 19. Jahrhunderts findet sie ein Modell, das sie in ihren eigenen Installationen und Aktionen wieder aufleben lässt: Gemeinsam mit der Künstlerin Lucy McKenzie betrieb Olowska in Warschau für einige Wochen die Bar *Nova Popularna* (2003), Gesamtkunstwerk, Trinkhalle und Veranstaltungsplattform zugleich. Eine Hommage an die Heldinnen der Literatur- und Kunstgeschichte entfaltet das von Olowska gestaltete Interieur *Sie musste die Idee eines Hauses als Metapher verwerfen* (2004), das zudem die Vorstellung vom Genie hinterfragt.

La révolution a-t-elle encore un sens? Cette question, soulevée de manière programmatique par l'installation de Paulina Olowska *Metaloplastyka* (2005), est un leitmotiv de son œuvre. Olowska fait appel aux différents manifestations de la modernité, à leurs conceptions utopiques du monde et à leurs projets d'interpénétration entre l'art et la vie. Fascinée par la promesse d'un village global avant l'heure, elle se réfère aussi bien à l'abstraction en tant que langage formel universel qu'à la tentative du Polonais Ludwig Zamenhof de surmonter les barrières linguistiques par la création de l'espéranto. Tout à fait au sens de l'avant-garde historique, Olowska intègre dans ses installations, performances, dessins et peintures, des enseignements et des pratiques extra-artistiques dans lesquels elle discerne des correspondances avec les concepts de la modernité. Ainsi, la performance *Bauhaus Yoga* (2001) réunit les deux écoles évoquées par le titre autour de leur recherche commune d'amélioration de la qualité de la vie. Mais c'est le rôle de la femme qui met tout particulièrement en lumière les projets sociaux utopiques et leur traduction. Olowska en suit la trace à travers l'histoire de la modernité et l'interroge sous l'aspect de sa pertinence pour les structures contemporaines. Dans la culture de salon du XIXe siècle, elle trouve un modèle qu'elle fait revivre dans ses propres installations et actions: en collaboration avec l'artiste Lucy McKenzie, Olowska a animé pendant plusieurs semaines à Varsovie le bar *Nova Popularna* (2003), à la fois œuvre d'art totale, buvette et plate-forme d'événements. L'intérieur d'Olowska *Sie musste die Idee eines Hauses als Metapher verwerfen* (2004), se présente comme un hommage aux héroïnes de l'histoire de la littérature et de l'art, tout en mettant en question l'idée du génie. A. M.

SELECTED EXHIBITIONS →
2005 *Metamorphosis*, Städtisches Museum Abteiberg, Mönchengladbach; *Dialectics of Hope*, 1. Moscow Biennale **2004** *Sie musste die Idee eines Hauses als Metapher verwerfen*, Kunstverein Braunschweig; *Who If Not We… ? Episode 2: Time and Again*, Stedelijk Museum, Amsterdam **2003** *Nova Popularna* (with Lucy McKenzie), temporary bar space, Warsaw (Foksal Gallery Foundation); 50. Biennale di Venezia, Venice **2001** *Heavy Duty* (with Lucy McKenzie), Inverleith House, Edinburgh; *Plastyczna Integracja*

(with Lucy McKenzie), Festiwal Malarstwa Sciennego, Gdansk **2000** *The Dream of Provincial Girl*, Apartment Space, Sopot

SELECTED PUBLICATIONS →
2004 *Sie musste die Idee eines Hauses als Metapher verwerfen*, Kunstverein Braunschweig, Braunschweig, Cologne **2000** *The Dream of Provincial Girl*, Paulina Olowska, Julita Wojcik (ed.), The City of Sopot, Sopot

1 **Metaloplastyka IX**, 2005, acrylic and oil on canvas, 180 x 160 cm

2 **Asymmetric Display**, 2004, fabric, mirror, painted wood, paper, mural, 2 painted mannequins, 300 x 600 x 450 cm, installation view, Art Cologne, 2004

Gabriel Orozco

1962 born in Jalapa, lives and works in Mexico City, Mexico, and New York (NY), USA

Gabriel Orozco's work, which often makes use of salvaged everyday materials, is frequently discussed in relation to the Duchampian ready-made. But for Orozco, significance lies not in the objects themselves, but in his encounter with them and their subsequent transformation. A rental truck becomes a mobile studio in which street-side detritus is salvaged, sculpturally rearranged and photographed (*Penske Works*, 1998). A human skull is graphed out with a chessboard grid turning into a densely allusive entity that contrasts ideas of intellect, modernist history and Mexican symbolism with death, the ultimate endgame (*Black Kites*, 1997). "It's about the body pressing against material" he has said of a small terracotta sculpture *Four and Two Fingers*, its form determined by the molding of his fingers. But this statement could also be true in a wider sense of his conceptual, sculptural and photographic practice as a whole, which constantly returns to the material collision of culture and nature, man and his environment. He articulates this in the most intimate of terms in fragile improvisational objects characterized by an ephemeral, modest beauty, such as *Lintels* (2001), a collection of flimsy lint mats saved from Laundromat tumble dryers after a year's worth of clothes washing, which seem to be poignant meditations on the passing of time and the intertwining of a body and its surroundings. Or with an almost comic simplicity, as in *Ping-Pond Table* (1998), a whimsical conflation of ping-pong table and lily pond.

Die Arbeit von Gabriel Orozco, der oft aufgelesene Alltagsmaterialien einsetzt, wird häufig im Hinblick auf das Ready-made von Duchamp erörtert. Für Orozco allerdings liegt die Bedeutung nicht in den Objekten selbst, sondern in seiner persönlichen Begegnung mit ihnen und in ihrer anschließenden Transformation. So wird ein Miet-LKW zum mobilen Atelier, in dem Straßenabfälle gesammelt, skulptural neu arrangiert und fotografiert werden (*Penske Works*, 1998). Ein menschlicher Schädel wird mit einem Schachbrettmuster überzogen, das ihn in eine anspielungsreiche Einheit verwandelt, die Vorstellungen von Intellekt, moderner Geschichte und mexikanischer Symbolik dem letzten Endspiel, dem Tod, gegenüberstellt (*Black Kites*, 1997). „Es geht um den Druck, den der Körper auf ein Material ausübt", sagte er in Bezug auf die kleine Terrakottaskulptur *Four and Two Fingers*, deren Form vom Abdruck seiner Finger geprägt ist. Diese Aussage könnte aber auch auf seine konzeptuelle, bildhauerische und fotografische Praxis insgesamt übertragen werden, die ständig auf den materiellen Zusammenprall von Kultur und Natur, Mensch und Umwelt verweist. Dieses Thema drückt Orozco auf intimste Weise in zerbrechlichen, improvisierten Objekten aus, die sich durch eine flüchtige, bescheidene Schönheit auszeichnen. Dazu zählt beispielsweise *Lintels* (2001), eine Reihe leichter Flusenmatten, die über den Zeitraum eines Jahres aus Münztrocknern eines Waschsalons gesammelt wurden und wie eine wehmütige Betrachtung über das Vergehen der Zeit und das Verwobensein eines Körpers mit seiner Umwelt erscheinen. Oder aber die in ihrer Schlichtheit fast komisch wirkende Arbeit *Ping-Pond Table* (1998), jene ungewöhnliche Verschmelzung einer Tischtennisplatte mit einem Seerosenteich.

L'œuvre d'Orozco, qui fait souvent appel à des matériaux de récupération quotidiens, est fréquemment mise en relation avec le ready-made de Duchamp. Chez Orozco toutefois, l'accent ne porte pas sur les objets eux-mêmes, mais sur la rencontre entre l'artiste, les objets et leur transformation. Un camion de location devient un atelier mobile dans lequel des objets de rebut récupérés dans la rue sont arrangés en sculpture avant d'être photographiés (*Penske Works*, 1998). Un crâne humain est isolé graphiquement au moyen d'une grille à damier qui le transforme en une entité fortement allusive, instaurant un dialogue entre les concepts d'intellect, d'histoire moderne, et le symbolisme mexicain au sein du jeu final, la mort (*Black Kites*, 1997). « Il s'agit du corps pressant contre le matériau », a dit Orozco à propos de la petite sculpture en terracote *Four and Two Fingers*, dont la forme parte l'empreinte de ses doigts. Mais cette déclaration s'applique très généralement à sa pratique conceptuelle, sculpturale et photographique conçue comme un tout, et qui revient constamment sur la collision matérielle entre culture et nature, homme et environnement. Orozco articule ces réflexions dans les termes les plus intimes à travers des objets improvisés, fragiles, caractérisés par une beauté éphémère, modeste, comme c'est par exemple le cas de *Lintels* (2001), un ensemble de tapis de ouate effilochés récupérés dans des sèche-linge de laveries au cours d'une année, ce qui en fait de poignantes méditations sur le temps qui passe et sur l'entrelacement entre un corps et son environnement. Ou encore, dans une simplicité toute cosmique, avec *Ping-Pond Table* (1998), assemblage fantasque d'une table de ping-pong et d'un bassin de nénuphars.

K. B.

SELECTED EXHIBITIONS →
2004 *Photographs*, Hirshhorn Museum, Washington D.C.; Serpentine Gallery, London **2003** *Common Wealth*, Tate Modern, London; *Ritardi e Rivoluzioni* and *Utopia Station*, 50. Biennale di Venezia, Venice; Museo de Arte Contemporáneo de Oaxaca; Centro de Artes Visuais, Coimbra **2002** documenta 11, Kassel 2001; 1. International Triennial of Contemporary Art, Yokohama **2000/01** The Museum of Contemporary Art, Los Angeles; Museo de Arte Contemporáneo Internacional Rufino Tamayo, Mexico City; Museo de Arte Contemporáneo de Monterey

SELECTED PUBLICATIONS →
2004 *Gabriel Orozco: Photographs*, Hirshhorn Museum, Smithsonian Institution, Göttingen; *Gabriel Orozco*, Serpentine Gallery, London, Cologne **2001** *Gabriel Orozco: From Green Glass to Airplane Recordings*, Stedelijk Museum, Amsterdam **2000** *Gabriel Orozco*, The Museum of Contemporary Art, Los Angeles

1 **Drops on Tiles (4)**, 2003, Xerox transfer, polyurethane foam,
45.7 x 50.8 x 25.4 cm
2 **Cemetery #2**, 2002, C-print, 40.6 x 50.8 cm
3 **Cemetery #1**, 2002, C-print, 40.6 x 50.8 cm
4 **Cemetery #6**, 2002, C-print, 40.6 x 50.8 cm
5 **Cemetery #4**, 2002, C-print, 40.6 x 50.8 cm

6 Installation view, Marian Goodman Gallery, New York, left: **Fleuve**, 2003,
polyurethane foam, styrofoam, cotton, plaster, wire, 226 x 43 x 81 cm,
on the floor: **Multiple Pourings**, 2003, polyurethane foam spheres,
each Ø 48 cm
7 **Double Tail**, 2003, polyurethane foam, 86 x 162 x 119 cm

„Ich versuche, die Realität gemäß ihren eigenen Regeln zu verwandeln."

«J'essaie de transformer la réalité à l'aide de ses propres règles.»

"I try to transform reality with its own rules."

2

4

6

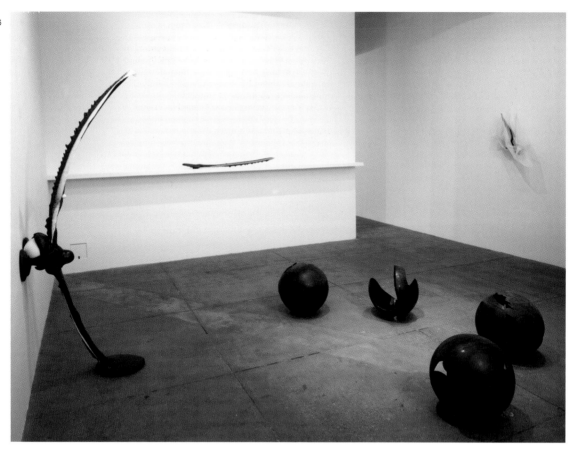

7

Damián Ortega

1967 born in Mexico City, lives and works in Mexico City, Mexico, and Rio de Janeiro, Brazil

For Mexican artist Damián Ortega, the object itself is not as important as the action it undergoes. This is not to say that Ortega is a process oriented artist, but rather that he sees the sculptural object (and the architectural environment) as inherently subject to change, whether at the hands of individuals, societies or natural occurrences. He uses modular units and colloquial materials to dissect analytically the evidence of modernist design or architecture, as if attempting to discover its energy source or the reason for its ubiquity. In *Cosmic Thing* (2002), a VW Beetle is taken apart and each separate component suspended in the air. The car's shape is still clearly recognisable but its function is thwarted; it is a car manual diagram animated in three dimensions, like a skeleton in a natural history museum. The potency of the VW Beetle as symbol lies in the fact that it is now manufactured solely on the outskirts of Mexico City: what was originally an icon for the "German people" now represents the dissemination and adaptation of design in the new world. In *Iglesia in rotación* (Cathedral in rotation, 2004) a cathedral's cruciform floor plan is mapped out in bricks three times on a gallery floor, each version slightly rotated. As the plans intersect, the clear forms disintegrate, destabilising their architectural certainties. A neighbouring work, *Clay Mountain* (2004), provides a binary contrast: a four-meter-high conical heap of primordial gunk, it is full of potential for change and remodelling, while the cathedral's fixed form shudders and fragments under the pressure of repetition and the shifting of time.

Der mexikanische Künstler Damián Ortega misst dem Objekt selbst eine geringere Bedeutung bei als der Aktion, der es unterzogen wird. Das bedeutet nicht, dass Ortega ein prozessorientierter Künstler ist, sondern dass für ihn die Skulptur (und ihre architektonische Umgebung) wesenhaft Veränderungen durch den Menschen, durch Gesellschaften oder natürliche Vorgänge unterworfen ist. Er nutzt in seinen analytischen Obduktionen von modernem Design und moderner Architektur modulare Strukturen und alltägliche Materialien, als wollte er so deren Energiequelle oder den Grund für ihre Allgegenwart offen legen. So wurde für die Arbeit *Cosmic Thing* (2002) ein VW-Käfer in seine nun in der Luft schwebenden Einzelteile zerlegt. Während die Form des Autos noch deutlich erkennbar ist, wurde seine Funktion doch durchkreuzt. Das Ergebnis ist die dreidimensional animierte Bedienungsanleitung eines Autos, vergleichbar einem Skelett in einem Naturkundemuseum. Das symbolische Potenzial des VW-Käfers begründet sich aus der Tatsache, dass er heute einzig noch in der Nähe von Mexico City produziert wird: Was ursprünglich als Ikone des „deutschen Volkes" galt, repräsentiert inzwischen die Verbreitung und Adaption von Design in der Neuen Welt. Für *Iglesia in rotación* (Kathedrale in Rotation, 2004) wurde der kreuzförmige Grundriss einer Kathedrale dreifach und jeweils leicht gedreht in Form von Ziegelsteinen auf dem Fußboden einer Galerie nachgelegt. Da sich die Umrisse überschnitten, lösten sich die Einzelformen auf, was zu einer Destabilisierung ihrer architektonischen Bestimmung führte. Die Arbeit *Clay Mountain* (2004) wiederum erzeugt einen zweiten Kontrast. Dieser vier Meter hohe kegelförmige Haufen aus urzeitlichem Schlamm bietet zahlreiche Möglichkeiten zur Veränderung und Neugestaltung, während die feste Form der Kathedrale unter dem Druck von Wiederholung und zeitlicher Verschiebung erschüttert und gebrochen wird.

Pour l'artiste mexicain Damián Ortega, l'objet en tant que tel est moins important que l'action à laquelle il est soumis. Ceci ne veut pas dire qu'Ortega soit un artiste de tendance processuelle, mais plutôt qu'il considère l'objet sculptural (et l'environnement architectural) comme par nature sujet au changement, que ce soit par le truchement de l'individu, de la société ou des phénomènes naturels. Ortega se sert d'unités modulaires et d'éléments de salles de congrès pour disséquer analytiquement les pièces à conviction du design moderne ou de l'architecture, comme s'il tentait de découvrir leur source d'énergie ou les raisons de leur omniprésence. Dans *Cosmic Thing* (2002), l'artiste a démonté une Coccinelle Volkswagen et suspendu chaque élément séparément en l'air. La forme de la voiture est encore clairement identifiable, mais sa fonction est contrecarrée. Il s'agit d'un diagramme de manuel d'utilisation en trois dimensions, apparenté au squelette exposé dans un musée d'histoire naturelle. La charge symbolique de la Coccinelle se doit au fait que ce modèle n'est plus construit aujourd'hui que dans la banlieue de Mexico. Ce qui fut à l'origine une icône du « peuple allemand » se présente aujourd'hui comme la diffusion du design et son adaptation au Nouveau Monde. Dans *Iglesia in rotación* (Cathédrale en rotation, 2004), le plan d'une cathédrale à plan cruciforme est développé trois fois en briques sur le sol d'une galerie, chaque version présentant une orientation légèrement différente. L'intersection des plans désintègre la clarté des formes et déstabilise leurs certitudes architecturales. Une œuvre similaire, *Clay Mountain* (2004), propose un contraste binaire : consistant en un amas conique de magma primitif de quatre mètres de haut, cette œuvre est pleine de changement et de remodèlement potentiels, alors que la forme fixe de la cathédrale s'ébranlait et se fragmentait sous l'effet de la répétition et des changements du temps. K. B.

SELECTED EXHIBITIONS →
2005 *Compression/Depression*, Tate Modern, London **2004** Kunsthalle Basel, Basle; *Made in Mexico*, Institute of Contemporary Art, Boston, The Hammer Museum, Los Angeles; Museu de Arte de Pampulha, Belo Horizonte **2003** *Il Quotidiano Alterato*, curated by Gabriel Orozco, 50. Biennale di Venezia, Venice **2002** Institute of Contemporary Art, Philadelphia; *The Air is Blue*, Casa Barragán, Mexico City **2001** *Animation*, P.S.1, New York

SELECTED PUBLICATIONS →
2004 *Damián Ortega*, Kunsthalle Basel, Basle

1 **Elote**, 2000–2005, corn, ink
2 **Extensión, Construcciones (autoconstrucción)**, 1997–2002, used furniture, rope, dimensions variable

3 **Spiral of Violence**, 2005, glass, metallic window frame, dimensions variable
4 **Cosmic Thing**, 2002, stainless steel, wire, Volkswagen Beetle '83, Plexiglass, installation view, Institute of Contemporary Art, Philadelphia

„Entstehung und Zerstörung in unaufhörlicher Wiederholung: bis die Zeit abgelaufen ist."

« La création et l'anéantissement, répétés à l'infini : jusqu'à ce que le temps s'épuise. »

"Creation and annihilation, repeated endlessly: until time runs itself out."

2

Jorge Pardo

1963 born in Havana, Cuba, lives and works in Los Angeles (CA), USA

Jorge Pardo's work, like the old truism about life, is what you make of it. On first glance his furniture and lighting sculptures, often seen in his interior schemes for bars or museum lobbies, are stylish reinterpretations of classic Modernist chairs, tables or beds by Eames, Aalto and Noguchi, brightly coloured in his Los Angelean palette of avocado and citrus hues. Unlike his 20th century forebears, however, there is no signature to Pardo's designs; instead he freely borrows a bentwood chair leg here, or an organic motif there, denying any claims to uniqueness and so forcing the viewer to think beyond the object's authorship, beyond even form and function, to contemplate the work's relationship to us and its surroundings. For example, Pardo lamps come in flocks installed at different heights, but would not look out of place on their own or in pairs suspended in a domestic environment. Similarly, Pardo's paintings range from patterned murals to expressive, ink-jet sprayed wallpapers – equally at home in art institutions, civic spaces or design showrooms. Individual themes, materials and textures are explored in museum or gallery shows that Pardo describes as experimental "sketches", essentially part-objects for his larger decorated environments and architectural projects. After responding to exhibition commissions by building a pier and a boat, Pardo built himself a split-level house, *4166 SeaView Lane* (1998), a monumental, but brief, public work of art, that became his private home after the duration of the show.

Das Werk von Jorge Pardo ist, was man daraus macht, wie schon die alte Binsenweisheit über das Leben sagt. Auf den ersten Blick handelt es sich bei seinen Möbel- und Lichtskulpturen, die man häufig im Rahmen seiner Raumprojekte für Bars beziehungsweise Museumsfoyers antrifft, um stilvolle Neuinterpretationen modernistischer Stühle, Tische oder Betten von Eames, Aalto und Noguchi, farblich in seiner für Los Angeles so typischen Farbpalette aus heiteren Avocado- und Zitrustönen gehalten. Anders aber als bei seinen Vorläufern des 20. Jahrhunderts tragen Pardos Entwürfe keine Handschrift, stattdessen entlehnt er auf ungezwungene Weise hier ein Stuhlbein aus Formholz oder dort ein organisches Formmotiv und negiert damit jeden Anspruch auf Einzigartigkeit, so dass der Betrachter gezwungen ist, über die Autorschaft eines Objekts, ja selbst über Form und Funktion hinauszudenken und das Verhältnis des Kunstwerks zu sich und seiner Umwelt ins Auge zu fassen. So sind die Pardo-Lampen beispielsweise scharenweise und verschieden hoch gehängt, während sie einzeln oder paarweise angebracht auch in einer häuslichen Umgebung nicht deplaziert wirken würden. Damit vergleichbar reichen Pardos Gemälde von gemusterten Wandbildern bis hin zu expressiven Inkjet-Tapeten – die sich ebenso gut in Kunstinstitutionen wie in den städtischen Raum oder in Design-Ausstellungsräume einpassen. In Museums- oder Galerieausstellungen untersucht Pardo einzelne Themen, Materialien und Strukturen, die er als experimentelle „Skizzen" beschreibt und die im Grunde Teilobjekte seiner größer ausgestalteten Environments und Architekturprojekte darstellen. Nachdem er auf Ausstellungsaufträge mit dem Bau eines Kais und eines Bootes reagiert hatte, errichtete Pardo ein Terrassenhaus, *4166 SeaView Lane* (1998), ein monumentales, aber flüchtiges öffentliches Kunstwerk, das er nach Ablauf der Ausstellung selbst bezog.

A l'instar de ce que dit un vieux truisme concernant la vie, le travail de Jorge Pardo est ce qu'on en fait. Au premier regard, le mobilier et les sculptures-luminaires qui apparaissent souvent dans ses projets d'architectures intérieures pour des bars ou des entrées de musées, sont d'élégantes relectures de chaises, de tables ou de lits de la modernité classique conçus par Eames, Aalto ou Noguchi, rehaussées par les couleurs éclatantes de sa palette de tons avocat ou citron, typique de Los Angeles. A la différence de ses prédécesseurs du XXe siècle, les designs de Pardo ne portent en revanche aucune signature. L'artiste préfère emprunter librement ici tel pied de chaise en bois courbé, là tel motif organique, refusant toute revendication d'unicité et obligeant ainsi le spectateur à porter sa réflexion au-delà de la notion de paternité, et même au-delà des forme et fonction, pour contempler le rapport entre l'œuvre, son environnement et lui-même. Les lampes de Pardo sont par exemple présentées en grappes sur différents niveaux, mais n'auraient rien de déplacé si elles étaient utilisées isolément ou suspendues par paires dans un cadre domestique. De même, les œuvres picturales de Pardo vont de peintures murales à motifs sériels à des papiers peints expressif au jet d'encre – convenant aussi bien à des institutions artistiques, ou des espaces publics qu'à des boutiques de design. Les thèmes individuels, les matériaux et les textures sont explorés au cours d'expositions dans des musées ou des galeries que Pardo décrit comme des « études » expérimentales, et fonctionnent essentiellement comme des objets partiels de ses vastes environnements décorés et projets architecturaux. Après avoir répondu à des projets d'exposition en construisant une barque et un embarcadère, Pardo s'est construit une maison à plusieurs niveaux au *4166 SeaView Lane* (1998), une œuvre d'art monumentale, mais éphémère et publique, dont l'artiste a fait son domicile privé une fois l'exposition terminée.

O. W.

SELECTED EXHIBITIONS →
2004 26. Bienal de São Paulo **2003** *I Moderni/The Moderns*, Castello di Rivoli, Turin; *On The Wall*, RISD Museum, Providence **2002** Le Consortium, Dijon; Museum Dhondt-Dhaenens, Deurle; Public Art Fund, New York; *Touch – Relational Art from the 1990s to Now*, San Francisco Art Institute; *Refraction, Jorge Pardo and Gerhard Richter*, Dia Center for the Arts, New York; *Penelope*, 2. Liverpool Biennial; *Culture Meets Culture*, 3. Busan Biennale **2001** *Public Offerings*, The Geffen Contemporary at MOCA, Los Angeles; *In Between Art and Architecture*, MAK Center for Art and Architecture, Los Angeles; *Beau Monde, Toward a Redeemed Cosmopolitanism*, 4. International Biennial, Santa Fe

SELECTED PUBLICATIONS →
2005 *DesignArt*, Tate Publishing, London **2003/04** *Jorge Pardo*, Haunch of Venison, London **2002** *International*, Liverpool Biennial, Liverpool; *Spoon*, London **2000** *37/2000: Jorge Pardo*, Kunsthalle Basel, Basle; *Jorge Pardo: What does this object do?*, Ostfildern-Ruit

1 **Untitled**, 2003, plywood, PVC, paper, ink jet, spar varnish, 4 lamps,
 3 drawings, dimensions variable, installation view, Galerie Gisela Capitain,
 Cologne
2 **Penelope**, 2004, concrete, steel (painted), stainless steel, fiberglass
 (painted), acrylic glass (silkscreened), lightning, frosted acrylic glass,

11.7 m x 35.2 m x 20.4 m, installation view, Wolstenholme Square,
Liverpool
3+4 **Oliver, Oliver, Oliver**, mixed media, installation view, "Braunschweig
Parcours, 2004", Kulturinstitut Braunschweig

„Man steht vor einer Skulptur, die plötzlich ein Haus ist,
oder man steht vor einem Gemälde, das plötzlich eine Skulptur ist.
In allem findet ein Spiel mit etwas anderem statt."

«Vous venez voir une sculpture et vous trouvez une maison, ou alors vous
allez voir une peinture et vous trouvez une sculpture. Chaque chose est
quelque chose qui joue avec autre chose.»

"You come to a sculpture, and get a house, or you go to a painting, and get a sculpture. Everything is something playing with something else."

2

Philippe Parreno

1964 born in Oran, Algeria, lives and works in Paris, France

During the past fifteen years Philippe Parreno has made collaboration an art form by working with artists Pierre Huyghe, Liam Gillick, Carsten Höller, Rirkrit Tiravanija, and the duo Inez van Lamsweerde and Vinoodh Matadin; the graphic design firm M/M Paris; filmmaker Charles de Meaux; and the architect François Roche, among others. The diversity of his creative partners is matched by the variety of Parreno's output: he has exhibited films and videos, posters, sculpture, magazines, fireworks, and helium balloons, and also has published a significant body of art criticism and essays. The best-known example of his collaborative endeavours may also be the most representative: for *No Ghost Just a Shell* (1999–2002) Parreno and Huyghe purchased the right to a generic anime character, named her Annlee, and, along with thirteen artist friends, turned her into the star of limited-time artwork presented in seventeen iterations. More recently, the artist has revisited his earlier artworks and collaborations, presenting them in exhibitions as posters silkscreened with phosphorescent ink: invisible until the lights are turned off, the images' in-the-dark afterglow acts as a survey in miniature. (Invited to present a survey exhibition a few years earlier, Parreno opted instead to publish a catalogue raisonné of his work to date and exhibit newer pieces.) A unifying thread can be found in his consistent attempts to explore alternative models for exhibition display and storytelling; Parreno treats each exhibition as a scenario into which multiple narratives – often blurring reality and its representation, fact and fiction – can be inserted.

In den vergangenen fünfzehn Jahren hat Philippe Parreno die Methode der Kooperation zur eigenen Kunstform erhoben, indem er mit Künstlern wie Pierre Huyghe, Liam Gillick, Carsten Höller, Rirkrit Tiravanija und dem Duo Inez van Lamsweerde und Vinoodh Matadin, dem Grafikbüro M/M Paris, dem Filmemacher Charles de Meaux sowie dem Architekten François Roche zusammenarbeitete. Die Verschiedenheit von Parrenos Kreativpartnern entspricht der Vielfalt seiner künstlerischen Produktion: Er stellte bislang Filme und Videos, Poster, Skulpturen, Zeitschriften, Feuerwerke und Heliumballons aus und hat eine beträchtliche Anzahl von Kunstkritiken und Aufsätzen verfasst. Das wohl bekannteste Beispiel für seine künstlerischen Partnerschaften ist vielleicht gleichzeitig das repräsentativste von allen: Für *No Ghost Just a Shell* (1999–2002) erwarben Parreno und Huyghe die Rechte an einer computergenerierten Anime-Figur, die sie Annlee tauften und zusammen mit dreizehn befreundeten Künstlern zum Star eines in siebzehn Versionen präsentierten, zeitlich begrenzten Kunstwerks machten. In jüngster Zeit hat sich der Künstler auf seine früheren (Zusammen-)Arbeiten bezogen und diese in Ausstellungen als phosphoreszierende Siebdruckplakate präsentiert: Das erst nach Ausschalten der Beleuchtung sichtbar werdende Bild fungiert so in seinem Nachleuchten als Miniaturüberblick. (Als man Parreno einige Jahre zuvor zu einer Retrospektive eingeladen hatte, zog er die Veröffentlichung eines Katalogs zu seinem Gesamtwerk vor und stellte lediglich neuere Arbeiten aus.) Es zieht sich ein roter Faden durch all seine Versuche der Erforschung alternativer Ausstellungs- und Erzählmodelle. Parreno behandelt jede Ausstellung als Szenario, in das sich mehrere Erzählungen einfügen lassen, in denen sich häufig die Realität und ihre Darstellung, Fakt und Fiktion miteinander vermischen.

Au cours des quinze dernières années, Philippe Parreno a fait de la collaboration un genre artistique à part entière en travaillant notamment avec des artistes comme Pierre Huyghe, Liam Gillick, Carsten Höller, Rirkrit Tiravanija et le duo Inez van Lamsweerde et Vinoodh Matadin, mais aussi avec l'agence de graphisme M/M Paris, le réalisateur Charles de Meaux et l'architecte François Roche. La diversité de ses partenaires à la création est liée à la variété de la production de Parreno, qui a présenté des films, des vidéos, des posters, des sculptures, des magazines, des feux d'artifices, des ballons d'hélium, et qui a publié un vaste corpus de critiques d'art et d'essais. L'exemple le plus connu de ses projets collaboratifs est peut-être aussi celui qui illustre le mieux son travail : pour *No Ghost Just a Shell* (1999–2002), Parreno et Huyghe ont acquis les droits d'un personnage animé générique qu'ils ont appelé Annlee et dont, en collaboration avec treize amis artistes, ils ont fait la star d'une œuvre d'art limitée dans le temps, présenté sous dix-sept variations. Plus récemment, l'artiste a revisité ses œuvres et collaborations passées, en les présentant sous forme de posters sérigraphiés à l'encre phosphorescente, invisible jusqu'à l'extinction des lumières, le rayonnement des images dans l'obscurité faisant l'effet d'une étude en miniature. (Invité à présenter une exposition rétrospective quelques années plus tôt, Parreno avait préféré publier un catalogue raisonné de son travail passé et exposer des pièces plus récentes.) Un fil conducteur peut être décelé dans ses tentatives régulières de rechercher des modèles alternatifs pour la présentation d'expositions et de narrations. Parreno traite chaque exposition comme un scénario dans lequel peuvent entrer de multiples récits – mélangeant souvent réalité et représentation, événement et document.

B. S.

SELECTED EXHIBITIONS →
2004 21st Century Museum of Contemporary Art, Kanazawa; *Fade Away*, Kunstverein München, Munich; *The Big Nothing*, Institute of Contemporary Art, Philadelphia **2003** *The Sky of the Seven Colors*, Center for Contemporary Art, Kitakyushu; 50. Biennale di Venezia, Venice **2002** *El Sueño de una cosa*, Portikus, Frankfurt/Main; *Alien Season*, Musée d'Art Moderne de la Ville de Paris; *No Ghost Just a Shell*, Kunsthalle Zürich, Institute of Visual Culture, Cambridge, San Francisco Museum of Modern Art, Van Abbemuseum, Eindhoven

SELECTED PUBLICATIONS →
2003 *AVANT*, Biennale de Lyon, Lyon; *Animations*, KW Institute for Contemporary Art, Berlin **2002** *Le Livre de Roland*, Cologne; *No Ghost Just a Shell*, Cologne; *Philippe Parreno*, Moderna Museet, Stockholm

1 **Fade to Black (Argentina vs. Netherlands 1978, Medina 2003)**, 2003,
 silkscreen, phosphorescent ink on paper, 185 x 120 cm
2 Exhibition view (ON), "Fade Away", Kunstverein München, 2004

3 **Fade to Black (Sound Pan, Paris 2002)**, 2003, silkscreen, phosphorescent
 ink on paper, 185 x 120 cm
4 Exhibition view (OFF), "Fade Away", Kunstverein München, 2004

„Ein Ausstellungsraum dient nicht nur der Präsentation von Objekten,
er ist auch ein Ort der Vermittlung, ein Ort, an dem man eine Reihe von
Spielen spielen kann."

«Un espace d'exposition n'est pas seulement un présentoir d'objets mais
aussi un espace de négociation, un endroit où l'on peut jouer toute une série
de jeux.»

"An exhibition space is not only a display of objects but also a space of negotiation, a place where a series of games can be played."

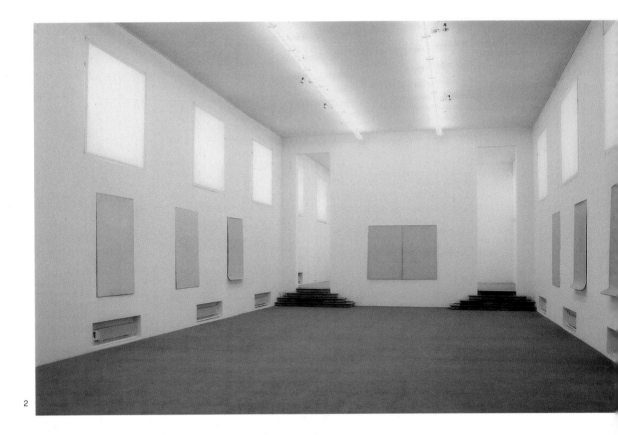

2

Bruno Peinado

1970 born in Montpellier, lives and works in Douarnenez, France

The impressive number of works created by Bruno Peinado since 2000 can be interpreted as a sudden eruption bursting forth after thirty years of a collective subconscious encountering a personal imagination (and vice versa). The result: a "chaos-world", to use the words of Martinique's poet Edouard Glissant. This "archipelago thinking" together with sampling as practised in music gives Peinado the means with which to joyfully blow up the world, whereby his aim is to "make it more complex again". Using mechanisms of inversion and visual and linguistic "approximations" (among these the irresistible works *Lost-it Note* and *Wild Disney*, 2003) Peinado energetically confronts the flood of images that inundates our present-day existence and our memories, subjecting them to a uniquely relentless process of mental "infusion" that triggers oblivion, bewilderment, and doubt. Following the lead of *Low Revolution 3*, Peinado's work has been focused on "mutating" installations that combine drawing, painting, sculpture, ready-mades, and items of furnishing (carpeting, furniture…). The visual attraction of the whole place symbols that hold great evocative power in the foreground, such as the Afro-Michelin Man (Bibendum) with one fist raised (*The Big One World*, 2000), which quickly became an emblem of "complex post colonialist multiculturalism without exoticism". As the apostle of constant movement together with its natural corollary, the pause ("Perpetuum mobile", 2004), Peinado pursues the strategy of the Trojan Horse. Thus the monumental version of this horse that he created in 2004 (*Ride Like Lightning, Counter Revolution Counter*) was completely covered with the most effective of all disguises: the mirror.

Die beeindruckende Menge an Werken, die Bruno Peinado seit 2000 geschaffen hat, kann als plötzliche Eruption gedeutet werden, die nach dreißig Jahren aus der Begegnung eines kollektiven Unterbewusstseins mit einer persönlichen Imagination (und umgekehrt) hervorbricht. Resultat: ein „Weltchaos", um das Wort des Dichters Edouard Glissant aus Martinique zu gebrauchen. Dieses „Archipel-Denken" liefert Peinado, zusammen mit dem aus der Musik bekannten Sampling, die Mittel, mit denen er die Welt jubelnd in die Luft sprengt, wobei er das Ziel verfolgt, sie „wieder komplexer zu gestalten". Peinado stellt sich mit Mechanismen der Umkehrung, mit visuellen und linguistischen „Ungefähren" (darunter die unwiderstehlichen Arbeiten *Lost-it Note* und *Wild Disney*, 2003) energisch der Bilderflut, die unsere heutige Existenz und unser Gedächtnis überschwemmt, und unterwirft sie einem schonungslosen Prozess der mentalen „Infusion", der Vergessen, Verwirrung und Zweifel auslöst. Nach dem Beispiel der *Low Revolution 3*, konzentriert sich die Arbeit von Peinado auf „mutierende" Installationen, die Zeichnung, Malerei, Skulptur, Ready-made und Ausstattungselemente (Teppichboden, Möbel …), miteinander verbinden. Die visuelle Attraktion des Ganzen stellte jene Symbole in den Vordergrund, die mit einer großen Beschwörungskraft aufwarten, wie das Afro-Michelin-Bibendum mit erhobener Faust (*The Big One World*, 2000), das schnell zu einem Wahrzeichen eines „komplexen postkolonialistischen Multikulturalismus ohne Exotismus" geworden ist. Als Apostel der ständigen Bewegung und deren natürlichem Pendant, der Pause („Perpetuum Mobile", 2004), verfolgt Peinado dabei die Strategie des Trojanischen Pferdes. So ist die monumentale Version, die er 2004 davon realisiert hat (*Ride Like Lightning, Counter Revolution Counter*) vollständig mit der wirksamsten aller Tarnungen bedeckt: dem Spiegel.

L'impressionnant corpus d'œuvres réalisées par Bruno Peinado depuis 2000 peut être vu comme la régurgitation brusque de trente années de rencontre d'un inconscient collectif et d'un imaginaire personnel (et réciproquement) soudainement rendues visibles, matérialisées. Résultat : un « chaos-monde », pour reprendre le mot du poète martiniquais Edouard Glissant. Cette « pensée de l'archipel » fournit à Peinado avec l'univers musical du sampling, la base des outils redoutables grâce auxquels il entreprend de dynamiter le monde avec jubilation dans l'objectif avoué de le « recomplexifier ». Prenant à bras-le-corps le flux d'images qui envahit notre existence présente et notre mémoire, Peinado, par des mécanismes de retournement, d'« à-peu-près » visuels et linguistiques (dont les irrésistibles *Lost-it Note* et autres *Wild Disney*, 2003), le soumet à un processus d'« infusion » mentale particulièrement décapant, qui sème l'oubli, la confusion et le doute. A l'image de la *Low Revolution 3*, la pratique de Peinado se concentre dans des installations « mutantes », qui mêlent dessin, peinture, sculpture, ready-made très assistés et éléments de décor (moquette, mobilier…), où l'impact visuel de l'ensemble sert d'écrin à des œuvres emblématiques dotées d'une grande force d'évocation, comme le Bibendum Michelin afro au poing levé (*The Big One World*, 2000) qui est rapidement devenu l'emblème d'un « multiculturalisme postcolonial complexe et sans exotisme ». Apôtre du mouvement perpétuel associé à son pendant naturel, la pause (« Perpetuum Mobile », 2004), Peinado adopte la stratégie du cheval de Troie. Ainsi, la version monumentale qu'il en a réalisée en 2004 (*Ride Like Lightning, Counter Revolution Counter*) est entièrement couverte du plus efficace des camouflages : le miroir.

S. C

SELECTED EXHIBITIONS →
2005 *Just do it!*, Lentos Kunstmuseum, Linz **2004** *Silence Is Sexy*, Ecole nationale supérieure des beaux-arts, Paris; *Perpetuum Mobile*, Palais de Tokyo, Paris; 26. Bienal de São Paulo **2003** *Influenza, Rainbow Warriors*, Museo Zauli, Faenza

SELECTED PUBLICATIONS →
2004 *Petit Journal #6: Bruno Peinado*, Palais de Tokyo, Paris
2003 *A Arte de Bruno Peinado*, Paço das Artes, São Paulo
2002 *Original*, Galerie Loevenbruck, Paris

1 **Untitled, Just as Dogs Tend to Look Like Their Boss**, 2005,
Lambda print mounted on Dibond, 150 x 100 cm
2 **Untitled, vanity Flight Case**, 2005, flight case, resin skull, mirrors,
4 night club's withe lights, motor, turntable, smoke machine

3 Exhibition view, "Perpetuum Mobile", Palais de Tokyo, Paris, 2004
4 **Untitled, Good Stuff 2**, 2002, 54 plywood cards, acrylic paint,
enamel paint, each 170 x 110 cm, exhibition view, "Perpetuum Mobile",
Palais de Tokyo, Paris 2004

„Wie die Künstler der Pop Art verwende ich Elemente aus der Kultur,
die mich umgibt, aber ich beziehe den Zweifel mit ein."

« A l'image des artistes du Pop Art, j'utilise des éléments de la culture
qui m'entoure, mais j'y introduis du doute. »

"Like the artists of Pop Art, I use elements from the culture that surrounds me, but I also include doubt."

2

Manfred Pernice

1963 born in Hildesheim, lives and works in Berlin, Germany, and Vienna, Austria

Manfred Pernice's sculptural objects and installations reflect the daily experience of architecture and sculpture in the midst of commerce and consumption. How can the expectations of the modernist vocabulary of form regarding clarity, readability and functionality be maintained within social and functional contexts? The tin as a prime example of a multi-purpose basic form, somewhere between preserved-food container and stereometric building shape, reappears in Pernice's works again and again: in a cumulative installation in *1a Dosenfeld* (2000), and in *Bahnpolizei-Dose* (2000), *Thai-Dose* (2000), *Park-Dose* (2000/01) and *Zentraldose* (1998). *ESTREL: Quattro Stagioni* (2002) a sculpture named after a conference hotel and made of particleboard, cardboard and glass, changes from a model of postmodern architecture to a multifunctional service terminal as one views the various layouts of its four sides. Pernice's installations appear to be under permanent reconstruction. Their transitory, inherently unfinished character reflects the temporality and disorder of today's experience of the city with its interim solutions and marginalized areas. For the installation *U5* (2004) Pernice went on a hunt for vestiges of the past in the Berlin U5 subway line, which was undergoing renovations. The individual stations contain the remains of GDR tile art alongside traces of use, graffiti and garbage. The individual models, fragments, sculptures, photographs and drawings trigger chains of associations that have no obligatory character. Both the construction of the subway line and its description become visible as hybrid constructions, which allow truly archaeological investigations.

Die skulpturalen Objekte und Installationen von Manfred Pernice reflektieren die alltägliche Erfahrung von Architektur und Skulptur inmitten von Verkehr und Konsum. Wie kann der Anspruch auf Klarheit, Lesbarkeit und Funktionalität des modernen Formenvokabulars innerhalb sozialer und funktionaler Zusammenhänge aufrechterhalten werden? Die Dose als exemplarisches Beispiel einer vielseitig einsetzbaren Grundform zwischen Konservenbehältnis und stereometrischer Gebäudeform kehrt in Pernices Arbeiten immer wieder: Als akkumulative Installation im *1a Dosenfeld* (2000), als *Bahnpolizei-Dose* (2000), *Thai-Dose* (2000), *Park-Dose* (2000/01) oder *Zentraldose* (1998). Eine Skulptur aus Pressspan, Pappe und Glas, *ESTREL: Quattro Stagioni* (2002), benannt nach einem Konferenzhotel, changiert in der unterschiedlichen Ausstattung ihrer vier Seiten zwischen einem Modell postmoderner Architektur und einem multifunktionalen Serviceterminal. Pernices Installationen scheinen sich in permanentem Umbau zu befinden. Ihr transitorischer, prinzipiell unabgeschlossener Charakter reflektiert die Temporalität und Unordnung zeitgenössischer Stadterfahrung mit ihren Übergangslösungen und Randzonen. Für die Installation *U5* (2004) begab sich Pernice auf Spurensuche in die in Renovierung befindliche Berliner U-Bahnlinie 5. Überbleibsel von DDR-Fliesenkunst in den einzelnen Stationen stehen neben Gebrauchsspuren, Graffiti und Müll. Die einzelnen Modelle, Bruchteile, Skulpturen, Fotografien und Zeichnungen lösen Assoziationsketten aus, die keinen verbindlichen Charakter haben. Der Bau der U-Bahnlinie ebenso wie seine Beschreibung werden als hybride Konstruktionen sichtbar, die wahrhaft archäologische Untersuchungen erlauben.

Les sculptures-objets et les installations de Manfred Pernice traduisent l'expérience quotidienne de l'architecture et de la sculpture dans les univers de la circulation et de la consommation. Comment la revendication de clarté, de lisibilité et de fonctionnalité du vocabulaire formel de la modernité peut-elle se maintenir au sein des rapports sociaux et fonctionnels ? La boîte, paradigme exemplaire d'une forme fondamentale diversement exploitable entre conserve et forme architecturale stéréométrique, revient sans cesse dans le travail de Pernice : sous forme d'installation accumulative dans *1a Dosenfeld* (2000), dans *Bahnpolizei-Dose* (2000), *Thai-Dose* (2000), *Park-Dose* (2000/01) ou encore dans *Zentraldose* (1998). *ESTREL : Quattro Stagioni* (2002), une sculpture faite d'aggloméré, de carton et de verre, et dont le titre est emprunté à un hôtel et centre de conférences, évolue au fil de ses quatre faces en présentant différents aménagements – entre modèle d'une architecture postmoderne et terminal de services multifonctionnel. Les installations de Pernice semblent être prises dans un processus de constant remaniement. Leur caractère transitoire rend compte de la temporalité et du désordre de l'expérience urbaine contemporaine, avec leurs solutions éphémères et leurs zones marginales. Pour l'installation *U5* (2004), Pernice s'est mis en quête de traces dans le cadre de la rénovation de la ligne 5 du métro de Berlin. Les restes de l'art du carrelage de la RDA dans les différentes stations viennent se juxtaposer à toutes sortes de traces d'utilisation, de graffitis et de déchets. Les différents fragments, maquettes, sculptures, photographies et dessins déclenchent des séries d'associations sans caractère fixe. La construction de la ligne de métro et sa description apparaissent comme des constructions hybrides permettant des recherches proprement archéologiques.

E. K

SELECTED EXHIBITIONS →
2004 *It's All an Illusion*, migros museum für gegenwartskunst, Zurich; *Sculptural Sphere*, Sammlung Goetz, Munich; *Artists' Favourites, Act II*, Institute for Contemporary Art, London; *Werke aus der Sammlung Boros*, Zentrum für Kunst und Medientechnologie, Karlsruhe; *LAB*, Kröller-Müller Museum, Otterlo **2003** 50. Biennale di Venezia, Venice **2002** documenta 11, Kassel; *Die Erfindung der Vergangenheit*, Pinakothek München; *Artists Imagine Architecture*, Institute of Contemporary Art, Boston **2001/02** *Liegende*, Sprengel Museum Hannover

SELECTED PUBLICATIONS →
2004 *Werke aus der Sammlung Boros*, Zentrum für Kunst und Medientechnologie, Karlsruhe; *Sculptural Sphere*, Sammlung Goetz, Munich **2003** *Manfred Pernice: infrastructure*, Brigitte Kölle, Anton Kern Gallery (ed.), New York **2002** *Manfred Pernice: Die dritte Dimension*, Cologne; *Artists Imagine Architecture*, Institute of Contemporary Art, Boston

1 **Hässliche Luise**, 2004, installation view, Galerie Neu, Berlin
2 **Commerzbank 1**, 2004, painted particle board, plaster,
 96.5 x 81.3 x 167.6 cm

3 **Commerzbank 3**, 2004, painted particle board, 61 x 91.4 x 274.3 cm
4 **Merzbank**, 2004, plastic buckets, stones, empty containers, TV monitor,
 DVD player, DVD, 55.9 x 111.8 x 238.8 cm

„Der Besucher betritt einen Unsinnszusammenhang, eine unerträgliche Zumutung von Einzelaspekten, die nur als künstlerischer Entwurf akzeptabel ist und doch potenziell einen Typus alltäglicher Wahrnehmung parallelisiert."

«Le visiteur aborde un espace de non-sens, un cumul intolérable d'aspects singuliers, qui est seulement acceptable au sein d'un projet artistique, mais qui parallélise potentiellement un type de perception quotidienne.»

"The visitor enters a context of nonsense, an unbearable imposition of individual aspects, which is only acceptable as an artistic model and yet potentially parallels a type of daily perception."

2

3

Grayson Perry

1960 born in Chelmsford, lives and works in London, UK

Embroidery, appliqué and pottery are considered amateurish pastimes or hobbies, at best crafts, but rarely as fine art media. Now that artists Thomas Schütte, Richard Deacon and Cindy Sherman have produced works in ceramic, the material has a growing stature in contemporary art; yet only Grayson Perry persists in the pursuit of such low-order, decorative arts as making vases, pots and blankets. Perry's classic container forms – fashioned using the novice's technique of stacking or winding successive coils of clay in layers, which he learnt in an evening class – are then embossed, painted and stencilled with dark or humorous subject matter, either of an autobiographical or observational nature. Cathartic scenes from his upbringing in a deprived area of London feature the artist wandering among the urban dereliction of burnt-out cars (*Nostalgia for the Bad Times*, 1999) or lonely men looking for prostitutes (*The Driven Man*, 2000), while responses to current affairs issues such as paedophilia or terrorism include his homage to the folk artistry of road-side shrines dedicated to Princess Diana (*Barbaric Splendour*, 2003). His satiric glare at the closeted British art scene flits between ironic inventories of the finery found in a collector's home (*Posh Bastards House*, 1999) to the rather more savage backbiting of *Art Dealer Being Beaten to Death*, 2003. A rebellious performer in early film works, Perry continues to shock through his transvestite alter ego, Claire, a contrary, "kidult" fantasy that mirrors the politically charged and autoerotic themes of his pots.

Sticken, Nähen und Töpfern gelten als laienhafte Hobbys, bestenfalls als Kunsthandwerk, selten jedoch als hochkünstlerische Medien. Inzwischen, da Künstler wie Thomas Schütte, Richard Deacon und Cindy Sherman Keramiken geschaffen haben, lässt sich eine Aufwertung dieses Materials innerhalb der bildenden Kunst verzeichnen. Trotzdem beharrt allein Grayson Perry auf der Beschäftigung mit so niederen kunsthandwerklichen Techniken wie der Herstellung von Vasen, Töpfen und Decken. Perrys klassische Behälterformen – die in Anfängermanier durch Aufeinanderschichten oder -wickeln mehrerer Tonschichten entstehen, wie er es in einem Fortbildungskurs lernte – werden anschließend mit Reliefs versehen und frei oder mithilfe von Schablonen mit düsteren beziehungsweise humorvollen Motiven bemalt, die einen biografischen Hintergrund haben oder persönlichen Beobachtungen entstammen. Kathartische Szenen aus seiner Kindheit in einem Londoner Arbeitervorort zeigen den Künstler zwischen den urbanen Überresten ausgebrannter Autos umherwandernd (*Nostalgia for the Bad Times*, 1999) oder einsame Männer auf der Suche nach Prostituierten (*The Driven Man*, 2000), während zu den Reaktionen auf aktuelle Themen wie Pädophilie und Terrorismus auch seine Hommage an die Volkskunst der Prinzessin Diana gewidmeten Bildstöcke zählt (*Barbaric Splendour*, 2003). Sein satirischer Blick auf die abgeschottete britische Kunstszene schwankt zwischen ironischer Bestandsaufnahme der im Haus eines Kunstsammlers vorgefundenen Pracht (*Posh Bastards House*, 1999) und wilder Hetze (*Art Dealer Being Beaten to Death*, 2003). Der in früheren Filmen als rebellischer Performer auftretende Perry provoziert weiterhin durch sein Alter ego, den Transvestiten Claire, eine widersprüchliche „Kidult"-Fantasiefigur, in der sich die politisch aufgeladenen und autoerotischen Themen seiner Töpfereien widerspiegeln.

La broderie, l'applique et la poterie sont considérées comme des passe-temps ou des hobbies d'amateurs, au mieux comme des artisanats, mais rarement comme des médiums relevant des beaux-arts. Aujourd'hui que Thomas Schütte, Richard Deacon et Cindy Sherman ont produit des œuvres céramiques, ce matériau occupe une place de plus en plus importante dans l'art contemporain, mais seul Grayson Perry persiste dans la pratique d'arts dits mineurs et décoratifs comme la fabrication de vases, de pots et de couvertures. Les formes classiques de réceptacles que Perry réalise à l'aide de la technique de débutant qui consiste à superposer ou à embobiner en couches des anneaux de glaise, telle que l'artiste l'a apprise en cours du soir, sont ensuite travaillées en relief, peintes et décorées de sujets sombres ou humoristiques tirés de son autobiographie ou de ses observations. Des scènes cathartiques de sa jeunesse, passée dans un quartier pauvre de Londres, montrent l'artiste parcourant la désolation des voitures brûlées (*Nostalgia for the Bad Times*, 1999) ou des hommes solitaires errant à la recherche de prostituées (*The Driven Man*, 2000), cependant que ses réponses aux sujets d'actualité comme la pédophilie ou le terrorisme incluent ses hommages à l'art populaire des autels de trottoir dédiés à la princesse Diana (*Barbaric Splendour*, 2003). Son regard satirique sur une scène artistique britannique refermée sur elle-même va des inventaires ironiques des parures découvertes chez un collectionneur (*Posh Bastards House*, 1999) à la médisance plutôt plus sauvage de *Art Dealer Being Beaten to Death* (2003). Après avoir été un performer rebelle dans ses premiers films, Perry continue de choquer avec son alter ego, le travesti Claire, un fantasme contraire et « kidulte » qui fait écho aux thèmes chargés politiquement et autoérotiques de ses poteries.

O. W.

SELECTED EXHIBITIONS →
2004 *Collection Intervention*, Tate St Ives; *A Secret History of Clay from Gauguin to Gormley*, Tate Liverpool **2003** *Turner Prize Exhibition*, Tate Britain, London; *For the Record: Drawing Contemporary Life*, Vancouver Art Gallery **2002** *Guerilla Tactics*, Barbican, London; Stedelijk Museum, Amsterdam **2001** *New Labour*, The Saatchi Gallery, London **2000** *Protest and Survive*, Whitechapel Gallery, London; *British Art Show 5*, Edinburgh, Southampton, Birmingham

SELECTED PUBLICATIONS →
2004 *Grayson Perry*, Victoria Miro Gallery, London; *A Secret History of Clay from Gauguin to Gormley*, Tate Publishing, London
2003 *For the Record: Drawing Contemporary Life*, Vancouver Art Gallery, Vancouver **2002** *Grayson Perry: Guerrilla Tactics*, Stedelijk Museum, Amsterdam

1 **Taste and Democracy**, 2004, glazed ceramic, Ø 41 x 26 cm
2 **Poverty Chinoiserie**, 2003, glazed ceramic, Ø 64 x 40 cm

3 **Black Dog**, 2004, glazed ceramic, Ø 52 x 33 cm
4 **Balloon**, 2004, glazed ceramic, Ø 82.5 x 45 cm

„Ich möchte etwas herstellen, das auf den ersten Blick wie ein schönes
Kunstwerk aussieht, sich bei genauerer Betrachtung hingegen als Polemik
oder Ideologie entpuppt."

« Je veux faire quelque chose qui vive du regard comme une
belle œuvre d'art, mais à y regarder de plus près, il en sortira une polémique
ou une idéologie. »

"I want to make something that lives with the eye as a beautiful piece of art, but on closer inspection, a polemic or an ideology will come out of it."

2

3

4

Raymond Pettibon

1957 born in Tucson (AZ), lives and works in Hermosa Beach (CA), USA

Although he has also created books, videos, murals and paintings, Raymond Pettibon is known primarily for the vast body of drawings he has made during the past twenty-five years. Employing a style reminiscent of mid-20th century cartoons – notably the pairing of a graphic image with fragments of text – the artist's black ink-wash and watercolor drawings depict a broad swathe of American icons and pastimes from an earlier era (Gumby, J. Edgar Hoover, baseball, Charles Manson, trains, surfers, Jesus Christ) paired with quotations from a dizzyingly erudite array of texts (from William Blake to James Joyce and the Bible to Mickey Spillane). Pettibon's career began in the late 1970s and early 1980s with the creation of show flyers and album covers for punk rock bands and the compilation of his drawings into fanzines-cum-artist's books. By the end of the 1980s, Pettibon had migrated to galleries, and he has exhibited regularly since then, often presenting his drawings in accumulative installations. These associations also operate within the artworks themselves, and the poignancy of Pettibon's art resides in the space between text and image, often laced with humour, pathos, or an affecting mixture of the two. His recent works toy with format (some have colour, some are quite large) and display a newfound topicality and political awareness. Yet Pettibon never succumbs to dogmatism, a fact that testifies to his mastery of a difficult trick: the ability to look at complex subjects like race, war, and religion with a sidelong glance, one that allows the viewer's mind to fill in the blanks.

Obwohl er auch Bücher, Videos, Wandbilder und Gemälde produziert, ist Raymond Pettibon vor allem für sein umfangreiches Œuvre an Zeichnungen bekannt, die er während der letzten fünfundzwanzig Jahre geschaffen hat. Die schwarz lasierten Tuschezeichnungen und Aquarelle, die stilistisch an Comics aus der Mitte des letzten Jahrhunderts erinnern – vor allem hinsichtlich der Kombination eines grafischen Bildes mit Textfragmenten –, zeigen ein weites Feld amerikanischer Ikonen und Vergnügungen aus einer früheren Zeit (Gumby, J. Edgar Hoover, Baseball, Charles Manson, Eisenbahnzüge, Surfer, Jesus Christus), gekoppelt mit Zitaten, die von erstaunlicher Belesenheit zeugen (von William Blake über James Joyce und die Bibel bis hin zu Mickey Spillane). Pettibon begann seine künstlerische Laufbahn während der späten siebziger und frühen achtziger Jahre mit Entwürfen für Konzertflyer und Plattencover für Punkbands sowie mit der Veröffentlichung seiner Zeichnungen in Musik- und Kunst-Fanzines. Ende der Achtziger vollzog Pettibon den Wechsel in die Galerieszene. Seitdem stellt er regelmäßig aus, wobei er seine Zeichnungen häufig in Form akkumulativer Installationen präsentiert. Derartige Assoziationen finden sich auch in den Arbeiten, deren Schärfe im Bereich zwischen Text und Bild angesiedelt und häufig von Humor, Pathos oder einer wirkungsvollen Kombination aus beidem getränkt ist. In seinen neueren Arbeiten spielt Pettibon mit dem ihnen eigenen Format (einige sind farbig, andere verhältnismäßig groß), während sie inhaltlich von einer neu gewonnenen Aktualität und einem ausgeprägten politischen Bewusstsein gekennzeichnet sind. Dennoch erliegt Pettibon niemals einem Dogmatismus, und diese Tatsache spricht für seine Beherrschung eines kniffligen Tricks: die Fähigkeit, komplexe Themen wie Rasse, Krieg und Religion mit einem verstohlenen Seitenblick zu betrachten, der es dem Betrachter überlässt, die Leerstellen zu füllen.

Bien qu'il ait aussi produit des livres, des vidéos, des peintures murales et des tableaux, Raymond Pettibon est surtout connu pour le vaste corpus de dessins qu'il a réalisés au cours des vingt-cinq dernières années. Dans un style rappelant les dessins animés du milieu du XXᵉ siècle – notamment par l'association d'images et de fragments textuels – les dessins de l'artiste, exécutés à l'aquarelle et au lavis, décrivent un vaste éventail d'icônes et de passe-temps américains appartenant à une époque révolue (Gumby, J. Edgar Hoover, le base-ball, Charles Manson, trains, surfers, Jésus-Christ), associés à des citations puisées dans une panoplie de textes stupéfiante d'érudition (de William Blake à James Joyce en passant par la Bible et Mickey Spillane). La carrière de Pettibon a débuté à la fin des années soixante-dix et au début des années quatre-vingt avec la création de prospectus d'expositions et de pochettes de disques pour des groupes punk, mais aussi de compilations de ses dessins dans des ouvrages à mi-chemin entre fanzine et livre d'artiste. Pettibon migre vers les galeries à la fin des années quatre-vingt. Depuis, il expose régulièrement, présentant souvent ses dessins dans des installations accumulatives. Ces associations opèrent aussi à l'intérieur des œuvres, et l'émotion distillée par l'art de Pettibon réside dans l'écart entre le texte et l'image, souvent empreint d'humour, de pathos ou d'un émouvant mélange des deux. Ses œuvres récentes jouent sur le format (certaines sont en couleurs, d'autres passablement grandes) et présentent une actualité et une conscience politique récemment découverte par l'artiste. Mais Pettibon ne succombe jamais au dogmatisme, ce qui illustre sa maîtrise d'un tour de force difficile : l'aptitude à porter un regard oblique sur des sujets complexes comme le racisme, la guerre et la religion, qui laisse au spectateur le soin de remplir lui-même les blancs.

B. S.

SELECTED EXHIBITIONS →
2004 *Disparities and Deformations: Our Grotesque*, 6. International Biennial, Santa Fe; Whitney Biennial, Whitney Museum of American Art, New York **2003** *Drawings 1979–2003*, Museion, Bolzano; Galleria d'Arte Moderna di Bologna **2002** *Plots Laid Thick*, Museu d'Art Contemporani de Barcelona, Barcelona, Tokyo Opera City Art Gallery, Gemeentemuseum Den Haag, The Hague; documenta 11, Kassel **2001** *Wolfgang-Hahn-Preis*, Museum Ludwig, Cologne

SELECTED PUBLICATIONS →
2003 *Raymond Pettibon*, Galleria d'Arte Moderna di Bologna, Bologna **2002** *Raymond Pettibon: Plots Laid Thick*, Museu d'Art Contemporani de Barcelona, Barcelona **2001** *Raymond Pettibon*, London **2000** *Raymond Pettibon. Aus dem Archiv der Hefte*, Cologne

WHEN IT COMES TO MAKING A STUDY OF A THING, I AM RIGHT THERE WITH ALL THE LIGHTS LIT AND BLINDS DRAWN.

1 **No Title (When It Comes)**, 2004, pen and ink on paper, 43.2 x 35.6 cm
2 Installation view, Regen Projects, Los Angeles, 2003

3 **No Title (Runs With a)**, 2004, pen and ink on paper, 45.7 x 61 cm
4 **No Title (War Is...)**, 2005, pen and ink on paper, 30.7 x 48.3 cm

„Es ist ein Fehler anzunehmen, dass es sich bei irgendeiner meiner
Arbeiten um meine eigene Stimme handelt. Denn das hieße, die einfältigste
und wirkungsloseste Kunst zu produzieren, die man nur machen kann."

« Il est faux d'assumer, à propos de n'importe laquelle de mes œuvres,
qu'il s'agit de ma propre voix. Car il s'agirait alors de l'art le plus simpliste
et inefficace que l'on puisse faire. »

**"It's a mistake to assume about any of my work that it's my own voice.
Because that would be the most simple-minded ineffective art that you
can make."**

2

3

4

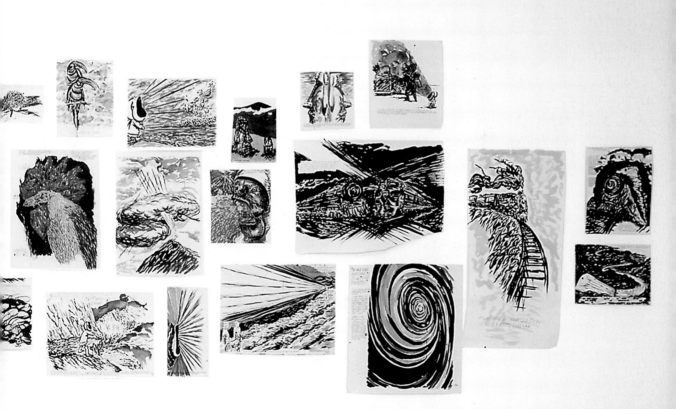

Elizabeth Peyton

1965 born in Danbury (CT), lives and works in New York (NY), USA

Like many painters of her generation, Elizabeth Peyton takes for granted the interrelationship of painting and photography and rather than sidestepping our saturated media culture, she integrates it into her work. Her portraiture, while occasionally the product of live sittings, is more often derived from photographs, whose sources may be magazine pictures of well-known actors, musicians or royalty; historical photographs of writers or artists; or photographs she has taken herself of close friends. Peyton's particular form of portraiture, whether loose small scale oil paintings, tightly composed colour pencil drawings or washy watercolours, is a form of veneration made manifest. Although it enacts another layer of mediation which should increase the distance between audience and subject, it rather has the paradoxical effect of drawing the subject closer by breathing him (or occasionally her) through with intimacy, emotion and belief. Peyton often produces many works of the same subject, such as tragic rock hero Kurt Cobain, who has recurred in Peyton's work since her first portraits of him in 1994 shortly before he took his own life, or her artist friend Tony Just who for a year was almost the exclusive subject of her work. This produces a seriality that in both cases exemplifies the interleaving of public and private, and celebrates the inspiring effect that one individual can have on another, whether through their music, art, public persona or the simple luxury of daily proximity.

Wie viele Maler ihrer Generation geht Elizabeth Peyton von einem selbstverständlichen Wechselverhältnis zwischen Malerei und Fotografie aus und bezieht dieses in ihre Arbeit ein, anstatt der übersättigten Medienkultur auszuweichen. Ihre Porträts, wenn auch zuweilen das Ergebnis von Modellsitzungen, entstehen doch wesentlich häufiger nach Fotos. Dabei kann es sich um Zeitschriftenabbildungen bekannter Schauspieler, Musiker oder Angehöriger des Hochadels handeln, aber auch um historische Fotos von Schriftstellern oder Künstlern oder um Fotos, die sie selbst von sich und engen Freunden macht. Peytons besondere Porträts, locker ausgeführte kleinformatige Ölbilder, streng komponierte Buntstiftzeichnungen und lasierte Aquarelle, sind eine Art manifestierter Heldenverehrung. Obwohl in ihnen eine weitere, die Distanz zwischen Betrachter und Gegenstand vergrößernde Vermittlungsschicht gesetzt wird, hat dies eher den paradoxen Effekt, dass der Porträtierte näher rückt, indem ihm (oder gelegentlich ihr) eine Vertrautheit, Emotion und Überzeugung eingehaucht wird. Peyton produziert oft mehrere Arbeiten von ein und demselben Modell, so beispielsweise von Kurt Cobain, jenem tragischen Rockhelden, der seit ihren ersten Porträts von ihm kurz vor seinem Selbstmord 1994 immer wieder in ihren Arbeiten auftaucht, wie auch von ihrem Künstlerfreund Tony Just, der ein Jahr lang nahezu ihr einziges Modell war. So entsteht eine Serialität, die in beiden Fällen die Durchdringung von Privatem und Öffentlichem erläutert und den inspirierenden Einfluss zelebriert, den ein Individuum auf ein anderes ausüben kann, egal ob durch seine Musik, Kunst, seine öffentliche Rolle oder den einfachen Luxus seiner täglichen Nähe.

Comme beaucoup de peintres de sa génération, Elizabeth Peyton considère l'interaction entre la peinture et la photographie comme un fait acquis, et plutôt que d'éluder notre culture médiatique saturée, elle l'intègre dans son œuvre. Même s'il lui arrive de s'appuyer sur des séances de pose, son art du portrait part le plus souvent de représentations dont les sources peuvent être des photos d'acteurs célèbres, de musiciens ou de personnalités royales publiées dans des magazines, mais aussi de photographies historiques d'écrivains ou d'artistes ou de photos de proches prises par l'artiste. La forme particulière du portrait qui est celle de Peyton – travail à l'huile, en petit format, aux crayons de couleurs pour les compositions denses de ses dessins, ou à l'aquarelle délavée – est une forme de vénération explicite. Bien qu'elle introduise aussi un niveau de communication censé accroître la distance entre le spectateur et le sujet, paradoxalement, cette forme a plutôt pour effet de rapprocher le sujet en lui insufflant (à lui, occasionnellement à elle) intimité, émotion et conviction. Peyton produit souvent un grand nombre d'œuvres sur le même thème, comme le héros rock tragique Kurt Cobain, sujet récurrent depuis les premiers portraits réalisés en 1994, peu avant que le chanteur se donne la mort, ou son ami artiste Tony Just, qui a été le sujet presque exclusif de son travail pendant un an. Cette démarche participe d'une sérialité qui illustre dans les deux cas l'interaction entre les sphères publique et privée et qui célèbre l'influence inspirante qu'un individu peut exercer sur un autre, que ce soit par sa musique, par son art, par ses apparitions publiques ou par le simple luxe de sa présence quotidienne.

K. B.

SELECTED EXHIBITIONS →
2004 Whitney Biennial, Whitney Museum of American Art, New York
2002 *Drawing Now: Eight Propositions*, The Museum of Modern Art, New York; *Dear Painter...*, Kunsthalle Wien, Vienna, Centre Pompidou, Paris, Schirn Kunsthalle, Frankfurt/Main; *16 Artists*, Salzburger Kunstverein **2001** Deichtorhallen Hamburg **2000** Aspen Art Museum **1999** Castello di Rivoli, Turin

SELECTED PUBLICATIONS →
2003 *Elizabeth Peyton: Works on paper*, RomaRomaRoma, Rome
2002 *Elizabeth Peyton: 16 Artists*, Salzburger Kunstverein, Salzburg; *Elizabeth Peyton*, Ostfildern-Ruit **2001** *Prince Eagle*, New York

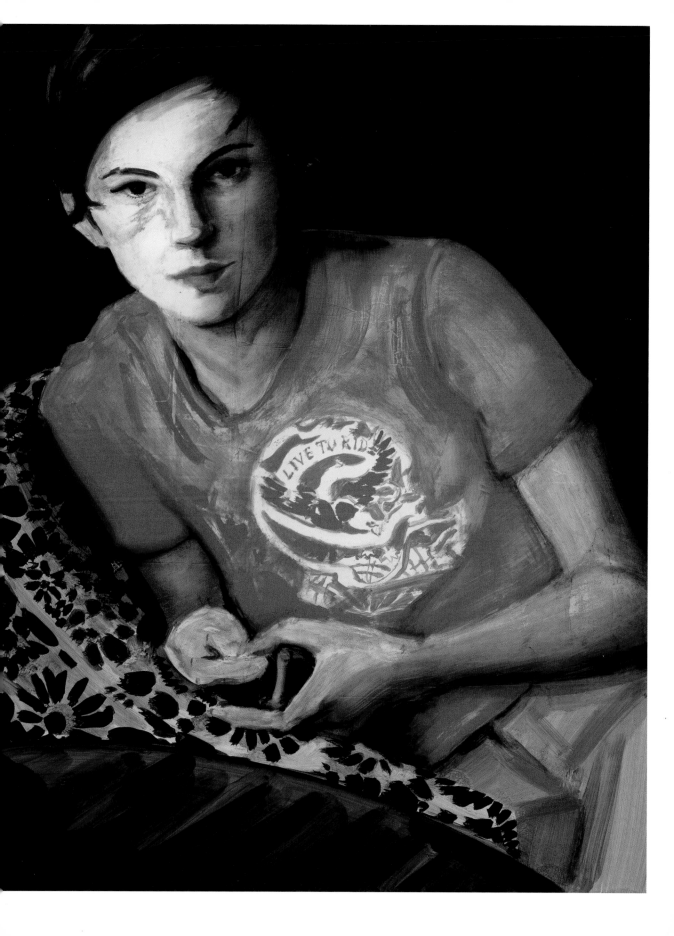

1 **Live to Ride (E.P.)**, 2003, oil on board, 38.1 x 30.5 cm
2 **Marc With a Broken Finger**, 2003, coloured pencil on paper, 22 x 15 cm
3 **Sofia**, 2003, coloured pencil on paper, 22 x 15 cm
4 **André (André 3000)**, 2004, oil on board, 35.6 x 28.6 cm

„Ich unterscheide nicht zwischen Menschen, die ich durch ihre Musik oder Fotos kenne, und jemandem, den ich persönlich kenne."

« Je ne fais aucune différence entre les gens que je connais par leur musique ou leur photographie et quelqu'un que je connais personnellement. »

"There is no separation for me between people I know through their music or photos and someone I know personally."

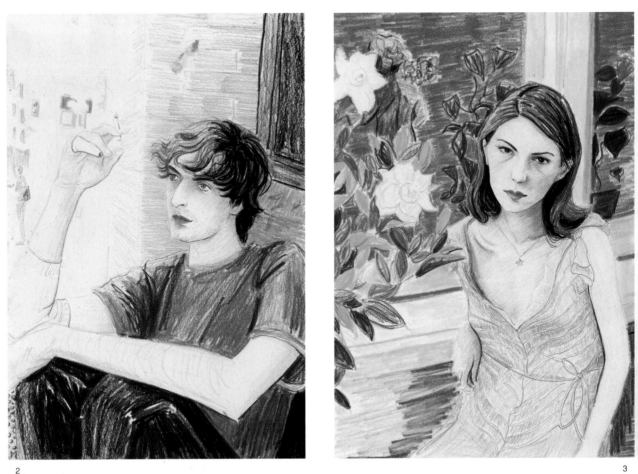

2 3

Richard Phillips

1962 born in Marblehead (MA), lives and works in New York (NY), USA

In his hyper-realistic oil portraits of politicians and pop icons, Richard Phillips puts a face to power and glamour. Although they clearly stand in the tradition of Pop Art's bold and simple star portraits, in material and technique the meticulously painted visages are also related to the tradition of classical oil painting. Phillips has found a subtly bewildering and eroticising visual language for his portraits of women painted from photos out of fashion and porn magazines – photos generally from the 1960s and 70s. For this he uses standard facial expressions and clichés prevalent in the pornographic context: in *Jazz* (2000), for example, the blonde's tousled hair falling across her face, and her half-open, moistly glistening lips. The work with the Japanese title, *Bukkake* (2004), on the other hand, is a close-up of a kneeling woman with semen-flecked hair, and depicts sexual practices as they are extolled on the appropriate websites. These generally over-lifesize pictures confuse us, because they not only adopt a pornographic aesthetic, but simultaneously take it as their theme. The portraits of famous males deal in similar terms with self-portrayal in the media. The picture of German Foreign Minister Joschka Fischer (*Spokesperson*, 2004), and the monumental painting of the Indian guru of alternative medicine, *Deepak Chopra* (2003), were created from official election or advertising posters. By copying these promotional photos, Phillips makes you conscious of how people are presented and thus of the power that these "images" exercise in a media-driven society.

In seinen hyperrealistischen Ölbildnissen von Politikern und Pop-Ikonen gibt Richard Phillips Macht und Glamour ein Gesicht. Obwohl die akribisch gemalten Antlitze deutlich in der Tradition der plakativen Starporträts der Pop Art stehen, schließen sie in Material und Technik an die Tradition der klassischen Ölmalerei an. Phillips hat für seine Frauenbildnisse, die er nach Fotos aus Modezeitschriften und Pornoheften – meist aus den sechziger und siebziger Jahren – malt, eine subtil verwirrende, erotisierende Bildsprache gefunden. Dabei verwendet er standardisierte Gesichtsausdrücke und im pornografischen Kontext verbreitete Klischees, wie etwa die halb geöffneten, feucht glänzenden Lippen und die zerzausten, ins Gesicht fallenden Haare wie bei der Blondine in *Jazz* (2000). Die japanisch betitelte Arbeit *Bukkake* (2004) wiederum, eine Nahaufnahme einer knienden Frau, deren Haar mit Sperma bekleckert ist, vermittelt Sexpraktiken, wie sie auf einschlägigen Websites angepriesen werden. Diese meist überlebensgroßen Bilder irritieren, weil sie eine pornografische Ästhetik nicht nur übernehmen, sondern sie gleichzeitig thematisieren. Ähnlich geht es in den Porträts von männlichen Berühmtheiten um die mediale Selbstdarstellung. Das Abbild des deutschen Außenministers Joschka Fischer (*Spokesperson*, 2004), sowie das monumentale Gemälde des indischen Gurus für alternative Medizin, *Deepak Chopra* (2003), sind nach offiziellen Wahl- oder Werbeplakaten entstanden. Durch das Kopieren dieser Promotionfotos rückt Phillips die Inszenierung von Personen und damit die Macht, die diese „Images" in einer von Medien gesteuerten Gesellschaft ausüben, ins Bewusstsein.

Dans ses peintures à l'huile hyperréalistes de politiciens et d'icônes de la pop, Richard Phillips donne un visage au pouvoir et au glamour. Bien qu'ils se situent clairement dans le sillage des portraits de stars affichistes du Pop Art, ces visages peints avec une extrême précision s'inscrivent avant tout dans la tradition classique de la peinture à l'huile. Pour les portraits de femmes qu'il réalise d'après des photos tirées de magazines de mode et de revues pornographiques – le plus souvent des années soixante et soixante-dix –, Phillips a inventé un langage pictural érotisant et subtilement troublant. Il se sert pour cela de mimiques standardisées et de clichés répandus dans le contexte pornographique : lèvres entrouvertes, humides et brillantes, cheveux décoiffés tombant dans le visage de la blondine de *Jazz* (2000). *Bukkake* (2004), œuvre au titre japonisant qui présente la vue rapprochée d'une femme agenouillée aux cheveux maculés de sperme, rend compte des pratiques sexuelles telles qu'elles sont vantées sur les sites Internet concernés. Généralement plus grandes que nature, ces représentations recèlent une charge provocatrice en ce qu'elles ne se contentent pas de reprendre l'esthétique pornographique, mais qu'elles la thématisent. La même chose vaut aussi pour l'autoreprésentation médiatique que dénoncent les portraits de célébrités masculines de Phillips. L'image du ministre des Affaires étrangères allemand Joschka Fischer (*Spokesperson*, 2004) et *Deepak Chopra* (2003), peinture monumentale du guru indien de la médecine alternative, ont été réalisées d'après des affiches de campagne ou des publicités officielles. Par la copie de ces photos promotionnelles, Phillips fait entrer dans la conscience du spectateur la mise en scène des personnages, et partant, du pouvoir exercé par ces « images » au sein d'un monde régi par les médias.

C.R.

1 **Similar to Squirrels after A. Dietrich**, 2004, oil on linen, 260.4 x 198.1 cm
2 **Deepak Chopra**, 2003, oil on canvas, 213.4 x 797.6 cm

3 **Spokesperson**, 2004, oil on linen, 198.1 x 254 cm
4 **Bukkake**, 2004, oil on linen, 217.8 x 198.1 cm

„Ich denke mir gerne Möglichkeiten aus, Porträts aus ihrem Kontext, ihrer Zeit und ihrer technischen Gegebenheit zu isolieren, indem ich diese Programme weiterführe, aufeinander zulaufen lasse und schließlich zur Koexistenz zwinge."

« J'aime concevoir des possibilités pour isoler les portraits de leur contexte, de leur époque et de leurs conditions techniques. Pour cela, je développe ces programmes, je les rapproche pour les contraindre finalement à coexister. »

"I like to think of ways to take portraiture out of context, out of time, and out of technical reality – running the programs ahead towards each other and then forcing them to coexist."

2

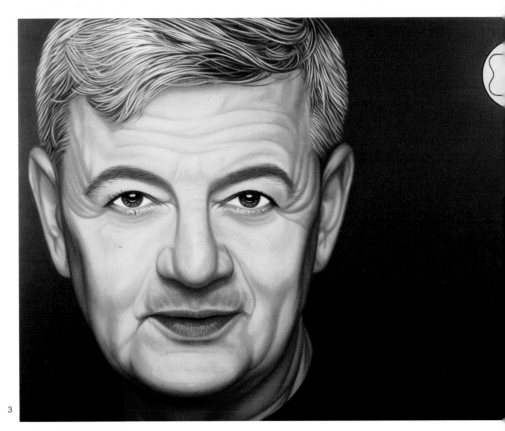

3

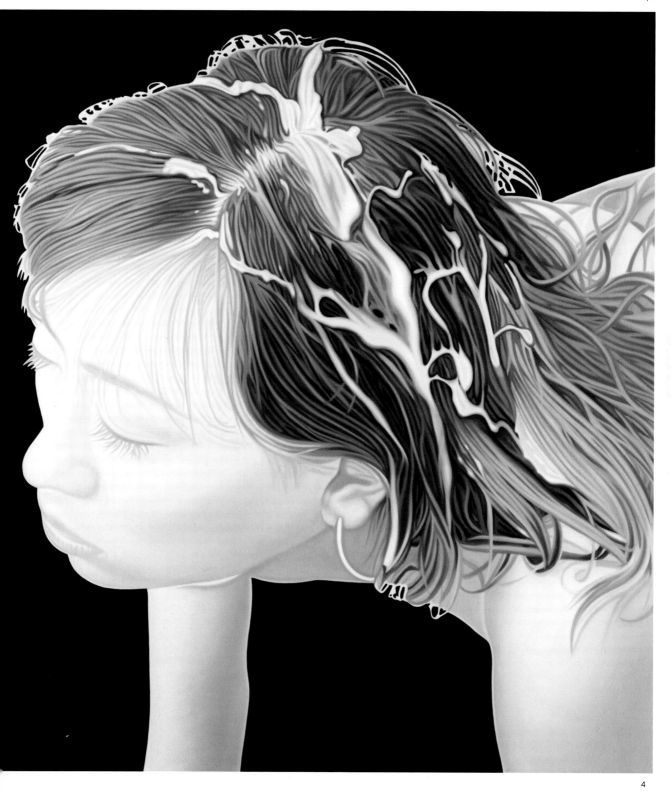

Richard Prince

1948 born in Panama Canal Zone, lives and works in New York (NY), USA

By now the back story is probably familiar: working at Time-Life in the 1970s, Richard Prince used a basement storeroom as an improvised studio, plucked advertisements out of mass-market magazines, rephotographed the images, and exhibited them as his own art. With these appropriations, of which his use of the Marlboro Man (or Men, as it were) is most famous, Prince began a long investigation of American cultural mythology that continues to this day. Working in series, he is an exacting cartographer of middle-American desire, and his cowboys and celebrities, hoodlums and automobile hoods, biker chicks and nurses become, in aggregate, a canny portrait of the United States. Since the mid-1980s he has created *Joke Paintings* that fuse lowbrow humour with the drips and dribbles of Abstract Expressionism, the apotheosis of high modernist painting. The stencilled texts, which sometimes repeat and overlap as if stuttering, reveal embarrassing inadequacies and psychologically fraught situations that counter the macho posturing of Prince's cowboys. These works have been complemented recently by his *Nurse Paintings*, in which the covers of 1940s and 1950s-era pulp novels featuring nurses are inkjet printed onto canvas and obscured to varying degrees by his brushstrokes, and *Hoods*, a series of muscle-car hoods cast in wood and fibreglass then loosely painted with gestural strokes. If Prince's early work analyzed a rural American vernacular, these ambitious recent works attempt to reconcile that argot with an American art history that he has already shaped indelibly.

Heute ist die Geschichte wohl allgemein bekannt: Als Angestellter bei Time-Life nutzte Richard Prince in den siebziger Jahren ein Kellerlager als improvisiertes Atelier, riss Anzeigen aus Zeitschriften für den Massenmarkt heraus, fotografierte die Bilder ab und stellte sie als seine Kunst aus. Mit diesen Aneignungen, von denen die Verwendung des Marlboro-Mannes (beziehungsweise der Männer) die wohl bekannteste ist, begann Prince seine bis heute fortgeführten Untersuchungen der kulturellen Mythologie Amerikas. In seinen Serien betätigt er sich als genauer Kartograf des Begehrens des Durchschnittsamerikaners, während seine Cowboys und Promis, Gauner und Kühlerhauben, Motorradbräute und Krankenschwestern sich im Ganzen genommen zu einem aussagekräftigen Abbild der USA verfestigen. Seit Mitte der achtziger Jahre produziert er *Joke Paintings*, die einen anspruchslosen Humor mit den Klecksen und Tropfen des Abstrakten Expressionismus, jener Apotheose der modernen Malerei, kombinieren. Die mit Schablonen aufgetragenen Texte, die sich zuweilen wie stotternd wiederholen und überlagern, enthüllen quasi als Gegenpol zu Princes Cowboys peinliche Unzulänglichkeiten und psychologisch aufgeladene Situationen. Diese Arbeiten fanden kürzlich eine Ergänzung in den *Nurse Paintings*, für die Cover von Groschenromanen mit Krankenschwestern aus den vierziger und fünfziger Jahren per Tintenstrahldruck auf Leinwand übertragen und mit nachträglich gesetzten Pinselstrichen unterschiedlich stark verdunkelt wurden. Ähnliches gilt auch für *Hoods*, eine Serie von in Holz und Glasfaser ausgeführten Muscle-Car-Kühlerhauben, locker bemalt mit gestischem Strich. Während Prince in seinem Frühwerk ein ländliches Amerika analysierte, unternimmt er in diesen neuen Arbeiten den Versuch, jenen Argot mit einer amerikanischen Kunstgeschichte zu versöhnen, die er bereits unauslöschlich mitgeprägt hat.

Son histoire est en principe connue : lorsqu'il travaille pour Time-Life dans les années soixante-dix, Richard Prince s'installe un atelier improvisé dans un entrepôt souterrain où il extrait toutes sortes de publicités de magazines à grand tirage, rephotographie les images et les expose comme son propre art. Avec ces appropriations, dont la plus célèbre est son utilisation de l'homme (respectivement – des hommes) Marlboro, Prince entame alors une longue exploration des mythes de la culture américaine qu'il poursuit jusqu'à ce jour. Travaillant en séries, sa démarche relève d'une minutieuse cartographie des désirs des classes moyennes américaines, tandis que son corpus de cowboys et de célébrités, de truands et de capots de voitures, de filles à vélo et d'infirmières présente un portrait éloquent des Etats-Unis. Depuis le milieu des années quatre-vingt, il a créé des *Joke Paintings* qui mêlent un humour de bas étage aux taches et coulures de l'expressionnisme abstrait dans l'apothéose d'une peinture ultra-moderne. Ces textes tamponnés, qui se répètent ou se superposent parfois comme un bégaiement, mettent en scène des situations pénibles, psychologiquement tendues, en contre point des poses machistes de ses cow-boys. Ces œuvres ont été récemment complétées par ses *Nurse Paintings*, dans lesquelles les couvertures de romans de gare des années quarante et cinquante montrant des infirmières sont jet d'encre imprimées sur toile et diversement obscurcies à coup de traits de pinceau, et par ses *Hoods*, une série de capots de voitures musclées, moulés en bois et en fibre de verre avant d'être peints négligemment à traits de pinceau gestuels. Si l'œuvre de Prince analysait à ses débuts la langue vernaculaire de l'Amérique profonde, ces œuvres récentes ambitieuses tentent d'en réconcilier l'argot avec l'histoire d'un art américain auquel Prince a déjà imprimé sa marque indélébile.

B. S.

SELECTED EXHIBITIONS →
2005 Sammlung Goetz, Munich **2004** Whitney Biennial, Whitney Museum of American Art, New York; *The Last Picture Show*, Walker Art Center, Minneapolis **2003** *American Tableaux*, Miami Art Museum; 50. Biennale di Venezia, Venice **2002** *Principal – Gemälde und Fotografien 1977–2001*, Kunstmuseum Wolfsburg

SELECTED PUBLICATIONS →
2004 *Richard Prince: Nurse Paintings*, Barbara Gladstone Gallery, New York **2003** *Richard Prince: American English*, Cologne **2002** *Richard Prince: Paintings*, Ostfildern-Ruit; *Richard Prince: Photographs*, Ostfildern-Ruit

1 **Nurse in Love**, 2003, ink jet print and acrylic on canvas, 175.3 x 124.5 cm
2 **Untitled (Publicity)**, 2003, 4 publicity photographs, 84.1 x 104.5 cm

3 **Nurses' Dormitory #2**, 2003, ink jet print and acrylic on canvas, 162.6 x 106.7 cm

„Der von mir gewählte Inhalt war nicht sonderlich populär, aber auch nicht unbekannt. Er war einfach nicht angesagt. Es ging ja eher um Mainstream-Kulte, die immer noch existieren. Man sieht sie auf jedem Flughafen. Sie verfügen über ihre eigenen Konventionen."

«Le sujet que j'ai choisi n'était pas précisément populaire, mais il n'était pas obscur. Il n'était pas à la mode, voilà tout. C'était davantage comme des cultes du mainstream. Ils existent encore. On les voit dans les aéroports. Ils ont leurs propres conventions.»

"The subject matter I chose wasn't exactly popular, but it wasn't obscure. It just wasn't fashionable. It was more like mainstream cults. They're still around. They show up at airports. They have their own conventions."

2

Neo Rauch

1960 born in Leipzig, lives and works in Leipzig, Germany

The stamp of biography has left an indelible impression on painter Neo Rauch's art: Born in East Germany a year before the Berlin Wall was erected and twenty-nine years old when it fell, the canvases he has produced since the mid-1990s juxtapose the utopian dreams of a forward-looking Communist ideology with the retrospective disillusionment of a society that witnessed its failure. In an idiosyncratic, harder-edged version of the Socialist Realism favoured by his art school professors, Rauch inserts myriad characters – often outsized and unwaveringly stern while busy at work – into a landscape that, despite bold colors and a sure hand, is marked by indeterminacy. In Rauch's often monumentally-scaled canvases, the delineation between inside and outside can be hard to discern; missed connections are denoted by thought- and speech-bubbles left empty; narratives are as disjointed as the multiple perspectives brought into uneasy alliance; representation dissolves into small pools of abstraction; and the accumulated work performed by Rauch's characters seems to lead nowhere. However, not even this last characteristic is used as condemnation; rather, the instability in these works can be seen as an allegory of the radical upheavals East German society has undergone while in transition to a new system of political governance and a new approach to everyday life. Rauch is too skeptical to take a singular position, so his eccentric jumbles – of man and machine, of past and future – are beautifully rendered, dispassionate autopsies of the myriad confusions of a tumultuous present.

Der Stempel der Biografie hat die Kunst des Malers Neo Rauch unauslöschlich geprägt: In den Bildern, die Rauch, geboren in der DDR ein Jahr vor dem Bau der Mauer und bei ihrem Fall 29 Jahre alt, seit Mitte der neunziger Jahre gemalt hat, stehen die Utopien einer vorwärts gerichteten kommunistischen Ideologie der retrospektiven Ernüchterung einer Gesellschaft gegenüber, die Zeuge ihres eigenen Scheiterns wurde. In einer idiosynkratischen, scharfkantigen Version des Sozialistischen Realismus, wie ihn noch seine Kunstprofessoren befürworteten, fügt Rauch unzählige Figuren – oft übergroß und von unbeirrbarer Strenge bei der Arbeit dargestellt – in eine Landschaft ein, die trotz kühner Farben und einer handwerklich sicheren Ausführung von einer gewissen Unbestimmtheit geprägt ist. In den nicht selten monumentalen Gemälden Rauchs ist die Schilderung von Innen und Außen unter Umständen schwer auszumachen, fehlende Verbindungen werden durch leere Denk- und Sprechblasen bezeichnet, die Erzählungen sind ebenso zusammenhanglos wie die unsicher miteinander verknüpften Mehrfachperspektiven, die Darstellung löst sich in kleine abstrakte Lachen auf, und die von Rauchs Figuren angehäufte Arbeit scheint zu keinem Ziel zu führen. Trotzdem ist nicht einmal jenes letzte Kennzeichen im Sinne einer Entwertung formuliert, vielmehr lässt sich die Instabilität dieser Arbeiten als Allegorie auf die radikalen Umbrüche lesen, die die ostdeutsche Gesellschaft bei ihrem Übergang zu einem neuen politischen Regierungssystem und einer neuen Alltagseinstellung durchlebt hat. Rauch steht der Einnahme einer Einzelposition ebenfalls skeptisch gegenüber, und so handelt es sich bei seinem verschrobenem Durcheinander – aus Mensch und Maschine, Vergangenheit und Zukunft – um schön ausgeführte, leidenschaftslose Autopsien der zahllosen Wirren einer stürmischen Gegenwart.

Sa propre biographie a laissé une empreinte indélébile dans l'art du peintre Neo Rauch : né en Allemagne de l'Est un an avant la construction du Mur de Berlin, âgé de vingt-neuf ans au moment de sa chute, il a produit depuis le milieu des années quatre-vingt-dix des toiles qui mettent en regard les rêves utopiques d'une idéologie communiste entièrement tournée vers l'avenir et la désillusion rétrospective d'une société qui a assisté à sa chute. Dans une version idiosyncrasique durcie du réalisme socialiste prôné par ses professeurs, Rauch insère des myriades de personnages – souvent démesurés ou farouchement sérieux dans leur affairement au travail – dans un paysage dont les couleurs vives et la facture assurée n'en demeurent pas moins empreintes d'indécision. Dans ces toiles souvent monumentales, la frontière entre intérieur et extérieur est parfois difficilement discernable : leur manque de rapport se manifeste notamment par des bulles – de parole ou de pensée – laissées vides, le fil de la narration est aussi disjoint que les perspectives multiples à la cohérence incertaine, la représentation se dissout en îlots d'abstraction et l'accumulation de travail réalisée par les personnages ne semble déboucher sur rien. Reste que cette dernière caractéristique ne débouche pas davantage sur une condamnation. L'instabilité de ces œuvres peut être plutôt considérée comme une allégorie des profonds bouleversements que le passage à un nouveau système de gouvernement et une nouvelle approche de la vie quotidienne ont fait subir à la société est-allemande. Rauch est bien trop sceptique pour prendre une position singulière, et ses enchevêtrements excentriques – d'hommes et de machines, de passé et d'avenir – se présentent en définitive comme une autopsie froide et magnifiquement rendue des innombrables confusions d'une époque tumultueuse.

B. S.

SELECTED EXHIBITIONS →
2004/05 Albertina, Vienna; 54. Carnegie International, Carnegie Museum of Art, Pittsburgh **2003** Saint Louis Art Museum; *Berlin–Moscow/Moscow–Berlin 1950–2000*, Martin-Gropius-Bau, Berlin, State Tretyakov Gallery, Moscow **2002** Bonnefantenmuseum, Maastricht; *Dear Painter, Paint Me...*, Centre Pompidou, Paris, Kunsthalle Wien, Vienna, Schirn Kunsthalle, Frankfurt/Main; *Drawing Now: Eight Propositions*, The Museum of Modern Art, New York **2001** 49. Biennale di Venezia, Venice

SELECTED PUBLICATIONS →
2004 *Fabulism*, Joslyn Art Museum, Omaha **2002** *Neo Rauch*, Bonnefantenmuseum, Maastricht; *Drawing Now: Eight Propositions*, The Museum of Modern Art, New York **2001** *Neo Rauch – Sammlung Deutsche Bank*, Deutsche Guggenheim, Berlin; *Neo Rauch*, Galerie für Zeitgenössische Kunst Leipzig, Leipzig

1 **Verrat**, 2003, oil on paper, 268 x 200 cm
2 **Reaktionäre Situation**, 2002, oil on canvas, 210 x 400 cm
3 **Zoll**, 2004, oil on canvas, 210 x 400 cm
4 **Aufstand**, 2004, oil on paper, 199 x 275 cm

„Wenn ich vor einer leeren Leinwand stehe, ist es, wie vor einer Nebelwand zu stehen. [...] Ich öffne verschiedene Kontaminierungskammern und entnehme ihnen zahlreiche Materialien, die ich vorübergehend in den Räumen meiner Bilder unterbringe."

«Quand je me tiens devant une toile vide, c'est comme si j'étais devant un mur de brouillard. [...] J'ouvre différentes chambres de contamination et j'en extrais une variété de matériaux que j'entrepose temporairement dans les espaces de mes tableaux.»

"When I stand in front of a blank canvas, it's as if I'm standing in front of a wall of fog. [...] I open various contamination chambers and remove a variety of material from them to temporarily store in the territories of my paintings."

2

3

Tobias Rehberger

1966 born in Esslingen, lives and works in Frankfurt/Main, Germany

Tobias Rehberger updates the modernist mandate to create objects that are equally functional and beautiful, and his atmospheric installations, furniture, sculpture, public gardens, clothing, and posters are often playful interpretations of classics of modern art and design, tweaked to emphasize unexpected connections and maximize public value. Many of Rehberger's projects respond to specific design problems (albeit in an unusual way): for a 1996/97 exhibition at Portikus in Frankfurt, Rehberger accepted suggestions for practical architectural changes from visitors to the space's previous two exhibitions. The artist often collaborates, as in an early project for which African carpenters created handmade replicas of classic modernist furniture based on Rehberger's drawings (the resultant objects, an "interpretation of an interpretation", were estranged from both cultures they were supposed to represent) and his project for the Venice Biennale in 2003, for which Murano craftsmen created coloured glass vessels that refracted light controlled at seven switches around the world. In an exhibition at the Whitechapel Art Gallery in London ("Private Matters", 2004), Rehberger translated the proportions of the windows and doors in his German studio to structures for gallery visitors to interact with and created an enclosed space, nominally for living, in which a custom-designed lamp is controlled by a man in Germany with the same name as the artist. Rehberger skilfully toes the line between art and design, the personal and the public, and aesthetics and utility.

Tobias Rehberger aktualisiert das modernistische Vorhaben, gleichermaßen funktionale wie schöne Objekte zu schaffen. Seine atmosphärischen Installationen, Möbelstücke, Skulpturen, Parks, Kleidungsstücke und Plakate sind dabei oft spielerische Interpretationen von Klassikern der modernen Kunst oder des Designs, deren Verzerrungen unerwartete Verbindungen offen legen und ihren gesellschaftlichen Wert maximieren. In vielen seiner Projekte reagiert Rehberger auf spezifische designimmanente Probleme (wenn auch auf ungewöhnliche Art und Weise): Für eine Ausstellung 1996/97 im Portikus in Frankfurt nahm Rehberger praktische architektonische Veränderungsvorschläge auf, die Besucher während der vergangenen beiden Ausstellungen vor Ort geäußert hatten. Zur Arbeitspraxis Rehbergers gehören häufig auch Kooperationen, wie in einem früheren Projekt, für das afrikanische Schreiner nach seinen Zeichnungen Repliken von Möbeln der klassischen Moderne anfertigten (die so entstandenen Objekte, eine „Interpretation einer Interpretation", wirkten beiden Kulturen, die sie repräsentieren sollten, entfremdet). Für sein Projekt anlässlich der Biennale in Venedig (2003) stellten Handwerker farbige Murano-Glasgefäße her, in denen sich das über sieben weltweit verteilte Schalter gesteuerte Licht brach. Anlässlich einer Ausstellung in der Whitechapel Art Gallery in London („Private Matters", 2004) übertrug Rehberger die Proportionen der Fenster und Türen seines deutschen Ateliers zur Interaktion mit den Besuchern auf den Galerieraum und schuf so einen als Wohnraum konzipierten „Raum im Raum", dessen maßgefertigte Lampe von einem Namensvetter des Künstlers in Deutschland ein- und ausgeschaltet wurde. Rehberger bewegt sich geschickt auf dem Grat zwischen Kunst und Design, Persönlichem und Öffentlichem, Ästhetik und Gebrauchswert.

Tobias Rehberger redonne vie au propos moderniste consistant à créer des objets aussi beaux que fonctionnels. Ses installations atmosphériques, ses mobiliers, sculptures, jardins publics, vêtements et posters proposent souvent une interprétation ludique des classiques de l'art et du design modernes, tout en les améliorant de manière à souligner des correspondances inattendues et à en renforcer la valeur publique. Beaucoup de ses projets apportent une réponse à des problèmes spécifiques du design (d'une manière certes inhabituelle) : pour une exposition présentée en 1996/97 au Portikus de Francfort, Rehberger prit connaissance des modifications architecturales suggérées par les visiteurs des deux précédentes expositions organisées par cet espace. Son travail s'appuie souvent sur des démarches collaboratives, comme ce fut le cas d'un projet ancien pour lequel des menuisiers africains créèrent des répliques artisanales de mobiliers de la modernité classique à partir des dessins de l'artiste (« interprétation d'une interprétation », les objets qui en résultèrent étaient éloignés des deux cultures qu'ils étaient censés représenter), et de son projet pour la Biennale de Venise 2003, pour lequel des artisans de Murano créèrent des coupes de verre coloré réfractant des lumières déclenchées par le truchement de sept interrupteurs disséminés dans le monde. Lors d'une exposition présentée à la Whitechapel Art Gallery de Londres (« Private Matters », 2004), Rehberger a transposé les proportions des portes et des fenêtres de son atelier allemand dans des structures qui incitaient les visiteurs à interagir avec elles, et il a créé un espace clos, théoriquement habitable, dans lequel une lampe personnalisée était contrôlée par un homme vivant en Allemagne et s'appelant lui aussi Rehberger. Rehberger trace avec beaucoup d'habileté la ligne entre art et design, espaces privé et public, domaines utilitaire et esthétique.

B. S.

SELECTED EXHIBITIONS →
2004 *Private Matters*, Whitechapel Art Gallery, London **2003** *Delays and Revolutions* and *Utopia Station*, 50. Biennale di Venezia, Venice **2002** *Prescrições, descrições, receitas e recibos*, Museu Serralves, Porto; *Night Shift*, Palais de Tokyo, Paris; *Treballant/Trabajando/Arbeitend*, Fundació "la Caixa", Barcelona; Galleria Civica d'Arte Moderna e Contemporanea, Turin; *Geläut – bis ich's hör'*, Museum für Neue Kunst, Karlsruhe **2001** *Do Not Eat Industrially Produced Eggs*, Staatliche Kunsthalle Baden-Baden

SELECTED PUBLICATIONS →
2003 *Somewhere Better Than This Place*, Contemporary Arts Center Cincinnati, Cincinnati **2002** *Geläut – bis ich's hör'*, Cologne; *Treballant/Trabajando/Arbeitend*, Fundació "la Caixa", Barcelona; *...(whenever you need me)*, Westfälischer Kunstverein, Münster **2001** *Tobias Rehberger, 005–000 [Pocket Dictionary]*, Ostfildern-Ruit

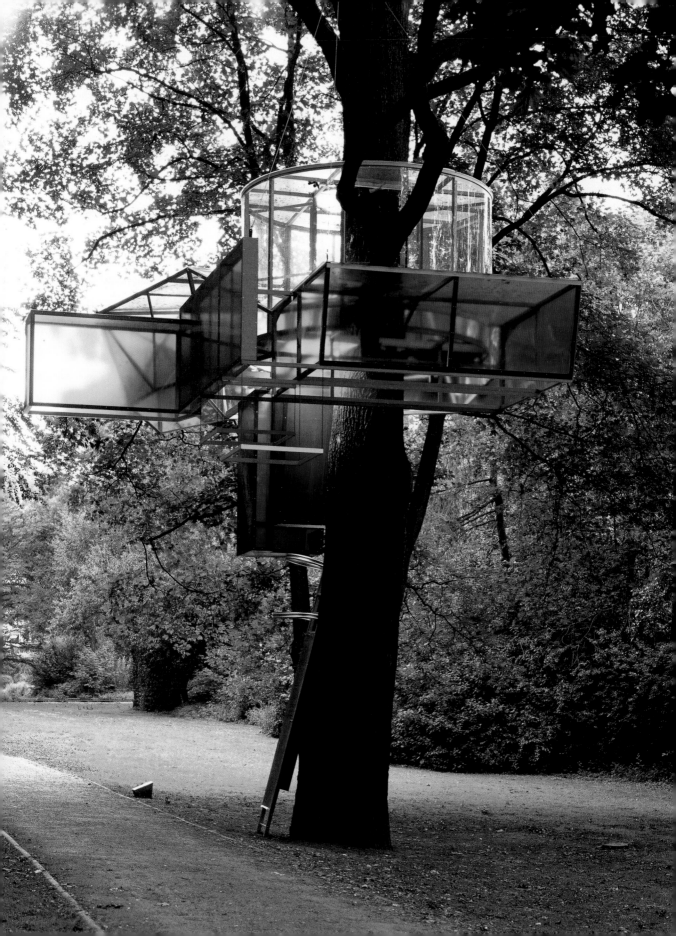

1 **Adipöse Enkelin**, 2004, mixed media, dimensions variable
2 **Männer verlieren Frauen. Frauen verlieren Männer. Menschen verlieren das Leben**, 2002, mixed media, 3 parts: 257 x 240 x 45 cm, 270 x 136 x 45 cm, 257 x 135 x 45 cm

3 **Mother Dying**, 2004, wire, wood, tape, paper, 240 x 300 x 200 cm
4 **7 Ends of the World**, 2003, 222 glass lamps, bulbs, holders, installation view, 50. Biennale di Venezia, Venice

„Um von einem Kunstwerk zu profitieren, muss man selbst dazu beitragen. Wenn man wirklich verstehen will, was in der Kunst vor sich geht, muss man häufig Ausstellungen besuchen und darüber nachdenken."

«Si l'on compte tirer quelque bénéfice d'une œuvre d'art, il faut y contribuer soi-même. Si l'on veut réellement comprendre ce qui se passe dans l'art, il faut constamment visiter des expositions et il faut réfléchir.»

"To receive the maximum benefit from a work of art, you must contribute as well. If you really want to comprehend what happens in art, you must constantly visit exhibitions and you must think."

2

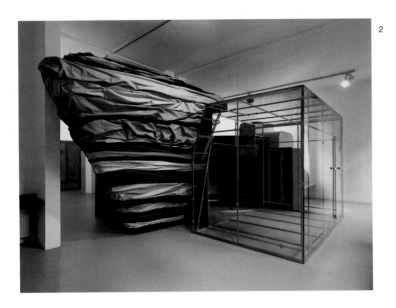

3

Pedro Reyes

1972 born in Mexico City, lives and works in Mexico City, Mexico

Trained as an architect, Pedro Reyes' activities develop on the intersections of art and community, architecture and cultural production and the politics and potential of the exhibition. *Psychoforum* (2003), a polyhedral structure built of multi-coloured prefabricated cell modules, is an ongoing archive of artistic collaboration devised to act like a parasite in a group show context, creating an exhibition within an exhibition. Since 1998 he has reactivated Gonzales Fonseca's modernist 1968 Olympic monument in Mexico City as a project centre, inviting artists to make site specific projects in it. Investigating the utopian potential of industrial design, particularly in his home context of Mexico, Reyes seeks to retrieve the spirit of cultural activism from the tradition of Mexican modern culture. Sculptures such as *Capula* (2002), a large iron domed framework woven with coloured plastic fibres of the type used to make cheap shopping baskets; or *Sombrero Colectivo 1* (2004), a nebulous lunar landscape of fused together sombreros, engage the talents of traditional local craftsmen and the network of micro-industries which characterize Mexico's economic structure, in contrast to the vast and impenetrable industrial mechanisms of their wealthier neighbours. In *Vertebras/The Chair as an Extension of the Backbone* (2003), a series of modular fibreglass structures which can be used as seating, tables, storage, human anatomy is fused with the utopian prototype to suggest a return to potent individualism as an agent of change.

Die Aktivitäten des studierten Architekten Pedro Reyes entfalten sich an der Schnittstelle zwischen Kunst und Gesellschaft, Architektur und kultureller Produktion sowie Ausstellungspolitik und -potenzial. *Psychoforum* (2003), ein polyedrisches Gebilde aus bunten, vorfabrizierten Zellmodulen, ist ein fortlaufendes Archiv künstlerischer Zusammenarbeit, das im Kontext einer Gruppenschau wie ein Parasit wirken soll, der eine Ausstellung innerhalb einer Ausstellung erzeugt. Seit 1998 beschäftigt Reyes sich mit der Reaktivierung von Gonzales Fonsecas modernistischem Olympia-Monument von 1968 in Mexico City als Projektzentrum, in das er Künstler zur Realisation ortsspezifischer Projekte einlädt. Bei seinen Untersuchungen des utopischen Potenzials von Industriedesign, insbesondere im Kontext seiner mexikanischen Heimat, versucht er den Geist des Kulturaktivismus aus der Tradition der modernen mexikanischen Kultur herauszufiltern. Bei Skulpturen wie *Capula* (2002), ein aus jenen farbigen Kunststofffasern gewebtes Kuppelgerüst, wie sie gewöhnlich zur Herstellung billiger Einkaufstaschen verwendet werden, oder *Sombrero Colectivo 1* (2004), eine nebelhafte Mondlandschaft aus miteinander verschmelzenden Sombreros, bedient sich Reyes der Kunstfertigkeit örtlicher traditioneller Handwerker und eines Netzwerks von Kleinstbetrieben, das Mexiko von den gewaltigen und undurchdringlichen industriellen Mechanismen seiner reicheren Nachbarn unterscheidet. In *Vertebras/The Chair as an Extension of the Backbone* (2003), einer Serie von modularen Glasfasergebilden, die als Sitzgelegenheit, Tisch oder Regalelement genutzt werden können, verschmilzt die menschliche Anatomie mit dem utopischen Prototyp und suggeriert so die Rückkehr zum Individualismus als Mittel zur Veränderung.

Formé comme architecte, Pedro Reyes déploie ses activités au carrefour de l'art et de la communauté, de l'architecture et de la production culturelle, de la politique et du potentiel de l'exposition. *Psychoforum* (2003), une structure polyédrique de modules cellulaires multicolores en préfabriqué, se présente comme une archive évolutive de la collaboration artistique destinée à agir comme un parasite au sein d'un contexte d'exposition de groupe en créant une exposition au sein de l'exposition. Depuis 1998, Reyes a réactivé le monument olympique moderniste que Gonzales Fonseca construisit à Mexico en 1968, et l'a transformé en centre de projets, invitant des artistes à y réaliser des projets *in situ*. Sondant le potentiel utopique du design industriel, en particulier dans le contexte familier de la ville de Mexico, Reyes cherche à faire revivre l'esprit de l'activisme culturel de la culture moderne mexicaine et de sa tradition. Des sculptures comme *Capula* (2002), une grande structure métallique en forme de dôme, tissée de fibres en plastique colorées du type de celles qui sont utilisées pour les filets à provisions bon marché, ou encore *Sombrero Colectivo 1* (2004), un nébuleux paysage lunaire de sombreros fondus les uns avec les autres, engage le talent des artisans traditionnels locaux et le réseau des micro-industries qui caractérise la structure économique du Mexique, par opposition aux vastes et insondables mécanismes de ses riches voisins. Dans *Vertebras/The Chair as an Extension of the Backbone* (2003), une série de structures modulaires en fibres de verre pouvant être utilisées tout à tour comme sièges, tables ou espaces de rangement, l'anatomie humaine est amalgamée au prototype de l'utopie pour suggérer le retour à un puissant individualisme comme agent majeur du changement. K. B.

SELECTED EXHIBITIONS →
2005 *Utopia Station*, Carpenter Center for the Visual Arts, Cambridge (MA), Haus der Kunst, Munich **2004** *Made in Mexico*, Institute of Contemporary Art, Boston **2003** 50. Biennale di Venezia, Venice; *To Be Political It has To Look Nice*, apexart, New York **2002** *Nomenclatura Arquimica*, Sala de Arte Público Siqueiros, Mexico City

SELECTED PUBLICATIONS →
2004 *Made in Mexico*, Institute of Contemporary Art, Boston **2003** *Mexico City: An Exhibition about the Exchange Rates of Bodies and Values*, P.S.1, New York

1 **A House for Computer Caveman**, 2003, concrete house with Mexican and Japanese furniture, Echigo-Tsumari Art Triennial, Matsunoyama

2+3 **Floating Pyramid**, 2004, wood, styrofoam, 488 x 488 x 366 cm

„Ich versuche nicht, meine Umgebung zu reflektieren, sondern sie zu verändern."

« Je ne cherche pas à refléter mon milieu, mais plutôt à le transformer. »

"I don't seek to reflect my milieu but instead to transform it."

Jason Rhoades

1965 born in Newcastle (CA), lives and works in Los Angeles (CA), USA

Jason Rhoades' room-filling installations represent an overwhelming array of associatively connected form and topic conglomerates, which frequently still bear traces of the artist's performative presence. Occasionally several exhibition projects overlap, and are interlaced and recycled into new arrangements that change in a process-like manner. The exhibition series *PeaRoeFoam: The Impetuous Process, My Special Purpose and The Liver Pool* (2002) is based on a colourful material mixture made up of small Styrofoam balls, salmon roe, and dried peas, which in different contexts of form draws attention to thoughts on virginity, detergent-like cleanliness, pornography, and karaoke. Rhoades' compulsively prolific installations materialize the different types of individuality in a consumer culture where subjects define themselves through their wishes, which express themselves in turn as purchasing power. Thereby Rhoades occasionally appears as more of a bricklayer than a do-it-yourselfer ("Jason the Mason"). The installation *My Madinah: In Pursuit of My Ermitage* (2004) associated Immanuel Kant with the soft-porn legend Emmanuelle, and thereby positioned the philosopher in a sequence of 1724 expressions for the female sexual organ (Kant/cunt). In colourful neon letters these formed the contemplative centre of a New Age environment. The visitors' task was to translocate the installation to Mecca, its spiritual centre – *Mecca, California*, however. The question about the role of the Enlightenment is concealed within a jungle of mysticism and phantasmagoria about (female) sexuality, which Rhoades focuses upon by way of his soft porn heroine and literary texts ranging from Novalis to D. H. Lawrence.

Jason Rhoades' raumgreifende Installationen stellen ein überwältigendes Aufgebot an assoziativ verknüpften Form- und Themenkomplexen dar, die häufig noch die Spuren der performativen Anwesenheit des Künstlers tragen. Zuweilen greifen mehrere Ausstellungsprojekte ineinander über und werden in neuen, prozesshaft sich wandelnden Anordnungen verschachtelt und recycelt. Die Ausstellungsserie *PeaRoeFoam: The Impetuous Process, My Special Purpose and The Liver Pool* (2002) basiert auf einem bunten Materialmix aus Styroporkügelchen, Lachsrogen und Trockenerbsen, der in unterschiedlichen Formzusammenhängen Überlegungen zu Jungfräulichkeit und Waschmittelsauberkeit, Pornografie und Karaoke in Szene setzt. Die Individualitätsentwürfe einer Konsumkultur, in der sich das Subjekt durch seine Wünsche definiert, die sich wiederum in Kaufkraft ausdrücken, materialisiert sich in der triebhaft wuchernden Installation, gezimmert von dem zuweilen mehr als Maurer denn als Bastler auftretenden Rhoades ("Jason the Mason"). Die Installation *My Madinah: In Pursuit of My Ermitage* (2004) verknüpft Immanuel Kant mit der Softpornolegende Emmanuelle und stellt den Philosophen damit in eine Reihe von 1724 Bezeichnungen für das weibliche Geschlechtsorgan (Kant/cunt), die in bunten Neonbuchstaben das kontemplative Zentrum eines New-Age-Environments bilden. Die Aufgabe der Besucher ist die Translokation der Installation zu ihrem geistigen Zentrum Mekka – allerdings *Mecca, California*. Die Frage nach der Rolle der Aufklärungsbewegung verbirgt sich innerhalb eines Dickichts von Mystizismen und Phantasmagorien um die (weibliche) Sexualität, die Rhoades anhand seiner Softpornoheldin und literarischer Texte von Novalis bis D. H. Lawrence thematisiert.

Les vastes installations spatiales de Jason Rhoades proposent une offre impressionnante de complexes thématiques et formels connectés entre eux sur le mode de l'association, et qui souvent portent encore les traces de l'activité performative de l'artiste. Parfois, plusieurs projets d'exposition se réfèrent les uns aux autres et sont imbriqués et recyclés en de nouveaux dispositifs qui se transforment de manière processuelle. La série d'expositions *PeaRoeFoam: The Impetuous Process, My Special Purpose and The Liver Pool* (2002) repose sur un mélange de matériaux multicolore composé de billes de polystyrène, d'œufs de saumon et de petits pois séchés dont les correspondances formelles mettent en scène diverses réflexions sur la virginité, la propreté de détergent, la pornographie et le karaoké. Les concepts d'individualité au sein d'une culture consumériste qui définit le sujet par ses désirs – lesquels s'expriment pour leur part à travers le pouvoir d'achat – se matérialise dans des installations au foisonnement pulsionnel, assemblées par un Rhoades qui apparaît parfois plus comme un maçon que comme un bricoleur (« Jason the Mason »). L'installation *My Madinah: In Pursuit of My Ermitage* (2004) rapproche Emmanuel Kant d'Emmanuelle, la légende du porno soft, et place le philosophe dans une série de 1724 désignations de l'organe sexuel féminin (Kant/cunt) réalisées dans un lettrage néon multicolore qui constitue le centre contemplatif d'un environnement *New Age*. La tâche proposée au spectateur est de délocaliser l'installation vers son centre spirituel, La Mecque – en fait : *Mecca, California*. La question du rôle de ce mouvement spirituel demeure enfouie sous un fouillis de mysticismes et de fantasmagories tournant autour d'une sexualité (féminine) que Rhoades thématise à l'appui de son héroïne du porno soft et de textes littéraires allant de Novalis à D. H. Lawrence. E.K.

SELECTED EXHIBITIONS →
2006 *le grand spectacle*, Museum der Moderne, Salzburg **2005** *Dionysiac*, Centre Georges Pompidou, Paris **2004** *Everything is connected, he he he*, Astrup Fearnley Museum, Oslo; *My Madinah: In Pursuit of My Ermitage...*, Sammlung Hauser & Wirth, St. Gallen **2002** *PeaRoe Foam. The Impetuous Process, My Special Purpose and The Liver Pool*, Museum für Moderne Kunst Wien, Vienna, Tate Liverpool Biennial, Liverpool **2001** *Costner Complex*, Portikus, Frankfurt; *Public Offerings*, Museum of Contemporary Art, Los Angeles

SELECTED PUBLICATIONS →
2002 *Shit Plug*, Cologne; *PeaRoe Foam. The Impetuous Process, My Special Purpose and The Liver Pool*, Museum für Moderne Kunst Wien/Tate Liverpool, Liverpool **2001** *Jason Rhoades/Costner Complex*, Portikus, Frankfurt

1 **My Madinah: In Pursuit of My Ermitage...**, 2004, installation view, Hauser & Wirth Sammlung, St. Gallen

2 With Paul McCarthy, **Shit Plug**, 2002, installation view, Hauser & Wirth, Zurich

3 **PeaRoeFoam: The Liver Pool**, 2002, installation view, 2. Liverpool Biennial

„Ich möchte ein Werk schaffen, das das Publikum mit einschließt, ohne den Künstler auszuschließen."

«Je veux construire une œuvre qui inclue le public sans exclure l'artiste.»

"I want to build a work which includes the public but does not exclude the artist."

2

3

Daniel Richter

1962 born in Eutin, lives and works in Berlin and Hamburg, Germany

In 1995 Daniel Richter, who studied under Werner Büttner in Hamburg, created a furore with his strongly coloured and exuberant abstract paintings. Works from this period abound with countless colourful veils, ribbons and small elements, which weave themselves into dense, all-encompassing textures, and which flood the pictorial space with riotous ornamentation. The crowded, troubling energy of these paintings and their propensity for abundance is less based in expressiveness as filtered through pop; it binds together the contemporary – as if the bulging surfaces wanted to engulf and reverse-translate today's general excess of the visual. He began in 1999 to transfer this attitude from abstraction to figuration. It was a sudden transition that also stands out in individual paintings, such as *Verzerrte Züge* and *Kritik* (both 1999), where faces and limbs appear like ghosts within an abstract framework. Richter paints sombre, stage-like and often violence-fraught scenarios. These are frequently civilization's wastelands – pedestrian zones, apartment blocks or forest – and are peopled by grotesque figures. They hang around, start an insurrection (*Duisen*, 2004) or rival one another (*Kein Gespenst geht um*, 2002). Richter has placed others of their type directly into lightless, abysmal scenarios of doom (*Flash*, 2002) or in free fall (*Duueh*, 2003). New paintings again show more sharply contoured figures, often borrowed from different contexts and placed in surreal constellations, where animals also play a further role such as in a night setting with a pack of wolves (*Tuwenig*, 2004). Richter's works want to remain riddles: dreamlike and nightmarish pendants of today's society.

Daniel Richter, der in Hamburg bei Werner Büttner studierte, machte ab 1995 schnell mit farbstark wuchernder abstrakter Malerei Furore. Arbeiten dieser Zeit sind von zahllosen bunten Schlieren, Bändern und kleinteiligen Elementen durchwuchert, die sich zu flächendeckend dichter Textur verschränken und den Bildraum mit entfesselter Ornamentik fluten. Die drängende, bedrängende Energie dieser Malerei, ihr Hang zur Fülle ist weniger expressiv verankert als vielmehr popgefiltert; sie bindet Jetztzeitigkeit – als ob die prallen Oberflächen das heute allgemeine Übermaß an Visuellem schlucken und rückübersetzen wollten. Diese Haltung übertrug er ab 1999 vom abstrakten Bild auf die Figuration. Ein rascher Übergang, der sich auch in einzelnen Bildern abzeichnet: In *Verzerrte Züge* und *Kritik* (beide 1999) etwa tauchen aus abstraktem Gefüge wie geisterhaft Gesichter und Gliedmaßen auf. Richter malt düstere, oft gewaltträchtige, bühnenhaft wirkende Szenarios, häufig Zivilisationsbrachen – Fußgängerzonen, Wohnblocks, Wald –, die von grotesken Figuren bevölkert werden. Sie hängen herum, formieren sich zum Aufstand (*Duisen*, 2004) oder rivalisieren miteinander (*Kein Gespenst geht um*, 2002). Andere ihrer Art hat Richter gleich in licht- und bodenlose Untergansszenarien (*Flash*, 2002) oder in den freien Fall (*Duueh*, 2003) versetzt. Neue Bilder zeigen wieder schärfer konturierte, oft aus unterschiedlichen Kontexten entlehnte und in surreale Konstellationen versetzte Figuren, auch Tiere spielen weiter eine Rolle – so etwa im Nachtstück mit Wolfsrudel (*Tuwenig*, 2004). Richters Arbeiten wollen Rätsel bleiben, traumhaft alptraumhafte Gegenbilder zur heutigen Gesellschaft.

A partir de 1995, Daniel Richter, qui a fait ses études à Hambourg chez Werner Büttner, a rapidement fait fureur avec sa peinture abstraite haute en couleurs. Les œuvres de cette époque débordent d'un foisonnement de traînées, de bandes et d'éléments colorés qui se chevauchent pour former une texture dense couvrant l'ensemble de la surface et nourrissant l'espace pictural d'une ornementalité débridée. L'énergie pressante et oppressante de cette peinture et sa tendance à la profusion sont moins enracinées dans l'expressivité que filtrées par l'esprit pop. Elles lient des aspects contemporains – comme si les surfaces débordantes voulaient engloutir et retraduire la surproduction aujourd'hui généralisée de l'image. A partir de 1999, Richter transpose cette attitude du tableau abstrait dans la figuration, une transition abrupte qui se traduit aussi dans ses différents tableaux. Dans *Verzerrte Züge* et dans *Kritik* (tous deux de 1999), on voit émerger d'une trame abstraite quelque chose comme des visages et des membres. Richter peint des scénarios crépusculaires, souvent chargés de violence et d'un effet théâtral : jachères de la civilisation – zones piétonnières, pâtés de maisons, forêts – peuplées de figures grotesques. Elles errent sans but, se constituent en émeutes (*Duisen*, 2004) ou en rivalités (*Kein Gespenst geht um*, 2002). D'autres figures similaires sont placées directement dans des scénarios du déclin, sans lumière ni point d'appui (*Flash*, 2002), voire en chute libre (*Duueh*, 2003). Les tableaux récents présentent à nouveau des figures plus précises, souvent empruntées à plusieurs contextes ou regroupées en constellations surréelles. Les animaux continuent eux aussi de jouer un rôle important, comme dans le nocturne avec meute de loups (*Tuwenig*, 2004). Contre-images oniriques et cauchemardesques de la société contemporaine, les œuvres de Richter entendent préserver leur énigme. J. A.

SELECTED EXHIBITIONS →
2004/05 *White Horse – Pink Flag*, The Power Plant, Toronto; National Gallery of Canada, Ottawa; Morris and Helen Belkin Art Gallery, Vancouver **2003** *Hirn*, Neuer Berliner Kunstverein, Berlin; *New Abstract Painting. Painting Abstract Now*, Museum Morsbroich Leverkusen **2002** *Grünspan*, K21 – Kunstsammlung Nordrhein-Westfalen, Düsseldorf **2001** *Billard um halb Zehn*, Kunsthalle zu Kiel; *Vantage Point*, Irish Museum of Modern Art, Dublin **2000** *Für Immer* (mit Tal R), Gesellschaft für Aktuelle Kunst, Bremen

SELECTED PUBLICATIONS →
2003 *New Abstract Painting – Painting Abstract Now*, Museum Morsbroich Leverkusen, Leverkusen; *Hirn*, Neuer Berliner Kunstverein, Ostfildern-Rint **2002** *Grünspan*, K21 – Kunstsammlung Nordrhein-Westfalen, Bielefeld **2001** *Billard um halb Zehn*, Kunsthalle zu Kiel, Kiel **2000** *German Open*, Kunstmuseum Wolfsburg, Wolfsburg; *Die Frau – Rock'n'Roll – Tod, Nein Danke!*, Contemporary Fine Arts, Berlin

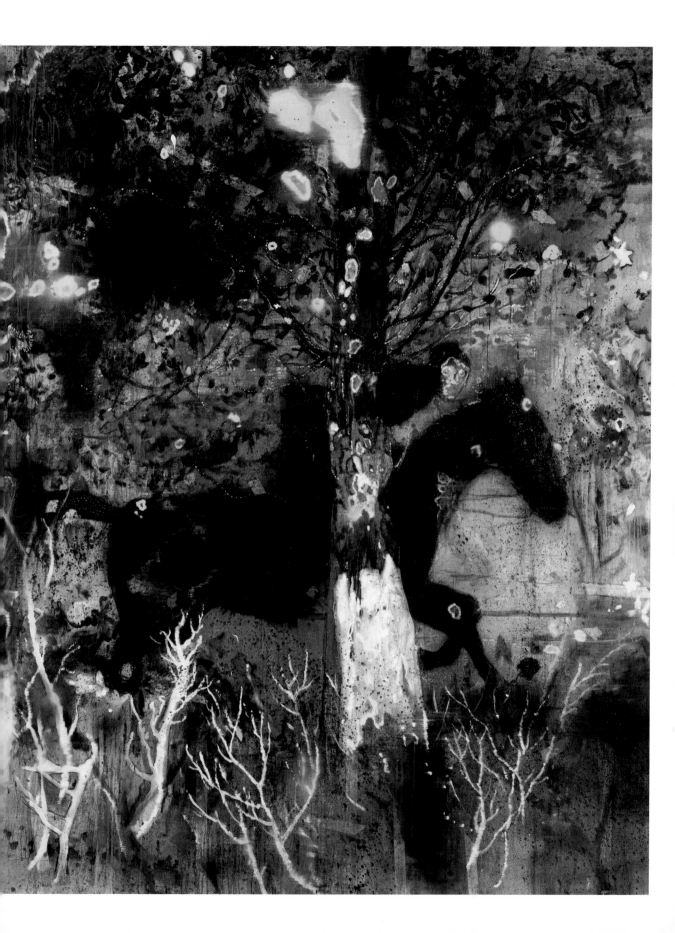

1 **Trevelfast**, 2004, oil on canvas, 283 x 232 x 4.4 cm

2 Exhibition view, "Grünspan", K21 – Kunstsammlung Nordrhein-Westfalen, Düsseldorf, 2002/03

„Schönheit durch Konfusion, Wahrheit durch Kollision."

«La beauté par la confusion, la vérité par la collision.»

"Beauty through confusion, truth through collision."

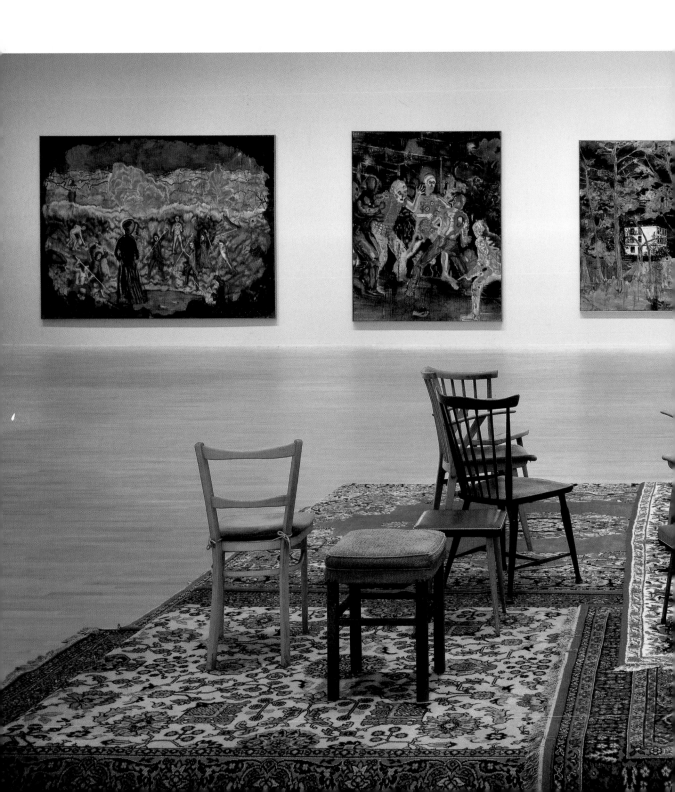

de Rijke/de Rooij

Jeroen de Rijke, 1970 born in Brouwershaven, and
Willem de Rooij, 1969 born in Beverwijk, live and work in Amsterdam, The Netherlands

Jeroen de Rijke and Willem de Rooij do not use film as a medium for making up stories or preserving history, but rather as a means of meditating upon the production and composition of pictures. Their films are presented in separate, sculptural rooms at specific times, in order to use distinctive moments to counter the burgeoning availability of pictures. The camera often gazes statically at its motif, and only changing lighting conditions or brief movements remind viewers that they are looking at moving pictures. In their latest works the artists investigate the structures underlying abstract pictures, and the ways in which complex subject matter and concepts can be transferred into other pictorial systems. The film *The Point of Departure* (2002) looks at the tradition of Islamic craftsmanship with its strict refusal of any qualities of realism. The camera penetrates deeply into the fabric of a carpet from the Caucasus, following its floral patterns, and finally allowing it to drift away into a black nothingness. In the arrangements of flowers entitled *Bouquets* the artists themselves initiated the transformation – into symbolic form – of representational art, text, and their various readings. Arranged by florists, *Bouquet II* and *Bouquet III* (2003) were inspired by press photographs and reports chronicling political, ideological, and religious conflicts, which were then concealed behind the works' vegetal beauty. How can an abstract picture generate itself? In the short films *Crystals I–IX* and *Crystals X–XII* (2003) de Rijke/de Rooij consulted nature itself on this question, filming through a microscope the solidification process of liquids and the formation of crystalline patterns and structures.

Jeroen de Rijke und Willem de Rooij setzen Film nicht als Medium ein, mit dem sie Geschichten erfinden oder Geschichte konservieren, sondern mit dem sie über die Erzeugung und Beschaffenheit von Bildern nachdenken. Ihre Filme werden in gesonderten, skulpturalen Räumen zu festgelegten Zeiten präsentiert, um der inflationären Verfügbarkeit von Bildern Momente der Besonderheit entgegenzusetzen. Oftmals blickt die Kamera statisch auf ihr Motiv, und es sind nur sich ändernde Lichtverhältnisse oder flüchtige Bewegungen, die daran erinnern, dass man auf bewegte Bilder schaut. In ihren jüngsten Arbeiten untersuchen die Künstler, welche Strukturen abstrakten Bildern zugrunde liegen, wie sich komplexe Sachverhalte und Konzepte in andere Bildsysteme übertragen lassen. Der Film *The Point of Departure* (2002) betrachtet die Tradition islamischer Handwerkskunst mit ihrer strikten Verweigerung jeglicher Abbildhaftigkeit. Die Kamera dringt tief in das Gewebe eines kaukasischen Teppichs ein, folgt seinen floralen Mustern und lässt ihn schließlich in ein schwarzes Nichts entschweben. In den *Bouquets*, Arrangements aus Blumen, initiieren die Künstler selbst die Transformation von Repräsentation, Text und deren vielfältigen Lesarten in eine symbolische Form. Von Floristen arrangiert sind *Bouquet II* und *Bouquet III* (2003), inspiriert von Pressefotografien und Reportagen, die von politischen, ideologischen und religiösen Konflikten berichten und die sich nun hinter der vegetabilen Schönheit verbergen. Wie entsteht ein ungegenständliches Bild? In den Kurzfilmen *Crystals I–IX* sowie *Crystals X–XII* (2003) befragen de Rijke/de Rooij die Natur selber und filmen durch ein Mikroskop den Prozess der Verfestigung von Flüssigkeiten und der Bildung kristalliner Muster und Strukturen.

Jeroen de Rijke et Willem de Rooij ne se servent pas du cinéma comme d'un médium permettant d'inventer des histoires ou de fixer des faits historiques, mais pour une réflexion sur la création et la nature des images. Leurs films sont présentés dans des espaces sculpturaux isolés et à des horaires définis pour opposer à la disponibilité inflationniste des images des moments privilégiés. Souvent la caméra pose un regard statique sur le motif, et seuls l'évolution des conditions d'éclairage ou quelques mouvements fugitifs rappellent que l'on regarde des images animées. Dans leurs œuvres les plus récentes, les deux artistes sondent la conformation des structures qui sous-tendent les images abstraites et la manière dont certains concepts et états de faits complexes peuvent être transposés dans d'autres systèmes visuels. Le film *The Point of Departure* (2002) se penche sur la tradition artisanale islamique et son strict rejet de toute représentation. La caméra pénètre profondément dans le tissage d'un tapis caucasien, suit ses motifs floraux et le fait finalement s'envoler lentement dans un néant noir. Dans les arrangements floraux des *Bouquets*, les artistes provoquent eux-mêmes l'évolution de la représentation, du texte et de ses multiples lectures vers une forme symbolique. Composés par des fleuristes professionnels, les *Bouquet II* et *Bouquet III* (2003) s'inspirent de photographies de presse et de reportages qui relatent des conflits politiques, idéologiques et religieux, et qui se cachent maintenant derrière la beauté végétale. Comment une image abstraite se produit-elle? Dans les courts métrages *Crystals I–IX* et *Crystals X–XII* (2003), de Rijke/de Rooij interrogent la nature elle-même en filmant le processus de solidification de certains liquides et la formation de motifs et de structures cristallines à travers un microscope.

A. M.

SELECTED EXHIBITIONS →
2005 *De Rijke/De Rooij*, Secession, Vienna; 51. Biennale di Venezia, Venice **2004** *De Rijke/De Rooij*, Kunsthalle Zürich; *Cordially Invited*, Centraal Museum, Utrecht; 14. Biennale of Sydney **2002** *De Rijke/De Rooij*, Villa Arson, Nice; *Time Zones: Recent Film and Video*, Tate Modern, London

SELECTED PUBLICATIONS →
2003/04 *Jeroen de Rijke & Willem de Rooij*, Kunsthalle Zürich, Zurich **2003** *Jeroen de Rijke & Willem de Rooij. Spaces and Films 1998–2002*, Eva Meyer-Hermann (ed.), Van Abbemuseum, Eindhoven, Villa Arson, Nice **2001** *Tre filmer/Three films*, Museet for samtidskunst, Oslo **2000** *De Rijke/De Rooij: Bantar Gebang*, Stedelijk Museum Bureau Amsterdam, Amsterdam

1 **Bouquet III**, first installed at the 14. Biennale of Sydney, 2004, flower bouquet, vase, wooden pedestal, mounted wall text and image, written description

2 **Mandarin Ducks**, 2005, 16mm film, 36 min., film stills

2

Pipilotti Rist

1962 born in Grabs, lives and works in Zurich, Switzerland, in the Swiss mountains, and in Los Angeles, USA

Like a story from the silver screen: at the end of the 1980s Pipilotti Rist became known as an internationally important artist for her hysterical and overemotional video installations. Rist was one of the first to bring the aesthetic of music videos to video art, quickly developing her own style through her love of experimentation with images, music and pop culture. Humorously and emotionally she describes a world of (female) dreams, visions, and everyday mythology. Rist always presents her videos as installations with close reference to the exhibition space. Thus in the early work *Selbstlos im Lavabad* (1994), she embedded a tiny monitor in the floor. The artist, naked and surrounded by flames, could only be seen through a tiny hole, out of which she cried despairingly in various languages for help and forgiveness. Rist later did away with the monitor and enlarged the projections, thereby creating an ambience with her installation and its sound in which she could completely immerse her audience. A further example, *Himalaya's Sister's Living Room* (2000) is a completely furnished living room in which various films flicker like daydreams across furniture and objects. Thereby fictitious and real spaces flow seamlessly into one another. In *Stir Heart Rinse Heart* (2004) transparent plastic objects hanging from the ceiling function both as "shadow puppets" and as projection screens for films taken of the human bloodstream. Underscored by music, the floating objects' oscillations and reflections mix with the pulsing movement of the blood. In a very direct manner, Rist successfully addresses all of the senses and creates environments full of positive emotions.

Filmreif: Mit ihren hysterischen und überemotionalen Video-Installationen avancierte Pipilotti Rist Ende der achtziger Jahre zu einer international anerkannten Künstlerin. Rist brachte als eine der Ersten die Ästhetik des Musik-Clips in die Videokunst ein und entwickelte durch ihren experimentierfreudigen Umgang mit Bild, Musik und Popkultur schnell ihren eigenen Stil. Humorvoll und gefühlsbetont beschreibt sie eine Welt der (weiblichen) Träume, Visionen und Alltagsmythen. Die Videos werden von Rist immer in engem Bezug zum Raum als Installation präsentiert. So versenkt sie in der frühen Arbeit *Selbstlos im Lavabad* (1994) den winzigen Bildschirm im Boden; die nackte, von Flammen umgebene Künstlerin ist nur durch ein kleines Loch zu sehen. Aus diesem bittet sie in verschiedenen Sprachen verzweifelt um Hilfe und Vergebung. Später dann lässt Rist die Monitore weg, vergrößert die Projektionen und schafft mit ihren Installationen und deren Ton ein Ambiente, in das sie das Publikum vollständig eintauchen lässt. *Himalaya's Sister's Living Room* (2000) etwa ist ein komplett eingerichtetes Wohnzimmer, in dem verschiedene Filme wie Tagträume über Möbel und Gegenstände flimmern. Fiktive und reale Räume fließen dabei nahtlos ineinander. In *Stir Heart Rinse Heart* (2004) funktionieren transparente, von der Decke hängende Plastikgegenstände gleichzeitig als Projektionsfläche und als „Schattenfiguren" für die Aufnahmen aus den Blutbahnen des menschlichen Körpers. Untermalt von Musik, vermischen sich die Schwingungen und Reflexionen der schwebenden Objekte mit den pulsierenden Bewegungen des Blutes. Rist gelingt es auf eine sehr direkte Art, alle Sinne anzusprechen und Environments voller positiver Emotionen zu schaffen.

Digne d'un film : à la fin des années quatre-vingt, ses installations vidéo hysterique et émotionellement surchargées ont fait accéder Pipilotti Rist au rang d'artiste mondialement reconnue. Rist a été l'une des premières à faire entrer l'esthétique du clip dans l'art vidéo et a rapidement développé son propre style à travers ses expériences ludiques sur l'image, la musique et la culture pop. Avec une indéniable dose d'humour et une tendance sentimentale, Rist décrit un univers de rêves (féminins), de visions et de mythes du quotidien. Elle présente toujours ses vidéos sous forme d'installations et en étroite correspondance avec l'espace. Dans une œuvre ancienne comme *Selbstlos im Lavabad* (1994), l'artiste insérait un minuscule moniteur dans le sol. Nue, cernée par les flammes, elle ne pouvait être vue qu'à travers une petite ouverture d'où elle appelait désespérément à l'aide et demandait pardon en plusieurs langues. Plus tard, Rist abandonne les moniteurs, agrandit la taille de ses projections et crée avec le ton et la forme de ses installations des ambiances dans lesquelles elle baigne intégralement le public. *Himalaya's Sister's Living Room* (2000) est un salon entièrement aménagé dans lequel plusieurs films papillotent comme des rêves éveillés sur les meubles et d'autres objets. Les espaces fictif et réel se fondent l'un dans l'autre de manière homogène. Dans *Stir Heart Rinse Heart* (2004), des objets en plastique transparents pendant du plafond fonctionnent comme des « silhouettes », mais aussi comme des surfaces de projection pour des prises de vue des vaisseaux sanguins du corps humain. Soulignées par la musique, les vibrations et les réflexions des objets en suspension se mêlent aux pulsions de la circulation sanguine. Rist parvient à s'adresser aux sens de manière très directe et à créer des environnements pleins d'émotions positives.

C. R.

SELECTED EXHIBITIONS →
2005 *Emergencias*, Centro Museo de Arte Contemporáneo de Castilla y León **2004** *Stir Heart Rinse Heart*, San Francisco Museum of Modern Art; *Opening Show*, 21st Century Museum of Contemporary Art, Kanazawa **2003** Museum of Contemporary Art Kiasma, Helsinki **2002** *The cake is in flames*, Shiseido Gallery, Tokyo; 5. Shanghai Biennale **2001** *Apricots Along the Street*, Museo Nacional Centro de Arte Reina Sofia, Madrid

SELECTED PUBLICATIONS →
2004 *Jestem swoja wlasna obca swinia/Ich bin mein eigenes fremdes Schwein/I am my own foreign pig*, Centrum Sztuki Wspolczesnej Zamek Ujazdowski, Warsaw **2001** *Pipilotti Rist*, London; *Apricots Along the Street*, Pipilotti Rist (ed.), Zurich

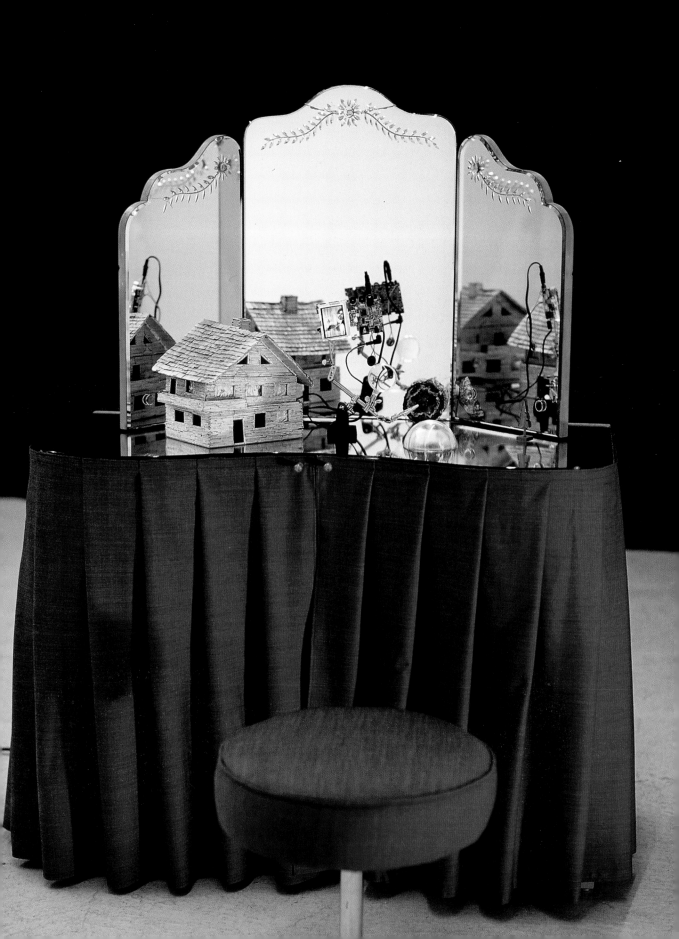

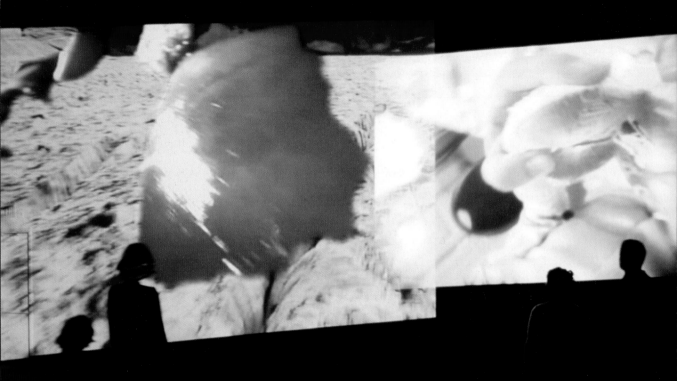

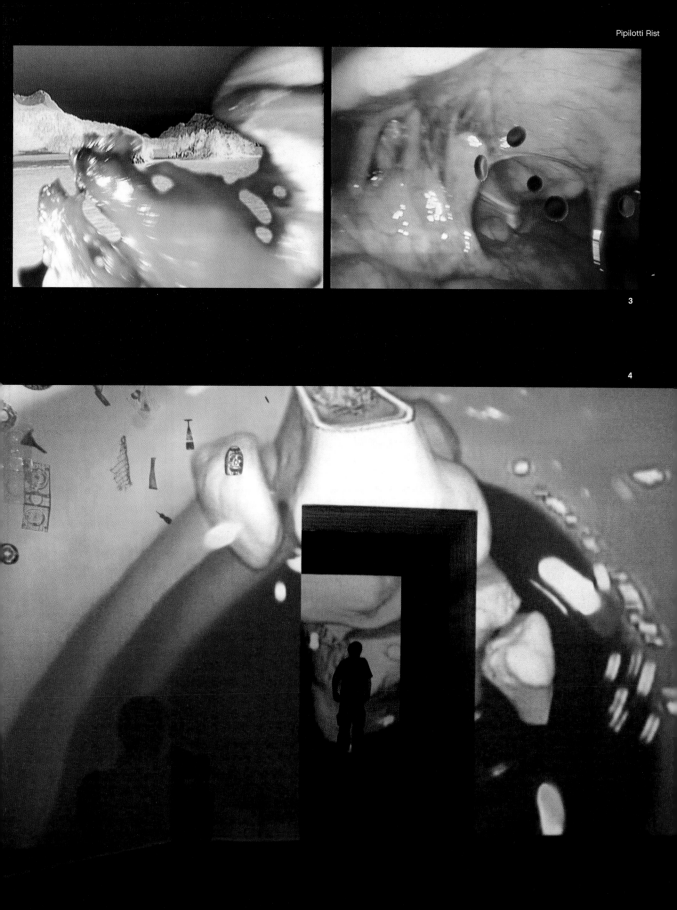

3

4

Matthew Ritchie

1964 in London, UK, lives and works in New York (NY), USA

Matthew Ritchie likes to remind us that we have exchanged more information within the last three years than throughout the whole history of mankind. His work is aimed at developing a cosmology containing the entirety of human knowledge, not in a static way, like a body of work that already exists, but dynamically. This alchemical and utopian cosmology spreads through time and space by means of contraction and expansion, but also through colour, light, and mass – to freely quote the inspired words of the artist, "more is more". Ritchie, also presented as the adoptive son of William Blake and Wonder Woman, began his career in a rather classical way as a student in Boston and then at the Camberwell School of Arts in London, where he shared a studio with Damien Hirst for some time. His "big bang" is a list of "all the things that interest him", which he compiled in 1995. He divided these into 49 categories, and assigned them seven characteristics: scientific, theological and narrative functions, a colour, a form, a dynamic function and a "hidden meaning". Ritchie's works are a continuing story of 49 imaginary people who embody these categories, and who are identified by forms, personalities, and names such as Azazel, Penemue or Metatron. This story (or at least the part of it we can see), which is partly developed in frescos, pictures or sculptures, and partly by using indirect means such as card or video games, and which is distinguished by a rare talent for symbolism, colouration and narrative, is acted out in real time. Every exhibition by Ritchie is a further chapter.

Matthew Ritchie erinnert gern daran, dass wir in den letzten drei Jahren mehr Informationen ausgetauscht haben als in der ganzen Menschheitsgeschichte zuvor. Seine Arbeit zielt darauf ab, eine Kosmologie zu erarbeiten, die das gesamte menschliche Wissen umfasst, und zwar nicht auf statische Weise, wie ein bereits vorhandener Korpus, sondern dynamisch. Diese alchemistische und utopische Kosmologie breitet sich durch Kontraktion und Ausdehnung in Zeit und Raum aus, aber auch durch Farbe, Licht, Masse, frei nach einem geflügelten Wort des Künstlers, „more is more". Ritchie, der gelegentlich als Adoptivsohn von William Blake und Wonder Woman präsentiert wird, begann seine Laufbahn eher auf klassische Weise, als Student in Boston und dann an der Camberwell School of Arts in London, wo er einige Zeit ein Atelier mit Damien Hirst teilte. Seinen Durchbruch markiert eine Liste „aller Dinge, die ihn interessieren", aufgestellt 1995. In 49 Kategorien eingeteilt, ordnete er diesen sieben Charakteristika zu: eine wissenschaftliche, eine theologische und eine erzählerische Funktion, eine Farbe, eine Form, eine dynamische Funktion und einen verborgenen Sinn. Die Werke von Ritchie sind eine sich fortschreibende Geschichte von 49 imaginären Personen, die diese Kategorien verkörpern, und mit Formen, Persönlichkeiten und Namen wie Azazel, Penemue oder Metatron bezeichnet sind. Diese Geschichte (zumindest der Teil, den wir davon sehen können), die sich zum einen durch Fresken, Bilder oder Skulpturen, zum anderen über den Umweg des Karten- oder Videospiels entwickelt, und die sich durch ein seltenes Zeichen-, Koloristen- und Erzähltalent auszeichnet, spielt sich in der realen Zeit ab. Jede Ausstellung von Ritchie ist ein anderes Kapitel.

Matthew Ritchie aime à rappeler que, dans les trois dernières années, on a échangé plus d'informations que dans toute l'histoire de l'humanité. Son travail vise à élaborer une cosmologie qui embrasserait l'ensemble du savoir humain de manière non pas statique, comme un corpus préexistant, mais dynamique. De nature alchimique et chimérique, cette cosmologie se déploie en effet par rétractation et dilatation dans le temps et dans l'espace, mais aussi dans la couleur, la lumière, la masse… suivant l'un des adages de l'artiste selon lequel «more is more». Parfois présenté comme l'enfant naturel de William Blake et de Wonder Woman, Ritchie a pourtant débuté par un parcours assez classique, étudiant à Boston puis à la Camberwell School of Arts de Londres, partageant un temps l'atelier de Damien Hirst. Son «big bang» à lui, c'est une liste qu'il rédige en 1995 de «toutes les choses qui l'intéressent». Regroupés en 49 catégories, ces éléments se voient attribuer chacun sept caractéristiques : une fonction scientifique, une fonction théologique, une fonction narrative, une couleur, une forme, une fonction dynamique et un «sens caché». Les œuvres de Ritchie sont l'histoire en train de s'écrire des 49 personnages imaginaires incarnant ces catégories, dotés de formes, de personnalités, et de noms tels Azazel, Penemue ou Metatron. Evoluant tantôt à travers des fresques, des tableaux ou des sculptures, tantôt par le biais de jeux de cartes ou de jeux vidéo, servie par un talent rare de dessinateur, de coloriste et de conteur, cette histoire (du moins la partie qu'il nous est laissé d'en voir) se déroule en temps réel. Chacune des expositions de Ritchie en est un chapitre.

S. C.

SELECTED EXHIBITIONS →
2005 The Fabric Workshop and Museum, Philadelphia; Portikus, Frankfurt/Main **2004** Massachusetts Museum of Contemporary Art, North Adams; *Proposition Player*, Contemporary Arts Museum, Houston; 26. Bienal de São Paulo; 14. Biennale of Sydney; *Monument to Now*, Deste Foundation, Athens **2003** *GNS (Global Navigation System)*, Palais de Tokyo, Paris

SELECTED PUBLICATIONS →
2004 *Matthew Ritchie: Proposition Player*, Contemporary Arts Museum, Houston, Ostfildern-Ruit **2000** *The Fast Set*, Museum of Contemporary Art, North Miami

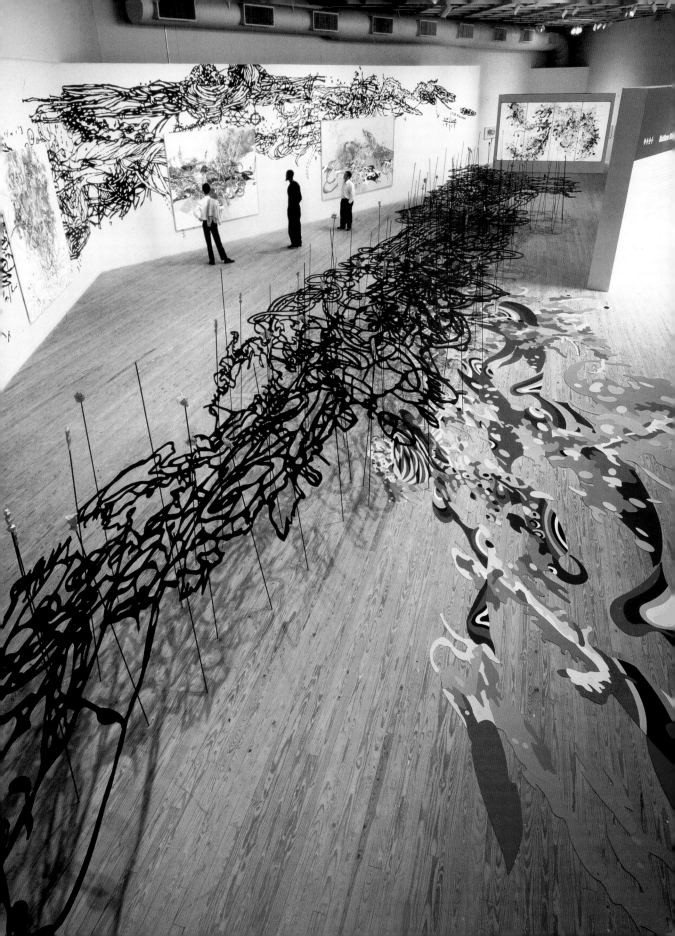

1 **Proposition Player**, 2003/04, installation view, Contemporary Arts
 Museum, Houston
2 **The Universal Cell**, 2004, installation view, 26. Bienal de São
 Paulo

3 **A Glorious Martyrdom Awaits Us All at the Hands of Our Tender and
 Merciful God**, 2003, oil and marker on canvas, 235 x 251 cm
4 **After the Father Costume**, 2003, installation view, c/o Atle Gerhardsen,
 Berlin

„Wir können nur 5 % des Universums sehen [...] Wir arbeiten nach einem
Modell, von dem uns 95 % an Information fehlen – es ist also nicht erstaun-
lich, dass sich alle so verhalten als würden sie sich im Dunkeln bewegen.
Folglich stellt sich für mich die große Frage: Wie stelle ich diese Abwesen-
heit visuell dar?"

«Nous ne pouvons voir que 5 % de l'univers. [...] Nous travaillons à partir
d'un modèle dont 95 % de l'information manque – il n'est donc pas étonnant
que tout le monde se comporte comme s'il était dans le noir. Par conséquent,
la grande question pour moi, c'est de savoir comment représenter visuelle-
ment cette absence.»

"We can only see 5 % of the universe [...] We're working from a model with 95 % of the information missing – so no wonder everybody's acting like they're in the dark. So the big question for me is: how do you visually represent that absence?"

2

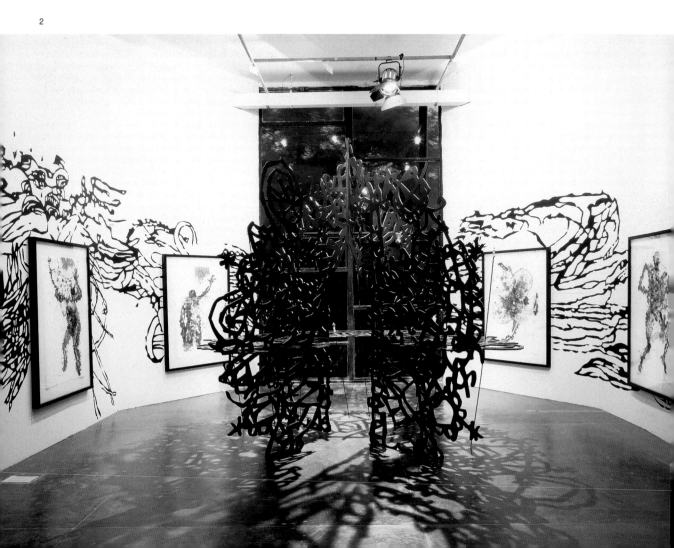

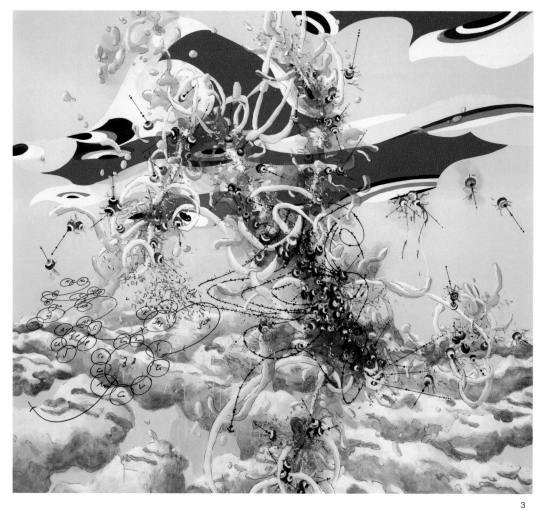

3

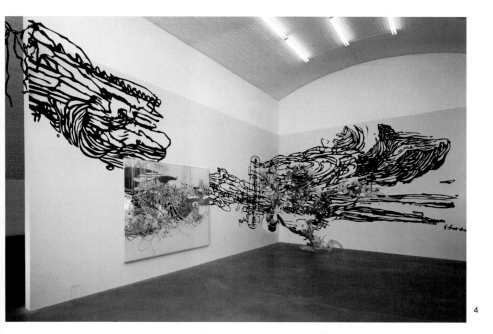

4

Ugo Rondinone

1963 born in Brunnen, lives and works in Zurich, Switzerland, and New York (NY), USA

Ugo Rondinone presents rooms loaded with memory and expectation, in which the concept of an intoxicating Other is celebrated, promising the totality of experience. With atmospheric drama, collectively understandable motifs combined with beguiling sounds evoke clear associations. These romantic moods recall memories and awaken longings. By thematically dealing with the feeling of being torn between addiction and satisfaction, between excess and boredom, he confuses our senses and breaches our space-time feeling. His targets, produced since 1995 and sprayed in cheerful colours, exude such an irresistible attractiveness that they seem like floodgates into a different, abysmal reality. Thus the architecture of the video installation *Roundelay* (2003) depicts a labyrinth of narrative bewilderments: six videos in a hexagonal chamber show a man and a woman walking, apparently at different times, through a desolate high-rise landscape. Due to the positioning of the screens the two people move past one another again and again without ever meeting. We wait in suspense for the meeting, which ultimately never occurs. Because Rondinone provokes certain expectations, his works seem like time spent waiting for something special. Thus the clowns who accompany some of his installations also maintain an attitude of waiting. The passive clown motif, through its inconsistency, strengthens the presentation's tragic character. The artist plays with the cliché that specifies the clown as mediator, and thereby allows the people to laugh at themselves. The idle, impassive clown underlines the masquerade's artificiality and reverses the mechanism: the public is brought up onto the stage.

Ugo Rondinone inszeniert erinnerungs- und erwartungsgeladene Räume, in denen die Vorstellung eines rauschhaft Anderen zelebriert wird, das die Ganzheit des Erlebens verspricht. In atmosphärischer Dichte führen kollektiv verständliche Motive, kombiniert mit verführerischen Geräuschen, zu eindeutigen Assoziationen. Durch diese romantische Stimmung werden Erinnerungen wachgerufen und Sehnsüchte geweckt. Indem er das Hin- und Hergerissensein zwischen Sucht und Sattheit, zwischen Exzess und Langeweile thematisiert, werden die Sinne verwirrt und das Raum-Zeit-Gefühl durchbrochen. Seine seit 1995 entstehenden, in fröhlichen Farben gesprayten Zielscheiben verströmen eine solche Sogwirkung, dass sie wie Schleusen in eine abgründige, andere Realität wirken. So stellt auch die Architektur der Video-Installation *Roundelay* (2003) ein Labyrinth narrativer Verunsicherungen dar: in einer sechseckigen Kammer zeigen sechs Videos, wie je ein Mann und eine Frau in scheinbar unterschiedlichen Zeiten durch eine öde Hochhauslandschaft gehen. Durch die Positionierung der Leinwände bewegen sich die beiden Personen immer aneinander vorbei, ohne sich je zu treffen. Gespannt warten wir auf die Begegnung, die letztlich nie eintritt. Weil Rondinone bestimmte Erwartungen hervorruft, erscheinen seine Arbeiten als Wartezeiten auf das Besondere. So verharren auch die Clowns, die einige seiner Installationen begleiten, in einer abwartenden Haltung. Das Motiv des passiven Clowns bestärkt aufgrund seiner Widersprüchlichkeit den tragischen Charakter der Inszenierung. Der Künstler spielt hierbei mit dem Klischee, das den Clown als Mittler festlegt und dem Menschen ermöglicht, über sich selbst zu lachen. Mit dem untätigen, stumpfen Clown wird die Künstlichkeit der Maskerade unterstrichen und der Mechanismus umgekehrt: Das Publikum wird auf die Bühne geholt.

Ugo Rondinone met en scène des espaces chargés de mémoire et d'attentes dans lesquels est célébrée la conception d'une altérité grisante qui promet la plénitude de l'expérience. Dans une grande densité atmosphérique, des motifs appartenant à la conscience collective, combinés avec des bruitages séduisants, suscitent des associations univoques. Cette ambiance romantique éveille toutes sortes de souvenirs et de langueurs. Avec la thématisation du déchirement entre addiction et satiété, surabondance et ennui, les sens sont brouillés et la notion de temps et d'espace est court-circuitée. Les cibles aux couleurs joyeuses qu'il réalise à la peinture au spray depuis 1995 mobilisent si puissamment l'attention qu'elles font l'effet d'écluses vers une réalité abyssale. Ainsi, l'architecture de l'installation vidéo *Roundelay* (2003) se présente elle aussi comme un labyrinthe d'insécurisations narratives : dans une chambre hexagonale, six vidéos montrent un homme et une femme marchant dans un désert d'immeubles – apparemment à des époques différentes. Du fait du positionnement des écrans, les deux personnages évoluent toujours en passant l'un à côté de l'autre sans jamais se rencontrer. L'on attend avec impatience une rencontre qui finalement n'aura jamais lieu. Dans la mesure où Rondinone suscite certaines expectatives, ses œuvres se présentent comme des temps d'attente d'un événement particulier. Les clowns qui accompagnent certaines installations demeurent eux aussi dans une attitude d'attente. Du fait de son caractère contradictoire, le motif du clown passif renforce le tragique de la mise en scène. L'artiste joue ainsi sur le cliché qui définit le clown comme un médiateur et qui permet à l'homme de rire de lui-même. Le clown inactif et apathique souligne le caractère artificiel de la mascarade et inverse le mécanisme : le public est invité sur scène.

C. E.

SELECTED EXHIBITIONS →
2005 *Zur Vorstellung des Terrors: Die RAF*, KW Institute for Contemporary Art, Berlin **2004** *Nothing Has Changed*, Gruppe Österreichische Guggenheim, Vienna; 54. Carnegie International, Carnegie Museum of Art, Pittsburgh **2003** *Roundelay*, Centre Pompidou, Paris; *Our Magic Hour*, Museum of Contemporary Art, Sydney **2002** *No How On*, Kunsthalle Wien, Vienna; *Drawing Now: Eight Propositions*, The Museum of Modern Art, New York

SELECTED PUBLICATIONS →
2003 *Ugo Rondinone: Our Magic Hour*, Museum of Contemporary Art, Sydney **2001** *Ugo Rondinone: Kiss Tomorrow Goodbye*, Palazzo delle Esposizioni, Rome **2000** *Ugo Rondinone: Guided by Voices*, Kunsthaus Glarus, Galerie für Zeitgenössische Kunst, Leipzig

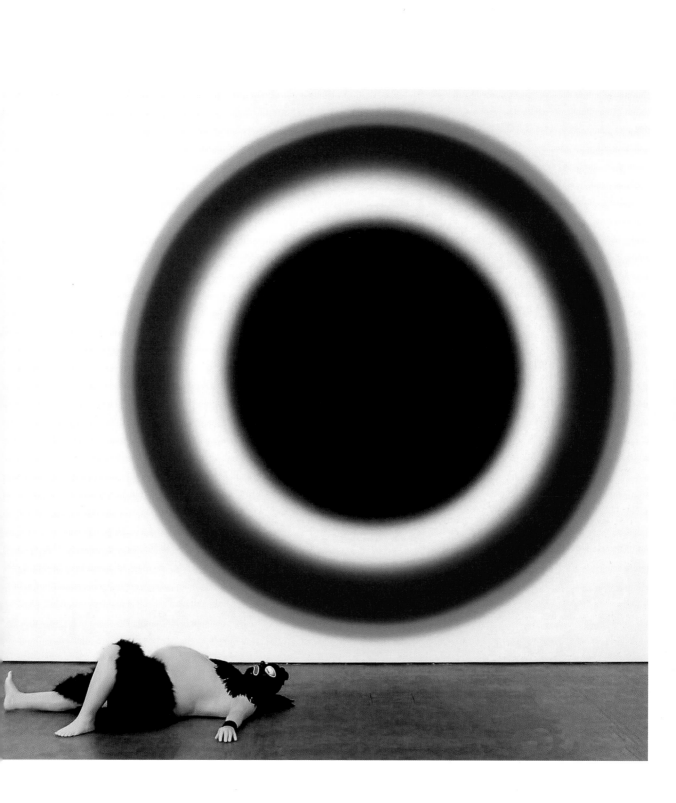

1 Exhibition view, "NO HOW ON", Kunsthalle Wien, Vienna, 2002
2 Exhibition view, "NO HOW ON", Kunsthalle Wien, Vienna, 2002
3 Exhibition view, La Criée centre d'art contemporain, Rennes, 2003

4 **MOONRISE. west. december**, 2004, black polyurethane
99 x 67 x 24 cm

„Es geht darum, dass wir das, woran wir uns erinnern,
nicht unterscheiden können von dem, wonach wir uns sehnen."

«Il s'agit du fait que nous sommes incapables de distinguer entre ce dont
nous nous souvenons et ce à quoi nous aspirons.»

"It is a matter of not being able to distinguish between that, which we remember and that, which we long for."

2

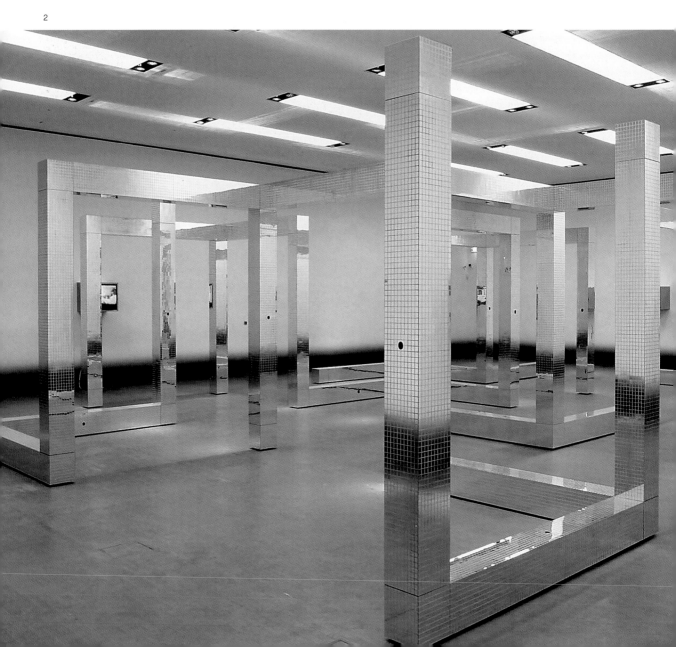

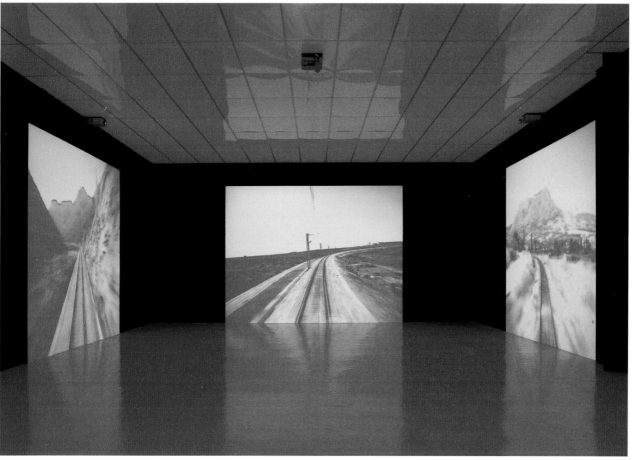

3

4

Thomas Ruff

1958 born in Zell am Hammersbach, lives and works in Düsseldorf, Germany

Every photograph is already a construct; the product of given technical conditions, and of the reproduction of image types and social conventions of perception. Thomas Ruff turns away from the concept of illustrating reality in his photographic works. Often conceived as series, he bases them not only on his own photographs but on other people's material as well. Thus *Zeitungsfotos* (1990/91) is an archive of cut-out newspaper photographs that have been reduced to their purely visual qualities by removing any explanatory text. For the series *Maschinen* (2003) Ruff used large-format glass negatives taken from 1930s and 40s product photography. Unusual for Ruff, this series is thematically related to the works of Bernd and Hilla Becher, in whose photography class he studied at the Düsseldorf Art Academy. However, Ruff's conceptual investigation of the medium of photography includes methods of image appropriation and image editing, and leads to a rejection of any hint of austerity. This becomes visible in the series *Portraits* (1981–2001), which revamps the tradition of New Objectivity in an abrupt manner. These frontal shots of individuals seem beyond any possible communication or interaction with the viewer, and allow fewer conclusions to be drawn about the depicted subjects. In the series *Nudes* (1999/2000) Ruff takes up the tradition of nude photography using digitally manipulated hardcore sex photos from the Internet. Even with minimal clarity, however, the finished pictures permit maximum readability: despite soft focus and editing, the language of pornography is also retained.

Jede Fotografie ist bereits eine Konstruktion, Ergebnis technischer Gegebenheiten ebenso wie Reproduktion von Bildtypen und gesellschaftlichen Wahrnehmungskonventionen. In seinen fotografischen Arbeiten wendet sich Thomas Ruff gegen die Vorstellung einer Abbildung von Realität. Ausgangspunkt seiner häufig als Werkgruppen konzipierten Arbeiten sind eigene Aufnahmen ebenso wie fremdes Material. So stellt *Zeitungsfotos* (1990/91) ein Archiv aus ausgeschnittenen Zeitungsaufnahmen dar, die, ohne den erläuternden Text, auf ihre reine Bildlichkeit reduziert werden. Für die Serie *Maschinen* (2003) verwendete Ruff großformatige Glasnegative aus der Produktfotografie der dreißiger und vierziger Jahre. Diese Serie zeigt eine für Ruff ungewöhnliche thematische Nähe zu den Arbeiten von Bernd und Hilla Becher, in deren Fotografieklasse an der Düsseldorfer Kunstakademie er studierte. Ruffs konzeptuelle Hinterfragung des Mediums Fotografie schließt jedoch Methoden der Bildaneignung und -bearbeitung mit ein und führt zu einer Zurückweisung jeglichen Gestus von Nüchternheit. Dies wird in der Serie *Portraits* (1981–2001) sichtbar, die der Tradition der Neuen Sachlichkeit eine schockhaft anmutende Aktualisierung verleihen. Die Frontalaufnahmen einzelner Personen scheinen außerhalb der Möglichkeit von Kommunikation und Interaktion mit dem Betrachter zu stehen und lassen wenige Vermutungen über die Dargestellten zu. In der Serie *Nudes* (1999/2000) greift Ruff die Tradition der Aktfotografie anhand von digital verfremdeten Hardcore-Sexfotos aus dem Internet auf. Die fertigen Bilder lassen bei minimaler Klarheit doch maximale Lesbarkeit zu: Die Sprache der Pornografie bleibt auch bei Unschärfen und Überarbeitungen erhalten.

Résultat de données techniques et reproduction de types iconiques et de perceptions sociales convenues, toute photographie est déjà une construction. Dans ses œuvres photographiques, Thomas Ruff se dresse contre l'idée d'une représentation de la réalité. Pour ses œuvres souvent conçues dans le cadre de séries, il part de prises de vues réalisées par lui-même aussi bien que par d'autres. *Zeitungsfotos* (1990/91) se présente comme un fonds d'archives constitué de photos de journaux dépourvues de texte explicatif et réduites de ce fait à leur pure fonction iconique. Pour la série *Maschinen* (2003), Ruff s'est servi de négatifs sur verre grand format issus de la photographie de produits des années trente et quarante. Elles dénotent une parenté thématique, inhabituelle chez Ruff, avec les œuvres de Bernd et Hilla Becher, dont il a suivi les cours de photographie à l'Académie des Beaux-Arts de Düsseldorf. Chez Ruff, l'approche critique du médium photographique inclut néanmoins des méthodes d'appropriation et de manipulation de l'image et conduit à un refus de toute sobriété, comme le montre clairement la série des *Portraits* (1981–2001), qui confèrent à la tradition de la Nouvelle Objectivité une actualité relevant de l'effet de choc. Les prises de vue frontales de personnes isolées semblent exclure toute possibilité de communication et d'interaction avec le spectateur et ne permettent que de rares conclusions sur les modèles. Dans la série *Nudes* (1999/2000), Ruff s'inscrit dans la tradition de la photographie de nus en faisant appel à des photos pornographiques trouvées sur Internet et détournées par manipulation numérique. Tout en présentant une netteté minimale, les images achevées offrent néanmoins une lisibilité maximale : le vocabulaire de la pornographie se maintient en dépit des flous et des remaniements.

E. K.

SELECTED EXHIBITIONS →
2004 *German Art. Deutsche Kunst aus amerikanischer Sicht*, Städelmuseum Frankfurt, Frankfurt/Main; *German Art Now*, Saint Louis Art Museum **2003** *Cruel and Tender*, Tate Modern, London, Museum Ludwig, Cologne; *Nudes* und *Maschinen*, kestnergesellschaft, Hanover; Busan Metropolitan Art Museum **2002** *Interieurs – Porträts – Häuser*, Museum Folkwang Essen, Städtische Galerie im Lenbachhaus, Munich **2000** *l. m. v. d. r.*, Museum Haus Esters/Haus Lange, Krefeld

SELECTED PUBLICATIONS →
2004 *Das Bild des Menschen in der Fotografie*, Berlin **2003** *Thomas Ruff. Erste Maschinen*, Staatliche Kunsthalle Baden-Baden, Baden-Baden; *Machines/Maschinen*, kestnergesellschaft, Hanover **2001** *Thomas Ruff*, Baden-Baden **2000** *l. m. v. d. r.*, Krefeld

1 **Substrat 18 II**, 2003, C-print, 217 x 180 cm
2 **nude ta11**, 2004, C-print, 110 x 150 cm
3 **jpeg pp01**, 2004, C-print, 244 x 188 cm

„Die Fotografie täuscht etwas vor. Man sieht alles, was sich vor der Kamera befindet, und doch gibt es da immer noch etwas anderes."

« La photographie fait semblant. On voit tout ce qui est devant l'objectif, mais il y a toujours quelque chose en dehors de ce qui est montré. »

"Photography pretends. You can see everything that's in front of the camera, but there's always something beside it."

2

Tom Sachs

1966 born in New York (NY), lives and works in New York (NY), USA

Bootlegging bricoleur Tom Sachs brings vulgarity and violence to the sheltered world of luxury goods and designer living. His object sculptures of the 1990s hint at a possible global brand meltdown in which classy jewellers Tiffany might peddle fast food value meals, while fashion houses would kit out war zones with chic label hand grenades and produce instruments of death such as *Chanel Guillotine (Breakfast Nook)* (1998) and *Prada Death Camp* (1999). Sachs is complicit in the ethical concerns he raises by manufacturing his own range of commodities exclusively for sale on the art market, which could otherwise be bought new and cheaper. As well as exploiting McDonald's or Hermès for his own macroeconomic, artistic contraband, Sachs has begun to target the twinned histories of Modern art and architecture, reinventing Duchamp's *Fountain* in a variety of pieces involving toilets or urinals, and building 1:25 scale models of Le Corbusier's Unité d'Habitation tower block and the Villa Savoye from humble, white polystyrene boards and glue. These latter sculptures form part of the crazed installation *Nutsy's World* (2002), painstakingly built over two years by Sachs and his studio of assistants Allied Cultural Prosthetics. Connected by a remote-controlled car racetrack, this deconstructivist act of town planning juxtaposes the colourless Le Corbusier remakes with a miniature ghetto and a drive-thru sculpture park, signifying a crossroads where faux-naïve art meets International Style and American pipe dreams crash head-on with the ideals of European high culture.

Mit seinen gebastelten Nachbildungen bringt Tom Sachs Vulgarität und Gewalt in die Welt der Luxuswaren und Designermöbel. Seine Objektskulpturen aus den neunziger Jahren weisen auf einen möglichen globalen Marken-Meltdown hin, bei dem Nobeljuwelier Tiffany Fastfood-Gerichte verhökern könnte, während Modehäuser vielleicht Kriegsgebiete mit schicken Markenhandgranaten ausstaffieren und Werkzeuge des Todes wie die *Chanel Guillotine (Breakfast Nook)* (1998) oder das *Prada Death Camp* (1999) produzieren würden. Sachs macht sich zum Komplizen der ethischen Belange, die er anspricht, wenn er seine eigene Warenkollektion exklusiv zum Vertrieb durch den Kunstmarkt produziert, die man andernorts auch neuwertig und vor allem preiswerter erstehen könnte: eine Art Ausbeutung von McDonald's oder Hermès für seine eigene Makroökonomie in Gestalt künstlerischer Schmuggelware. Gleichzeitig begann Sachs damit, sich auf die parallel ablaufende Geschichte der modernen Kunst und Architektur zu konzentrieren. So erfand er Duchamps *Springbrunnen* neu, indem er ihn in eine Vielzahl von aus Toiletten und Pissoirs bestehenden Arbeiten umwandelte und Modelle von Le Corbusiers Wohnblock Unité d'Habitation und der Villa Savoye im Maßstab 1:25 aus schlichten weißen Styroporplatten und Kleber anfertigte. Letztgenannte Skulpturen sind Teil der wirren Installation *Nutsy's World* (2002), die im Lauf von zwei Jahren in Sachs' Werkstatt Allied Cultural Prosthetics entstand. Verbunden über eine Spielzeugautorennbahn, werden in diesem dekonstruktivistischen Akt der Stadtplanung die farblosen Le-Corbusier-Nachbildungen einem Minighetto und einem Durchfahrskulpturenpark gegenübergestellt, an deren Kreuzung pseudonaive Kunst auf den Internationalen Stil trifft und amerikanische Hirngespinste frontal mit den Idealen der europäischen Hochkultur kollidieren.

Le bricoleur-bootlegger Tom Sachs infuse la violence et la vulgarité dans le monde préservé des articles de luxe et du style de vie. Ses sculptures-objets du milieu des années quatre-vingt-dix renvoient à la possibilité d'une déchéance des marques globale dans laquelle le joaillier de luxe Tiffany vendrait de repas fast-food au rabais, pendant que les grands couturiers équiperaient les zones de guerre en grenades customisées et produiraient des instruments de mort comme la *Chanel Guillotine (Breakfast Nook)* (1998) et le *Prada Death Camp* (1999). Sachs se rend complice des considérations éthiques qu'il soulève en réservant au marché de l'art sa propre ligne d'articles, que l'on achèterait sinon moins cher ailleurs. Tout en exploitant McDonald's ou Hermès pour sa propre contrebande artistique macroéconomique, Sachs a commencé à prendre en ligne de mire les histoires mêlées de l'art et de l'architecture modernes, réinventant la *Fontaine* de Duchamp par le truchement d'une série de pièces faisant appel à des urinoirs ou à des cuvettes de WC, et construisant des maquettes au 1/25ème de l'Unité d'Habitation et de la Villa Savoye de Le Corbusier en panneaux de polystyrène blanc bon marché. Ces dernières font partie de la délirante installation *Nutsy's World* (2002), minutieusement construite pendant deux ans par Sachs et son équipe d'assistants regroupée dans l'atelier Allied Cultural Prosthetics. Relié par un circuit automobile télécommandé, cet acte déconstructiviste de planification urbaine juxtapose les artefacts incolores de Le Corbusier, un ghetto miniature et un parc de sculptures accessible en voiture, matérialisant ainsi un carrefour où se produisent la rencontre entre l'art faux-naïf et le style international, et la collision frontale entre les chimères américaines et les idéaux européens de haute culture.

O. W.

SELECTED EXHIBITIONS →
2004 *Sculptural Sphere*, Sammlung Goetz, Munich **2003** *Nutsy's*, Deutsche Guggenheim, Berlin; *Materials, Metaphors, Narratives: Work by Six Contemporary Artists*, Albright-Knox Art Gallery, Buffalo **2002** 25. Bienal de São Paulo; *Five by Five: Contemporary Artists on Contemporary Art*, Whitney Museum of American Art at Philip Morris, New York; *2002*, Deste Foundation, Athens **2001** *Art at the Edge of the Law*, The Aldrich Contemporary Art Museum, Ridgefield

SELECTED PUBLICATIONS →
2004 *Sculptural Sphere*, Sammlung Goetz, Munich **2003** *Nutsy's*, Solomon R. Guggenheim Museum, New York **2001** *Art at the Edge of the Law*, The Aldrich Contemporary Art Museum, Ridgefield; *Luci in Galleria. Da Warhol al 2000. Gian Enzo Sperone: 35 Years of Exhibitions between Europe and America*, Turin **2000** *American Bricolage*, Sperone Westwater, New York

1 **Nutsy's 1:1 McDonald's**, 2001, wood, metal, paint, soda, hamburger, floor tiles, heat lamp, flourescent lights, fryalator
2 **Skull**, 2003, foamcore, hot glue

3 **Barcelona Pavilion**, 2002, metal, wood, foamcore, hot glue, hardware
4 **Nutsy's**, 2002, installation views

„Die Wirkung der Verwendung von Marken – in meinem Fall aus dem Modebereich – und ihrer Vermischung mit einer Ikonografie der Gewalt besteht in der Verschmelzung zweier Dinge, die so ein drittes bilden."

«Le pouvoir d'utiliser des marques – dans mon cas, celles de la mode – et de les associer à une iconographie violente consiste à fusionner deux choses pour en produire une troisième.»

"The power of using brands – in my case, from fashion – and mixing it up with violent iconography lies in merging two things together to form a third."

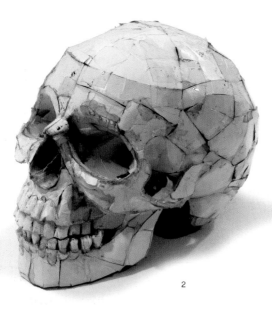

2

Anri Sala

1974 born in Tirana, Albania, lives and works in Paris, France

Anri Sala trains his focus on trivial details of everyday life to create films and photographs that capture the elusive and fragmentary nature of individual experience, national identity or social history. *Intervista – Finding the Words* (1998) appears to fit into the conventions of documentary film making: having found a film recording his mother's political past in communist Albania, Sala attempts to reconstruct the missing soundtrack, interviewing his mother's friends and recruiting deaf children to find the missing words through lip reading. But the complex relationships his film reveals: between the artist and his mother; her documented past and her memories of it; personal and official history; define it instead as a poetic study of the transposition of experience as time passes. The question of artistic intention and, by extension, personal power, are played out in films such as *Ghostgames* (2002) or *Mixed Behaviour* (2004) which demonstrate its limitations in the face of natural events beyond the individual's control. Sometimes there is synchrony, but there is also conflict, and Sala reveals the aesthetic qualities of both. The intersection of politics and aesthetics is the subject of *Dammi i Colori* (2003) which tells the story of the Mayor of Tirana's decision to paint the depressing facades of the city's housing projects in bright colours. The optimistic narrative is only partially supported by the alternately dispiriting and hopeful images scanning the buildings and the film resonates with unresolved questions. We are left to wonder what deeper troubles lie beneath the renovated surfaces of Albania's failed socialist past.

Das Interesse von Anri Sala gilt den trivialen Details des Alltags, und seine Filme und Videos erfassen das trügerische und fragmentarische Wesen individueller Erfahrung, nationaler Identität und gesellschaftlicher Geschichte. Der Film *Intervista – Finding the Words* (1998) scheint die Bedingungen eines Dokumentarfilms zu erfüllen. Nachdem er zufällig auf einen Film gestoßen war, der die politische Vergangenheit seiner Mutter im kommunistischen Albanien aufzeichnete, versuchte Sala die fehlende Tonspur zu rekonstruieren, indem er Freunde seiner Mutter interviewte und taube Kinder engagierte, die durch Lippenlesen die fehlenden Wörter ermitteln sollten. Aber der Film enthüllt auch die komplexen Beziehungen zwischen dem Künstler und seiner Mutter, zwischen ihrer dokumentierten Vergangenheit und ihren eigenen Erinnerungen sowie zwischen persönlicher und offizieller Geschichte. Damit lässt sich die Arbeit als poetische Studie über die Veränderung von Erfahrungen im Wandel der Zeit definieren. In Filmen wie *Ghostgames* (2002) oder *Mixed Behaviour* (2004) geht es um Fragen künstlerischer Absicht und, darüber hinaus, persönlicher Macht, deren Grenzen sich angesichts von Naturereignissen zeigen, die sich der Kontrolle des Einzelnen entziehen. Zuweilen liegt ein Synchronismus vor, dennoch besteht auch ein Konflikt, wobei Sala die ästhetischen Eigenschaften beider Elemente zeigt. Der Schnittpunkt von Politik und Ästhetik ist das Thema des Films *Dammi i Colori* (2003), der von der Entscheidung des Bürgermeisters von Tirana erzählt, die deprimierenden Fassaden der städtischen Sozialwohnungen leuchtend bunt streichen zu lassen. Die optimistische Stimmung der Geschichte wird nur zum Teil von den abwechselnd desillusionierenden und hoffnungsvollen Bildern der Gebäude unterstützt, während die im Film gestellten Fragen nach den tieferen Problemen unter der renovierten Oberfläche von Albaniens gescheiterter sozialistischer Vergangenheit letztlich offen bleiben.

Anri Sala concentre son attention sur des détails ordinaires de la vie quotidienne pour créer des films et des photographies qui captent la nature éphémère et fragmentaire de l'expérience individuelle, de l'identité nationale ou de l'histoire sociale. *Intervista – Finding the Words* (1998) semble entrer dans les conventions du film documentaire : après avoir trouvé un film traitant du passé politique de sa mère dans l'Albanie communiste, Sala s'efforce d'en reconstituer la bande son manquante en réalisant des interviews d'amis de sa mère et en engageant des enfants sourds pour lire sur les lèvres les mots manquants. Mais la complexité des correspondances révélées par ce film – entre l'artiste et sa mère, entre son passé documenté et les souvenirs qu'elle en a, entre l'histoire personnelle et l'histoire officielle – en font plutôt une étude poétique de la traduction de l'expérience au fil du temps qui passe. La question du propos artistique, et partant du pouvoir personnel, est illustrée par des films comme *Ghostgames* (2002) ou *Mixed Behaviour* (2004), qui en démontrent les limites face à des événements naturels qui échappent à tout contrôle individuel. Parfois il y a synchronie, mais on y trouve aussi le conflit, et Sala révèle les qualités esthétiques de ces deux possibilités. L'intersection entre la politique et l'esthétique est au centre de *Dammi i Colori* (2003), qui relate la décision du maire de Tirana de repeindre en couleurs vives les façades déprimantes des habitations sociales de la ville. Le récit optimiste n'est que partiellement soutenu par des images tantôt décourageantes, tantôt porteuses d'espoir, qui balaient les immeubles, et le film résonne de questions sans réponses. Le spectateur est laissé à sa perplexité quant aux troubles plus profonds qui sous-tendent les surfaces rénovées de l'échec du socialisme en Albanie. K. B.

1 **Long Sorrow**, video stills, 2005, DVD-projection, PAL, colour, stereo, 12 min. 57 sec.

2 **Dammi i Colori**, 2003, video projection with sound, 15 min. 24 sec. loop, video still

3 **Blindfold**, 2002, DVD-projection, dolby sound, 15 min., video stills

„Vielleicht halte ich daran fest, Dinge sichtbar zu machen, die ich für bedeutsam halte, die wir in unserer heutigen Schnelllebigkeit aber nicht mehr wahrnehmen können und deshalb vergessen und zum Verschwinden bringen."

«Il se peut que je persiste à rendre visibles des choses que je juge signifiantes et que notre vie trépidante nous empêche d'apprécier, que nous oublions et laissons disparaître.»

"Maybe I am insisting on making visible things that I find meaningful, which in our rush, we fail to appreciate, forget and let disappear."

2

Wilhelm Sasnal

1972 born in Tarnów, lives and works in Tarnów and Warsaw, Poland

"The world is everything that is the case" – this famous formulation was once coined by Ludwig Wittgenstein to open his investigations, and the world in Wilhelm Sasnal's pictures also seems enchanted in related equanimity. In his painting he reveals a wilful "positivism" that seeks no initial logical order, but instead interprets the world by its appearance in pictures. Sasnal's emphatically barren painting style, often black and white and reduced to contrasts, is based on definite but widely divergent contexts. Whether these be record labels, classic photographs, magazines, school or children's books, sports, porn, comics, advertising or architecture – Sasnal's characteristically desolate paintings contain a comprehensive recapitulation of reality, which, from the domestic refrigerator to the nuclear threat, concerns everything contemporary. Often the sources cannot be directly made out, and Sasnal purposely makes them visually vague and undefined. Kim Gordon from the pop group Sonic Youth dissolves in motes of light in *Untitled (Kim Gordon)* (2002). In *Shadow* (2003) the image's indecipherability becomes the painting's immediate topic, and in *Untitled (Chicago)* (2003), an abstract composition reveals itself as a cityscape. Sasnal works with various fragmentation strategies, with an extreme view for details, and with elimination and reduction. Using these methods he transforms a given image (assimilating it in a painterly way), until he has achieved a density that is as succinct as it is relevant. These paintings seem simple, but in fact they are condensations: substrata of a complex and multifaceted appropriation strategy for which Sasnal invents new interpretations again and again.

„Die Welt ist alles, was der Fall ist" – so hatte Ludwig Wittgenstein den Ausgangspunkt seiner Untersuchungen formuliert und in verwandtem Gleichmut scheint die Welt auch in Bildern von Wilhelm Sasnal gebannt. Er legt in seiner Malerei einen eigenwilligen, „Positivismus" an den Tag, der keine logische Ordnung sucht, sondern die Welt über ihr Auftauchen in Bildern interpretiert: Sasnals betont karge, oft schwarz-weiße und auf Kontrast reduzierte Malerei basiert auf Vorlagen bestimmter, aber weit gestreuter Kontexte. Ob Plattenlabel, Fotoklassiker, Magazine, ob Schul- und Kinderbücher, Sport, Porno, Comic, Werbung oder Architektur – Sasnals charakteristisch karge Bilder enthalten eine umfassende Realitätsauflistung, die vom heimischen Kühlschrank bis zur atomaren Bedrohung alles Gegenwärtige betrifft. Oft sind die Quellen nicht direkt entzifferbar, werden von Sasnal visuell sogar regelrecht ins Vage, Offene gestoßen: Kim Gordon von der Popgruppe Sonic Youth ist in Lichtflecken aufgelöst (*Untitled [Kim Gordon]*, 2002), in *Shadow* (2003) wird die Unkenntlichkeit des Abbilds unmittelbares Bildthema, eine abstrakte Komposition entpuppt sich als Stadtansicht: *Untitled (Chicago)*, 2003. Sasnal arbeitet mit unterschiedlichen Strategien der Fragmentierung, mit extremer Detailsicht, mit Auslöschung und Reduktion, durch die er ein vorgegebenes Bild so weit (malerisch sich an-)verwandelt, bis er es zu gleichermaßen lapidarer wie treffender Dichte getrieben hat. Diese Bilder wirken einfach – tatsächlich sind es Kompressionen, Substrate einer komplexen und vielgestaltigen Aneignung, für die Sasnal immer wieder neue Übersetzungsmuster erfindet.

« Le monde est tout ce qui arrive » – tel est le fondement global et laconique à partir duquel Ludwig Wittgenstein a formulé ses analyses, et c'est avec le même détachement que la peinture de Wilhelm Sasnal semble vouloir capter le monde. Dans ses tableaux, l'artiste révèle un « positivisme » très personnel qui ne cherche aucun ordre logique, mais qui interprète le monde comme sa manifestation sous forme d'images. Résolument aride, souvent réduite au noir et blanc et aux contrastes, la peinture de Sasnal repose sur des modèles issus de contextes particuliers, mais aussi très éclectiques. Qu'ils s'attachent aux labels de maisons de disques, aux classiques de la photographie, aux magazines, aux manuels scolaires ou aux livres d'enfants, au monde du sport, de la pornographie, de la bande dessinée, de la publicité ou de l'architecture, ses tableaux à l'âpreté très caractéristique contiennent le vaste inventaire d'une réalité qui, du réfrigérateur familier à la menace nucléaire, s'étend à toutes les choses de l'époque contemporaine. Souvent les sources sont difficilement décryptables, voire délibérément reléguées dans le flou : dans *Untitled (Kim Gordon)* (2002), Kim Gordon, du groupe Sonic Youth, se résout en taches de lumières, dans *Shadow* (2003), l'impossibilité d'identifier le sujet devient elle-même le sujet du tableau, et dans *Untitled (Chicago)* (2003), une composition abstraite se révèle être une vue urbaine. Sasnal utilise différentes stratégies de la fragmentation, de l'approche extrême du détail, de la suppression et de la réduction pour transformer (et s'approprier picturalement) une image donnée et la pousser jusqu'à un point de densité aussi lapidaire que pertinent. Si ses tableaux laissent une impression de simplicité, ils sont en fait des compressions, substrats d'une appropriation complexe et multiforme pour laquelle l'artiste invente sans cesse de nouveaux schémas de traduction. J. A.

SELECTED EXHIBITIONS →
2005 *The Triumph of Painting*, The Saatchi Gallery, London
2003 Westfälischer Kunstverein, Münster; Kunsthalle Zürich; *Interventions*, Museum van Hedendaagse Kunst, Antwerp
2002 *Painting on the Move*, Kunsthalle Basel, Basle; 4. Gwangju Biennale; *Urgent Painting*, Musée d'Art Moderne de la Ville de Paris

SELECTED PUBLICATIONS →
2004 *MATRIX 213: Some Forgotten Place*, Berkeley Art Museum, Berkeley **2003** *Night Day Night*, Ostfildern-Ruit; *Dissimile. Prospektionen: Junge europäische Kunst*, Staatliche Kunsthalle Baden-Baden, Baden-Baden **2002** *Urgent Painting*, Musée d'Art Moderne de la Ville de Paris, Paris; *Painting on the Move*, Kunsthalle Basel, Basle; *UProject 1. Pause Realization*, Gwangju; *Vitamin P*, London

1 **Untitled (Black Thing/Bromba)**, 2002, oil on canvas, 180 x 135 cm
2 **Zawa srod**, 2004, oil on canvas, 85 x 100 cm
3 **Untitled (Kill This Love 4)**, 2002, ink on paper, 30 x 42 cm
4 **Untitled**, 2004, oil on canvas, 150 x 190 cm

„Ich male Bilder über Dinge, die ich nicht weiß, die sich nicht präzise in Worte fassen lassen. Die Bilder sehen aus, wie sie aussehen, aber die Assoziationen und Anspielungen verleihen ihnen etwas Geheimnisvolles. Das ist ein bisschen psychedelisch."

« Je peins des tableaux sur des choses que je ne connais pas, qu'on ne peut exprimer en paroles de manière concise. Les tableaux sont ce qu'ils sont, mais leurs associations et insinuations leur confèrent un mystère. C'est quelque chose de psychédélique. »

"I am painting pictures about things that I do not know, that cannot be put concisely into words. The pictures look the way they look, but their associations and insinuations lend mystery. It's a kind of psychedelic thing."

2

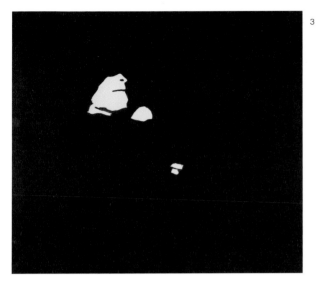

3

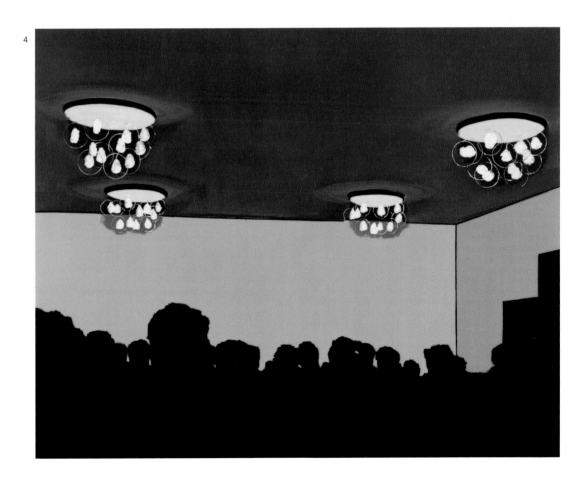

4

Jenny Saville

1970 born in Cambridge, lives and works in London, UK

Jenny Saville paints intimate portraits, self-portraits and corporal landscapes on a billboard scale. Working steadily on canvases for years at a time, some measuring over four meters wide, she sculpts the oil paint into living mounds of flesh, often rendering herself implausibly obese or scarifying her painted skin with handwriting. Elsewhere, human form is reduced to cuts of meat by lines of demarcation scored into the surface around each limb or protuberance, as in a butcher's shop or a plastic surgeon's operating theatre. By studying anatomical journals and live reconstructive surgery, Saville gained an understanding of excess fat and how the body could be manipulated or moulded from within. Her fleshy vistas often appear as though an unseen hand was intervening inside a breast or stomach cavity and for her collaboration with fashion photographer Glen Luchford (*Closed Contact*, 2002) she performs her own bodily reconfigurations and disfigurements while smeared against a pane of glass. Responses to actual violence and pain can be seen in images of a bloodied woman gripped from behind, *Pause* (2002/03), and the stitched, bruised face of *Knead* (1995) inspired by photographs of a Palestinian suicide bombing in Israel and the aftermath of aesthetic surgery respectively. A conceptual, as well as visceral artist, Saville's feminist interrogation of art history's predatory male painters recasts sebaceous ladies à la Rubens as unromanticised looming hulks, and replaces the traditional reclining nude with a transsexual (*Matrix*, 1999) or a pig torso, in *Host* (2000) and *Suspension* (2002/03).

Jenny Saville malt intime Porträts, Selbstbildnisse und Körperlandschaften in riesigen Plakatformaten. An einigen Bildern, die zum Teil vier Meter breit sind, arbeitet sie stetig über mehrere Jahre hinweg, wobei sie die Ölfarbe zu lebenden Fleischbergen formt und sich selbst häufig als unglaublich fettleibig darstellt oder ihrer gemalten Haut Narben in Form ihrer eigenen Handschrift zufügt. An anderer Stelle reduziert sie wie in einem Metzgerladen oder im Operationssaal für plastische Chirurgie die menschliche Form durch Markierungslinien auf der Oberfläche jedes Körperteils und jeder Wölbung auf bloße Fleischschnitte. Durch das Studium anatomischer Fachzeitschriften und die Beobachtung der plastischen und Wiederherstellungschirurgie vor Ort hat sich Saville ihr Wissen über Fettpolster und die Manipulations- beziehungsweise Verformungsmöglichkeiten des Körpers von innen angeeignet. Ihre fleischigen Ansichten wirken häufig, als griffe eine unsichtbare Hand in die Brust- oder Bauchhöhle ein. Für ihre Zusammenarbeit mit dem Modefotografen Glen Luchford (*Closed Contact*, 2002) vollzieht sie gegen eine Glasscheibe gepresst ihre eigene körperliche Neugestaltung und Deformation. Reaktionen auf gegenwärtige Gewalt und Schmerz lassen sich ablesen im Bild einer von hinten gepackten blutigen Frau in *Pause* (2002/03), ebenso wie in *Knead* (1995), das ein genähtes, geschwollenes Gesicht zeigt, zu dem Fotografien eines palästinensischen Selbstmordanschlags in Israel beziehungsweise die Folgen einer Schönheitsoperation die Anregung gaben. In den feministischen Befragungen der räuberischen männlichen Maler der Kunstgeschichte durch die Konzept- und Eingeweidekünstlerin Saville werden die beleibten Rubensdamen zu unromantischen, bedrohlichen Rümpfen, während der traditionelle liegende Akt durch einen Transsexuellen (*Matrix*, 1999) oder einen Schweinetorso in *Host* (2000) und *Suspension* (2002/03) ersetzt wird.

Jenny Saville peint des portraits et autoportraits intimes et des paysages corporels dans des dimensions tenant du panneau publicitaire. Travaillant régulièrement pendant des années sur chaque toile, certaines mesurant plus de quatre mètres de large, elle sculpte la peinture à l'huile pour en faire des monticules de chair vivante, se rendant souvent improbablement obèse ou scarifiant sa peau couverte d'écritures. Dans d'autres œuvres, la forme humaine est réduite à des tranches de viande par des lignes de séparation incisées dans la surface autour de chaque membre ou protubérance, comme dans une boucherie ou un bloc opératoire de chirurgie esthétique. Ayant étudié des revues d'anatomie et la chirurgie réparatrice in vivo, Saville en a tiré une compréhension des excès de graisse et de la manière dont le corps pourrait être manipulé ou moulé de l'intérieur. Ses vues charnelles se présentent souvent comme si une main invisible était à l'œuvre à l'intérieur d'un sein, d'une cavité stomacale, et pour sa collaboration avec le photographe de mode Glen Luchford (*Closed Contact*, 2002), elle exécute ses propres reconfigurations corporelles et défigurations étalée sur une plaque de verre. Les images d'une femme ensanglantée agrippée par derrière dans *Pause* (2002/03) peuvent être considérées comme une réponse à une violence et une souffrance véritables, de même que le visage contusionné de *Knead* (1995), inspiré par les photographies respectivement d'un attentat suicide palestinien en Israël et des suites d'une intervention chirurgicale. Artiste aussi viscérale que conceptuelle, son questionnement féministe des peintres prédateurs masculins de l'histoire de l'art réinterprète les femmes sébacées à la Rubens en mastodontes dressés aussi peu romantiques que possible, et remplace le traditionnel nu couché par un transsexuel (*Matrix*, 1999) ou un torse de porc (*Host*, 2000, et *Suspension*, 2002/03). O. W.

SELECTED EXHIBITIONS →
2003 *Pittura/Painting – From Rauschenberg to Murakami 1964–2003*, 50. Biennale di Venezia, Venice; *The Nude in 20th-Century Art*, Kunsthalle in Emden, Arken Museum for Moderne Kunst **2001** *Narcissus – 20th-Century Self-Portraits*, Scottish National Portrait Gallery, Edinburgh; *Great British Paintings From American Collections*, Yale Center for British Art, New Haven **2000** *Ant Noises II*, The Saatchi Gallery, London; *Ant Noises*, The Saatchi Gallery, London

SELECTED PUBLICATIONS →
2002 *Jenny Saville & Glen Luchford: Closed Contact*, Gagosian Gallery, London **2001** *Ant Noises*, The Saatchi Gallery, London; *Art and Feminism*, London; *Great British Paintings from American Collections*, Yale Center for British Art, New Haven **2000** *Territories*, Gagosian Gallery, New York

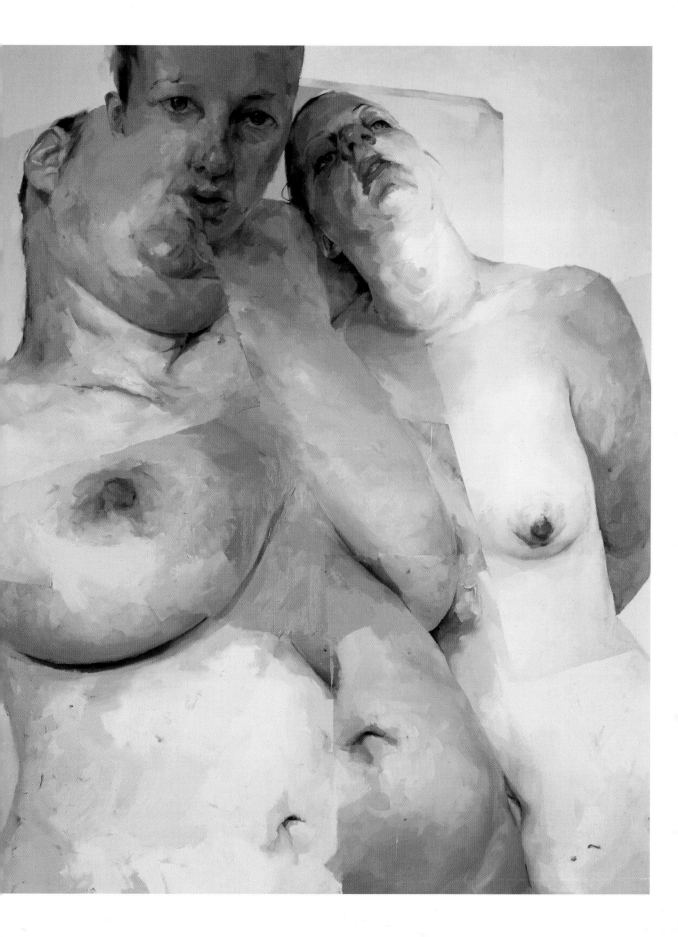

1 **Ruben's Flap**, 1999, oil on canvas, 304.8 x 243.8 cm
2 **Reverse**, 2003, oil on canvas, 213 x 243.9 cm

3 **Untitled (Paint Study)**, 2003/04, oil on watercolour paper, 152 x 121.5 cm
4 **Matrix**, 1999, oil on canvas, 213.4 x 304.8 cm

„Ich verwende meinen Körper als Requisite, so als stellte ich mir selbst meinen eigenen Körper zur Verfügung. Somit wird das Fleisch zu einer Art Material."

« J'utilise mon corps comme accessoire. C'est comme si je me prêtais mon propre corps. Ainsi la chair devient un matériau. »

"I use my body as a prop. It's like loaning my body to myself. So the flesh becomes like a material."

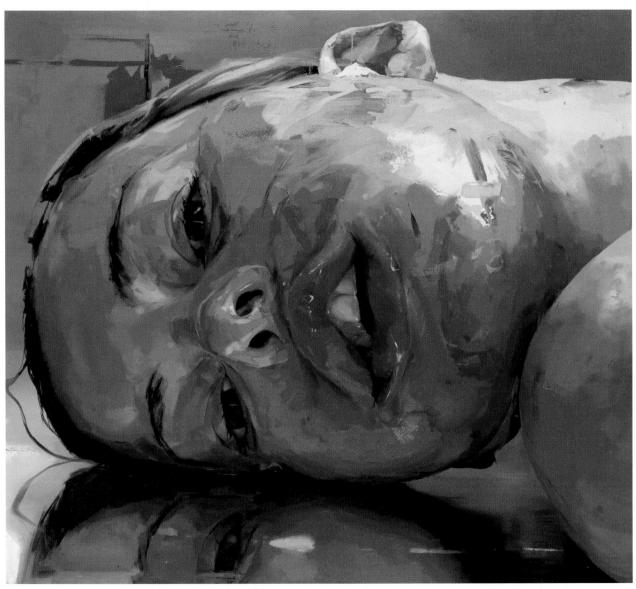

2

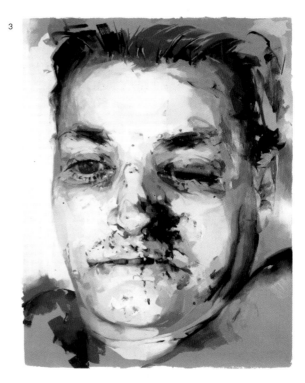

3

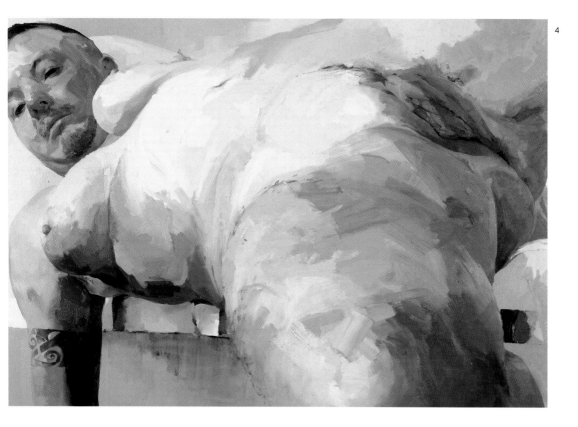

4

Thomas Scheibitz

1968 born in Radeburg, lives and works in Berlin, Germany

Thomas Scheibitz's paintings teeter at the brink of legibility. Realistic forms – a house, a flower, a bird – are lodged between flat planes of colour, sharp outlines and patchy areas that render them almost unrecognizable and establish a tense exchange between abstraction and realism. The space they describe does not have an illusionistic depth but rather a conceptual breadth of allusion, encouraging free association and preventing any single reading from adhering. Scheibitz's sculptural objects, usually exhibited alongside the paintings, translate these questions into three dimensions. These hybrid objects, which could be experimental architectural models or maquettes of a multi-dimensional reality, do not concern themselves with material or production values, but rather with a concentration of geometry and colour which finds echoes in the paintings. Visual aids or diagrammatic methods come under scrutiny in a series of paintings and objects (*Brot & Spiele*, 2004), which resemble maps, sundials or board games. *Sundial* (2004) could be a sociological pie chart, each segment filled in a different colour, but the descriptive information necessary to determine its meaning is blanked out. Scheibitz refers to a visual world where a three dimensional reality (landscape, interior, still life) no longer dominates but simply exists alongside a barrage of other visual material in magazines, television, computer screens. His paintings and objects present a distilled compound of this visual information, representations of representations perhaps, that deny any hierarchy between an urban landscape and a computer generated map.

Die Gemälde von Thomas Scheibitz bewegen sich am Rand der Lesbarkeit. Realistische Formen – ein Haus, eine Blume, ein Vogel – sind zwischen planen Farbflächen, harten Konturen und flickenhaften Bereichen untergebracht, die sie fast unkenntlich werden lassen, so dass ein dichter Austausch zwischen Abstraktion und Gegenständlichkeit entsteht. Der von ihnen beschriebene Raum verfügt nicht über eine illusionistische Tiefe, dafür aber über eine konzeptuelle Anspielungsbreite, die ein freies Assoziieren erlaubt und das Festhalten an einer singulären Deutung verhindert. Scheibitz' skulpturale Objekte, die in der Regel zusammen mit den Gemälden ausgestellt werden, übertragen jene Fragen ins Dreidimensionale. Diese zwitterhaften Objekte, die experimentellen Architekturmodellen oder Entwürfen für eine mehrdimensionale Realität ähneln, beschäftigen sich nicht mit Material- oder Produktionswerten, sondern mit einer sich in den Bildern widerspiegelnden Konzentration von Geometrie und Farbe. In einer Serie von Gemälden und Objekten (*Brot & Spiele*, 2004), die an Landkarten, Sonnenuhren oder Brettspiele erinnern, werden Schautafeln und Diagrammformen einer genaueren Prüfung unterzogen. *Sundial* (2004) könnte ein soziologisches Kreisdiagramm sein, bei dem jedes Segment andersfarbig gekennzeichnet ist, doch fehlt die zur Bestimmung der Bedeutung notwendige Legende. Scheibitz bezieht sich auf eine visuelle Welt, in der die dreidimensionale Wirklichkeit (Landschaft, Interieur, Stillleben) nicht mehr dominiert, sondern lediglich eine Koexistenz neben der Fülle anderen visuellen Materials in Zeitschriften, Fernsehen und auf Computerbildschirmen führt. Seine Bilder und Objekte sind eine destillierte Verbindung dieser visuellen Daten, man könnte auch sagen Repräsentationen von Repräsentationen, die jede Hierarchie zwischen einer urbanen Landschaft und einer computergenerierten Karte verneinen.

Les peintures de Thomas Scheibitz s'articulent en équilibre au bord de la lisibilité. Des formes réalistes – une maison, une fleur, un oiseau – sont engoncées entre aplats de couleur, contours aigus et zones brouillées, qui les rendent quasiment méconnaissables et génèrent une tension entre abstraction et réalisme. L'espace qu'elles décrivent ne dénote aucune profondeur illusionniste, mais plutôt toute une série d'allusions conceptuelles qui favorisent les associations libres et empêchent toute lecture univoque. Les objets sculpturaux de Scheibitz, ordinairement exposés côte à côte avec ses peintures, transposent ces problèmes dans la troisième dimension. Ces hybrides, qui pourraient être les maquettes ou les modèles architecturaux expérimentaux d'une réalité multidimensionnelle, ne s'intéressent pas aux valeurs matérielles ou à la production, mais plutôt à une concentration de géométrie et de couleur à laquelle font écho les peintures. Les outils visuels ou les méthodes graphiques sont analysés dans une série de peintures et d'objets (*Brot & Spiele*, 2004) apparentés à des cartes, à des cadrans solaires ou à des jeux de société. *Sundial* (2004) pourrait être un « camembert » sociologique, chaque segment étant coloré en différentes teintes, mais on n'y trouve aucune information descriptive permettant de le déchiffrer. Scheibitz se réfère à un univers visuel où la réalité tridimensionnelle (paysage, intérieur, nature morte) ne domine plus, mais coexiste simplement avec un déluge d'autres éléments visuels déversé par les magazines, la télévision et les écrans d'ordinateur. Ses peintures et objets présentent un composé mixte de toute cette information visuelle – peut-être des représentations de représentations – qui refuse toute hiérarchie entre un paysage urbain et une carte générée par ordinateur. **K. B.**

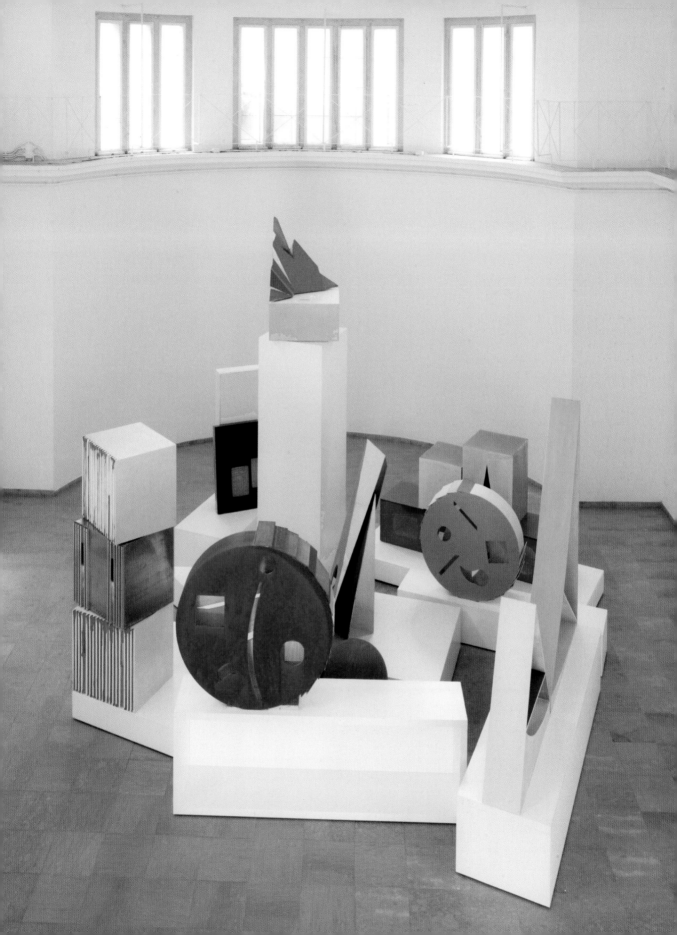

1 **Der Tisch, der Ozean und das Beispiel**, 2005, mixed media,
500 x 715 x 770 cm, installation view, 51. Biennale di Venezia, Venice

2 **Ohne Titel (Spielfilm & Roman)**, 2005, oil on canvas, 285 x 350 cm
3 **Heckroth**, 2003, c-print, 29.7 x 21 cm

„Wir haben alle ein gemeinsames öffentliches Gedächtnis, von dem wir
zunächst wissen und das wir später verstehen."

« Nous partageons tous une mémoire publique que nous connaissons et
que nous comprenons plus tard. »

"We all share a public memory, which we know and later we understand."

Gregor Schneider

1969 born in Rheydt, lives and works in Rheydt, Germany

Haus ur, Gregor Schneider's best known work, has only actually been seen by a few people. The narrow, three-store 1870s building in Rheydt, which Schneider took over when he was sixteen years old, is family property. Since 1985 he has made labyrinthine additions to the house, placing walls in front of walls, and windows in front of windows; allowing doors to lead into nothingness, and passageways into menacing narrowness. He has created soundless rooms – windowless chambers lined with lead – and he has doubled rooms by building smaller versions within existing ones. Even he soon lost track of whether these, for their part, were the original ones. In reproducing and hybridising rooms he was interested in "experienced interludes within activities", and thus a Sisyphus task. A cold orderliness reigns in some rooms; a feeling that they are oppressively and unsophisticatedly overbuilt, and that everything is too narrow and in a vague way numb. Other passages are more chaotic, leading from knee-high gaps to steep ladders, along narrow corridors, between nested walls and around numerous corners, until the visitor is seized by a claustrophobic confusion. Schneider is fascinated by the idea of an endless interior space that never lets you out again. He spectacularly exhibits extracted sections of *Haus ur* – walls or rooms, and also video and photo works – under the title *Totes Haus ur* (Dead Haus ur), such as at the Venice Biennale in 2001. However, he also creates independent installations such as *Doppelgarage* (2002, Rheydt), or *ur 45 Steindamm* (2003, Hamburg). The mysterious abbreviation "ur" is derived from the address: Unterheydener Strasse, Rheydt. It could just as well stand for rebuilt or "unperceived" space. Schneider leaves that open.

Haus ur, die bekannteste Arbeit von Gregor Schneider, haben nur wenige tatsächlich gesehen. Das schmale, dreistöckige Gründerzeitgebäude in Rheydt ist in Familienbesitz, Schneider hat es als Sechzehnjähriger übernommen. Seit 1985 hat er das Haus mit labyrinthischen Einbauten versehen, setzte Wand vor Wand, Fenster vor Fenster, ließ Türen im Nichts und Gänge in bedrohlicher Enge münden. Er schuf schalltote Räume, mit Blei isolierte fensterlose Kammern, und er verdoppelte Zimmer, die er verkleinert in bestehende einbaute. Ob die ihrerseits die ursprünglichen waren, wusste auch er bald nicht mehr zu sagen. Bei der Vervielfachung und Hybridisierung von Räumen geht es ihm um „erlebten Leerlauf von Handlungen", Sisyphusarbeit also. In manchen Zimmern herrscht kalte Ordentlichkeit, eine beklemmend biedere Verbautheit, in der alles zu eng und auf diffuse Weise dumpf ist. Andere Passagen sind chaotischer, führen von kniehohen Luken über steile Leitern und enge Korridore zwischen verschachtelten Wänden hindurch und um etliche Ecken, bis den Besucher die klaustrophobische Verwirrung packt. Schneider ist fasziniert von der Idee eines unendlichen Innenraums, der niemanden je wieder aus sich entlässt. Auskopplungen aus *Haus ur* – Wände oder Räume, auch Video- und Fotoarbeiten – zeigt Schneider unter dem Titel *Totes Haus ur*, spektakulär etwa im Jahr 2001 auf der Biennale in Venedig. Es entstehen aber auch eigenständige Installationen wie zum Beispiel *Doppelgarage* (2002, Rheydt) oder *ur 45 Steindamm* (2003, Hamburg). Das mysteriöse Kürzel „ur" leitet sich von der Adresse ab: Unterheydener Straße, Rheydt. Es könnte ebenso gut für „umbauter" oder „unsichtbarer Raum" stehen. Schneider lässt das offen.

Si *Haus ur* est l'œuvre la plus célèbre de Gregor Schneider, rares sont ceux qui l'ont vue *de visu*. Cet étroit immeuble de trois étages des années 1870, un bien de famille situé à Rheydt, est devenu la propriété de l'artiste alors qu'il n'avait que seize ans. Depuis 1985, Schneider a doté sa maison d'aménagements labyrinthiques, doublant murs et fenêtres, faisant déboucher les portes sur rien et les couloirs se finir en menaçantes exiguïtés. Des pièces insonorisées, des chambres sans fenêtres isolées au plomb ont été créées, Schneider a doublé des pièces entières inscrites en plus petit dans les pièces existantes. Pour ce qui est de savoir si ces dernières étaient d'origine, lui-même ne pourra bientôt plus le dire. Dans ce processus de multiplication et d'hybridation des espaces, le propos tourne autour de « l'expérience vécue de l'inanité des actes » – un travail de Sisyphe donc. Dans certaines pièces règne un ordre glacial, un figement bourgeois oppressant où tout est trop exigu et confusément assourdi. D'autres parties sont plus chaotiques : des ouvertures ménagées à hauteur de genou, des échelles escarpées et des corridors étroits conduisent le spectateur le long de murs imbriqués et d'angles morts jusqu'à ce qu'une désorientation claustrophobique s'empare de lui. L'artiste est fasciné par l'idée d'un espace intérieur infini qui ne vous laisse plus jamais échapper. Schneider présente des extraits de *Haus ur* – murs ou pièces, mais aussi des vidéos et des travaux photographiques – sous le titre *Totes Haus ur*, de manière spectaculaire comme en 2001 à la Biennale de Venise. Mais des installations autonomes voient aussi le jour, comme *Doppelgarage* (2002, Rheydt) ou *ur 45 Steindamm* (2003, Hambourg). L'énigmatique syllabe « ur » vient de l'adresse : Unterheydener Straße, Rheydt. Mais il pourrait tout aussi bien s'agir d'une abréviation signifiant « umbauter » ou « unsichtbarer Raum » (espace remanié ou invisible). Schneider ne s'est pas prononcé sur le sujet. J. A.

SELECTED EXHIBITIONS →
2003 *Hannelore Reuen und das Tote Haus ur*, Hamburger Kunsthalle; *Dead House ur*, The Museum of Contemporary Art, Los Angeles **2002** Stiftung DKM, Duisburg; *Fotografie und Skulptur*, Museum für Gegenwartskunst, Siegen **2001** *Totes Haus ur*, 49. Biennale di Venezia, Venice; Kabinett für aktuelle Kunst, Bremerhaven **2000** *Wonderland*, Saint Louis Art Museum

SELECTED PUBLICATIONS →
2004 *Seele - Konstruktionen des Innerlichen in der Kunst*, Staatliche Kunsthalle Baden-Baden, Baden-Baden **2003** *Gregor Schneider: Hannelore Reuen und das Tote Haus ur*, Hamburg; *Das Lebendige Museum*, Museum für Moderne Kunst, Frankfurt/Main **2002** *Gregor Schneider: Haus ur*, Duisburg

1 **517West24th**, New York 2003
2 **Bathroom, DieFamilieSchneider**, WaldenstreetNo. 16, London2004

3 **Bathroom, DieFamilieSchneider**, WaldenstreetNo. 14, London2004

„Die Arbeit besteht eigentlich darin, dass ich immer wieder mit dem Arbeiten beginne."

«En fait, le travail consiste en ce que je recommence sans cesse le travail.»

"The work actually consists of my beginning the work again and again."

2

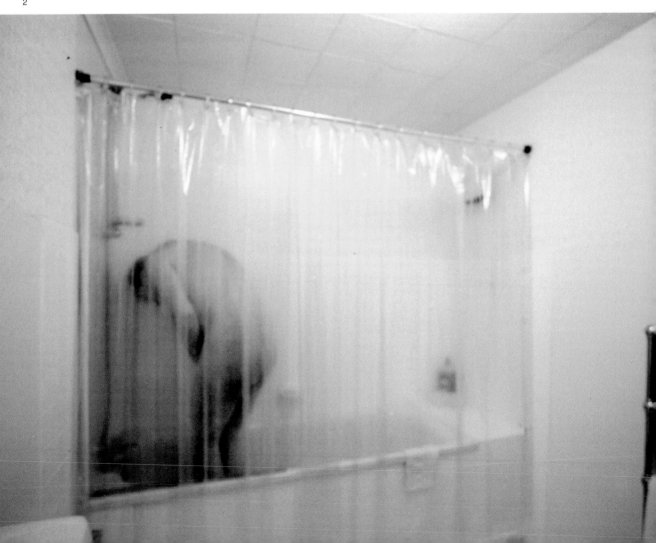

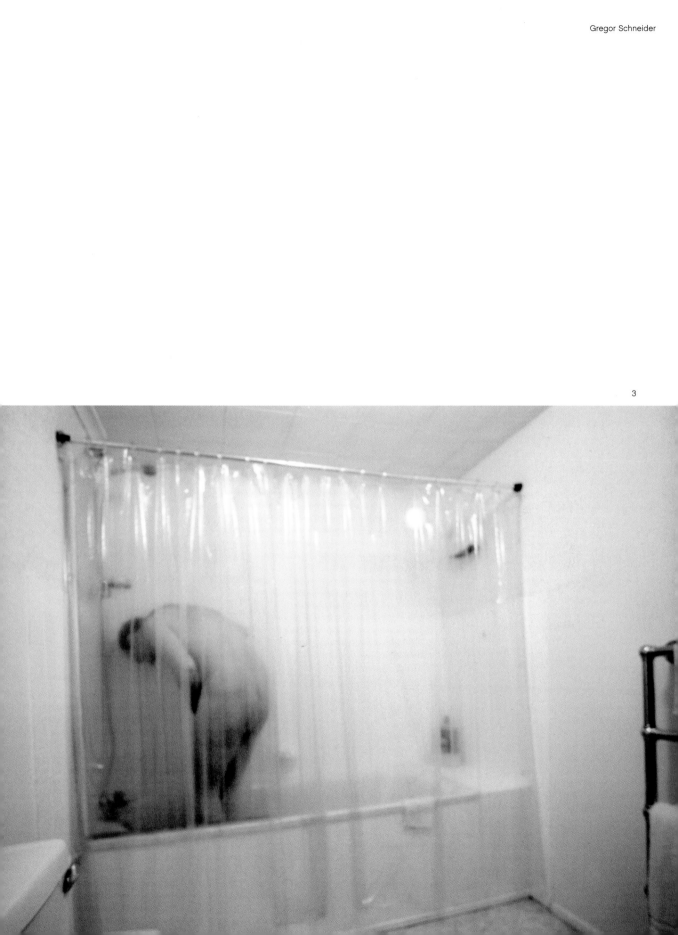

Thomas Schütte

1954 born in Oldenburg, lives and works in Düsseldorf, Germany

It is with an insistent materiality that Thomas Schütte erects his large-format, bulky sculptures, and his architectural models that are as robust as they are elegant. Independently of this work, but on equal terms with it, he also produces photographs and graphics. In his work Schütte combines language jokes with laconic titles, links illustrations with surreal distortions, and introduces social commentary to its own strict proscription. Despite all of its disparity, his work is unified by the seriousness with which he approaches the respective materials and the process of creation. Thus his architectural models are not replicas of existing buildings or miniatures awaiting realization. Instead they are sculptures that flaunt themselves self-confidently, reflecting upon their own history, and upon the state of our society and its forms of expression. In *Känguru Siedlung* (2004) small, simple cardboard buildings are crowded closely together on a pedestal. Schütte constructed this work's roughly built minimal architecture from boxes used for moving, thus merging his materials and statement smoothly together. His *Hotel for the Birds* (2004), to be built in London's Trafalgar Square, is in a completely different style. The five-meter tall, fragile and transparent construction that consists of an intimated skeletal framework in modernism's signature colours of red, blue and yellow, will simultaneously be an alien element in the midst of the historic square, and a comment on urban development. *Bronzefrauen* and *Stahlfrauen*, the colossal sculptures of female bodies with strangely distorted poses and anatomical deformations, which Schütte has produced from the late nineties until today, raise existential questions.

Mit beharrlicher Materialität stellt Thomas Schütte seine großformatigen, sperrigen Skulpturen und robusten wie eleganten Architekturmodelle auf. Gleichberechtigt und eigenständig entstehen Fotografien und grafische Arbeiten. Bei Schütte trifft Sprachwitz auf lakonische Titelgebung, Abbild auf surreale Verzerrung, Gesellschaftskommentar auf dessen strikte Verweigerung. Was sein Werk bei aller Verschiedenheit eint, ist die Ernsthaftigkeit, mit der er sich dem jeweiligen Material und dem Prozess des Schaffens stellt. So sind seine Architekturmodelle nicht Repliken existierender Bauten oder Miniaturen, die der Ausführung harren, sondern Skulpturen, die sich selbstbewusst zur Schau stellen und über ihre eigene Geschichte, den Zustand unserer Gesellschaft und deren Ausdrucksformen reflektieren: In *Känguru Siedlung* (2004) drängen sich kleine, schlichte Papphäuser auf einem Sockel dicht aneinander. Schütte hat seine grob gestalteten Minimalarchitekturen aus Umzugskartons konstruiert und fügt so Material und Aussage fugenlos zusammen. Eine ganz andere Handschrift trägt sein Entwurf *Hotel for the Birds* (2004), der auf dem Trafalgar Square in London realisiert werden wird. Die fragile und transparente, fünf Meter hohe Konstruktion, ein angedeuteter Skelettbau in den Signetfarben der Moderne, Rot, Blau und Gelb, wird ein Fremdkörper inmitten des historischen Platzensembles und Kommentar zum Städtebau zugleich werden. Seit den späten neunziger Jahren bis heute entstehen Schüttes *Bronzefrauen* und *Stahlfrauen*, kolossale Skulpturen weiblicher Körper in seltsam verrenkten Posen und anatomischer Deformation, die existenzielle Fragen aufwerfen.

Thomas Schütte dresse ses encombrantes sculptures grand format et ses modèles architecturaux aussi robustes qu'élégants avec un sens obstiné de la matérialité. Ses travaux photographiques et graphiques, auxquels l'artiste accorde un même statut d'œuvre, voient le jour de manière indépendante. Chez Schütte, l'humour verbal se concentre sur des titres laconiques, l'image sur la déformation surréaliste, le commentaire social sur son strict refus. Ce qui fait l'homogénéité de son œuvre nonobstant toute sa diversité, c'est le sérieux avec lequel l'artiste aborde le matériau respectif, mais aussi le processus de création. Ainsi, ses maquettes d'architectures ne sont pas des répliques de constructions existantes ou des miniatures en attente d'exécution, mais des sculptures qui s'exposent fièrement et qui réfléchissent sur leur histoire comme sur l'état et les formes d'expression de notre société : dans *Känguru Siedlung* (2004) de petites et sobres maisons en carton posées sur un socle se pressent les unes contre les autres. Schütte a construit ses architectures minimales rudimentaires à partir de cartons de déménagement et parvient ainsi à fondre le message et le matériau en une indissociable unité. Une toute autre écriture caractérise son projet *Hotel for the Birds* (2004), qui sera réalisé à Trafalgar Square à Londres. Cette construction fragile et transparente de cinq mètres de haut, une structure évoquant un squelette aux couleurs caractéristiques de la modernité – rouge, bleu, jaune – constituera un corps étranger dans le cadre de l'architecture historique de la place, mais aussi un commentaire sur l'urbanisme. Depuis la fin des années quatre-vingt-dix et jusqu'à ce jour, Schütte poursuit la réalisation de ses *Bronzefrauen* et ses *Stahlfrauen*, des sculptures colossales de corps féminins affectés de contorsions et de déformations anatomiques singulières, et qui soulèvent des questions existentielles.

A. M.

SELECTED EXHIBITIONS →
2005 *The Experience of Art*, 51. Biennale di Venezia, Venice; *Zur Vorstellung des Terrors: Die RAF-Ausstellung*, KW Institute for Contemporary Art, Berlin **2004** *Quengelware*, Hamburger Kunsthalle; *Flick Collection*, Hamburger Bahnhof, Berlin; Site Sante Fe; *Skulptur. Prekärer Realismus zwischen Melancholie und Komik*, Kunsthalle Wien, Vienna **2003/04** *Croisade/Kreuzzug*, Kunstmuseum Winterthur, Musée de Grenoble, K21 – Kunstsammlung Nordrhein-Westfalen, Düsseldorf **2002** *Große Geister*, Museum Folkwang, Essen

SELECTED PUBLICATIONS →
2004 *Thomas Schütte: Künstlermonographie der Flick Collection*, Ulrich Look (ed.), Cologne **2003/04** *Thomas Schütte: Croisade/Kreuzzug*, Kunstmuseum Winterthur, Musée de Grenoble, K21 – Kunstsammlung Nordrhein-Westfalen, Düsseldorf **1998** *Thomas Schütte*, Julian Heynen, James Lingwood, Angela Vettese (ed.), London

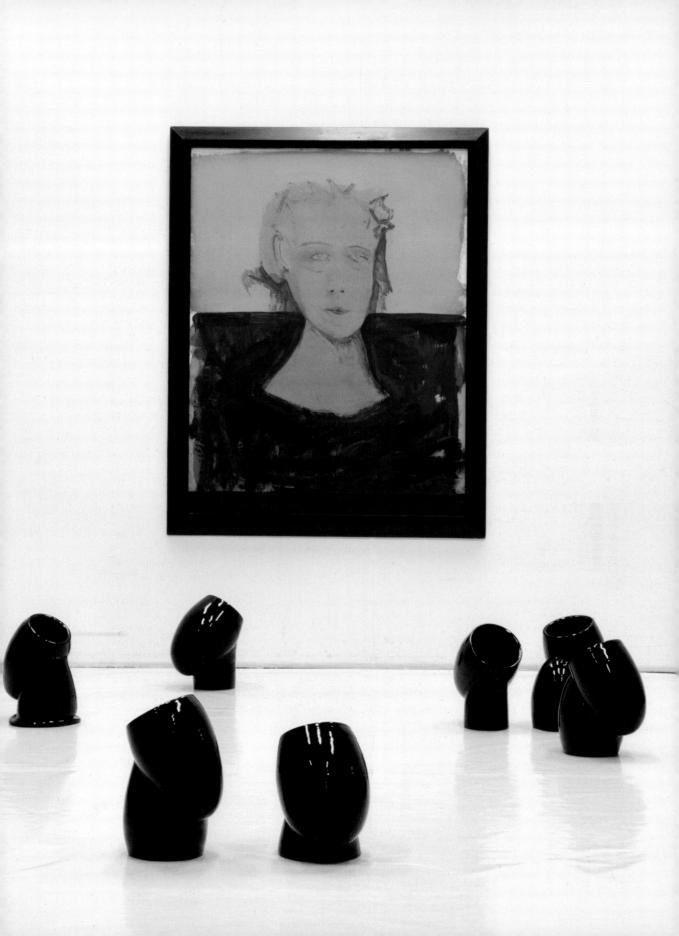

1 **Ohne Titel**, 1986–2001, 7 ceramic vases, colour on paper, painting: 142 cm x 109.5 cm
2 **Köpfe**, 2002, ceramic, glazed, 220 x 80 x 80 cm, exhibition view, "Kreuzzug", K21 – Kunstsammlung Nordrhein-Westfalen, Düsseldorf, 2004

3 **Große Geister**, 1996–1998, aluminium, height: 250 cm, exhibition view, "Kreuzzug", K21 – Kunstsammlung Nordrhein-Westfalen, Düsseldorf, 2004

„Es ist ein gutes Gefühl, manchmal nützlich zu sein."

«C'est bon de se sentir parfois utile.»

"It feels good to be useful sometimes."

2

Raqib Shaw

1974 born in Calcutta, India, lives and works in London, UK

Paradisiacal (in)culpability: in a blue-gold underwater world, a human form with a zebra's head copulates with a frog while they both ride a red fish between strange sea plants. Rising in the centre of the scene is another bizarre shape with its wings spread: She seems majestic against the blue background, and holds a penis-shaped sceptre in her right hand (*The Garden of Earthly Delights IV*, 2004). Raqib Shaw was celebrated as a shooting star on the London art scene for his *Garden of Earthly Delights* series. On large-format plywood panels the painter creates a surreal world full of imaginary creatures who amuse themselves in erotically fanciful scenes. His pictures are fascinating not only for their wealth of precisely formulated details, but equally for their refined surfaces: Besides the car paint that he uses to obtain an enamel-like shine, Shaw works glitter, gold colour and rhinestones into his paintings. Hieronymus Bosch appears to be godfather to Shaw's colourful and fun-loving visions. The motifs unite western influences with models taken from eastern cultures. Shaw was definitely influenced by the patterns of carpets and jewellery traded by his family as he was growing up in Kashmir, but influences from Hokusai's flower woodcuts, the works of old masters, and scientific plant and animal studies from the 17th century also find their way into his work. In this stimulating sphere filled with exotic, decorative and surreal props, Raqib Shaw develops his paintings like fairytales or pieces of music in whose lavish turmoil and sonorous rhythms observers can lose themselves.

Paradiesische (Un-)Schuld: In einer blau-goldenen Unterwasserwelt, zwischen seltsamen Meerespflanzen kopulieren eine menschliche Gestalt mit dem Kopf eines Zebras und ein Frosch, während sie auf einem roten Fisch reiten. In der Mitte der Szenerie erhebt sich eine weitere bizarre Gestalt mit ausgebreiteten Flügeln. Majestätisch erscheint sie auf dem blauen Hintergrund und hält ein penisförmiges Zepter in der rechten Hand (*The Garden of Earthly Delights IV*, 2004). Mit der Serie *The Garden of Earthly Delights* wurde Shaw als Shootingstar der Londoner Kunstszene gefeiert. Auf großformatigen Paneelen aus Sperrholz erschafft Shaw eine surreale Welt voller Fantasiewesen, die sich in erotisch-fantastischen Szenen vergnügen. Seine Bilder faszinieren nicht nur durch ihren Reichtum an präzise ausgearbeiteten Details, sondern ebenso durch ihre raffinierte Oberfläche: Neben Autolack, mit dem er einen emailartigen Glanzeffekt erzielt, arbeitet Shaw Glitter, Goldfarbe und Strass-Steine in seine Gemälde ein. Hieronymus Bosch scheint Pate zu stehen für Shaws farben- und lebensfrohe Visionen. Die Motive vereinen westliche Einflüsse mit Vorbildern aus östlichen Kulturen: Nicht nur die Muster der Teppiche und der Schmuck, mit denen die Familie des in Kaschmir aufgewachsenen Shaw handelt, prägten den Maler, auch die Blumenholzschnitte Hokusais, die Werke Alter Meister oder naturwissenschaftliche Pflanzen- und Tierstudien aus dem 17. Jahrhundert finden Eingang in seine Arbeit. In diesem Spannungsfeld aus exotischen, dekorativen und surrealen Versatzstücken entwickelt Shaw seine Gemälde wie Märchen oder Musikstücke, in deren opulentem Getümmel und klangvollen Rhythmen sich die Betrachter verlieren.

(In)culpabilité paradisiaque: dans un monde sous-marin bleu et or, un crapeau et une figure humaine à tête de zèbre copulent parmi d'étranges plantes aquatiques en chevauchant un poisson rouge. Au milieu de cette scène s'élève une autre figure bizarre aux ailes déployées, qui se détache majestueusement sur le fond bleu en tenant dans sa main droite un sceptre en forme de pénis (*The Garden of Earthly Delights IV*, 2004). Avec la série *The Garden of Earthly Delights*, Shaw a été célébré comme la *shooting star* de la scène artistique londonienne. Sur de grands panneaux en contreplaqué, Shaw crée un monde surréel empli d'êtres imaginaires qui batifolent dans des scènes érotico-fantastiques. Ses tableaux ne fascinent pas seulement par le foisonnement de détails travaillés avec précision, mais aussi par le traitement raffiné des surfaces: à côté de la laque automobile qui lui permet d'obtenir des effets de brillance proches de l'émail, Shaw introduit dans ses œuvres des paillettes, de la peinture dorée et des pierres de strass. Jérôme Bosch semble être le parrain de ses visions hautes en couleur et pleines de gaieté. Ses motifs associent des influences occidentales et des modèles issus de cultures orientales: si les motifs des tapis et les bijoux dont font commerce les parents de Shaw, qui a passé son enfance au Cachemire, ont laissé leur empreinte sur le style du peintre, on y relève aussi l'influence des estampes florales de Hokusaï, des œuvres de maîtres anciens ou des études botaniques et zoologiques du XVIIᵉ siècle. C'est dans ce champ de tension fait d'accessoires exotiques, décoratifs et surréels que Shaw développe ses peintures comme des contes ou des pièces musicales, dans l'opulente cohue et les rythmes sonores desquels se perdent les spectateurs.

C. R.

SELECTED EXHIBITIONS →
2004 *Plantmania! Art and the World of Plants*, Sunderland Museum & Winter Gardens **2003** *Nation and Nature: Vaster Than Empires*, Hastings Museum and Art Gallery **2002** *Direction 2002*, London Institute Gallery; *Chancellor's Forum Exhibition*, London College of Fashion

SELECTED PUBLICATIONS →
2005 *Prague Biennale 2: Expanded Painting*, Milan

1 **Untitled**, 2004, mixed media on paper, 59.1 x 41.8 cm
2 **Untitled**, 2005, mixed media on paper, 42 x 59.5 cm

3+4 **The Garden of Earthly Delights III**, 2003, mixed media on board,
 3 panels, each 305 x 152.5 cm

„Ich tanze mit meinen Bildern und ich tanze zur Musik, die aus dem
Wahnsinn des Herzens kommt."

«Je danse avec mes tableaux, et je danse sur la musique qui vient de la
folie du cœur.»

"I dance with my paintings and I dance to the music that comes from the madness of the heart."

2

3

Cindy Sherman

1954 born in Glen Ridge (NJ), lives and works in New York (NY), USA

The tradition of staged photography experienced a dramatic revitalization towards the end of the 1970s in Cindy Sherman's works. In 1977 she abruptly attracted the interest of a broad public with her *Untitled Film Stills*. These 69 small-format black-and-white photographs show the artist in various female roles, which are vaguely reminiscent of Hollywood movie idols of the 1950s and 60s. This unspectacular series of images brilliantly reveals the narrowness and interchangeability of characteristically male clichés about woman, as well as their propagation in film and television. With its affinity to the absurd and grotesque, Sherman's later work follows certain traditions of surrealist photography (Hans Bellmer, among others). Over the past three decades the artist has developed a complex role-playing game of frightening intensity, which in very diverse contexts questions fixed social ideas about feminine identity. In the 1980s and 90s her illustrations of violence and sexuality, created with the aid of prostheses and masks, led to considerable controversy. In the strangely painterly colour photographs depicting collections of materials arranged like still lifes and made up of faeces, slime, blood, penis prostheses, etc., Sherman's aesthetic of the ugly underwent an early intensification. Sherman has again stayed herself in *Untitled* (2004), one of her latest series of photos. These eighteen garishly coloured, digitally manipulated photographs show the artist in various clown costumes. Besides the subject's ambivalent position between tragedy and comedy, these works also seem to critically question the artist's role in society.

Mit dem Werk von Cindy Sherman erfuhr die Tradition der fotografischen Inszenierung gegen Ende der siebziger Jahre eine dramatische Wiederbelebung. 1977 erreichte sie mit den *Untitled Film Stills* schlagartig die Aufmerksamkeit einer breiten Öffentlichkeit. 69 kleinformatige Schwarzweißaufnahmen zeigen die Künstlerin in verschiedenen Frauenrollen, die unbestimmt an Vorbilder des Hollywoodkinos der fünfziger und sechziger Jahre erinnern. In genialer Weise entlarvt diese unscheinbare Bildserie die Beschränktheit und Austauschbarkeit männlich geprägter Klischees des Weiblichen sowie deren mediale Verdopplung in Film und Fernsehen. In seiner Nähe zum Absurden und Grotesken schließt das spätere Werk Shermans an bestimmte Traditionen der surrealistischen Fotografie (zum Beispiel Hans Bellmer) an. Im Lauf der vergangenen drei Jahrzehnte entwickelte die Künstlerin ein komplexes Rollenspiel von beängstigender Intensität, das in unterschiedlichen Kontexten die Frage nach der gesellschaftlichen Festschreibung femininer Identität aufwirft. In den achtziger und neunziger Jahren führten ihre unter Zuhilfenahme von Prothesen und Masken entstandenen Gewalt- und Sexualdarstellungen zu erheblichen Kontroversen. Mit den seltsam malerisch wirkenden Farbaufnahmen von stilllebenartig angeordneten Materialsammlungen aus Kot, Schleim, Blut, Penisprothesen etc. erfuhr Shermans Ästhetik des Hässlichen eine frühe Zuspitzung. In einer ihrer letzten Bildserien, *Untitled* (2004), inszeniert sich Sherman wieder selbst. Achtzehn grellbunte, digital manipulierte Aufnahmen zeigen die Künstlerin in wechselnden Clownskostümen. Neben der Ambivalenz von Tragik und Komik des Sujets scheinen diese Werke auch die Rolle der Künstlerin in der Gesellschaft kritisch zu hinterfragen.

A la fin des années soixante-dix, la tradition de la mise en scène photographique allait connaître une renaissance dramatique avec l'œuvre de Cindy Sherman. En 1977, ses *Untitled Film Stills* attiraient soudain sur elle l'attention d'un large public. 69 photos petit format en noir et blanc montraient l'artiste dans différents rôles de femmes qui rappelaient confusément certaines figures du cinéma hollywoodien des années cinquante et soixante. Cette série photographique démasquait de manière géniale l'étroitesse et l'interchangeabilité des clichés masculins de la femme, ainsi que leur diffusion médiatique par le cinéma et la télévision. Proche de l'absurde et du grotesque, l'œuvre ultérieur de Sherman se rattache à certains courants de la photographie surréaliste (notamment Hans Bellmer). Au cours des trois dernières décennies, l'artiste a développé un jeu de rôles complexe d'une effrayante intensité, à travers lequel elle pose le problème du figement social de l'identité féminine dans différents contextes. Dans les années quatre-vingt et quatre-vingt-dix, les représentations de la violence et de la sexualité qu'elle réalise en faisant appel à des prothèses et à des masques ont suscité de vives controverses. Avec ses photos en couleurs étrangement picturales, proches de la nature morte avec leurs agencements de matériaux composés d'excréments, de glaires, de sang, de pénis artificiels etc., son esthétique de la laideur connaît une exacerbation précoce. Dans *Untitled* (2004), une de ses récentes séries photographiques, Sherman se remet de nouveau en scène elle-même. Dix-huit photos aux couleurs criardes, retouchées par ordinateur, montrent l'artiste dans différents costumes de clown. Au-delà de l'ambivalence tragi-comique du sujet, ces œuvres semblent aussi vouloir fonder une critique sociale du rôle de l'artiste.

D. M.

SELECTED EXHIBITIONS →
2005 *Faces in the Crowd – Picturing Modern Life from Manet to Today*, Whitechapel Art Gallery, London **2004/05** *The Last Picture Show*, Fotomuseum Winterthur; *Visions of America*, Sammlung Essl, Klosterneuburg **2004** kestnergesellschaft, Hanover **2000** *Die verletzte Diva*, Kunstverein München, Städtische Galerie im Lenbachhaus, Munich

SELECTED PUBLICATIONS →
2004 *Cindy Sherman*, kestnergesellschaft, Hanover
2000 *Cindy Sherman*, Hasselblad Center, Gothenburg

1 **Untitled**, 2004, colour photograph, 173.4 x 114.3 cm
2 **Untitled**, 2003, colour photograph, 147.3 x 99.7 cm
3 **Untitled**, 2004, colour photograph, 167.6 x 124.5 cm
4 **Untitled**, 2004, colour photograph, 139.7 x 137.2 cm

„Ich habe mich überhaupt nicht für traditionelle Kunst interessiert." « Je n'avais pas le moindre intérêt pour l'art traditionnel. »

"I didn't have any interest in traditional art."

2

3

Santiago Sierra

1966 born in Madrid, Spain, lives and works in Mexico City, Mexico

With performance, installation, photography, and video-based work, Santiago Sierra addresses controversial socio-political issues of labour and exploitation, concentrating on the current power structures of our evolving global economy. Sierra sets about exposing systems of power by paying people to perform labour-intensive tasks that are often absurd and degrading, as a means to reveal structures of political or cultural authority. He focuses on the plight of the exploited labourer by demonstrating the oppressive monotony of his or her daily routine. His work has included the hiring of labourers (below minimum wage) to push and drag cement blocks throughout a gallery space, or to hold up a gallery wall at a 60-degree angle. Sierra has also tattooed a line across the backs of four prostitutes in exchange for a hit of heroin. The artist's actions are tied to the specific reality of a particular location. For example, in Guatemala City in 1999, Sierra remunerated eight illegal workers to remain inside cardboard boxes for the duration of one of his exhibitions. The wretched material recalled the shantytowns where these "invisible" men struggle to live and work in a society in which they possess no social status. At the Venice Biennale 2003, Sierra, occupying the Spanish Pavilion, granted access only to Spaniards carrying proof of their national identity (*Wall Enclosing a Space*). In doing so, he commented on the exclusionary nature of our national borders. For his latest action *Haus im Schlamm* (2005) Sierra filled the exhibition room at the kestnergesellschaft in Hanover with mud to remind visitors of the Nazi's job-creation schemes.

In seinen Performances, Installationen, Foto- und Videoarbeiten spricht Santiago Sierra umstrittene gesellschaftspolitische Themen wie Arbeit und Ausbeutung an, wobei er sich besonders auf aktuelle Machtstrukturen der sich entwickelnden globalisierten Ökonomie konzentriert. Sierra deckt Machtsysteme auf, indem er Menschen dafür bezahlt, dass sie häufig absurde und erniedrigende arbeitsintensive Aufgaben bewältigen. Dies nutzt er als Instrument zur Entlarvung politischer und kultureller Autoritätsstrukturen. Sein Hauptinteresse gilt dem Elend des ausgebeuteten Proletariats, dessen beklemmende Monotonie täglicher Routine er uns vor Augen führt. So hat er für seine Arbeiten beispielsweise Arbeiter engagiert, die (für weniger als den tariflichen Mindestlohn) Betonblöcke durch den Ausstellungsraum ziehen oder schieben oder aber eine Wand der Galerie in einem Winkel von 60 Grad halten mussten. Ebenso ließ Sierra vier Prostituierten für eine Dosis Heroin eine Linie auf den Rücken tätowieren. Die Aktionen des Künstlers sind stets an die spezifische Wirklichkeit eines bestimmten Ortes gebunden. 1999 bezahlte er in Guatemala City acht illegale Arbeiter dafür, dass sie während der Dauer einer seiner Ausstellungen in ihren Pappkartons ausharrten. Die armselige Materialität der Kartons erinnerte an die Barackensiedlungen, in denen jene „unsichtbaren" Menschen in einer Gesellschaft, die ihnen keinen Status zuerkennt, hausen und arbeiten müssen. Im Rahmen der Biennale von Venedig 2003 gewährte Sierra, der den spanischen Pavillon bespielte, nur Spaniern Einlass, die sich als solche ausweisen konnten (*Wall Enclosing a Space*). Damit kommentierte er den Ausschlusscharakter nationaler Grenzen. Bei seiner jüngsten Aktion *Haus im Schlamm* (2005) füllte Sierra den Ausstellungsraum der kestnergesellschaft in Hannover mit Schlamm. Sierra erinnerte damit an eine Arbeitsbeschaffungsmaßnahme der NSDAP.

A travers ses performances, ses installations, ses photographies et ses œuvres fondées sur la vidéo, Santiago Sierra aborde les sujets socio-politiques controversés du travail et de l'exploitation en se concentrant sur les structures du pouvoir de notre économie globale en marche. Sierra se propose d'en exposer les rouages en payant des gens pour accomplir des tâches intensives souvent absurdes et dégradantes, comme un moyen pour mettre en lumière les structures de l'autorité politique ou culturelle. Il met l'accent sur la détresse des travailleurs exploités en montrant l'oppressante monotonie de leur routine quotidienne. Son travail a inclus l'embauche de travailleurs (en-dessous du salaire minimum) pour pousser et tirer des blocs de ciment à travers une galerie ou pour soutenir la cloison d'une galerie inclinée à un angle de 60 degrés. Sierra a aussi tatoué une ligne sur le dos de quatre prostituées contre une dose d'héroïne. Les actions de l'artiste s'adaptent à la réalité spécifique de chaque lieu. Ainsi, en 1999 à Guatemala City, il a rémunéré huit travailleurs en situation irrégulière pour qu'ils restent confinés dans des boîtes en carton pendant toute la durée d'une de ses expositions. Le matériau miséreux de ces boîtes renvoyait aux bidonvilles où ces hommes «invisibles» se battent pour travailler et survivre dans une société qui ne leur accorde aucun statut social. A la Biennale de Venise 2003, Sierra, occupant le pavillon espagnol, n'a laissé accès qu'aux seuls ressortissants espagnols pouvant prouver leur identité, et commentait ainsi le phénomène d'exclusion inhérent aux frontières nationales (*Wall Enclosing a Space*). Pour une intervention récente, intitulée *Haus im Schlamm* (2005), Sierra fit remplir de boue l'espace d'exposition de la kestnergesellschaft à Hannovre. Par ce travail, Sierra rappelait une mesure d'aide au travail décidée par le NSDAP.

A. S.-S.

SELECTED EXHIBITIONS →
2005 *Police*, Landesgalerie am Oberösterreichischen Landesmuseum, Linz **2004** *Soziale Kreaturen – Wie Körper Kunst wird*, Sprengel Museum Hannover; *Seven Sins*, Museion, Bolzano; *Paintings*, Sala de Arte Público Siqueiros; *300 Tons*, Kunsthaus Bregenz **2003** 50. Biennale di Venezia, Venice **2002** *Hiring and Arrangement of 30 Workers in Relation to Their Skin Color*, Kunsthalle Wien, Vienna

SELECTED PUBLICATIONS →
2005 *Santiago Sierra: 300 Tons and Previous Works*, Kunsthaus Bregenz, Bregenz **2004** *Seven Sins*, Museion, Bolzano; *Santiago Sierra: Spanish Pavilion, 50. Biennale di Venezia*, London; *Material Witness*, Museum of Contemporary Art Cleveland, Cleveland **2002** *Santiago Sierra: Works 2000–1990*, Ikon Gallery, Birmingham; *Santiago Sierra*, Kunsthalle Wien, Vienna

494

„Menschen sind Gegenstände des Staates und des Kapitals und werden auch so behandelt. Genau das versuche ich zu zeigen."

«Les individus sont des objets de l'Etat et du Capital et sont utilisés comme telles. C'est précisément ce que j'essaie de montrer.»

"Persons are objects of the State and of Capital and are employed as such. This is precisely what I try to show."

2

3

Simon Starling

1967 born in Epsom, lives and works in Glasgow, UK, and Berlin, Germany

Simon Starling is a storyteller. His works reveal themselves if you view them as the end product of a meticulously staged sequence of activities, and then interpret them in light of this new horizon. "In a certain sense I think up novels when I make art", he says – and in this process everything can literally become language. Starling weaves objects, places, materials, everyday patterns of behaviour, cultural codes and historical facts into precisely intertwined chains of symbolism. He also creates tautly drawn, astonishingly convincing relationships between factors that one would almost never have linked in this way. Thereby the life that his works enjoy beyond the actual display is gained primarily from their reference field, which is traversed continually by the artist himself and then retained in the final result like a subtext. Narration becomes a process bound to materials, and by aiming to create an exhibit Starling melds substance and context. An example of this was his use of wood from an old Scottish museum showcase to build a boat that he used to go fishing in France. The fish caught in France were subsequently cooked at an exhibition elsewhere, where he used the wood once again by burning it. Starling succinctly expresses his often immense efforts through the destruction or complete transformation of his material or activities: this is the final stage of a dematerialisation strategy revealed step by step in which the wood, for example, acts as an evolving signifier right up to the point of its incineration. Using the semantic power of such references he slowly develops a process of interpretation, which produces an increasingly hybrid and therefore completely real object. Thereby instead of the object being the goal, it becomes the most interesting detour to reach it.

Simon Starling ist ein Geschichtenerzähler. Seine Arbeiten erschließen sich, indem man sie als Zielpunkt einer minuziös inszenierten Abfolge von Handlungen begreift und in diesen Horizont erneut hineinliest. „In gewissem Sinn denke ich mir Romane aus, wenn ich Kunst mache", sagt er – und darin kann dann buchstäblich alles zu Sprache werden. Starling verstrickt Dinge, Orte, Materialien, alltägliche Handlungsmuster, kulturelle Kodes und historische Fakten zu präzise verflochtenen Zeichenketten und stellt weit gespannte, verblüffend schlüssige Bezüge her zwischen Faktoren, die man so wohl nie in Verbindung gebracht hätte. Dadurch leben seine Werke über das eigentliche Exponat hinaus vor allem von ihrem Bezugsfeld, das stets vom Künstler selbst durchlaufen wurde und dann im Resultat wie ein Subtext aufgehoben ist. Erzählen wird zum materialgebundenen Verfahren, und indem Starling auf das Exponat zusteuert, verschmilzt er Stoff und Kontext. Etwa, wenn er das Holz einer historischen schottischen Museumsvitrine für den Bau eines Bootes verwendet, damit in Frankreich zum Angeln fährt, um dort gefangene Fische andernorts bei einer Ausstellung zuzubereiten und dafür jenes Holz nun abermals zu nutzen, indem er es verfeuert. Den oft immensen Aufwand lässt Starling lapidar in Aufhebung oder kompletter Umwandlung seines Materials beziehungsweise seiner Handlungen münden: Schlusspunkt einer stückweise vorgetragenen Dematerialisierungsstrategie, in der hier das Holz bis in die Aufzehrung hinein als wandelnder Bedeutungsträger fungiert. Von der semantischen Fallhöhe solcher Bezüge herab entspinnt er einen Übersetzungsvorgang, der einen zunehmend hybriden und dennoch ganz reellen Gegenstand hervorbringt. Dabei wird nicht das Objekt zum Ziel, sondern der interessanteste Umweg zu ihm.

Simon Starling est un conteur. Ses œuvres ne dévoilent leur sens que si on les comprend comme une suite d'actions minutieusement mises en scène et qu'on les relit à la lumière de cette perspective. «En un certain sens, quand je fais de l'art, j'invente des romans», dit-il – et tout peut alors littéralement y trouver son expression. Starling relie les objets, les lieux, les matériaux, les schémas comportementaux quotidiens, les codes culturels et les faits historiques en des chaînes de signes enchevêtrés avec précision et opère des rapprochements saisissants de pertinence entre des faits apparemment éloignés que l'on n'aurait sans doute jamais songé à mettre en rapport. De ce fait, par-delà l'objet exposé, ses œuvres vivent avant tout d'un champ référentiel qui a toujours été préalablement parcouru par l'artiste lui-même, et que le résultat final résorbe ensuite comme un sous-texte. La narration devient un processus lié aux matériaux : dans la démarche qui le conduit à l'œuvre, Starling opère la fusion entre le contexte et le sujet. Par exemple en se servant du bois de la vitrine d'un musée historique écossais pour la construction d'une barque avec laquelle il part pêcher en France avant de cuire dans une exposition les poissons qu'il a pêchés sur un autre site, et de réutiliser le bois de la barque comme combustible du feu de cuisson. Starling fait souvent déboucher lapidairement ses immenses efforts dans l'abolition ou la transformation complète de son matériau ou de ses actions : terme d'une stratégie de la dématérialisation présentée étape par étape, dans laquelle le bois fait en l'occurrence office de support de sens transformateur jusqu'en sa consomption. De la hauteur de dénivelé sémantique de ces correspondances, Starling file alors un processus de traduction qui produit un objet de plus en plus hybride, mais non moins réel. Dans cette démarche, le but n'est pas l'objet en lui-même, mais l'intérêt du détour qui y conduit. J. A.

SELECTED EXHIBITIONS →
2004 *Exposition*, Fundació Miró, Barcelona **2003** *Zenomap*, 50. Biennale di Venezia, Venice; Villa Arson, Nice; *Djungel*, South London Gallery **2002** *Kakteenhaus*, Portikus, Frankfurt/Main; *Jones/Starling*, Museum of Contemporary Art, Sydney **2001** *Burn-Time*, Lichthaus Plus Neue Kunst, Bremen; Secession, Vienna **2000** *Method I*, Gallery Signal, Malmö

SELECTED PUBLICATIONS →
2004 *Simon Starling*, Villa Arson, Nice **2003** Skulptur-Biennale Münsterland, Kreis Warendorf; *Simon Starling*, Museo d'Arte Contemporanea Roma, Rome **2002** *Kakteenhaus*, Portikus, Frankfurt/Main **2001** *Inverted Retrograde Theme*, Secession, Vienna

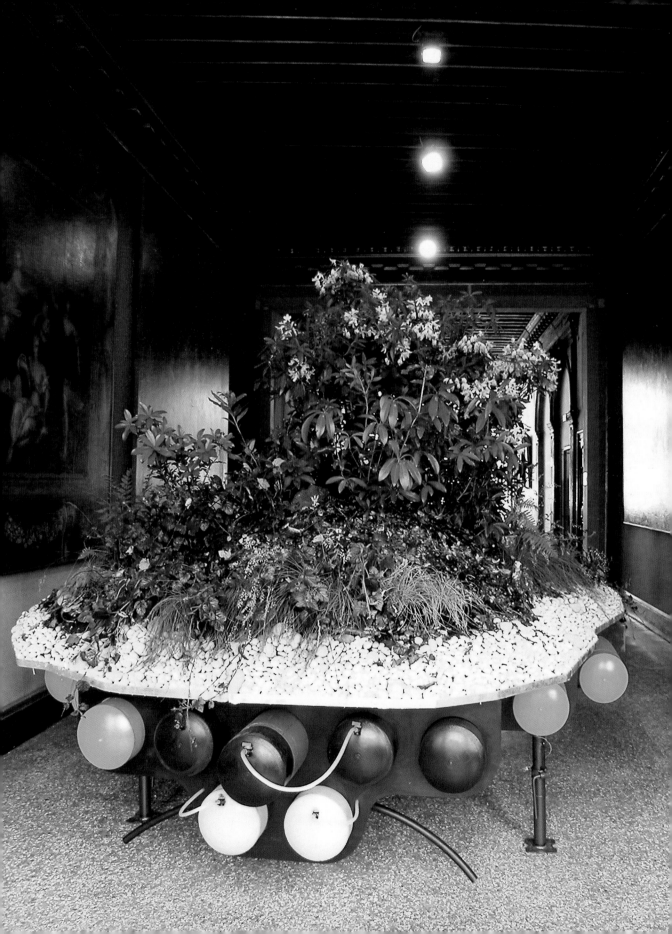

1 **Island for Weeds (Prototype)**, installation view,
50. Biennale di Venezia, Venice, 2003
2 **Notes on the Buildings of Mr. Naujok and Mr. Jeanneret**, 2003,
installation view, Villa Arson, Nice

3+4 **Kakteenhaus**, 2002, Volvo 240, cactus, dimensions variable,
installation view, Portikus, Frankfurt am Main

„Natürlich gehe ich nicht wie ein Historiker vor. Ich zerlege bloß historisches
Material in seine Bestandteile und arrangiere Objekte und Fakten neu."

«Bien entendu, je ne procède pas comme un historien. Je me contente de
décomposer le matériau en ses éléments constitutifs et de réorganiser les
objets et les faits.»

"Naturally I don't proceed like a historian. I only break historical material into its component parts and rearrange objects and facts."

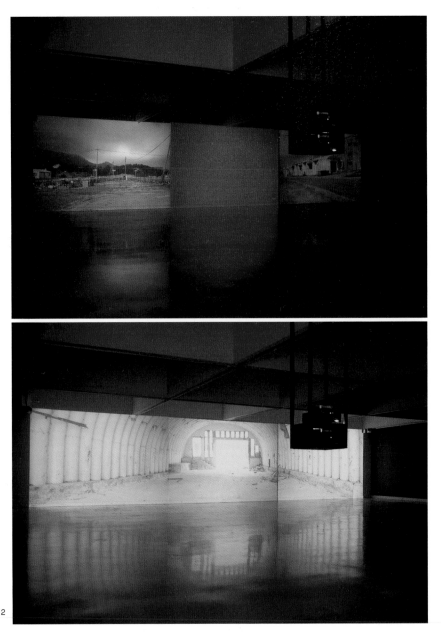

2

3

4

Thomas Struth

1954 born in Geldern, lives and works in Düsseldorf, Germany

For the past twenty-five years, Thomas Struth has used his camera for what has been called absorptive scrutiny, as if he has simultane- ously looked at, around, and through his subjects, and the large-scale prints of his photographs present dizzying amounts of information about the empty and populated street scenes, flowers, families, jungles, and visitors at the museums or churches he depicts. A leading member of a generation of German photographers who studied under the stringent conceptualists Bernd and Hilla Becher at the Düsseldorf Art Academy in the late 1970s and early 1980s, early on in his career Struth shifted the timeless, frontal-view objectivity of their serial imagery to the side. The resultant oblique perspective, instead of freezing its subjects, decelerates them just enough to make a viewer conscious of the act of look- ing. (Or, as he phrases it, his works offer an opportunity to "locate yourself in time".) Your eyes wander across his elegant, near-classically for- mal compositions, channeled by diagonal perspectival lines that allow his buildings and people to elude the taxonomy of the Bechers' inves- tigations. Indeed, in Struth's photographs, no person, plant, or building is reduced to an illustration of a type, but is instead depicted fully enmeshed in the conditions in and on which it exists in the world; his camera emphasizes both uniqueness and contingency. Uniquely skilled at depicting objects as they are experienced and time as it felt, Struth's chronicles function as history paintings for the new millennium.

Seit nunmehr fünfundzwanzig Jahren betreibt Thomas Struth mit der Kamera seine Art der aufnehmenden Untersuchung, die wirkt, als blicke er gleichzeitig auf, um und durch seine Motive hindurch. Seine großformatigen Abzüge bieten eine überwältigende Fülle von Informatio- nen zu den auf ihnen abgebildeten leeren und belebten Straßenszenen, Blumen, Familien, Urwäldern und Museums- oder Kirchenbesuchern. Struth, ein führender Vertreter jener Generation von deutschen Fotografen, die in den späten siebziger und frühen achtziger Jahren als Schüler der strengen Konzeptualisten Bernd und Hilla Becher an der Kunstakademie Düsseldorf begannen, schob schon zu Beginn seiner Laufbahn die zeitlose, frontale Objektivität der Becher'schen Bildserien zur Seite. Die daraus resultierende schräge Perspektive ließ das Motiv nicht er- starren, sondern verlangsamte es gerade in dem Maß, dass der Betrachter sich seines eigenen Sehaktes bewusst wurde (oder wie Struth selbst formuliert, seine Arbeiten bieten eine Möglichkeit, „sich in der Zeit zu verorten"). So wandert das Auge über seine eleganten, fast klassischen Bildkompositionen, gelenkt durch diagonal verlaufende Perspektivlinien, dank derer sich seine Gebäude und Menschen jener einordnenden Erfassung der Becher-Untersuchungen verweigern. Tatsächlich wird in Struths Fotografien eine Figur, eine Pflanze oder ein Gebäude nicht auf die Illustration eines Typs reduziert, sondern vielmehr vollständig verstrickt in die Umstände und die Bedingungen dargestellt, unter denen sie/ es in der Welt existiert. Dabei unterstreicht die Kamera die Einmaligkeit ebenso wie den Zufall. Aufgrund seiner einzigartigen Fähigkeit, Objekte so darzustellen, wie sie wahrgenommen werden, und Zeit so abzubilden, wie sie empfunden wird, fungieren Struths Aufzeichnungen als Historienbilder des neuen Jahrtausends.

Au cours des vingt-cinq dernières années, Thomas Struth s'est servi de son appareil photo pour pratiquer ce qu'on a pu appeler l'étu- de absorptive – comme s'il pénétrait et absorbait ses sujets sous tous les angles à la fois. Ses tirages grand format présentent un nombre époustouflant d'informations sur les scènes de rue peuplées ou désertes qu'il dépeint, les fleurs, familles, jungles et visiteurs de musées ou d'églises. Représentant majeur d'une génération de photographes ayant étudié à l'Académie des Beaux-Arts de Düsseldorf sous le concep- tualisme rigoureux de Bernd et Hilla Becher à la fin des années soixante-dix et au début des années quatre-vingt, Struth allait se défaire de l'objectivité intemporelle et frontale de leur style au début de sa carrière. Plutôt que de figer les sujets, la perspective oblique qui en a résulté les ralentit juste assez pour rendre le spectateur conscient de l'acte visuel. (Ou encore, comme il le dit lui-même, ses œuvres offrent la pos- sibilité de « se situer soi-même dans le temps ».) Le regard se promène alors dans ses compositions élégantes, empreintes d'un certain clas- sicisme et canalisées par des lignes de perspective obliques qui permettent à ses immeubles et à ses personnages d'éviter la fixation taxo- nomique des études des Becher. Et de fait, dans les photographies de Struth, les personnes, les plantes et les immeubles ne sont jamais réduits à l'illustration d'un type, mais sont au contraire décrits emmaillotés dans les conditions au sein desquelles et sur lesquelles ils vivent dans le monde, l'appareil photo faisant ressortir à la fois l'unicité et la contingence. Grâce à l'exceptionnelle faculté de Struth de décrire les objets tels qu'ils sont ressentis et le temps tel qu'il a été vécu, ses chroniques fonctionnent comme des peintures d'histoire pour le nouveau millénaire.

B. S.

SELECTED EXHIBITIONS →
2004 Pergamonmuseum, Museum für Fotografie, Hamburger Bahnhof, Berlin; *Portraits-Une heure*, capcMusée d'art contemporain, Bordeaux **2002/03** Dallas Museum of Art; The Museum of Contem- porary Art, Los Angeles; The Metropolitan Museum of Art, New York; Museum of Contemporary Art, Chicago; *Moving Pictures*, Solomon R. Guggenheim Museum, New York, Guggenheim Museum Bilbao; *German Art Now*, Saint Louis Museum of Art; *Cruel and Tender: The Real in the Twentieth-Century Photograph*, Tate Modern, London;

Museum Ludwig, Cologne **2002** *Dschungelbilder*, Staatliche Kunstsammlungen Dresden; *Wallflowers*, Kunsthaus Zürich

SELECTED PUBLICATIONS →
2004 *Thomas Struth: Pergamon Museum 1–6*, Munich **2002** *Thomas Struth: 1977–2002*, Munich; *Thomas Struth: Pictures from Paradise*, Munich; *Fotografie in Düsseldorf*, museum kunst palast, Düsseldorf **2001** *Abbild*, Landesmuseum Joanneum, Graz; *Thomas Struth: Löwenzahnzimmer*, Munich

502

„Wenn man mit Fotografie arbeitet, ist es fast natürlich, dass man sich nach Langsamkeit sehnt, weil man ja beabsichtigt, etwas zu erfassen, ein Bild zu präsentieren, das ein breiteres Bedeutungsspektrum ausdrückt und in der Lage ist, eine Erfahrung anzubieten, die sich mit anderen Menschen teilen lässt."

« Lorsqu'on travaille avec la photographie, il est presque naturel qu'on ait envie de lenteur, puisqu'on a pour intention de saisir quelque chose, de présenter une image qui exprime un large éventail de significations et qui soit en mesure de proposer une expérience pouvant être partagée avec d'autres personnes. »

„When you work with photographs, it's almost natural to long for slowness because the intention is to grasp something, to present a work that expresses a broader range of meanings, that is intense and capable of offering a shared experience with other people."

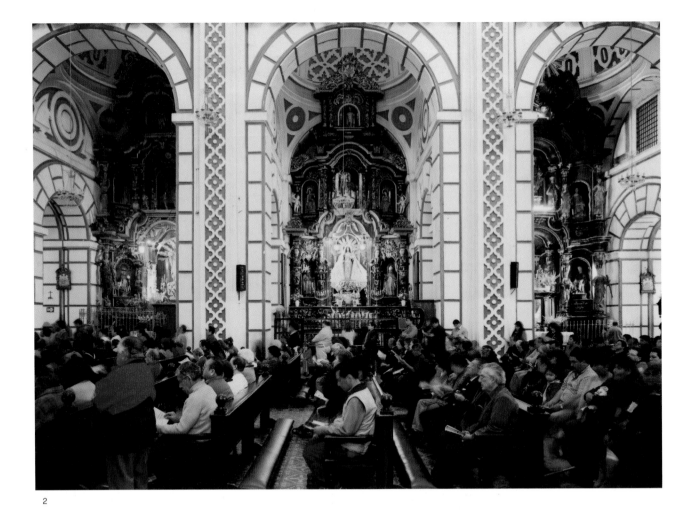

2

3

4

Catherine Sullivan

1968 born in Los Angeles (CA), lives and works in Los Angeles (CA), USA

Catherine Sullivan is equally comfortable in the black box and the white cube. Trained as an actress and a visual artist, Sullivan has recently brought her career as a scriptwriter, actor, and fringe theatre director to museums and galleries. Her complex multi-screen video installations (and related photographs) – which often appropriate scenes and footage from well-known films, charged historical moments, or stories taken from the news – present actors performing in a dizzying array of styles. Sullivan sometimes renders multiple iterations of each scene, and her protagonists swap roles as freely as the emotions they convey. Recently, she has presented *Ice Floes of Franz Joseph Land* as both video installation (2003) and performance (2004). The piece is based on the 2002 Chechen rebel takeover of the Russian musical "Nord Ost" – itself based on "Two Captains", a classic adventure novel – and features dozens of actors cycling through seemingly random combinations of over fifty pantomime-like actions. The actors rant and rave – or stare silently – in unison, their sounds building to a crescendo from which various repeated phrases ("And father never returned!") can be isolated. Footage for the video version was shot at the Polish American Army Veterans Association in Chicago, whose interior contains nationalistic insignia, military photographs, and artworks that add another layer of meaning to the action. Sullivan picks apart the cohesion offered by the narrative drive of typical theatrical productions; what results is a lucid portrayal of the instability of identity in the face of repeated transformation.

Catherine Sullivan fühlt sich auf der Bühne genauso wohl wie im Galerieraum. Als ausgebildete Schauspielerin und bildende Künstlerin führte sie ihr Weg nach Stationen als Drehbuchautorin, Darstellerin und Leiterin eines Off-Theaters zuletzt in Museen und Galerien. Ihre komplexen Multiscreen-Video-Installationen (und die im Zusammenhang mit ihnen entstandenen Fotografien), in denen häufig Szenen und Zitate aus bekannten Filmen, bedeutende historische Momente oder aus den Nachrichten übernommene Geschichten aufgegriffen werden, zeigen in einer irritierenden Stilvielfalt agierende Schauspieler. Zuweilen produziert Sullivan mehrere Wiederholungen einer Szene, bei denen die Akteure ihre Rollen genauso frei tauschen, wie die von ihnen vermittelten Emotionen wechseln. Kürzlich präsentierte sie ihre Arbeit *Ice Floes of Franz Joseph Land* als Video-Installation (2003) sowie als Performance (2004). Als Grundlage diente der Überfall tschetschenischer Rebellen auf das russische Musical „Nord Ost" im Jahr 2002 – welches seinerseits auf dem klassischen Abenteuerroman „Zwei Kapitäne" basiert. In dieser Arbeit durchlaufen Dutzende von Schauspielern scheinbar zufällige Kombinationen aus über fünfzig pantomimischen Handlungen. Die Schauspieler toben und rasen unisono – wenn sie nicht vor sich hin starren –, während sich ihre Geräusche zu einem Crescendo steigern, aus dem sich verschiedene wiederholte Phrasen („Und Vater kehrte niemals heim!") abheben. Die Videoaufnahmen entstanden in der Polish American Army Veterans Association in Chicago, in deren Räumen sich nationalistische Insignien, Militärfotografien und Kunstwerke befinden, die der Handlung eine weitere Bedeutungsebene verleihen. Sullivan zerpflückt den durch die narrative Richtung typischer Theaterproduktionen erzeugten Zusammenhang und lässt anhand wiederholter Verwandlungen ein scharfes Abbild der Unbeständigkeit von Identität entstehen.

Catherine Sullivan est tout aussi à l'aise dans la chambre noire que dans le *white cube*. Formée comme comédienne et plasticienne, elle a récemment fait entrer son itinéraire de script, d'actrice et de metteur en scène de théâtre alternatif dans les musées et les galeries. Avec les photographies qui s'y rattachent, ses installations vidéo complexes réalisées simultanément sur plusieurs écrans – qui s'approprient souvent des scènes et des images de films célèbres, de moments historiques chargés ou d'événements tirés de l'actualité – présentent des acteurs jouant dans une gamme de styles époustouflante. Sullivan produit parfois des déclinaisons multiples de chaque scène, et ses protagonistes échangent leurs rôles aussi librement que les émotions qu'ils véhiculent. Récemment, elle a présenté *Ice Floes of Franz Joseph Land* successivement sous forme d'installation vidéo (2003) et de performance (2004). Basée sur l'assaut par un commando tchétchène, en 2002, d'un théâtre moscovite où se jouait la comédie musicale « Nord Ost » – elle-même tirée de « Deux capitaines », un classique du roman d'aventures – cette pièce montre des douzaines d'acteurs décliner des combinaisons apparemment aléatoires de plus de cinquante actions apparentées à la pantomime. Les acteurs pestent et tempêtent – ou ont le regard figé – à l'unisson, leurs voix construisant des crescendos dans lesquels peut être isolée la répétition de certaines phrases (« Et papa n'est jamais revenu ! »). Les images de la version vidéo ont été filmées à la Polish Army Veterans Association de Chicago, dont les espaces contiennent des insignes nationalistes, des photos militaires et des œuvres d'art qui ajoutent une strate sémantique supplémentaire à l'action. Sullivan démonte la cohérence donnée par le flux narratif des productions dramatiques habituelles – il en résulte le portrait lucide de l'instabilité de l'identité face à des transformations répétées. B. S.

SELECTED EXHIBITIONS →
2005 Kunsthalle Zürich; *Michael Krebber, Catherine Sullivan, Terence Koh,* Secession, Vienna; *Life, Once More. Forms of Reenactment in Contemporary Art,* Witte de With, Rotterdam **2004** *Ice Floes of Franz Joseph Land/House of Alex/House of Peter (and Some of Those Crappy Details),* Kunstverein Braunschweig; *Getting Out of The 20th Century Alive,* Neuer Aachener Kunstverein; Whitney Biennial, Whitney Museum of American Art, New York **2003** *Five Economies (big hunt/little hunt),* Metro Pictures, New York; *Matrix 149,*

Wadsworth Atheneum, Hartford **2002** *Five Economies (big hunt/little hunt),* The Renaissance Society, Chicago

SELECTED PUBLICATIONS →
2002 *Five Economies (big hunt/little hunt),* The Renaissance Society, Chicago

1 **Audimax/Volksbühne Manifestation**, 2004, performance view, Volksbühne am Rosa-Luxemburg-Platz, Berlin

2 **Ice Floes of Franz Joseph Land**, 2004, video, installation view, Kunstverein Braunschweig

3+4 **Ice Floes of Franz Joseph Land**, 2004, film production stills

2

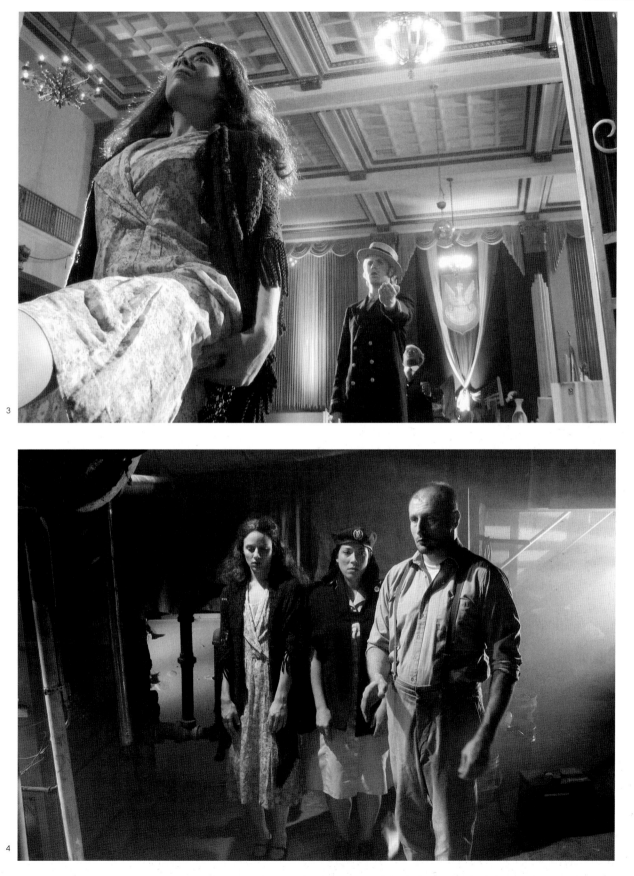

3

4

Wolfgang Tillmans

1968 born in Remscheid, Germany, lives and works in London, UK

Kate Moss smiling smartly in front of a colourful pile of wax fruit, a pair of jeans hanging over the knob of a banister, an airline break-fast to which the erect penis of the person in the neighbouring seat seems to belong: Wolfgang Tillmans' highly diverse photographs confront us with the immediacy of chance snapshots. Tillmans worked for fashion and music magazines before switching to the art context in the 1990s, and in 2000 he became the first non-Briton and first photographer to receive the renowned Turner Prize. The authentic character of his works may occasionally belie the fact that Tillmans certainly does employ classical methods of photographic composition: staging, framing, lighting, editing, and selection of format. The shots also show the influence of pictorial traditions such as still life and cartography. The abstract series *Blushes* or *Freischwimmer* (2000–2004), were created as photographic experiments without a camera by using light pens or colour chemicals on photographic paper. Tillmans reflects the diversity of his works' origins in his exhibitions: large-format photographic prints hang beside cut-out magazine pages; photocopies in post-card format beside greatly enlarged digital printouts. Even his work for magazines and artist's books is an important component of Tillmans' practice: over several pages of the book *Concorde* (1997), he followed the flight of one of these super-sonic aircraft across the London city sky, its increasing distance already seeming to announce a farewell to the utopia. With an estimated 2400 illustrations, the catalogue *if one thing matters, everything matters* (2003) provides access to Tillmans' diverse photographic archive.

Die adrett lächelnde Kate Moss vor einem bunten Häufchen Wachsobst, eine Jeans, die über einen Geländerknauf gehängt ist, ein Flug-zeugfrühstück, zu dem auch der erigierte Penis des Sitznachbarn zu gehören scheint: Die vielseitigen Fotografien von Wolfgang Tillmans begegnen uns mit der Unmittelbarkeit zufälliger Momentaufnahmen. Tillmans arbeitete für Mode- und Musikmagazine, bevor er in den frühen neunziger Jahren in den Kunstkontext wechselte und 2000 als erster Nichtbrite und Fotograf den renommierten Turner-Preis erhielt. Der authentische Charakter seiner Arbeiten mag zuweilen darüber hinwegtäuschen, dass Tillmans durchaus klassische fotografische Gestaltungs-mittel einsetzt: Inszenierung, Ausschnitt, Belichtung, Nachbearbeitung, Wahl des Formats. Die Aufnahmen zeigen zudem Einflüsse von Bild-traditionen des Stilllebens oder der Kartografie. Die abstrakten Serien *Blushes* oder *Freischwimmer* (2000–2004) entstanden als fotografische Experimente ohne Kamera durch die Bearbeitung von Fotopapier mit Lichtstiften oder Farbchemie. In seinen Ausstellungen reflektiert Tillmans diese unterschiedlichen Entstehungskontexte: Großformatige Fotoabzüge hängen neben ausgeschnittenen Magazinseiten, Fotokopien im Postkartenformat neben vielfach vergrößerten Digitalausdrucken. Auch die Arbeiten für Zeitschriften und Künstlerbücher sind ein wichtiger Bestandteil von Tillmans' Praxis: In *Concorde* (1997) verfolgt er über mehrere Buchseiten hinweg den Flug einer der Überschallmaschinen über den Londoner Stadthimmel, deren zunehmende Entfernung bereits den Abschied der Utopie anzukündigen scheint. Der Katalog *if one thing matters, everything matters* (2003) erschließt mit rund 2400 Abbildungen Tillmans' vielseitiges fotografisches Archiv.

Le sourire gracieux de Kate Moss devant un monceau de fruits multicolores en cire, un jeans accroché à une boule de rampe d'esca-lier, un petit-déjeuner dans une cabine d'avion, dont semble aussi faire partie le pénis en érection du voisin de siège : les photographies très diverses de Tillmans se présentent à nous avec l'immédiateté d'instantanés fortuits. Avant de passer dans le contexte de l'art au début des années quatre-vingt-dix, Tillmans a travaillé pour des revues de mode et de musique. En 2000, il fut le premier photographe – qui plus est non britannique – à recevoir le prestigieux Prix Turner. L'authenticité de ses œuvres peut parfois faire oublier que ses moyens – mise en scène, cadrage, éclairage, retouches, choix du format – relèvent fondamentalement de la photographie classique. Ses prises de vue dénotent en outre l'influence de certaines traditions picturales, de la nature morte ou de la cartographie. Les séries abstraites *Blushes* ou *Freischwimmer* (2000–2004) ont vu le jour comme des expérimentations photographiques sans appareil, par impression de papier photographique à l'aide de crayons optiques ou de colorants chimiques. Dans ses expositions, Tillmans revient sur les différents contextes de la genèse de ses œuvres : tirages grand format accrochés à côté de coupures de magazines, photocopies au format de carte postale à côté d'agrandissements numériques. Les travaux réalisés pour des revues ou des livres d'artistes constituent un élément important de sa démarche : dans *Concorde* (1997), Tillmans suivait sur plusieurs pages l'envol, dans le ciel de Londres, d'un des appareils supersoniques, dont l'éloignement progressif semblait déjà annoncer l'adieu à l'utopie. Avec ses quelque 2400 reproductions, le catalogue *if one thing matters, everything matters* (2003) ouvre l'accès aux archives photographiques très diverses de Tillmans.

E. K.

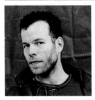

SELECTED EXHIBITIONS →
2004 *Freischwimmer*, Tokyo Opera City Art Gallery **2003** *if one thing matters, everything matters*, Tate Britain, London; *Architekturen der Obdachlosigkeit*, Pinakothek der Moderne, Munich
2002 *Unterbrochene Karrieren/Partnerschaften – Jochen Klein, Wolfgang Tillmans*, Neue Gesellschaft für Bildende Kunst, Berlin
2001/02 *Aufsicht/View from Above*, Deichtorhallen Hamburg; Castello di Rivoli, Turin, Palais de Tokyo, Paris, Louisiana Museum for Moderne Kunst, Humlebæk **2001** *Wolfgang Tillmans & Isa Genzken:*

Science Fiction/Hier und jetzt zufrieden sein, Museum Ludwig, Cologne **2000** *Turner Prize Exhibition*, Tate Britain, London

SELECTED PUBLICATIONS →
2005 *Wolfgang Tillmans, truth study center*, Cologne **2003** *if one thing matters, everything matters*, London **2001** *Wolfgang Tillmans & Isa Genzken: Science Fiction/Hier und jetzt zufrieden sein*, Museum Ludwig, Cologne; *Aufsicht*, Hamburg; *Wolfgang Tillmans: Wako Book 2*, Wako Works of Art, Tokyo

1 **Anders Pulling a Splinter from His Foot**, b/w photograph, 2004 3 **Freischwimmer 40**, colour photograph, 2004
2 Exhibition view, "View from Above", Louisiana Museum for Moderne Kunst,
 Humlebæk, 2003

„Mir geht es vor allem um Textur, um Oberfläche und um Gerüche." « Je m'intéresse avant tout à la texture, aux surfaces et aux senteurs. »

"Above all I am interested in texture, in surface, and in smells."

2

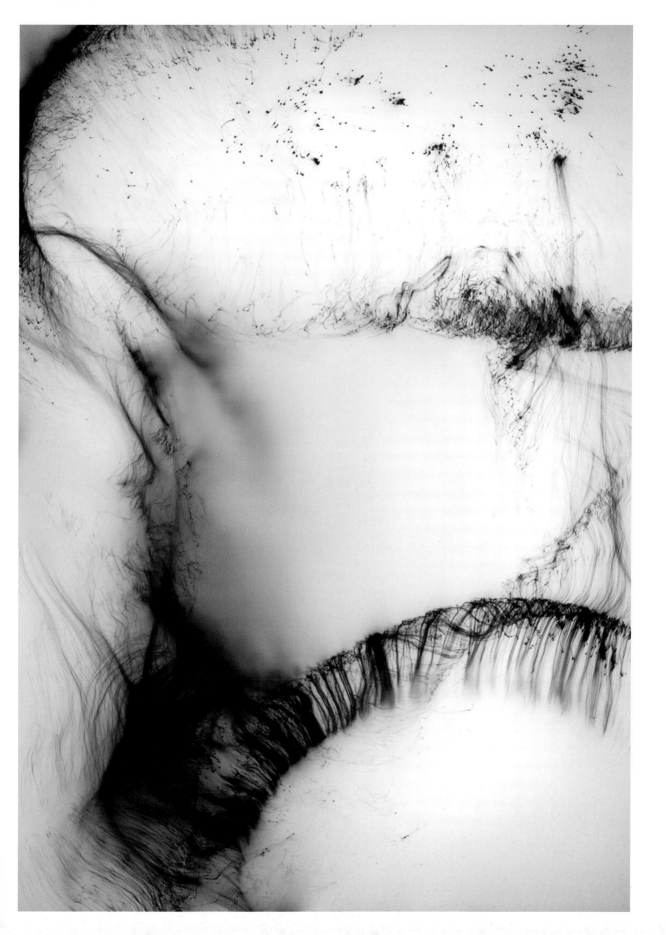

Rirkrit Tiravanija

1961 born in Buenos Aires, Argentina, lives and works in New York (NY), USA, and Berlin, Germany

An open-ended fluidity informs Rirkrit Tiravanija's projects and installations, as well as a softly-spoken determination to dissolve the boundaries between the institution and its outside, artwork and daily life, audience and active participant. Over the past ten years he has taken a bicycle trip across Spain; converted galleries into free-for-all curry kitchens; built a full-size model of his New York apartment in a German museum, complete with working kitchen and bathroom and open 24 hours a day; and opened a mini supermarket inside a Swiss museum. For Tiravanija the building process is as vital as the final structure itself, and in all cases the key ingredient is "lots of people" without whose involvement the work remains incomplete. An exhibition at Vienna's Secession in 2002 saw Tiravanija coordinating the construction of a full-size stainless steel replica of early modernist architect Rudolf M. Schindler's house inside the museum. The house was constructed throughout the duration of the exhibition, as and when the parts arrived from Mexico, shifting the focus from the presentation of a finished object to the time-consuming communal task of construction, like the raising of a barn roof. The structures he builds are loose frameworks within which any number of unprescribed activities may take place, where success or failure are not at stake but rather breadth of experience and the opening up of possibilities for creativity, community and, above all, communication. He embraces the chaos this proposes, leaving almost everything to chance and welcoming the inconclusiveness this brings with it.

Die Projekte und Installationen von Rirkrit Tiravanija zeichnen sich durch einen fließenden Charakter und die leise formulierte Entschlossenheit aus, die Grenzen zwischen Institution und ihrer Außenwelt, zwischen Kunst und Alltag, Publikum und aktiv Beteiligten aufzuweichen. Während der letzten zehn Jahre hat der Künstler Spanien mit dem Fahrrad bereist, Galerien in kostenlos zugängliche Currygarküchen verwandelt, in einem deutschen Kunstverein ein Tag und Nacht geöffnetes 1:1-Modell seiner New Yorker Wohnung, komplett mit Arbeitsküche und Bad, aufgebaut und außerdem einen Mini-Supermarkt in einem Museum in der Schweiz eröffnet. Für Tiravanija ist der Entstehungsprozess von ebenso großer Bedeutung wie der endgültige Bau selbst, und in allen Fällen ist die Hauptzutat „jede Menge Leute", ohne deren Mitwirkung das Werk unvollendet bleibt. Im Rahmen einer Ausstellung in der Wiener Secession 2002 koordinierte Tiravanija innerhalb des Museums die Konstruktion eines maßstabgerechten Edelstahlnachbaus eines Hauses des Architekten der frühen Moderne Rudolf M. Schindler. Die Bautätigkeit zog sich über die gesamte Dauer der Ausstellung hin, während der die Bauteile nach und nach aus Mexiko eintrafen. Dies verlagerte den Schwerpunkt von der Präsentation eines vollendeten Objekts auf den zeitaufwändigen Aufbau vor Ort, beispielsweise bei der Errichtung eines Scheunendachs. Die von Tiravanija geschaffenen Bauten bilden ein loses Gerüst, innerhalb dessen eine beliebige Anzahl nicht vorgegebener Aktivitäten stattfinden kann, bei denen es nicht um Gelingen oder Scheitern geht, sondern um das Sammeln von Erfahrungen und die Möglichkeiten von Kreativität, Gemeinschaft und vor allem Kommunikation. Tiravanija macht sich das so provozierte Chaos bewusst zunutze, räumt dem Zufall eine wesentliche Rolle ein und bezieht die damit einhergehende Zwanglosigkeit in seine Arbeit mit ein.

Une fluidité permettant de multiples interprétations caractérise les projets et installations de Rirkrit Tiravanija, ainsi qu'une subtile volonté de dissoudre les limites entre l'institution et l'extérieur, l'œuvre d'art et la vie quotidienne, le spectateur et le participant actif. Au cours des dix dernières années, il a effectué un tour d'Espagne en vélo ; transformé des galeries en échoppes indiennes servant des plats au curry gratuits ; construit une réplique grandeur nature, ouverte 24 heures sur 24, de son appartement new-yorkais, cuisine et salle de bains compris, dans un musée en Allemagne ; et ouvert une supérette à l'intérieur d'un musée en Suisse. Pour Tiravanija, le processus de construction est aussi vital que la structure finale elle-même, et dans tous les cas, l'ingrédient clef est « beaucoup de gens », sans l'implication desquels l'œuvre reste incomplète. Une exposition à la Sécession de Vienne en 2002 a vu Tiravanija coordonner la construction, à l'intérieur du musée, d'une réplique grandeur nature de la maison de Rudolf M. Schindler, l'architecte du début de l'ère moderne. La maison a été édifiée pendant la durée de l'exposition à mesure que les pièces détachées arrivaient du Mexique, déplaçant l'attention de la présentation d'un objet fini à l'ouvrage commun et au temps nécessaire à la construction, comme lors de l'érection d'un toit de grange. Les structures qu'il construit sont des cadres souples au sein desquels peuvent se déployer toutes sortes d'activités libres dont l'enjeu n'est pas la réussite ou l'échec, mais plutôt l'étendue de l'expérience, l'émergence de possibilités créatives, la communauté, et surtout la communication. Tiravanija englobe le chaos suscité par son propos, laissant presque tout au hasard et saluant le caractère non concluant induit par sa démarche. K. B.

SELECTED EXHIBITIONS →
2005 The Hugo Boss Prize 2004, Solomon R. Guggenheim Museum, New York **2004** *Nothing: A Retrospective*, Chiang Mai University Museum **2003** *Utopia Station*, co-curator with Molly Nesbit/Hans-Ulrich Obrist, 50. Biennale di Venezia, Venice **2002** *Untitled, 2002 (the promised)*, Secession, Vienna; *Untitled, 2002 (the raw and the cooked)*, Tokyo Opera City Art Gallery **2001** *Untitled, 2001 (Demo Station No.1)*, Portikus, Frankfurt/Main; *Public Offerings*, The Museum of Contemporary Art, Los Angeles

SELECTED PUBLICATIONS →
2002 *Rirkrit Tiravanija*, Secession, Cologne; *Rirkrit Tiravanija: Untitled, 2002 (the raw and the cooked)*, Tokyo Opera City Art Gallery, Tokyo **2001** *Rirkrit Tiravanija: Untitled, 2001 (Demo Station No.1)*, Frankfurt/Main **2000** *Where the Grass Is Green, Use It*, Galería Salvador Díaz, Fundación Arq Art, Madrid

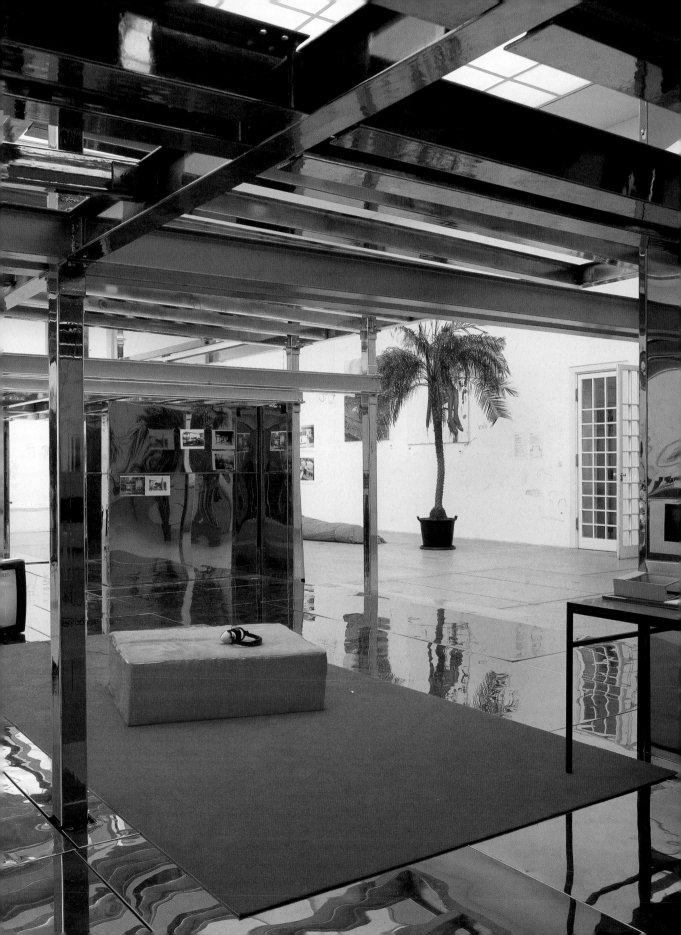

1 **Untitled 2002 (he promised)**, 2002, installation view, Secession, Vienna
2 **Untitled 2004 (tomorrow is another fine day)**, 2004, installation view, Museum Boijmans Van Beuningen, Rotterdam

3 **Untitled 2004 (Nothing: A Retrospective)**, 2004, installation view, Chiang Mai University Museum

„Es geht eher um Möglichkeiten als um Lösungen."

«Il est plus question de possibilités que de solutions.»

"It's more about possibilities, not solutions."

2

Luc Tuymans

1958 born in Mortsel, lives and works in Antwerp, Belgium

The figures and objects in Luc Tuymans' pictures often confront the viewer like phantoms. With indifferent, pallid-toned painting and limited texture, the Belgian artist evokes reality like a ghostly reflection, a sallow afterimage. Tuymans often develops his motifs in thematic series and works from materials out of the media – photos, Polaroids, newspaper clippings and models. Never, however, does he work from nature. This lends his pictures even more of an air of things past, of things viewed from a distance. Tuymans is generally and primarily interested in the representation of memory, and in questioning its possibility. The extremely wide spectrum of his visual world is also based on this. Thus he often refers to difficult and taboo-laden topics from recent history – such as Nazism and the holocaust (*Gas Chamber*, 1986; *Die Zeit*, 1988), or to unrest in the Belgian Congo (*Mwana Kitoko – Beautiful White Man*, 2000). Seemingly banal motifs also appear, however, in an apparently unrelated manner: a piece of wrapping paper, a lamp (*Lampe*, 1994), a meagerly furnished room (*Stille Musik*, 1992), or even pale windows of light from projections of empty slides (*Slide 1–3*, 2002). In his characteristic painting style, Tuymans handles all of these identically. Much here is close to nothing. This vagueness in Tuymans' pictures, the simply suggested and surmisable, is precisely that which conjures up a quiet, boundless intensity, and then approaches content from this point as well. In these paintings the weighty and actually unrepresentable is transformed into something almost nameless and threatening. Their power is that of a suggestive apprehension that lingers close to its own dissolution.

Die Gestalten und Gegenstände in den Bildern von Luc Tuymans begegnen dem Betrachter nicht selten wie Phantome. Mit indifferent blasstoniger Malerei und reduzierter Textur ruft der belgische Künstler die Wirklichkeit wie einen geisterhaften Widerschein, ein fahles Nachbild auf. Tuymans entwickelt seine Motive oft in thematischen Reihen und geht dabei von medialen Vorlagen aus – Fotos, Polaroids, Zeitungsausschnitte, Modelle. Nie jedoch arbeitet er nach der Natur. Das verleiht den Bildern umso mehr den Gestus des Vergangenen, des aus der Distanz Betrachteten. Generell und grundlegend geht es Tuymans um die Repräsentation von Erinnerung, um das Befragen ihrer Möglichkeit. Darauf gründet auch das äußerst breite Spektrum seiner Bildwelt: So bezieht er sich vielfach auf schwierige, auch tabubelegte Themen jüngerer Zeitgeschichte – etwa auf Nationalsozialismus und Holocaust (*Gaskammer*, 1986; *Die Zeit*, 1988) oder Unruhen in Belgisch-Kongo (*Mwana Kitoko – Beautiful White Man*, 2000). Scheinbar unzusammenhängend tauchen aber auch vermeintlich banale Motive auf: ein Stück Packpapier, eine Lampe (*Lampe*, 1994), ein karg möblierter Raum (*Stille Musik*, 1992) oder gar blasse Lichtfenster von leeren Diaprojektionen (*Slide 1–3*, 2002). In der charakteristischen Ausführung seiner Malerei macht Tuyman's zwischen all dem keinen Unterschied. Vieles ist hier nahe am Nichts. Und es ist gerade die Vagheit, das bloß Angedeutete und Erahnbare in Tuymans' Bildern, das eine leise, bodenlose Intensität heraufbeschwört und sich von da aus auch Inhalten nähert. In dieser Malerei verwandelt sich das Schwere, eigentlich Undarstellbare in ein nahezu namenlos Bedrohliches. Ihre Kraft ist die einer suggestiven Ahnung, die nah an der eigenen Auflösung verweilt.

Il n'est pas rare que les figures et les objets des tableaux de Luc Tuymans nous apparaissent comme des fantômes. A travers la pâle indifférence et la texture réduite de sa peinture, l'artiste belge évoque la réalité comme une réflexion spectrale, comme une trace blafarde de l'image. Tuymans développe souvent ses motifs en séries thématiques et s'appuie pour cela sur des modèles empruntés aux médias – photos, polaroïds, coupures de journaux, maquettes. Il ne travaille jamais à partir du modèle naturel, ce qui confère à ses tableaux une note d'autant plus passéiste, un point de vue distancé. Fondamentalement et globalement, le propos de Tuymans s'attache à la représentation de la mémoire, à l'interrogation de ses possibilités. C'est de ce même champ que se nourrit aussi l'éventail très étendu de son univers : Tuymans se réfère souvent à des thèmes difficiles, marqués par le tabou, de l'histoire récente – par exemple le nazisme et la Shoah (*Gaskammer*, 1986 ; *Die Zeit*, 1988) ou encore les troubles au Congo belge (*Mwana Kitoko – Beautiful White Man*, 2000). Mais des motifs plus banals parsèment son œuvre de manière apparemment décousue : morceau de papier d'emballage, lampe (*Lampe*, 1994), pièce meublée avec parcimonie (*Stille Musik*, 1992), et même les pâles fenêtres lumineuses de diapos vides (*Slide 1–3*, 2002). La facture très caractéristique de la peinture de Tuymans ne fait aucune distinction entre toutes ces choses, et nombreuses sont celles qui confinent au néant. C'est précisément ce caractère vague, allusif et pressenti de ses tableaux qui évoque une silencieuse et abyssale intensité à partir de laquelle l'artiste aborde aussi les contenus. Dans cette peinture, la lourdeur et, en définitive, l'irreprésentabilité, se transforment en une menace presque innommable. Leur force est celle d'un pressentiment suggestif qui est toujours au bord de sa propre dissolution.

J. A.

SELECTED EXHIBITIONS →
2005 Compton Verney House Trust, Warwickshire **2004/05** K21 – Kunstsammlung Nordrhein-Westfalen, Düsseldorf **2004** Tate Modern, London; *Tracing*, Museo de Arte Contemporáneo Internacional Rufino Tamayo, Mexico City **2003** *The Arena*, Kunstverein Hannover, Hanover; Pinakothek der Moderne, Munich; Kunstmuseum Sankt Gallen **2002** documenta 11, Kassel **2001** *Mwana Kitoko – Beautiful White Man*, 49. Biennale di Venezia, Venice

SELECTED PUBLICATIONS →
2004 *Not Afraid: Rubell Family Collection*, London; *Luc Tuymans*, Tate Gallery, London **2003** *Luc Tuymans: Curtains, Reconstitution*, Frac Auvergne, Clermont-Ferrand; *The Arena*, Hanover, Munich, Sankt Gallen; *Luc Tuymans: Display*, Centro de Arte de Salamanca, Salamanca **2002** *Painting on the Move*, Kunstmuseum Basel, Basle

1 **Plant**, 2003, oil on canvas, 167.5 x 95.5 cm
2 **Dough**, 2005, wallpainting on canvas, 431 x 575 cm, installation view,
 carlier I gebauer, Berlin

3 **Dusk**, 2004, oil on canvas, 166 x 260 cm
4 **Still-life**, 2002, oil on canvas, 347 x 500 cm

„Der kleine Raum zwischen der Erklärung des Bildes und dem Bild
selbst gibt die einzig mögliche Perspektive auf die Malerei. Jedes Bild ist
unvollständig, so wie auch jede Erinnerung unvollständig ist."

« Le petit décalage entre l'explication du tableau et le tableau lui-même
produit la seule perspective possible sur la peinture. Tout tableau est incom-
plet, de même que l'est aussi tout souvenir. »

**"The small space between the picture's explanation and the picture itself
provides the only possible perspective on the painting.
Every picture is incomplete, just as every memory is also incomplete."**

2

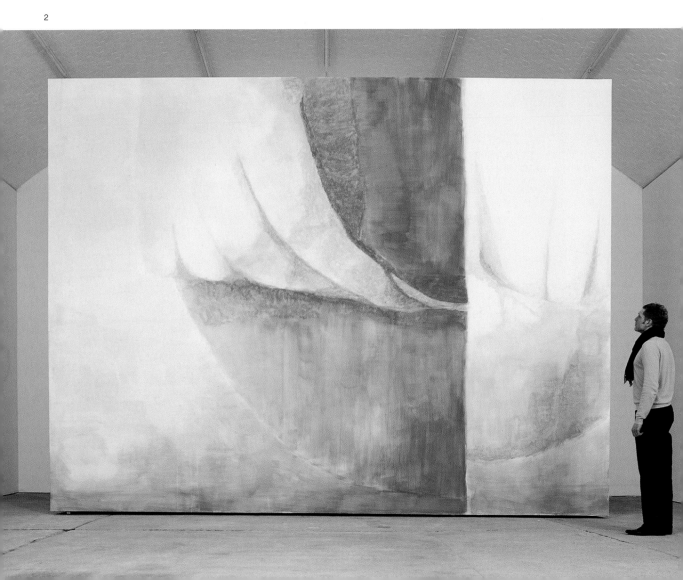

3

4

Francesco Vezzoli

1971 born in Brescia, lives and works in Milan, Italy

Francesco Vezzoli's work unites two practices that at first glance appear completely disparate: the art of film, and the art of embroidery. Both are thematically very closely interwoven, however, and converge in Vezzoli's theatrical installations, which are dedicated to the world of the cinema and its stars. *Trilogia della morte* (2004) is a tribute to Pier Paolo Pasolini, and recreates scenes from two of his films. Vezzoli's video *Not Love Meeting*s (2004) translates Pasolini's documentary film "Comizi d'amore" into a TV talk show, in which – as in the original – film stars discuss questions of sexuality and love. For *The 120 Seats of Sodom* (2004) Vezzoli arranged an ensemble of Mackintosh chairs, which had served as props in the notorious final sequence of Pasolini's *Salò, or The 120 Days of Sodom*. Vezzoli covered the seats of the chairs with embroidered portraits of the actors from "Comizi d'amore". Embroidered pictures often have a life of their own in Vezzoli's oeuvre, however, for upon the portraits of female film stars printed on fabric he embroiders scintillating make-up or shimmering tears in the style of traditional devotional images. The artist's personal style is also unmistakable in his videos, which are interpretations, in which Vezzoli makes cameo appearances, of films by famous directors of the 1960s and 70s. In his works he amalgamates allusions to and collages of stylistically highly diverse films, which unite depictions of human dramas and their banality. Vezzoli's *La fine della voce umana* (2001) quotes both Rossellini as well as Cocteau – it is the drama of a woman who fights for her lover: a reference to Bianca Jagger and the fulfilment of the dreams of the artist.

Das Werk von Francesco Vezzoli vereint zwei auf den ersten Blick völlig disparate Praktiken: die der Film- und die der Stickkunst. Doch sind beide thematisch eng miteinander verwoben und überkreuzen sich in Vezzolis theatralischen Installationen, die der Welt des Kinos und seiner Stars gewidmet sind. *Trilogia della morte* (2004) ist eine Hommage an Pier Paolo Pasolini und stellt Szenen aus zweien seiner Filme nach. Vezzolis Video *Not Love Meetings* (2004) übersetzt Pasolinis Dokumentarfilm „Comizi d'amore" in eine Fernsehtalkshow, in der – wie im Original – Filmstars Fragen zu Sexualität und Liebe diskutieren. Für *The 120 Seats of Sodom* (2004) hat Vezzoli ein Ensemble aus Mackintosh-Stühlen arrangiert, die in der berüchtigten Schlusssequenz von Pasolinis *Salò, oder die 120 Tage von Sodom* als Requisiten dienten. Vezzoli hat die Stuhlsitze mit Stickarbeiten überzogen, die Porträts der Darsteller aus „Comizi d'amore" zeigen. Das Stickbild führt oftmals aber auch ein Eigenleben im Œuvre Vezzolis, denn den auf Stoff gedruckten Porträts weiblicher Filmstars stickt er im Stile volkstümlicher Devotionalienbilder funkelndes Make-up oder schillernde Tränen auf. Die Handschrift des Künstlers ist auch in seinen Videos unverkennbar, Interpretationen von Filmen berühmter Regisseure der sechziger und siebziger Jahre, in denen Vezzoli Cameo-Auftritte hat. Er verquickt in seinen Werken Anspielungen und Collagen stilistisch sehr verschiedener Filme, die inhaltlich die Schilderung menschlicher Dramen sowie deren Banalität eint: Vezzolis *La fine della voce umana* (2001) zitiert sowohl Rossellini als auch Cocteau – es ist das Drama einer Frau, die um ihren Liebhaber kämpft, eine Referenz an Bianca Jagger und eine Erfüllung der Träume des Künstlers.

L'œuvre de Francesco Vezzoli réunit deux pratiques à première vue totalement disparates : le cinéma et la broderie. Les deux y sont néanmoins étroitement liées sur le plan thématique et se superposent dans des installations théâtrales dédiées au monde du cinéma et à ses stars. *Trilogia della morte* (2004) est un hommage à Pier Paolo Pasolini et reconstitue des scènes de deux œuvres du cinéaste. La vidéo *Not Love Meetings* (2004) transforme le documentaire de Pasolini « Comizi d'amore » en un talk-show télévisé dans lequel – comme dans l'original – des stars du cinéma débattent de questions de sexe et d'amour. Pour *The 120 Seats of Sodom* (2004), Vezzoli a arrangé un ensemble de chaises Mackintosh qui avaient servi d'accessoires dans la sulfureuse séquence finale de *Saló ou les 120 jours de Sodome*. L'artiste a recouvert ces sièges de broderies montrant des portraits des acteurs de « Comizi d'amore ». Dans l'œuvre de Vezzoli, l'image brodée prend souvent une vie propre dans la mesure où l'artiste affuble ses portraits de stars féminines du cinéma imprimés sur tissu de make-up étincelants ou de larmes chatoyantes réalisés dans le style des images dévotionnelles populaires. L'écriture de Vezzoli est tout aussi reconnaissable dans ses vidéos, interprétations de films de metteurs en scène célèbres des années soixante et soixante-dix dans lesquelles l'artiste fait lui-même de brèves apparitions caméos. Dans ses œuvres, Vezzoli mélange des références et des collages de films stylistiquement très différents. Au niveau du contenu, il unifie ainsi la description aussi bien que la banalité de drames humains : *La fine della voce umana* (2001) cite Rossellini aussi bien que Cocteau – il s'agit du drame d'une femme qui se bat pour son amant, une référence à Bianca Jagger et un accomplissement des rêves de l'artiste.

A. M.

SELECTED EXHIBITIONS →
2005 51. Biennale di Venezia, Venice; Museu Serralves, Porto
2004 *Trilogy of Death*, Fondazione Prada, Milan; 26. Bienal de São Paulo **2002** *The Films of Francesco Vezzoli*, New Museum of Contemporary Art, New York; 2. Liverpool Biennial; Castello di Rivoli, Turin **2001** *Plateau of Humankind*, 49. Biennale di Venezia, Venice **2000** *Migrazioni*, Centro Nazionale per le Arti Contemporanee, Rome

SELECTED PUBLICATIONS →
2004 *Francesco Vezzoli*, Germano Celant (ed.), Fondazione Prada, Milan **2002** *Francesco Vezzoli*, Castello di Rivoli, Turin **2002** *The Needleworks of Francesco Vezzoli*, Galerie für Zeitgenössische Kunst Leipzig, Leipzig

1 Comizi di non amore – the prequel (Contestant No. 1 – Catherine Deneuve), 2004, b/w laserprint on canvas with metallic embroidery, 61 x 51.5 cm

2 Trailer for a Remake of Gore Vidal's "Caligula", 2005, 35mm film transferred to DVD, 5 min. 20 sec., stills

3 Poster for a Remake of Gore Vidal's "Caligula", 2005, silkscreen, 140 x 100 cm

„Ich mag es, mich zwischen extremen Situationen zu bewegen. So mag ich zum Beispiel Filme von Fassbinder *und* Hollywood-Filme. Man findet zahlreiche literarische und filmische Referenzen in meiner Arbeit. Man kann meine Arbeit als völlig oberflächlich oder völlig tiefgründig betrachten."

«J'aime me déplacer entre les extrêmes. Par exemple, j'aime Fassbinder *et* les films hollywoodiens. Dans mon œuvre, on peut trouver de nombreuses références à la littérature et au cinéma. On peut voir mon œuvre comme totalement superficielle ou totalement profonde.»

"I like to travel within extreme situations. For example I like Fassbinder films *and* Hollywood movies. One can find a lot of references to literature and cinema in my work. You can look at my work as complete surface or as complete depth."

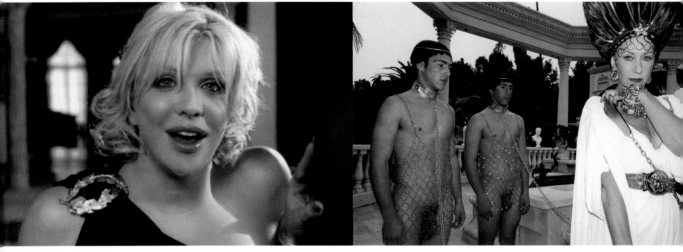

2

FROM THE CREATOR OF "COMIZI DI NON AMORE"
THE REIMAGINING OF A MOVIE THAT SCANDALIZED THE WORLD

FRANCESCO VEZZOLI
IN
GORE VIDAL'S

CALIGULA

STARRING

ADRIANA ASTI KAREN BLACK BARBARA BOUCHET
GERARD BUTLER BENICIO DEL TORO MILLA JOVOVICH
HELEN MIRREN MICHELLE PHILLIPS GLENN SHADIX
TASHA TILBERG SPECIAL APPEARANCE BY GORE VIDAL

SPECIAL GUEST STAR
COURTNEY LOVE

COMING SOON TO A THEATRE NEAR YOU

3

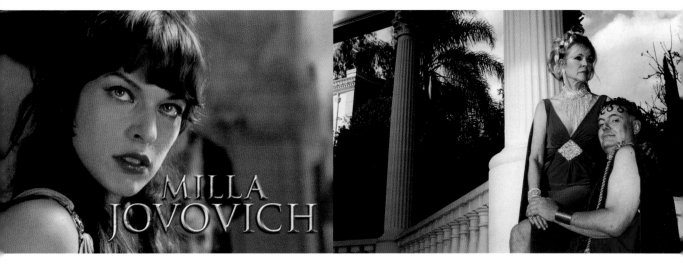

MILLA JOVOVICH

Kara Walker

1969 born in Stockton (CA), lives and works in New York (NY), USA

The plight of slaves in America from 1619 to 1863 is a story seldom told. Despite a rash of publishing on slavery and the African diaspora over the last two decades, schools have tended to avoid this painful period of history. Kara Walker uses a didactic tool from the classroom, the overhead projector, for light-based works such as *Insurrection! Our Tools Were Rudimentary, Yet We Pressed On* (2000) to reveal the way in which half-truths, rumours and fictions can be presented as factual documents. These phantasmagoric backdrops, combined with primitive "magic lanterns" and projected videos (*Fibbergibbet and Mumbo Jumbo*, 2004), involve the viewer's shadow in the tawdry activities up on the walls, implying that we are party to the degrading scenes of sexual misconduct, mutilation and humiliation. Walker bases her characters and narratives on first-hand sources that popularized racist images of the "sambo" or the "pickaninny" from Thomas Dixon's propagandist novel "The Clansman" to glimpses of uncomfortable racism in "Gone with the Wind", yet her seductive silhouettes do not redress these wrongs but blur historical detail, as with the passing of time. There is humour too, found in the artist's self-portrayal as slave for one exhibition title: "Works of a certain interest created entirely by a young Negress of unusual ability". However, while the use of 19th-century language establishes a certain distance from the horror, Walker's unique talent lies in reminding the civilised world of a grim spectre that must not be forgotten.

Über die missliche Lage der Sklaven in Amerika in der Zeit von 1619 bis 1863 wird weitgehend geschwiegen. Trotz der in den letzten zwanzig Jahren zu beobachtenden Fülle von Publikationen zur Sklaverei und der afrikanischen Diaspora neigte man dazu, in den Schulen diese schmerzliche Epoche zu umgehen. Kara Walker nutzt ein aus dem Klassenzimmer bekanntes Lehrmittel, den Overheadprojektor, in ihren mit Licht operierenden Arbeiten wie *Insurrection! Our Tools Were Rudimentary, Yet We Pressed On* (2000), um zu enthüllen, wie Halbwahrheiten, Gerüchte und Fiktionen als Tatsachenmaterial präsentiert werden können. Diese phantasmagorischen Hintergründe in Verbindung mit primitiven Laternae magicae und projizierten Videos (*Fibbergibbet and Mumbo Jumbo*, 2004) beziehen den Schatten des Betrachters in die übersteigerten Vorgänge an der Wand mit ein und deuten an, dass wir Teil der erniedrigenden Szenen aus sexueller Verfehlung, Verstümmelung und Demütigung sind. Walkers Figuren und Geschichten basieren auf Vorlagen, die das rassistische Bild des "Sambo" oder des "Pickaninny" popularisierten, von Thomas Dixons Propagandaroman „The Clansman" bis hin zu Momenten eines heiklen Rassismus in „Vom Winde verweht", und doch werden diese Übel in ihren Schattenrissen nicht aufgehoben, vielmehr verschwimmen historische Details, als würden sie mit der Zeit verblassen. Man findet in ihnen durchaus auch Humor, beispielsweise in der Selbstdarstellung der Künstlerin als Leibeigene in einem Ausstellungstitel: „Works of a certain interest created entirely by a young Negress of unusual ability". Während die Verwendung der Sprache des 19. Jahrhunderts auch eine gewisse Distanz zu jenen Gräueln schafft, besteht Walkers einzigartiges Talent darin, die zivilisierte Welt an ein Schreckgespenst zu erinnern, das nicht vergessen sein soll.

La détresse des esclaves d'Amérique entre 1619 et 1863 est une histoire peu racontée. Malgré la vague de publications sur l'esclavage et la diaspora africaine qui a déferlé au cours des deux dernières décennies, les écoles ont plutôt eu tendance à éviter cette période historique déplorable. Kara Walker se sert d'un outil pédagogique du milieu scolaire, le rétroprojecteur, pour des œuvres fondées sur la lumière comme *Insurrection! Our Tools Were Rudimentary, Yet We Pressed On* (2000), pour montrer la manière dont les demi-vérités, les rumeurs et les fictions peuvent être présentées comme des documents objectifs. Ces toiles de fond fantasmagoriques associées à des «lanternes magiques» primitives et des projections vidéo (*Fibbergibbet and Mumbo Jumbo*, 2004), associent l'ombre du spectateur aux actes navrants qui sont projetés au mur, laissant entendre que nous sommes impliqués dans l'avilissement des méfaits sexuels, de la mutilation et de l'humiliation. Walker tire ses personnages et ses récits de sources connues ayant popularisé les images racistes du «nègre agressif» (sambo) ou de la «négrillone» (pickaninny), du roman propagandiste de Thomas Dixon, «The Clansman», aux instants d'un racisme délicat dans «Autant en emporte le vent.» Pour autant, les séduisantes silhouettes de Walker ne tentent pas de réparer les préjudices, mais occultent plutôt certains détails historiques à l'instar du temps qui passe. L'on rencontre aussi l'humour dans ses œuvres, comme le montre l'autoportrait de l'artiste en esclave utilisé pour le titre d'exposition «Works of a certain interest created entirely by a young Negress of unusual ability». Mais tandis que l'utilisation du vocabulaire du XIXᵉ siècle dans l'image comme dans le langage crée une certaine distance avec l'horreur, le talent unique de Walker consiste à rappeler au monde civilisé un spectre sinistre qui ne doit pas être oublié.

O.W.

SELECTED EXHIBITIONS →
2005 *Quartet: Barney, Gober, Levine, Walker*, Walker Art Center, Minneapolis **2004** *Fibbergibbet and Mumbo Jumbo: Kara E. Walker in Two Acts*, The Fabric Workshop and Museum, Philadelphia; *Grub for Sharks: A Concession to the Negro Populace*, Tate Liverpool **2002** *Slavery! Slavery!*, 25. Bienal de São Paulo; *Moving Pictures*, Solomon R. Guggenheim Museum, New York; *For the Benefit of All the Races of Mankind (Mos' Specially the Master One, Boss)*, Kunstverein Hannover, Hanover

SELECTED PUBLICATIONS →
2003 *Narratives of a Negress*, MIT Press, The Tang Museum, Saratoga Springs; *Kara Walker*, Deutsche Bank Collection, Berlin **2002** *Pictures from Another Time*, D.A.P., The University of Michigan Museum of Art, Ann Arbor; *Kara Walker*, Kunstverein Hannover, Hanover; *Slavery! Slavery!*, International Arts and Artists, Washington D.C.

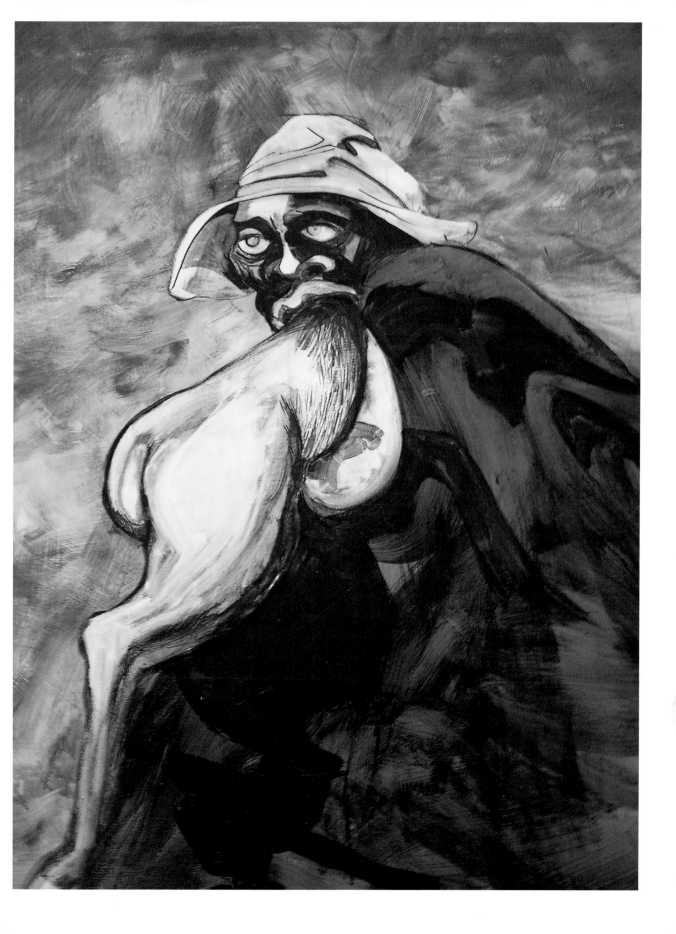

1 **Motherland**, 2004, gouache and gesso on paper, 203.2 x 154.3 cm

2 **For the Benefit of All the Races of Mankind (Mos' Specially the Master One, Boss). An Exhibition of Artifacts, Remnants, and Effluvia Excavated from the Black Heart of a Negress**, 2002, cut paper, projection on wall, installation view, Kunstverein Hannover, Hanover

„Der Scherenschnitt war eine fast perfekte Lösung für ein komplexes Projekt, das ich mir vorgenommen habe – für den Versuch, die häufig subtilen und unheimlichen Methoden der Beeinflussung und Vorbestimmung unseres Alltags durch Rassismus und rassistische oder sexistische Stereotypen bloß-zulegen."

«La silhouette était une solution presque parfaite pour le projet complexe que je m'étais fixé... d'essayer de mettre en évidence la manière souvent subtile et pénible dont le racisme et les stéréotypes racistes et sexistes influencent et écrivent nos vies quotidiennes.»

"The silhouette was a near perfect solution to a complex project that I set for myself... to try and uncover the often subtle and uncomfortable ways racism, and racist and sexist stereotypes influence and script our everyday lives."

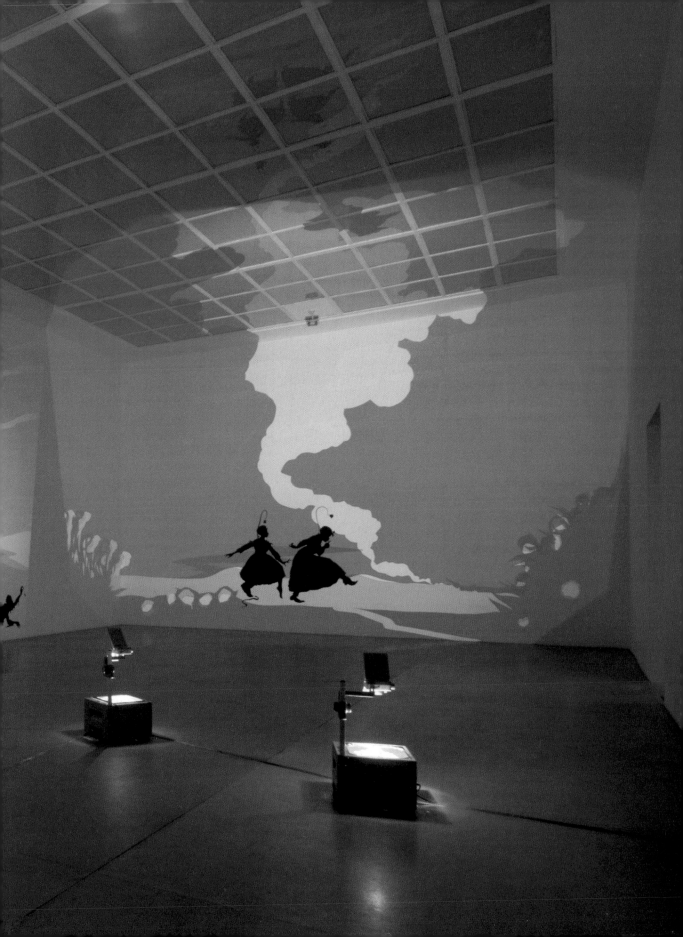

Jeff Wall

1946 born in Vancouver, lives and works in Vancouver, Canada

The immediacy of photographic images, captured in the blink of a shutter, means that they can lack the forethought and compositional complexity that create grandeur or gravitas in painting. While some photographers have combated this tendency by merely monumentalizing the scale and print-sizes of their work, Jeff Wall has spent the last thirty years instilling the photograph with the innovative and interactive philosophies of painters such as Manet and Velázquez, while adopting the latest techniques of photo-manipulation and Hollywood-style production along the way. Generally presented as backlit lightboxes, Wall's ambiguous, character-driven narratives, depicting the assumed generosity of *A Woman with a Covered Tray* (2003) or a prone man's desperation in *Insomnia* (1994), go beyond spontaneous documentation into the realms of staged drama and theatrical spectacle (*The Giant*, 1992). Indeed, single-image distillations of cinematic intensity such as *After Invisible Man by Ralph Ellison, the Preface* (1999–2001) that include actors, lighting, props and sets, can take as long to produce as a feature-film or a 19th-century masterpiece of history painting. Ultimately, Wall constructs autonomous worlds within each frame with such a convincing synthesis of styles that the individual remnants of documentary photography, cinema and painting become difficult to differentiate, and the long moment becomes immediate and decisive once more. An academic art-historian, Wall has proved to be an innovative analyst of the photographic pictorial construction (and its limits).

Die Unmittelbarkeit fotografischer Bilder, eingefangen durch ein kurzes Drücken des Auslösers, ermöglicht den Verzicht auf jede Vorbereitung und kompositorische Komplexität, durch die in der Malerei Erhabenheit und Bedeutungsschwere entstehen. Während einige Fotografen dieser Tendenz begegneten, indem sie lediglich den Maßstab und das Format ihrer Abzüge monumentalisierten, verbrachte Jeff Wall die letzten dreißig Jahre damit, die Fotografie mit den innovativen und interaktiven Betrachtungen von Malern wie Manet und Velázquez aufzuladen und gleichzeitig die neuesten Techniken der Bildbearbeitung sowie Hollywood-ähnliche Produktionsmethoden aufzugreifen. Die vieldeutigen, in der Regel als Großdias in Leuchtkästen präsentierten, von Figuren bestimmten Erzählungen Walls, wie beispielsweise die vorgebliche Großzügigkeit in *A Woman with a Covered Tray* (2003) oder die Verzweiflung eines auf dem Boden Liegenden in *Insomnia* (1994) zeigen, gehen über eine spontane Dokumentation hinaus und sind eher dem Bereich des inszenierten Dramas, des bühnenhaften Schauspiels zuzurechnen (*The Giant*, 1992). Tatsächlich kann sich die Produktion eines Einzelbilddestillats von filmischer Intensität wie etwa *After Invisible Man by Ralph Ellison, the Preface* (1999–2001), für das Akteure, Beleuchtung, Requisiten und Kulissen notwendig waren, ebenso lange hinziehen wie die Dreharbeiten zu einem Spielfilm oder der Entstehung eines Historienbildes im 19. Jahrhundert. Letztlich konstruiert Wall mit jedem Bild eine eigenständige Welt, und zwar in einer so überzeugenden Stilsynthese, dass die einzelnen Überreste aus Dokumentarfotografie, Film und Malerei schwer zu differenzieren sind und jener lange Augenblick wieder unmittelbar und entscheidend wirkt. Der studierte Kunsthistoriker Wall erweist sich als innovativer Analytiker der fotografischen Bildkonstruktion (und ihrer Grenzen).

Le caractère immédiat de l'image photographique captée au moment du déclic suggère que celle-ci peut se passer de la profondeur de réflexion et de la complexité de composition qui fondent la grandeur ou la gravité de la peinture. Alors que certains photographes ont contrecarré cette tendance par la seule monumentalisation des échelles et des tirages, Jeff Wall a passé les trente dernières années à infuser dans la photographie les philosophies innovatrices et interactives de peintres comme Manet et Velázquez, sans jamais renoncer à l'utilisation des dernières techniques de manipulation digitale et des moyens de production hollywoodiens. Présentés le plus souvent sous forme de caissons lumineux rétro-éclairés, les récits ambigus, supportés avant tout par les personnages, qui décrivent l'hypothétique générosité de *A Woman with a Covered Tray* (2003) ou le désespoir d'un homme allongé sur le ventre dans *Insomnia* (1994), vont au-delà de la documentation spontanée pour aborder les domaines de la mise en scène ou du spectacle théâtral (*The Giant*, 1992). De fait, la réalisation des distillations mono-iconiques à l'intensité cinématographique comme *After Invisible Man by Ralph Ellison, the Preface* (1999–2001) – qui font appel à des acteurs, à des éclairages, à des accessoires et à des décors de théâtre – peut demander autant de temps qu'un long métrage ou un chef-d'œuvre de la peinture du XIXᵉ siècle. En dernier ressort, Wall construit des mondes autonomes au sein de chaque cadre, et la synthèse de styles qu'il pratique est si convaincante qu'il s'avère difficile de discerner les vestiges spécifiques de la photographie documentaire, du cinéma et de la peinture – l'instant durable redevenant ainsi le facteur immédiat et décisif. Historien de l'art diplômé, Wall s'avère être un analyste innovateur de la structure de l'image photographique et de ses limites.

O. W.

SELECTED EXHIBITIONS →
2005 *Photographs 1978–2004*, Schaulager, Basle, Tate Modern, London **2004** *Tableaux*, Astrup Fearnley Museum for Moderne Kunst, Oslo; 5. Shanghai Biennale **2003** *Photographs*, Museum Moderner Kunst Stiftung Ludwig Wien, Vienna; *Landscapes*, Norwich Castle Museum & Art Gallery; Manchester Art Gallery, Manchester **2002** Hasselblad Award, Hasselblad Center, Göteborg; documenta 11, Kassel **2001** *Figures and Places*, Museum für Moderne Kunst, Frankfurt/Main

SELECTED PUBLICATIONS →
2004 *Jeff Wall: Tableaux*, Astrup Fearnley Museum for Moderne Kunst, Oslo **2003** *Jeff Wall: Photographs*, Cologne **2002** *Jeff Wall*, London; *Jeff Wall Photographs*, Hasselblad Center, Göteborg **2001** *Jeff Wall: Figures and Places*, Museum für Moderne Kunst, Frankfurt/Main

1 **A Woman with a Covered Tray**, 2003, transparency in lightbox,
 164 x 208.5 x 26 cm
2 **A Wall in a Former Bakery**, 2003, transparency in lightbox,
 119 x 151 x 24 cm

3 **Staining Bench, Furniture Manufacturer's, Vancouver**, 2003,
 transparency in lightbox, 77.5 x 96 x 20 cm

„Ich glaube, dass ernsthafte Kunst ganz und gar nicht exklusiv ist,
trotzdem ist sie nicht für alle, sondern für irgendwen."

«J'aime à penser que l'art sérieux n'est pas du tout exclusif, mais
il n'est pas pour tous, il est pour quiconque.»

"I like to think that serious art is not at all exclusive, but it is not for everyone, it's for anyone."

Matthias Weischer

1973 born in Elte, lives and works in Leipzig, Germany

Matthias Weischer's paintings lead a double life: seen from a distance they show interiors that are meagrely appointed, or are strangely and outlandishly furnished. They allow no view to the outside and have no residents. Only once in *Erfundener Mann* (2003) did a "fictional man" simply place himself in the picture, but he was a strangely constructed figure made up of planes and structures: not a representation of a human, but a pretext for painting. Weischer creates picture puzzles in which genre and the act of painting, representation and abstraction present themselves alternately to the eye of the beholder. Viewed closely, the pictures reveal a wealth of picturesque details, gestural brush strokes, impasto surfaces, and carefully executed patterns. In *Kleiner Vorhang* (2004) a splendid drape of fabric has insinuated itself into the painting on the left, and allows a glimpse into an empty interior. To increase the tension in his painting Weischer plays with the expectations one has on the motif, which traditionally reveals something sacred or mysterious. He frequently inserts small irritations into his unspectacular rooms, thereby clearly identifying them as artificial. Thus in *Kartenhaus* (2004) two playing cards leaning against each other form the picture's foreground, and are the only detail in front of the empty walls. In some untitled paintings (2004) the back wall of the interior changes into a landscape-like flow of colour, its painterly substance pressing into the picture as a viscous mass. Both in his choice of details and motifs, as well as in his painting technique, Weischer inserts elements into his pictures again and again that breach every possible form of illusionism, and they permanently remind us that we are not looking at illustrations, but at paintings.

Die Gemälde von Matthias Weischer führen ein Doppelleben: Von weitem betrachtet zeigen sie Interieurs, kärglich ausgestattet oder seltsam und fremdartig möbliert, die keinen Ausblick auf ein Draußen erlauben, keine Bewohner haben. Nur einmal hat sich ein *Erfundener Mann* (2003) einfach in ein Bild gesetzt, aber er ist eine merkwürdig konstruierte Figur aus Flächen und Strukturen, keine Darstellung eines Menschen, sondern Vorwand für Malerei. Weischer schafft Vexierbilder, in denen Genre und Malakt, Repräsentation und Abstraktion sich wechselweise im Auge des Betrachters materialisieren. Tritt man nahe an ein Bild heran, bricht eine Fülle malerischer Details hervor, gestische Pinselspuren, pastos gemalte Oberflächen, sorgsam ausgeführte Muster. In *Kleiner Vorhang* (2004) hat sich links ein prachtvoller Faltenwurf in das Gemälde hineingeschoben und gibt den Blick in einen leeren Innenraum frei. Weischer spielt mit der Erwartung an das Motiv, das traditionell Sakrales oder Geheimnisvolles enthüllt, und erhöht die Spannung in seinem Gemälde. Häufig versieht er seine unspektakulären Räume mit kleinen Irritationen und weist sie dadurch eindeutig als artifiziell aus. So bilden in *Kartenhaus* (2004) zwei aneinander gelehnte Spielkarten den Bildvordergrund und das einzige Detail vor leeren Wänden. In einigen unbetitelten Gemälden (2004) verwandelt sich die Rückwand des Interieurs in einen landschaftlich anmutenden Farbverlauf, dessen Malmittel als zähe Masse ins Bild drängt. Weischer fügt sowohl in der Auswahl seiner Details und Motive als auch in seiner Maltechnik immer wieder Elemente in seine Bilder ein, die jede mögliche Form von Illusionistik durchbrechen, und die ständig daran gemahnen, dass wir nicht auf Abbilder, sondern auf Bilder blicken.

Les peintures de Matthias Weischer mènent une double vie : considérées de loin, elles montrent des intérieurs équipés pauvrement ou meublés de manière étrange ou étrangère, n'offrant aucune vue vers l'extérieur et dépourvus d'occupants. Une seule fois, dans *Erfundener Mann* (2003), un « homme inventé » s'est immiscé en toute simplicité dans le tableau, mais il s'agit d'une figure curieusement constituée de surfaces et de structures, non pas de la représentation d'un homme, mais d'un prétexte à peinture. Weischer crée des devinettes visuelles dans lesquelles le genre et l'acte pictural, la représentation et l'abstraction se matérialisent tour à tour dans l'œil du spectateur. Lorsqu'on se rapproche du tableau, on voit émerger une foule de détails picturaux – traces de pinceau gestuelles, surfaces peintes en pleine pâte, motifs méticuleusement exécutés. Dans *Kleiner Vorhang* (2004), un somptueux drapé s'introduit dans le tableau par la gauche et ouvre le regard sur un intérieur vide. Weischer joue sur les attentes posées à un motif qui dévoile traditionnellement un fait sacré ou mystérieux, et accroît ainsi la tension dans son tableau. Souvent, il introduit de petites perturbations dans ses espaces peu spectaculaires et les caractérise ainsi clairement comme des artefacts. Dans *Kartenhaus* (2004), deux cartes à jouer adossées l'une contre l'autre au premier plan constituent l'unique détail devant des murs vides. Dans quelques peintures sans titre (2004), le mur de fond de l'intérieur se transforme en un jeu de couleurs évoquant un paysage, et dont les moyens picturaux s'imposent dans le tableau sous la forme d'une masse épaisse. Par le choix des détails et des motifs comme par la technique picturale, Weischer introduit sans cesse dans ses peintures des éléments qui court-circuitent toute forme d'illusionnisme éventuel et nous rappellent constamment que nous ne regardons pas des représentations, mais des tableaux.

A. M.

SELECTED EXHIBITIONS →
2005 *The Experience of Art*, 51. Biennale di Venezia, Venice; *Life After Death: New Paintings from the Rubell Family Collection*, Massachusetts Museum of Contemporary Art, North Adams; *Prague Biennale 2*; *From Leipzig*, The Cleveland Museum of Art **2004** *Northern Light: Leipzig in Miami*, Rubell Family Collection, Miami; *Simultan*, Künstlerhaus Bremen **2003** *sieben mal malerei*, Neuer Leipziger Kunstverein im Museum der bildenden Künste Leipzig **2002** *Räumen*, Kunsthaus Essen

SELECTED PUBLICATIONS →
2005 *David, Matthes und ich*, Kunstverein Nürnberg, Bielefelder Kunstverein, Nuremberg **2004** *Matthias Weischer: Simultan*, Künstlerhaus Bremen, Ostfildern-Ruit

1 **Vogel**, 2004, oil on canvas, 121 x 91 cm
2 **Bühne**, 2003, oil on canvas, 200 x 280 cm

3 Exhibition view, "Simultan", 2004, Künstlerhaus Bremen
4 **Erfundener Mann**, 2003, oil on canvas, 260 x 200 cm

„Ich bin der Maler, die anderen deuten."

«Je suis le peintre, les autres interprètent.»

"I am the painter, the others interpret."

2

3

Franz West

1947 born in Vienna, lives and works in Vienna, Austria

Franz West's artistic concept revolves around the connection between sculpture and the human body. His *Passstücke* from the 1980s were already designed to make the body adapt to them. They were objects with strange, non-representational forms made of papier mache, or plaster and metal. Visitors were invited to take these apparently functionless objects in their hands and carry them, which led to clumsy, unnatural bodily contortions. West documented the use of the *Passstücke* in videos and photos, and presented these as a type of "operating instructions". This idea of performance and the active integration of the body makes West's closeness to Viennese Actionism obvious. His furniture sculptures and pieces of furniture work in a manner similar to the *Passstücke*. West designed seating for the hall and open-air cinema of documenta X (*Dokustuhl*, 1997), and he created sofas, tables and chairs for the cafeteria of the Wexner Centre for the Arts in Columbus, Ohio (*2Topia*, 2001/02). Despite its functionality, the furniture clearly retains its sculptural aspect due to its amorphous forms, rough finish, and selection of materials. With these environments West can be seen as a precursor of "relational aesthetics" by artists such as Jorge Pardo, Liam Gillick and Rirkrit Tiravanija, although he doesn't claim to want to create social spaces in the museums and institutions. Sculptures such as *Drama (Modell)* (2001), on the other hand, evoke direct associations to bodily parts or bodily functions by means of their formal, colour and material composition. The *Drama* in the laconic title of the bloated, pink-painted aluminium sculpture in the form of a knotted intestine with no beginning and no end, is thus also a physical one.

Das künstlerische Konzept von Franz West dreht sich um den Bezug der Skulptur zum menschlichen Körper. Schon die *Passstücke* aus den achtziger Jahren sind darauf angelegt, dass sich der Körper ihnen anpasst. Es sind Objekte aus Papiermaché oder Gips und Metall, mit seltsamen, gegenstandslosen Formen. Die Besucher sind aufgefordert, diese scheinbar funktionslosen Gegenstände in die Hand zu nehmen und zu tragen, was zu ungeschickten, unorganischen Verrenkungen führt. Mit Videos und Fotos dokumentiert West die Benutzung der *Passstücke* und präsentiert sie als „Gebrauchsanweisung". An dieser Idee der Performance und dem aktiven Einbezug des Körpers wird Wests Nähe zum Wiener Aktionismus deutlich. Ähnlich wie die *Passstücke* funktionieren seine Möbelskulpturen und Einrichtungsgegenstände. Für die Halle und das Open-Air-Kino der documenta X entwarf West die Bestuhlung (*Dokustuhl*, 1997) und für die Cafeteria des Wexner Center for the Arts in Columbus, Ohio, schuf er Sofas, Tische und Stühle (*2Topia*, 2001/02). Trotz ihrer Funktionalität behalten die Möbel mit ihren amorphen Formen, der groben Bearbeitung und der Wahl des Materials ihre eindeutig skulpturale Erscheinung. Mit diesen Environments kann West als Vorläufer der „relationalen Ästhetik" von Künstlern wie Jorge Pardo, Liam Gillick oder Rirkrit Tiravanija gesehen werden, ohne dass er jedoch den Anspruch stellt, soziale Räume in den Museen und Institutionen schaffen zu wollen. Skulpturen wie *Drama (Modell)* (2001) wiederum rufen formal, farblich und in der Materialverarbeitung direkte Assoziationen an Körperteile oder -funktionen hervor. Das *Drama* im lakonischen Titel der aufgeblähten, rosa lackierten Aluminiumskulptur in der Form eines verknoteten Darms ohne Anfang und Ende ist denn auch ein körperliches.

Le concept artistique de Franz West tourne autour du rapport entre la sculpture et le corps humain. Ses *Passstücke* des années quatre-vingt, des objets en papier mâché, ou en plâtre et métal, présentant des formes étranges et non figuratives, sont conçus de manière à obliger le corps à s'y adapter. Les spectateurs sont invités à prendre dans leurs mains et à porter ces objets apparemment dénués de fonction, ce qui oblige le corps à des contorsions maladroites et contre nature. West a documenté la manipulation des *Passstücke* dans des vidéos et des photographies présentées comme des sortes de « modes d'emploi ». Les idées de performance et d'intégration active du corps attestent les liens de West avec l'actionnisme viennois. Ses meubles-sculptures et objets mobiliers fonctionnent un peu comme les *Passstücke*. West a conçu les sièges du hall et du cinéma de plein air de la documenta X (*Dokustuhl*, 1997) et a créé des canapés, des tables et des chaises (*2Topia*, 2001/02) pour la cafétéria du Wexner Center for the Arts à Columbus, Ohio. Du fait de leurs formes amorphes, de leur traitement grossier, de leur matériau spécifique, et malgré leur fonctionnalité, ces meubles conservent leur aspect clairement sculptural. Ces environnements permettent de voir en West un précurseur de l'« esthétique relationnelle » prônée par des artistes comme Jorge Pardo, Liam Gillick ou Rirkrit Tiravanija, sans que West revendique toutefois de vouloir créer des espaces sociaux au sein des musées et institutions. Sur les plans formel, chromatique et du matériau, des sculptures comme *Drama (Modell)* (2001) n'en suscitent pas moins des associations avec des parties ou des fonctions corporelles. Très logiquement, le « drame » du titre laconique de cette sculpture boursouflée en aluminium laqué en rose, mais aussi sa forme d'intestin noué sans début ni fin, est donc lui aussi de nature corporelle.

C. R.

SELECTED EXHIBITIONS →
2004 *Mostly West*, Lincoln Center for the Performing Arts, New York
2003 *Franzwestite. Works 1973–2003*, Whitechapel Art Gallery, London **2002** *Appartement*, Deichtorhallen Hamburg; *Burning*, MAC-Galeries Contemporaines des Musées de Marseille **2001** *Gnadenlos/Merciless*, MAK, Vienna; Wexner Center for the Arts, Columbus

SELECTED PUBLICATIONS →
2003 *Franzwestite: Franz West: Works 1973–2003*, London
2002 *Appartement*, Hamburg **2001** *Gnadenlos/Merciless*, MAK Wien, Vienna; *Alpenglühn*, Galerie Bärbel Grässlin, Frankfurt/Main
2000 *Franz West: Aluskulptur*, Cologne

1 **Wall on Wall Paint**, 2003, wooden ladder, papier mache, metal, gauze bandage, dispersion, 245 x 130 x 105 cm
2 **Corona**, 2002, varnished aluminium, 500 x 700 x 700 cm, installation view, MuseumsQuartier Wien
3 Installation view, Galerie Gisela Capitain, Cologne, 2003
4 **Onkel**, 2001, metal, textile strips, 87 x 51 x 45 cm each, exhibition view, "Franzwestite. Works, 1973–2003", Whitechapel Art Gallery, London 2003

„Vielleicht besteht ein Unterschied oder gar ein Widerspruch zwischen der Rezeption eines Kunstwerks im Sitzen und dem Missverständnis meiner Kunststühle [als Plätze zum Sitzen und Rezipieren], das ich ausgebeutet habe."

«Peut-être y a-t-il une différence ou même une contradiction que j'exploite entre la réception d'une œuvre d'art quand on est assis d'une part, et le malentendu de mes chaises artistiques [comme endroits pour s'asseoir et recevoir l'œuvre] d'autre part.»

"Perhaps there is a difference or even a contradiction, which I have exploited, between the reception of an artwork in sitting, and the misunderstanding of my art chairs [as places for sitting and receiving]."

2

3

4

Pae White

1963 born in Pasadena (CA), lives and works in Los Angeles (CA), USA

Whether in a playful series of advertisements in the art magazine "Frieze" (2000/01) for her Berlin gallery neugerriemschneider, the lay-out for diverse exhibition catalogues and book covers ("Women Artists"), or her room-filling mobiles and fragile installations of glass cubes: Pae White creates poetic, light compositions – in space just as on paper. She moves assuredly between the fields of graphics, design and fine art, and thereby understands how to subtly change and question the conventional status of things. The advertisements often make do without any informative message, while the animal-shaped iron sculptures on the picnic grounds in Bear Mountain State Park, New York, prove, upon closer inspection, to be functional barbecues (*Briquettes and Support*, 2003). In this reinterpretation of objects, White allows herself to be led by the game with aesthetic charm, and with the material and its surfaces. This becomes particularly clear in the mobiles made of colourful paper forms hanging closely together on thin threads from the ceiling, or the bird cages made of filigree wire, in which snippets of newspaper seem to flutter like butterflies or birds (*Oiseaux d'ordure*, 2004). Through their fragile appearance, the installations give the impression of delicate volumes and shimmering movement. Glazed blocks of ceramic (*Silverfish*, 2002), or coloured Plexiglass slabs, which White arranges on the gallery floor, create a similar spatial experience with their reflections. The selection of simple materials and the admittance of a certain handicraft aesthetic, for example in the hand-cut paper forms, break with the perfection of graphics and design and emphasise the weight-less poetry of the works.

Ob eine verspielte Anzeigenserie für ihre Berliner Galerie neugerriemschneider in der Kunstzeitschrift „Frieze" (2000/01), das Layout für diverse Ausstellungskataloge und Buchumschläge („Women Artists") oder ihre raumgreifenden Mobiles und fragilen Installationen aus Glas-quadern: Pae White schafft poetische, leichte Kompositionen – im Raum ebenso wie auf dem Papier. Sie bewegt sich sicher zwischen den Bereichen Grafik, Design und bildende Kunst, und versteht es dabei, auf subtile Art den konventionellen Status der Dinge zu verändern und zu hinterfragen. Die Werbung kommt oft ohne einen informativen Hinweis aus; die Eisenplastiken in der Form von Tieren auf den Picknickplätzen im Bear Mountain State Park, New York, entpuppen sich hingegen beim genauen Hinsehen als funktionstüchtige Grilleinrichtungen (*Briquettes and Support*, 2003). In dieser Umdeutung der Objekte lässt sich White vom Spiel mit ästhetischen Reizen, mit dem Material und dessen Ober-flächen leiten. Besonders deutlich wird dies in den Mobiles aus bunten Papierformen, die an dünnen Fäden dicht von der Decke hängen oder den Vogelkäfigen aus filigranem Draht, in denen Schnipsel aus Zeitschriften wie Schmetterlinge oder Vögel (*Oiseaux d'ordure*, 2004) zu flat-tern scheinen. Gerade durch ihre fragile Erscheinung vermitteln die Installationen den Eindruck von filigranem Volumen und flirrender Bewe-gung. Glassteine (*Silverfish*, 2002) oder farbige Plexiglasplatten, die White auf dem Galerieboden anordnet, erzeugen durch die Spiegelungen eine ähnliche Raumerfahrung. Die Wahl des einfachen Werkstoffs und das Zulassen einer gewissen Bastelästhetik, etwa bei den von Hand aus-geschnittenen Papierformen, brechen mit der Perfektion von Grafik und Design und betonen die schwerelose Poesie der Arbeiten.

Qu'il s'agisse d'une série d'annonces enjouées publiées dans la revue d'art «Frieze» (2000/01) pour le compte de sa galerie berlinoise neugerriemschneider, des mises en page réalisées pour différents catalogues d'exposition et jaquettes de livres («Women Artists»), ou de ses grands mobiles et de ses fragiles installations de parpaings de verre, Pae White crée des compositions légères et poétiques – dans l'espace comme sur le papier. Elle se meut avec une grande aisance dans les domaines du graphisme, du design et des arts plastiques et s'entend à modifier et interroger de manière subtile le statut conventionnel des choses. Ses publicités se passent souvent de toute indication informati-ve. A bien y regarder, les sculptures animalières en fer exposées sur les aires de pique-nique du Bear Mountain State Park à New York, s'avè-rent en revanche être des grills fonctionnels (*Briquettes and Support*, 2003). Pour cette réinterprétation des objets, White se laisse guider par le jeu des stimuli sensoriels, par les matériaux et leurs textures de surface. Ceci est clairement illustré par les mobiles constitués de formes de papier multicolores suspendues à des fils ténus ou par les cages en fin fil de fer, dans lesquelles de petits bouts de papier journal ou de revues semblent voleter comme des papillons ou des oiseaux (*Oiseaux d'ordure*, 2004). C'est précisément leur fragilité qui confère aux instal-lations de White l'impression de volumes filigranes et d'un mouvement vibrant. Les briques de verre (*Silverfish*, 2002) ou les plaques de plexi-glas teinté que White dispose à même le sol de la galerie génèrent par leurs réflexions la même expérience de l'espace. La simplicité des matériaux choisis et l'acceptation d'une certaine esthétique du bricolage, notamment dans les formes de papier découpées à la main, rom-pent avec la perfection du graphisme et du design et soulignent la poétique de la légèreté qui caractérise ses œuvres. C. R.

SELECTED EXHIBITIONS →
2004 *Ohms and Amps*, La Salle de bains, Lyon; *Amps and Ohms*, Centre d'Art Contemporain, La Synagogue de Delme; *Hammer Projects*, The Hammer Museum, Los Angeles **2003** *Utopia Station*, 50. Biennale di Venezia, Venice **2002** *Ghost Towns*, Govett-Brewster Art Gallery, New Plymouth; *The Object Sculpture*, Henry Moore Institute, Leeds; *A Grotto, Some Nightfish and a Second City*, Contemporary Art Gallery, Vancouver **2001** *Zero Gravity*, Kunstverein für die Rheinlande und Westfalen, Düsseldorf **2000** *What If: Art on* the Verge of Architecture and Design, Moderna Museet, Stockholm; *Against Design*, Institute of Contemporary Art, Philadelphia

SELECTED PUBLICATIONS →
2002 *Ghost Towns*, Govett-Brewster Art Gallery, New Plymouth; *The Object Sculpture*, Henry Moore Institute, Leeds **2001** *Zero Gravity*, Kunstverein für die Rheinlande und Westfalen, Düsseldorf **2000** *What If: Art on the Verge of Architecture and Design*, Moderna Museet, Stockholm; *Against Design*, Institute of Contemporary Art, Philadelphia

1 **Some Kind of Leone Story**, 2004, paper, plastic, wire, wax, magnets,
 iron fillings, 86.4 x 55.9 x 38.1 cm

2 Project view, Frieze Art Fair, London, 2004
3 **Cotton Mouth**, 2005, installation view, neugerriemschneider, Berlin

„Bezogen auf mein ‚Grafik-Design' halte ich meine Kunst tatsächlich für zwei-
dimensional. Ich behandle das Weiße und den Raum bei einem Blatt Papier
ähnlich, wenn nicht genauso, wie ich es bei einem Ausstellungsraum tue."

«Pour ce qui est de mon ‹design graphique›, je le considère en fait comme
un art bidimensionnel. J'approche la surface blanche d'une page de manière
similaire, sinon identique, à celle d'un espace d'exposition.»

"In terms of my 'graphic design', I really consider it as two-dimensional artwork. I always approach the whiteness and the space of a page, to be similar, if not identical to that of an exhibition space."

2

Johannes Wohnseifer

1967 born in Cologne, lives and works in Cologne, Germany

In his work Johannes Wohnseifer creates a dense network out of references to his own and to general history, to design and art-historical allusions, as well as to popular culture. Thus in the work *Elimination of the Dialogue* (2002) he associates the year of his birth, 1967, with the fact that the American Stealth programme went into operation that same year. The bomber – called the "Cube" just like the white cube of the showroom or the white wooden boxes which the artist exhibited – was shot down in 1999 despite being considered invisible to enemy air defence systems. Wohnseifer described his personal life-story in the exhibited paintings, and let the music of the band N. E. R. D. (an abbreviation for No One Ever Really Dies) roar in the background. Wohnseifer combines his interest in history (particularly that of his native Germany), and his research in this respect, with his fascination for design, for fast cars, and for the products of popular culture. Language as a means of creating links and of shifting meaning is thereby present not only in plays on words like "cube" and "white cube". In the exhibition "Into the light" (2003) in the Ludwig Forum in Aachen, he combined the concepts of light, lightness, and speed. He associated his penchant for cars, race drivers and speed with the female mania for slimming and quest for the perfect body, and saw the complete dissolution of their subjects as the logical conclusion of both of these cults. Conceptually as well as visually, Wohnseifer addresses a global visual memory forged by the media and advertising, and evokes the knowledge that one's own self is inseparably connected with world events.

In seinen Arbeiten schafft Johannes Wohnseifer ein dichtes Netz aus Referenzen auf seine eigene und die allgemeine Geschichte, auf design- und kunsthistorische Bezüge sowie aus Hinweisen auf die Popkultur. So verbindet er in der Arbeit *Elimination of the Dialogue* (2002) sein Geburtsjahr 1967 mit der Tatsache, dass im selben Jahr das amerikanische Stealth-Flugzeugprogramm in Betrieb genommen wurde. Einer dieser Tarnkappenbomber – „Cube" genannt, eben wie der White Cube des Ausstellungsraums oder die weißen Holzkisten, die der Künstler ausstellte – wurde, obwohl er als unsichtbar für gegnerische Flugabwehrsysteme galt, 1999 abgeschossen. In den ausgestellten Gemälden beschrieb Wohnseifer seine Biografie und ließ dazu die Musik der Band N. E. R. D. (deren Name die Abkürzung von No One Ever Really Dies ist) dröhnen. Das Interesse an der Geschichte (besonders derjenigen seiner Heimat Deutschland) und seine diesbezüglichen Recherchen verbindet Wohnseifer mit seiner Faszination für Design, schnelle Autos und die Erzeugnisse der Popkultur. Die Sprache als Mittel der Verkettung und der Bedeutungsverschiebung ist dabei nicht nur in Wortspielen wie „Cube" und „White Cube" präsent: In der Ausstellung „Into the light" (2003) im Ludwig Forum Aachen fügte er die Begriffe von Licht, Leichtigkeit und Geschwindigkeit zusammen. Seine Vorliebe für Autos, Rennfahrer und Schnelligkeit ließ er mit dem weiblichen Schlankheitswahn und Streben nach dem perfekten Körper einhergehen, und sah als Endpunkt der beiden Kulte eine gänzliche Auflösung ihrer Inhalte. Konzeptionell wie visuell spricht Wohnseifer ein globales, durch Medien und Werbung geprägtes Bildgedächtnis an und evoziert das Wissen, dass das eigene Ich untrennbar mit den Geschehnissen der Welt verknüpft ist.

Dans ses œuvres, Johannes Wohnseifer crée tout un réseau de références à sa propre histoire comme à l'histoire en général, de correspondances qui renvoient à l'histoire de l'art et du design, mais aussi à la culture pop. Ainsi, dans une œuvre comme *Elimination of the Dialogue* (2002), l'artiste met son année de naissance en relation avec l'utilisation, la même année, de la furtivité dans les programmes militaires américains. Un de ces bombardiers furtifs – appelé « Cube », tout comme le white cube de la salle d'exposition ou les caisses en bois blanc exposées par l'artiste – fut abattu en 1999 alors qu'il était considéré comme invisible pour les systèmes de défense antiaérienne ennemis. Dans ses peintures, Wohnseifer décrivait sa biographie en les accompagnant de la musique tonitruante du groupe N. E. R. D. (acronyme de No One Ever Really Dies). L'intérêt de l'artiste pour l'histoire, en particulier celle de sa patrie allemande, et ses recherches dans ce domaine, sont associés à sa fascination pour le design, les voitures de course et les produits de la culture pop. En tant que moyen de mise en relation et de détournement de sens, le langage n'intervient pas seulement dans des jeux de mots comme « cube » et « white cube » : pour l'exposition au Ludwig Forum d'Aix-la-Chapelle « Into the light » (2003), Wohnseifer jouait sur les notions de lumière, de vitesse et de légèreté. Son amour des voitures, des coureurs automobiles et de la vitesse y était mis en parallèle avec l'obsession féminine de la sveltesse et la recherche de la perfection corporelle, deux cultes dont Wohnseifer voyait le terme dans la dissolution intégrale de leurs contenus. Sur le plan conceptuel et formel, Wohnseifer fait appel à une mémoire iconique globale marquée par les médias et la publicité et à la conscience du fait que le moi est inextricablement lié aux événements du monde.

C. R.

SELECTED EXHIBITIONS →
2004 *Firewall*, Ausstellungshalle zeitgenössische Kunst Münster **2003** *Into the Light*, Ludwig Forum für Internationale Kunst Aachen; *Intervention*, Sprengel Museum Hannover; *Precise Models*, Galerija Remont, Belgrade **2002** *Kunst nach Kunst*, Neues Museum Weserburg Bremen, Moving Collection, Tokyo **2001** *Repubblica dell'arte: Germania*, Palazzo delle Papesse, Siena **2000** Centre d'Art Contemporain, Geneva

SELECTED PUBLICATIONS →
2003 *Into the Light*, Ludwig Forum für Internationale Kunst, Aachen; *Johannes Wohnseifer: Self Destroying History*, Zug; *Johannes Wohnseifer: HfG 53/03*, Kunstverein Ulm; *deutschemalereizweitausenddrei*, Frankfurter Kunstverein, Frankfurt/Main **2001** *Ars Viva*, Museum für Angewandte Kunst, Cologne

1 **Kapelle**, 2004, Piezo print on net-vinyl, lacquer, 2 banners, 3.50 x 12.40 m each, installation view, Johann König, Berlin

2 Exhibition view, "Into the Light", 2003, Ludwig Forum für Internationale Kunst, Aachen

3 **Body Image Distortion**, 2003, acrylic and Scotchlite on aluminium, 140 x 200 cm

4 Installation view, "Irresistible Impulse", Galerie Gisela Capitain, Cologne, 2005

2

3

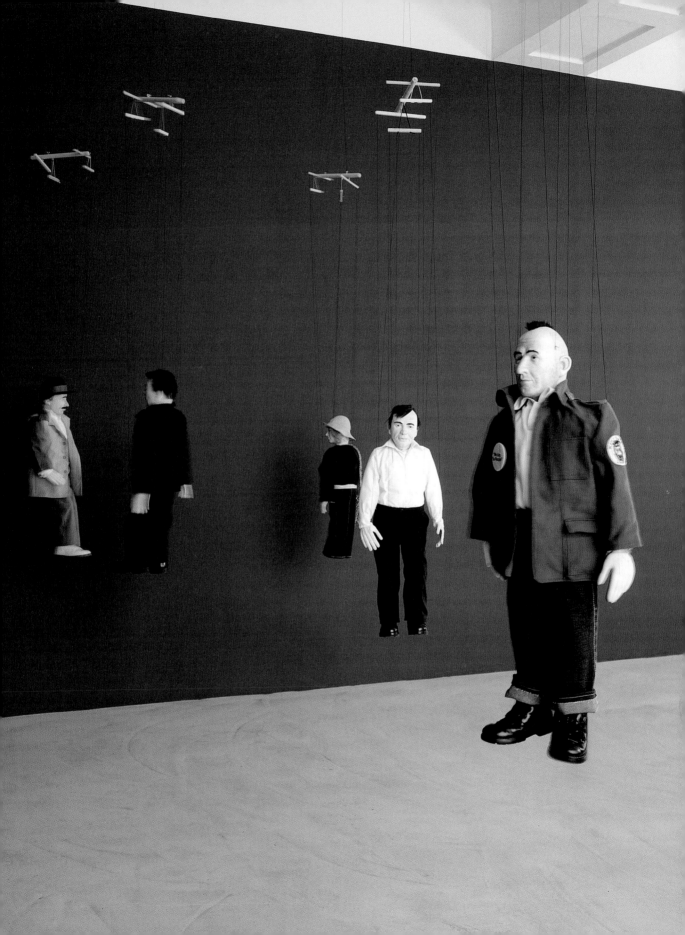

Christopher Wool

1955 born in Chicago (IL), lives and works in New York (NY), USA

In his painting, Christopher Wool develops reduced pictorial forms with a radical orientation towards flatness and an aloof, ornamental, all-over style. He seldom employs colour, almost always working in black and white. Wool became known at the end of the 1980s for his characteristic word pictures. As early as 1986 he also began making paintings with floral patterns, for which he used stamps and rollers. He uses methods like these to counter the mannerisms of personal mark-making. By no means, however, does this give the paintings a neutral appearance. By strictly formalizing his painting, Wool also demonstrates its materiality. The loosely applied layers, generally of thin enamel paint, are often marked by smears or drips at the edges of the stencil-like letters. Corrections remain visible, and patterns applied with a roller are often not placed to match up perfectly. More recently he has developed a free, gestural and complexly layered painting style that at first glance seems to contradict his earlier formalizations. This is perhaps even more intense in his newer paintings, which seem like freely floating stopping points in an open process of placement and cancellation. Wool works with enamel paint on canvas. He leaves spatters and drips on the canvas, and with broad brush strokes creates flat planes that block off the pictorial space like a dense grid. He erases some pictures almost completely, and then overwrites them with black spray paint in a loose graffiti-like gesture. Wool has also used silkscreen to duplicate some paintings, working the reproductions further. Besides being a convincing permutation of his earlier stencil techniques, this also contains a new shred of fruitful indifference.

In seiner Malerei entwickelt Christopher Wool reduzierte Bildformen, die radikal auf Flächigkeit und spröde ornamentales Allover ausgerichtet sind. Selten setzt er Farbe ein, arbeitet fast immer in Schwarzweiß. Bekannt wurde Wool Ende der achtziger Jahre durch seine charakteristischen Wortbilder, bereits seit 1986 entstanden auch Gemälde mit floralen Mustern, bei denen er mit Stempeln und Rollen arbeitete. Mit solchen Matrizen kontert er den Gestus des Handschriftlichen. Doch die Bilder erscheinen deshalb keineswegs neutral. Indem Wool seine Malerei strikt formalisiert, demonstriert er auch deren Materialität: Der raue, meist mit dünnen Lacken vorgenommene Farbauftrag ist an den Rändern der schablonenhaften Buchstaben oft verwischt oder verlaufen, Korrekturen bleiben sichtbar, mit Rollen aufgetragene Muster sind oft nicht ganz passgenau gesetzt. In jüngerer Zeit hat er eine freie, gestische, auch komplexer geschichtete Malerei entwickelt, die den früheren Formalisierungen auf den ersten Blick widerspricht. Die neueren Gemälde sind darin vielleicht noch stärker zugespitzt, erscheinen wie frei schwebende Haltepunkte im offenen Prozess von Setzung und Auslöschung. Wool arbeitet mit Lack auf Leinwand. Er lässt Tropf- und Verlaufspuren stehen, baut aus groben Pinselstrichen Flächen auf, die den Bildraum wie dichtes Gitterwerk sperren, löscht manche Bilder fast komplett, um sie dann in lockerer Handbewegung graffitiartig mit schwarzer Sprayfarbe zu überschreiben. Einige der Gemälde hat Wool mittels Siebdruck dupliziert und weiter bearbeitet. Darin liegt neben einer schlüssigen Übersetzung früher verwendeter Schablonentechniken auch ein neues Moment fruchtbarer Indifferenz.

Dans sa peinture, Christopher Wool élabore des formes picturales réduites résolument tournées vers la planéité et un raboteux all-over ornemental. Il utilise rarement la couleur et travaille presque toujours en noir et blanc. Wool s'est fait connaître à la fin des années quatre-vingt par ses caractéristiques tableaux de lettres. Dès 1986, il réalise aussi des peintures avec des motifs floraux appliqués au rouleau et au tampon. Ces matrices lui permettent d'abolir l'écriture picturale personnelle, mais l'effet de ses peintures n'en est pas neutre pour autant. Par la formalisation rigoureuse de ses peintures, Wool affiche aussi leur matérialité : la facture aride, qui travaille généralement avec de fines couches de laque, présente souvent des coulures ou des effets de flou en bordure des lettres qui rappellent la technique du pochoir. Les retouches restent visibles, les motifs appliqués au rouleau débordent souvent l'espace imparti. Récemment, Wool a développé une peinture libre, gestuelle, qui présente aussi des stratifications plus complexes et semble contredire à première vue ses formalisations antérieures. Les peintures récentes exacerbent peut-être encore cet aspect, elles semblent être des points d'appui flottants au sein du processus ouvert de l'affirmation et de l'extinction. Wool travaille à la laque sur toile. Il laisse sur la toile les traces de coulures et les mélanges des couleurs limitrophes ; à l'aide de grands coups de brosse, il construit des surfaces qui barrent l'espace pictural comme la trame serrée d'un grillage, efface presque complètement certains tableaux avant de les couvrir de peinture au spray noire d'un geste souple. Wool a aussi transposé certaines de ses œuvres en sérigraphies avant de les retravailler. Au-delà d'une transposition logique des techniques de pochoir utilisées dans ses tableaux antérieurs, cette démarche recèle aussi un nouveau facteur de féconde indifférence.

J. A.

1 **Last Year Halloween Fell on a Weekend**, 2004, enamel, silkscreen ink on linen, 264.2 x 198.1 cm

2 Installation view, 2003, Galerie Gisela Capitain, Cologne
3 **Untitled (P 441)**, 2004, enamel on linen, 243.84 x 180.34 cm

„Ich habe immer gedacht, dass ich male, Bilder mache. Gewisse Kritiker haben das nicht so gesehen. Sie meinten, ich hätte mit der Dekonstruktion der Malerei zu tun, mit Malereikritik oder einer Art Anti-Malerei. Ironischerweise erlaubte dieses Missverständnis es denen, die gegen Malerei waren, meine Arbeit zu ‚schätzen'."

« J'ai toujours pensé que je peignais, que je faisais des tableaux. Certains critiques ont vu cela d'un autre œil. Pour eux, j'avais quelque chose à voir avec la déconstruction de la peinture, une critique picturale ou une sorte d'anti-peinture. Ironiquement, ce malentendu a permis à ceux qui étaient contre la peinture d'‹apprécier› mon travail. »

"I have always thought that I paint – make pictures. Certain critics have not seen it that way. They think I am involved in the deconstruction of painting, in painting criticism, or in a type of anti-painting. Ironically this misunderstanding allows those who were against painting to 'value' my work."

3

2

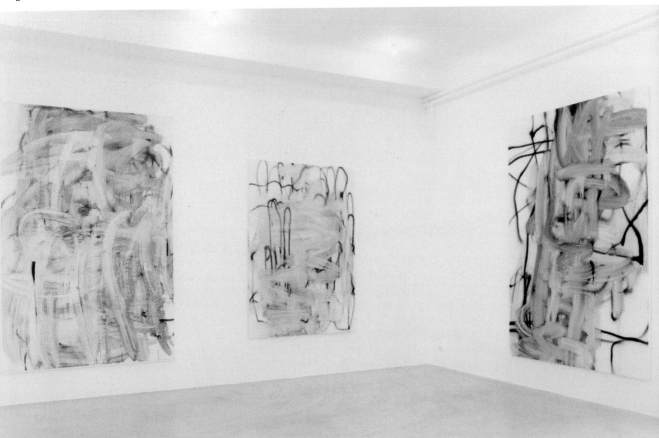

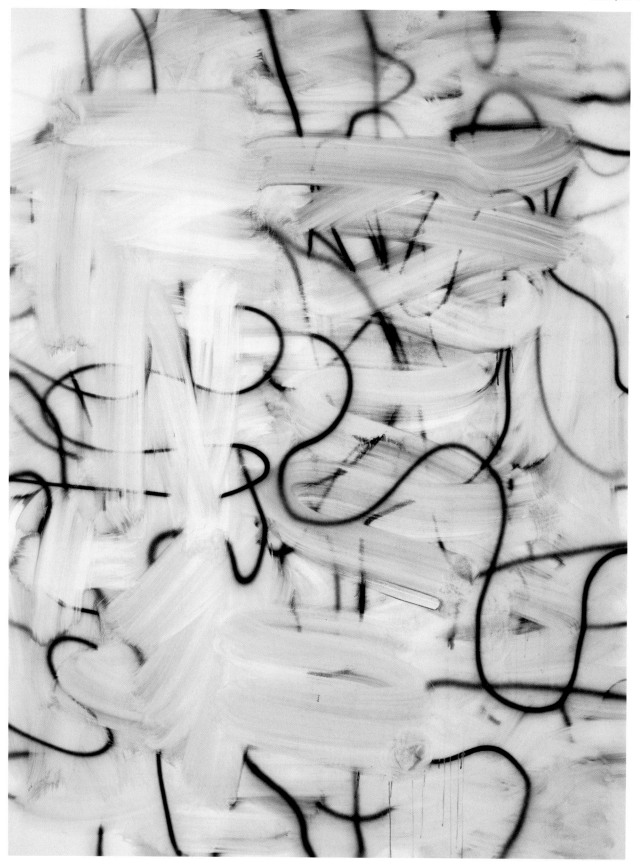

Erwin Wurm

1954 born in Bruck-an-der-Mur, lives and works in Vienna, Austria, and New York (NY), USA

Erwin Wurm, conceptual artist of the absurd, inventor of daring Fluxus events, and equipped with a dry sense of humour, has been working on broadening the field of sculpture for about fifteen years. At what moment does an action become a sculpture? The deconstruction of traditional elements of sculpture, based on projects by Marcel Duchamp in which absence was made visible by traces left in the dust by objects, is the starting point for a number of works for which Erwin Wurm has become known: the *One Minute Sculptures*, which were documented in a book in 1998. The work exists as a template, and is taken further through drawing and instructions. The photograph or video are only traces of the executed action, one possible realization among many. Wurm believes that a sculpture consists more in the interpretation of its instructions, in the process it initiates, and less in its always only potential and secondary execution. The birth of sculpture involved a transition from two- to three-dimensionality, and Wurm materializes this unpretentiously in the act of repeatedly folding a simple jumper. In the video *Fabio Getting Dressed* (1992), which is a continuation of this, you see a boy putting on all of his clothes, while in 1993 the book *Size L to XXL* explained in detail how to change your stature in only eight days. The photographic diptych *Me, Me Fat* from 1993, a self-portrait that shows the artist simultaneously thin and fat, is characteristic of this aloof and ironic look at sculpture as overblown reality, illustrated through the monumental works *Fat Car* (2002) and *Fat House* (2003). A car and a house, overflowing and forced into too-narrow containers, are symbolic of this "self-consciousness" which Wurm reveals in the relationship between world and body.

Erwin Wurm, konzeptueller Künstler des Absurden, Erfinder gewagter Fluxus-Events, ausgestattet mit trockenem Humor, arbeitet seit etwa fünfzehn Jahren an der Ausdehnung der Skulptur. Von welchem Augenblick an wird eine Aktion zur Skulptur? Die Dekonstruktion traditioneller Elemente der Bildhauerei, den Projekten von Marcel Duchamp nachempfunden, Abwesenheit durch im Staub hinterlassene Spuren von Objekten sichtbar zu machen, ist Ausgangspunkt einer Reihe von Arbeiten, die Wurm bekannt gemacht haben: die *One Minute Sculptures*, die 1998 in einem Buch publiziert wurden. Das Werk existiert in der Vorlage, wird weitergeführt durch die Zeichnung und durch Anweisungen. Die Fotografie oder das Video sind nur Spuren der ausgeführten Handlung, eine Möglichkeit der Verwirklichung unter vielen. Nach Wurm besteht die Skulptur eher in der Interpretation der Anleitung, im Prozess, den sie initiiert, und weniger in der immer potenziellen und sekundären Verwirklichung. In der Entstehungsgeschichte der Bildhauerei gibt es den Übergang von der Zwei- zur Dreidimensionalität, von Wurm bescheiden durch mehrfaches Zusammenlegen eines einfachen Pullovers verwirklicht. Im Video *Fabio Getting Dressed* (1992), in dem dies weitergeführt wird, ist ein Junge zu sehen, der alle seine Kleider anzieht, während 1993 in dem Buch *Size L to XXL* detailliert erklärt wird, wie man in nur acht Tagen seine Statur ändern kann. Das fotografische Diptychon *Me, Me Fat* von 1993, ein Selbstporträt, das den Künstler gleichzeitig dünn und dick zeigt, ist kennzeichnend für diesen distanzierten und ironischen Blick auf die Skulptur als aufgeblähte Wirklichkeit, veranschaulicht durch die monumentalen Werke *Fat Car* (2002) und *Fat House* (2003). Ein Auto und ein Haus, überbordend, eingezwängt in zu engen Behältnissen, sind Abbilder dieser „Befangenheit", die Wurm in der Beziehung zwischen Welt und Körper aufzeigt.

Artiste conceptuel de l'absurde, ordonnateur d'*events* Fluxus incongrus et pince-sans-rire, Erwin Wurm travaille, depuis une quinzaine d'années, à l'extension du domaine de la sculpture. A partir de quel moment une action devient-elle une sculpture? Engagée autour du projet duchampien de rendre visible l'absence, par les traces laissées par des objets dans la poussière, cette déconstruction des éléments traditionnels de la sculpture est à l'origine de la série de travaux qui ont fait connaître Wurm: les *One Minute Sculptures*, regroupées dans un livre en 1998. L'œuvre réside dans l'énoncé, relayé par le dessin, des instructions; la photographie ou la vidéo n'est qu'une trace de l'acte exécuté, une possibilité parmi d'autres de matérialisation. La sculpture, selon Wurm, tient plus dans la lecture des instructions, le processus qu'elle initie, que dans sa réalisation, toujours potentielle et secondaire. A la genèse de la sculpture, il y a le passage de deux à trois dimensions, modestement réalisé par Wurm grâce à divers pliages d'un simple pull-over. Poursuivant dans cette voie, la vidéo *Fabio Getting Dressed* (1992) montre un garçon enfilant toute sa garde-robe, tandis qu'en 1993, le livre *Size L to XXL* détaille comment changer radicalement de stature en huit jours seulement. Le diptyque photographique de 1993, *Me, Me Fat*, autoportrait où l'artiste apparaît simultanément mince et gros, est emblématique de ce regard distancié et ironique sur la sculpture comme boursouflement du réel, illustré par les œuvres monumentales *Fat Car* (2000) et *Fat House* (2003). Débordantes, engoncées dans des contenants trop exigus pour elles, cette voiture et cette maison sont l'image même de cet «embarras» que Wurm désigne dans la relation entre le monde et les corps.

S. C.

SELECTED EXHIBITIONS →
2005 *Foto/Skulptur/Zeichnung*, Kunstverein Wilhelmshöhe, Ettlingen **2004/05** *I Love My Time, I Don't Like My Time*, Yerba Buena Center for the Arts, San Francisco **2004** 1. Bienal Internacional de Arte Contemporáneo de Sevilla **2003** Zentrum für Kunst und Medientechnologie, Karlsruhe; *Erwin Wurm Videos*, Rhode Island School of Design, Providence **2002** Centre national de la photographie, Paris; *Fat Car*, Palais de Tokyo, Paris

SELECTED PUBLICATIONS →
2004 *Erwin Wurm: I Love My Time, I Don't Like My Time*, Ostfildern-Ruit **2002** *Erwin Wurm: Fat Survival. Handlungsformen der Skulptur*, Neue Galerie am Landesmuseum Joanneum, Graz, Ostfildern-Ruit; *Erwin Wurm: Videoarbeiten 1989–2002*, Hungarian Academy of Fine Arts, Budapest; *Erwin Wurm: Sculptures with Embarrassment*, Museum of Contemporary Art Kiasma, Helsinki

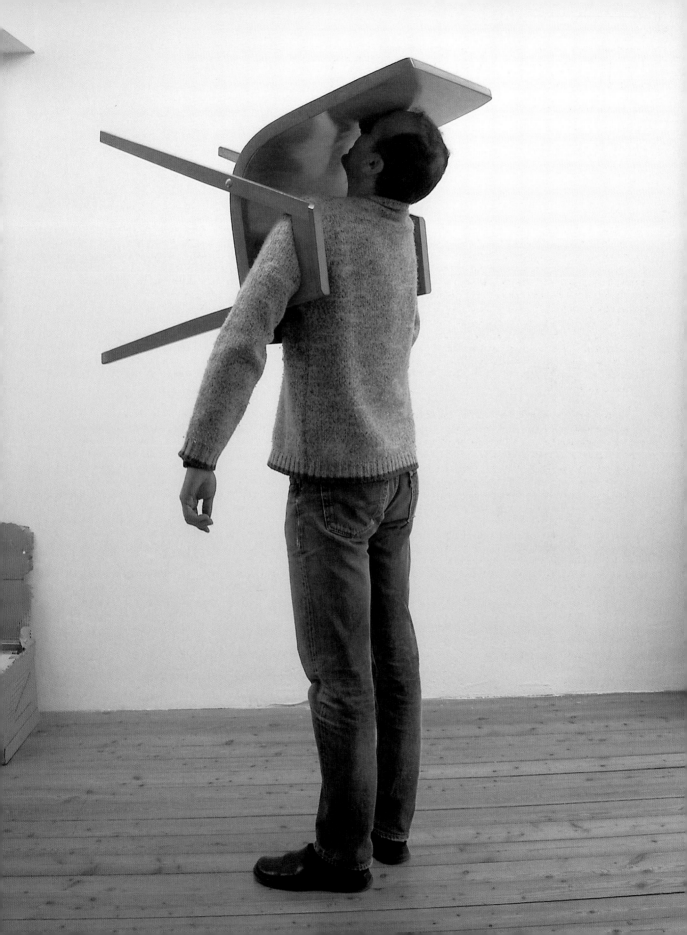

1 **The Idiot**, 2003, chair instruction drawing, realised by the public,
83 x 55 x 53 cm
2 **Freud's Ass**, 2004, seat sack, instruction drawing, realised by the public

3 **Keep a Cool Head**, 2003, refrigerator, instruction drawing, realised by
the public, 85 x 50 x 61 cm
4 **Fat Car**, 2001, styrofoam, polyester, car, 480 x 265 x 130 cm

„Ich habe mich gefragt, in welchem Maß man die Eigenschaften des
Spiels – Ernährung, Körperpflege und Verlangen – in Skulpturen umwandeln
und verändern könnte."

«Je me suis demandé dans quelle mesure on pouvait convertir et transformer
les attributs du jeu – alimentation, soins corporels, désirs – en sculptures.»

"I have asked myself to what extent one could transform and mutate the attributes of the game – diet, personal hygiene and desire – into sculptures."

2

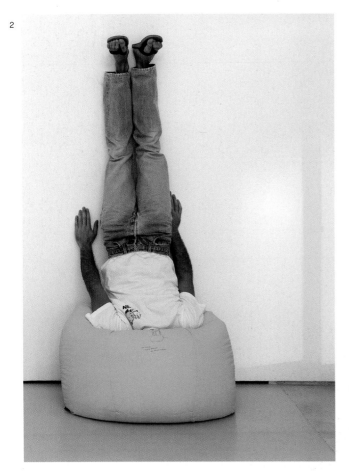

stand on your head
lean your legs against the wall
and think about Freud's ass

4

3

put your head and arm hand in the fridge
and have a line are smoke a joint
or drink a beer

Glossary

ANIME → Japanese cartoon films, whose simply drawn figures and straightforward plots are based on Japanese manga comics. In the 1990s, anime and their extravagant soundtracks became famous outside Japan.

APPROPRIATION ART → In Appropriation Art, objects, images and texts are lifted from their cultural context and placed unchanged in a new one. They thus become charged with a new significance.

ARTE POVERA → Art movement which began in Italy in the 1960s. Artists used "humble" materials and the simplest design principles to reduce artworks to their barest essentials.

ASSEMBLAGE → A three-dimensional picture made of different materials, usually of everyday use.

AURA → The radiance that makes a person or work of art subject to veneration. People or works of art possessing an aura are at once remote and approachable. They fascinate by their precious uniqueness.

AUTONOMY → Condition of self-reliance and independence. In art, autonomy means freedom from any conditioning by non-artistic objectives.

BODY ART → Art that takes the body for its subject and makes it the object of performances, sculptures or videos.

CAMP → Persons or objects whose appearance is exaggeratedly stylised are called camp. Admiration for them generates a mocking and at the same time emotion-laden cult of artificiality.

CATALOGUE RAISONNÉ → Annotated catalogue of an artist's work, with a claim to completeness.

CIBACHROME → A colour print (usually large format) made from a slide.

CLUB CULTURE → The 1990s' club culture was shaped by the aesthetics of techno-music. However, it was not confined to dance-floor activities but also found expression through a whole lifestyle, influencing fashion, design and typography.

CODE → Sign system providing the basis for communication and conveying information.

COLLAGE → Work of art made up of a variety of unconnected objects or fragments that were not created by the artist.

COMPUTER ANIMATION → Apparently three-dimensional models produced on a computer which can be "walked through" or seen from different perspectives by the user; or virtual figures which move on the screen.

COMPUTER-GENERATED → Produced by computer.

CONCEPTUAL ART → Conceptual Art emerged in the 1960s. It gives primacy to the basic idea of a work's content. This is often revealed in language alone, i. e. texts or notes. The actual execution of the work is considered secondary and may be totally lacking.

CONSTRUCTIVISM → Early 20th-century art movement that coined a mostly abstract formal language and sought to put modern art to everyday use.

CONTEXT ART → Criticises the art business and its institutions. Power structures are disclosed, distribution mechanisms and exhibition forms are investigated for their political function. Various artistic means of expression are adopted to present this criticism, such as performances, installations and Object Art.

C-PRINT → A colour print from a photographic negative.

CROSSOVER → Crossover refers to crossing the boundaries between art and popular culture and between different cultures; also to the inclusion of music, design and folklore etc in artistic work.

CULTURAL STUDIES → A new trend in Anglo-American quasi-academic studies that is concerned with the examination of popular culture. Cultural studies pays particular attention to the influence of racial, class or gender factors on cultural expression.

CULTURE JAMMING → Reconstruing and playing with cultural symbols such as advertising messages or company logos.

CURATOR → A curator decides what exhibitions are about, and selects the participating artists.

DADA → Revolutionary art movement at its peak in the 1920s, whose collages, performances and public readings of nonsense poetry called all existing cultural values into question.

DECONSTRUCTION → A means of interpretation that regards a work not as a closed entity but as an open and many-layered network of the most varied elements in form and content. These elements, their functions and contradictions, are revealed by deconstruction.

DIGITAL ART → Art that makes use of new digital media such as computers and the Internet.

DOCUMENTARY ART → This type of art concentrates on giving a more or less factual, uninterpreted account of social reality.

ECLECTICISM → A common resort of postmodernism, characterised by extensive quotation from largely historical styles and other artists' works.

ENTROPY → A concept derived from thermodynamics signifying the degree of disorder in closed systems. Total entropy would be reached when a system collapsed in chaos. By analogy, entropy indicates the informational value of news. The ultimate here would be a meaningless rushing noise.

ENVIRONMENT → An interior or exterior space entirely put together by the artist which integrates the viewer in the aesthetic experience.

FICTION → A picture or a story is a fiction when it is based on free invention.

FLUXUS → Radical experimental art movement embracing a variety of forms, including happenings, poetry, music and the plastic arts, whose ephemeral nature removed art from its accepted museum context.

FOLK ART → Traditional arts and crafts connected to particular regions – especially rural areas – or ways of life, which remain relatively unaffected by changes of style.

FUTURISM → Founded in Italy around 1910 by a group of writers and artists, the Futurist movement made a radical break with the past. It promoted a type of art reflecting life in the modern age, characterised by simultaneity, dynamism and speed.

GENDER SURFING → The confusing game with sexual roles whose point is to mix them up, to humorous effect.

GENTRIFICATION → Describes the process of displacement of existing urban social structures. It takes place when, for example, galleries move into districts that were previously occupied predominantly by socially disadvantaged residents.

GLOBALISATION → Globalisation means that economic or cultural processes increasingly have worldwide implications.

GOVERNMENTALITY → Coined by Michel Foucault to describe the workings of power. This concept is primarily of importance in contemporary "political art". (cf. political art)

HAPPENING → An artistic action in front of a public that normally becomes involved in what happens.

HETEROGENEITY → Variety.

HIGH AND LOW CULTURE (HI 'N' LO) → A complex of themes concerning the influence of trivial culture (low art) on modern art (high art). The concept derives from an exhibition assembled by Kirk Varnedoe in 1990 at the New York Museum of Modern Art.

HYBRID → Of many forms, mixed, incapable of single classification.

ICON → Image or person venerated by a cult.

ICONOGRAPHY → The language of images or forms that is typical of a particular cultural context; for example, the iconography of advertising, Western, postmodern architecture etc.

ICONOLOGY → The interpretation of the content of a work of art, based on its iconography.

IDEOLOGY → Refers to a political consciousness that is critically analysed by "political art". (cf. political art)

IMMATERIAL WORK → Work in which the final result is not the production of material things, but the processing of immaterial data, images, or sounds.

INSTALLATION → A work of art that integrates the exhibition space as an aesthetic component.

INSTITUTIONAL CRITICISM → This art form is concerned with reflecting upon the structures of the art system.

INTERACTIVE ART → Works of art intended for the viewer's direct participation. Normally this participation is made possible by computer technology.

LEIPZIG SCHOOL → A neo-conservative current in figurative painting, the dominant players of which studied at the Leipzig Academy of Visual Arts.

LOCATION → Site of an event or exhibition etc.

MAINSTREAM → Predominant style reflecting the taste of the general public.

MANGA → Comics and cartoon films, the most popular type of reading matter in Japan, where manga is produced and consumed in large quantities.

MEMENTO MORI → An event or object reminding one of death.

MICROPOLITICS → Political strategy based on interventions involving small social groups rather than overall social change.

MINIMAL ART → Art trend of the 1960s that traces sculptures and pictures back to clear basic geometric forms and places them in a concrete relation to the space and the viewer.

MIXED MEDIA → Combination of different media, materials and techniques in the production of a work of art.

MONTAGE → Joining together pictorial elements or sequences in photography, film and video.

MULTIPLE → In the 1960s, the classical concept of a work of art came under fire. Instead of a single original, works of art were produced in longer runs, i. e. as "multiples". The idea was to take art out of museums and galleries and make it more available.

Glossary

NARRATION → Telling a story in art, film or literature.

NEO-CONCEPTUAL ART → This artistic direction is linked to the conceptual art of the sixties, whereby it places considerably more emphasis on the narrative moment.

NEO-CONCRETE ART → A movement in the tradition of Concrete Art. Since the 1950s, Concrete Art, like Abstract Art, has emphasised the material, "concrete" properties of aesthetic means.

NEO-FORMALISM → This contemporary artistic direction subjects modernism's stylistic idiom to critical revision.

NEO-GEO → 1980s style of painting that operates highly objectively with geometric patterns and colour compositions.

NETWORK → Organisational form used by artists and groups of artists can be established and non-hierarchical to varying degrees.

NEW AGE → A form of esoteric culture that believes a "new age" in human civilization is beginning.

OBJECT ART → All works of art that contain already existing objects or materials, or are entirely composed of them. (cf. readymade)

OP ART → A type of 1960s Abstract Art that played with optical, rather than visual, effects on the eye.

PERFORMANCE → Artistic work performed in public as a (quasi-theatrical) action. The first performances took place during the 1960s in the context of the Fluxus movement, which tried to widen the concept of art.

PHENOMENOLOGY → A branch of philosophy which examines the way external reality appears to humans.

PHOTOREALISM → Hyper-realistic painting and sculpture using exaggerated photographic sharpness to take a critical look at the details of reality.

POLITICAL ART → This type of art explicitly deals with political problem areas such as globalisation and neo-liberalism.

POLITICAL CORRECTNESS → A socio-political attitude particularly influential in the USA. The purpose of Political Correctness is to change public language. The principal requirement is to refer to social "minorities" in a non-judgmental way.

POP ART → Artistic strategy of the 1960s which transformed the popular iconography of film, music and commerce into art.

POP CULTURE → Pop culture finds its expression in the mass circulation of items from areas such as fashion, music, sport and film. The world of pop culture entered art in the early 60s, through Pop Art.

POST HUMAN → A complex of themes centering on the influence of new technologies and the influence of a media-based society on the human body. "Post human" was the title of an exhibition put together by Jeffrey Deitch in 1992.

POST-CONCEPTUALISM → Aesthetic approach that, like 1960s Concept Art, concentrates more on the idea and concept of art than on its visual and perceptible form.

POST-MINIMALISM → Following on from Minimal Art, post-minimalist art uses simple forms and structures, functioning within clearly defined limits.

POSTMODERNISM → Unlike modernism, Postmodernism starts from the assumption that grand utopias are impossible. It accepts that reality is fragmented and that personal identity is an unstable quantity transmitted by a variety of cultural factors. Postmodernism advocates an irreverent, playful treatment of one's own identity, and a liberal society. (cf. utopia)

POST-PRODUCTION → This term taken from the field of film describes, among other things, the post-processing of visual material.

POST-STRUCTURALISM → Whereas structuralism considers sign systems to be closed, post-structuralism assumes that sign systems are always dynamic and open to change. (cf. structuralism)

PROCESS ART → Since the 1960s, Process Art has replaced the concept of a work as a definitive and self-contained entity with the ideas of changeability of form, collaboration and incompleteness within the creative process.

PRODUCTION STILL → Photo of a scene from a film or of an actor in a film, taken on the set by a specialist photographer and used for publicity or documentary purposes.

PROJECTED IMAGE → Refers to projected images of different formats in artistic installations.

READYMADE → A readymade is an everyday article which the artist declares to be an artwork and exhibits without major alterations. The idea derives from French artist Marcel Duchamp, who displayed the first readymades in New York in 1913, e. g. an ordinary urinal *(Fountain)* or a bottle drier.

SAMPLING → Arrangement of existing visual or audio material with the main intention of playing with the material's formal characteristics. Rather than quoting from the material, whose sources are often unclear, sampling aims to reformulate it.

SCATTER ART → Installation art consisting of everyday objects, including objets trouvés and junk, scattered seemingly at random around exhibition spaces.

SELF-REFERENTIAL ART → Art that refers exclusively to its own formal qualities and so rejects any idea of portrayal.

SEMANTICS → The study of the significance of linguistic signs, i. e. the meaning of words.

SERVICE ECONOMY → Describes the transformation from an industrial society to a postmodern one, in which aspects such as administration or service are more important than production.

SETTING → An existing or specially created environment surrounding a work of art.

SIMULACRUM → An illusionary image which is so seductive that it can supplant reality.

SITUATIONISM → The International Situationists are a group of artists who introduced the concept of "situation" in art in the mid-20th century. According to its practitioners, situationism means constructing temporary situations and transforming them to produce a higher level of passionate intensity.

SOCIAL WORK → Art here is understood as a service that quite deliberately accepts socio-political functions.

STEREOTYPE → A standardised, non-individual image that has become generally accepted.

STRUCTURAL FILM → Expression commonly used since the 1960s in the USA to describe experimental films that reveal the material composition and the physical processes of film making.

STRUCTURALISM → Structuralism systematically examines the meaning of signs. The purpose of structuralism is to explore the rules of different sign systems. Languages and even cultural connections are seen and interpreted by structuralism as sign systems.

SURREALISM → Art movement formed in the 1920s around the writer André Breton and his followers, whose main interest was Automatism, or the suspension of conscious control in creating art.

TERROR → This artistic subject gained increasing popularity after "9/11".

TRANSCENDENCE → In philosophy and religion, transcendence is what is beyond normal human perception. In the extraordinary experience of transcendence, therefore, the boundaries of consciousness are crossed.

TRASH → The US word for "rubbish" aims at a level below accepted aesthetic and qualitative norms, with ironic intent.

URBANISM → City-planning and city-living considered as a concept.

UTOPIA → Refers to social models of a "better world" which (so far) have not been realized. The concept is becoming increasingly important in political art. (cf. political art)

VIDEO STILL → Still image taken by stopping a running videotape on screen or scanning a videotape.

VIENNESE ACTIONISM → Artform based around happenings of a ritualistic, bloodthirsty and apparently painful nature. Actionists often used sadomasochism and orgies for their systematic attack on the apparent moral and religious hypocrisy of Austrian society in the early 1960s.

VIRTUAL REALITY → An artificial world created on computer. (cf. computer-generated, computer animation)

WHITE CUBE → The neutral white exhibition room which in modern times has succeeded older forms of presenting art, e. g. hanging of pictures close to each other on coloured wallpaper. The white cube is supposed to facilitate the concentrated and undisturbed perception of the work of art.

WORK-IN-PROGRESS → Work which the artist does not attempt to complete, focusing instead on the actual creative process.

YOUNG BRITISH ARTISTS (YBA) → Group of young British artists who since the beginning of the 1990s have created a furore with object and video art inspired by pop culture.

Ariane Beyn and Raimar Stange

Glossar

ANIME → Japanische Zeichentrickfilme, deren einfach gezeichnete Figuren und schlichte Handlungen auf den japanischen Manga-Comics basieren. In den neunziger Jahren wurden diese Filme und ihre aufwendigen Soundtracks auch über Japan hinaus bekannt.

APPROPRIATION ART → Bei der Appropriation Art werden Objekte, Bilder und Texte aus ihrem kulturellen Zusammenhang genommen und unverändert in einen neuen gestellt. Dadurch laden sie sich mit neuer Bedeutung auf.

ARTE POVERA → In den sechziger Jahren in Italien entstandene Kunstrichtung, die vor allem „ärmliche" Materialien und einfachste Gestaltungsprinzipien nutzte, um die Werke auf ihre ureigensten Qualitäten zu reduzieren.

ASSEMBLAGE → Dreidimensionales Bild aus verschiedenen, meist dem Alltag entnommenen Materialien.

AURA → Die Aura bezeichnet die Ausstrahlung, die eine Person oder ein Kunstwerk verehrungswürdig macht. Auratische Personen oder Kunstwerke sind entrückt und zugänglich zugleich, sie faszinieren durch ihre kostbare Einzigartigkeit.

AUTONOMIE → Zustand der Selbstständigkeit und Unabhängigkeit. Für die Kunst bedeutet Autonomie die Freiheit von jeder Bestimmung durch außerkünstlerische Zwecke.

BODY ART → Kunst, die den Körper thematisiert und zum Gegenstand von Performances, Skulpturen oder Videoarbeiten macht.

CAMP → Personen oder Objekte, deren Erscheinungsbild übertrieben stilisiert ist, sind camp. Ihre Verehrung mündet in einen ironischen und zugleich emotionsgeladenen Kult der Künstlichkeit.

CATALOGUE RAISONNÉ → Kommentiertes Werkverzeichnis eines Künstlers, mit dem Anspruch auf Vollständigkeit.

CIBACHROME → Ein meist großformatiger Farbpapierabzug von einem Dia.

CLUBKULTUR → Die Clubkultur der neunziger Jahre wurde wesentlich von der Ästhetik der Techno-Musik geprägt. Sie beschränkt sich aber nicht auf das reine Tanzen auf dem „Dancefloor", sondern drückt sich als umfassende Lebenshaltung auch in Mode, Design und Typografie aus.

COLLAGE → Ein künstlerisches Werk, das aus aneinandergefügten, vom Künstler nicht selbst angefertigten zusammenhanglosen Objekten beziehungsweise Objektteilen besteht.

COMPUTERANIMATION → Im Computer erzeugte, scheinbar dreidimensionale Modelle, die vom Benutzer „durchwandert" beziehungsweise von verschiedenen Perspektiven aus gesehen werden können; virtuelle Figuren, die sich auf dem Bildschirm bewegen.

COMPUTERGENERIERT → Durch Computereinsatz erzeugt.

C-PRINT → Ein „colour-print", der Farbpapierabzug eines Fotonegativs.

CROSSOVER → Beim Crossover werden die Grenzen zwischen Kunst und Populärkultur sowie zwischen verschiedenen Kulturen überschritten und Musik, Design, Folklore etc. in die künstlerische Arbeit einbezogen.

CULTURAL STUDIES → Neuere Strömung in der angloamerikanischen Kulturwissenschaft, die sich der Untersuchung der Populärkultur widmet. Die Cultural Studies legen ein besonderes Augenmerk darauf, inwieweit kulturelle Äußerungen durch Rasse, Klassenzugehörigkeit und Geschlecht bedingt sind.

CULTURE JAMMING → Das Umkodieren von und Spielen mit kulturellen Zeichen wie zum Beispiel Werbebotschaften oder Firmenlogos ohne Rücksicht auf Copyrights.

DADA → Revolutionäre Künstlerbewegung, die in den zwanziger Jahren des 20. Jahrhunderts vor allem mit ihren Collagen, Lautdichtungen und Performances sämtliche kulturellen Werte infrage stellte.

DEKONSTRUKTION → Eine Interpretationsweise, die ein Werk nicht als geschlossene Einheit betrachtet, sondern als offenes und vielschichtiges Geflecht aus unterschiedlichsten formalen und inhaltlichen Elementen. Diese Elemente, ihre Funktionen und Widersprüche werden in der Dekonstruktion aufgedeckt.

DIENSTLEISTUNGSGESELLSCHAFT → Der Begriff umschreibt den Wandel von einer industriellen zu einer postmodernen Gesellschaft, in der Aspekte wie Verwaltung oder Service wichtiger sind als die bloße Produktion.

DIGITALE KUNST → Kunst, die mit neuen Medien wie Computer oder Internet arbeitet.

DOKUMENTARISCHE KUNST → Diese Kunst konzentriert sich auf die mehr oder weniger sachliche, uninterpretierte Wiedergabe von gesellschaftlicher Wirklichkeit.

EKLEKTIZISMUS → In der Postmoderne übliches Verfahren, das durch das ausgiebige Zitieren von (historischen) Stilen und Werken anderer Künstler charakterisiert ist.

ENTROPIE → Der aus der Wärmelehre stammende Begriff benennt dort den Grad der Unordnung in geschlossenen Systemen. Vollständige Entropie wäre dann erreicht, wenn ein System sich im Chaos auflöst. Analog dazu zeigt die Entropie die Größe des Informationswertes einer Nachricht an. Der Endpunkt hier: ein bedeutungsloses Rauschen.

ENVIRONMENT → Komplett durchgestalteter Innen- oder Außenraum, der den Betrachter in das ästhetische Geschehen integriert.

FIKTION → Ein Bild oder eine Geschichte ist dann eine Fiktion, wenn sie auf freier Erfindung beruht.
FLUXUS → Radikal experimentelle Kunstströmung, die unterschiedliche Formen wie Happening, Poesie, Musik und bildende Kunst zusammenbringt. Das Flüchtige dieser Aktionen tritt an die Stelle von auratischer Musealität.
FOLK ART → Kunsthandwerkliche und volkstümliche Ästhetik, die an bestimmte Regionen oder Berufsstände, zum Beispiel das bäuerliche Milieu, gebunden ist und von Stilwandlungen relativ unberührt bleibt.
FOTOREALISMUS → Hyperrealistische Malerei und Skulptur, die mit überzogener fotografischer Schärfe Ausschnitte der Realität kritisch beleuchtet.
FUTURISMUS → Die um 1910 von Dichtern und bildenden Künstlern in Italien ausgerufene futuristische Bewegung vollzog einen radikalen Bruch mit der Vergangenheit. Sie forderte stattdessen eine den Lebensbedingungen der Moderne angemessene Kunst der Simultaneität, Dynamik und Geschwindigkeit.

GENDER SURFING → Das verwirrende Spiel mit den Geschlechterrollen, das auf die lustvolle Überschreitung ihrer Grenzen abzielt.
GENTRIFICATION → Prozess, der die Verdrängung bestehender urbaner sozialer Strukturen beschreibt. Sie findet statt, wenn zum Beispiel Galerien in Gegenden ziehen, die zuvor von eher sozialschwachen Mietern bewohnt wurden.
GLOBALISIERUNG → Globalisierung bedeutet, dass wirtschaftliche oder kulturelle Prozesse zunehmend weltweite Auswirkungen haben.
GOUVERNEMENTALITÄT → Nach Michel Foucault ein Terminus, der die Funktionsweisen von Macht beschreibt. Dieser Begriff ist vor allem in der aktuellen „politischen Kunst" von Bedeutung. (vgl. Politische Kunst)

HAPPENING → Künstlerische Aktion in Anwesenheit des Publikums, das zumeist in das Geschehen einbezogen wird.
HETEROGENITÄT → Unvereinbare Gegensätzlichkeit.
HIGH AND LOW CULTURE (HI 'N' LO) → Themenkomplex, der den Einfluss der Trivialkultur (Low Art) auf die moderne Kunst (High Art) beleuchtet. Der Begriff geht zurück auf eine von Kirk Varnedoe 1990 im New Yorker Museum of Modern Art konzipierte Ausstellung.
HYBRID → Vielgestaltig, gemischt, nicht eindeutig zuzuordnen.

IDEOLOGIE → Politisches Bewusstsein, das von „politischer Kunst" kritisch hinterfragt wird. (vgl. Politische Kunst)
IKONE → Bilder oder Personen, die kultisch verehrt werden.
IKONOGRAFIE → Bild- oder Formensprache, die für einen bestimmten kulturellen Zusammenhang typisch ist, zum Beispiel die Ikonografie der Werbung, des Westerns, der postmodernen Architektur etc.
IKONOLOGIE → Wissenschaft von der inhaltlichen Interpretation eines Kunstwerks, die auf seiner Ikonografie basiert.
IMMATERIELLE ARBEIT → Arbeit, deren Produkte nicht auf das Produzieren von materiellen Dingen abzielt, sondern auf das Bearbeiten von immateriellen Daten, Bildern oder Tönen.
INSTALLATION → Ein Kunstwerk, das den Ausstellungsraum als ästhetische Komponente mit einbezieht.
INTERAKTIVE KUNST → Kunstwerke, die die direkte Einflussnahme des Betrachters – meist durch computergestützte Technik – vorsehen.
INSTITUTIONSKRITIK → Kunst, die sich auf die Reflexion der Strukturen des Kunstsystems konzentriert.

KODE → Zeichensystem als Grundlage für Kommunikation und Informationsübermittlung.
KONSTRUKTIVISMUS → Künstlerische Richtung zu Beginn des 20. Jahrhunderts, die in Anlehnung an die moderne Technik eine zumeist abstrakte Formensprache und die alltägliche Anwendung moderner Kunst suchte.
KONTEXTKUNST → Kritisiert den Kunstbetrieb und seine Institutionen: Machtstrukturen werden offengelegt, Verteilungsmechanismen und Ausstellungsformen auf ihre politische Funktion hin befragt. Unterschiedliche künstlerische Ausdrucksmittel wie Performance, Installation oder Objektkunst werden eingesetzt, um diese Kritik vorzutragen.
KONZEPTKUNST → Die Konzeptkunst entstand in den sechziger Jahren und stellt die inhaltliche Konzeption eines Werkes in den Vordergrund. Diese wird oft nur durch Texte oder Notizen präsentiert, die tatsächliche Umsetzung eines Werkes wird für zweitrangig erklärt und bleibt manchmal auch aus.
KURATOR → Ein Kurator legt die inhaltlichen Schwerpunkte einer Ausstellung fest und trifft die Auswahl der beteiligten Künstler.

LEIPZIGER SCHULE → Neokonservative Strömung der figurativen Malerei, deren Hauptakteure an der Leipziger Kunstakademie studiert haben.
LOCATION → Ort einer Veranstaltung, Ausstellung etc.

Glossar

MAINSTREAM → Bereits etablierte, dem Geschmack der breiten Masse entsprechende Stilrichtung.

MANGA → Comics und Zeichentrickfilme, die bevorzugte Populärliteratur Japans, die dort in großen Mengen produziert und konsumiert wird.

MEMENTO MORI → Ereignis oder Objekt, das an den Tod erinnert.

MIKROPOLITIK → Politische Strategie, die statt auf gesamtgesellschaftliche Veränderung auf Interventionen in kleineren Lebenseinheiten setzt.

MINIMAL ART → Kunstströmung der sechziger Jahre, die Skulpturen und Bilder auf klare geometrische Grundformen zurückführte und in eine konkrete Beziehung zu Raum und Betrachter setzte.

MIXED MEDIA → Verbindung verschiedener Medien, Materialien und Techniken bei der Produktion eines Kunstwerks.

MONTAGE → Zusammenfügen von Bildelementen oder Bildfolgen in Fotografie, Film und Video.

MULTIPLE → In den sechziger Jahren entwickelte sich eine kritische Haltung gegenüber dem klassischen Werkbegriff: Anstelle eines einzelnen Originals wurden Kunstwerke in höherer Auflage, das heißt als Multiples, produziert. Kunst sollte auf diese Weise die Museen und Galerien verlassen können und mehr Menschen zugänglich gemacht werden.

NARRATION → Erzählung in Kunst, Film und Literatur.

NEO-FORMALISMUS → Aktuelle Kunstrichtung, die die Formensprache der Moderne einer kritischen Revision unterzieht.

NEO-GEO → Tendenz in der Malerei der achtziger Jahre, die überaus sachlich mit geometrischen Mustern und Farbkompositionen operiert.

NEOKONKRETE KUNST → Kunstrichtung in der Tradition der Konkreten Kunst. Seit den fünfziger Jahre betont diese, ähnlich wie die abstrakte Kunst, die materiellen, also „konkreten" Eigenschaften der ästhetischen Mittel.

NEO-KONZEPTKUNST → Knüpft an die Konzeptkunst der sechziger Jahre an, wobei sie deutlich mehr Wert auf das Moment des Narrativen legt.

NETZWERK → Mehr oder weniger feste und hierarchiefreie Organisationsform von Künstlern und Künstlergruppen.

NEW AGE → Esoterische Bewegung, die an den Beginn eines neuen Zeitalters glaubt.

OBJEKTKUNST → Kunstwerke, die bereits existierende Gegenstände oder Materialien beinhalten oder ganz aus ihnen bestehen. (vgl. Readymade)

OP ART → Kunstströmung der sechziger Jahre, deren Vertreter mit der visuellen Wirkung von Linien, Flächen und Farben experimentieren.

PERFORMANCE → Künstlerische Arbeit, die in Form einer (theatralischen) Aktion einem Publikum vorgeführt wird. Erste Performances fanden während der sechziger Jahre im Rahmen der Fluxus-Bewegung statt, die auf die Erweiterung des Kunstbegriffs abzielte.

PHÄNOMENOLOGIE → Bereich der Philosophie, in dem untersucht wird, wie die äußere Wirklichkeit dem Menschen erscheint.

POLITICAL CORRECTNESS → Eine engagierte Haltung, die besonders einflussreich in den USA vertreten wird. Ziel der Political Correctness ist es, die moralischen Standards des öffentlichen Lebens zu erhöhen. Gefordert wird vor allem ein gerechter Umgang mit sozialen Minderheiten.

POLITISCHE KUNST → Kunst, die sich explizit mit politischen Problemfeldern, zum Beispiel Globalisierung oder Neoliberalismus, beschäftigt.

POP ART → Eine künstlerische Strategie der sechziger Jahre, die populäre Ikonografien aus Film, Musik und Kommerz in die Kunst überführte.

POPKULTUR → Die Popkultur findet ihren Ausdruck in massenhaft verbreiteten Kulturgütern aus Bereichen wie Mode, Musik, Sport oder Film. Anfang der sechziger Jahre fand die Welt der Popkultur durch die Pop-Art Eingang in die Kunst.

POST HUMAN → Themenkomplex, bei dem der Einfluss neuer Technologien und der Einfluss der Mediengesellschaft auf den menschlichen Körper im Mittelpunkt steht. „Post human" war der Titel einer 1992 von Jeffrey Deitch organisierten Ausstellung.

POSTKONZEPTUALISMUS → Ästhetischer Ansatz, der sich, wie die Konzeptkunst in den sechziger Jahren, mehr auf die Idee und das Konzept der Kunst als auf ihre visuell wahrnehmbare Form konzentriert.

POSTMINIMALISMUS → Kunst, die in der Tradition der Minimal Art mithilfe einfacher Formen und Strukturen ihr Funktionieren innerhalb präzise abgesteckter Rahmenbedingungen untersucht.

POSTMODERNE → Die Postmoderne geht, im Gegensatz zur Moderne, von der Unmöglichkeit großer Utopien aus. Sie akzeptiert die Wirklichkeit als eine zersplitterte und die persönliche Identität als eine unstabile Größe, die durch eine Vielzahl kultureller Faktoren vermittelt wird. Die Postmoderne plädiert für einen ironisch-spielerischen Umgang mit der eigenen Identität sowie für eine liberale Gesellschaft. (vgl. Utopie)

POSTPRODUKTION → Ein aus dem Filmbereich übernommener Begriff, der die Nachbearbeitung von Bildmaterial u. ä. beschreibt.

POSTSTRUKTURALISMUS → Während der Strukturalismus Zeichensysteme als geschlossen begreift, nimmt der Poststrukturalismus an, dass Zeichensysteme immer dynamisch und offen für Veränderungen sind. (vgl. Strukturalismus)

PROCESS ART → Die Veränderbarkeit der Form, Zusammenarbeit und der unvollendete kreative Prozess ersetzen in der Process Art seit den sechziger Jahren einen definitiven und abgeschlossenen Werkbegriff.

PRODUCTION STILL → Foto von einer Filmszene oder von den Protagonisten eines Films, das am Filmset von einem speziellen Fotografen für die Werbung oder zu dokumentarischen Zwecken aufgenommen wird.

PROJECTED IMAGES → Projizierte Bilder unterschiedlicher Formate in künstlerischen Installationen.

READYMADE → Ein Alltagsgegenstand, der ohne größere Veränderung durch den Künstler von diesem zum Kunstwerk erklärt und ausgestellt wird. Der Begriff geht auf den französischen Künstler Marcel Duchamp zurück, der 1913 in New York die ersten Readymades, zum Beispiel ein handelsübliches Pissoir *(Fountain)* oder einen Flaschentrockner, präsentierte.

SAMPLING → Arrangement von vorhandenem Bild- oder Tonmaterial, das vor allem mit den formalen Eigenschaften des verarbeiteten Materials spielt. Anders als das Zitieren zielt das Sampling dabei auf neue Formulierungen ab und lässt seine Quellen häufig im Unklaren.

SCATTER ART → Raumfüllende Installationskunst, bei der alltägliche, oftmals gefundene und trashige Objekte scheinbar chaotisch angeordnet am Ausstellungsort verteilt sind.

SELBSTREFERENZIELLE KUNST → Kunst, die sich ausschließlich auf ihre eigenen formalen Eigenschaften bezieht und jeden Abbildcharakter zurückweist.

SEMANTIK → Lehre von der Bedeutung sprachlicher Zeichen.

SETTING → Eine vorgefundene oder inszenierte Umgebung, in die ein Werk kompositorisch eingebettet ist.

SIMULAKRUM → Ein „Trugbild", das so verführerisch ist, dass es die Wirklichkeit zu ersetzen vermag.

SITUATIONISMUS → Die Künstlergruppe der Internationalen Situationisten führte Mitte des 20. Jahrhunderts den Begriff der „Situation" in die Kunst ein. Die Situation ist demnach eine Konstruktion temporärer Lebensumgebungen und ihre Umgestaltung in eine höhere Qualität der Leidenschaft.

SOZIALARBEIT → Kunst wird hier als Dienstleistung begriffen, die sich ganz konkret sozialpolitischen Aufgaben stellt.

STEREOTYP → Klischeehafte Vorstellung, die sich allgemein eingebürgert hat.

STRUKTURALISMUS → Der Strukturalismus untersucht systematisch die Bedeutung von Zeichen. Ziel des Strukturalismus ist es, die Regeln verschiedener Zeichensysteme zu erforschen. Sprachen und auch kulturelle Zusammenhänge werden vom Strukturalismus als Zeichensysteme verstanden und interpretiert.

STRUKTURELLER FILM → In den USA geläufige Bezeichnung für Experimentalfilme seit den sechziger Jahren, die die materielle Beschaffenheit und die Wahrnehmungsbedingungen des Films offen legen.

SURREALISMUS → Kunstbewegung, die sich Mitte der zwanziger Jahren des 20. Jahrhunderts um den Literaten André Breton und seine Anhänger formierte und psychische Automatismen in den Mittelpunkt ihres Interesses stellte.

TERROR → Sujet, das nach „9/11" mehr und mehr an Attraktivität gewinnt.

TRANSZENDENZ → In Philosophie und Religion der Begriff für das, was außerhalb der normalen menschlichen Wahrnehmung liegt. In der Erfahrung der Transzendenz werden also die Grenzen des Bewusstseins überschritten.

TRASH → Trash – ursprünglich: „Abfall" – ist die ironische Unterbietung ästhetischer und qualitativer Normen.

URBANISMUS → Reflexionen über Städtebau und das Zusammenleben in Städten.

UTOPIE → Gesellschaftliche Modelle einer „besseren Welt", die (bisher) unrealisiert sind. Der Begriff wird zunehmend für politische Kunst wichtig. (vgl. Politische Kunst)

VIDEO STILL → Durch Anhalten des laufenden Videobandes auf dem Bildschirm erscheinendes oder aus den Zeilen eines Videobandes herausgerechnetes (Stand-)Bild.

VIRTUAL REALITY → Im Computer erzeugte künstliche Welt. (vgl. computergeneriert, Computeranimation)

WHITE CUBE → Begriff für den neutralen weißen Ausstellungsraum, der in der Moderne ältere Formen der Präsentation von Kunst, zum Beispiel die dichte Hängung von Bildern auf farbigen Tapeten, ablöste. Der White Cube soll die konzentrierte und ungestörte Wahrnehmung eines Kunstwerks ermöglichen.

WIENER AKTIONISMUS → Blutig und schmerzhaft erscheinende Happening-Kunst rituellen Charakters, die mit oftmals sadomasochistischen Handlungen und Orgien systematisch die moralisch-religiöse Scheinheiligkeit der österreichischen Gesellschaft der frühen sechziger Jahre angreift.

WORK-IN-PROGRESS → Werk, das keine Abgeschlossenheit anstrebt, sondern seinen prozessualen Charakter betont.

YOUNG BRITISH ARTISTS (YBA) → Gruppe junger englischer Künstler, die seit Anfang der neunziger Jahre mit ihrer von der Popkultur inspirierten Objekt- und Videokunst Furore macht.

Ariane Beyn und Raimar Stange

Glossaire

ACTIONNISME VIENNOIS → Happening à caractère rituel, dont les manifestations sanglantes et douloureuses s'attaquent à la bigoterie morale et religieuse de la société autrichienne du début des années soixante, dans des actions et des orgies à caractère sadomasochiste.

ANIMATION → Module d'apparence tridimensionelle produit par ordinateur et pouvant être «parcouru» par le spectateur → en fait : pouvant être vu sous des points de vue changeants ; figures virtuelles qui se meuvent sur un écran.

ANIME → Dessins animés japonais dans lesquels le graphisme simple des figures et l'action sobre sont issus des mangas, les bandes dessinées japonaises. Depuis les années 90, ces films et leurs bandes-son très élaborées se sont aussi fait connaître au-delà des frontières japonaises.

APPROPRIATION ART → Des objets, des images, des textes sont extraits de leur contexte culturel pour être transplantés tels quels dans un nouveau contexte, où ils se chargent d'une nouvelle signification.

ART CONCEPTUEL → L'art conceptuel, qui a vu le jour dans les années 60, met au premier plan le contenu de l'œuvre, dont la conception n'est souvent présentée que par des textes ou des notes, la réalisation concrète étant déclarée secondaire, voire éludée.

ART CONTEXTUEL → Il critique le marché de l'art et ses institutions : les structures du pouvoir sont mises en évidence, les mécanismes de distribution et les formes d'exposition remises en cause sous l'angle de leur fonction politique. Des moyens d'expression aussi différents que la performance, l'installation ou l'art de l'objet y sont employés pour présenter cette critique.

ART DE L'OBJET → On peut y classer toutes les œuvres d'art entièrement composées ou comportant des objets ou des matériaux préexistants. (cf. Ready-made)

ART DIGITAL → Art s'appuyant sur les moyens offerts par les nouveaux médias tels que l'informatique ou l'internet.

ART DOCUMENTAIRE → Forme d'art qui se concentre sur la représentation plus ou moins objective de la réalité sociale sans ajout d'aucune interprétation.

ART INTERACTIF → Art qui prévoit une intervention directe du spectateur dans l'œuvre. Le plus souvent, cette intervention est rendue possible par des techniques s'appuyant sur l'informatique.

ART NEO-CONCEPTUEL → Ce courant artistique se rattache à l'art conceptuel des années soixante tout en attachant davantage d'importance à l'aspect narratif.

ART NEO-CONCRET → Courant artistique dans la tradition de l'«Art concret». Depuis les années 50, celle-ci souligne, de manière similaire à l'art abstrait, les qualités matérielles, donc «concrètes» des moyens esthéthiques.

ART POLITIQUE → Art qui se préoccupe de problématiques explicitement politiques – par exemple la globalisation ou le néolibéralisme.

ARTE POVERA → Mouvement artistique né en Italie dans les années 1960, qui se servit surtout de matériaux et de principes de création «pauvres», en vue de réduire les œuvres à leurs qualités intrinsèques.

ASSEMBLAGE → Image en trois dimensions composée de matériaux divers issus le plus souvent de la vie courante.

AURA → L'aura désigne le rayonnement qui rend une personne ou une œuvre d'art digne d'admiration. Les personnes ou les œuvres d'art douées d'une aura sont à la fois distantes et accessibles, elles fascinent par leur incomparable unicité.

AUTONOMIE → Etat d'indépendance. Dans le contexte de l'art, l'autonomie signifie la liberté à l'égard de tout conditionnement par un propos extra-artistique.

AUTO-REFERENCE → Se dit d'un art qui renvoie exclusivement à ses propres propriétés formelles et rejette ainsi tout caractère représentatif.

BODY ART → Art qui prend le corps pour thème et qui en fait l'objet central de performances, de sculptures ou d'œuvres vidéo.

CAMP → Personnes ou objets dont la manifestation visuelle est exagérément stylisée. L'admiration dont ils bénéficient débouche sur un culte de l'artificiel à la fois ironique et chargé d'émotion.

CATALOGUE RAISONNE → Liste commentée des œuvres d'un artiste, avec une recherche d'exhaustivité.

CIBACHROME → Tirage papier d'une diapositive, le plus souvent en grand format.

CLUBCULTURE → La clubculture des années quatre-vingt-dix a été fortement marquée par l'esthétique de la musique techno. Au-delà de la danse sur le «dancefloor», elle traduit aussi une attitude de vie globale dans les domaines de la mode, du design et de la typographie.

CODE → Système de signes qui sous-tend la communication et la transmission d'informations.

COLLAGE → Œuvre d'art constituée d'objets ou de parties d'objets juxtaposés qui ne sont pas des productions personnelles de l'artiste.

COMMISSAIRE → Le commissaire d'une exposition fixe le contenu d'une présentation et procède au choix des artistes participants.

CONSTRUCTIVISME → Courant artistique du début du siècle dernier dont la recherche formelle, le plus souvent abstraite, s'appuie sur la technique moderne et vise à l'application de l'art dans la vie quotidienne.

COURANT DOMINANT → Tendance stylistique qui s'est imposée et qui correspond au goût de la masse.

C-PRINT → «Colour-print», tirage papier en couleurs à partir d'un négatif.

CRITIQUE DES INSTITUTIONS → Art qui concentre sa réflexion sur les structures du système artistique.

CROSSOVER → Dans le Crossover, les limites entre l'art et la culture populaire, ainsi qu'entre les différentes cultures, sont rendues perméables. La musique, le design, le folklore etc. sont intégrés dans le travail artistique.

CULTURAL STUDIES → Dans les sciences humaines anglo-saxonnes, courant récent qui étudie la culture populaire. Un domaine de recherches particulier des Cultural Studies consiste à déterminer jusqu'à quel point les manifestations culturelles sont conditionnées par la race, l'appartenance à une classe sociale et à un sexe.

CULTURE JAMMING → Jeu sur les signes et les codes culturels, notamment sur les messages publicitaires ou les logos des firmes, sans égards pour les droits d'auteurs.

CULTURE POP → La culture pop trouve son expression dans des biens culturels répandus en masse et issus de domaines tels que la mode, la musique, le sport ou le cinéma. Au début des années 60, le monde de la culture pop devait entrer dans l'art par le biais du Pop Art.

DADA → Mouvement artistique révolutionnaire des années 20 qui remit en question l'ensemble des valeurs culturelles, surtout dans des collages, des poèmes phonétiques et des performances.

DECONSTRUCTION → Mode d'interprétation qui ne considère pas l'œuvre comme une unité finie, mais comme un ensemble d'éléments formels et signifiants les plus divers, et qui met en évidence leurs fonctions et leurs contradictions.

ECLECTISME → Procédé courant dans l'art postmoderne qui se caractérise par la citation généreuse d'œuvres et de styles d'autres artistes.

ECOLE DE LEIPZIG → Courant néo-conservateur de la peinture figurative dont les principaux acteurs ont étudié à l'École des Beaux-Arts de Leipzig.

ENTROPIE → Concept issu de la thermodynamique, où il désigne l'état de désordre dans les systèmes clos. L'entropie totale serait ainsi atteinte lorsqu'un système se dissout en chaos. Par analogie, l'entropie indique la valeur informative d'une nouvelle. L'entropie totale serait atteinte par un bruit de fond vide de sens.

ENVIRONNEMENT → Espace intérieur ou extérieur entièrement formé par l'artiste et intégrant le spectateur dans l'événement esthétique.

FICTION → Une image ou une histoire est une fiction lorsqu'elle repose sur l'invention libre.

FLUXUS → Courant artistique expérimental et radical qui réunit différentes formes d'art comme le happening, la poésie, la musique et les arts plastiques. Le caractère fugace de ces actions y remplace l'aura de la muséalité.

FOLK ART → Esthétique artisanale et folklorique liée à certaines régions ou à certains métiers → par exemple le monde rural →, et qui reste relativement à l'écart des évolutions stylistiques.

FUTURISME → Le mouvement futuriste, proclamé vers 1910 par des poètes et des plasticiens italiens, accomplit une rupture radicale avec le passé, dont il exigeait le remplacement par un art rendant compte des conditions de vie modernes, avec des moyens nouveaux comme la simultanéité, la dynamique et la vitesse.

GENDER SURFING → Jeu troublant sur les rôles des sexes, et qui vise à la voluptueuse transgression de leurs limites.

GENERE PAR ORDINATEUR → Produit à l'aide de l'ordinateur.

GENTRIFICATION → Processus caractérisé par l'élimination de certaines structures sociales urbaines. Un tel processus se produit par exemple lorsque des galeries s'installent dans des zones majoritairement habitées auparavant par des locataires à faibles revenus.

GLOBALISATION → La globalisation renvoie au fait que certains processus économiques ou culturels ont de plus en plus fréquemment des répercussions au niveau mondial.

GOUVERNEMENTALITE → Par référence à Michel Foucault, terme qui décrit les modes de fonctionnement du pouvoir. Cette notion joue surtout un rôle important dans «l'art politique» d'aujourd'hui. (cf. Art politique)

HAPPENING → Action artistique menée en présence du public, qui est le plus souvent intégré à l'événement.

HETEROGENEITE → Opposition inconciliable.

HIGH AND LOW CULTURE (HI 'N' LO) → Complexe thématique dans lequel l'influence de la culture triviale (Low Art) éclaire l'art moderne (High Art). Ce concept remonte à une exposition organisée par Kirk Varnedoe en 1990 au Museum of Modern Art de New York.

HYBRIDE → Multiforme, mixte, qui ne peut être classé clairement.

ICONE → Image ou personne faisant l'objet d'une vénération ou d'un culte.

ICONOLOGIE → Science de l'interprétation du contenu d'une œuvre sur la base de son iconographie.

ICONOGRAPHIE → Vocabulaire d'images ou de formes caractéristiques d'un contexte culturel déterminé. Ex. : l'iconographie de la publicité, du western, de l'architecture postmoderne …

Glossaire

IDEOLOGIE → Mode de conscience politique que «l'art politique» interroge de manière critique. (cf. Art politique)

INSTALLATION → Œuvre d'art qui intègre l'espace d'exposition comme une composante esthétique.

LOCATION → Site of an event or exhibition etc.

MANGA → Bandes dessinées et dessins animés, littérature populaire du Japon, où elle est produite et consommée en grande quantité.

MEMENTO MORI → Evénement ou objet qui rappelle la mort.

MICROPOLITIQUE → Stratégie politique qui mise sur une action dans des domaines particuliers de la vie, plutôt que sur des changements sociaux-globaux.

MINIMAL ART → Courant artistique des années 60 qui réduit les sculptures et les tableaux à des formes géométriques clairement définies et qui les place dans un rapport concret avec l'espace et le spectateur.

MIXED MEDIA → Mélange de différents médias, matériaux et techniques dans la production d'une œuvre d'art.

MONTAGE → Agencement d'éléments visuels ou de séquences d'images dans la photographie, le cinéma et la vidéo.

MULTIPLE → Au cours des années 60 est apparue une attitude critique à l'égard de la notion classique d'œuvre : au lieu d'un original unique, les œuvres furent produites en tirages plus élevés (comme «multiples» précisément), ce qui devait permettre à l'art de quitter les musées et les galeries et d'être accessible à un plus grand nombre.

NARRATION → Récit dans l'art, le cinéma et la littérature.

NEO-FORMALISME → Courant artistique actuel qui soumet le langage formel de la modernité à une relecture critique.

NEO-GEO → Tendance de la peinture des années 80 qui travaille d'une façon extrêmement concrète avec les motifs géométriques et les compositions chromatiques.

NEW AGE → Mouvement ésotérique qui croit à l'avènement d'une ère nouvelle.

OP ART → Courant artistique des années 60 dont les représentants travaillent sur le jeu visuel des lignes, des surfaces et des couleurs. Ces artistes composent des motifs déterminés visant à produire des effets d'optique.

PERFORMANCE → Travail artistique présenté à un public sous la forme d'une action (théâtrale). Les premières performances furent présentées pendant les années 60 dans le cadre du mouvement Fluxus, qui visait à l'élargissement du concept d'art.

PHENOMENOLOGIE → Domaine de la philosophie qui étudie la manière dont la réalité extérieure apparaît à l'homme.

PHOTO DE PLATEAU → Photo d'une scène de cinéma ou de protagonistes d'un film, prise pendant le tournage, à des fins publicitaires, par un photographe spécialisé. Les photos d'une documentation prises durant le tournage sont également appelées stills.

PHOTOREALISME → Peinture et sculpture hyperréaliste qui porte un regard critique sur des morceaux de réalité à travers une amplification extrême de la vision photographique.

POLITICAL CORRECTNESS → Attitude engagée particulièrement influente aux Etats-Unis, et qui se fixe pour but de relever les standards moraux de la vie publique. Une revendication majeure en est le traitement plus juste des minorités sociales.

POP ART → Stratégie artistique des années 1960 qui fit entrer dans l'art l'iconographie populaire du cinéma, de la musique et du commerce.

POST HUMAN → Complexe thématique dans lequel l'influence des nouvelles technologies et de la société médiatique sur le corps humain, est au centre du propos artistique. Ce concept remonte au titre d'une exposition organisée en 1992 par Jeffrey Deitch.

POST-CONCEPTUALISME → A l'instar de l'art conceptuel des années 60, démarche esthétique qui repose davantage sur l'idée et le concept artistique que sur la forme perceptible visuellement.

POST-MINIMALISME → Dans le sillage du Minimal Art, art qui analyse son propre fonctionnement à l'aide de formes et de structures simples, dans le cadre de conditions définies avec précision.

POSTMODERNISME → Par opposition à l'art moderne, le postmodernisme postule l'impossibilité des grandes utopies. Il accepte la réalité comme étant éclatée et l'identité personnelle comme une valeur instable fondée par un grand nombre de facteurs culturels. Le postmodernisme plaide en faveur d'un maniement ironique et ludique de l'identité personnelle et pour une société libérale. (cf. utopie)

POSTPRODUCTION → Terme emprunté à l'industrie du cinéma et qui désigne le traitement *a posteriori* d'un matériau visuel ou autre.

POST-STRUCTURALISME → Tandis que le structuralisme conçoit les systèmes de signes comme des systèmes clos, le post-structuralisme suppose que les systèmes de signes sont toujours dynamiques et sujets à modification. (cf. Structuralisme)

PROCESS ART → Dans le Process Art, la modifiabilité de la forme, de la collaboration et du processus créateur se substituent depuis les années 60 à une conception définitive et figée de l'œuvre.

PROJECTED IMAGES → Images projetées en différents formats dans des installations artistiques.

READY-MADE → Un objet quotidien déclaré œuvre d'art par l'artiste et exposé comme tel sans changement notoire. Le terme remonte à l'artiste français Marcel Duchamp, qui présente les premiers ready-mades – par exemple un urinoir du commerce *(Fountain)* ou un porte-bouteilles – en 1913 à New York.

REALITE VIRTUELLE → Monde artificiel généré par ordinateur. (cf. Généré par ordinateur, Animation)

RESEAU → Forme d'organisation plus ou moins définie et non hiérarchique d'artistes et de groupes d'artistes.

SAMPLING → Arrangement de matériaux visuels ou sonores jouant essentiellement des caractéristiques formelles du matériau utilisé. Contrairement à la citation, le sampling vise à des formulations nouvelles et ne cite généralement pas ses sources.

SCATTER ART → Art producteur d'installations globales dans lesquelles des objets quotidiens, souvent trouvés et trash, semblent disposés de manière chaotique sur le lieu d'exposition.

SEMANTIQUE → Etude de la signification des signes linguistiques.

SETTING → Environnement existant ou mis en scène qui vient s'insérer dans la composition d'une œuvre.

SIMULACRE → «Mirage» que sa séduction met à même de se substituer à la réalité.

SITUATIONNISME → Au milieu du siècle dernier, le groupe d'artistes de l'Internationale situationniste a introduit dans l'art le concept de situation, construction temporaire d'environnements de la vie et leur transformation en une intensité de passion.

SOCIETE DE SERVICES → Terme qui décrit l'évolution d'une société industrielle vers une société postmoderne dans laquelle des aspects comme l'administration ou les services prennent plus d'importance que la pure production de biens.

STEREOTYPE → Idée qui a acquis droit de cité sous forme de cliché.

STRUCTURAL FILM → Depuis les années 1960, terme couramment employé aux Etats-Unis pour désigner des films d'art et d'essai qui mettent en évidence la conformation matérielle et les conditions de perception du cinéma.

STRUCTURALISME → Le structuralisme étudie systématiquement la signification des signes. Il a pour but d'étudier les facteurs qui régissent différents systèmes de signes. Les langues, mais aussi les contextes sociaux y sont compris et interprétés comme des systèmes de signes.

SURREALISME → Mouvement artistique formé au milieu des années 1920 autour du littérateur André Breton et de ses partisans, et qui plaça l'automatisme psychique au centre de ses préoccupations.

TERRORISME → Sujet qui gagne de plus en plus en attractivité depuis les attentats du 11 septembre 2001.

TRANSCENDANCE → En philosophie et en religion, terme employé pour désigner l'au-delà de la perception humaine ordinaire. Dans l'expérience inhabituelle de la transcendance, les limites de la conscience sont donc transgressées.

TRASH → Trash – à l'origine: «ordure, déchet» – est l'abaissement ironique des normes esthétiques et qualitatives.

TRAVAIL IMMATERIEL → Travail dont les produits ne visent pas à la création de choses matérielles, mais au traitement artistique de données, d'images ou de sons immatériels.

TRAVAIL SOCIAL → L'art y est compris comme une prestation de service qui se propose de remplir des tâches socio-politiques.

URBANISME → Réflexions sur la construction des villes et la vie urbaine.

UTOPIE → Modèles sociaux d'un «monde meilleur» restés irréalisés (à ce jour). Ce terme prend une importance croissante dans l'art politique. (cf. Art politique)

VIDEO STILL → Image (fixe) obtenue à l'écran par arrêt d'une bande vidéo ou calculée à partir des lignes d'une bande vidéo.

WHITE CUBE → Terme désignant la salle d'exposition blanche, neutre, qui dans l'art moderne remplace des formes plus anciennes de présentation, par exemple l'accrochage dense de tableaux sur des papiers peints de couleur. Le White Cube propose une perception concentrée et non troublée de l'œuvre d'art.

WORK-IN-PROGRESS → Œuvre qui ne recherche pas son achèvement, mais qui souligne au contraire son caractère processuel.

YOUNG BRITISH ARTISTS (YBA) → Groupe de jeunes artistes anglais qui, depuis les années 90, fait parler de lui avec son art de l'objet et ses vidéos inspirés du Pop Art.

Ariane Beyn et Raimar Stange

Photo Credits — Fotonachweis — Crédits photographiques

We would like to thank all the individual people, galleries and institutions who placed photographs and information at our disposal for ART NOW 2.
Unser Dank gilt allen Personen, Galerien und Institutionen, die großzügig Bildmaterial und Informationen für ART NOW 2 zur Verfügung gestellt haben.
Nous remercions toutes les personnes, galeries et institutions qui ont mis gracieusement à la disposition de ART NOW 2 leurs documentations, images et informations.

Ackermann, Franz → 1 – 4 Courtesy neugerriemschneider, Berlin **Ahtila, Eija-Liisa** → © VG Bild-Kunst, Bonn 2005 / 1 – 3 Courtesy Crystal Eye Ltd., Helsinki, and Klemens Gasser & Tanja Grunert Inc., New York **Aitken, Doug** → 1 – 3 Courtesy 303 Gallery, New York **Almond, Darren** → 1, 2 + 5 Courtesy Galerie Max Hetzler, Berlin / 3 + 4 Courtesy Jay Jopling/White Cube, London **Alÿs, Francis** → 1 – 3 Courtesy Galerie Peter Kilchmann, Zurich / 3 © Photos Jenni Carter **Amer, Ghada** → © VG Bild-Kunst, Bonn 2005 / 1 – 3 Courtesy Gagosian Gallery, New York / 1 + 2 © Photos Robert McKeever **assume vivid astro focus** → 1 – 7 Courtesy John Connelly Presents, New York / Peres Projects, Los Angeles/Berlin / 1 © Photo Tom Powel / 3 © Photo Andy Keate / 4 + 6 © Photos Mauro Restiffe / 7 © Photo C. M. Guerio **Ataman, Kutlug** → 1 – 5 Courtesy the artist and Lehmann Maupin Gallery, New York **The Atlas Group** → 1 – 4 Courtesy the artist / Sfeir Semler Galerie, Hamburg / Anthony Reynolds Gallery, London **Barney, Matthew** → 1 – 4 Courtesy Barbara Gladstone Gallery, New York / 1 + 2 © Photos Chris Wingert **Beecroft, Vanessa** → 1 – 3 Courtesy the artist **Bock, John** → 1 + 2 Courtesy Klosterfelde, Berlin / Anton Kern Gallery, New York / 1 © Photos Knut Klaßen **Bonin, Cosima von** → 1 + 2 Courtesy Galerie Christian Nagel, Köln/Berlin / 3 + 4 © Photos Larry Lamay / 4 Courtesy Friedrich Petzel Gallery, New York **Bonvicini, Monica** → © VG Bild-Kunst, Bonn 2005 / 1 – 4 Courtesy Galleria Emi Fontana, Milan / Portrait © Photo Monica Bonvicini **Breitz, Candice** → 1 + 2 Courtesy Sonnabend Gallery, New York / galleria francesca kaufmann, Milan / 3 Courtesy Galerie Max Hetzler, Berlin / galleria francesca kaufmann, Milan / 1 + 2 © Photos Alexander Fahl **Brown, Cecily** → 1 – 3 Courtesy Contemporary Fine Arts, Berlin / 1 – 3 © Photos Robert McKeever / Portrait © Photo Jessica Craig-Martin **Brown, Glenn** → 1 + 2 Courtesy Patrick Painter, Santa Monica / 3 Courtesy Gagosian Gallery, New York / 4 + 5 Courtesy Galerie Max Hetzler, Berlin / 1 – 5 © Photos Robert McKeever / Portrait © Photo Alan Smithee **Bruguera, Tania** → 1 – 5 Courtesy the artist and Rhona Hoffman Gallery, Chicago / 1, 2 + 4 © Photos Michael Tropea / 5 © Photo Cassey Stoll **Butzer, André** → 1 – 4 Courtesy Galerie Max Hetzler, Berlin / Galerie Hammelehle und Ahrens, Cologne / 1 © Photo Boris Becker / 2 + 4 © Photos Jörg von Bruchhausen / 3 © Photo Alistair Overbruck / Portrait © Photo Thomas Biber **Calderón, Miguel** → 1 + 2 Courtesy Andrea Rosen Gallery, New York / kurimanzutto, Mexico City **Carpenter, Merlin** → 1 Courtesy Distrito 4, Madrid / 2 – 4 Courtesy Galerie Christian Nagel, Cologne / 1 © Photo Andy Keate / 2 © Photo Simon Vogel / 3 + 4 © Photos Takahiro Immamura **Cattelan, Maurizio** → 1 – 4 Courtesy Marian Goodman Gallery, New York **Chapman, Jake + Dinos** → 1 – 8 Courtesy Jay Jopling/White Cube, London / 1 – 6 © Photos Stephen White **Currin, John** → 1, 4 + 6 Courtesy Gagosian Gallery, New York / 2, 3 + 5 Courtesy Sadie Coles HQ, London / 1 – 6 © Photos Robert McKeever **Deller, Jeremy** → 1 + 2 Courtesy The Modern Institute, Glasgow / 2 © Photo Martin Jenkinson / Portrait © Photo Hainsley Brown **Demand, Thomas** → © VG Bild-Kunst, Bonn 2005 / 1 Courtesy the artist / 2 – 4 Courtesy Victoria Miro Gallery, London / Esther Schipper, Berlin / 303 Gallery, New York / Courtesy Monika Sprüth/Philomene Magers, Cologne/Munich / 3 © Photo Mancia/Bodmer **Dijkstra, Rineke** → 1 – 3 Courtesy Galerie Max Hetzler, Berlin **Doig, Peter** → 1 – 4 Courtesy the artist and Contemporary Fine Arts, Berlin / 1 – 4 + Portrait © Photos Jochen Littkemann **Douglas, Stan** → 1 – 9 Courtesy David Zwirner Gallery, New York **Dumas, Marlene** → 1 + 2 Courtesy the artist and Galerie Paul Andriesse, Amsterdam / 1 © Photo Peter Cox / 2 © Photo Annalisa Guidetti / Portrait © Photo Andre Vannoord **Eder, Martin** → © VG Bild-Kunst, Bonn 2005 / 1 – 4 Courtesy EIGEN + ART, Leipzig/Berlin **Eitel, Tim** → © VG Bild-Kunst, Bonn 2005 / 1 – 4 Courtesy EIGEN + ART, Leipzig/Berlin / 1 – 4 © Photos Uwe Walter / Portrait © Photo Gregor Hohenberg **Eliasson, Olafur** → 1 – 4 Courtesy neugerriemschneider, Berlin / 1 © Photo Marcus Leith and Andrew Dunkley, Tate Modern / 3 + 4 © Photos Jens Ziehe / Portrait © Photo Tacita Dean **Elmgreen & Dragset** → 1 + 2 Courtesy Galleria Massimo de Carlo, Milan / 3 Courtesy Galleri Nicolai Wallner, Copenhagen **Emin, Tracey** → 1 – 5 Courtesy Jay Jopling/White Cube, London / 1, 4 + 5 © Photos Stephen White **Esser, Elger** → © VG Bild-Kunst, Bonn 2005 / 1 – 5 Johnen + Schöttle, Cologne **Fudong, Yang** → 1 – 5 Courtesy ShanghARTs, Shanghai **Gallagher, Ellen** → 1 + 2 Courtesy Gagosian Gallery, New York / 1 + 2 © Photos D. James Dee/Two Palms Press **Gaskell, Anna** → 1 – 5 Courtesy the artist and Casey Kaplan, New York **Gober, Robert** 1 – 4 Courtesy Matthew Marks Gallery, New York **Goicolea, Anthony** → 1 – 3 Courtesy Galerie Aurel Scheibler, Cologne / 4 + 5 Courtesy TORCH Gallery, Amsterdam **Gonzalez-Foerster, Dominique** → © VG Bild-Kunst, Bonn 2005 / 1 – 5 Courtesy Esther Schipper, Berlin **Gordon, Douglas** → 1 – 4 Courtesy the artist and Lisson Gallery, London / 5 Courtesy Galerie Yvon Lambert, Paris / 6 Courtesy Gagosian Gallery, New York **Grotjahn, Mark** → 1 – 4 Courtesy the artist, Blum & Poe, Los Angeles / Anton Kern Gallery, New York / 5 + 6 Courtesy the artist and Blum & Poe, Los Angeles / 1 – 6 © Photos Joshua White **Gursky, Andreas** → © VG Bild-Kunst, Bonn 2005 / 1 – 3 Courtesy Monika Sprüth/Philomene Magers, Cologne/Munich / Portrait © Photo Kira Bunse **Hein, Jeppe** → 1 – 4 Courtesy Johann König, Berlin / 2 © Photos Ludger Paffrath / 3 © Photo Thorsten Arendt / 4 © Photo Anne Gold **Hernández, Jonathan** → 1 – 3 Courtesy the artist and kurimanzutto, Mexico City **Hernández-Diez, José Antonio** → 1 – 5 Courtesy Galeria Fortes Vilaça, São Paulo / 2 + 5 © Photos Eduardo Ortega / Portrait © Photo Bea Espejo **Hirschhorn, Thomas** → © VG Bild-Kunst, Bonn 2005 / 1 + 4 Courtesy Stephen Friedman Gallery, London / 2 Courtesy Barbara Gladstone Gallery, New York / 3 Courtesy Galerie Chantal Crousel, Paris / 5 Courtesy the artist **Hodges, Jim** → 4 Courtesy the artist, CRG Gallery, New York / Stephen Friedman Gallery, London **Höfer, Candida** → © VG Bild-Kunst, Bonn 2005 / 1 – 3 Courtesy the artist **Hume, Gary** → 1 – 4 Courtesy the artist and Matthew Marks Gallery, New York / 1 – 4 © Photos Stephen White **Huyghe, Pierre** → 1 – 5 Marian Goodman Gallery, New York/Paris / 1 © Photos Michael Vahrenwald / 3 + 4 © Photos KuB, Markus Tretter (Kunsthaus Bregenz) / 2 + 5 © Photos Aaron S. Davidson **Jacir, Emily** → 1 – 3 Courtesy Anthony Reynolds Gallery, London / Alexander and Bonin, New York **Kelley, Mike** → 1, 3 + 4 Courtesy Metro Pictures, New York / 2 Courtesy Patrick Painter, Los Angeles / Portrait © Photo Fredrik Nilsen **Khan, Hassan** → 1 – 6 Courtesy Galerie Chantal Crousel, Paris **Koons, Jeff** → 1 – 6 Courtesy the artist / Portrait © Photo Todd Eberle **Lambie, Jim** → 1 – 4 Courtesy the artist, The Modern Institute, Glasgow / Anton Kern Gallery, New York / Sadie Coles HQ, London / 1 © Photo A. Reich / 2 © Photo Richard Stoner / 3, 4 + Portrait © Photos Adrian Barry **Lamsfuß, Ulrich** → 1 – 4 + Portrait Courtesy Galerie Max Hetzler, Berlin **Leonard, Zoe** → 1 – 4 Courtesy the artist and Galerie Gisela Capitain, Cologne **Lim, Won Ju** → 1 Courtesy Patrick Painter Inc., Santa Monica / 2 + 3 Courtesy Galerie Max Hetzler, Berlin / 4 Courtesy the artist and Patrick Painter Inc., Santa Monica / Emily Tsingou Gallery, London / 5 Courtesy the artist and Patrick Painter Inc., Santa Monica / 1 © Photo Fredrik Nilsen **Lockhart, Sharon** → 1 – 3 Courtesy neugerriemschneider, Berlin **Lucas, Sarah** → 1 + 3 Courtesy the artist and Sadie Coles HQ, London / 2 Courtesy Contemporary Fine Arts, Berlin / Portrait © Photo Steff Rushton **Lutter, Vera** → © VG Bild-Kunst, Bonn 2005 / 1, 3 + 4 Courtesy Galerie Max Hetzler, Berlin/Gagosian Gallery, New York / 2 Courtesy Galerie Max Hetzler, Berlin / Portrait © Photo Jürgen Frank **Macchi, Jorge** → 1 – 4 Galeria Luisa Strina, São Paulo / 1 © Photo Gustavo Lowry / 2 + Portrait © Photos Jorge Macchi / 4 © Photo Francisca Lopez **Marepe** → 1 – 4 Galeria Luisa Strina, São Paulo / 1 © Photo Douglas Garcia / 2 + 4 © Photos

Ding Musa **McCarthy, Paul** → 1 – 5 Courtesy the artist and Hauser & Wirth Zurich/London / 2 © Photo Barbora Gerny / 4 © Photo Goswin Schwendinger **McKenzie, Lucy** → 1 – 3 Courtesy Galerie Daniel Buchholz, Cologne / 4 Courtesy Foksal Gallery Foundation **Meese, Jonathan** → 1 Courtesy Contemporary Fine Arts, Berlin / 2 Courtesy Schirn Kunsthalle Frankfurt, 2005 / 1 © Photo Jochen Littkemann / 2 © Photo Norbert Miguletz / Portrait © Photo Andrea Stappert **Mehretu, Julie** → 1 Courtesy carlier I gebauer, Berlin / 2 Courtesy carlier I gebauer, Berlin / Projectile Gallery, New York / 3 + 4 Courtesy Projectile Gallery, New York **Mik, Aernout** → 1 – 3 Courtesy carlier I gebauer, Berlin / 1 © Photo Mark Chandler and Martin Seck / 2 © Photo Stefan Maria Rother **Milhazes, Beatriz** → 1 Courtesy Galeria Fortes Vilaça, São Paulo/Galerie Max Hetzler, Berlin / 2 + 3 Courtesy Galeria Fortes Vilaça, São Paulo / 1 – 3 © Photos Fausto Fleury **Miyake, Shintaro** → 1 Courtesy Museum der Moderne – Rupertinum, Salzburg / 2 – 6 Courtesy c/o Atle Gerhardsen, Berlin/Tomio Koyama Gallery, Tokyo / 1 © Photo Axel Heil, fluid **Mori, Mariko** → 1 Courtesy Mariko Mori Studio, New York / 2 + 3 Courtesy Deitch Projects, New York / 1 © Photo Mori Kohda / 2 © Photo Richard Learoyd / 3 © Photo Tom Powel / Portrait © Photo David Sims **Morris, Sarah** → 1 – 3 Courtesy Jay Jopling/White Cube, London / 1 + 2 © Photos Stephen White **Mueck, Ron** → 1 + 2 Courtesy Anthony d'Offay, London / 3 Courtesy National Gallery of Australia, Canberra / 1 – 3 © Photos Mike Bruce / Portrait © Photo Gautier Deblonde **Muniz, Vik** → © VG Bild-Kunst, Bonn 2005 / 1 + 3 Courtesy Brent Sikkema, New York / 2 Courtesy Galeria Fortes Vilaça, São Paulo / Portrait © Photo Barney Kulok **Murakami, Takashi** → © Takashi Murakami/Kaikai Kiki Co., Ltd. / 1 Courtesy Marianne Boesky Gallery, New York / 2 Courtesy Galerie Emmanuel Perrotin, Paris **Nara, Yoshitomo** → 1 Courtesy Tomio Koyama Gallery, Tokyo / 2 Courtesy Tokyo Opera City Art Gallery, Tokyo / 1 © Photo Norihiro Ueno / 2 © Photo Keizo Kioku / Portrait © Photo Masako Nagano **Neshat, Shirin** → 1 – 4 Courtesy Barbara Gladstone Gallery, New York **Neto, Ernesto** → 1 Courtesy Galeria Fortes Vilaça, São Paulo/21st Century Museum of Contemporary Art, Kanazawa / 2 Courtesy Galeria Fortes Vilaça, São Paulo/Fundament Foundation – De Pont, Tilburg / 3 + 4 Courtesy Galeria Fortes Vilaça, São Paulo / Tanya Bonakdar Gallery, New York, and Museum Boijmans van Beuningen, Rotterdam / 1 © Photo Shigeo Anzai / 2 © Photo Peter Cox / 3 + 4 © Photo Bob Goedewdagen / Portrait © Photo Joana Traub Csekö **Nguyen-Hatsushiba, Jun** → 1 – 3 Courtesy the artist, Lehmann Maupin Gallery, New York/Mizuma Gallery, Tokyo / 2 © Photo Keizo Kioku **Nitsche, Frank** → 1 Courtesy Galerie Max Hetzler, Berlin / 2 Courtesy Galerie Nathalie Obadia, Paris / 3 Courtesy Galerie Gebrüder Lehmann, Dresden / 4 Courtesy Leo Koenig Inc., New York **Noble and Webster** → 1 – 4 Courtesy Stuart Shave I Modern Art, London / 1 – 4 © Photos Andy Keate **Odani, Motohiko** → 1 – 4 Courtesy Yamamoto Gendai, Tokyo / 2 – 4 © Photos Keizo Kioku **Oehlen, Albert** → 1 – 4 Courtesy Galerie Max Hetzler, Berlin **Ofili, Chris** → 1 + 2 Courtesy the artist – AFROCO and Victoria Miro Gallery, London / 1 © Photo Cameraphoto Arte / 2 © Photo Stephen White **Ohanian, Mélik** → 1 Courtesy Yvon Lambert Gallery, New York / Galerie Chantal Crousel, Paris / 2 + 3 Courtesy Galerie Chantal Crousel, Paris / 4 Courtesy Yvon Lambert Gallery, New York / Galerie Chantal Crousel, Paris/CCA Kitakyushu, Japan / 5 Courtesy Yvon Lambert Gallery, New York / 3 + 5 © Photos Mélik Ohanian / Portrait © Photo D. R. / Rajak Ohanian **Olesen, Henrik** → 1 – 3 Galerie Daniel Buchholz, Cologne / 2 © Photo Lothar Schnepf / 3 © Photo Matthias Herrmann **Olowska, Paulina** → 1 + 2 Courtesy Galerie Daniel Buchholz, Cologne / 1 © Photo John Berens **Orozco, Gabriel** → 1, 6 + 7 Courtesy Marian Goodman Gallery, New York / 2 – 5 Courtesy Galerie Chantal Crousel, Paris / 1 © Photo Marcus Leith and Andrew Dunkley, Tate Modern / 4 + Portrait © Photos Isadora Hastings **Ortega, Damián** → 1 – 4 Courtesy the artist and kurimanzutto, Mexico City / 1 + 2 © Photos Damián Ortega / 3 © Photo Marcus Leith and Andrew Dunkley, Tate Modern / 4 © Photo Marcus Leith and Andrew Dunkley, Tate Modern / 4 + Portrait © Photos Isadora Hastings **Pardo, Jorge** → 1 Courtesy Galerie Gisela Capitain, Cologne / Friedrich Petzel Gallery, New York / 2 – 4 Courtesy neugerriemschneider, Berlin / Portrait © Photo Pierre Even **Parreno, Philippe** → 1 – 4 Courtesy Air de Paris, Paris / Portrait © Drawing V. Barré **Peinado, Bruno** → 1 – 3 Courtesy Galerie Hervé Loevenbruck, Paris / Courtesy Galleria Continua, San Gimingnano/Beijing / Portrait © Photo Pierre Even **Pernice, Manfred** → 1 – 4 Courtesy Galerie Neu, Berlin / Anton Kern Gallery, New York **Perry, Grayson** → 1 – 4 Victoria Miro Gallery, London **Pettibon, Raymond** → 1 – 4 Courtesy Regen Projects, Los Angeles **Peyton, Elizabeth** → 1 + 4 Courtesy Gavin Brown's enterprise (modern), New York / 2 + 3 Courtesy neugerriemschneider, Berlin / Portrait © Photo Albrecht Fuchs **Philipps, Richard** → 1, 3 + 4 Courtesy Friedrich Petzel Gallery, New York / 2 Courtesy Galerie Max Hetzler, Berlin **Prince, Richard** → 1 – 3 Courtesy Barbara Gladstone Gallery, New York / Portrait © Photo Steven Rubin **Rauch, Neo** → © VG Bild-Kunst, Bonn 2005 / 1 – 4 Courtesy EIGEN + ART, Leipzig/Berlin / 1 – 4 © Photos Uwe Walter / Portrait © Photo Gregor Hohenberg **Rehberger, Tobias** → 1 + 4 Courtesy neugerriemschneider, Berlin / 2 + 3 Courtesy Galerie Bärbel Grässlin, Frankfurt am Main / 3 © Photo Wolfgang Günzel / Portrait © Photo Dieter Schwer **Reyes, Pedro** → 1 – 3 Courtesy Galeria Enrique Guerrero, Mexico City **Rhoades, Jason** → 1 – 3 Courtesy the artist and Hauser & Wirth, Zurich/London / 1 – 2 © Photos A. Burger **Richter, Daniel** → 1 + 2 Courtesy Contemporary Fine Arts, Berlin / 1 © Photo Jochen Littkemann / 2 © Photo Achim Kukulies / Portrait © Photo Albrecht Fuchs **de Rijke/de Rooij** → 1 + 2 Courtesy Galerie Daniel Buchholz, Cologne / 2 © Photos Thomas Manneke **Rist, Pipilotti** → 1 –5 Courtesy Hauser & Wirth, Zurich/London / 1 © Photo Andrea Rist / 2 © Photo Ian Reeves / 5 © Photo Anna Bedynska / Portrait © Photo Christian Scholz **Ritchie, Matthew** →1 – 3 Courtesy Andrea Rosen, New York / 4 Courtesy c/o Atle Gerhardsen, Berlin / 1 © Photo Hester + Hardaway / 3 © Photo Oren Slor / Portrait © Photo Nancy Palmieri **Rondinone, Ugo** → 1 – 4 Courtesy Galerie Eva Presenhuber, Zurich / Matthew Marks Gallery, New York **Ruff, Thomas** → © VG Bild-Kunst, Bonn 2005 / 1 – 3 Courtesy the artist and Johnen + Schöttle, Cologne/Berlin **Sachs, Tom** → 1 – 4 Courtesy the artist / 1 © Photo Van Neistat / 3 + 4 © Photos Tom Powel **Sala, Anri** → 1 – 3 Courtesy Johnen + Schöttle, Cologne/Berlin **Sasnal, Wilhelm** → 1 + 2 Courtesy Johnen + Schöttle, Cologne / 3 Courtesy Foksal Gallery Foundation, Warsaw / 4 Courtesy the artist Hauser & Wirth, Zürich/London / 4 © Photo A. Burger **Saville, Jenny** → 1 – 4 Courtesy Gagosian Gallery, New York / Portrait © Photo Reto Guntli **Scheibitz, Thomas** → © VG Bild-Kunst, Bonn 2005 / 1 – 3 Tanya Bonakdar Gallery, New York / Monika Sprüth/Philomene Magers, Cologne/Munich / Produzentengalerie, Hamburg / 1 + 2 © Photos Jens Ziehe / 3 © Photo Thomas Scheibitz / Portrait © Photo Lisa Junghanß **Schneider, Gregor** → © VG Bild-Kunst, Bonn 2005 / 1 Courtesy Barbara Gladstone Gallery, New York / 2 + 3 Courtesy Artangel, London **Schütte, Thomas** → © VG Bild-Kunst, Bonn 2005 / 1 – 3 Courtesy carlier I gebauer, Berlin / 2 + 3 © Photos Nic Tenwiggenhorn / Portrait © Photo Matthias Duschner/Essener Revue **Shaw, Raqib** → 1– 4 Courtesy the artist and Victoria Miro Gallery, London **Sherman, Cindy** → 1 – 4 Courtesy Metro Pictures, New York / 3 + 4 Courtesy Monika Sprüth/Philomene Magers, Cologne/Munich **Sierra, Santiago** → 1 + 2 Courtesy the artist and Galerie Peter Kilchmann, Zurich / 3 Courtesy the artist and Lisson Gallery, London **Starling, Simon** → 1 Courtesy neugerriemschneider, Berlin / The Modern Institute, Glasgow / 2 + 3 Courtesy neugerriemschneider, Berlin / Portrait © Photo Wolfgang Günzel **Struth, Thomas** → 1 – 4 Courtesy the artist **Sullivan, Catherine** → 1 – 4 Galerie Christian Nagel, Cologne **Tillmans, Wolfgang** → 1 – 3 Galerie Daniel Buchholz, Cologne **Tiravanija, Rirkrit** → 1 – 3 Courtesy neugerriemschneider, Berlin / Gavin Brown's enterprise (modern), New York **Tuymans, Luc** → 1 – 4 Courtesy Zeno X Gallery, Antwerp / 2 + 3 Courtesy carlier I gebauer, Berlin / 1 + 4 © Photos Felix Tirry / 2 + 3 © Photos Stefan Maria Rother **Vezzoli, Francesco** → 1 – 3 Courtesy Galleria Giò Marconi, Milan / Galleria Franco Noero, Turin / 2 © Photos Matthias Vriens **Walker, Kara** 1 + 2 Courtesy Brent Sikkema, New York **Wall, Jeff** → 1 – 3 Courtesy Johnen + Schöttle, Cologne / Rüdiger Schöttle, Munich **Weischer, Matthias** → © VG Bild-Kunst, Bonn 2005 / 1 – 4 Courtesy EIGEN + ART, Leipzig/Berlin / 1, 2 + 4 © Photos Uwe Walter / Portrait © Photo Gregor Hohenberg **West, Franz** → 1, 2 + 4 Courtesy Galerie Bärbel Grässlin, Frankfurt am Main / 3 Courtesy Galerie Gisela Capitain, Cologne / 1 © Photo Marco Fedele di Catrano / 2 © Photo Robert Rubak / 3 © Photo Lothar Schnepf / 4 © Photo Ben Johnson / Portrait © Photo Albrecht Fuchs **White, Pae** → 1 – 3 Courtesy neugerriemschneider, Berlin **Wohnseifer, Johannes** → 1 Courtesy Johann König, Berlin / 2 – 4 Courtesy Galerie Gisela Capitain, Cologne / 1 © Photo Ludger Paffrath **Wool, Christopher** → 1 – 3 Courtesy Luhring Augustine Gallery, New York / Galerie Gisela Capitain, Cologne **Wurm, Erwin** → © VG Bild-Kunst, Bonn 2005 / 1 – 4 Courtesy Galerie Aurel Scheibler, Cologne / 2 © Photo Francisco Soares

Biographical notes on the authors — Kurzbiografien der Autoren — Les auteurs en bref

J. A. – JENS ASTHOFF
Lives as an author, editor and translator in Hamburg. Writes articles and critiques on contemporary art for numerous catalogues and magazines such as "Kunst-Bulletin", "Kunstforum", "artforum.com", and "SITE", and has edited "BE-Magazin" at Künstlerhaus Bethanien, Berlin, since 1998.
Lebt als Autor, Redakteur und Übersetzer in Hamburg. Aufsätze und Kritiken zu zeitgenössischer Kunst in zahlreichen Katalogen und Zeitschriften, u. a. „Kunst-Bulletin", „Kunstforum", „artforum.com", „SITE"; seit 1998 Redakteur beim „BE-Magazin", Künstlerhaus Bethanien, Berlin.
Vit à Hambourg comme auteur, rédacteur et traducteur. Auteur de critiques et d'essais sur l'art contemporain dans de nombreux catalogues et revues, notamment « Kunst-Bulletin », « Kunstforum », « artforum.com », « SITE ». Depuis 1998, rédacteur au « BE-Magazin », Künstlerhaus Bethanien, Berlin.

K. B. – KIRSTY BELL
Studied Literature and History of Art in Cambridge, spent the 90s working in galleries in London and New York. Is based in Berlin working as a writer and curator and contributing regularly to "Frieze", "Camera Austria" and "Art Review", amongst others.
Studium der Literatur und Kunstgeschichte in Cambridge, arbeitete in den neunziger Jahren in Galerien in London und New York. Lebt als freie Autorin und Kuratorin in Berlin, regelmäßige Veröffentlichungen u. a. in „Frieze", „Camera Austria" und „Art Review".
Etudes de littérature et d'histoire de l'art à Cambridge ; a travaillé dans différentes galeries à Londres et à New York dans les années quatre-vingt-dix. Travaille comme auteure et commissaire d'expositions à Berlin. Contributions régulières notamment à « Frieze », « Camera Austria » et « Art Review ».

S. C. – STEPHANE CORREARD
Lives in Paris as a journalist and curator of exhibitions on design and contemporary art. Founded the gallery Météo in Paris in 1992, which he ran until 1998.
Lebt als Journalist und Kurator von Ausstellungen zum Thema Design und zeitgenössische Kunst in Paris. 1992 gründete er die Galerie Météo in Paris, die er bis 1998 leitete.
Vit à Paris comme journaliste et commissaire d'expositions de design et d'art contemporain. Fondateur, en 1992, de la Galerie Météo à Paris, qu'il a dirigée jusqu'en 1998.

C. E. – CAROLINE EGGEL
Studied Art History and Social History in Zurich and Berlin. Assisted in the studio of Olafur Eliasson. Lives as a critic and curator in Berlin, writing for "Kunst-Bulletin", "Neue Review" and "artforum", among other publications.
Studium der Kunstgeschichte und Sozialgeschichte in Zürich und Berlin. Mitarbeit im Atelier von Olafur Eliasson. Lebt als Kritikerin und Kuratorin in Berlin. Veröffentlichungen u. a. in „Kunst-Bulletin", „Neue Review" und „artforum".
Etudes d'histoire de l'art et d'histoire sociale à Zurich et à Berlin. Collaboratrice dans l'atelier d'Olafur Eliasson. Vit à Berlin comme critique d'art et commissaire d'expositions. Publications notamment dans « Kunst-Bulletin », « Neue Review » et « artforum ».

E. K. – EVA KERNBAUER
Studied art history in Vienna and Berlin. Worked in galleries in New York and Vienna, working thereafter as a curatorial assistant as well as a freelance critic and author. Currently a junior fellow at the International Research Centre for Cultural Sciences (IFK), Vienna.
Studium der Kunstgeschichte in Wien und Berlin. Tätigkeit in Galerien in New York und Wien. Danach kuratorische Assistentin sowie freie Kritikerin und Autorin. Zurzeit Junior Fellow am Internationalen Forschungszentrum Kulturwissenschaften, Wien.
Etudes d'histoire de l'art à Vienne et à Berlin. A travaillée pour des galeries à New York et Vienne, puis comme commissaire d'expositions associée, critique d'art et auteure indépendante. Actuellement, Junior Fellow au Internationales Forschungszentrum Kulturwissenschaften, Vienne.

A. M. – ASTRID MANIA
PhD in History of Art on "Komar & Melamid: 'Nostalgic Socialist Realism Series'". Lives as writer and free-lance curator for contemporary art in Berlin. Recently appointed guest tutor at the MA course in Curating Contemporary Art, Royal College of Art, London.
Promotion im Fach Kunstgeschichte über „Komar & Melamid: ‚Nostalgic Socialist Realism Series'". Lebt als freiberufliche Autorin und Kuratorin für zeitgenössische Kunst in Berlin, war 2004/05 Gasttutorin für den Studiengang Curating Contemporary Art, The Royal College of Art, London.

Doctorat d'histoire de l'art sur « Komar & Melamid: ‹ Nostalgic Socialist Realism Series › ». Vit à Berlin comme auteure et commissaire d'expositions d'art contemporain indépendante. Depuis peu, professeure invitée au cours Curating Contemporary Art du Royal College of Art à Londres.

D. M. – DANIEL MARZONA

Lives as freelance author and curator in Berlin and New York. The former associate curator of the P. S. 1 Contemporary Art Center in New York, he has written two books for TASCHEN's basic art series "Minimal Art" (2004), and "Conceptual Art" (2005).
Lebt als freier Autor und Kurator in Berlin und New York. Der frühere Associate Curator am P. S. 1 Contemporary Art Center in New York hat für TASCHEN in der Kleinen Reihe die Bücher „Minimal Art" (2004) und „Conceptual Art" (2005) geschrieben.
Vit à Berlin et New York comme auteur et commissaire d'expositions indépendant. L'ancien commissaire associé du P. S. 1 Contemporary Art Center à New York est l'auteur de deux volumes de la petite collection TASCHEN : « Minimal Art » (2004) et « Conceptual Art » (2005).

C. R. – CHRISTIANE REKADE

Studied Art History and German Literature in Basle, Dresden and Berlin, and has worked in galleries for many years. Lives as a critic and curator in Berlin and runs the archive of the estate of Michel Majerus. Writes for publications such as "Kunst-Bulletin" and "Neue Review", among others.
Studium der Kunstgeschichte und der deutschen Literatur in Basel, Dresden und Berlin. Mehrjährige Tätigkeit in Galerien. Lebt als Kritikerin und Kuratorin in Berlin und betreut das Archiv des Nachlasses von Michel Majerus. Veröffentlichungen u. a. in „Kunst-Bulletin", „Neue Review".
Etudes d'histoire de l'art et de littérature allemande à Bâle, Dresde et Berlin. Plusieurs années d'activité dans différentes galeries. Vit à Berlin comme critique d'art et commissaire d'expositions et responsable des archives de la succession Michel Majerus. Publications notamment dans « Kunst-Bulletin » et « Neue Review ».

B. S. – BRIAN SHOLIS

Writes for "Artforum", "Flash Art", and other magazines, and has written essays for the Whitney Museum of American Art, New York, The Hammer Museum, Los Angeles, and Moderna Museet, Stockholm. He lives in Brooklyn, New York.
Schreibt für „Artforum", „Flash Art" sowie andere Kunstzeitschriften und hat Essays in Katalogen des Whitney Museum of American Art, New York, des Hammer Museum, Los Angeles, und des Moderna Museet, Stockholm, veröffentlicht. Er lebt in Brooklyn, New York.
Ecrit pour « Artforum », « Flash Art » et nombreuses autres revues d'art. Auteur d'essais pour le Whitney Museum of American Art, New York, le Hammer Museum, Los Angeles, et le Moderna Museet, Stockholm. Vit à Brooklyn, New York.

A. S.-S. – AMY SMITH-STEWART

Curator at P. S. 1 Contemporary Art Center, New York. Selected solo exhibitions include Aleksandra Mir, Christian Holstad, Mika Rottenberg and Petra Lindholm. Most recently she co-curated "Katharina Sieverding: Close Up" and "Greater New York 2005".
Kuratorin am P. S. 1 Contemporary Art Center in New York. Sie organisierte u. a. Einzelausstellungen mit Aleksandra Mir, Christian Holstad, Mika Rottenberg und Petra Lindholm. Außerdem war sie Ko-Kuratorin von „Katharina Sieverding: Close Up" und „Greater New York 2005".
Commissaire d'expositions au P. S. 1 Contemporary Art Center, New York. A notamment organisé des expositions personnelles d'Aleksandra Mir, Christian Holstad, Mika Rottenberg et Petra Lindholm. Plus récemment, elle a été commissaire associée des expositions « Katharina Sieverding: Close Up » et « Greater New York 2005 ».

O. W. – OSSIAN WARD

Writer on contemporary art, contributing to publications such as "Art in America", "Art + Auction", "Art", "Frieze", and newspapers including "The Guardian", "The Times" and the "Independent". Formerly editor of "Art Review", he has just published "The Artist's Yearbook 2006", London 2005.
Autor für zeitgenössische Kunst, schreibt u. a. für Publikationen wie „Art in America", „Art + Auction", „Art", „Frieze", und Tageszeitungen wie „The Guardian", „The Times" und den „Independent". Der ehemalige Herausgeber der „Art Review" veröffentlichte „The Artist's Yearbook 2006", London 2005.
Critique d'art contemporain. A notamment collaboré à des publications comme « Art in America », « Art + Auction », « Art », « Frieze » et des quotidiens comme « The Guardian », « The Times » et « The Independent ». Ancien éditeur d'« Art Review », il a publié récemment « The Artist's Yearbook 2006 », Londres 2005.

Imprint — Impressum — Imprint

To stay informed about upcoming TASCHEN titles, please request our magazine at www.taschen.com/magazine or write to TASCHEN, Hohenzollernring 53, D–50672 Cologne, Germany, contact@taschen.com, Fax: +49-221-254919. We will be happy to send you a free copy of our magazine which is filled with information about all of our books.

© 2005 TASCHEN GmbH
Hohenzollernring 53, D–50672 Köln
www.taschen.com

Texts: Jens Asthoff, Kirsty Bell, Ariane Beyn, Stéphane Corréard, Caroline Eggel, Eva Kernbauer, Astrid Mania, Daniel Marzona, Christiane Rekade, Brian Sholis, Raimar Stange, Amy Smith-Stewart, Ossian Ward

English translation: Sean Gallagher, Berlin
German translation: Ralf Schauff, Cologne; Gisela Rueb, Paris (p. 104, 220, 228, 276, 328, 444, 552)
French translation: Wolf Fruhtrunk, Paris

Copy-editing: Sabine Bleßmann, Cologne
Coordination: Viktoria Hausmann, Cologne
Design: Sense/Net, Andy Disl and Birgit Reber, Cologne
Production: Ute Wachendorf, Cologne

Printed in Italy
ISBN 3-8228-3996-5

Practical guide — Serviceteil — Guide pratique

The artists featured in this book exist in the context of the contemporary art market. As this market is very active, the position of an artist may shift quickly for very different reasons. In this section of the book we provide an overview of their place in this market. You will find details of:

— **Art Galleries (artists' representatives)**
— **Primary Market Prices (if available)**
— **The Five Best Auction Results (where applicable)**

Except where exclusive representation has been agreed, most artists will be represented simultaneously by different galleries, each dealing with sales and marketing within its region.

If available, the primary market prices listed for each artist appear in varying degrees of detail, as dictated by each gallery. These prices relate only to new works by the artist and are referred to as the "Primary Market". Primary market prices may shift after an artist takes part in an important international art event such as the Venice Biennial or documenta, and also as the result of a prize, a sale to an important collection, or a particular good or poor result at an auction. Furthermore, the combination of two or more of these factors can change the artist's prices dramatically in short period of time. Therefore, the prices presented here should be considered as a guide only.

The five best auction results provided by **artprice.com** are listed for those artists who have already reached the "secondary market" of the auction houses. Results may vary depending on the position of the artist in the contemporary art market. The prices achieved by emerging artists may not be so representative of the artist's real value as they are with older generations. But as time goes by, and both the sales and the reputation of a particular artist become stronger, the auction results for old and new works by the same artist may change. These auction results can sometimes reach extraordinary levels, much higher than achieved in the primary market for a charismatic work by an artist. **The auctioneer's prices stated are hammer prices. Depending on the auctioneer and the hammer price for the individual artwork, an additional surcharge amounting to an average of 10%–15% (staggered according to the price of the artwork) is also due. As a rule, the national taxes are then added to this sum.**

Owing to their internal policies not all galleries wished to provide their price ranges; sometimes a gallery would do so for one artist, but not for another. We thank them for their collaboration, while apologizing for any shortcomings.

Finally, we very much urge anybody interested to contact the listed galleries directly for further information. The aim of this part of the book is to encourage the spirit of a new collector who wants to start the adventure of creating an art collection.

Christian Domínguez

Die Künstler, die in diesem Buch vorgestellt werden, sind auch auf dem Markt für zeitgenössische Kunst präsent. Da dieser Markt sehr aktiv ist, kann die Stellung eines Künstlers sich aus unterschiedlichen Gründen sehr schnell verändern. In diesem Abschnitt des Buches geben wir einen Überblick über die Position des Künstlers in diesem Markt. Sie werden im Einzelnen Informationen finden über:

— **Galerien (Repräsentanten der Künstler)**
— **Verkaufspreise der Galerien (soweit bekannt)**
— **die fünf besten Auktionsergebnisse (sofern verfügbar)**

Falls nicht eine exklusive Vertretung vereinbart wurde, werden die meisten Künstler von mehreren Galerien gleichzeitig repräsentiert, die sich alle mit Verkauf und Marketing in ihrer jeweiligen Region befassen.

Falls verfügbar, wurden die Direktverkaufspreise so aufgelistet, wie sie von den einzelnen Galerien genannt wurden, und sind deshalb unterschiedlich detailliert. Diese Preise beziehen sich nur auf neue Werke des Künstlers und werden als „Primary Market Prices" bezeichnet. Diese Preise können sich ändern, nachdem der Künstler an einem bedeutenden internationalen Kunstereignis wie der Biennale in Venedig oder der documenta teilgenommen hat oder nach einer Auszeichnung mit einem Kunstpreis, dem Verkauf an eine wichtige Sammlung oder einem besonders guten oder schlechten Ergebnis bei einer Auktion.

Außerdem kann das Zusammentreffen zweier oder mehrerer dieser Faktoren die Preise eines Künstlers in kurzer Zeit grundlegend verändern. Daher sollten die hier angegebenen Preise nur als Richtwerte betrachtet werden.

Die fünf besten Auktionsergebnisse, die von **artprice.com** veröffentlicht werden, sind für diejenigen Künstler aufgeführt, die bereits den „Secondary Market" (Wiederverkaufsmarkt) der Auktionshäuser erreicht haben. Die Auktionserlöse können je nach Position des Künstlers im gegenwärtigen Kunstmarkt schwanken. Die Preise, die von jungen Künstlern erzielt werden, spiegeln unter Umständen nicht in dem Maß den wahren Wert der Kunstwerke wider, wie es bei Künstlern der älteren Generationen der Fall ist. Aber im Lauf der Zeit, wenn sich die Künstler etablieren und die Preise steigen, können sich auch die Auktionserlöse für alte und neue Arbeiten desselben Künstlers verändern. Diese Auktionsergebnisse können manchmal außergewöhnlich hoch ausfallen, viel höher als die Preise, die im Verkauf in einer Galerie für ein charismatisches Werk eines Künstlers erzielt werden. **Die angegebenen Auktionspreise sind Zuschlagpreise. Je nach Auktionshaus und Zuschlagpreis für das jeweilige Kunstwerk wird zusätzlich ein Aufgeld von durchschnittlich 10 bis 15 Prozent (gestaffelt nach Preis des Kunstwerks) erhoben. Zu dieser Summe werden in der Regel die inländischen Steuern noch hinzugerechnet.**

Entsprechend ihren Geschäftsgepflogenheiten wollten nicht alle Galerien ihre Preise bekannt geben, manchmal hat eine Galerie die Preise für die Werke eines Künstlers zur Verfügung gestellt, für einen anderen aber nicht. Wir danken ihnen für ihre Zusammenarbeit und entschuldigen uns zugleich für alle Unzulänglichkeiten.

Schließlich möchten wir jedem Interessierten raten, die aufgeführten Galerien direkt anzusprechen und um weitere Informationen zu bitten. Das Ziel dieses Teils des Buches ist es, den neuen Sammler zu ermutigen, der sich in das Abenteuer stürzen möchte, eine Kunstsammlung zu beginnen.

Christian Domínguez

Les artistes qui figurent dans ce livre sont également présents dans le contexte du marché de l'art contemporain. Ce marché étant très actif, leur position peut changer rapidement pour les raisons les plus diverses. Dans la section qui suit, nous donnons un aperçu de la place qu'ils occupent sur ce marché. Vous y trouverez des détails sur :

— **Les galeries d'art (représentants des artistes)**
— **Les prix sur le premier marché (si disponibles)**
— **Les cinq meilleurs résultats obtenus en maisons de ventes (s'il y a lieu)**

Hormis les cas d'exclusivité, la plupart des artistes sont représentés par plusieurs galeries à la fois, chacune traitant les ventes et le marché dans sa région.

Lorsqu'ils sont disponibles, les prix des artistes sur le premier marché sont détaillés avec une précision qui varie selon les recommandations des galeries concernées. Ces prix se réfèrent uniquement aux œuvres récentes et c'est à eux que renvoie le terme « premier marché ». Les prix du premier marché sont susceptibles d'évoluer avec la participation d'un artiste à un grand événement international – par exemple la Biennale de Venise ou la documenta –, suite à l'obtention d'un prix artistique, après une vente à une grande collection ou en fonction d'un résultat obtenu lors d'une vente aux enchères, sachant que le cumul de deux ou plusieurs de ces facteurs peut influer fortement sur la cote d'un artiste dans un laps de temps très court. Les prix indiqués dans ce livre ne sont donc destinés qu'à donner des ordres de grandeur et à servir de ligne directrice.

Les cinq meilleurs résultats donnés par **artprice.com** sont mentionnés pour les artistes qui sont déjà arrivés sur le « second marché » des maisons de ventes. Ces résultats varient selon la position de l'artiste sur le marché de l'art contemporain. Les prix atteints par un artiste émergent ne reflètent pas nécessairement sa cote réelle aussi fidèlement que dans le cas d'artistes appartenant à une précédente génération. Au fil du temps, avec l'augmentation de ses ventes et de sa notoriété, les résultats obtenus par les œuvres anciennes ou récentes d'un même artiste peuvent évoluer. Lorsqu'il s'agit d'œuvres particulièrement charismatiques, les résultats obtenus en maisons de ventes atteignent parfois des niveaux extraordinaires se situant très au-dessus de ceux pratiqués sur le premier marché. **Les prix des maisons de ventes renvoient au prix d'adjudication. Selon le commissaire-priseur et le montant de l'adjudication, un surcoût oscillant généralement entre 10 et 15% est également perçu (échelonné en fonction du prix de l'œuvre). La règle vaut que les taxes dues au titre des impôts intérieurs viennent ensuite s'ajouter à cette somme.**

Pour des raisons inhérentes à leur politique interne, certaines galeries n'ont pas souhaité fournir leurs listes de prix. D'autres les ont fournies pour tel artiste, mais pas pour tel autre. Nous leur adressons tous nos remerciements pour leur collaboration et les prions d'excuser par avance toute erreur qui aurait pu se glisser dans nos informations.

Pour toute information complémentaire, nous invitons vivement toutes les personnes intéressées à s'adresser directement aux galeries citées. Le but de cette section est de fortifier le courage du nouveau collectionneur qui veut se lancer dans l'aventure de créer une collection d'art.

Christian Domínguez

FRANZ ACKERMANN

REPRESENTATION →
neugerriemschneider
Linienstraße 155
D – 10115 Berlin
Tel: +49 (0)30 2 88 77 277
Fax: +49 (0)30 2 88 77 278
www.neugerriemschneider.com

Gavin Brown's enterprise
620 Greenwich Street
US – New York, NY 10014
Tel: +1 212 62 75 258
Fax: +1 212 62 75 261
www.gavinbrown.biz

Meyer Riegger Galerie
Klauprechtstraße 22
D – 76137 Karlsruhe
Tel: +49 (0)721 82 12 92
Fax: +49 (0)721 98 22 141
www.meyer-riegger.de

PRIMARY MARKET PRICES →
$6.000 – $150.000 (installations)

AUCTION SALES →
Price: $241.696
Untitled (Evasion VI), 1996
Oil/canvas, 195 x 210 cm
Date sold: 10-Feb-05
Auction house: Sotheby's,
London

Price: $180.095
Untitled (Mental Map: Evasion III),
1996
Oil/canvas, 280 x 285 cm
Date sold: 04-Feb-04
Auction house: Christie's, London

Price: $170.000
Zooropa, 2001
Oil/canvas, 200 x 250 cm
Date sold: 11-Nov-04
Auction house:
Christie's, New York

Franz Ackermann, Evasion VI, 1996

Price: $60.000
White Man Staying, White Man
Coming, White Man Leaving,
2000, Wall painting,
two mixed media drawings
Date sold: 11-Nov-04
Auction house: Phillips, de Pury
& Company, New York

Price: $42.320
Untitled (Mental Map:
Evasion I), 1996
Oil/canvas, 280 x 290 cm
Date sold: 08-Dec-99
Auction house: Christie's, London

EIJA-LIISA AHTILA

REPRESENTATION →
Klemens Gasser &
Tanja Grunert, Inc.
524 West 19th Street
US – 10011 New York, NY
Tel: +1 212 80 79 494
Fax: +1 212 80 76 594
www.gassergrunert.net

Galerie Roger Pailhas
20, quai de Rive Neuve
F – 13007 Marseille
Tel: +33 (0)4 9 15 40 222
Fax: +33 (0)4 9 15 56 688
www.rogerpailhas.com

Anthony Reynolds Gallery
60 Great Marlborough
Street / GB – London W1F 7BG
Tel: +44 (0)20 7 43 92 201
Fax: +44 (0)20 7 43 91 869
www.anthonyreynolds.com

PRIMARY MARKET PRICES →
$7.000 – $20.000 (photographs)
$120.000 – $240.000
(film/video installations)
$60.000 (sculpture)

DOUG AITKEN

REPRESENTATION →
303 Gallery
525 West 22nd Street
US – New York, NY 10011
Tel: +1 212 25 51 121
Fax. +1 212 25 50 024
www.303gallery.com

Victoria Miro Gallery
16 Wharf Road
GB – London N1 7RW
Tel: +44 (0)20 7 33 68 109
Fax: +44 (0)20 7 25 15 596
www.victoria-miro.com

Galerie Eva Presenhuber
Limmatstraße 270
CH – 8031 Zürich
Tel: +41 (0)43 44 47 050
Fax: +41 (0)43 44 47 060
www.presenhuber.com

PRIMARY MARKET PRICES →
Not available

AUCTION SALES →
Price: $95.000
Electric Earth, 1999
Film

Date sold: 13-May-04
Auction house: Phillips,
de Pury & Company, New York

Price: $45.000
Turbulence, triptych, 1999
C-print, 85.1 x 108.6 cm
Date sold: 08-Nov-04
Auction house: Phillips, de Pury
& Company, New York

Price: $37.500
2 Second Separation, 2000
C-print, 48.2 x 237.2 cm
Date sold: 13-Nov-03
Auction house:
Sotheby's, New York

Doug Aitken, Electric Earth, 1999

Price: $30.000
The Mirror #1 – 11, 1998
Eleven C-prints, 50.6 x 63.3 cm each
Date sold: 12-Nov-03
Auction house: Christie's, New York

Price: $22.000
Passenger, 1999
C-print, 99.1 x 123.8 cm
Date sold: 14-Nov-02
Auction house:
Christie's, New York

DARREN ALMOND

REPRESENTATION →
Galerie Max Hetzler
Zimmerstraße 90/91
D – 10117 Berlin
Tel: +49 (0)30 22 92 437
Fax: +49 (0)30 22 92 417
www.maxhetzler.com

Matthew Marks Gallery
523 West 24th Street
US – New York, NY 10011
Tel: +1 212 24 30 200
Fax: +1 212 24 30 047
www.matthewmarks.com

White Cube
48 Hoxton Square
GB – London N1 6PB
Tel: +44 (0)20 7 93 05 373
Fax.: +44 (0)20 7 74 97 480
www.whitecube.com

PRIMARY MARKET PRICES →
$15.000 – $20.000
(photographs and drawings)

$70.000 – $150.000
(films and video installations)
$200.000 – $250.000
(large sculptures)

AUCTION SALES →
Price: $25.000
Diary
Sculpture, 28.5 x 77.5 x 30 cm
Date sold: 16-May-02
Auction house: Sotheby's,
New York

Price: $17.000
Alfred, 1999
Aluminium, 114.5 x 22.3 x 1.2 cm
Date sold: 13-Nov-03
Auction house:
Sotheby's, New York

Price: $13.000
Alfred, 1997
Metal, 115 x 22 cm
Date sold: 16-May-02
Auction house:
Sotheby's, New York

Price: $12.204
Thames to Hudson, 2000
C-print, 76.5 x 76.5 cm
Date sold: 27-Jun-02
Auction house: Sotheby's, London

Darren Almond, Thames to Hudson,
2000

Price: $9.000
Fullmoon Aronine, 2001
Colour photography, 128 x 128 cm
Date sold: 16-May-02
Auction house:
Sotheby's, New York

FRANCIS ALŸS

REPRESENTATION →
Galerie Peter Kilchmann
Limmatstraße 270
CH – 8005 Zürich
Tel: +41 (0)1 44 03 931
Fax: +41 (0)1 44 03 932
www.kilchmanngalerie.com

Lisson Gallery
52–54 Bell Street
GB – London NW1 5DA
Tel: +44 (0)20 7 72 42 739

Fax. +44 (0)20 7 72 47 124
www.lisson.co.uk

Yvon Lambert
108, rue vieille du Temple
F – 75003 Paris
Tel: +33 (0)1 4 27 10 933
Fax: +33 (0)1 4 27 18 747
www.yvon-lambert.com

David Zwirner
525 West 19th Street
US – New York, NY 10011
Tel: +1 212 72 72 070
Fax: +1 212 72 72 072
www.davidzwirner.com

Francis Alÿs, Untitled (Man with
Shoe on the Head), Detail, 1995

PRIMARY MARKET PRICES →
ca. $20.000 (drawing)
ca. $40.000 (painting)
ca. $130.000 (installation)

AUCTION SALES →
Price: $160.000
Untitled
Oil/canvas/panel
Date sold: 12-Nov-03
Auction house:
Christie's, New York

Price: $140.000
Hands on White, ca. 1994
Oil/wood
Date sold: 13-Nov-03
Auction house:
Sotheby's, New York

Price: $109.164
Untitled, 1993–94
Oil/canvas
Date sold: 23-Jun-04
Auction house:
Sotheby's, London

Price: $100.000
Head and Foot, 1995
Painting
Date sold: 10-Nov-04
Auction house:
Sotheby's, New York

Price: $70.000
Untitled (Man with Shoe on the

Head/Woman with Shoe
on the Head), 1995
Mixed media, 20.3 x 17.8 cm
and 111.8 x 91.5 cm
Date sold: 12-May-04
Auction house:
Christie's, New York

GHADA AMER

REPRESENTATION →
Gagosian Gallery
555 West 24th Street
US – New York, NY 10011
Tel: +1 212 74 11 111
Fax: +1 212 74 19 611
www.gagosian.com

PRIMARY MARKET PRICES →
Not available

AUCTION SALES →
Price: $96.455
Pink, 2001
Mixed media, 122 x 127 cm
Date sold: 09-Feb-05
Auction house: Christie's,
London

Price: $60.000
Untitled, 2000
Tapestry, 45.7 x 50.8 cm
Date sold: 13-May-05
Auction house:
Phillips, de Pury & Company,
New York

Price: $38.941
Untitled, 1994
Mixed media, 180 x 150 cm
Date sold: 09-Dec-03
Auction house: Artcurial (S. V. V.),
Paris

Price: $36.707
Untitled, 1993
Mixed media, 180 x 150 cm
Date sold: 04-Jun-02
Auction house:
Artcurial (S. V. V.), Paris

Ghada Amer, Pink, 2001

Price: $35.000
Blanc, noir Maureen, 2000
Acrylic, 172.5 x 162.5 cm
Date sold: 12-Nov-01
Auction house:

Phillips, de Pury & Luxembourg,
New York

PRIMARY MARKET PRICES →
Not available

ASSUME VIVID ASTRO FOCUS

REPRESENTATION →
John Connelly Presents
526 West 26th Street
Suite 1003
US – New York, NY 10001
Tel: +1 212 33 79 563
Fax: +1 212 33 79 613
www.johnconnellypresents.com

Peres Projects
969 Chung King Road
US – Los Angeles, CA 90012
Tel: +1 213 61 71 100
Fax: +1 213 61 71 141
www.peresprojects.com

PRIMARY MARKET PRICES →
$1.000 – $3.000 (prints)
$1.500 – $8.000 (drawings)
$3.500 – $5.000 (video)
$2.500 (decals)
$15.000 – $45.000
(wallpapers and sculptures)

KUTLUG ATAMAN

REPRESENTATION →
Lehmann Maupin
540 West 26th Street
US – New York, NY 10001
Tel: +1 212 25 52 923
Fax: +1 212 25 52 924
www.lehmannmaupin.com

Rhona Hoffman Gallery
118 N. Peoria Street
US – Chicago, IL 60607
Tel: +1 312 455 1 990
Fax: +1 312 45 51 727

PRIMARY MARKET PRICES →
Not available

THE ATLAS GROUP

REPRESENTATION →
Anthony Reynolds Gallery
60 Great Marlborough
Street / GB – London W1F 7BG
Tel: +44 (0)20 7 43 92 201
Fax: +44 (0)20 7 43 91 869
www.anthonyreynolds.com

Galerie Sfeir-Semler
Admiralitätstraße 71
D – 20459 Hamburg
Tel: +49 (0)40 3 75 19 940
Fax: +49 (0)40 3 75 19 637
www.sfeir-semler.de

MATTHEW BARNEY

REPRESENTATION →
Barbara Gladstone Gallery
515 West 24th Street
US – New York, NY 10011
Tel: +1 212 20 69 300
Fax: +1 212 20 69 301
www.gladstonegallery.com

Regen Projects
633 North Almont Drive
US – Los Angeles, CA 90069
Tel: +1 310 27 65 424
Fax: +1 310 27 67 430
www.regenprojects.com

PRIMARY MARKET PRICES →
Not available

AUCTION SALES →
Price: $350.000
Cremaster 5:
A Dance for the Queen's
Menagerie, 1997
C-print, 137.2 x 110.5 cm
Date sold: 09-Nov-04
Auction house:
Sotheby's, New York

Price: $350.000
Cremaster 4, 1994–95
Construction, 120 x 120 x 90 cm
Date sold: 19-May-99
Auction house:
Christie's, New York

Price: $310.000
Transexualis, 1991
Installation
365.8 x 426.7 x 259.1 cm
Date sold: 06-May-97
Auction house:
Sotheby's, New York

Price: $230.000
Cremaster 5: Her Giant, 1997
C-print, 134 x 108.3 cm
Date sold: 08-Nov-04
Auction house:
Phillips, de Pury & Company,
New York

Price: $230.000
Cremaster 5: Elvàlàs, 1997
Gelatin silver print
Date sold: 13-Nov-03
Auction house: Phillips, de Pury
& Luxembourg, New York

VANESSA BEECROFT

REPRESENTATION →
Gagosian Gallery
555 West 24th Street
US – New York, NY 10011
Tel: +1 212 74 11 111
Fax: +1 212 74 19 611
www.gagosian.com

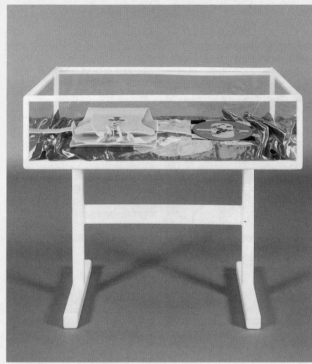

Matthew Barney, Cremaster 4, 1994–95

PRIMARY MARKET PRICES →
Not available

AUCTION SALES →
Price: $80.000
VB 34 Royal Opening, Moderna
Museet, Stockholm, 1998
Colour photography
Date sold: 18-May-00
Auction house:
Sotheby's, New York

Price: $43.056
VB 34 Royal Opening, Moderna
Museet, Stockholm, 1998
4 colour photographies
Date sold: 06-Feb-02
Auction house:
Christie's, London

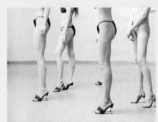

Vanessa Beecroft, Show
(Performance Solomon R.
Guggenheim Museum, New York),
1998

Price: $40.000
VB 39, US Navy SEALS,
Museum of Contemporary Art,
San Diego, 1999

C-print, 244 x 305 cm
Date sold: 16-May-02
Auction house:
Sotheby's, New York

Price: $38.851
Show (Performance Solomon R.
Guggenheim Museum, New York),
1998
Photograph, 108 x 138 cm
Date sold: 28-Jun-00
Auction house: Christie's, London

Price: $35.000
VB 39, US Navy SEALS,
Museum of Contemporary Art,
San Diego, 1999
C-print, 101.6 x 152.4 cm
Date sold: 13-Nov-03
Auction house:
Sotheby's, New York

JOHN BOCK

REPRESENTATION →
Klosterfelde
Zimmerstraße 90/91
D – 10117 Berlin
Tel: +49 (0)30 28 35 305
Fax: +49 (0)30 28 35 306
www.klosterfelde.de

Anton Kern Gallery
532 West 20th Street
US – New York, NY 10011
Tel: +1 212 36 79 663
Fax: +1 212 36 78 135
www.antonkerngallery.com

PRIMARY MARKET PRICES →
Not available

AUCTION SALES →
Price: $70.000
Untitled, 2000
Photograph
Date sold: 12-May-05
Auction house: Phillips,
de Pury & Company, New York

Price: $24.000
Gribbohm II Sir, Mumsir, 2002
Installation, 60 x 110 x 60 cm
Date sold: 12-Nov-04
Auction house: Phillips,
de Pury & Company, New York

Price: $8.952
Heu in der Kadernwelle:
Jerry Hall's Kunstwohlfahrts-
gebirgsgondel, 1998
Assemblage, 220 x 250 x 125 cm
Date sold: 08-Dec-99
Auction house: Christie's, London

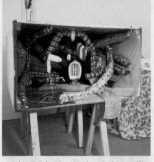

John Bock, Heu in der Kadernwelle:
Jerry Hall's Kunstwohlfahrtsgebirgs-
gondel, 1998

Price: $6.500
Untitled, 1999 – 2000
4 mixed media drawings
28.2 x 25.1 cm
Date sold: 15-Mar-05
Auction house:
Christie's, New York

Price: $6.000
Screaming Man, 2001
Construction, 27 x 33.3 x 27.9 cm
Date sold: 12-Nov-04
Auction house: Phillips,
de Pury & Company, New York

COSIMA VON BONIN

REPRESENTATION →
Galerie Christian Nagel
Richard-Wagner-Straße 28
D – 50674 Cologne
Tel: +44 (0)221 25 70 591
Fax: +49 (0)221 25 70 592
www.galerie-nagel.de

Friedrich Petzel Gallery
535 West 22nd Street
US – New York, NY 10011
Tel: +1 212 68 09 467
Fax: +1 212 68 09 473
www.petzel.com

PRIMARY MARKET PRICES →
$1.250 – $68.750 (paintings)
$312.500 (large installation)

AUCTION SALES →
Price: $4.500
Untitled
Sculpture, 50.5 x 60 x 19.4 cm
Date sold: 13-Dec-04
Auction house:
Phillips, de Pury & Company,
New York

MONICA BONVICINI

REPRESENTATION →
Mehdi Chouakri
Holzmarktstraße 15–18
D – 10179 Berlin
Tel: +49 (0)30 2 83 91 153
Fax: +49 (0)30 2 83 91 154
www.mehdi-chouakri.com

Galleria Emi Fontana
Viale Bligny 42
I – 20136 Milan
Tel: +39 (0)2 5 83 22 237
Fax: +39 (0)2 5 83 06 855

PRIMARY MARKET PRICES →
$3.750 – $31.250
(drawings and collages)
$6.250 – $212.500 (photographs,
sculptures, and installations)

CANDICE BREITZ

REPRESENTATION →
Galleria Francesca Kaufmann
Via dell'Orso 16
I – 20121 Milan
Tel: +39 (0)2 7 20 94 331
Fax: +39 (0)2 7 20 96 873

Sonnabend Gallery
536 West, 22nd Street
US – New York, NY 10011
Tel: +1 212 62 71 018
Fax: +1 212 62 70 489
www.artnet.com/sonnabend.html

White Cube
48 Hoxton Square
GB – London N1 6PB
Tel: +44 (0)20 7 93 05 373
Fax.: +44 (0)20 7 74 97 480
www.whitecube.com

PRIMARY MARKET PRICES →
$5.000 – $12.000 (photographs)
$15.000 – $120.000
(video installations)

AUCTION SALES →
Price: $2.800
Rainbow Series #11, 1996
C-print, 152.4 x 101.6 cm
Date sold: 13-Dec-04
Auction House: Phillips, de Pury
& Company, New York

Price: $2.600
Rainbow Series #1, 1996
C-print, 152.5 x 101.6 cm
Date sold: 10-Jun-04
Auction house: Phillips, de Pury
& Company, New York

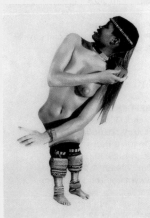

Candice Breitz, Rainbow Series #10,
1996

Price: $2.600
Rainbow Series #7, 1996
C-print, 152.4 x 101.6 cm
Date sold: 10-Jun-04
Auction house: Phillips, de Pury
& Company, New York

Price: $2.000
Rainbow Series #10, 1996
C-print, 142.2 x 101 cm
Date sold: 13-Dec-04
Auction house:
Phillips, de Pury & Company,
New York

CECILY BROWN

REPRESENTATION →
Gagosian Gallery
555 West 24th Street
US – New York, NY 10011
Tel: +1 212 74 11 111
Fax: +1 212 74 19 611
www.gagosian.com

Contemporary Fine Arts
Sophienstraße 21
D – 10178 Berlin
Tel: +49 (0)30 28 87 870
Fax: +49 (0)30 2 88 78 726
www.cfa-berlin.com

PRIMARY MARKET PRICES →
Not available

AUCTION SALES →
Price: $95.000
Untitled, 1997
Oil/canvas, 122 x 152.5 cm
Date sold: 18-May-01
Auction house: Christie's, New York

Price: $80.000
Seven Brides for
Seven Brothers, 1997–98
Oil/canvas, 193 x 248.9 cm
Date sold: 15-May-02
Auction house:
Sotheby's, New York

Price: $75.000
Twenty Million Sweethearts,
1998–99
Oil/canvas, 193 x 249 cm
Date sold: 14-Nov-00
Auction house:
Sotheby's, New York

Price: $75.000
Kiss Me Stupid, 1999
Oil/canvas, 152.5 x 190.5 cm
Date sold: 17-Nov-00
Auction house:
Christie's, New York

Price: $72.500
Untitled (Boy Trouble), 1999
Oil/canvas, 190.5 x 190.5 cm
Date sold: 13-May-04
Auction house:
Sotheby's, New York

Cecily Brown, Untitled, 1997

GLENN BROWN

REPRESENTATION →
Galerie Max Hetzler
Zimmerstraße 90/91
D – 10117 Berlin
Tel: +49 (0)30 22 92 437
Fax: +49 (0)30 22 92 417
www.maxhetzler.com

Gagosian Gallery
555 West 24th Street
US – New York, NY 10011
Tel: +1 212 74 11 111
Fax: +1 212 74 19 611
www.gagosian.com

Patrick Painter Inc.
2525 Michigan Ave B2
US – Santa Monica, CA 90404
Tel: +1 310 26 45 988

Fax: +1 310 26 45 998
www.patrickpainter.com

PRIMARY MARKET PRICES →
$150.000 – $300.000 (sculptures)
$200.000 – $400.000 (paintings)

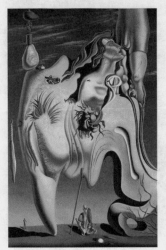

Glenn Brown, You Take my Place in
This Showdown, 1996

AUCTION SALES →
Price: $316.064
Beatification, 1999
Oil/board, 59 x 56 cm
Date sold: 10-Feb-05
Auction house: Sotheby's, London

Price: $300.000
You Take my Place in This
Showdown, 1996
Oil/canvas, 322 x 215 cm
Date sold: 10-May-05
Auction house:
Sotheby's, New York

Price: $40.185
Ornamental Despair
(Painting for Ian Curtis), 1994
Oil/canvas, 201 x 300 cm
Date sold: 06-Feb-02
Auction house: Christie's, London

Price: $28.870
Exercise One (for Ian Curtis)
after Chris Foss, 1995
Oil/canvas/board, 50 x 70 cm
Date sold: 09-Feb-01
Auction house: Christie's, London

Price: $28.391
You Take my Place in This
Showdown, 1996
Oil/canvas, 296.5 x 214.5 cm
Date sold: 28-Jun-00
Auction house: Christie's, London

TANIA BRUGUERA

REPRESENTATION →
Rhona Hoffman Gallery

118 N. Peoria Street
US – Chicago, IL 60607
Tel: +1 312 45 51 990
Fax: +1 312 45 51 727

PRIMARY MARKET PRICES →
$2.000 (video)
$3.000 (print)
$3.500 – $10.000 (drawings)
$75.000 (installation)
$25.000 – $40.000
(rights to reproduce or re-enact
a performance)

ANDRÉ BUTZER

REPRESENTATION →
Galerie Guido W. Baudach
Oudenarder Straße 16–20
D – 13347 Berlin
Tel: +49 (0)30 2 80 47 727
www.guidowbaudach.com

Galerie Max Hetzler
Zimmerstraße 90/91
D – 10117 Berlin
Tel: +49 (0)30 22 92 437
Fax: +49 (0)30 22 92 417
www.maxhetzler.com

Galerie Hammelehle und Ahrens
An der Schanz 1a
D – 50735 Cologne
Tel: +49 (0)221 28 70 800
Fax: +49 (0)221 28 70 801
www.haah.de

PRIMARY MARKET PRICES →
$1.500 – $5.000 (drawings)
$10.000 – $20.000 (paintings)

MIGUEL CALDERÓN

REPRESENTATION →
Andrea Rosen Gallery
525 West 24th Street
US – New York, NY 10011
Tel: +1 212 62 76 000
Fax: +1 212 62 75 450
www.andrearosengallery.com

kurimanzutto
Mazatlán 5 depto. t-6
col condesa
MEX – 06140 Mexico City
Tel: +52 55 5 28 63 059
Fax: +52 55 5 25 62 408
www.kurimanzutto.com

PRIMARY MARKET PRICES →
Not available

MERLIN CARPENTER

REPRESENTATION →
Galerie Christian Nagel
Richard-Wagner-Straße 28
D – 50674 Cologne

Tel: +44 (0)221 25 70 591
Fax: +49 (0)221 25 70 592
www.galerie-nagel.de

PRIMARY MARKET PRICES →
$1.875 (work on paper)
$15.000 – $37.500 (paintings)

MAURIZIO CATTELAN

REPRESENTATION →
Marian Goodman Gallery
24 West 57th Street
US – New York, NY 10019
Tel: +1 212 97 77 160
Fax: +1 212 58 15 187
www.mariangoodman.com

Galerie Emmanuel Perrotin
76, rue de Turenne
F – 75003 Paris
Tel: +33 (0)1 4 21 67 979
Fax: +33 (0)1 4 21 67 974
www.galerieperrotin.com

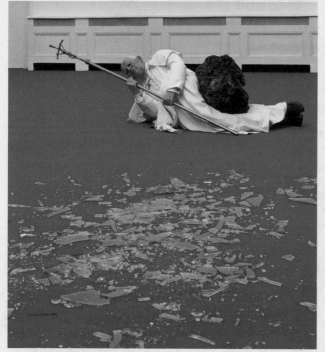
Maurizio Cattelan, La nona ora, 1999

PRIMARY MARKET PRICES →
Not available

AUCTION SALES →
Price: $2.700.000
La nona ora, 1999
Installation, dimensions variable
Date sold: 11-Nov-04
Auction house: Phillips,
de Pury & Company, New York

Price: $2.450.000
Not Afraid of Love, 2000

Sculpture, 205.7 x 312.4 x 137.2 cm
Date sold: 10-Nov-04
Auction house:
Christie's, New York

Price: $1.850.000
The Ballad of Trotsky, 1996
Taxidermy (horse),
dimensions variable
Date sold: 12-May-04
Auction house:
Sotheby's, New York

Price: $1.800.000
Untitled, 2001
Sculpture, 150 x 60 x 40 cm
Date sold: 10-Nov-04
Auction house: Christie's,
New York

Price: $1.115.520
Charlie Don't Surf, 2000
Installation
112 x 71 x 70 cm
Date sold: 10-Feb-05
Auction house: Sotheby's, London

JAKE & DINOS CHAPMAN

REPRESENTATION →
White Cube
48 Hoxton Square
GB – London N1 6PB
Tel: +44 (0)20 7 93 05 373
Fax.: +44 (0)20 7 74 97 480
www.whitecube.com

PRIMARY MARKET PRICES →
$800 – $800.000
(objects, installations)

AUCTION SALES →
Price: $83.763
Cyber-Iconic Man, 1996
Mixed media, 150 x 180 x 140 cm
Date sold: 08-Feb-01
Auction house: Christie's,
London

Price: $71.493
Fuckface, 1994
Sculpture, 90 x 50 x 30 cm
Date sold: 06-Apr-05
Auction house:
Christie's-South-Kensington,
London

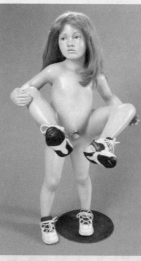
Jake & Dinos Chapman,
Cockroach Kid, 1997

Price: $45.000
Cockroach Kid, 1997
Sculpture, 104.1 x 59.7 x 47 cm
Date sold: 12-Nov-04
Auction house: Phillips, de Pury
& Company, New York

Price: $42.500
Gogo Fuckface, 1997
Sculpture, 104.1 x 45.7 x 55.9 cm
Date sold: 10-Nov-04
Auction house:
Sotheby's, New York

Price: $34.867
Island of Dr. Moron
Sculpture, 160 x 130 x 220 cm
Date sold: 27-Jun-01
Auction house:
Sotheby's, London

JOHN CURRIN

REPRESENTATION →
Gagosian Gallery
555 West 24th Street
US – New York, NY 10011
Tel: +1 212 74 11 111
Fax: +1 212 74 19 611
www.gagosian.com

Regen Projects
633 North Almont Drive
US – Los Angeles, CA 90069
Tel: +1 310 27 65 424
Fax: +1 310 27 67 430
www.regenprojects.com

PRIMARY MARKET PRICES →
Not available

AUCTION SALES →
Price: $750.000
Homemade Pasta, 1999
Oil/canvas, 127 x 106.7 cm
Date sold: 10-Nov-04
Auction house:
Christie's, New York

Price: $420.000
The Kennedy's, 1996
Oil/canvas, 91.4 x 81.2 cm
Date sold: 12-May-05
Auction house: Phillips, de Pury
& Company, New York

Price: $390.000
Standing Nude, 1993
Oil/canvas, 122 x 91 cm
Date sold: 11-Nov-04
Auction house: Phillips, de Pury
& Company, New York

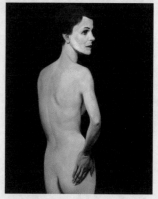
John Currin, Standing Nude, 1993

Price: $380.000
Entertaining Mr. Acker Bilk, 1995
Oil/canvas, 121.9 x 96.5 cm
Date sold: 15-May-02
Auction house:
Sotheby's, New York

Price: $380.000
The Optimist, 1996
Oil/canvas, 81.3 x 66 cm
Date sold: 12-May-04
Auction house:
Sotheby's, New York

JEREMY DELLER

REPRESENTATION →
The Modern Institute
73 Robertson Street
GB – Glasgow G2 8QD

Tel: +44 (0)141 24 83 711
Fax: +44 (0)141 24 83 280
www.themoderninstitute.com

Gavin Brown's enterprise
620 Greenwich Street
US – New York, NY 10014
Tel: +1 212 62 75 258
Fax: +1 212 62 75 261
www.gavinbrown.biz

PRIMARY MARKET PRICES →
Not available

THOMAS DEMAND

REPRESENTATION →
Esther Schipper
Linienstraße 85
D – 10119 Berlin
Tel: +49 (0)30 2 83 90 139
Fax: +49 (0)30 2 83 90 140
www.estherschipper.com

Thomas Demand, Copyshop, 1999

303 Gallery
525 West 22nd Street
US – New York, NY 10011
Tel: +1 212 25 51 121
Fax: +1 212 25 50 024
www.303gallery.com

Victoria Miro Gallery
16 Wharf Road
GB – London N1 7RW
Tel: +44 (0)20 7 33 68 109
Fax: +44 (0)20 7 25 15 596
www.victoria-miro.com

PRIMARY MARKET PRICES →
Not available

AUCTION SALES →
Price: $150.000
Room, 1995
C-print, 182.9 x 269.2 cm
Date sold: 09-Nov-04
Auction house:
Sotheby's, New York

Price: $150.000
Calculator (Rechner), 2001
Photograph, 175 x 437 cm
Date sold: 11-May-05
Auction house:
Christie's, New York

Price: $130.000
Copyshop, 1999
Colour photography
183.5 x 300 cm

Date sold: 10-May-05
Auction house:
Sotheby's, New York

Price: $120.000
Wand (Mural), 1999
Photograph, 183.5 x 270 cm
Date sold: 14-May-02
Auction house:
Christie's, New York

Price: $93.287
Studio, 1997–98
C-print, 183 x 350 cm
Date sold: 06-Feb-02
Auction house:
Christie's, London

RINEKE DIJKSTRA

REPRESENTATION →
Marian Goodman Gallery
24 West 57th Street
US – New York, NY 10019
Tel: +1 212 97 77 160
Fax: +1 212 58 15 187
www.mariangoodman.com

Galerie Max Hetzler
Zimmerstraße 90/91
D – 10117 Berlin
Tel: +49 (0)30 22 92 437
Fax: +49 (0)30 22 92 417
www.maxhetzler.com

PRIMARY MARKET PRICES →
$12.000 – $90.000

AUCTION SALES →
Price: $360.000
Hilton Head Island, US/Kolobrzeg,
Poland/De Panne, Belgium/Coney
Island, N.Y., US/Odessa, Ukraine/
Dubrovnik, Croatia, 1992–96
6 photographs, 190 x 156 cm
each
Date sold: 14-May-02
Auction house:
Christie's, New York

Price: $160.000
Odessa, Ukraine, 1993
C-print, 124.5 x 104.1 cm
Date sold: 13-Nov-03
Auction house:
Phillips, de Pury & Luxembourg,
New York

Price: $90.000
Julie, Den Haag/Saskia,
Harderwijk/Tecla,
Amsterdam, 1994
3 photographs, 154 x 130 cm each
Date sold: 15-Nov-01
Auction house:
Christie's, New York

Price: $88.000
Selfportrait, Marnixbad,
Amsterdam, 1991

Colour photography, 153 x 129 cm
Date sold: 17-Nov-00
Auction house:
Christie's, New York

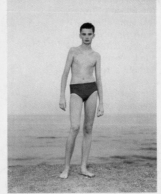

Rineke Dijkstra, Odessa, Ukraine,
1993

Price: $80.000
Selfportrait, Marnixbad,
Amsterdam, 1991
Photograph, 153 x 129 cm
Date sold: 11-Nov-02
Auction house:
Phillips, de Pury & Luxembourg,
New York

PETER DOIG

REPRESENTATION →
Victoria Miro Gallery
16 Wharf Road
GB – London N1 7RW
Tel: +44 (0)20 7 33 68 109
Fax: +44 (0)20 7 25 15 596
www.victoria-miro.com

Contemporary Fine Arts
Sophienstraße 21
D – 10178 Berlin
Tel: +49 (0)30 28 87 870
Fax: +49 (0)30 2 88 78 726
www.cfa-berlin.com

PRIMARY MAKET PRICES →
ca. $7.800 (drawings) –
$114.000 (paintings)

AUCTION SALES →
Price: $550.000
Briey, concrete Cabin, 1994–96
Oil/canvas, 275 x 200 cm
Date sold: 11-May-05
Auction house:
Christie's, New York

Price: $422.548
The Architect's Home in the
Ravine, 1991
Oil/canvas, 200 x 275 cm
Date sold: 26-Jun-02
Auction house:
Sotheby's, London

Price: $409.654
Swamped, 1990
Oil/canvas, 197 x 241 cm
Date sold: 07-Feb-02
Auction house:
Sotheby's, London

Price: $332.840
Grasshopper, 1990
Oil/canvas, 200 x 250 cm
Date sold: 25-Jun-03
Auction house:
Sotheby's, London

Price: $320.000
White Creep, 1995–96
Oil/canvas, 289.6 x 199.4 cm
Date sold: 11-Nov-03
Auction house:
Christie's, New York

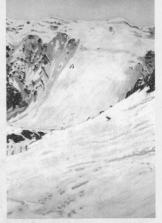

Peter Doig, White Creep, 1995–96

STAN DOUGLAS

REPRESENTATION →
David Zwirner
525 West 19th Street
US – New York, NY 10011
Tel: +1 212 72 72 070
Fax: +1 212 72 72 072
www.davidzwirner.com

Galería Helga de Alvear
Doctor Fourquet, 12
E – 28012 Madrid
Tel: +34 91 46 80 506
Fax: +34 91 46 75 134
www.helgadealvear.net

PRIMARY MARKET PRICES →
Not available

AUCTION SALES →
Price: $60.000
Detroit Series, 1998
25 colour photographies
Date sold: 14-Nov-02
Auction house:
Christie's, New York

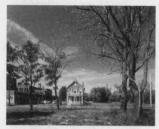

Stan Douglas, Detroit Series, 1998

Price: $30.000
Untitled, from Berlin Garden
Views, 1994
Photograph
Date sold: 13-May-05
Auction house:
Phillips, de Pury & Company,
New York

Price: $3.500
14th Floor of the Michigan Central
Station, 1998
C-print, 45.5 x 56 cm
Date sold: 16-May-02
Auction house:
Sotheby's, New York

Price: $3.500
Stracona and False Creek Flats,
1999
C-print, 45.5 x 89 cm
Date sold: 16-May-02
Auction house:
Sotheby's, New York

Price: $3.200
Hummingbird/Cormorant
at Hanna Channel
(Nootka Sound Series), 1996
Colour photography, 56 x 46 cm
Date sold: 17-May-00
Auction house:
Christie's, New York

MARLENE DUMAS

REPRESENTATION →
Galerie Paul Andriesse
Prinsengracht 116
NL – 1015 EA Amsterdam
Tel: +31 (0)20 62 36 237
Fax: +31 (0)20 63 90 083
www.galeries.nl

Frith Street Gallery
59–60 Frith Street
GB – London W1D 3JJ UK
Tel: +44 (0)20 7 49 41 550
Fax: +44(0)20 7 28 73 733
www.frithstreetgallery.com

Jack Tilton Gallery
8 East 76th Street
US – New York, NY 10021
Tel: +1 212 73 72 221
Fax: +1 212 39 61 725
www.jacktiltongallery.com

PRIMARY MARKET PRICES →
Not available

AUCTION SALES →
Price: $2.967.840
The Teacher (sub a), 1987
Oil/canvas, 160 x 200 cm
Date sold: 09-Feb-05
Auction house: Christie's, London

Price: $1.100.000
Jule, die Vrou, 1985
Oil/canvas, 125 x 105 cm
Date sold: 10-Nov-04
Auction house:
Christie's, New York

Price: $950.000
Cracking the Whip, 2000
Oil/canvas, 230 x 60 cm
Date sold: 12-May-05
Auction house:

Phillips, de Pury & Company,
New York

Price: $880.000
Young Boys, 1993
Oil/canvas, 100.3 x 300 cm
Date sold: 13-May-04
Auction house: Phillips, de Pury
& Company, New York

Price: $830.000
The Taboo, 2000
Oil/canvas, 229.9 x 60 cm
Date sold: 09-Nov-04
Auction house:
Sotheby's, New York

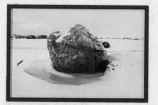

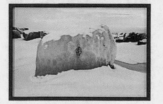

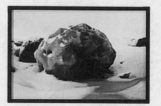

Olafur Eliasson, The Ice Series (detail), 1997

D – 10117 Berlin
Tel: +49 (0)30 28 06 605
Fax: +49 (0)30 28 06 616
www.eigen-art.com

PRIMARY MARKET PRICES →
$1.000 (print)
$1.500 – $3.000 (drawings)
$10.000 – $40.000 (paintings)

OLAFUR ELIASSON

REPRESENTATION →
neugerriemschneider
Linienstraße 155

D – 10115 Berlin
Tel: +49 (0)30 2 88 77 277
Fax: +49 (0)30 2 88 77 278
www.neugerriemschneider.com

Tanya Bonakdar Gallery
521 West 21st Street
US – New York, NY 10011
Tel: +1 212 41 44 144
Fax: +1 212 41 41 535
www.tanyabonakdargallery.com

PRIMARY MARKET PRICES →
$2.000 – $200.000

AUCTION SALES →
Price: $148.590
Komposition, 1993
Oil/canvas, 80 x 221 cm
Date sold: 05-Oct-04
Auction house:
Bruun Rasmussen,
Copenhagen

MARTIN EDER

REPRESENTATION →
Galerie Eigen + Art
Auguststraße 26
D – 10117 Berlin
Tel: +49 (0)30 28 06 605
Fax: +49 (0)30 28 06 616
www.eigen-art.com

PRIMARY MARKET PRICES →
$1.500 (print)
$3.125 – $5.000 (drawings)
$3.750 (video)
$31.250 – $150.000 (installations)
$3.750 – $7.500 (photographs)
$25.000 – $100.000 (paintings)

TIM EITEL

REPRESENTATION →
Galerie Eigen + Art
Auguststraße 26

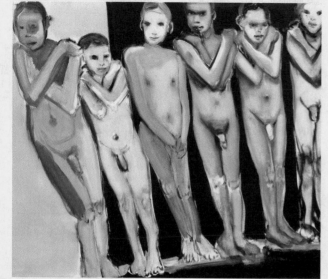

Marlene Dumas, Young Boys (detail), 1993

Price: $100.000
Bridge Series, 1997
68 c-prints, each 20.3 x 30.5 cm
Date sold: 11-May-05
Auction house:
Sotheby's, New York

Price: $95.000
The Ice Series, 1997
28 c-prints, 23.2 x 35.2 cm each
Date sold: 11-May-05
Auction house:
Sotheby's, New York

Price: $68.000
Untitled (Waterfall Series), 1996
58 c-prints, 36.2 x 24.1 cm each
Date sold: 13-May-05
Auction house:
Phillips, de Pury & Company,
New York

ELMGREEN & DRAGSET

REPRESENTATION →
Klosterfelde
Zimmerstraße 90/91
D – 10117 Berlin
Tel: +49 (0)30 28 35 305
Fax: +49 (0)30 28 35 306
www.klosterfelde.de

Tanya Bonakdar Gallery
521 West 21st Street
US – New York, NY 10011
Tel: +1 212 41 44 144
Fax: +1 212 41 41 535
www.tanyabonakdargallery.com

Galleri Nicolai Wallner
Njalsgade 21, building 15
DK – 2300 Copenhagen
Tel: +45 32 7 50 970
Fax: + 45 32 57 00 971
www.nicolaiwallner.com

PRIMARY MARKET PRICES →
$10.000 – $250.000
(objects, installations)

TRACEY EMIN

REPRESENTATION →
White Cube
48 Hoxton Square
GB – London N1 6PB
Tel: +44 (0)20 7 93 05 373
Fax.: +44 (0)20 7 74 97 480
www.whitecube.com

PRIMARY MARKET PRICES →
$110 – $352.000
(objects, installations, videos)

AUCTION SALES →
Price: $137.199
Exorcism of the Last Painting
I Ever Made, 1996
Installation

Date sold: 08-Feb-01
Auction house: Christie's,
London

Price: $127.358
My Coffin, 1996–97
Sculpture, 39.3 x 94.5 x 3.8 cm
Date sold: 23-Jun-04
Auction house:
Sotheby's, London

Tracey Emin, My Coffin, 1996–97

Price: $70.000
Every Part of Me's Bleeding, 1999
Light installation
99.1 x 200.2 x 8.6 cm
Date sold: 11-May-05
Auction house:
Sotheby's, New York

Price: $45.605
Is Legal Sex Anal? / Is Anal Sex
Legal?, 1998
Light installation
34 x 158 x 410 cm
Date sold: 25-Jun-04
Auction house: Christie's, London

Price: $30.000
Trying on Clothes from my
Friends, 1997
Photograph, 10.5 x 15 cm
Date sold: 12-Nov-01
Auction house:
Phillips, de Pury & Luxembourg,
New York

ELGER ESSER

REPRESENTATION →
Johnen + Schöttle
Maria-Hilf-Straße 17
D – 50677 Cologne
Tel: +49 (0)221 3 10 270
Fax: +49 (0)221 31 02 727
www.johnen-schoettle.de

Sonnabend Gallery
536 West, 22nd Street
US – New York, NY 10011
Tel: + 1 212 62 71 018
Fax: + 1 212 62 70 489
www.artnet.com/sonnabend.html

PRIMARY MARKET PRICES →
$12.000 – $34.000

AUCTION SALES →
Price: $80.000
Matera I Italien/
Matera II Italien, 1998
C-print, 137.2 x 177.5 cm
Date sold: 13-May-05
Auction house:
Phillips, de Pury & Company,
New York

Price: $78.086
Blois, Frankreich, 1998
Colour coupler print
189.3 x 236.3 cm
Date sold: 10-Feb-05
Auction house:
Christie's, London

Price: $54.000
Lyon, 1996
Photograph, 88.9 x 128.2 cm
Date sold: 27-Apr-05
Auction house:
Sotheby's, New York

Price: $42.000
Gien, Frankreich, 1997
Colour coupler print
63.5 x 127.5 cm
Date sold: 27-Apr-05
Auction house:
Phillips, de Pury & Company,
New York

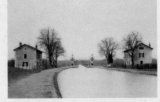

Elger Esser, St. Briare, France, 1998

Price: $38.000
St. Briare, France, 1998
Colour coupler print
124.5 x 177.3 cm
Date sold: 11-Nov-04
Auction house:
Christie's, New York

YANG FUDONG

REPRESENTATION →
ShanghART
50, Moganshan Rd., Bldg 16
CHINA – 200020 Shanghai
Tel: +86 21 6 35 93 923
Fax: +86 21 6 35 94 570
www.shanghart.com

PRIMARY MARKET PRICES →
Not available

ELLEN GALLAGHER

REPRESENTATION →
Gagosian Gallery
555 West 24th Street
US – New York, NY 10011
Tel: +1 212 74 11 111
Fax: +1 212 74 19 611
www.gagosian.com

Hauser & Wirth
Limmatstraße 270
CH – 8005 Zürich
Tel: +41 (0)44 44 68 050
Fax: +41 (0)44 44 68 055
www.ghw.ch

Galerie Max Hetzler
Zimmerstraße 90/91
D – 10117 Berlin
Tel: +49 (0)30 22 92 437
Fax: +49 (0)30 22 92 417
www.maxhetzler.com

PRIMARY MARKET PRICES →
$8.000 – $250.000 (prints)
$40.000 – $100.000 (drawings)
$150.000 – $350.000 (paintings)
$100.000 (film)

AUCTION SALES →
Price: $100.000
Soma, 1998
Oil/canvas, 244 x 213.5 cm
Date sold: 15-May-01
Auction house:
Sotheby's, New York

Price: $95.000
Wild Kingdom, 1995
Mixed media, 213.5 x 183 cm
Date sold: 14-May-02
Auction house:
Christie's, New York

Ellen Gallagher, Wild Kingdom, 1995

Price: $85.000
Untitled, 1999
Mixed media, 304.8 x 243.8 cm
Date sold: 13-Nov-02
Auction house:
Sotheby's, New York

Price: $60.000
Fronts, 1997

Mixed media, 304.8 x 243.8 cm
Date sold: 10-Nov-04
Auction house:
Sotheby's, New York

Price: $40.000
Untitled
Mixed media, 152.5 x 96.5 cm
Date sold: 20-May-99
Auction house:
Christie's, New York

ANNA GASKELL

REPRESENTATION →
Casey Kaplan
525 West 21st Street
US – New York, NY 10011
Tel: +1 212 64 57 335
Fax: +1 212 64 57 835
www.caseykaplangallery.com

White Cube
48 Hoxton Square
GB – London N1 6PB
Tel: +44 (0)20 7 93 05 373
Fax: +44 (0)20 7 74 97 480
www.whitecube.com

PRIMARY MARKET PRICES →
$10.000 – $25.000
(photographic prints)
$3.0000 – $6.000 (drawings)
$25.000 – $40.000 (videos)
$20.000 – $55.000 (installations)

Anna Gaskell, Untitled #49, 1999

AUCTION SALES →
Price: $28.000
Untitled #5 (Wonder Series), 1996
Colour coupler print, 127 x 101.6 cm
Date sold: 15-May-03
Auction house:
Christie's, New York

Price: $18.000
Untitled #49, 1999
C-print, 149.8 x 177.2 cm
Date sold: 11-Nov-04
Auction house:
Christie's, New York

Price: $16.000
Untitled #21 (Override), 1997
C-print, 144 x 174.5 cm
Date sold: 17-May-00
Auction house:
Christie's, New York

Price: $15.000
Untitled #21, 1997
C-print, 144.2 x 174.3 cm
Date sold: 13-Nov-01
Auction house:
Phillips, de Pury & Luxembourg,
New York

Price: $14.000
Untitled #56 (by proxy), 1999
Colour coupler print, 127 x 152.5 cm
Date sold: 12-Nov-03
Auction house:
Christie's, New York

ROBERT GOBER

REPRESENTATION →
Matthew Marks Gallery
523 West 24th Street
US – New York, NY 10011
Tel: +1 212 24 30 200
Fax: +1 212 24 30 047
www.matthewmarks.com

PRIMARY MARKET PRICES →
Not available

AUCTION SALES →
Price: $800.000
Leg, 1990
Sculpture, mixed media
Date sold: 10-May-05
Auction house:
Sotheby's, New York

Price: $750.000
Deep Basin Sink, 1984
Plaster, 66 x 73.5 x 61 cm
Date sold: 14-Nov-00
Auction house:
Sotheby's, New York

Price: $720.000
Untitled (Leg with Candle), 1991
Sculpture, wood, 34 x 18 x 96.5 cm
Date sold: 19-May-99
Auction house: Christie's, New York

Robert Gober, Untitled
(Leg with Candle), 1991

Price: $650.000
Untitled, 1990
Sculpture, 60.4 x 44.5 x 28.5 cm
Date sold: 13-Nov-02
Auction house:
Christie's, New York

Price: $500.000
Untitled, Man in Drain, 1993–94
Construction
Date sold: 12-Nov-98
Auction house:
Christie's, New York

ANTHONY GOICOLEA

REPRESENTATION →
Galerie Aurel Scheibler
St.-Apern-Straße 20–26
D – 50667 Cologne
Tel: +49 (0)221 3 11 011
Fax: +49 (0)221 33 19 615
www.aurelscheibler.com

Torch Gallery
Lauriergracht 94
NL – 1016 RA Amsterdam
Tel: +31 (0)20 62 60 284
Fax: +31 (0)20 62 38 892
www.torchgallery.com

Anthony Goicolea, Last Supper, 1999

PRIMARY MARKET PRICES →
$2.500 – $10.000 (drawings)
$4.250 – $25.000 (photoprints)
$5.000 – $12.000 (videos)
$7.000 – $29.500
(video installations)

AUCTION SALES →
Price: $9.500
Last Supper, 1999
C-print, 101.6 x 195.6 cm
Date sold: 15-Sep-04
Auction house:
Christie's, New York

Price: $4.000
Rowboat, 2000
C-print, 76.2 x 76.2 cm
Date sold: 18-Nov-04
Auction house: Phillips, de Pury
& Company, New York

DOMINIQUE
GONZALEZ-FOERSTER

REPRESENTATION →
Esther Schipper
Linienstraße 85
D – 10119 Berlin

Tel: +49 (0)30 2 83 90 139
Fax: +49 (0)30 2 83 90 140
www.estherschipper.com

Galerie Jan Mot
Antoine Dansaerstraat 190
BE – 1000 Brussels
Tel: +32 (0)2 51 41 010
Fax: +32 (0)2 51 41 446
www.galeriejanmot.com

PRIMARY MARKET PRICES →
Not available

DOUGLAS GORDON

REPRESENTATION →
Lisson Gallery
52–54 Bell Street
GB – London NW1 5DA
Tel: +44 (0)20 7 72 42 739
Fax: +44 (0)20 7 72 47 124
www.lisson.co.uk

Gagosian Gallery
555 West 24th Street
US – New York, NY 10011
Tel: +1 212 74 11 111
Fax: +1 212 74 19 611
www.gagosian.com

PRIMARY MARKET PRICES →
Not available

AUCTION SALES →
Price: $55.000
The End (Bird Man of Alcatraz),
1995–2000
Acrylic/canvas, 180.4 x 238.8 cm
Date sold: 14-Nov-02
Auction house:
Christie's, New York

Price: $54.328
Bootleg (Stoned), 1996
Video installation
Date sold: 26-Jun-02
Auction house:
Sotheby's, London

Douglas Gordon, Bootleg (Stoned),
1996

Price: $45.000
I'm not Sure this is working,
1997–2000
Installation
Date sold: 16-May-02
Auction house:
Sotheby's, New York

Andreas Gursky, Paris, Montparnasse (detail), 1993

Price: $42.500
Words and Pictures, 1996
Video installation
Date sold: 16-May-02
Auction house:
Sotheby's, New York

Price: $36.728
Instruction (Number 8), 1994
Mixed media
Date sold: 07-Feb-02
Auction house: Sotheby's, London

MARK GROTJAHN

REPRESENTATION →
Blum & Poe
2754 S. La Cienaga Boulevard
US – Los Angeles, CA 90034
Tel: +1 310 83 62 062
Fax: + 1 310 83 62 104
www.blumandpoe.com

Anton Kern Gallery
532 West 20th Street
US – New York, NY 10011
Tel: +1 212 36 79 663
Fax: +1 212 36 78 135
www.antonkerngallery.com

PRIMARY MARKET PRICES →
$4.500 – $15.000 (drawings)
$20.000 – $30.000 (paintings)

ANDREAS GURSKY

REPRESENTATION →
Galerie Monika Sprüth
Philomene Magers
Wormser Straße 23
D – 50677 Cologne
Tel: +49 (0)221 3 80 415
Fax: +49 (0)221 3 80 417
Schellingstraße 48
D – 80799 Munich
Tel: +49 (0)89 3 30 40 600

Fax: +49 (0)89 3 79 302
www.spruethmagers.com

Matthew Marks Gallery
523 West 24th Street
US – New York, NY 10011
Tel: +1 212 24 30 200
Fax: +1 212 24 30 047
www.matthewmarks.com

PRIMARY MARKET PRICES →
$125.000 – $375.000

AUCTION SALES →
Price: $559.724
Untitled V, 1997
Photograph, 185.4 x 442.6 cm
Date sold: 06-Feb-02
Auction house:
Christie's, London

Price: $550.000
May Day IV, 2000
Colour photography
208.3 x 508 cm
Date sold: 10-May-05
Auction house:
Sotheby's, New York

Price: $540.000
Paris, Montparnasse, 1993
Colour photography
161.5 x 306.5 cm
Date sold: 15-Nov-01
Auction house:
Christie's, New York

Price: $420.000
Chicago, Board of Trade, 1997
C-print, 186 x 242 cm
Date sold: 12-Nov-03
Auction house:
Sotheby's, New York

Price: $410.000
Klitschko, 1999
Colour photography, 207 x 261 cm
Date sold: 15-May-03

Auction house: Phillips, de Pury
& Luxembourg, New York

JEPPE HEIN

REPRESENTATION →
Johann König
Weydingerstraße 10
D – 10178 Berlin
Tel: +49 (0)30 308 82 688
Fax: +49 (0)30 308 82 690
www.johannkoenig.de

Galleri Nicolai Wallner
Njalsgade 21, building 15
DK – 2300 Copenhagen
Tel: +45 32 7 50 970
Fax: + 45 32 57 00 971
www.nicolaiwallner.com

PRIMARY MARKET PRICES →
$9.375 – $25.000
(sculptures/objects: edition of 5)
$18.750 – $75.000 (sculptures/
objects: edition of 3)
$187.500 (large installation)

JONATHAN HERNÁNDEZ

REPRESENTATION →
kurimanzutto
Mazatlán 5 depto. t-6 col condesa
MEX – 06140 Mexico City
Tel: +52 55 5286 3059
Fax: +52 55 5256 2408
www.kurimanzutto.com

PRIMARY MARKET PRICES →
Not available

JOSÉ ANTONIO HERNÁNDEZ-DÍEZ

REPRESENTATION →
Galeria Fortes Vilaça
Rua Fadrique Coutinho 1500
BRA – 05416 – 001 São Paulo
Tel: +55 11 30 32 70 66
Fax: +55 11 30 97 03 84
www.fortesvilaca.com.br

PRIMARY MARKET PRICES →
$5.000 – $10.000 (photographs)
$9.000 – $18.000
(drawings, paintings)
$8.000 – $35.000 (sculptures)

AUCTION SALES →
Price: $20.000
San Guinefort, 1991
Construction, 146 x 200 x 85 cm
Date sold: 17-Nov-99
Auction house:
Christie's, New York

Price: $15.000
Experiencia, 1995, object
Date sold: 02-Jun-99

Auction house:
Christie's-East, New York

Price: $7.500
Drag, 1995
Video installation, 60 x 44 cm
Date sold: 26-May-05
Auction house:
Christie's, New York

José Antonio Hernández-Díez,
Experiencia, 1995

THOMAS HIRSCHHORN

REPRESENTATION →
Barbara Gladstone Gallery
515 West 24th Street
US – New York, NY 10011
Tel: +1 212 20 69 300
Fax: +1 212 20 69 301
www.gladstonegallery.com

Arndt & Partner
Zimmerstraße 90/91
D – 10117 Berlin
Tel: +49 (0)30 28 08 123
Fax: +49 (0)30 28 33 738
www.arndt-partner.de

PRIMARY MARKET PRICES →
$5.000 (works on paper)
$6.250 (smaller works)
$22.500 (lay outs)
$87.500 – $125.000
(representative sculptures)
$187.500 – $437.500
(room encompassing sculptures)

AUCTION SALES →
Price: $30.000
Fahrplan 2000:
agents de l'extrême, 2000
Mixed media
161.3 x 243.8 x 21.6 cm

Date sold: 13-Nov-03
Auction house: Phillips, de Pury
& Luxembourg, New York

Thomas Hirschhorn,
Provide Crying, 2003

Price: $10.874
Provide Crying I–IV, 2003
Mixed media collage
49.2 x 59.4 cm each
Date sold: 22-Oct-03
Auction house: Christie's, London

Price: $6.000
Thank You, 1996
Installation, 30 x 134.5 cm
Date sold: 13-Nov-01
Auction house: Phillips, de Pury
& Luxembourg, New York

JIM HODGES

REPRESENTATION →
CRG Gallery
535 West 22nd St., 3rd Fl.
US – New York, NY 10011
Tel: +1 212 22 92 766
Fax: +1 212 22 92 788
www.crggallery.com

PRIMARY MARKET PRICES →
Not available

Jim Hodges, A Line to You, 1994

AUCTION SALES →
Price: $240.000
A Line to You, 1994
Plastic, 536 cm

Date sold: 10-Nov-04
Christie's, New York

Price: $165.000
Tremling & Joy, 1994
Installation
Date sold: 12-Nov-03
Auction house:
Christie's, New York

Price: $105.000
It happened before, 1996
Mixed media
Date sold: 13-May-05
Auction house: Phillips, de Pury
& Company, New York

Price: $37.000
A Certain Land of Alone III, 1994
Ink, 74.3 x 57.2 cm
Date sold: 12-Nov-04
Auction house: Phillips, de Pury
& Company, New York

Price: $35.000
A Line to You, 1994
Plastic, 536 cm
Date sold: 18-May-00
Auction house:
Sotheby's, New York

CANDIDA HÖFER

REPRESENTATION →
Johnen + Schöttle
Maria-Hilf-Straße 17
D – 50677 Cologne
Tel: +49 (0)221 3 10 270
Fax: +49 (0)221 31 02 727
www.johnen-schoettle.de

Sonnabend Gallery
536 West, 22nd Street
US – New York, NY 10011
Tel: +1 212 62 71 018
Fax: +1 212 62 70 489
www.artnet.com/sonnabend.html

PRIMARY MARKET PRICES →
$12.000 – $42.000

AUCTION SALES →
Price: $34.538
Museum of Modern Art
New York XII, 2001
C-print, 119.5 x 161.5 cm
Date sold: 21-Oct-04
Auction house:
Sotheby's Olympia, London

Price: $30.000
U-Bahnstation Theaterplatz, 2000
Colour coupler print
149.8 x 149.8 cm
Date sold: 11-Nov-04
Auction house:
Christie's, New York

Price: $26.000
Museum für Völkerkunde

Dresden II, 1999
Colour coupler print,
120 x 120 cm
Date sold: 12-May-04
Auction house:
Christie's, New York

Price: $25.000
Schloss Karlsruhe II, 1999
Photograph, 120 x 120 cm
Date sold: 13-May-05
Auction house:
Phillips, de Pury & Company,
New York

Price: $24.304
Spiegelkantine Hamburg, 2000
Colour photography
154.5 x 154.5 cm
Date sold: 11-Feb-05
Auction house:
Sotheby's, London

Candida Höfer, Spiegelkantine
Hamburg, 2000

GARY HUME

REPRESENTATION →
Matthew Marks Gallery
523 West 24th Street
US – New York, NY 10011
Tel: +1 212 24 30 200
www.matthewmarks.com

Gary Hume, Love Loves Unlovable, 1994

White Cube
48 Hoxton Square
GB – London N1 6PB
Tel: +44 (0)20 7 93 05 373

Fax: +44 (0)20 7 74 97 480
www.whitecube.com

PRIMARY MARKET PRICES →
Not available

AUCTION SALES →
Price: $245.514
Love Loves Unlovable, 1994
Painting, 216 x 366 cm
Date sold: 08-Feb-01
Auction house: Christie's, London

Price: $140.000
Pauline, 1996
Painting, 208.5 x 117 cm
Date sold: 14-Nov-00
Auction house:
Sotheby's, New York

Price: $131.096
3, 2000
Enamel, 305 x 241.3 cm
Date sold: 22-Oct-02
Auction house: Sotheby's,
London

Price: $120.000
Song, 1998
Enamel, 208.4 x 116.8 cm
Date sold: 13-May-04
Auction house:
Phillips, de Pury & Company,
New York

Price: $97.593
Tony Blackburn, 1993
Painting, 193 x 137 cm
Date sold: 06-Feb-02
Auction house: Christie's,
London

PIERRE HUYGHE

REPRESENTATION →
Marian Goodman Gallery
24 West 57th Street

US – New York, NY 10019
Tel: +1 212 977-7160
Fax: +1 212 581-5187
www.mariangoodman.com

Esther Schipper
Linienstraße 85
D – 10119 Berlin
Tel: +49 (0)30 2 83 90 139
Fax: +49 (0)30 2 83 90 140
www.estherschipper.com

PRIMARY MARKET PRICES →
Not available

EMILY JACIR

REPRESENTATION →
Alexander and Bonin
132 Tenth Avenue
US – New York, NY 10011
Tel: +1 212 36 77 474
Fax: +1 212 36 77 337
www.alexanderandbonin.com

Anthony Reynolds Gallery
60 Great Marlborough Street
GB – London W1F 7BG
Tel: +44 (0)20 7 43 92 201
Fax: +44 (0)20 7 43 91 869
www.anthonyreynolds.com

PRIMARY MARKET PRICES →
Not available

MIKE KELLEY

REPRESENTATION →
Gagosian Gallery
555 West 24th Street
US – New York, NY 10011

Mike Kelley, Memory Ware Flat #15, 2001

Tel: +1 212 74 11 111
Fax: +1 212 74 19 611
www.gagosian.com

Metro Pictures
519 West 24th Street
US – New York, NY 10011
Tel: +1 212 20 67 100
Fax: +1 212 33 70 070
www.metropicturesgallery.com

Jablonka Galerie
Hahnenstraße 37
D – 50667 Cologne
Tel: +49 (0)221 24 03 426
Fax: +49 (0)221 24 08 132
www.jablonkagalerie.com

Patrick Painter Inc.
2525 Michigan Ave B2
US – Santa Monica, CA 90404
Tel: +1 310 26 45 988
Fax: +1 310 26 45 998
www.patrickpainter.com

PRIMARY MARKET PRICES →
$30.000 – $500.000 (drawings)
$400.000 – $1.000.000
(installations)

AUCTION SALES →
Price: $360.000
Ahh...Youth, 1991
C-print, 61.9 x 43 cm
Date sold: 08-Nov-04
Auction house:
Phillips, de Pury & Company,
New York

Price: $350.000
ET's Long Neck, two Brains,
Penis and Scrotum, 1989
Sculpture, 330 x 26 x 166 cm
Date sold: 11-May-05
Auction house:
Christie's, New York

Price: $330.000
Memory Ware Flat #34, 2003

Mixed media, 132.4 x 193.7 cm
Date sold: 12-May-05
Auction house: Phillips, de Pury
& Company, New York

Price: $320.000
The Poltergeist, 1979
Gelatin silver print
Date sold: 12-May-05
Auction house: Christie's,
New York

Price: $280.000
Memory Ware Flat #15, 2001
Mixed media, 180 x 256 cm
Date sold: 11-Nov-04
Auction house:
Phillips, de Pury & Company,
New York

HASSAN KHAN

REPRESENTATION →
Galerie Chantal Crousel
10, rue Charlot
F – 75003 Paris
Tel: +33 (0)1 4 27 73 887
Fax: +33 (0)1 4 27 75 900
www.crousel.com

PRIMARY MARKET PRICES →
$2.750 – $25.000
(videos and video-installations)

JEFF KOONS

REPRESENTATION →
Gagosian Gallery
555 West 24th Street
US – New York, NY 10011
Tel: +1 212 74 11 111
Fax: +1 212 74 19 611
www.gagosian.com

Galerie Max Hetzler
Zimmerstraße 90/91
D – 10117 Berlin
Tel: +49 (0)30 22 92 437
Fax: +49 (0)30 22 92 417
www.maxhetzler.com

Sonnabend Gallery
536 West, 22nd Street
US – New York, NY 10011
Tel: + 1 212 62 71 018
Fax: + 1 212 62 70 489
www.artnet.com/sonnabend.html

PRIMARY MARKET PRICES →
$600.000 – $1.200.000
(paintings)
$600.000 – $5.000.000
(sculptures)

AUCTION SALES →
Price $5.100.000
Michael Jackson and Bubbles, 1988
Porcelain
106.5 x 179 x 82.5 cm
Date sold: 15-May-01
Auction house:
Sotheby's, New York

Price: $4.900.000
Jim Beam J.B. Turner Train, 1986
Stainless steel & bourbon
28 x 289.5 x 16.5 cm, Ed. 3
Date sold: 11-May-04
Auction house:
Christie's, New York

Price: $2.600.000
Cake, 1995–97
Oil/canvas, 318.5 x 295.6 cm
Date sold: 10-May-05
Auction house:
Sotheby's, New York

Price: $2.600.000
Woman in Tub, 1988
Porcelain, 62 x 91 x 69 cm, Ed. 3
Date sold: 17-May-01
Auction house:
Christie's, New York

Price: $2.600.000
Bear and Policeman, 1988
Sculpture, wood (polychrome),
Ed. 3, 215.9 x 109.2 x 91.4 cm
Date sold: 11-Nov-04
Auction house:
Phillips, de Pury & Company,
New York

Jeff Koons, Bear and Policeman,
1988

JIM LAMBIE

REPRESENTATION →
The Modern Institute
73 Robertson Street
GB – Glasgow G2 8QD
Tel: +44 (0)141 24 83 711
Fax: +44 (0)141 24 83 280
www.themoderninstitute.com

Sadie Coles HQ
35 Heddon Street
GB – London W1B 4BP
Tel: +44 (0)20 7 43 42 227
Fax: +44 (0)20 7 43 42 228
www.sadiecoles.com

Anton Kern Gallery
532 West 20th Street
US – New York, NY 10011
Tel: +1 212 36 79 663
Fax: +1 212 36 78 135
www.antonkerngallery.com

Zoe Leonard, Bullfight I, …, 1986–90

PRIMARY MARKET PRICES →
$5.000 (drawing)
$60.000 (large sculpture)

ULRICH LAMSFUSS

REPRESENTATION →
Galerie Max Hetzler
Zimmerstraße 90/91
D – 10117 Berlin
Tel: +49 (0)30 22 92 437
Fax: +49 (0)30 22 92 417
www.maxhetzler.com

Galerie Daniel Templon
30, rue Beaubourg
F – 75003 Paris
Tel: +33 (0)1 42 72 14 10
Fax: +33 (0)1 42 77 45 36
www.danieltemplon.com

Lombard-Freid Projects
531 West 26th Street
US – New York, NY 10001
Tel: +1 212 96 78 040
Fax: +1 212 96 70 669
www.lombard-freid.com

PRIMARY MARKET PRICES →
$1.200 – $2.500 (drawings)
$6.000 – $36.000 (paintings)

ZOE LEONARD

REPRESENTATION →
Galerie Gisela Capitain
Aachener Straße 5
D – 50674 Cologne
Tel: +49 (0)221 25 66 76
Fax: +49 (0)221 25 65 93
www.galerie-capitain.de

PRIMARY MARKET PRICES →
Not available

AUCTION SALES →
Price: $28.000
Bullfight I, Baseball field, Untitled

aerial, Map, Paris,
Cappadocia…, 1986–90
9 gelatin silver prints
Date sold: 20-May-99
Auction house:
Christie's, New York

Price: $11.000
Mirror No. 2/Gravestone
with two Hearts/Untitled

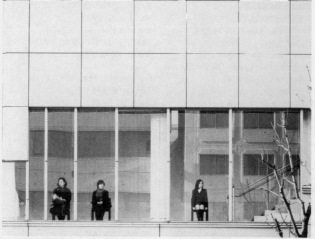

Sharon Lockhart, Untitled (detail), 1998

Gelatin silver print
Date sold: 09-Nov-04
Auction house:
Phillips, de Pury & Company,
New York

WON JU LIM

REPRESENTATION →
Galerie Max Hetzler
Zimmerstraße 90/91
D – 10117 Berlin
Tel: +49 (0)30 22 92 437
Fax: +49 (0)30 22 92 417
www.maxhetzler.com

Patrick Painter Inc.
2525 Michigan Ave B2
US – Santa Monica, CA 90404
Tel: +1 310 26 45 988
Fax: +1 310 26 45 998
www.patrickpainter.com

PRIMARY MARKET PRICES →
$6.000 – $20.000 (prints)
$10.000 – $50.000 (installations)

SHARON LOCKHART

REPRESENTATION →
neugerriemschneider
Linienstraße 155
D – 10115 Berlin
Tel: +49 (0)30 28 87 72 77
Fax: +49 (0)30 28 87 72 78
www.neugerriemschneider.com

Barbara Gladstone Gallery
515 West 24th Street
US – New York, NY 10011
Tel: +1 212 20 69 300
Fax: +1 212 20 69 301
www.gladstonegallery.com

Blum & Poe
2754 S. La Cienaga Boulevard
US – Los Angeles, CA 90034
Tel: +1 310 83 62 062
Fax: + 1 310 83 62 104
www.blumandpoe.com

PRIMARY MARKET PRICES →
$5.000 – $120.000

AUCTION SALES →
Price: $60.000
Goshogaoka Girls Baseball
Team/Goshogaoka Girls
Basketball…, 1997
10 c-prints
Date sold: 12-Nov-03
Auction house:
Christie's, New York

Price: $29.000
Julie/Thomas, 1993
C-print, 152.5 x 122 cm
Date sold: 14-Nov-03
Auction house: Phillips, de Pury
& Luxembourg, New York

Price: $29.000
Untitled, 1998
2 colour coupler prints
124.5 x 165 cm each
Date sold: 14-Nov-02
Auction house: Christie's, New York

Price: $12.000
Manioc Production: Elenilde
Correa, Elian Correa, Neide
Correa, 1999
C-print, 61 x 48.3 cm
Date sold: 13-May-05
Auction house: Phillips, de Pury
& Company, New York

Price: $12.000
Chronicle of Masonry Work in the
Oaxacan Exhibit Hall,
Mexico City, 1999
Photograph
Date sold: 13-May-05
Auction house: Phillips, de Pury
& Company, New York

SARAH LUCAS

REPRESENTATION →
Sadie Coles HQ
35 Heddon Street
GB – London W1B 4BP
Tel: +44 (0)20 7 43 42 227
Fax: +44 (0)20 7 43 42 228
www.sadiecoles.com

Barbara Gladstone Gallery
515 West 24th Street
US – New York, NY 10011
Tel: +1 212 20 69 300
Fax: +1 212 20 69 301
www.gladstonegallery.com

Contemporary Fine Arts
Sophienstraße 21
D – 10178 Berlin
Tel: +49 (0)30 28 87 870
Fax: +49 (0)30 2 88 78 726
www.cfa-berlin.com

PRIMARY MARKET PRICES →
$9.000 – $60.000 (photographs)
$1.500 (small edition)
$15.000 – $40.000
(small sculptures)
$90.000 – $165.000
(large sculptures)

AUCTION SALES →
Price: $173.304
Fighting Fire with Fire 6 Pack,
1997
6 photographs with ink and
acrylic, 152.4 x 106.6 cm each

Date sold: 08-Feb-01
Auction house: Christie's,
London

Price: $140.000
Bunny gets Snookered #10, 1997
Mixed media sculpture
Date sold: 13-Nov-03
Auction house:
Phillips, de Pury & Luxembourg,
New York

Price: $109.164
Seven up, 1991
Photograph on paper
218.5 x 312.5 cm
Date sold: 23-Jun-04
Auction house: Sotheby's, London

Price: $100.000
Is Suicide Genetic?, 1996
Assemblage, 100.5 x 89 x 68 cm
Date sold: 12-Nov-01
Auction house: Phillips, de Pury
& Luxembourg, New York

Price: $67.243
Self-Portrait with Fried Eggs, 1996
C-print, 167 x 119 cm
Date sold: 28-June-00
Auction house: Christie's, London

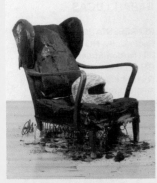

Sarah Lucas, Is Suicide Genetic?,
1996

VERA LUTTER

REPRESENTATION →
Gagosian Gallery
555 West 24th Street
US – New York, NY 10011
Tel: +1 212 74 11 111
Fax: +1 212 74 19 611
www.gagosian.com

Galerie Max Hetzler
Zimmerstraße 90/91
D – 10117 Berlin
Tel: +49 (0)30 22 92 437
Fax: +49 (0)30 22 92 417
www.maxhetzler.com

PRIMARY MARKET PRICES →
$10.000 – $100.000

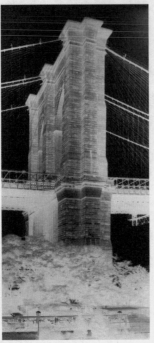

Vera Lutter, The Tower, Fire Boat
House, Fulton Ferry Landing,
New York, July 7, 1996

AUCTION SALES →
Price: $70.000
The Tower, Fire Boat House,
Fulton Ferry Landing,
New York, July 7, 1996
Gelatin silver print, 279.5 x 132 cm
Date sold: 11-Nov-04
Auction house:
Christie's, New York

Price: $60.000
Frankfurt Airport IV, 2001
Gelatin silver print
204.8 x 424.7 cm
Date sold: 11-May-04
Auction house:
Christie's, New York

Price: $42.000
Rockefeller Center, West II, 1998
Gelatin silver print
221 x 284.5 cm
Date sold: 17-Oct-03
Auction house: Phillips, de Pury
& Luxembourg, New York

Price: $40.000
View of Cleveland Flats,
V Crittenden Court
Apartments 955, 1997
Photograph, 141 x 254 cm
Date sold: 14-Nov-02
Auction house:
Christie's, New York

Price: $20.000
The Bridge, Fireboat, from
Brooklyn, NY, 1996
Photograph, 101.6 x 95.9 cm

Date sold: 27-Apr-05
Auction house:
Sotheby's, New York

JORGE MACCHI

REPRESENTATION →
Ruth Benzacar
Florida 1000
ARG – Buenos Aires 1005
Tel: + 54 11 4 31 38 480
Fax: + 54 11 4 31 38 480
www.ruthbenzacar.com

Galeria Luisa Strina
Rua Oscar Freire, 502
BRA – CEP 01426-000
São Paulo, SP
Tel: +55 (0)11 3 08 82 471
Fax: +55 (0)11 3 06 46 391
www.galerialuisastrina.com.br

PRIMARY MARKET PRICES →
Not available

MAREPE

REPRESENTATION →
Galeria Luisa Strina
Rua Oscar Freire, 502
BRA – CEP 01426-000
São Paulo, SP
Tel: +55 (0)11 3 08 82 471
Fax: +55 (0)11 3 06 46 391
www.galerialuisastrina.com.br

Galerie Max Hetzler
Zimmerstraße 90/91
D – 10117 Berlin
Tel: +49 (0)30 22 92 437
Fax: +49 (0)30 22 92 417
www.maxhetzler.com

PRIMARY MARKET PRICES →
Not available

PAUL MCCARTHY

REPRESENTATION →
Hauser & Wirth
Limmatstraße 270
CH – 8005 Zürich
Tel: +41 (0)44 44 68 050
Fax: +41 (0)44 44 68 055
www.ghw.ch

Luhring Augustine
531 West 24th Street
US – New York, NY 10011
Tel: +1 212 20 69 100
Fax: +1 212 20 69 055
www.luhringaugustine.com

PRIMARY MARKET PRICES →
$45.000 (photographs)
$85.000 – $850.000
(sculptures, videos and
installations)

AUCTION SALES →
Price: $260.000
Rear View, 1991–94
Sculpture, 117 x 168 x 94 cm
Date sold: 11-Nov-04
Auction house: Phillips, de Pury
& Company, New York

Price: $200.000
Assortment (the Trunks:
Human Object), 1973–83
Installation, 335.5 x 254 x 122 cm
Date sold: 12-Nov-01
Auction house: Phillips, de Pury
& Luxembourg, New York

Paul McCarthy, Rear View, 1991–94

Price: $130.000
Bavarian Deer, 1987–89
Colour coupler print
274.3 x 181.6 cm
Date sold: 12-May-05
Auction house: Christie's, New York

Price: $95.000
Propo Object:
Donald Duck, 1972–94
C-print, 182.9 x 121.9 cm
Date sold: 13-May-05
Auction house: Phillips, de Pury
& Company, New York

Price: $82.000
Propo Object: Donald Duck, 1995
C-print, 182.9 x 121.9 cm
Date sold: 08-Nov-04
Auction house: Phillips, de Pury
& Company, New York

LUCY MCKENZIE

REPRESENTATION →
Galerie Daniel Buchholz
Neven-DuMont-Straße 17
D – 50667 Cologne
Tel: +49 (0)221 25 74 946
Fax: +49 (0)221 2 53 351
www.galeriebuchholz.de

The Modern Institute
73 Robertson Street

GB – Glasgow G2 8QD
Tel: +44 (0)141 24 83 711
Fax: +44 (0)141 24 83 280
www.themoderninstitute.com

Metro Pictures
519 West 24th Street
US – New York, NY 10011
Tel: +1 212 20 67 100
Fax: +1 212 33 70 070
www.metropicturesgallery.com

PRIMARY MARKET PRICES →
$5.000 – $25.000 (paintings)

JONATHAN MEESE

REPRESENTATION →
Contemporary Fine Arts
Sophienstraße 21
D – 10178 Berlin
Tel: +49 (0)30 28 87 870
Fax: +49 (0)30 2 88 78 726
www.cfa-berlin.com

Leo Koenig Inc.
545 West 23rd Street
US – New York, NY 10011
Tel: +1 212 33 49 255
Fax: +1 212 33 49 304
www.leokoenig.com

Galerie Krinzinger
Seilerstaette 16
A – 1010 Vienna
Tel: +43 (0)1 51 33 006
Fax: +43 (0)1 51 33 00 633
www.galerie-krinzinger.at

Galerie Daniel Templon
30, rue Beaubourg
F – 75003 Paris
Tel: +33 (0)1 4 27 21 410
Fax: +33 (0)1 4 27 74 536
www.danieltemplon.com

PRIMARY MARKET PRICES →
ca. $3.000 (drawings) –
ca. $38.400 (paintings)

JULIE MEHRETU

REPRESENTATION →
carlier I gebauer
Holzmarktstraße 15–18
Bogen 51/52
D – 10179 Berlin
Tel: +49 (0)30 28 08 110
Fax: +49 (0)30 28 08 109
www.carliergebauer.com

The Project
37 West 57th St. 3rd Fl.
US – New York, NY 10019
Tel: +1 212 68 84 673
Fax: +1 212 68 81 589
6086 Comey Ave.
US – Los Angeles, CA 90034
Tel: +1 323 93 93 777

Fax: +1 323 93 93 553
www.elproyecto.com

White Cube
48 Hoxton Square
GB – London N1 6PB
Tel: +44 (0)20 7 93 05 373
Fax: +44 (0)20 7 74 97 480
www.whitecube.com

PRIMARY MARKET PRICES →
Not available

Julie Mehretu, Ringside, 1999

AUCTION SALES →
Price: $61.925
Ringside, 1999
Ink and polymer/canvas
183 x 213 cm
Date sold: 23-Sep-03
Auction house: Christie's, New York

Price: $55.000
Untitled, 2000
Gouache, 48.2 x 61 cm
Date sold: 12-May-05
Auction house:
Christie's, New York

Price: $55.000
Skybox, 1998
Mixed media, 106.8 x 152.4 cm
Date sold: 12-May-05
Auction house:
Christie's, New York

AERNOUT MIK

REPRESENTATION →
carlier I gebauer
Holzmarktstraße 15–18
Bogen 51/52
D – 10179 Berlin
Tel: +49 (0)30 28 08 110
Fax: +49 (0)30 28 08 109
www.carliergebauer.com

Galleria Massimo de Carlo
Via Giovanni Ventura 5
I – 20135 Milan
Tel: +39 (0)2 7 00 03 987
Fax: +39 (0)2 74 92 135
www.massimodecarlo.it

The Project
37 West 57th St. 3rd Fl.
US – New York, NY 10019
Tel: +1 212 68 84 673

Fax: +1 212 68 81 589
6086 Comey Ave.
US – Los Angeles, CA 90034
Tel: +1 323 93 93 777
Fax: +1 323 93 93 553
www.elproyecto.com

PRIMARY MARKET PRICES →
$35.000 – $145.000
(video installations)

BEATRIZ MILHAZES

REPRESENTATION →
Galeria Fortes Vilaça
Rua Fadrique Coutinho 1500
BRA – 05416 – 001 São Paulo
Tel: +55 11 3 03 27 066
Fax: +55 11 3 09 70 384
www.fortesvilaca.com.br

Galerie Max Hetzler
Zimmerstraße 90/91
D – 10117 Berlin
Tel: +49 (0)30 22 92 437
Fax: +49 (0)30 22 92 417
www.maxhetzler.com

Stephen Friedman Gallery
25–28 Old Burlington Street
GB – London W1S 3AN
Tel: +44 (0)20 74 94 14 34
Fax: +44(0)20 74 94 14 31
www.stephenfriedman.com

James Cohan Gallery
533 West 26th Street
US – New York, NY 10001
Tel: +1 212 71 49 500
Fax: +1 212 71 49 510
www.jamescohan.com

PRIMARY MARKET PRICES →
$20.000 – $50.000 (collages)
$80.000 – $150.000 (paintings)

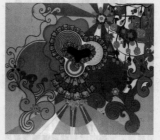
Beatriz Milhazes, Romantico
americano, 1998

AUCTION SALES →
Price: $111.294
Romantico americano, 1998
Oil/canvas, 180 x 220 cm
Date sold: 09-Feb-05
Auction house:
Christie's, London

Price: $62.000
Mundo civilizado, 1998

Oil/canvas, 150 x 250 cm
Date sold: 18-Nov-03
Auction house:
Christie's, New York

Price: $35.000
A planta e allá da banana, 1994
Mixed media, 84.5 x 100 cm
Date sold: 10-Nov-04
Auction house:
Sotheby's, New York

Price: $30.000
Meu prazer, 1998
Acrylic, 98.8 x 138.6 cm
Date sold: 25-May-05
Auction house:
Sotheby's, New York

Price: $30.000
A planta da banana, 1994
Mixed media, 61 x 129 cm
Date sold: 11-May-05
Auction house:
Sotheby's, New York

SHINTARO MIYAKE

REPRESENTATION →
Tomio Koyama Gallery
Shinkawa 1-31-6-1F
JAP – Chuo-ku Tokyo 104-0033
Tel: +81 3 6 22 21 006
Fax: +81 3 3 55 12 615
www.tomiokoyamagallery.com

c/o – Atle Gerhardsen
Holzmarktstraße 15–18
D – 10179 Berlin
Tel: +49 (0)30 6 95 18 341
Fax: +49 (0)30 6 95 18 342
www.atlegerhardsen.com

PRIMARY MARKET PRICES →
$1.000 – $14.000 (drawings)
$10.000 – $40.000 (installations)

MARIKO MORI

REPRESENTATION →
Deitch Projects
76 Grand Street
US – New York, NY 10012
Tel: +1 212 34 37 300
Fax: +1 212 34 32 954
www.deitch.com

PRIMARY MARKET PRICES →
$5.000 (drawing)
$35.000 (video)
$25.000 – $1.500.000
(installations)
$12.000 – $150.000 (photos)
$5.000 – $275.000 (paintings)

AUCTION SALES →
Price: $140.000
Red Light, 1994
Photograph, 305 x 381 x 6.3 cm

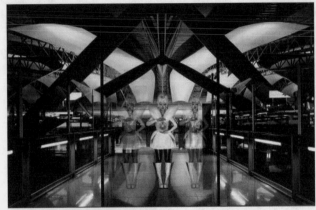

Mariko Mori, Last Departure (detail), 1996

Date sold: 13-May-02
Auction house: Phillips, de Pury
& Luxembourg, New York

Price: $134.500
Last Departure, 1996
Photograph, 213.5 x 366.5 cm
Date sold: 14-May-01
Auction house:
Phillips, New York

Price: $105.000
Red Light, 1994
Photograph, 305 x 381 x 6.3 cm
Date sold: 11-Nov-04
Auction house: Phillips, de Pury
& Company, New York

Price: $100.968
Play with me, 1994
Photograph, 305 x 366 x 7.6 cm
Date sold: 26-Oct-00
Auction house: Sotheby's, London

Price: $90.000
Red Light, 1994
Photograph, 305 x 381 x 6.3 cm
Date sold: 19-May-99
Auction house: Christie's,
New York

SARAH MORRIS

REPRESENTATION →
White Cube
48 Hoxton Square
GB – London N1 6PB
Tel: +44 (0)20 7 93 05 373
Fax: +44 (0)20 7 74 97 480
www.whitecube.com

Friedrich Petzel Gallery
535 West 22nd Street
US – New York, NY 10011
Tel: +1 212 68 09 467
Fax: +1 212 68 09 473
www.petzel.com

Galerie Max Hetzler
Zimmerstraße 90/91
D – 10117 Berlin

Tel: +49 (0)30 22 92 437
Fax: +49 (0)30 22 92 417
www.maxhetzler.com

PRIMARY MARKET PRICES →
$10.000 – $20.000 (drawings)
$50.000 – $100.000 (paintings)

AUCTION SALES →
Price: $28.000
First Bank (Miami), 1998
Mixed media, 213.4 x 213.4 cm
Date sold: 16-May-03
Auction house:
Phillips, de Pury & Luxembourg,
New York

Price: $18.000
Instant, 1996
Lacquer, 152.4 x 244 cm
Date sold: 13-May-05
Auction house:
Phillips, de Pury & Company,
New York

Sarah Morris, NMCMBLL, 1998

Price: $16.000
NMCMBLL, 1998
Painting, 256.5 x 198.8 cm
Date sold: 14-Nov-02
Auction house:
Christie's, New York

Price: $12.000
Mental, 1995

Oil/canvas, 152.5 x 219.5 cm
Date sold: 17-Nov-00
Auction house:
Christie's, New York

Price: $8.965
Sorry, 1996
Mixed media/canvas
152.5 x 244 cm
Date sold: 28-Jun-00
Auction house: Christie's, London

RON MUECK

REPRESENTATION →
Anthony d'Offay
9 Dering Street
GB – London W1
Tel: +44 (0)20 7 49 94 100
Fax: +44 (0)20 7 49 34 443
www.doffay.com

PRIMARY MARKET PRICES →
Not available

Ron Mueck, Big Baby 2, 1996–97

AUCTION SALES →
Price: $460.000
Pinocchio, 1996
Mixed media sculpture
83.8 x 20 x 20 cm
Date sold: 12-May-05
Auction house: Phillips, de Pury
& Company, New York

Price: $59.497
Big Baby 2, 1996–97
Sculpture, 85 x 71 x 70 cm
Date sold: 08-Dec-98
Auction house: Christie's, London

VIK MUNIZ

REPRESENTATION →
Galeria Fortes Vilaça
Rua Fadrique Coutinho 1500
BRA – 05416 – 001 São Paulo
Tel: +55 11 3 03 27 066
Fax: +55 11 3 09 70 384
www.fortesvilaca.com.br

Brent Sikkema
530 West 22nd Street
US – New York, New York 10011
Tel: +1 212 92 92 262
Fax: +1 212 92 92 340
www.brentsikkema.com

PRIMARY MARKET PRICES →
$9.000 – $60.000 (small prints)
$15.000 – $75.000 (large prints)

AUCTION SALES →
Price: $85.000
Action Photo III (after Hans
Namuth), from Pictures in
Chocolate, 1997
Photograph, 122 x 153 cm
Date sold: 27-Apr-05
Auction house: Phillips, de Pury
& Company, New York

Price: $78.148
Liz (cayenne, black pepper, curry,
chilli pepper), 1999
C-print, 199 x 199 cm
Date sold: 24-Jun-04
Auction house: Sotheby's, London

Price: $65.000
Action Photo III (after Hans
Namuth), 1997
C-print, 120 x 150 cm, Ed. 3
Date sold: 15-May-02
Auction house:
Christie's, New York

Price: $65.000
Action Photo, 1997
C-print, 151.8 x 121.3 cm
Date sold: 13-Nov-03
Auction house:
Sotheby's, New York

Price: $64.000
Sugar Children, 1996
Gelatin silver print
34 x 26 cm
Date sold: 19-Nov-01
Auction house:
Christie's, New York

Vik Muniz, Liz…, 1999

TAKASHI MURAKAMI

REPRESENTATION →
Tomio Koyama Gallery

Shinkawa 1-31-6-1F
JAP – Chuo-ku Tokyo 104-0033
Tel: +81 (0)3 6 22 21 006
Fax: +81 (0)3 3 55 12 615
www.tomiokoyamagallery.com

Marianne Boesky Gallery
535 West 22nd Street
US – New York, NY 10011
Tel: +1 212 68 09 889
Fax: +1 212 68 09 897
www.marianneboesky.com

PRIMARY MARKET PRICES →
Not available

Takashi Murakami, Miss Ko², 1996

AUCTION SALES →
Price: $550.000
Flower Ball (3-R), 2002
Acrylic/canvas, 250 cm
Date sold: 12-May-04
Auction house:
Sotheby's, New York

Price: $550.000
Untitled, 1999–2001
Acrylic/canvas/panel
203.2 x 203.2 cm
Date sold: 11-Nov-03
Auction house:
Christie's, New York

Price: $500.000
Miss Ko², 1996
Painted fibreglass
188 x 61 x 88.9 cm
Date sold: 14-May-03
Auction house:
Christie's, New York

Price: $450.000
In the Deep DOB,
Yellow/Green/Pink/Aqua/Blue/

Purple, 1999
Acrylic/canvas, 5 separated
panels, 70 x 100 cm each
Date sold: 11-May-04
Auction house:
Christie's, New York

Price: $440.000
Mega Mushroom, 2000
Acrylic/canvas, 180 x 141.8 cm
Date sold: 12-Nov-03
Auction house:
Sotheby's, New York

YOSHITOMO NARA

REPRESENTATION →
Tomio Koyama Gallery
Shinkawa 1-31-6-1F
JAP – Chuo-ku Tokyo 104-0033
Tel: +81 3 6 22 21 006
Fax: +81 3 3 55 12 615
www.tomiokoyamagallery.com

Johnen + Schöttle
Maria-Hilf-Straße 17
D – 50677 Cologne
Tel: +49 (0)221 3 10 270
Fax: +49 (0)221 31 02 727
www.johnen-schoettle.de

Marianne Boesky Gallery
535 West 22nd Street
US – New York, NY 10011
Tel: +1 212 68 09 889
Fax: +1 212 68 09 897
www.marianneboesky.com

Galerie Zink & Gegner
Theresienstraße 122a
D – 80333 Munich
Tel: +49 (0)89 5 23 89 449
Fax: +49 (0)89 5 23 89 455
www.zink-gegner.de

PRIMARY MARKET PRICES →
$5.000 – $20.000 (drawings)
$36.000 – $100.000 (paintings)

Yoshitomo Nara,
Nice to See You Again, 1996

AUCTION SALES →
Price: $320.000
Your Dog, 2002

Fibreglass
182.9 x 129.5 x 274.3 cm
Date sold: 12-May-05
Auction house:
Phillips, de Pury & Company,
New York

Price: $280.000
Nice to See You Again, 1996
Acrylic/canvas, 180 x 150 cm
Date sold: 11-May-05
Auction house:
Sotheby's, New York

Price: $260.000
Doll, 2000
Acrylic/canvas, 165 x 150 cm
Date sold: 11-Nov-04
Auction house:
Christie's, New York

Price: $180.000
Present, 1994
Oil/canvas, 180.3 x 149.9 cm
Date sold: 09-Nov-04
Auction house:
Sotheby's, New York

Price: $170.000
Blue Sheep, 1999
Acrylic/canvas, 121.9 x 111.8 cm
Date sold: 12-May-04
Auction house:
Sotheby's, New York

SHIRIN NESHAT

REPRESENTATION →
Barbara Gladstone Gallery
515 West 24th Street
US – New York, NY 10011
Tel: +1 212 20 69 300
Fax: +1 212 20 69 301
www.gladstonegallery.com

PRIMARY MARKET PRICES →
Not available

AUCTION SALES →
Price: $70.700
Speechless, 1996
Gelatin silver print
124.5 x 91.5 cm
Date sold: 14-May-01
Auction house:
Phillips, New York

Price: $58.000
Unveiling, 1993
Coloured inks on gelatin
silver print, 148.6 x 102.2 cm
Date sold: 18-May-01
Auction house:
Christie's, New York

Price: $57.000
Offered Eyes,
Unveiling Series, 1993
Gelatin silver print
144 x 99.5 cm

Date sold: 15-May-01
Auction house:
Phillips, New York

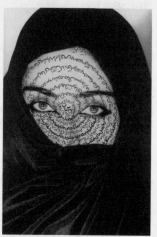

Shirin Neshat, Unveiling, 1993

Price: $48.339
Offered Eyes, 1993
Ink on gelatin silver print
35.5 x 28 cm
Date sold: 10-Feb-05
Auction house:
Christie's, London

Price: $45.000
Fervor Series, 2000
Gelatin silver print
56.5 x 45.4 cm
Date sold: 10-Nov-04
Auction house:
Sotheby's, New York

ERNESTO NETO

REPRESENTATION →
Galeria Fortes Vilaça
Rua Fadrique Coutinho 1500
BRA – 05416 – 001 São Paulo
Tel: +55 11 30 3 27 066
Fax: +55 11 30 9 70 384
www.fortesvilaca.com.br

Galerie Max Hetzler
Zimmerstraße 90/91
D – 10117 Berlin
Tel: +49 (0)30 22 92 437
Fax: +49 (0)30 22 92 417
www.maxhetzler.com

Tanya Bonakdar Gallery
521 West 21st Street
US – New York, NY 10011
Tel: +1 212 41 44 144
Fax: +1 212 41 41 535
www.tanyabonakdargallery.com

PRIMARY MARKET PRICES →
$6.000 – $27.000 (drawings)
$9.000 – $300.000 (objects,
installations)

AUCTION SALES →
Price: $45.000
It happens in the Frictions of
the Bodies, 1999
Sculpture, 1000 x 500 cm
Date sold: 14-Nov-01
Auction house:
Sotheby's, New York

Ernesto Neto, Puff, 1997

Price: $30.000
Concreta Sonho, Female, 1994
Construction, 230 x 166 x 25 cm
Date sold: 02-Jun-99
Auction house:
Christie's-East, New York

Price: $30.000
Apolo 3, 1997
Construction
335.5 x 335.5 x 274.5 cm
Date Sold: 22-Nov-00
Auction house:
Christie's, New York

Price: $16.866
Puff, 1997
Sculpture, 91.5 x 23 x 15 cm
Date sold: 10-Jun-04
Auction house:
Christie's, Paris

Price: $16.000
Live Crawl, 2000
Installation
Date sold: 18-Nov-03
Auction house:
Christie's, New York

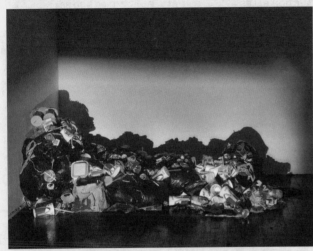

Tim Noble & Sue Webster, Wasted Youth, 2000

JUN NGUYEN-HATSUSHIBA

REPRESENTATION →
Lehmann Maupin
540 West 26th Street
US – New York, NY 10001
Tel: +1 212 22 52 923
www.lehmannmaupin.com

PRIMARY MARKET PRICES →
Not available

FRANK NITSCHE

REPRESENTATION →
Galerie Max Hetzler
Zimmerstraße 90/91
D – 10117 Berlin
Tel: +49 (0)30 22 92 437
Fax: +49 (0)30 22 92 417
www.maxhetzler.com

Leo Koenig Inc.
545 West 23rd Street
US – New York, NY 10011
Tel: +1 212 33 49 255
Fax: +1 212 33 49 304
www.leokoenig.com

Galerie Gebr. Lehmann
Görlitzer Straße 16
D – 01099 Dresden
Tel: +49 (0)351 80 11 783
Fax: +49 (0)351 80 14 908
www.galerie-gebr-lehmann.de

Galerie Nathalie Obadia
3, rue du Cloître Saint-Merri
F – 75004 Paris
Tel: +33 (0)1 4 27 46 768
Fax: +33 (0)1 4 27 46 866
www.galerie-obadia.com

PRIMARY MARKET PRICES →
$900 – $1.500 (drawings)
$10.000 – $30.000 (paintings)

TIM NOBLE & SUE WEBSTER

REPRESENTATION →
Gagosian Gallery
555 West 24th Street
US – New York, NY 10011
Tel: +1 212 74 11 111
Fax: +1 212 74 19 611
www.gagosian.com

Deitch Projects
76 Grand Street
US – New York, NY 10012
Tel: +1 212 34 37 300
Fax: +1 212 34 32 954
www.deitch.com

Modern Art
10 Vyner Street
GB – London E2 9DG
Tel: +44 (0)20 89 80 77 42
Fax: +44 (0)20 89 80 77 43
www.modernartinc.com

PRIMARY MARKET PRICES →
$17.600 – $264.000 (sculptures)

AUCTION SALES →
Price: $390.000
Toxic Schizophrenia, 1997
Light installation
260 x 200 cm
Date sold: 12-May-05
Auction house:
Phillips, de Pury & Company,
New York

Price: $260.000
Happy, 1999
Light installation
101.6 x 203.2 x 10.2 cm
Date sold: 11-Nov-04
Auction house:
Christie's, New York

Price: $200.000
The Sweet Smell of Excess, 1998
Light installation
299.7 x 248.9 x 11.4 cm
Date sold: 12-May-04
Auction house:
Sotheby's, New York

Price: $200.000
$, 2001
Light installation
182.9 x 121.9 x 25.4 cm
Date sold: 12-May-04
Auction house:
Christie's, New York

Price: $190.000
Wasted Youth, 2000
Light installation
134 x 210 x 66 cm
Date sold: 13-Nov-03
Auction house:
Phillips, de Pury & Luxembourg,
New York

MOTOHIKO ODANI

REPRESENTATION →
Yamamoto Gendai
3-7-4F, Nishi-gokencho
Shinjuku-ku
JAP – Tokyo 162-0812
Tel: +81 (0)3 5 22 53 669
Fax: +81 (0)3 5 22 53 669
www.yamamotogendai.org

Galerie Rafael Vostell Berlin
Friedrichstraße 134
D – 10117 Berlin
Tel: +49 (0)30 88 52 280
Fax: +49 (0)30 88 17 677
www.vostell.de

PRIMARY MARKET PRICES →
Not available

ALBERT OEHLEN

REPRESENTATION →
Galerie Max Hetzler
Zimmerstraße 90/91
D – 10117 Berlin
Tel: +49 (0)30 22 92 437
Fax: +49 (0)30 22 92 417
www.maxhetzler.com

Luhring Augustine
531 West 24th Street
US – New York, NY 10011
Tel: +1 212 20 69 100
Fax: +1 212 20 69 055
www.luhringaugustine.com

Galería Juana de Aizpuru
c/ Barquillo 44,1°
E – 28004 Madrid
Tel: +34 (0)91 31 05 561
Fax: +34 (0)91 31 95 286
www.galeriajuanadeaizpuru.com

Galerie Nathalie Obadia
3, rue du Cloître Saint-Merri
F – 75004 Paris
Tel: +33 (0)1 4 27 46 768
Fax: +33 (0)1 4 27 46 866
www.galerie-obadia.com

PRIMARY MARKET PRICES →
$10.000 – $30.000 (drawings)
$100.000 – $250.000 (paintings)

AUCTION SALES →
Price: $123.474
Untitled, 1989
Oil/canvas, 240 x 200 cm
Date sold: 24-Jun-05
Auction house: Christie's, London

Price: $66.000
Bild und Auge, 1996–2000
Oil/canvas, 234.6 x 343.5 cm
Date sold: 14-May-04
Auction house:
Phillips, de Pury & Company,
New York

Albert Oehlen, Untitled, 1993

Price: $55.000
Untitled, 1993
Oil/canvas, 240 x 240 cm
Date sold: 16-Nov-00
Auction house:
Christie's, New York

Price: $47.866
Untitled, 1984
Oil/canvas, 50 x 130 cm
Date sold: 01-Dec-04
Auction house:
Sotheby's, Amsterdam

Price: $40.747
Goldener Mann
schlägt Schlampe II, 1984
Acrylic/canvas, 261 x 200 cm
Date sold: 05-Dec-01
Auction house:
Lempertz, Cologne

CHRIS OFILI

REPRESENTATION →
Victoria Miro Gallery
16 Wharf Road
GB – London N1 7RW
Tel: +44 (0)20 7 33 68 109
Fax: +44 (0)20 7 25 15 596
www.victoria-miro.com

Contemporary Fine Arts
Sophienstraße 21
D – 10178 Berlin
Tel: +49 (0)30 28 87 870
Fax: +49 (0)30 2 88 78 726
www.cfa-berlin.com

David Zwirner
525 West 19th Street

US – New York, NY 10011
Tel: +1 212 72 72 070
Fax: +1 212 72 72 072
www.davidzwirner.com

Chris Ofili, Foxy Roxy, 1997

PRIMARY MARKET PRICES →
Not available

AUCTION SALES →
Price: $880.000
Afrodizzia, 1996
Mixed media, 243.8 x 182.9 cm
Date sold: 12-May-05
Auction house:
Phillips, de Pury & Company,
New York

Price: $211.500
Foxy Roxy, 1997
Mixed media, 244 x 183 x 14 cm
Date sold: 14-May-01
Auction house:
Phillips, New York

Price: $210.000
X + Y = 0, 2000
Mixed media, 244 x 366 cm
Date sold: 17-May-01
Auction house:
Christie's, New York

Price: $139.470
Flower Heads, 1996
Mixed media, 244 x 183 cm
Date sold: 27-Jun-01
Auction house:
Christie's, London

Price: $139.470
Blind Popcorn, 1996
Mixed media, 183 x 122 cm
Date sold: 27-Jun-01
Auction house:
Christie's, London

MÉLIK OHANIAN

REPRESENTATION →
Galerie Chantal Crousel
10, rue Charlot
F – 75003 Paris
Tel: +33 (0)1 4 27 73 887
Fax: +33 (0)1 4 27 75 900
www.crousel.com

Yvon Lambert Gallery
564 West 25th Street
US – New York, NY 10001
Tel: +1 212 24 23 611
Fax: +1 212 24 23 920
www.yvon-lambert.com

PRIMARY MARKET PRICES →
$8.750 (lambda print)
$17.500 (five 16mm films,
continuous projection)
$33.125 (16mm film
transferred on DVD)
$60.000 – $125.000
(installations and
video installations)

HENRIK OLESEN

REPRESENTATION →
Galerie Daniel Buchholz
Neven-DuMont-Straße 17
D – 50667 Cologne
Tel: +49 (0)221 25 74 946
Fax: +49 (0)221 2 53 351
www.galeriebuchholz.de

PRIMARY MARKET PRICES →
$6.000 – $25.000
(photographs, collages,
installations, researches,
computerprints)

PAULINA OLOWSKA

REPRESENTATION →
Foksal Gallery Foundation
Górskiego 1A
PL – 00-033 Warsaw
Tel: +48 22 82 65 081
Fax: +48 22 82 65 081
www.fgf.com.pl

Galerie Daniel Buchholz
Neven-DuMont-Straße 17
D – 50667 Cologne
Tel: +49 (0)221 25 74 946
Fax: +49 (0)221 2 53 351
www.galeriebuchholz.de

PRIMARY MARKET PRICES →
$4.750 – $15.000
(drawings, paintings, objects,
video, performances)

GABRIEL OROZCO

REPRESENTATION →
Marian Goodman Gallery
24 West 57th Street
US – New York, NY10019
Tel: +1 212 97 77 160
Fax: +1 212 58 15 187
www.mariangoodman.com

Gabriel Orozco, Horses Running Endlessly, 1995

kurimanzutto
Mazatlán 5 depto. t-6 col condesa
MEX – 06140 Mexico City
Tel: +52 5 55 28 63 059
Fax: +52 5 55 25 62 408
www.kurimanzutto.com

PRIMARY MARKET PRICES →
Not available

AUCTION SALES →
Price: $173.119
Horses Running Endlessly, 1995
Sculpture, wood, 2 x 88 x 88 cm,
Ed. 3
Date sold: 23-Jun-05
Auction house: Christie's, London

Price: $98.000
Pelotas y plátanos/caballo/dos
parejas/paleta derretida/interior
C-print
Date sold: 09-Nov-04
Auction house:
Phillips, de Pury & Company,
New York

Price: $75.000
Horses Running Endlessly, 1995
Sculpture, wood, 2 x 88 x 88 cm,
Ed. 3
Date sold: 16-Nov-00
Auction house:
Christie's, New York

Price: $48.000
Soccer, 1996
Mixed media, 200.7 x 219.7 cm
Date sold: 13-May-05
Auction house: Phillips, de Pury
& Company, New York

Price: $35.000
Orange without Space, 1993
Sculpture, 50 cm, Ed. 3
Date sold: 16-Nov-01
Auction house:
Christie's, New York

DAMIÁN ORTEGA

REPRESENTATION →
Galeria Fortes Vilaça
Rua Fadrique Coutinho 1500
BRA – 05416 – 001 São Paulo
Tel: +55 11 3 03 27 066
Fax: +55 11 3 09 70 384
www.fortesvilaca.com.br

kurimanzutto
Mazatlán 5 depto. t-6 col condesa
MEX – 06140 Mexico City
Tel: +52 55 52 86 30 59
Fax: +52 55 52 56 24 08
www.kurimanzutto.com

PRIMARY MARKET PRICES →
Not available

Jorge Pardo, Untitled, 1999

JORGE PARDO

REPRESENTATION →
neugerriemschneider
Linienstraße 155
D – 10115 Berlin
Tel: +49 (0)30 30 87 28 10
Fax: +49 (0)30 30 87 28 11
www.neugerriemschneider.com

Friedrich Petzel Gallery
535 West 22nd Street
US – New York, NY 10011
Tel: +1 212 68 09 467
Fax: +1 212 68 09 473
www.petzel.com

Galerie Gisela Capitain
Aachener Straße 5
D – 50674 Cologne
Tel: +49 (0)221 2 56 676
Fax: +49 (0)221 2 56 593
www.galerie-capitain.de

PRIMARY MARKET PRICES →
$5.000 – $125.000
(sculptures, installations)

AUCTION SALES →
Price: $130.000
Untitled (1 – 5), 2000
Silkscreen/canvas, 250 x 400 cm
Date sold: 12-May-05
Auction house: Phillips, de Pury
& Company, New York

Price: $100.000
Untitled, 1999
Acrylic/canvas, 250 x 400 cm
Date sold: 13-Nov-03
Auction house: Phillips, de Pury
& Luxembourg, New York

Price: $23.000
Untitled 9
Ink, 133.5 x 133.5 cm
Date sold: 16-May-01
Auction house:
Sotheby's, New York

Price: $17.000
Untitled, 2000

Print, 99 x 101.3 cm
Date sold: 10-Nov-04
Auction house: Sotheby's, London

Price: $10.580
1, 2, 3, 4, 5, 6, 7, 8, 10, 1994
Installation, 8 x 100 x 65 cm
Date sold: 08-Dec-99
Auction house: Christie's, New York

PHILIPPE PARRENO

REPRESENTATION →
Air de Paris
32, rue Louise Weiss
F – 75013 Paris
Tel: +33 (0)1 4 42 30 277
Fax: +33 (0)1 5 36 12 284
www.airdeparis.com

Esther Schipper
Linienstraße 85
D – 10119 Berlin
Tel: +49 (0)30 2 83 90 139
Fax: +49 (0)30 2 83 90 140
www.estherschipper.com

Friedrich Petzel Gallery
535 West 22nd Street
US – New York, NY 10011
Tel: +1 212 68 09 467
Fax: +1 212 68 09 473
www.petzel.com

PRIMARY MARKET PRICES →
Not available

BRUNO PEINADO

REPRESENTATION →
Galerie Loevenbruck
40, rue de Seine,
2, rue de l'Echaudé
F – 75006 Paris
Tel: +33 (0)1 5 31 08 568
Fax: +33 (0)1 5 31 08 972
www.loevenbruck.com

Parker's Box
193 Grand Street

US – Brooklyn, NY 11211
Tel: +1 718 38 82 882
www.parkersbox.com

PRIMARY MARKET PRICES →
$1.000 – $5.000 (drawings)
$2.500 – $20.000 (paintings)
$5.000 – $45.000 (ceramics)
$5.000 – $250.000
(sculptures and installations)

MANFRED PERNICE

REPRESENTATION →
Galerie Neu
Phillipstraße 13
D – 10115 Berlin
Tel: +49 (0)30 28 57 550
Fax: +49 (0)30 28 10 085

Anton Kern Gallery
532 West 20th Street
US – New York, NY 10011
Tel: +1 212 36 79 663
Fax: +1 212 36 78 135
www.antonkerngallery.com

PRIMARY MARKET PRICES →
Not available

GRAYSON PERRY

REPRESENTATION →
Victoria Miro Gallery
16 Wharf Road
GB – London N1 7RW
Tel: +44 (0)20 7 33 68 109
Fax: +44 (0)20 7 25 15 596
www.victoria-miro.com

PRIMARY MARKET PRICES →
Not available

RAYMOND PETTIBON

REPRESENTATION →
Regen Projects
633 North Almont Drive
US – Los Angeles, CA 90069
Tel: +1 310 27 65 424
Fax: +1 310 27 67 430
www.regenprojects.com

Contemporary Fine Arts
Sophienstraße 21
D – 10178 Berlin
Tel: +49 (0)30 28 87 870
Fax: +49 (0)30 2 88 78 726
www.cfa-berlin.com

David Zwirner
525 West 19th Street
US – New York, NY 10011
Tel: +1 212 72 72 070
Fax: +1 212 72 72 072
www.davidzwirner.com

PRIMARY MARKET PRICES →
ca. $4.000 – $12.000 (drawings)

AUCTION SALES →
Price: $58.157
A big wave.../And in this he.../
The Lady in the.../There...
Watercolour
Date sold: 24-Jun-04
Auction house: Sotheby's, London

Raymond Pettibon, Untitled, 1990

Price: $56.080
Untitled, 1990
Ink, watercolour/paper,
10 drawings
Date sold: 06-Feb-03
Auction house: Christie's, London

Price: $29.000
Untitled, 1993
Mixed media drawing
91.4 x 152.4 cm
Date sold: 12-May-05
Auction house: Christie's, New York

Price: $28.000
Untitled, 1984–2000
Ink, pen/paper
Date sold: 14-May-04
Auction house: Phillips, de Pury
& Company, New York

Price: $27.000
Vavoom/The Day the Loving
Stopped/The Ufo Sighting/
Life size, 1984–1992 / Ink
Date sold: 12-Nov-04
Auction house: Phillips, de Pury
& Company, New York

ELIZABETH PEYTON

REPRESENTATION →
neugerriemschneider
Linienstraße 155
D – 10115 Berlin
Tel: +49 (0)30 28 87 72 77
Fax: +49 (0)30 28 87 72 78
www.neugerriemschneider.com

Gavin Brown's enterprise
620 Greenwich Street

US – New York, NY 10014
Tel: +1 212 62 75 258
Fax: +1 212 62 75 261
www.gavinbrown.biz

Sadie Coles HQ
35 Heddon Street
GB – London W1B 4BP
Tel: +44 (0)20 7 43 42 227
Fax: +44 (0)20 7 43 42 228
www.sadiecoles.com

PRIMARY MARKET PRICES →
$2.000 – $250.000
(prints, drawings, watercolours
and paintings)

AUCTION SALES →
Price: $700.000
John Lennon, 1964
Oil/masonite, 61.2 x 48.5 cm
Date sold: 11-May-05
Auction house: Christie's,
New York

Price: $114.413
Matthew, 1997
Oil/canvas, 99 x 70.5 cm
Date sold: 27-Jun-02
Auction house: Christie's, London

Price: $90.000
Jarvis and Liam smoking, 1997
Oil/canvas, 30.5 x 22.9 cm
Date sold: 13-Nov-03
Auction house:
Sotheby's, New York

Price: $80.000
David, Victoria + Brooklyn, 1999
Oil/canvas, 152.5 x 101.5 cm
Date sold: 17-May-01
Auction house:
Christie's, New York

Elizabeth Peyton, Colin de Land,
1994

Price: $77.300
Colin de Land, 1994
Oil/canvas, 152.5 x 101.5 cm
Date sold: 14-May-01
Auction house: Phillips, New York

A traveling salesman's car broke down one evening
on a lonely road and he asked at the only farm
house in sight. "Can you put me up for the nite?"
"I reckon I can," said the farmer. "But you'll have to
share the room with my young son ." "How about
that!" gasped the salesman. "I'm in the wrong joke."

Richard Prince, The Wrong Joke, 1994

RICHARD PHILLIPS

REPRESENTATION →
Friedrich Petzel Gallery
535 West 22nd Street
US – New York, NY 10011
Tel: +1 212 68 09 467
Fax: +1 212 68 09 473
www.petzel.com

Galerie Max Hetzler
Zimmerstraße 90/91
D – 10117 Berlin
Tel: +49 (0)30 22 92 437
Fax: +49 (0)30 22 92 417
www.maxhetzler.com

White Cube
48 Hoxton Square
GB – London N1 6PB
Tel: +44 (0)20 7 93 05 373
Fax: +44 (0)20 7 74 97 480
www.whitecube.com

PRIMARY MARKET PRICES →
$4.000 (print)
$5.000 – $18.000 (drawings)
$100.000 – $175.000 (paintings)

RICHARD PRINCE

REPRESENTATION →
Barbara Gladstone Gallery
515 West 24th Street
US – New York, NY 10011
Tel: +1 212 20 69 300
Fax: +1 212 20 69 301
www.gladstonegallery.com

Regen Projects
633 North Almont Drive
US – Los Angeles, CA 90069
Tel: +1 310 27 65 424
Fax: +1 310 27 67 430
www.regenprojects.com

Sadie Coles HQ
35 Heddon Street
GB – London W1B 4BP
Tel: +44 (0)20 7 43 42 227
Fax: +44 (0)20 7 43 42 228
www.sadiecoles.com

PRIMARY MARKET PRICES →
Not available

AUCTION SALES →
Price: $900.000
A Nurse Involved, 2002
Mixed media, 183 x 114 cm
Date sold: 12-May-05
Auction house: Phillips, de Pury
& Company, New York

Price: $700.000
The Wrong Joke, 1994
Acrylic/canvas, 142 x 122 cm
Date sold: 11-May-05
Auction house:
Christie's, New York

Price: $660.000
My Name, 1987
Acrylic/canvas, 142 x 244 cm
Date sold: 13-May-04
Auction house:
Phillips, de Pury & Company,
New York

Price: $650.000
Women Looking in the Same
Direction, 1980
Photograph, 50.8 x 61 cm
Date sold: 09-Nov-04
Auction house:
Sotheby's, New York

Price: $550.000
Oriental Glasses, 1982
Ektachrome, 76.1 x 101.6 cm
Date sold: 12-May-05
Auction house:
Christie's, New York

NEO RAUCH

REPRESENTATION →
Galerie Eigen + Art
Auguststraße 26
D – 10117 Berlin
Tel: +49 (0)30 28 06 605
Fax: +49 (0)30 28 06 616
www.eigen-art.com

David Zwirner
525 West 19th Street
US – New York, NY 10011
Tel: +1 212 72 72 070
Fax: +1 212 72 72 072
www.davidzwirner.com

PRIMARY MARKET PRICES →
$3.000 (prints)
$25.000 – $120.000 (drawings)
$160.000 – $400.000
(paintings)

AUCTION SALES →
Price: $170.000
Gegenlicht, 2000
Oil/canvas, 250 x 200 cm
Date sold: 15-May-03
Auction house: Phillips, de Pury
& Luxembourg, New York

Price: $170.000
Hauptgebäude, 1997
Oil/canvas, 110 x 203 cm
Date sold: 13-May-05
Auction house: Phillips, de Pury
& Company, New York

Price: $160.000
Kamin, 2000
Oil/canvas, 100 x 70 cm
Date sold: 12-May-04
Auction house:
Christie's, New York

Price: $140.000
Hafenstadt, 1995
Oil/paper/canvas, 130 x 205 cm
Date sold: 14-Nov-03
Auction house: Phillips, de Pury
& Luxembourg, New York

Price: $120.000
Produktion, 1998
Oil/canvas, 200 x 250 cm

Date sold: 13-May-02
Auction house: Phillips, de Pury
& Luxembourg, New York

Neo Rauch, Kamin, 2000

TOBIAS REHBERGER

REPRESENTATION →
neugerriemschneider
Linienstraße 155
D – 10115 Berlin
Tel: +49 (0)30 2 88 77 277
Fax: +49 (0)30 2 88 77 278
www.neugerriemschneider.com

Galerie Bärbel Grässlin
Bleichstraße 48
D – 60313 Frankfurt
Tel: +49 (0)69 2 80 961
Fax: +49 (0)69 2 94 277
www.galerie-graesslin.de

Friedrich Petzel Gallery
535 West 22nd Street
US – New York, NY 10011
Tel: +1 212 68 09 467
Fax: +1 212 68 09 473
www.petzel.com

PRIMARY MARKET PRICES →
$4.000 – $180.000

AUCTION SALES →
Price: $22.000
Suck, Watch, Sucked,
Watched, 1999
Installation, 160 x 160 x 90.5 cm
Date sold: 12-Nov-04
Auction house: Phillips, de Pury
& Company, New York

PEDRO REYES

REPRESENTATION →
Galería Enrique Guerrero
Horacio 1549-A Polanco
MEX – 11540 México DF
Tel: +52 55 5 28 02 941
Fax: +52 55 5 28 03 283
www.arte-mexico.com/eguerrero

Yvon Lambert Gallery
564 West 25th Street
US – New York, NY 10001
Tel: +1 212 24 23 611
Fax: +1 212 24 23 920
www.yvon-lambert.com

PRIMARY MARKET PRICES →
$1.000 – $2.000 (drawings)
$1.000 – $5.000 (objects)
$10.000 – $20.000 (installations)

JASON RHOADES

REPRESENTATION →
Hauser & Wirth
Limmatstraße 270
CH – 8005 Zürich
Tel: +41 (0)44 44 68 050
Fax: +41 (0)44 44 68 055
www.ghw.ch

PRIMARY MARKET PRICES →
Not available

DANIEL RICHTER

REPRESENTATION →
Contemporary Fine Arts
Sophienstraße 21
D – 10178 Berlin
Tel: +49 (0)30 28 87 870
Fax: +49 (0)30 2 88 78 726
www.cfa-berlin.com

David Zwirner
525 West 19th Street
US – New York, NY 10011
Tel: +1 212 72 72 070
Fax: +1 212 72 72 072
www.davidzwirner.com

PRIMARY MARKET PRICES →
ca. $7.800 (drawings) –
$114.000 (paintings)

Daniel Richter, Gedion, 2002

AUCTION SALES →
Price: $210.000
Gedion, 2002
Mixed media, 306 x 339 cm
Date sold: 13-Nov-03
Auction house: Phillips, de Pury
& Luxembourg, New York

Price: $125.000
Grünspan, 2002

Lacquer, 339 x 295 cm
Date sold: 11-Nov-04
Auction house:
Phillips, de Pury & Company,
New York

Price: $109.044
Ein schöner Traum von Anarchie
und Gewalt, 1999
Oil/canvas, 218.5 x 179 cm
Date sold: 24-Jun-04
Auction house:
Christie's, London

Price: $72.389
Frühling, Flirrung, Flüchtung, 1999
Oil/canvas, 172.5 x 215 cm
Date sold: 12-May-04
Auction house:
Chochon-Barré-Allardi (S. V. V.),
Paris

Price: $68.000
Mistress of Puppets, 2002
Oil/canvas, 269 x 230 cm
Date sold: 13-May-04
Auction house:
Phillips, de Pury & Company,
New York

DE RIJKE/DE ROOIJ

REPRESENTATION →
Galerie Daniel Buchholz
Neven-DuMont-Straße 17
D – 50667 Cologne
Tel: +49 (0)221 25 74 946
Fax: +49 (0)221 2 53 351
www.galeriebuchholz.de

Galerie Chantal Crousel
10, rue Charlot
F – 75003 Paris
Tel: +33 (0)1 4 27 73 887
Fax: +33 (0)1 4 27 75 900
www.crousel.com

Regen Projects
633 North Almont Drive
US – Los Angeles, CA 90069
Tel: +1 310 27 65 424
Fax: +1 310 27 67 430
www.regenprojects.com

PRIMARY MARKET PRICES →
$9.375 – $68.750 (films)

PIPILOTTI RIST

REPRESENTATION →
Hauser & Wirth
Limmatstraße 270
CH – 8005 Zürich
Tel: +41 (0)44 44 68 050
Fax: +41 (0)44 44 68 055
www.ghw.ch

Luhring Augustine
531 West 24th Street

Pipilotti Rist, Bar, 1999

US – New York, NY 10011
Tel: +1 212 20 69 100
Fax: +1 212 20 69 055
www.luhringaugustine.com

PRIMARY MARKET PRICES →
Not available

AUCTION SALES →
Price: $104.601
Bar, 1999
Installation, 110 x 180 x 76 cm
Date sold: 27-Jun-00
Auction house: Christie's, London

Price: $90.220
Bar, 1999
Installation, 110 x 180 x 76 cm
Date sold: 20-Oct-04
Auction house:
Christie's-South-Kensington,
London

Price: $60.000
Wunderlampe, 1993
Installation, 150 x 55 x 44 cm
Date sold: 16-Nov-00
Auction house:
Christie's, New York

Price: $26.000
Hallo, Guten Tag! Kassmund, 1995
Video installation
40 x 29.8 x 5.1 cm
Date sold: 14-Nov-03
Auction house:
Phillips, de Pury & Luxembourg,
New York

Price: $26.000
Remake of the Weekend (Stills),
1998
Video stills, 49.5 x 65.5 cm, Ed. 30
Date sold: 17-Nov-00
Auction house:
Christie's, New York

MATTHEW RITCHIE

REPRESENTATION →
Andrea Rosen Gallery
525 West 24th Street
US – New York, NY 10011
Tel: +1 212 62 76 000
Fax: +1 212 62 75 450
www.andrearosengallery.com

c/o – Atle Gerhardsen
Holzmarktstraße 15–18
D – 10179 Berlin
Tel: +49 (0)30 6 95 18 341
Fax: +49 (0)30 6 95 18 342
www.atlegerhardsen.com

PRIMARY MARKET PRICES →
Not available

UGO RONDINONE

REPRESENTATION →
Galerie Eva Presenhuber
Limmatstraße 270
CH – 8031 Zürich
Tel: +41 (0)43 44 47 050
Fax: +41 (0)43 44 47 060
www.presenhuber.com

Sadie Coles HQ
35 Heddon Street
GB – London W1B 4BP
Tel: +44 (0)20 7 43 42 227
Fax: +44 (0)20 7 43 42 228
www.sadiecoles.com

Esther Schipper
Linienstraße 85
D – 10119 Berlin
Tel: +49 (0)30 2 83 90 139
Fax: +49 (0)30 2 83 90 140
www.estherschipper.com

PRIMARY MARKET PRICES →
Not available

AUCTION SALES →
Price: $230.000
No. 69, 1996
Indian ink/paper, 274 x 500 cm
Date sold: 12-May-05
Auction house:
Phillips, de Pury & Company,
New York

Price: $102.020
No. 280 Einundzwanzigstermai-
zweitausendundzwei, 2002
Acrylic/canvas, 220 cm
Date sold: 09-Feb-05
Auction house: Christie's, London

Price: $98.000
No. 114 Fünfzehnteroktober-
neunzehnhundertachtund-
neunzig, 1998
Acrylic/canvas, 220 cm
Date sold: 14-Nov-03
Auction house:
Phillips, de Pury & Luxembourg,
New York

Price: $90.000
No. 70, 1996
Acrylic/canvas, 274.3 x 500 cm
Date sold: 13-Nov-03
Auction house:
Phillips, de Pury & Luxembourg,
New York

Ugo Rondinone, No. 280
Einundzwanzigstermaizweitausend-
undzwei, 2002

Price: $85.000
No. 174, 1996
Zweiundzwanzigsterfebruar-
zweitausendundnull, 2000
Acrylic/canvas, 270 cm
Date sold: 13-Nov-03
Auction house:
Sotheby's, New York

THOMAS RUFF

REPRESENTATION →
Johnen + Schöttle
Maria-Hilf-Straße 17
D – 50677 Cologne

Tel: +49 (0)221 3 10 270
Fax: +49 (0)221 31 02 727
www.johnen-schoettle.de

David Zwirner
525 West 19th Street
US – New York, NY 10011
Tel: +1 212 72 72 070
Fax: +1 212 72 72 072
www.davidzwirner.com

PRIMARY MARKET PRICES →
$36.000 – $80.000

Thomas Ruff, Sterne 02h 56m – 65°,
1989

AUCTION SALES →
Price: $125.000
Nudes gr21, 2002
Photograph, 130 x 145 cm
Date sold: 12-May-05
Auction house:
Christie's, New York

Price: $102.000
Substrat 4III, 2003
C-print, 186 x 240 cm
Date sold: 09-Nov-04
Auction house;
Phillips, de Pury & Company,
New York

Price: $101.584
Sterne 02h 56m – 65°, 1989
Photograph, 252 x 180 cm, Ed. 2
Date sold: 23-Oct-01
Auction house: Christie's, London

Price: $86.610
09h 58m – 40°, 1990
C-print, 201 x 134 cm, Ed. 2
Date sold: 09-Feb-01
Auction house: Christie's, London

Price: $85.000
04h 40m – 45°, 1992
Photograph, 260 x 188 cm
Date sold: 13-May-05
Auction house:
Phillips, de Pury & Company,
New York

TOM SACHS

REPRESENTATION →
Sperone Westwater
415 West 13th Street
US – New York, NY 10014
Tel: +1 212 99 97 337
Fax: +1 212 99 97 338
www.speronewestwater.com

Galerie Thaddaeus Ropac
7, rue Debelleyme
F – 75003 Paris
Tel: +33 (0)1 427 29 900
Fax: +33 (0)1 427 26 166
www.ropac.net

PRIMARY MARKET PRICES →
Not available

AUCTION SALES →
Price: $32.500
Test Module Six (Mini Urinal),
2000
Construction
36.5 x 39.4 x 14 cm
Date sold: 11-May-05
Auction house:
Sotheby's, New York

Tom Sachs, Test Module Six
(Mini Urinal), 2000

Price: $28.000
High line (12 gauge), 2004
Mixed media sculpture
Date sold: 18-Nov-04
Auction house:
Phillips, de Pury & Company,
New York

Price: $18.000
Chanel Happy Meal, 1999
Construction, 11 x 35.5 x 26.5 cm
Date sold: 15-May-01
Auction house:
Phillips, New York

Price: $18.000
Miffy, 2002
Sculpture, 23.8 x 11.4 x 10.8 cm
Date sold: 14-May-04
Auction house: Phillips, de Pury
& Company, New York

Price: $15.000
Tiffany Value Meal, 2000

Construction, 29.9 x 45.1 x 32.1 cm
Date sold: 12-Nov-04
Auction house:
Phillips, de Pury & Company,
New York

ANRI SALA

REPRESENTATION →
Johnen + Schöttle
Maria-Hilf-Straße 17
D – 50677 Cologne
Tel: +49 (0)221 3 10 270
Fax: +49 (0)221 31 02 727
www.johnen-schoettle.de

Marian Goodman Gallery
24 West 57th Street
US – New York, NY 10019
Tel: +1 212 97 77 160
Fax: +1 212 58 15 187
www.mariangoodman.com

Hauser & Wirth
Limmatstraße 270
CH – 8005 Zürich
Tel: +41 (0)44 44 68 050
Fax: +41 (0)44 44 68 055
www.ghw.ch

PRIMARY MARKET PRICES →
$6.000 – $12.000 (photographs)
$36.000 – $55.000 (videos)

WILHELM SASNAL

REPRESENTATION →
Foksal Gallery Foundation
Górskiego 1A
PL – 00-033 Warsaw
Tel: +48 22 82 65 081
Fax: +48 22 82 65 081
www.fgf.com.pl

Johnen + Schöttle
Maria-Hilf-Straße 17
D – 50677 Cologne
Tel: +49 (0)221 31 02 70
Fax: +49 (0)221 31 02 727
www.johnen-schoettle.de

Hauser & Wirth
Limmatstraße 270
CH – 8005 Zürich
Tel: +41 (0)44 44 68 050
Fax: +41 (0)44 44 68 055
www.ghw.ch

PRIMARY MARKET PRICES →
Not available

AUCTION SALES →
Price: $52.000
Untitled, 1999
Oil/canvas, 88.9 x 88.9 cm
Date sold: 12-Nov-04
Auction house:
Phillips, de Pury & Company,
New York

JENNY SAVILLE

REPRESENTATION →
Gagosian Gallery
555 West 24th Street
US – New York, NY 10011
Tel: +1 212 74 11 111
Fax: +1 212 74 19 611
www.gagosian.com

PRIMARY MARKET PRICES →
Not available

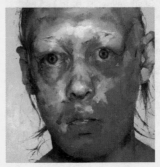
Jenny Saville, Figure 11.23, 1997

AUCTION SALES →
Price: $480.000
Figure 11.23, 1997
Oil/canvas, 152.5 x 152.5 cm
Date sold: 14-May-02
Auction house:
Christie's, New York

Price: $465.976
Untitled, 1990
Oil/canvas, 204.5 x 183.5 cm
Date sold: 25-Jun-03
Auction house:
Sotheby's, London

Price: $418.410
Branded, 1992
Oil/canvas, 213.5 x 183 cm
Date sold: 27-Jun-01
Auction house:
Christie's, London

Price: $350.000
Factor 8, 1992
Oil/canvas, 129.5 x 97.8 cm
Date sold: 09-Nov-04

Auction house:
Sotheby's, New York

Price: $327.132
Knead, 1995–96
Oil/canvas: 137.5 x 157.5 cm
Date sold: 24-Jun-04
Auction house:
Christie's, London

THOMAS SCHEIBITZ

REPRESENTATION →
Tanya Bonakdar Gallery
521 West 21st Street
US – New York, NY 10011
Tel: +1 212 41 44 144
Fax: +1 212 41 41 535
www.tanyabonakdargallery.com

White Cube
48 Hoxton Square
GB – London N1 6PB
Tel: +44 (0)20 7 93 05 373
Fax.: +44 (0)20 7 74 97 480
www.whitecube.com

Galerie Monika Sprüth
Philomene Magers
Wormser Straße 23
D – 50677 Cologne
Tel: +49 (0)221 3 80 415
Fax: +49 (0)221 3 80 417
Schellingstraße 48
D – 80799 Munich
Tel: +49 (0)89 3 30 40 600
Fax: +49 (0)89 3 79 302
www.spruethmagers.com

PRIMARY MARKET PRICES →
Not available

AUCTION SALES →
Price: $88.000
Untitled (Nr. 128), 1997
Acrylic/canvas, 150 x 270 cm
Date sold: 12-May-04
Auction house:
Christie's, New York

Price: $68.000
Untitled (Nr. 372), 2003
Oil/canvas, 145 x 250 cm

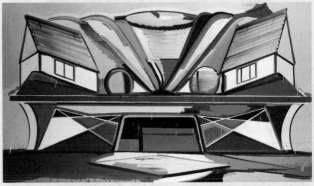
Thomas Scheibitz, Untitled (Nr. 128), 1997

Date sold: 14-May-04
Auction house: Phillips, de Pury
& Company, New York

Price: $50.000
Haus (Nr. 159), 1998
Oil/canvas, 150 x 270 cm
Date sold: 12-Nov-03
Auction house:
Christie's, New York

GREGOR SCHNEIDER

REPRESENTATION →
Galerie Luis Campaña
An der Schanz 1a
D – 50735 Cologne
Tel: +49 (0)221 2 56 712
Fax: +49 (0)221 2 56 213
www.luiscampana.com

Barbara Gladstone Gallery
515 West 24th Street
US – New York, NY 10011
Tel: +1 212 20 69 300
Fax: +1 212 20 69 301
www.gladstonegallery.com

Konrad Fischer Galerie
Platanenstraße 7
D – 40233 Düsseldorf
Tel: +49 (0)211 6 85 908
Fax: +49 (0)211 6 89 780
www.konradfischergalerie.de

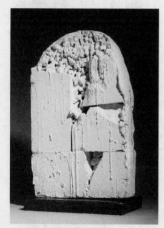

Gregor Schneider, Grabstein Totes
Haus ur, Rheydt, 2000

PRIMARY MARKET PRICES →
$625 – $437.500 (installations)

AUCTION SALES →
Price: $57.408
Kellerfenster, 1985–99
Sculpture, 237 x 135 x 47.5 cm
Date sold: 06-Feb-02
Auction house: Christie's, London

Price: $15.505
Grabstein Totes Haus ur,
Rheydt, 2000
Plaster, 78.1 x 47 x 33 cm

Date sold: 25-Jun-04
Auction house: Christie's, London

Price: $12.000
Totes Haus ur, 1999
Photograph, 25.4 x 19.7 cm
Date sold: 13-Nov-01
Auction house: Phillips, de Pury
& Luxembourg, New York

Price: $10.000
Das Total Isolierte Gästezimmer –
Gästezimmer, Rheydt,
Kunsthalle, 1996
Photograph, 31 x 23 cm
Date sold: 16-May-02
Auction house:
Sotheby's, New York

Price: $6.927
Haus ur Rheydt, Raum ur 20/
Im Kern/Das letzte Loch/
Liebeslaube, 1996
Gelatin silver print, 16 x 11 cm
Date sold: 06-Feb-03
Auction house: Christie's, London

THOMAS SCHÜTTE

REPRESENTATION →
Marian Goodman Gallery
24 West 57th Street
US – New York, NY10019
Tel: +1 212 97 77 160
Fax: +1 212 58 15 187
www.mariangoodman.com

Konrad Fischer Galerie
Platanenstraße 7
D – 40233 Düsseldorf
Tel: +49 (0)211 6 85 908
Fax: +49 (0)211 6 89 780
www.konradfischergalerie.de

carlier | gebauer
Holzmarktstraße 15–18
Bogen 51/52
D – 10179 Berlin
Tel: +49 (0)30 28 08 110
Fax: +49 (0)30 28 08 109
www.carliergebauer.com

PRIMARY MARKET PRICES →
$18.000 – $25.000 (prints)
$60.000 – $400.000
(sculptures)

AUCTION SALES →
Price: $206.587
Große Geister, 1996
3 Figures
Date sold: 08-Dec-98
Auction house: Christie's, London

Price: $160.000
Untitled, 1994
Photograph, 68.9 x 47 cm
Date sold: 08-Nov-04
Auction house: Phillips, de Pury
& Company, New York

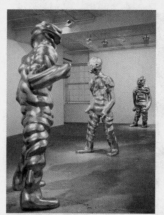

Thomas Schütte, Große Geister,
1996

Price: $58.597
Study for Die Fremden, 1992
Gouache, 108 x 197.3 cm
Date sold: 26-Jun-03
Auction house: Sotheby's, London

Price: $53.794
Geister, 1997
Sculpture, metal
Date sold: 27-Jun-00
Auction house: Christie's, London

Price: $50.499
Boats, 1986
Sculpture, wood
160 x 175 x 380 cm
Date sold: 29-Jun-99
Auction house: Christie's, London

RAQIB SHAW

REPRESENTATION →
Victoria Miro Gallery
16 Wharf Road
GB – London N1 7RW
Tel: +44 (0)20 7 33 68 109
Fax: +44 (0)20 7 25 15 596
www.victoria-miro.com

Cindy Sherman, Untitled Film Still #48, 1979

Deitch Projects
76 Grand Street
US – New York, NY 10012
Tel: +1 212 34 37 300
Fax: +1 212 34 32 954
www.deitch.com

PRIMARY MARKET PRICES →
Not available

CINDY SHERMAN

REPRESENTATION →
Metro Pictures
519 West 24th Street
US – New York, NY 10011
Tel: +1 212 20 67 100
Fax: +1 212 33 70 070
www.metropicturesgallery.com

Galerie Monika Sprüth
Philomene Magers
Wormser Straße 23
D – 50677 Cologne
Tel: +49 (0)221 3 80 415
Fax: +49 (0)221 3 80 417
Schellingstraße 48
D – 80799 Munich
Tel: +49 (0)89 3 30 40 600
Fax: +49 (0)89 3 79 302
www.spruethmagers.com

PRIMARY MARKET PRICES →
$25.000 – $187.500
(b/w and colour photographs)

AUCTION SALES →
Price: $420.000
Untitled N° 92, 1981
Colour coupler print, 61 x 121.9 cm
Date sold: 08-Nov-04
Auction house: Phillips, de Pury
& Company, New York

Price: $360.000
Untitled #234 #235 #236 #237
#238 #239, 1987–91
Colour photography

Thomas Struth, Pantheon, Rome, 1990

228.6 x 152.4 cm
Date sold: 12-May-05
Auction house:
Phillips, de Pury & Company,
New York

Price: $300.000
Untitled Film Still #48, 1979
Gelatin silver print
20 x 25.5 cm, Ed. 10
Date sold: 17-May-01
Auction house:
Christie's, New York

Price: $280.000
Untitled Film Still #48, 1979
Photograph, 40 x 51 cm
Date sold: 12-May-04
Auction house:
Sotheby's, New York

Price: $240.000
Untitled #209, 1989
Colour photography, 145 x 104 cm
Date sold: 17-May-00
Auction house:
Sotheby's, New York

SANTIAGO SIERRA

REPRESENTATION →
Galerie Peter Kilchmann
Limmatstraße 270
CH – 8005 Zürich
Tel: +41 (0)1 44 03 931
Fax: +41 (0)1 44 03 932
www.kilchmanngalerie.com

Lisson Gallery
52–54 Bell Street
GB – London NW1 5DA
Tel: +44 (0)20 7 72 42 739
Fax: +44 (0)20 7 72 47 124
www.lisson.co.uk

Galería Helga de Alvear
Doctor Fourquet, 12
E – 28012 Madrid
Tel: +34 91 46 80 506

Fax: +34 91 46 75 134
www.helgadealvear.net

PRIMARY MARKET PRICES →
ca. $20.000 (video, edition of 3)
ca. $13.000 (photographs, edition
of 5 or 6, ca. 150 x 220 cm)
ca. $3.000 – $5.000 (photographs,
edition of 10, small size)
ca. $50.000 (the right to repeat
a performance one time)

SIMON STARLING

REPRESENTATION →
The Modern Institute
73 Robertson Street
GB – Glasgow G2 8QD
Tel: +44 (0)141 24 83 711
Fax: +44 (0)141 24 83 280
www.themoderninstitute.com

neugerriemschneider
Linienstraße 155
D – 10115 Berlin
Tel: +49 (0)30 28 87 72 77
Fax: +49 (0)30 28 877 278
www.neugerriemschneider.com

PRIMARY MARKET PRICES →
$5.000 – $90.000

THOMAS STRUTH

REPRESENTATION →
Galerie Max Hetzler
Zimmerstraße 90/91
D – 10117 Berlin
Tel: +49 (0)30 22 92 437
Fax: +49 (0)30 22 92 417
www.maxhetzler.com

Marian Goodman Gallery
24 West 57th Street
US – New York, NY 10019
Tel: +1 212 97 77 160
Fax: +1 212 58 15 187
www.mariangoodman.com

PRIMARY MARKET PRICES →
$7.800 – $180.000

AUCTION SALES →
Price: $367.950
Pantheon, Rome, 1990
C-print, 137 x 194.5 cm
Date sold: 21-Oct-03
Auction house:
Sotheby's, London

Price: $280.000
Fassade, 1998
Colour photography
189.2 x 235 cm
Date sold: 14-May-02
Auction house:
Christie's, New York

Price: $261.331
Galleria dell'Accademia,
Venice, 1992
C-print, 189 x 234 cm
Date sold: 07-Feb-02
Auction house:
Sotheby's, London

Price: $240.000
Pantheon, Rome, 1992
C-print, 188 x 241.5 cm
Date sold: 16-May-00
Auction house:
Christie's, New York

Price: $210.000
Pantheon, Rome, 1990
C-print, 183.5 x 238 cm
Date sold: 14-Nov-00
Auction house:
Sotheby's, New York

CATHERINE SULLIVAN

REPRESENTATION →
Galerie Christian Nagel
Richard-Wagner-Straße 28
D – 50674 Cologne
Tel: +44 (0)221 25 70 591
Fax: +49 (0)221 25 70 592
www.galerie-nagel.de

Metro Pictures
519 West 24th Street
US – New York, NY 10011
Tel: +1 212 20 67 100
Fax: +1 212 33 70 070
www.metropicturesgallery.com

PRIMARY MARKET PRICES →
$2.500 – $16.875 (photographs)
$37.500 – $93.750
(DVD, video and installations)

WOLFGANG TILLMANS

REPRESENTATION →
Galerie Daniel Buchholz
Neven-DuMont-Straße 17
D – 50667 Cologne

Tel: +49 (0)221 2 53 351
Fax: +49 (0)221 2 53 351
www.galeriebuchholz.de

Andrea Rosen Gallery
525 West 24th Street
US – New York, NY 10011
Tel: +1 212 62 76 000
Fax: +1 212 62 75 450
www.andrearosengallery.com

neugerriemschneider
Linienstraße 155
D – 10115 Berlin
Tel: +49 (0)30 28 87 72 77
Fax:+49 (0)30 28 87 72 78
www.neugerriemschneider.com

PRIMARY MARKET PRICES →
$5.625 – $37.500 (photographs)

Wolfgang Tillmans, Suzanne & Lutz,
White Dress, Army Skirt, 1993

AUCTION SALES →
Price: $42.000
After Midnight, 1999
Photograph, 132 x 157.5 cm
Date sold: 12-Nov-02
Auction house:
Phillips, de Pury & Luxembourg,
New York

Price: $35.000
White Jeans on White, 1991
C-print, 150 x 200 cm
Date sold: 13-Nov-03
Auction house:
Phillips, de Pury & Luxembourg,
New York

Price: $35.000
Adam/Rachel Auburn/Adam
doing up Boot/Alex & Lutz holding
each other
C-print
Date sold: 08-Nov-04
Auction house:
Phillips, de Pury & Company,
New York

Price: $28.000
Aufsicht Yellow, 1999

C-print, 217.5 x 148.9 cm
Date sold: 09-Nov-04
Auction house:
Phillips, de Pury & Company,
New York

Price: $24.000
Suzanne & Lutz, White Dress,
Army Skirt, 1993
Photograph, 61 x 50.8 cm, Ed. 3
Date sold: 14-Nov-02
Auction house:
Christie's, New York

RIRKRIT TIRAVANIJA

REPRESENTATION →
neugerriemschneider
Linienstraße 155
D – 10115 Berlin
Tel: +49 (0)30 28 87 72 77
Fax: +49 (0)30 28 87 72 78
www.neugerriemschneider.com

Gavin Brown's enterprise
620 Greenwich Street
US – New York, NY 10014
Tel: +1 212 62 75 258
Fax: +1 212 62 75 261
www.gavinbrown.biz

PRIMARY MARKET PRICES →
$5.000 – $250.000 (installations)

AUCTION SALES →
Price: $37.549
Untitled (Cure), 1993
Installation, 350 x 350 x 350 cm
Date sold: 08-Feb-01
Auction house:
Christie's, London

Price: $14.000
Untitled, 1995
7 colour coupler prints
20.3 x 25.4 cm each
Date sold: 15-May-03
Auction house:
Christie's, New York

Rirkrit Tiravanija, Untitled (Cure),
1993

Luc Tuymans, Illegitimate VIII, 1997

Price: $8.000
Untitled (Cure), 1994
Graphite, 49.5 x 39.5 cm
Date sold: 18-May-00
Auction house:
Sotheby's, New York

Price: $6.000
Atlas, 1995
Installation
149.9 x 259.1 x 124.5 cm
Date sold: 12-Nov-04
Auction house:
Phillips, de Pury & Company,
New York

LUC TUYMANS

REPRESENTATION →
Zeno X Gallery
Leopold De Waelplaats 16
B – 2000 Antwerp
Tel: +32 (0) 3 21 61 626
Fax: +32 (0) 3 21 60 992
www.zeno-x.com

carlier | gebauer
Holzmarktstraße 15–18
Bogen 51/52
D – 10179 Berlin
Tel: +49 (0)30 28 08 110
Fax: +49 (0)30 28 08 109
www.carliergebauer.com

David Zwirner
525 West 19th Street
US – New York, NY 10011
Tel: +1 212 72 72 070
Fax: +1 212 72 72 072
www.davidzwirner.com

PRIMARY MARKET PRICES →
$120.000 – $610.000 (paintings)

AUCTION SALES →
Price: $1.300.000
Sculpture, 2000
Oil/canvas, 154.9 x 63.7 cm
Date sold: 11-May-05

Auction house:
Christie's, New York

Price: $500.000
Fish, 1999
Oil/canvas, 67.6 x 62.2 cm
Date sold: 12-May-05
Auction house: Phillips, de Pury
& Company, New York

Price: $380.000
Within, 2001
Oil/canvas, 223 x 243 cm
Date sold: 13-Nov-03
Auction house: Phillips, de Pury
& Luxembourg, New York

Price: $300.000
T. V. Set, 2000
Oil/canvas, 83.2 x 81.3 cm
Date sold: 10-May-05
Auction house:
Sotheby's, New York

Price: $218.088
Illegitimate VIII, 1997
Acrylic/canvas, 55.5 x 81.5 cm
Date sold: 24-Jun-04
Auction house: Christie's, London

FRANCESCO VEZZOLI

REPRESENTATION →
Galleria Franco Noero
Via Giolitti 52A
I – 10123 Turin
Tel: +39 (0)1 18 82 208
Fax: +39 (0)1 11 97 03 024
www.franconoero.com

Galleria Giò Marconi
Via Tadino 15
I – 20124 Milano
Tel: +39 (0)22 94 04 373
Fax: +39 (0)22 94 05 573
www.giomarconi.com

PRIMARY MARKET PRICES →
Not available

AUCTION SALES →
Price: $29.384
The Bitter Tears of Vera von
Lehndorff, 2002
Mixed media, 56 x 46 cm
Date sold: 21-Oct-02
Auction house:
Sotheby's, London

Price: $26.877
Veruschka will be here soon, 2001
Mixed media, 50 x 41 cm
Date sold: 20-Oct-03
Auction house:
Sotheby's, London

Price: $17.000
Garbo Cries!, 2001
Mixed media, 60 x 51 cm
Date sold: 14-May-04
Auction house: Phillips, de Pury
& Company, New York

Francesco Vezzoli, The Bitter Tears
of Vera von Lehndorff, 2002

Price: $16.733
Bianca Jagger as
Anna Magnani, 2002
Mixed media, 45.1 x 35.5 cm
Date sold: 10-Feb-05
Auction house: Christie's, London

KARA WALKER

REPRESENTATION →
Brent Sikkema
530 West 22nd Street
US – New York, NY 10011
Tel: +1 212 92 92 262
Fax: +1 212 92 92 340
www.brentsikkema.com

Galerie Max Hetzler
Zimmerstraße 90/91
D – 10117 Berlin
Tel: +49 (0)30 22 92 437
Fax: +49 (0)30 22 92 417
www.maxhetzler.com

PRIMARY MARKET PRICES →
Not available

AUCTION SALES →

Price: $280.000
The Battle of Atlanta: Being
the Narrative of a Negress…,
1995
Paper cutting
Date sold: 10-May-05
Auction house:
Sotheby's, New York

Price: $42.500
Uncle Remus spins a Yarn, 1995
Mixed media, 121.9 x 137.2 cm
Date sold: 13-May-04
Auction house:
Sotheby's, New York

Price: $35.000
Equality, 1995
Mixed media/paper
120.5 x 106.5 cm
Date sold: 18-May-00
Auction house:
Sotheby's, New York

Price: $22.000
Gatorbait, 1996
Oil/paper/canvas, 152.5 x 132 cm
Date sold: 13-Nov-98
Auction house:
Christie's, New York

Kara Walker, Gatorbait, 1996

Price: $16.000
Revolt, 1996
Oil/paper/canvas, 152.5 x 132 cm
Date sold: 13-Nov-98
Auction house:
Christie's, New York

JEFF WALL

REPRESENTATION →

Marian Goodman Gallery
24 West 57th Street
US – New York, NY 10019
Tel: +1 212 97 77 160
Fax: +1 212 58 15 187
www.mariangoodman.com

Johnen + Schöttle
Maria-Hilf-Straße 17
D – 50677 Cologne
Tel: +49 (0)221 31 02 70

Jeff Wall, Sunken Area, 1996

Fax: +49 (0)221 31 02 727
www.johnen-schoettle.de

PRIMARY MARKET PRICES →

$75.000 – $475.000

AUCTION SALES →

Price: $250.000
The Well, 1989
C-print, 229 x 179 cm
Date sold: 13-Nov-00
Auction house: Phillips, New York

Price: $230.000
Octopus, 1990
C-print, 201.6 x 248.9 x 22 cm
Date sold: 08-Nov-04
Auction house: Phillips, de Pury
& Company, New York

Price: $180.000
Sunken Area, 1996
Light installation
234 x 290 x 26 cm
Date sold: 13-Nov-03
Auction house: Phillips, de Pury
& Luxembourg, New York

Price: $154.953
Insomnia, 1994
Cibachrome transparency in light
box, 172.5 x 214 x 22 cm
Date sold: 08-Oct-98
Auction house: Christie's, London

Price: $130.000
The Crooked Path, 1991
Cibachrome transparency in light
box, 135 x 165 x 22 cm
Date sold: 17-May-01
Auction house:
Christie's, New York

MATTHIAS WEISCHER

REPRESENTATION →

Galerie Eigen + Art

Auguststraße 26
D – 10117 Berlin
Tel: +49 (0)30 28 06 605
Fax: +49 (0)30 28 06 616
www.eigen-art.com

PRIMARY MARKET PRICES →

$1.000 (print)
$1.500 – $4.300 (drawings)
$9.000 – $40.000 (paintings)

FRANZ WEST

REPRESENTATION →

Galerie Bärbel Grässlin
Bleichstraße 48
D – 60313 Frankfurt
Tel: +49 (0)69 28 09 61
Fax: +49 (0)69 29 42 77
www.galerie-graesslin.de

Zwirner & Wirth
32 East 69th Street

US – New York, NY 10021
Tel: +1 212 51 78 677
Fax: +1 212 51 78 959
wwwzwirnerandwirth.com

Gagosian Gallery
555 West 24th Street
US – New York, NY 10011
Tel: +1 212 74 11 111
Fax: +1 212 74 19 611
www.gagosian.com

Galerie Eva Presenhuber
Limmatstraße 270
CH – 8031 Zürich
Tel: +41 (0)43 44 47 050
Fax: +41 (0)43 44 47 060
www.presenhuber.com

Galerie Ghislaine Hussenot
5 bis, rue des Haudriettes
F – 75003 Paris
Tel. +33 (0)1 4 88 76 081
Fax: +33 (0)1 4 88 70 501

PRIMARY MARKET PRICES →

from $28.000 (collages)
from $40.000 (sculptures)

AUCTION SALES →

Price: $42.000
Bench covered by linen/
Club Fauteuil/Table, 1996–99
Mixed media sculpture
Date sold: 10-Jun-04
Auction house: Phillips, de Pury
& Company, New York

Price: $34.706
Curaçào, 1996
Installation, 145 x 266 x 122 cm
Date sold: 08-Dec-98
Auction house: Christie's, London

Price: $32.615
Ohne Titel, 1985
Mixed media, 59 x 84 cm

Franz West, Curaçào, 1996

Date sold: 23-Nov-04
Auction house:
Palais Dorotheum, Vienna

Price: $31.416
Autosex, 1996
Installation
Date sold: 19-Jun-02
Auction house:
Cornette de Saint-Cyr, Paris

Price: $28.000
Passtück Maske, 1981–82
Plaster, 33.4 x 68.6 x 35.6 cm
Date sold: 14-May-04
Auction house: Phillips, de Pury
& Company, New York

PAE WHITE

REPRESENTATION →
neugerriemschneider
Linienstraße 155
D – 10115 Berlin
Tel: +49 (0)30 2 88 77 277
Fax: +49 (0)30 2 88 77 278
www.neugerriemschneider.com

Galerie Daniel Buchholz
Neven-DuMont-Straße 17
D – 50667 Cologne
Tel: +49 (0)221 253-351
Fax: +49 (0)221 253-351
www.galeriebuchholz.de

greengrassi
1a Kempsford Road
GB – London SE11 4NU
Tel: +44 (0)20 78 40 91 01
Fax: +44 (0)20 78 40 91 02
www.greengrassi.com

1301PE
6150 Wilshire Boulevard
US – Los Angeles, CA 90048
Tel: +1 323 93 85 822

PRIMARY MARKET PRICES →
$3.500 – $35.000 (installations)

JOHANNES WOHNSEIFER

REPRESENTATION →
Galerie Gisela Capitain
Aachener Straße 5
D – 50674 Cologne
Tel: +49 (0)221 2 56 676
Fax: +49 (0)221 2 56 593
www.galerie-capitain.de

Johann Koenig
Weydingerstraße 10
D – 10178 Berlin
Tel: +49 (0)30 3 08 82 688
Fax: +49 (0)30 3 08 82 690
www.johannkoenig.de

Casey Kaplan
416 West 14th Street

US – New York, NY 10014
Tel: +1 212 64 57 335
Fax: +1 212 64 57 835
www.caseykaplangallery.com

PRIMARY MARKET PRICES →
$1.875 (print)
$1.250 – $1.500 (photographs)
$1.250 – $3.750 (drawings)
$7.500 – $22.500 (paintings)
$31.250 – $93.750 (installations)

CHRISTOPHER WOOL

REPRESENTATION →
Galerie Gisela Capitain
Aachener Straße 5
D – 50674 Cologne
Tel: +49 (0)221 2 56 676
Fax: +49 (0)221 2 56 593
www.galerie-capitain.de

Luhring Augustine
531 West 24th Street
US – New York, NY 10011

Christopher Wool, Untitled (W26A-E) (detail), 1990

Tel: +1 212 20 69 100
Fax: +1 212 20 69 055
www.luhringaugustine.com

Galerie Max Hetzler
Zimmerstraße 90/91
D – 10117 Berlin
Tel: +49 (0)30 22 92 437
Fax: +49 (0)30 22 92 417
www.maxhetzler.com

PRIMARY MARKET PRICES →
$100.000 – $150.000 (paintings)

AUCTION SALES →
Price: $750.000
Untitled (W26A-E), 1990
Enamel, 274 x 183 cm
Date sold: 13-May-04
Auction house:
Phillips, de Pury & Company,
New York

Price: $440.000
Fuckem, 1992
Enamel, 132.1 x 91.4 cm
Date sold: 09-Nov-04
Auction house:
Sotheby's, New York

Price: $380.000
Untitled (Fool), 1990
Enamel, 274.5 x 183 cm
Date sold: 19-May-99
Auction house:
Christie's, New York

Price: $370.000
Untitled, 1990
Enamel, 244 x 183 cm
Date sold: 13-Nov-03
Auction house: Phillips, de Pury
& Luxembourg, New York

Price: $275.000
If You, 1992
Enamel, 274.5 x 183 cm
Date sold: 13-Nov-00
Auction house: Phillips, New York

ERWIN WURM

REPRESENTATION →
Galerie Aurel Scheibler
St.-Apern-Straße 20–26
D – 50667 Cologne
Tel: +49 (0)221 3 11 011
Fax: +49 (0)221 33 19 615
www.aurelscheibler.com

Galerie Krinzinger
Seilerstaette 16
A – 1010 Vienna
Tel: +43 (0)1 51 33 006
Fax: +43 (0)1 51 33 00 633
www.galerie-krinzinger.at

PRIMARY MARKET PRICES →
$2.500 – $5.000 (drawings)
$13.750 (video)
$12.500 – $287.500 (sculptures)

AUCTION SALES →
Price: $12.900
Schreitender
Sculpture, wood, 240 cm
Date sold: 29-Nov-95
Auction house: Wiener
Kunstauktionen, Vienna

Price: $7.445
Landschaft, 1985
Mixed media
150 x 125 x 106 cm
Date sold: 25-Mar-03
Auction house: Wiener
Kunstauktionen, Vienna

Price: $6.637
Me/Me Fat, 1993
C-print, 180 x 126.5 cm
Date sold: 30-Nov-04
Auction house: Wiener
Kunstauktionen, Vienna

Price: $5.971
Ohne Titel
Sculpture, 58 x 87 cm
Date sold: 28-Apr-04
Auction house: Wiener
Kunstauktionen, Vienna

AUCTION RESULTS BY:

Artprice.com – The world's leader in art market information.

Images of Francis Alÿs, Ghada Amer, Matthew Barney, Vanessa Beecroft, John Bock, Cecily Brown, Rineke Dijkstra, Peter Doig, Stan Douglas, Elger Esser, Ellen Gallagher, Anna Gaskell, Robert Gober, Anthony Goicolea, Andreas Gursky, José Antonio Hernández-Díez, Thomas Hirschhorn, Jim Hodges, Gary Hume, Zoe Leonard, Sharon Lockhart, Vera Lutter, Julie Mehretu, Beatriz Milhazes, Sarah Morris, Ron Mueck, Takashi Murakami, Shirin Neshat, Ernesto Neto, Albert Oehlen, Gabriel Orozco, Raymond Pettibon, Richard Prince, Neo Rauch, Pipilotti Rist, Ugo Rondinone, Thomas Ruff, Jenny Saville, Thomas Scheibitz, Gregor Schneider, Thomas Schütte, Cindy Sherman, Wolfgang Tillmans, Rirkrit Tiravanija, Luc Tuymans, Kara Walker and Franz West: courtesy Christie's Images Ltd.

Images of Franz Ackermann, Darren Almond, Glenn Brown, Thomas Demand, Olafur Eliasson, Tracey Emin, Douglas Gordon, Candida Höfer, Vik Muniz, Yoshitomo Nara, Jorge Pardo, Tom Sachs, Thomas Struth and Francesco Vezzoli: courtesy Sotheby's.

Images of Doug Aitken, Candice Breitz, Maurizio Cattelan, Jake & Dinos Chapman, John Currin, Marlene Dumas, Mike Kelley, Jeff Koons, Sarah Lucas, Paul McCarthy, Mariko Mori, Tim Noble & Sue Webster, Chris Ofili, Elizabeth Peyton, Daniel Richter and Jeff Wall: courtesy Phillips, de Pury & Company.